An Italian American Odyssey

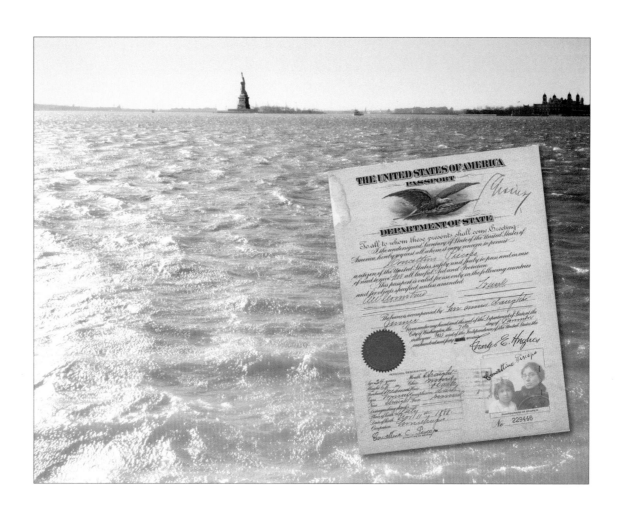

An *Italian American Odyssey*

Life line – filo della vita

Through Ellis Island and Beyond

by B. Amore

Translation by Franco Bagnolini

2006
Center for Migration Studies
New York

The Center for Migration Studies is an educational, nonprofit institute founded in New York in 1964 to encourage and facilitate the study of sociological, demographic, historical, legislative and pastoral aspects of human migration movements and ethnic group relations. The opinions expressed in this work are those of the author.

An Italian American Odyssey
Life line – filo della vita
Through Ellis Island and Beyond

First Edition
Copyright ©2006 by
The Center for Migration Studies of New York, Inc.

Center for Migration Studies
209 Flagg Place
Staten Island, New York 10304

Cover and interior design and layout by Jennifer Black

Library of Congress Cataloging-in-Publication Data
 Amore, B.
 An Italian American Odyssey Life line–filo della vita: Through Ellis Island and Beyond / B. Amore.
 p. cm.
 Companion book to an exhibit and installation entitled *Life line–filo della vita* which opened on Nov. 4, 2000 at the Ellis Island Immigration Museum in New York, N.Y.
 Includes bibliographical references and index.
 ISBN 1-57703-045-1 (alk. paper) — ISBN 1-57703-046-X (soft cover)
 1. Amore, B. (Bernadette)—Family—Exhibitions. 2. Italian American families—Exhibitions. 3. Italian Americans—Biography—Exhibitions. 4. Italian Americans—Social life and customs—Exhibitions. 5. Immigrants—United States—Biography—Exhibitions. 6. United States—Social life and customs—Exhibitions. 7. United States—Ethnic relations—Exhibitions. 8. Ellis Island Immigration Museum—Exhibitions. I. Title. II. Title: Filo della vita.

 E184.I8
 [A535 2006]
 973'.04510747471—dc22

 2006008184

Printed in China through Four Colour Imports.

DEDICATION

"Where there's a will, there's a way"

This exhibit is dedicated to Concettina De Iorio, my maternal grandmother. It is because of her collections of objects, from the everyday to the sacred, that this work exists. Her stories and legacy inspired a deep curiosity about human nature. What does it mean – to look at history? Whose "truth" is revealed? Is everything that happened "in the past?" We remember – does memory make it real? We wonder, we question. Sometimes we find answers, sometimes more questions.

DEDICA

"Dove c'è la volontà, la via si trova"

Questa mostra è dedicata a Concettina De Iorio, la mia nonna materna. È grazie alle sue collezioni di oggetti, dal quotidiano al sacro, che questo lavoro esiste. Le sue storie ed il suo lascito mi hanno ispirato una curiosità profonda per la natura umana. Che significa osservare la storia? La verità di "chi" viene rivelata? Tutto ciò che è accaduto si trova "nel passato"? Lo ricordiamo e la memoria lo rende reale? Ci chiediamo, ci interroghiamo. A volte, troviamo delle risposte; a volte, altre domande.

Table of Contents

Acknowledgements

The list of people whom I would like to thank is most likely longer than my memory and so I hope that all of you who are not mentioned by name will consider yourselves thanked in spirit. First, I would like to thank Diana Pardue, Chief of Museum Services, who invited me to create *Life line – filo della vita* for the Ellis Island Immigration Museum. This exhibit was the basis for the present volume, *An Italian American Odyssey*. Judy Giuriceo, Curator of Exhibits, was extraordinarily generous with her support and staff time. Special thanks to Eric Byron who was the chief assistant at Ellis, Barry Moreno and Jeff Dosik who assisted me with the historical and photographic files, George Tselos who helped with archival material, Janet Levine and Paul Sigrist who guided me through the hundreds of interviews that they had conducted as part of the Statue of Liberty Ellis Island Oral History Project, Paul Roper, the chief "techie" who got every machine running and who videotaped every presentation, Mike Conklin and Robert Foley who made it possible to have *Life line* material on hand for visitors, and all of the staff at Ellis, from the maintenance men and women to the guards who supported me with their continuing interest in the project as well as with their care of the exhibit in its five months in their museum.

Enormous thanks go to Lydio F. Tomasi, c.s., Ph.D., Director Emeritus of the Center for Migration Studies, for inviting me to publish this book and for his generosity in sharing the resources of the Center's Library and photo archives when I was in the process of creating *Life line*. Diana J. Zimmerman, Director of CMS Library and Archives, and Professor Mary Brown were invaluable and patient consultants.

A heartfelt thank-you to Father Joseph Fugolo, present Director of CMS, for continuing assistance in bringing the project to fruition. Don Heisel, Research Director, has been a dedicated advocate, grant writer and guide for the publication. Both he and Tom Sullivan, Publications Editor, have been encouraging and supportive throughout the lengthy publishing journey. Photographs by Chris Burke, Kevin Daley, Tad Merrick and Mark Malin form an essential visual core. Without the excellent design and graphic-arts skills of Jennifer Black, the book would not be present in such beautiful form. This copy would probably not be in your hands were it not for the marketing expertise of Bob Oppedisano of the Fordham Press.

The National Italian American Foundation and the Italian Ministry of Foreign Affairs deserve particular thanks for their considerable support for the publication and translation of *An Italian American Odyssey*. A grant from the Istituto Italiano di Cultura of New York assisted in the creation of the exhibit, *Life line*. Thanks to all of you who supported *Life line* with donations to the *Donors' Arch — L'Arco della Memoria*. *Life line* was primarily a grassroots project with little organizational funding, so every donation, no matter how small, was essential to its growth.

Thanks also for the consistent support from The John D. Calandra Italian American Institute; the Department of Italian American Studies at Stony Brook University; *Fieri*; *Malia*, the Collective of Italian American Women; The Italian American Writers Association; the National Organization of Italian American Women; the International Institute of Boston; the Lower East Side Tenement Museum; the Dante Society of Massachusetts; the *Circolo Letterario* of Boston; the Pirandello Lyceum of Boston; and the Carving Studio and Sculpture Center in Vermont.

Ethan Mitchell, Madeleine Dorsey, Samantha Yelinak and Leah Czisar were invaluable assistants in various phases of the *Life line* venture. Dan Hnatio generously offered his services in producing the video, "The Thread of Life in One Italian American Family." Poet Luigi Fontanella assisted with the Italian translations of the chapter introductions. My volunteer "readers," in particular Pino and Rickey Magno, *Life line's* staunchest Italian supporters, gave me optimal advice when the book was in draft form. Franco Bagnolini has completed the extraordinary task of sifting through the many layers of *Life line* and has provided the excellent and sensitive Italian translation of the text. Rosanna Scippacercola patiently transcribed the manuscript. Caterina Romeo and Clara Antonucci accomplished the vast work of revision for final publication of the text in Italian. Caterina Romeo also translated the commentaries of Jennifer Guglielmo and Joseph Sciorra.

To my eldest daughter, Larisa, I owe special thanks for being my *spalla forte,* or "strong shoulder" – always willing to help me with the myriad tasks of fundraising, video editing, installation, packing and traveling with *Life line* as it moves to different venues.

In closing, I would like to thank my entire family from the fullness of my heart for their willingness to share stories, photographs, emotional and economic support and for having the patience to live with me through the years of effort that *Life line* required. In particular, I owe a deep debt of gratitude to my husband and life partner, Woody Dorsey, without whose support on many levels *Life line,* the exhibit and subsequently this book, *An Italian American Odyssey,* would not exist.

Preface

The Thread of Life
B. Amore

I had a great-grandmother who lived two doors away from us. She and I were constantly together. But one thing I do remember is when we left Italy. A few days before, she and I took a walk to her land and she was very, very sad. She said, "Ah." She said, "you're going to America now. Someday you will remember me." But, "she said, "remember when you get there, when you reach the Battery there is a row of fountains there. You have to see that there is one, find out which one it is, that you cannot drink out of. Because when you drink from that certain fountain you're going to forget all of us that you're leaving here." So when I arrived at the Battery I was looking for the row of fountains, but I didn't see the row of fountains. So I said I guess since I didn't see them it must be okay. She also wanted me to write and tell her about the Brooklyn Bridge, because she had heard about the Brooklyn Bridge. But she died before I saw the Brooklyn Bridge. Today, when I'm driving along, many, many times I think of her. The words echo in my memory. "You're going to America now. Some day you will remember me."

—Domenica Calabrese (Sunday Wood)[1]

My own grandmother, Concettina De Iorio Piscopo, never uttered the words, "Someday you will remember me," but living with her indelibly imprinted my life. It was she who taught me to drink from the fountain of memory. Because of her, "home" was always in another place. We were in America: the "true home" was Italy – the heart place where dreams had their source, where life was nurtured.

My grandmother's stories were the first I heard. They were all about Italy, her childhood play there in *Il Giardino* (the garden), her strict grandfather who made her sit silently at the dinner table, carriage trips with her father from Lapio in the mountains to Via Carracciolo in Naples. Her childhood was my place of beginning. I inhabited these stories in my own earliest years.

Italian was the language of lullaby as she walked me to sleep as a newborn. I grew up by the ocean always knowing that there was "another shore" – Italy. There was the ever-present sensation of suspension between the two, a floating sense of feeling, a floating sense of language, an easy movement from the mother tongue, Italian, to English and back. The dialect, which I was not allowed to speak, was the language of intimacy between the women, the language of secrets which I divined through attentive listening.

As a child, my world was centrally Italian. Everyone who was not Italian was American. That included Irish, English, French, Jewish, etc. There was nothing derogatory said about any nationality. In fact, we were encouraged to accept everyone but I most certainly was not American; I was Italian! It took me until my mid-twenties, post-Bachelor of Arts, to realize that there were Italian Americans; that in fact, I was not only Italian, I was also American.

There is always a sense of history in being Italian. A moment is never only that moment. It stretches back in time to other related happenings which are attached to it like sticky, spidery strands, barely visible, missing if you blink, blowing in a breeze of memory which, in actuality, can sometimes feel like a forged chain binding one to the past. The past almost seemed more important than the future. There was, for me, growing up, always the sense of people looking back more than forward.

Curiosity about these differences between America and Italy prompted a year of study when I was nineteen, at the University of Rome in the *Facoltá di Lettere e Filosofia*; a year when, most of the time, the university was on strike, a year of exploring museums and ruins, but more importantly a year of frequent visits to the village of my maternal grandmother…watching a cow being slaughtered on the cobbled street, following a life-sized Christ carried in procession on the shoulders of village men, participating in the viewing of the *Misteri* figures at Easter on their yearly tour of the village, attending mass in the churches of my great-grandparents, listening to the high-pitched nasal sing-song chanting of the women as they stood before the rush-seated chairs on smooth marble floors. These direct, authentic experiences led me back to the places I inhabited as a child in my imagination and connected me, in the present, to my grandmother's past.

The sense of my Italian heritage is a point of departure for many aspects of my creative expression in art and writing. The clearest example of this is a recently completed multi-media exhibit for the Ellis Island Immigration Museum called *Life line – filo della vita*. I sometimes call it a visual memoir which sets the destinies of two families from Italy's *Mezzogiorno* (Midday or

South) in the historical context of emigration from Italy and assimilation in America in the one hundred years of the twentieth century. The exhibit is traveling in the United States and Italy and my fond hope is that it will become a permanent exhibit in an Italian American museum. The dream of publishing it as a book, *An Italian American Odyssey,* has now come true.

The exhibit was planned specifically for the Ellis Island Museum but was also designed to travel to other venues. I spent months on the Island, studying the bare rooms, white-tiled from floor to ceiling, listening to the lapping of the waves, ruminating on the sea being the connector between the old world, Italy, and the new world, America. These very rooms had been dormitories for detained immigrants. Throughout my research I reflected on the dreams that had inspired their long journeys and the harsh realities that had greeted them.

Life line weaves the personal histories and documents of my families of origin – the De Iorios and the D'Amores – with the history and documents from the century of immigration that occurred between 1901 and 2001. Ten years of research and art creation culminated in both the exhibit at Ellis Island, the proverbial "Golden Door" to America, and in this book.

The story is a mirror of the lives of all immigrants who left their homes in the latter parts of the nineteenth century and traveled to America seeking a "better life." It explores the complex tidal wave of change that engulfed immigrants and subsequently affected their descendants. Research into the archives of Ellis Island, the Lower East Side Tenement Museum and the Center for Migration Studies yielded many historic photographs and first-person accounts of the immigrant experience. These are supplemented by videotaped interviews that I conducted with older immigrants and their descendants.

It is a story that spans two countries, told in a nontraditional way, across the boundaries of class, gender, race, and identity. The entire installation is like a huge shrine with smaller sub-chapels. I grew up in an Italian Catholic milieu where the magic of the liturgy was always present: the gold, the glow, the mystery of bread and wine being transformed. That is also the essence of making art: to transform material so that it has a possibility of expressing the inexpressible. *Life line* takes popular devotional forms, triptychs and altars, and elevates the everyday to the status of the sacred. It speaks of ordinary lives which were lived with extraordinary courage. We are used to thinking of history as a recounting of major occurrences. The "story of humanity" is, more often, a compendium of the events of daily life, and of small memories.

In the exhibit, the pickaxe of my grandfather, elegant in form and still bearing the scars of his labor, becomes the central element in a reliquary dedicated to the two Anthonys – Antonio, the pick-and-shovel guy who dug the foundations of Harvard University and his son, Tony, who was able to pursue the dream of an education but not the full dream of his life. The sense of the sacred was part and parcel of my Italian American youth; not only in church, but also within the family. Certain memories were sacred. When my grandmother spoke of her father or mother, she spoke as if they were saints. There was always a reverence for the ancestors, for history.

Life line, the exhibit, and *An Italian American Odyssey,* the book, is a complex narrative utilizing text and visual stimuli. The narrative is processed along the red thread of memory, the life line, the death line, stretching back to the past and into the future. It is a powerful metaphor for immigration. As in De Crescenzo's poem, the strands of connection to the ancestors persist whether we are aware of them or not. Their sufferings of dislocation and the requisite accommodation continue to mark our lives across genera-tions, perhaps a bit less than they marked the second-generation daugh-ters and sons of immigrants, but marking us just the same.

The story is often told through the objects. Many families have lost their talismanic objects. My grandmother kept so many that they have become the material of art. The objects themselves are key elements. There is a physical relationship to each one which is indexically connected to the

ancestors. The hand-fashioned brass ravioli cutter, the *vecchia caffettiera Napoletana*, the bound bundles of fabric and coarse linen sheets woven in the 1800s all stand for a whole way of life, an entire culture. The scholar, Pellegrino D'Acierno, felt that both the red thread of *Life line* and these material remnants functioned as transitional objects in an immigrant life, akin to a baby's thumb or favorite blanket. Looking up through seven glass layers of objects in a three-meter-high "reliquary," one has the sense of an archaeological dig, like looking up and through history. Viewers often spoke of rediscovering their own family history through experiencing *Life line*. In this way the narrative functions as collective memory. The narrative, itself, becomes a sort of homeland.

In the exhibit, there is an installation of person-sized black Trentino marble figures swathed in fabric. They are kin to the Italian village women carrying jugs of water and baskets of produce on their heads. In America, there were different burdens, not all so easily definable. The tall, strong, stone women carry bundles on their heads, the bundles of their history. The stones are wrapped with fabric: fabric which was so much a part of my childhood, of my mother's life and my grandmother's and great-grandmother's existence. They used fabric to make beautiful clothes, but were often trapped in their traditional roles. Here we experience the torn fabric of the immigrant's life in a re-visioning of history. I use fabric to bind things together – pieces of experience – to make it whole. Sometimes, images and fabric are layered as if the "truths" are floating under an opaque surface, difficult to see clearly.

Creating *Life line* was a homing-in on my past, with everything I had been taught in my Italian American family. My hands were always worker's hands, like my paternal grandfather's. The work ethic came from family example. Becoming a stone sculptor is not unrelated to these early experiences, which were imbued with a strong sense of the material world. I often speak of collaborating with my grandmother, using her objects, her memories, and the unanswered questions of her life which reverberate in mine. Her collections, my heritage, have become part of my artistic expression. There was a deep transmission from her to me, in the religious sense, of passing on a lineage.

My search into family had as much to do with what was not said, what was not divulged in addition to all that was told. It is interesting how one can hold the "facts" of lives lived, but not really know the truth. There will always

be unanswered questions that provoke more questioning, more imagining, more writing, more art.

Memory "fixes" things, like a photographic fix. The flow gets stopped and we take that image-feeling and it becomes "hardened" in a sense; but this is an illusion because reality can never really be made firm. It is always moving and changing and even what we "remember" is only like a glint of light off a faceted surface. If we "remember" to remember this, memory takes on a different hue and we can recognize with a "grain of salt" that what we recall is really only a very partial "truth" of a moment in time, but it is "our truth" and it is a Point of Departure.

To create the exhibit *Life line*, and the subsequent writing for this book, *An Italian American Odyssey*, I had to deconstruct the "truth" as I knew it. By opening the carved box of memory where stories lie secreted, the brittle pages and faded writing are exposed to a different sort of light which occasionally brings transparency to the page, providing the possibility that the "truth" can be "seen through." I peer into the history that has been given me and either find the deeper history, or discern something that resembles an intuited reality. There is a constant weaving back and forth of layers of remembered and recorded histories throughout the exhibit. Quite often, there are conflicting facts presented which relate to the same person. Isn't this more true to the actuality we are often faced with in life?

I inherited a *Libro di Memorie*, a diary from 1802 containing memories and experiences of my great-great-grandfather and my great-grandfather. I've been translating many of these entries written in an old cursive script that even my friends in Naples have a hard time reading. It is to enter a profoundly intimate and moving world, where Don Lorenzo's voice whispers from a distance of nearly two hundred years: relating his experiences of joy in his daughter's marriage, grief at her death two months later, describing in detail all the attendant circumstances: wedding rituals, medical practices, burials, learning that a snowfall is measured in *palmi di neve* (palms of snow) and that lightning can course through a house and set a good woolen mattress on fire. When I read of him using weights and measures to figure taxes and hold the very same weights and measures in my hands, the objects become a direct connection to him whom I never met.

There seems a responsibility in the wealth of inheritance of objects and stories, a sense of duty, a sense of *destino*, or destiny. The stories and the

objects seem to have chosen me. It is both a burden and a joy, which I seem to have no choice in accepting if I am to be truly who I am. Whenever something was inexplicable, *Nonni* (grandmother) called it *destino* – ever-present, inescapable.

Concettina, my grandmother, never wrote in the diary. Only men wrote in the diary, even though all of the women in her family were educated and could read and write, which was no small accomplishment in the last half of the nineteenth century when illiteracy exceeded 80 percent in the southern provinces of Italy. Her writings were done at school, American International College, which she attended from 1911–1913 as one of eleven Italian immigrant women in higher education at that time.

It was in Concettina's college themes, in which she spoke through another's voice, that I feel her own feelings were most truly expressed. Not in photographs of her, where, for the most part, she appears quite composed. There is only one revelatory picture of her, a side view, taken in a kitchen in Italy, circa 1924, where the bold pose is relaxed. She sits, fuller bodied than her norm, wearing an apron, leaning into the support of the chair's back, staring loosely into the space in front of her. In this picture, there are no pat answers. Her life has decomposed. She is permanently separated from her husband, a scoundrel. She is the mother of a seven-year-old child and head of the household comprising her daughter, father and sister. Having returned to Italy for two years, perhaps with the intention of remaining, she looks devastatingly unhappy in the tiny village of her youth. She left for America soon after and did not see Italy again until 1956, a span of thirty-two years. She was always Italian in her demeanor and mores, but no longer fit into the Italy of her origin. She spoke English perfectly, but was never "American." She was always between the two.

My paternal grandfather, Antonio D'Amore, left Italy in 1902 and never returned. The Italy of his childhood was so harsh, so self-defeating, so poor, so pained, that he never looked back. He also never became an American citizen. His wife did renounce her Italian citizenship, yet returned with her children many times. Two of them married Italians, so the present generation of cousins has a lively relationship back and forth across an ocean, which used to take two weeks to cross but now takes only eight hours. My grandmother's garden, *Il Giardino*, is still in my name.

Life line, and *An Italian American Odyssey*, as well as my present writing, both

poetry and prose, are an intricate intermingling of myriad layers of under-standing, perception, and questioning. Because the stories that were told did not "explain it all" and despite the insistence that they were "telling the truth," there remains the necessity of searching back within oneself to see what can be seen. There is a song that my father used to sing called "The bear went over the mountain to see what he could see." And so I inherited the mountain. Perhaps it was Lapio or Montefalcione, the primal Irpinian mountain towns of my family's origin. I find myself on a continual journey of inquiry. Although some of the paths may be familiar as related to me by my parents or grandmother, I am traveling with a different pair of eyes. They traveled down the mountain to America and I am traveling up the mountain with a sack of questions about the reality they related and conveyed as well as the gaps in the story. It is actually through making the work that I discover myself and my roots more profoundly. They reveal themselves unexpectedly through dark, densely packed soil which I am excavating in the seemingly slowest of ways, digging by hand, a small bit at a time, until a gnarled node is unearthed almost without my knowing, but the light catches it and shows me the way forward.

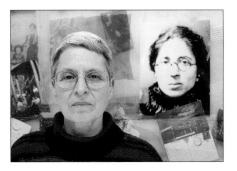

Grandmother and granddaughter: Concettina and B.

I use her scissors to cut the puzzle pieces, trying to figure the pattern of a life which has so affected mine. —B. Amore

Guide to the Exhibition and Book

Life line, the exhibit, was conceived and executed in 2000–2001 by B. Amore as a temporary installation in the six original dormitory rooms that comprise the traveling exhibition galleries at the Ellis Island Immigration Museum. She spent months visiting the space, reflecting on the weave of past and present, and ruminating on the history of individual stories and commonly shared experiences.

Life line became the fourth and most complete in a series of exhibits created by artist B. Amore as a meditation on the history of her family – immigrants from Italy at the turn of the century. In this site-specific installation, Amore presents an evocative interpretation of the personal experience of immigration – an experience explored in more traditional formats throughout the Ellis Island Immigration Museum. *Life line* is, in fact, a visual memoir set against the backdrop of immigration in the twentieth century.

Incorporating photographs, ancestral objects, family writings, sculpture, installations, oral histories and video, this mixed-media exhibit traces the history of Amore's family through seven generations as they left Italy, emigrated to the United States, and built new lives in this country. Although a personal artistic vision, Amore provides a venue for visitors to reflect upon their own family histories and the journeys and struggles faced by their ancestors. These visual stories are set against the fabric of the general history of immigration since one family exists not as a solitary entity but within the sociological context of its times. In this installation, the immigrant experience is extended to become a metaphor for the journey of the whole human race.

In all cases, the language of each person (including misspellings and grammatical particularities in English and Italian) is preserved. This is also true of original letters, interviews and diary entries, many of which come from the unpublished diary, the *Libro di Memorie,* written by Don Lorenzo De Iorio, B.'s great-great-grandfather. Most of the immigrant interviews are from the Ellis Island Oral History Project and are listed under the heading "Voices" – Ellis Island Interviews. The Baldizzi interview is from The Lower East Side Tenement Museum, and the Villanova interview and family interviews were conducted as part of the *Life line* project.

The term "First Generation" indicates the first generation who came to America. "Second Generation" signifies the daughters and sons of the original immigrants. As much as possible, Amore attempted to convey their stories through their own words written in diaries, letters and interviews. All of the personal photographs and artifacts included in the exhibit were loaned by various members of the D'Amore, Benevento and Masiello families. Historic photographs are used with permission from various private and public collections. B. conceived and executed the artwork, wrote the text, and translated family documents for the entire exhibit, as well as the book.

Life line is composed of several distinct elements within a unified whole. The exhibit utilizes each of the six dormitory rooms so that the entire space becomes a work of art. The grid-like pattern of horizontal and vertical lines of the original bunks that formerly filled these dormitory rooms runs throughout and lends a subtle structural component of order and continuity.

B. Amore has stated:

I really see Life line *as a play between the intimacy of personal immigrant experience and the vastness of the undertaking that each person who passed through this building embarked upon. Their entire journey unquestionably ended up being much greater than anything they could possibly have imagined…* Life line *is a testament to the continuous thread of history, the sense that the past affects and animates the present, that even as we live it, the present is becoming the past as we move into the future.*

Notes (page 1) from an informative flyer distributed at the Ellis Island Immigration Museum.

Following the Thread

As visitors proceed from room to room, fifteen horizontal panels form a nearly continuous visual band. Each contains the symbolic red thread representing the metaphorical ties to the Old World, as well as the actual practice of emigrants and dock-side relatives holding the opposite ends of balls of yarn as ships pulled away from their berths beginning their journeys to America. Family text and images set against a soft background of waves suggests both the physical and mystical link between the Old World and the New for most immigrants, as well as the journey they undertook.

The frames of these panels reference the metal frames of the rows of suspended bunks that once lined these dormitory rooms. The copper, with its green patina, relates to the Statue of Liberty.

Columns of History

These ten vertical panels contain quotes and images of Italian immigrants. The stories on the "columns" refer to the endlessness of the human story if it is recorded or remembered. The columns were inspired by the "Graffiti Columns" on the third floor of the Ellis Island Immigration Museum, which display the verbal and visual evidence of countless immigrants who passed through the Island.

Ancestor Scrolls

Each of these scrolls represents an individual ancestor with a photographic representation of his or her face. Layered over this image, and composing the ancestor's body, is the life history of this person. Each "body" is as complete or incomplete as the remembered or recorded history of the person.

Family Triptychs

The triptychs, consisting of a central panel and two flanking panels, reference European altarpieces and serve as memorials to the families and individuals enshrined within them. Combining photographs, written histories, and artifacts, these assemblages commemorate the faith and endurance of ordinary lives lived with extraordinary courage. The closed and open boxes represent the revelation that happens when you look into your own life, your own history.

Polishing the Mirror

This wall installation includes a series of photographic impressions of the artist's ancestors and present-day members of her family – seven generations in all. When we look at our own faces in the mirror, it can be in some ways the experience of looking into the faces of our ancestors. Personal history is often a reflection of family history.

Odyssey

Each of the five sculptural works in this installation symbolizes an immigrant carrying his or her belongings to the New World. These works are constructed from blocks of carved black Italian marble and contain ancestral objects.

Closet Installations

There are four closets in the Dormitory Rooms Space. Amore utilized these to create "mini worlds" within the context of the larger exhibit space. Many personal artifacts, photographs and writings were combined to give the impression of another time and place.

Reliquaries

Finally, a series of "Reliquaries of the Ordinary" contain fabrics and objects that the artist's grandmother saved, along with her original notes about the objects. Reliquaries usually contain the remains of saints (extraordinary people), or objects which saints have touched or blessed. These reliquaries contain the objects of "ordinary" people which take on a deeper import as the vestiges of lives lived in the past.

In addition to this guide, there is a partial genealogy of the seven generations of characters involved in following the thread of history from the latter years of the nineteenth century to the end of the twentieth – one hundred years in all. The book follows the format of the exhibition and is divided into six sections, to reflect the passage from one room to another. Each section addresses a particular stage of the immigrant journey: Departure and Arrival, Work, Assimilation, Integration, Return to Roots, and Questions about the Future.

At Ellis Island, visitors were taken on a journey through time, beginning with actual voices from immigrant interviews that Amore culled from the Ellis archives. As one moved through the rooms, these voices spoke the universal stories of immigration. These are included under specific sections entitled "Voices." Some of the stories may seem familiar because they mirror your own family's experiences. Enjoy the journey!

Notes (page 2) from an informative flyer distributed at the Ellis Island Immigration Museum.

Guide to the Main Characters in *An Italian American Odyssey*

De Iorio Family

Don Lorenzo De Iorio: (1820–1896) wrote the *Libro di Memorie* in the 1800s

Luigi De Iorio: (1847–1937) Don Lorenzo's son who emigrated to America in 1901

Giovannina Forte: (1847–1909) married Luigi De Iorio in 1881 and bore him four children

Eufrasia De Iorio Anzalone: (1882–1967) Eldest daughter of Giovannina and Luigi (also called Annie)

Concetta Immacolata De Iorio Piscopo (Concettina): (1884–1979) Second oldest daughter of Luigi and Giovannina (also called Concettina)

Lorenzino De Iorio: (1887–1902) Only son of Giovannina and Luigi

Teresina De Iorio: (1889–1893) Youngest child of Giovannina and Luigi

Ernesto Piscopo: (1885–1958) Married Concettina De Iorio (also called Billie)

Adolfo Anzalone: (1895–1952) Married Eufrasia De Iorio

Nina Piscopo D'Amore: (1917–1994) daughter of Concettina and Ernesto, wife of Anthony D'Amore; mother of four children, Bernadette, Denis, Ronald, Stephanie

D'Amore Family

Antonio D'Amore: (1878–1966) Emigrated to America in 1902; patriarch of the D'Amore family

Luisella Guarino (Luigia Garino) and Michelangelo Catalano: Parents of Maria Grazia Catalano D'Amore

Maria Grazia Catalano D'Amore: (1891–1974) Married Antonio in 1909 and with him, bore eight children who lived: Tony, Marie, Phil, Mike, Rico, Susie, Adolph, Luisa (Dolly)

Anthony (Tony) D'Amore: (1913–1984) Oldest son of Maria Grazia and Antonio; Married Nina Piscopo in 1941 and fathered four children with her

Rico D'Amore: (1918–2003) Tony's younger brother

Luisa D'Amore: (1929–1976) Youngest daughter in the D'Amore family; married Nino Benevento of Avellino, Italy and bore three children with him, **Susan, Margaret and Joey (Giuseppe)**, "the Italian cousins"

Bernadette D'Amore (B. Amore): (1942–) Eldest daughter of Tony and Nina

Gene "Gino" Lawrence: (1942–) Married Bernadette, later divorced, always a part of the family

Larisa (D'Amore) Lawrence: (1966–) Eldest daughter of Bernadette D'Amore and Gene Lawrence

Clare Sean De Iorio (D'Amore) Lawrence: (1968–) Only son of Bernadette D'Amore and Gene Lawrence

Tiffany (D'Amore) Lawrence: (1972–) Youngest daughter of Bernadette D'Amore and Gene Lawrence

Denis D'Amore: (1944–) Eldest son of Tony and Nina

Ronald D'Amore: (1946–) Second son of Tony and Nina, married to **Sandi Forman** (1953–)

Stephanie D'Amore Maruzzi: (1952–) Youngest daughter of Tony and Nina

Allen Maruzzi: (1947–) Husband of Stephanie D'Amore

Andrea (D'Amore) Maruzzi: (1983–) Eldest daughter of Stephanie D'Amore and Allen Maruzzi

Nicole (D'Amore) Maruzzi: (1987–) Youngest daughter of Stephanie D'Amore and Allen Maruzzi

Gerald (D'Amore) Masiello: (1940–) Oldest son of Marie D'Amore and Ray Masiello; married to **Lynne Archangelo Masiello** (1944–)

Eric (1969–), **Jeffrey** (1973–) **and Christopher** (1975–) **Masiello:** sons of Gerald Masiello

Richard (D'Amore) Masiello: (1948–) Youngest son of Marie D'Amore and Ray Masiello

Tullio J. Baldi: (1920–) Husband of Susie D'Amore

Marian (D'Amore) Baldi Snyder: (1954–) Youngest daughter of Susie D'Amore and Tullio Baldi

Christine Chen Baldi: (1996–) Grand-daughter of Susie D'Amore and Tullio Baldi

Michelle Chen Baldi: (1991–) Grand-daughter of Susie D'Amore and Tullio Baldi

Paul (D'Amore) Baldi: (1949–) Eldest son of Susie D'Amore and Tullio Baldi; married to **Diane Biancardi Ustinovich Baldi** (1951–)

Maria Mauriello D'Amore: (1927–) Wife of Michael D'Amore

Anthony John D'Amore: (1952–) Eldest son of Maria Mauriello and Michael D'Amore

Maria Grazia D'Amore: (1954–) Daughter of Maria Mauriello and Michael D'Amore; mother of **Christiana** (1993–)

Michael Louis D'Amore: (1959–) Youngest son of Maria Mauriello and Michael D'Amore

Introduction

Many immigrants had brought on board balls of yarn, leaving one end of the line with someone on land. As the ship slowly cleared the dock, the balls unwound amid the farewell shouts of the women, the fluttering of handkerchiefs, and the infants held high. After the yarn ran out, the long strips remained airborne, sustained by the wind long after those on land and those at sea had lost sight of each other.

> —*Luciano De Crescenzo*

An Italian American Odyssey follows the one-hundred year intertwined history of two families from Southern Italy who arrived in America at the turn of the century. Their stories mirror the experiences of many immigrants. *La Merica* was the fabled "golden land" of opportunity and the dream of following the sun westward ignited many an imagination. Some left for adventure; most left for survival.

Introduzione

Tanti immigrati hanno portato a bordo gomitoli di lana, lasciando un'estremità del filo con qualcuno a terra. Mentre la nave partì lentamente dal molo, i gomitoli si sfilarono fra i gridi d'addio delle donne, i battiti dei fazzoletti, ed i bambini in braccio mantenuti in alto. Dopo che la lana si esaurì, le strisce lunghe rimanevano in aria, sostenute dal vento finché non si persero di vista sia a quelli di terra sia a quelli di mare.

> —*Luciano De Crescenzo*

An Italian American Odyssey *segue i cento anni della storia intrecciata di due famiglie del Mezzogiorno d'Italia venute in America all'alba del secolo. Le loro storie diventano lo specchio delle esperienze di tanti immigrati. "La Merica" era la rinomata "terra d'oro" di opportunità e il sogno di seguire il sole verso ovest spesso ha infuocato l'immaginazione. Alcuni sono partiti in cerca di avventura; la maggior parte sono partiti per sopravvivere.*

Dreams

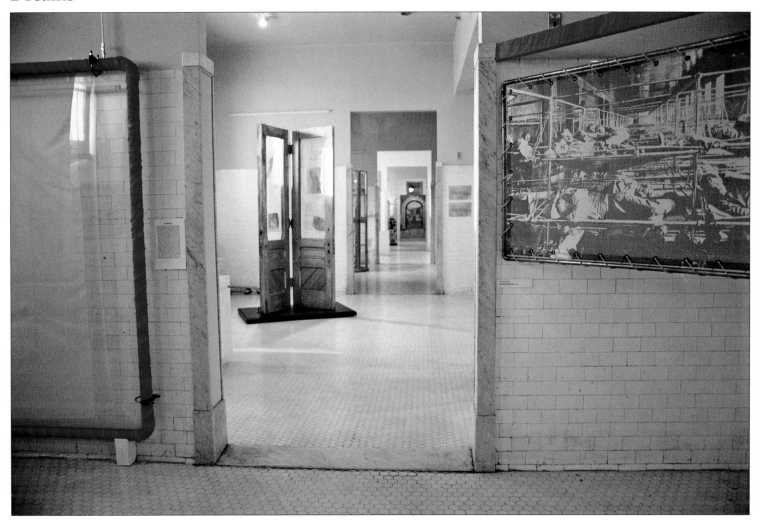

1. View of the six rooms of *Life line* exhibit at Ellis Island from the *Room of Dreams*.
Life line was inaugurated in the former dormitory rooms which have now become galleries for traveling exhibitions.

Dreams

"Chi esce, riesce"
"He who leaves, succeeds"

The 1800s saw a migration of populations that previously was unimaginable. The advent of the steam engine made possible the traversing of long distances both by boat and train. Poverty in much of Europe forced people to leave their countries of origin in order to survive. Letters from friends in America promised work, and so they came, "seguendo il sole"–following the sun–with the hope of finding a new life. The reality that faced immigrants was often very different than the dream.

Sogni

"Chi esce, riesce"

L'Ottocento ha visto una migrazione di popolazioni che non si poteva neanche concepire nei tempi precedenti. L'invenzione del motore a vapore ha reso possibile la traversata di lunghe distanze sia per nave che per treno. La povertà in tanta parte dell'Europa ha forzato la gente a partire dal paese d'origine proprio per salvarsi. Lettere scritte dagli amici in America promettevano lavoro, e così son venuti, "seguendo il sole," con la speranza di trovare una vita nuova. La realtà che li aspettava era spesso ben diversa dal sogno.

In the early 1900s, Italy, newly unified, was still suffering from the unrest of the past century when Mazzini, Cavour, Crispi and Garibaldi had struggled to bring order to an ailing and divided country. Socialism and Anarchism had found fertile soil in the atmosphere of economic recession and repression which permeated the latter half of the nineteenth century. The extreme poverty of conditions in Italy, from the Po Valley to Sicily, forced many to leave for the new land – to follow the sun and pursue their dreams of a more comfortable life in America. At least in America, one could dream. The dream was the first step, and hard work was the next. The disparity between the promise and the reality was larger than anyone could have imagined, but their new situation often offered better economic conditions than the immigrants had left behind.

Many Italians, both in the North and South, were accustomed to seasonal migratory patterns. In the north, Alpine winters forced laborers to look for work in warmer climes during the coldest months. Artisans and musicians traditionally traveled to ply their trades. Groups of migrant laborers followed the harvesting of various crops and the making of wine and olive oil. Accustomed as they were, by necessity, to adapting to changing economic conditions, the most adventurous often left for *La Merica*. In 1900, it cost less to go from Palermo to New York than to Paris![2] Still, the purchase of a *biglietto* (ticket) was no small matter for most immigrants.

The South of Italy, the *Meridione*, was populated largely by *contadini*, peasant farmers, who worked the land for the *padrone* (literally the "big father"). The *padroni* were nobles or landed gentry. As waves of immigrants abandoned the stony southern Italian soil, the *padroni* often found themselves without adequate help to cultivate their farms. In the last decade of the 1800s more than a million-and-a-half *contadini* settled abroad.[3] By 1924, that number had become five-and-a-half million.[4] The landed gentry of the south had been increasingly challenged by a restive socialism, poor crops and drought during the latter part of the 1800s. Prior to World War I, more than two thirds of all personal wealth was in buildings, furniture and land, so even a family that was considered well-off was deeply affected by the depressed economic conditions.

Either you steal or you emigrate. I'm not allowed to steal nor do I want to, because God and law forbid it. But in this place there is no way I can earn a living for me and my children. So what can I do? I have to emigrate: it's the only thing left…

—Anonymous Northern *contadino*
(related by Bishop Scalabrini)[5]

My father told us that in Sicily you were exploited by the landowners and authorities and the best policy to follow in life was as follows: you have eyes you no see; you have nose you no smell; you have tongue you no speak; you have hands you no touch; I wondered many times what a story could be told if they were free to tell all the real hardships they suffered in Sicily.

—Michael Lamont[6]

2. *Column of History I: Why Did We Come?*

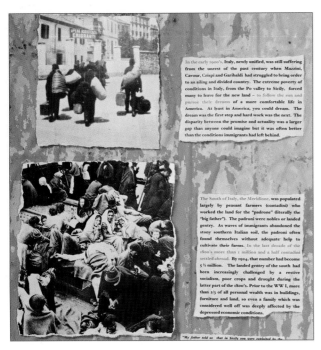

In the early 1900's, **Italy, newly unified, was still suffering from the unrest of the past century when Mazzini, Cavour, Crispi and Garibaldi had struggled to bring order to an ailing and divided country. The extreme poverty of conditions in Italy, from the Po valley to Sicily, forced many to leave for the new land** – to follow the sun and pursue their dreams **of a more comfortable life in America. At least in America, you could dream. The dream was the first step and hard work was the next. The disparity between the promise and actuality was a larger gap than anyone could imagine but it was often better than the conditions immigrants had left behind.**

The South of Italy, the Meridione, was populated largely by peasant farmers (contadini) who worked the land for the "padrone" (literally the "big father"). The padroni were nobles or landed gentry. As waves of immigrants abandoned the stony southern Italian soil, the padroni often found themselves without adequate help to cultivate their farms. In the last decade of the 1800's more than 1 million and a half contadini settled abroad. By 1924, that number had become 5½ million. The landed gentry of the south had been increasingly challenged by a restive socialism, poor crops and drought during the latter part of the 1800's. Prior to the W W I, more than 2/3 of all personal wealth was in buildings, furniture and land, so even a family which was considered well off was deeply affected by the depressed economic conditions.

"My father told us that in Sicily you were exploited by the

3. Detail of *Column of History I.*

Departure

Leaving Italy was a heart-rending decision which no emigrant made lightly. The men customarily preceded the women and children; separations sometimes lasted lifetimes. The journey itself across the vast, mysterious ocean called for every ounce of ingenuity and perseverance that could be mustered. In steerage, which comprised the deepest spaces below deck, emigrants slept – dormitory style – in iron bunks. The burlap bag mattresses, filled with straw or grass, gave scant comfort. Meals were served twice a day, most often a combination of moldy biscuits and thin gruel passing for soup. Many emigrants brought cheese and biscotti from home and these became precious staples on board. Seasickness was a fact of life. The smell of vomit mixed with putrid food and the odor of crowded bodies made the passage nearly intolerable.

"VOICES"—Ellis Island Interviews

Yes. I thought America was like a heaven where everybody, it must, I thought it was full of kings and queens and princes and everybody was rich. That was generally told in general by all of the people that the streets were made of gold, that everybody did so well here.

We had two, just two suitcases, and it was what we called an American Trunk. It's the basic storage trunk that you have today in the stores that's made out of some kind of tin or something.

The night before [we left] we had people through the three rooms sitting all over the furniture, on the floor, on top of the trunks, on top of the bed, on top of the tables. We had people sitting all over, spending the last evening with us. In the garden outside in the front. The next day the whole town accompanied us, which was about, say, a half a mile to three-quarters of a mile. Then some started bidding us goodbyes, and there was crying. Then we reached my uncle's house, which was in the country, and we had to pass it, and there was a big crowd there. My grandmother, my father's mother, she cried, and so did my great-grandmother. It was a sad farewell.

Was it a rough voyage? Yes, a couple of days it was very rough. Well, not really too rough, but it was dark, very, very dark. We looked out the window. There was nothing to see. There was no sky, no trees, no water you saw. For at least two days you saw nothing. We were just floating in mid-air, so to speak. And there was a little fear, too, among some people. But they all started saying a prayer or two. It was raining some too. And all we know there was just the ship and us and nothing surrounding us, no matter which time we looked out.

—Domenica Calabrese (Sunday Wood), born May 30, 1920, Camparni, Calabria; left at age eleven on the *Roma*[7]

"VOICES"—Ellis Island Interviews

I remember one day my father wrote a letter to my mother and he wanted us to come over here. She didn't want to come, you know. She was thirty-three years old, you know, and she was settled in Italy. So, when my mother received this letter, I started jumping up and down. "We've got to go, Ma. We've got to go to America." Because America in those days was, you know, something like astronauts going to the moon now, too.

My mother had her baggage. This, I'll never forget this. My mother put one, she made one big bundle with a sack, like, you know and she sold it. And she put all my grandmother's jewelry in it. And she put it over the bus, over the compartment, you know, where you keep your luggage. Overhead. Well, we were riding in Naples, and all of a sudden it's time to get up and go, and this young fellow, I can see him now. He took my mother's bundle and went off with it, and my mother's jewelry with it. I can still see it, honest. This young fellow. I said, "Ma, Ma, Ma!" And he was gone in a flash.

How long? We left Naples the ninth of December. We didn't arrive until the ninth of January on the next year. One month. I think it must have been one of Christopher Columbus' boats. Well, on the boat, I remember a few things on the boat. I remember them feeding us with the tin plates. It was like a soup, very salty, with a little pastina in it. That's about all I remember. And I would feed my mother, because she could not get up. She was helpless.

They gave it [food] to us where, right there, you know. Wherever they were, you know. Right on the cots, or whatever. As we, well, as the boat, we were coming over, I remember sneaking here and there, because I could sneak, you know, when you're a child you sneak up the stairs, you know, looking here, looking there. And I saw the first-class and the second-class with the round tables and the tablecloths. You know, my God, my eyes opened, you know. Then one day. This I will never forget. One day I'm just leaning over the ship you know, right in the water, over the banister, the railing there. All of a sudden these four men, they come up from nowhere. I don't know where they came from, and they had this, like this rack with something on it they were carrying over their heads. You follow me? All of a sudden I looked out and there's a body went right in the ocean. So someone died. That's what they did with them when they died. Out you went, to the fish. Right. I'll never forget that. What an impression it made on me, really.

—Dena Ciaramicoli Buroni, born May 26, 1912 in Mondavio, Pesaro, Italy; left at age eight on the *Pesaro*[8]

*Mamma mia dammi cento lire
Ché in America voglio andar,
Cento lire te li do
Ma in America no, no, no*

*Mamma mia, give me a hundred lire
Because in America I want to go
One hundred lire I will give you
But to America, no, no, no*

Refrain from an Italian Song popular
at the beginning of the twentieth century[9]

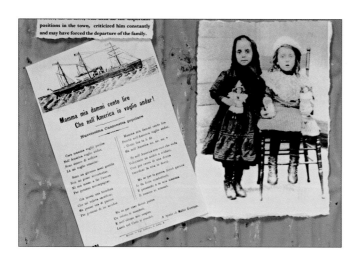

4. An Italian song popular at the turn of the nineteenth century and two young girls, Angela Piazza and Maria Carmela Calimeri, arriving at Ellis Island.

"VOICES"—Ellis Island Interviews

There was a little station about five, four miles away from my town, a rail-road station. We had to walk there. Right away, half of the town see me off. The thing that was left with me the most is that when the train was leaving my mother was hanging on, she won't let the train go. And that stays with me, because she had a feeling that maybe she'd never see me again, which she never did. I felt foolish. The thing is, we was in the station, in the waiting room, and everybody talking and things like that. So the train was coming around the curve. The minute they blow the whistle, it choked me up, I couldn't say another word. Why, I don't know, but that's what happened. I just, I couldn't say nothing else. And good thing I had a friend of mine, he was traveling to Italy, part of Italy, over to Verona, and he kept me company, my best friend, same age and everything, you know. So when we got to Milan, I met a cousin of mine in Milan, you know, there, I traveled during the night. Then we went to Genoa. I had to go through a physical examination with the American consul. The first time I had to sign my name backwards. In Italy you always sign "Lorenzini, Ettore." Over here it was "Ettore Lorenzini." You know, you have to sign the last name first. But I never understood why in this country they call it "last name." See, in other words, when you're born, you're Lorenzini, not Ettore. So supposed to be second name. I don't know. But over there you would go with Lorenzini first.

> —Ettore Lorenzino, born March 20, 1913 in Anduins, Udine; came to America in 1930, at age seventeen, on the *Conte Bianco Mano*[10]

The De Iorio Family

The De Iorio family seems to have had complex reasons for leaving Italy. They came from Lapio, province of Avellino, just outside Naples. As the south of Italy deteriorated, their fortunes also may have shifted. It is still a mystery as to exactly why they left Italy. Luigi, the father of the branch of the family who emigrated, was the first-born son. His father, Don Lorenzo, had died in 1896. Tradition dictated that the eldest son then become the patriarch of the family. This would leave him as head of the De Iorio family and responsible for the supervision of their land but he was never interested in being a *padrone*.

"Memory"

Ricordo di Luigi de Iorio del suo Caro Padre, morto adì 18 Agosto nel 1896, alle ora 21 di Sabeto, vigilia di S. Antonio di Padova, e si ricitava anche il suo drama in suo onore, successa questa disgrazia, I maestri di Feste volevano suspenderla, ma noi non vollemo, al perché il pubblico si era incomingiato arrivarne, e non si poteva tralasciarla, il Signore così aveva disposto in quel giorno, come anche S. Antonio, che era tanto divoto, e speriamo che gli accogliesse in Cielo, come non tralasciava la messa ogni mattina.

Memory of Luigi De Iorio for his dear father, died the 18th of August in 1896 at the hour of 9PM, Saturday, vigil of Saint Anthony of Padova, whose life was being recited in his honor, when this unfortunate occurrence happened. The masters of the feast wanted to cancel it but we didn't want that because the public had begun to arrive, and we couldn't ignore that, the Lord had decided thusly in that day, as had Saint Anthony, to whom he was so devoted, and we hope that he will greet him in heaven, since he never failed to go to Mass every morning.

> —Luigi's account of the death of his father, Don Lorenzo, written in the *Libro di Memorie*, Don Lorenzo's unpublished diary

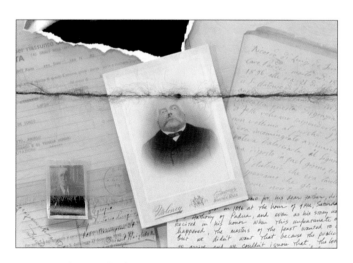

5. Photograph of Don Lorenzo De Iorio on his deathbed.

White bread for all

Luigi was a *tipo democratico* (a democratic type), influenced by the socialist ideas that were popular in Italy when he was growing up. He didn't believe in the divisions between the classes and would take the white bread from the family larder and eat with the *contadini* in the fields. He would frequent the town café and play cards with the working people. He was considered a disgrace to the family because of this behavior. The Fortes, his in-laws, who held all the important political and religious positions in the town, criticized him constantly and may have forced the departure of the family.

"VOICES"—Ellis Island Interviews

My father's people, none of them are in this country. They came here, they went back. Their lifestyle was different. You know, they would never accept this kind of a lifestyle. Things have changed here in America today. But there was a great deal of contrast between Europe and America then.

This is what happened. My father starts seeing, you know, the way these people were treated, and he would have a servant sit at the table with him, servants that did live with them, they sat at the table with my father, which was absolutely nuts.

So then, the family, they were left, because people, well, idealists like my father and people like that, they don't think of money, or the future. They put everything into their dreams and helping people and all that.

> —Marjorie (Maggiorana) Corsi Notini, born June 24, 1924, Capestrano, Abbruzzi[11]

She [my mother] came from a real rich family, considered really affluent in Italy. And my dad was a gardener taking care of the estate there and they just, they threatened and then they, I mean, my cousin said after the first child they kept her and warned her, "You're not to see him again. Otherwise, you'll get thrown out." Well, she had a second child. They threw her out. And she never saw her siblings or mother or father again other than, one of her brothers was a priest. And he maintained a friendship with her. And that's the only connection she had with her entire family.

> —Elda Del Bino Willitts, born April 29, 1909, Lucca, Florence; left Italy at age seven on the *Caserta*. She was originally supposed to sail on the *Ancona* which was bombed.[12]

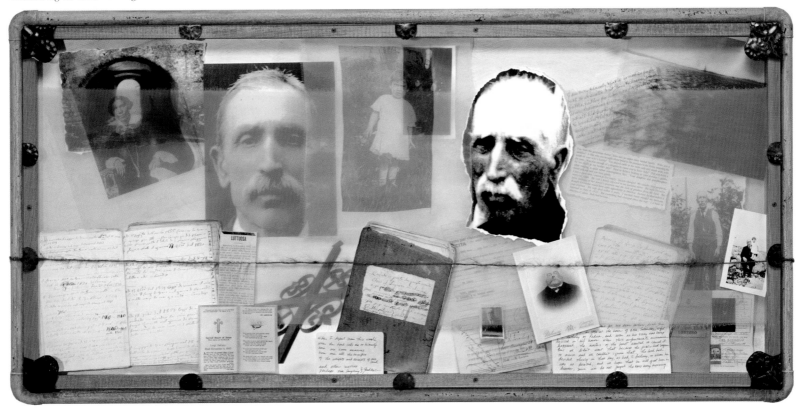

6. *Following the Thread I: Luigi De Iorio.*

Diary with lists of
births, deaths

Croce di San Lorenzo, Lapio

Luigi's birth certificate,
June 25, 1847

Diary account and photo of
Don Lorenzo on his deathbed

Holy Card with Luigi's death and
notice from the Italian newspaper

Libro di Memorie
Diary of Don Lorenzo,
Luigi's father

Mrs. Eldredge's letter
expressing concern for
Luigi and journal notes

Luigi's passport with seal of
King of Italy, June 2, 1924

Ancestor Scroll: Luigi De Iorio

My great-grandfather, Luigi De Iorio, was a gentleman farmer born into an upper-class landed family from Lapio, a tiny stone village in southern Italy, province of Avellino, outside Naples. He came to America with his wife and children. Who knows exactly why? He had socialist sympathies which conflicted with the larger family values. One of my brothers wonders whether Luigi may have had a drinking problem. My mother never told me that. When I asked Nonni, she said he drank one glass of wine a day. My mother, Nina, said he was very gentle, not prepossessing at all, worked at a menial job in his new country and lived quietly. In most of his photographs, he is reading. He saw his only son, Lorenzino (little Lawrence) die within one year of coming to America. His wife died after eight years. My mother loved him. He passed on when she was in college. As I write this, I realize that my mother married a man like her grandfather in some ways – pretty mild-mannered, given to quiet, study and hard work. The women were the strength in my family. Luigi's father, Don Lorenzo De Iorio, wrote down some history of the family in an old paper book from the mid-1800s. We still have that. We also have the Lives of the Saints *which belonged to him as well. My grandmother said that he would read it to them "when they were good." So there are a lot of mysteries about the real reason the De Iorios came to America and I guess we may never really understand why. I know that in the De Iorio family they would alternate the names of Luigi and Lorenzo (Lawrence). I married a man with the last name Lawrence. I gave my son the middle name De Iorio to preserve the lineage.*

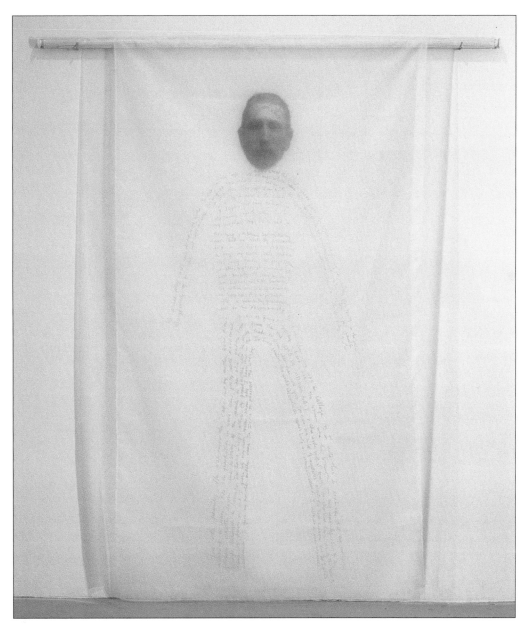

7. Ancestor Scroll: Luigi De Iorio.

The Book of Memories

Don Lorenzo De Iorio, Luigi's father, kept a *Libro di Memorie* (Book of Memories) in which he wrote down the records of marriages, births, deaths, purchases and sales of land and happenings in the life of their small village. Many of these pages give a vivid picture of rural village life in nineteenth-century Italy. The oldest "memory" is dated 1802.

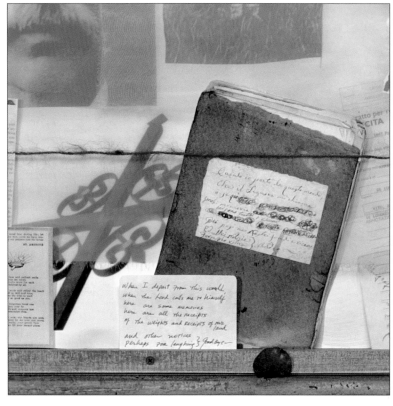

8. *"Libro di Memorie" (Book of Memories)* written by Don Lorenzo De Iorio (1820–1896).

Quando io parto da questo mondo,

che il Signore mi chiama,

qui sono memorie

e tutti I ricevi

e pesi dei nostri fondi

e altre notizie—

forse per ridere—Addio

When I depart from this world,

that the Lord calls me to himself

here are memories

and all the receipts

and weights [taxes] of our lands

and other notices—

perhaps for laughing—Good bye

—Don Lorenzo De Iorio

Luigi and Giovannina

The marriage of Luigi De Iorio to Giovannina Forte was noted in this book. Born in the same year, 1847, they were both thirty-four years old. The De Iorios and Fortes had lived next door to each other for generations. Despite the positions of the two families in the town, the ceremony was a simple one. The bans of marriage, which had been publicly announced both in the Church and with the civil authorities, were about to expire. Luigi's sister, Eufrasia, had died scarcely a month before and the De Iorio family was in deep mourning, hence the small private wedding which contrasts greatly with the festive accounts of other family weddings in Don Lorenzo's *Libro di Memorie.*

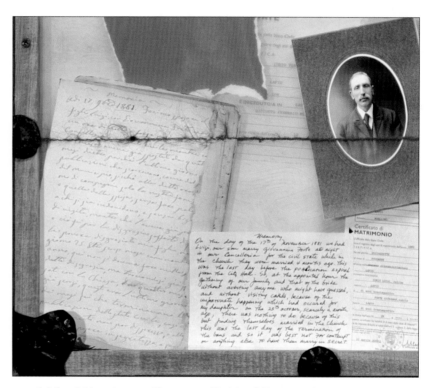

9. *Libro di Memorie* page with account of Luigi and Giovannina's marriage written by Don Lorenzo De Iorio; copy of their marriage certificate.

"Memory"

Memoria: Adi 17, 9bre1881, Fecimo sposare il figlio Luigi, con Giovannina Forte verso un ora di notte, e forse più nella nostra Cangelleria per il stato civile, mentre con la Chiesa aveva già sposte…da quattro mesi dietro perché l'ultimo giorno di publicazione che scorrevano, come del…del municipio, sicché alla detta ora,…uno di compagnia solo la nostra famiglia e quella della sposa, senza fare palesare a chi si sia indovidono, e senza biglietti di visita, mentre che l'aveva già…e ciò fù per la disgrazia sofferta di quella povera disgraziata mia figlia, nel giorno 25 8bre scorso mese caminande…anno, qui non si doveva fare nulla per detta disgrazia, ma trovandosi già sposati con la Chiesa, da quattro mesi già scorsi, questa era l' ultimo giorno di mesi sei che terminavano le publicazione dello stato civile, cosi ci è convenuto non per disprezzo, o altro di farli sposare in segretezza, e senza lusso verso come vi ho spiegato che nessuno lo conosceva. Fiat volundas tua. Lodate Iddio che ciò ha stabilito, mentre così doveva succedere.

On the day of the 17th of November 1881 we had our son, Luigi, marry Giovannina Forte around an hour of night and perhaps more in our Chancery for the civil state while with the Church they were already married for four months because the last day of publication [of the bans] was running out. Thus, at the appointed hour, in the company of only our family and that of the bride without making it known to anyone who might have guessed, and without visiting cards, while they had already understood and that was for the misfortune suffered by that poor unfortunate daughter of mine on the day of the 25th of October, last month…here, there was nothing to be done for that said misfortune but finding themselves already married with the church for nearly four months, these were the last days of the six months which terminated the publications of the civil state so it was agreed upon not for contempt or other reasons, to have them be married secretly – and without luxury so that no one would know.

May the will of God be done. Praise God who has decided that this had to happen in this manner.

—Don Lorenzo De Iorio, *Memory*

This page of the *Diario* is faded and torn, so many words are difficult to decipher.

10. *Following the Thread II: Giovannina Forte.*

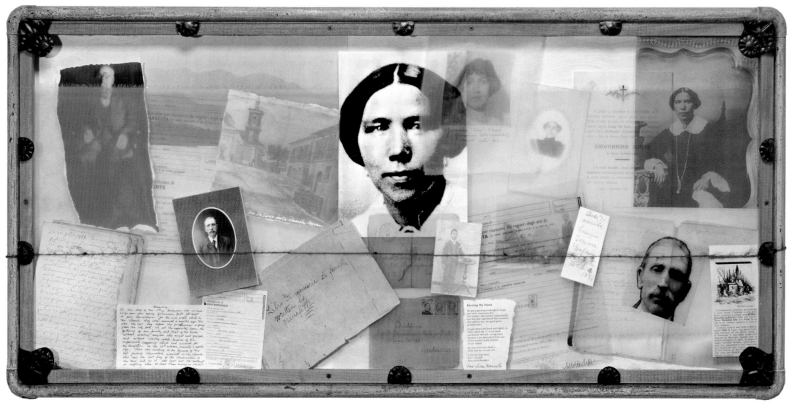

Marriage account
from diary

Marriage certificate

Wrapping paper of
Libro di Memorie

Giovannina's
death mask

Giovannina's death
notice published by
her brothers

Death Notice
from *Campana
del Mattino,*
Naples, 1909.

Birth and death certificates
of Baby Teresa, age three

Letter to Ornatissima
Donna G. Forte

Giovannina's
birth certificate,
December 2, 1847

Diario pages with births
of Giovannina and
Luigi's children

Leo Luke Marcello's poem[13]

Ancestor Scroll: Giovannina Forte

Giovannina Forte came from an educated and landed family. Her brothers held the important positions in the town. Ermengildo was the town lawyer and magistrate. Davide was the arciprete, *or pastor, of the Church. Achille was the postmaster. She and Luigi De Iorio lived in a large capacious house right on the town square. When the traveling players came to town, they would perform right under their* balcone. *My grandmother remembers stealing out to watch through the stone balustrade when she was a child. Giovannina wove her linen dowry sheets, embroidered her initials in the corners and on her embroidered night gowns – or did the nuns in the convent do some or all of this? She never combed her own hair. Once a week, a servant woman would comb and oil her dark tresses. Her fourth child, Teresina, died early. Her only son died at fourteen. Her two daughters, Concetta and Eufrasia, became the survivors of the family in America. So Giovannina succumbed to family pressure and followed her daughter to America. Giovannina's brothers felt that her husband, Luigi, continually disgraced the family by keeping company with people beneath his "class." When Concetta returned to Lapio in 1922 with my mother, who was five years old, Giovannina's brothers, the lawyer and* arciprete, *gave my grandmother a hard time because one of the "peasants" took my mother on a donkey ride! In her photograph, Giovannina wears a locket that I now wear. Her garnet beads and gold earrings are part of her legacy to me.*

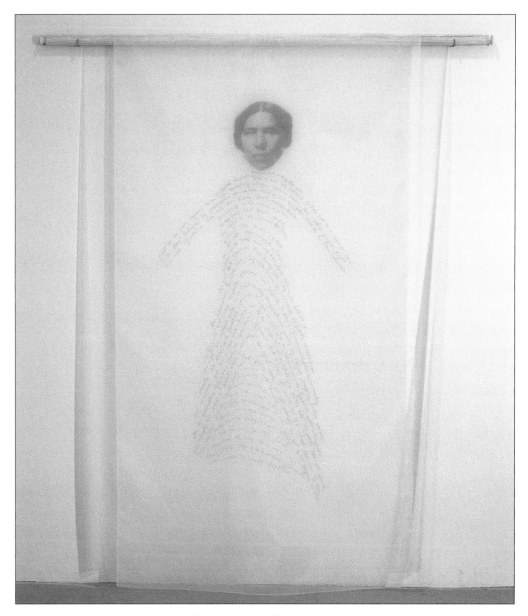

11. *Ancestor Scroll: Giovannina Forte.*

Emigrant to Immigrant

Giovannina and Luigi De Iorio were fifty-four years old when they emigrated to America in 1901. Their children were Eufrasia, aged nineteen, Concettina, aged seventeen, and Lorenzino aged fourteen. Eufrasia didn't want to leave the convent in Italy where she had been studying to be a nun, but eventually she agreed. They left the port of Naples on May 11, 1901, sailing on the ship, S.S. *Gallia*. The boat stopped in Marseilles and landed in New York harbor on May 29, 1901. They were listed as laborers on the ship's manifest. Concettina and Eufrasia's ages were incorrect. Lorenzino was listed as a woman!

This confusion of basic facts was a common occurrence during the peak of the immigration era. The De Iorios entered America through Ellis Island with only $40.00 to their name – five of the nearly 136,000 immigrants from Italy that year. At the time, the Italian government imposed strict restrictions on the amount of money that could be taken out of Italy. They proceeded to Boston where they were greeted by *paesani* – people from their hometown who had come before them. They had become immigrants.

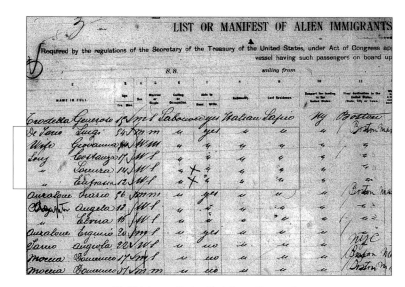

12. Ship's manifest with information on the De Iorio Family's arrival at Ellis Island in 1901.

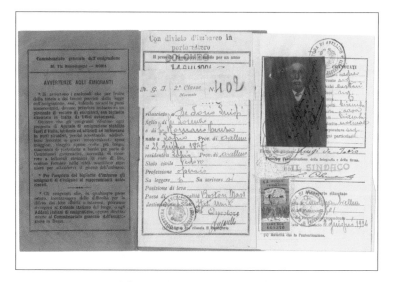

13. Luigi De Iorio's passport issued by the Kingdom of Italy, King Victor Emmanuel I.

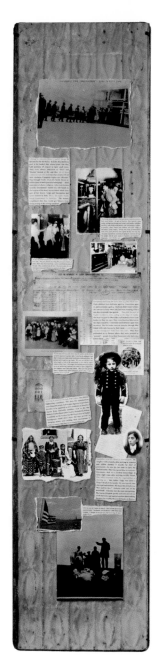

"VOICES"—Ellis Island Interviews

First we saw the Statue of Liberty. And everyone up on deck started to holler. "La libertà, la libertà! Viva la libertà!" I didn't know what it meant. I thought it was just the saint protecting the port. That's how I thought of it, as a saint. And the ship, it seemed to go to the left and then turn to the right. And we saw this big, beautiful building. And then beyond that there were tall buildings, and I pictured in my mind that we were going to live in one of those buildings. Then when we arrived, as far as I remember, the ship docked there. It wasn't such a huge ship. It docked there at Ellis Island…There was a huge canopy, and my father was standing there between the end of the canopy and the sun shining on him. We had to go down the steps, from below, the names were called before we came down, because somebody had to claim us.

—Domenica Calabrese (Sunday Wood)[14]

14. *Column of History II: Arrival.*

Ellis Island – "Isle of Hope, Isle of Tears"

Arriving in America through Ellis Island was often a frightening experience. The lines for examinations were long and people had to pass rigorous inspections in order to be approved as new residents of America. Agents from charitable societies, such as the San Rafael's Italian Benevolent Society founded by Bishop Scalabrini, or the Society for the Protection of Italian Immigrants, would often assist the new arrivals in changing money and reaching their destinations in order to ensure that they were treated honestly.

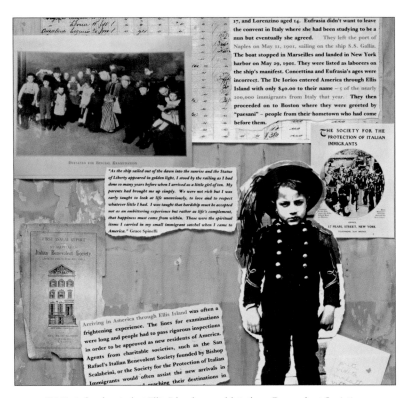

15. Details of arrival at Ellis Island; pamphlets from Benevolent Societies.

"VOICES" — Ellis Island Interviews

Well then they assigned a guard to me. They put a tag on me. I ripped it right off. I don't want to go around with a tag. [he laughs] I don't want to look like a package. I don't know why. I took the tag right off.

—Ettore Lorenzini[15]

"VOICES" — Lower East Side Tenement Museum

The men would come from Europe on their own. Their wives or whatever would be in Italy. And they lived in one apartment. My father's story was that he came here by way of the Swiss, through France, sort of—they came here illegally at the time. Even my mother. She told the story of when she came to America, she knew she had to have money to get off the boat. My father borrowed $25.00 and he threw it up to her—to the ship from the dock, from the pier. And it went into the water! And she was very depressed.

—Josephine Baldizzi, family emigrated from Palermo, Sicily in 1928[16]

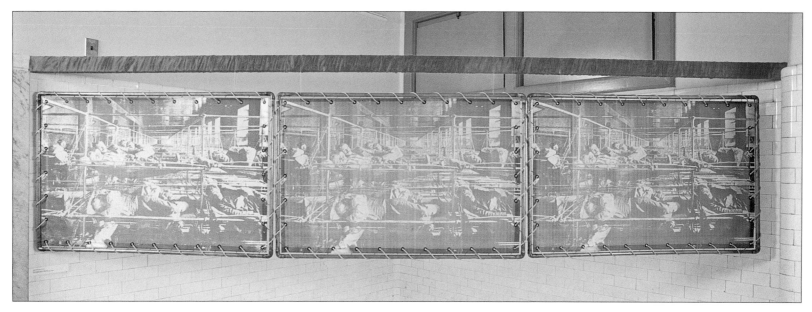

16. *Dormitory Room Panel*. Detained immigrants in bunks at Ellis Island. This is the only extant photograph of the original dormitory rooms.

The Gate of America

There were rigorous examinations of all immigrants as they passed through the inspection stations at Ellis Island. People were required to climb a long stone staircase up to the Great Hall. Inspectors observed them closely and placed chalk marks on the arms of anyone who limped, became short of breath or who stood out in any remarkable way. Some people were detained if they were ill. Some were actually sent back to their country of origin. It was an excruciating situation when families were separated in this way since often every penny of savings had gone to pay for the voyage.

On they go, from this pen to that, pen by pen, towards a desk at a little metal wicket – the gate of America. The great majority are young men and women, between seventeen and thirty, good, youthful, hopeful, peasant stock. They stand in a long string, waiting to go through that wicket, with bundles, with little tin boxes, with cheap portmanteaus, with odd packages, in pairs, in families, alone, women with children, men with strings of dependents, young couples. All day that string of human beads waits there, jerks forward, waits again; all day and every day, constantly replenished, constantly dropping the end beads through the wicket, till the units mount to hundreds and hundreds to thousands…

—H. G. Wells, 1906[17]

"VOICES"—Ellis Island Interviews

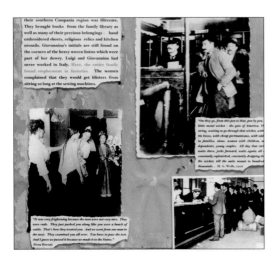

17. Close-up of Italian girl being examined; San Rafael Society agent assisting an immigrant through the entry process.

It was very frightening because the men were not very nice. They were rude. They just pushed you along like you were a bunch of cattle. That's how they treated you. And we went from one man to the next. They examined you all over. You have to pass the test. And I guess we passed it because we made it to the States.

—Dena Ciaramicoli Buroni[18]

Even then, in Italy, Ellis Island was a dreaded part of the journey…because they, they knew you could be deported, you could be detained if something was wrong with you. It was well known what you had to go through so it was important that we all stay healthy and all be examined. I was only five and this little, this gentleman who had been back and forth several times…took me on a walk one day and he said, "you know what? When you go over to Ellis Island, they're going to be examining your eyes with a hook," and he says, "Don't let them do it because you know what? They did it to me. One eye fell in my pocket." So we get over there and everybody has to pass and I'm on the floor screaming. I will not let them touch me. And you know what? I passed without a physical. I passed without it because the other seven passed.

—Elda Del Bino Willitts[19]

The only thing that I remember, we came in with a boat, we, as a matter of fact we didn't get off the boat, when we got here we had to go through the, through the doctor examination. If you're okay they let you off, if you're not you're supposed to stay someplace in there, I don't know where, until you're, you're well enough, then to let you in the United State. As matter of fact, one of the inspector was telling me when he was asking the question who's going to receive me. He know I was all alone and he know that I didn't have nobody to take care of me in the United States. And he was talking to this guy that is supposed to watch for me, he was telling this guy maybe we should send me back to Italy. I said, "Why should I go back to Italy?" I said, "I came here to stay in the United State." I said, "If I go back to Italy, I figure, look at the money that I spent to come to the United State; then I'm right back in the hole." And so that's why I got together with my friend, that his brother-in-law would receive me, and I went off with him to his brother-in-law. His brother-in-law was there.

—Carmine Martucci, born December 25, 1904, Bidetto, Province of Bari; came from Italy in 1919, age fifteen[20]

I didn't have too much, you know, correspondence with him [my father], you know. I know my mother had to take a picture of us every year to send him to see how we're growing, you know. [he laughs] In our town there used to be a photographer in the summer to take pictures of these tourists, you know. So he takes a picture, she send to my father to see the way we're growing, you know. We go four years at a time without seeing him, you know, and I really don't know what he comes from. I tell you. It was hard for him and hard for us, you know.

When I stopped, my father was right outside the train. [he laughs] You know. I get off the train. When he left me I was thirteen years old. I was seventeen. I got off, and he was standing right behind me still looking on the train. Still looking on the train, you know. Because I left a little boy. I was a man already, you know.

—Ettore Lorenzini[21]

New Country, New Life

Coming to America meant a great change in lifestyle for the De Iorios. In Italy, they had been part of the landed class which meant that they held positions of respect in their small town. They were always addressed as *"Don"* and *"Donna"* instead of the usual "Mr." and "Mrs." Both the women and men could read and write at a time when between 70 and 90 percent of their southern Campania region was illiterate.[22]

They brought books from the family library which are now conserved in America, as well as many of their precious belongings – traditional *biancheria*, hand-embroidered sheets, religious relics and kitchen utensils. Giovannina's initials are still found on the corners of the heavy woven linens that were part of her dowry. Luigi and Giovannina had never worked in Italy. Here, the entire family found employment in factories. The women complained that they would get blisters from sitting so long at the sewing machines.

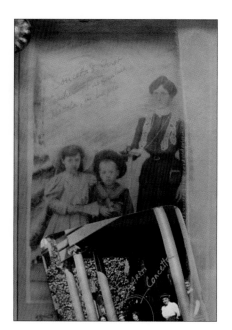

18. Pasqualina Mottola, who taught Concettina when she was four years old, in Lapio.

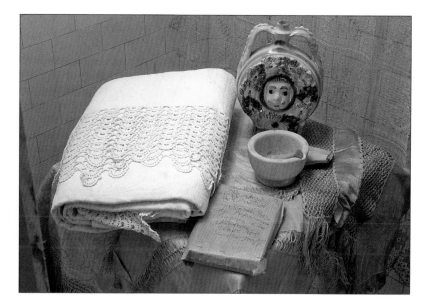

19. *De Iorio Closet Installation:* Details of *biancheria* (linens) with hand-crocheted edging; gold silk bedspread; linen lace overlay; amphora with De Iorio initials; mortar and pestle; Don Lorenzo's copy of *Book of the Saints*.

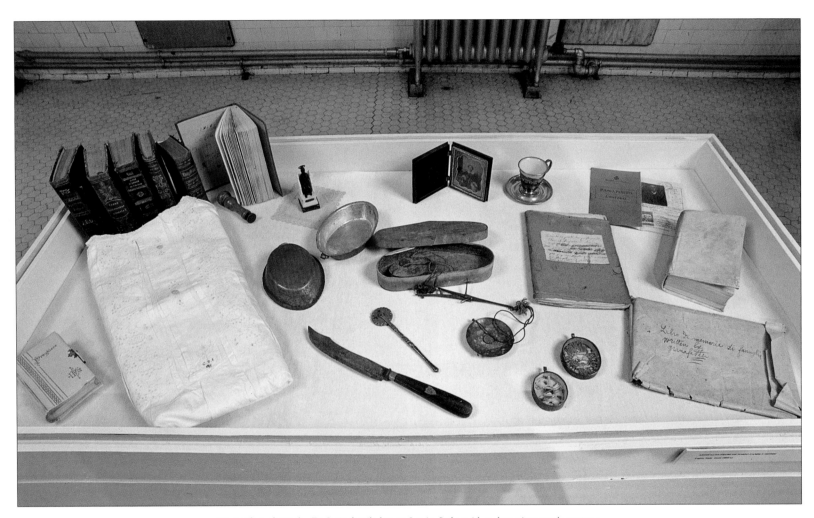

20. Artifacts from the De Iorio family home, Lapio, Italy, mid-to-late nineteenth century.

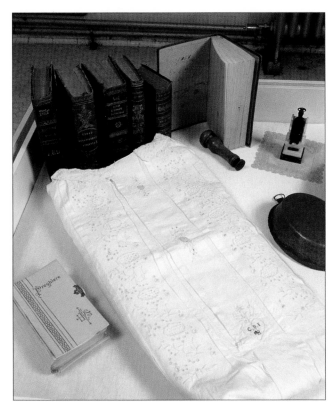

21. De Iorio family selected artifacts: Concetta's dowry nightgown and prayer book; books from the De Iorio library (1858); Luigi's seal; bronze statue of St. Peter from the Vatican resting on silk lace; a copper and tin *tegamino* (small pan) for cooking.

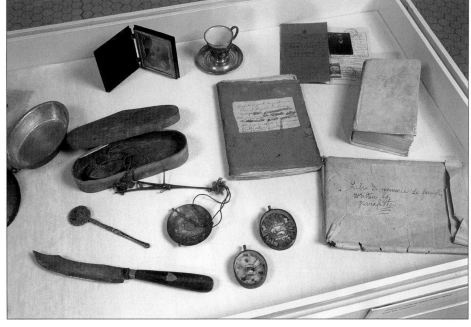

22. De Iorio family selected artifacts: Giovannina's dowry knife with her initials; two reliquaries (S. Filomena); *Libro di Memorie;* Luigi's passport; Giovannina's portrait; wedding cup; Don Lorenzo's weights and measures; handmade tin-and-copper *tegamino* (small pan); handmade brass ravioli cutter.

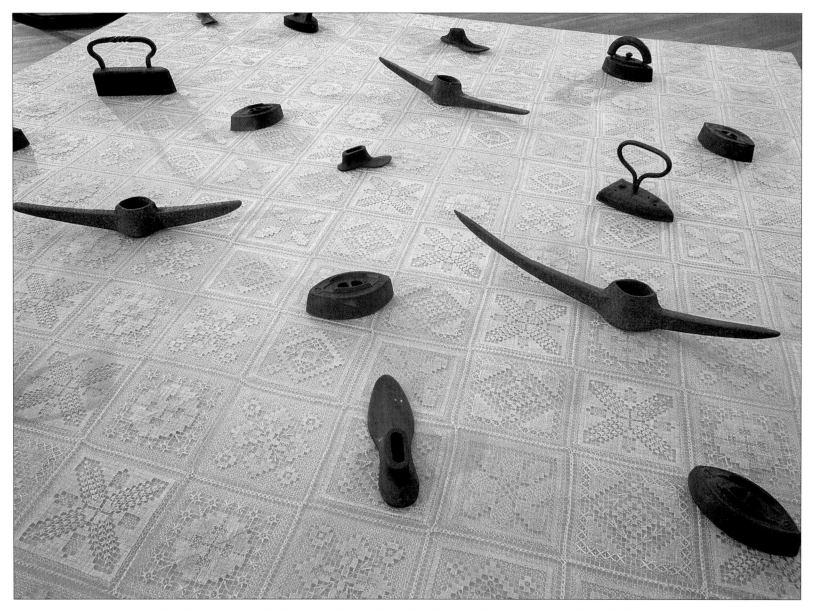

23. *Great-Grandmother's Ocean Installation:* Dowry bedspread made by Giovannina Forte using the rare "filet net" method of creating an openwork pattern with diminutive crochet hooks. Each square was made separately, then joined with the others.

Artifacts from the De Iorio Family Home, Lapio Italy, mid-to-late 1800s

24. Giovannina's *biancheria* with embroidered initials on woven-linen dowry sheet; broken hand-carved marble mortar.

26. Giovannina's initials embroidered on her woven-linen dowry sheet.

25. Concettina's embroidery on her wedding nightgown, with her initials and small dog carrying a basket.

"Weaving," Giovannina thought. Weaving. Her mind wandered to the loom which was usually the purview of one of the servants or the women who hired themselves out to create dowry pieces for other women. She had been entranced with the loom as a child – watching the shuttle speed back and forth between the warp threads, creating the weft pattern. She had insisted on learning how to use the heavy, but movable, treadle, nearly standing upright as she leaned against the bench, her small hands sending the shuttle only half-way through the first few times she tried. But with persistence, a key to her nature, she mastered the technique and had happily woven her own dowry sheets. Her initials embroidered in red, GF, in one corner, clearly marked them as her own. They had hung like large, nubbed sails on the loom as she got near to finishing. Looking out over the hills, her imagination played with what might lie beyond. She knew of other villages. She could see them, each on its tiny hilltop with a view of the valleys between. Could the sheet be like a sail which brought her to another place? Could she know in these moments of musing, that her life journey would actually carry her beyond even these imaginings?

—B. Amore

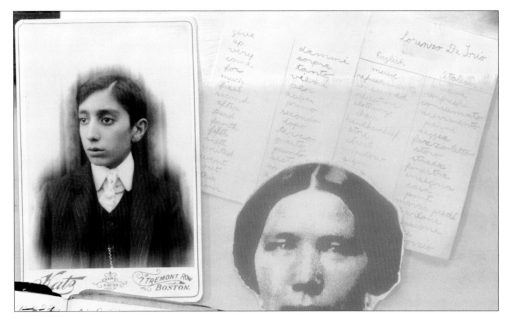

27. Lorenzino's first lessons in English.

First Lessons

Lorenzino went to school to learn English. He was following the De Iorio tradition of pursuing an education despite the fact that it was considered a luxury by most immigrants. His first lessons in English, as well as a photograph of him as a young boy in Lapio, were saved by Concettina. He caught a cold three or four months after arriving in America and within another six months he died of pneumonia. He was the last male to carry the De Iorio name. His death was a great blow to everyone in the family and a difficult beginning to the challenges they would face in their new country. The mourners listed in the *Libro di Memorie* included many friends from Lapio who had also emigrated.

28. Following the Thread III: Lorenzino De Iorio.

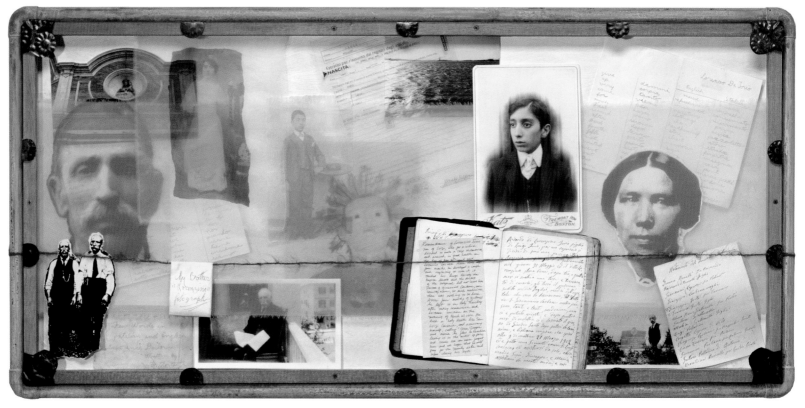

Santa Maria delle Neve,
De Iorio Parish Church

Concettina's note with
Lorenzino's photograph

Lorenzino's birth certificate,
April 10, 1887

Lorenzino's first lessons
in English

Envelope with "Few Words in Italian
and English, Lawrence De Iorio"

Luigi's account of Lorenzino's
death and funeral attendees

Luigi reading

Statue of San Lorenzo which was
always in the De Iorio House in Lapio

Notamento of people who
attended Lorenzino's funeral

"Memory"

Ricordo di Lorenzino Iorio figlio di Luigi Iorio, per un capriccio si dicise di farsi una passeggiata in America, e giunsero a salutamento nel giorno 30 Maggio, ed il detto Lorenzino stava bene, dopo tre, o quattro mesi si sentiva una tosse e trascurava di curarla, gli toccò il polmone, subito medici Inglesi, medici dell'ospedale che non lo lasciavano, il Dottore G. Giovannino Carbone nostro paesano, tante e tante medicine, non ci è potuto niente, e dopo Quattro mesi di malattia ci è lasciato il giorno di Giovedi Santo dopo fattosi la Comunione, e l'estreme unzione che spirò alle 9 di mattina 27 Marzo 1902 ed e fatto un S. morte come S. Luigi Consaca, ed assistersi da solo, chiamando Gesù, Giuseppe, e Maria assistemi la morte mia, e così chiamando volò in Paradiso lasciando a noi in mezzo a dolori, e pianti, che non possiamo dementicarci giammai, e speriamo che precasse per la famiglia come lui disse prima di chiudere gli occhi.

Memory of Lorenzino Iorio, son of Luigi Iorio, who for a whim decided to take a trip to America and arrived in good health on the 30th day of May, and the said Lorenzino was well. After three or four months he had a cough and neglected to care for it and it touched his lungs. Quickly, English doctors, doctors from the hospital never left him. The Doctor Giovannino Carbone, our countryman, more and more medicine; there was nothing to do, and after Four months of sickness he left us the day of Holy Thursday after having made communion and extreme unction, he expired on the morning of March 27, 1902 and he had a sainted death like Saint Luigi Consaca, and aided himself, calling Jesus, Joseph and Mary – help me in my death, and still crying out, he flew into Paradise leaving us in the midst of suffering and tears, we can never forget him and we hope that he prays for the family as he said [he would] before closing his eyes.

—Luigi De Iorio, *Memory*

The family also lost Giovannina, who died of a cerebral hemorrhage in 1909, eight years after arriving at Ellis Island. This left Concettina with the responsibility of carrying on. Her father, Luigi, was never a *capo* (head of the family). He was a gentle man who read and worked. His basic attitude toward life was "live and let live." Eufrasia took care of the household. Concettina was the most enterprising. She learned English quickly and soon moved out of the factory.

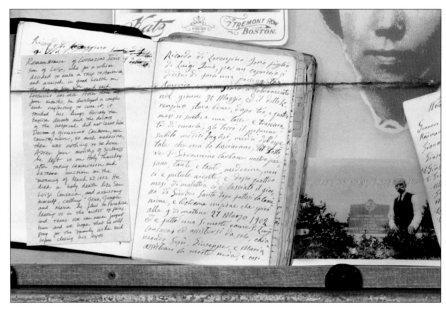

29. Original and translation of the account of Lorenzino's death and funeral written in the *Libro di Memorie* by his father, Luigi. Photograph is of Luigi in front of the De Iorio Family gravestone.

In confronting the difficulties of resettlement and adjustments to radically different surroundings, most immigrants clung closely to their families, which provided a sense of security as they moved into the larger world. Transition was aided by friends or family who had come before. Still, it was a demanding and confusing task to move from a closely-knit rural society with defined boundaries to an urban setting bursting with possibilities.

The First Generation

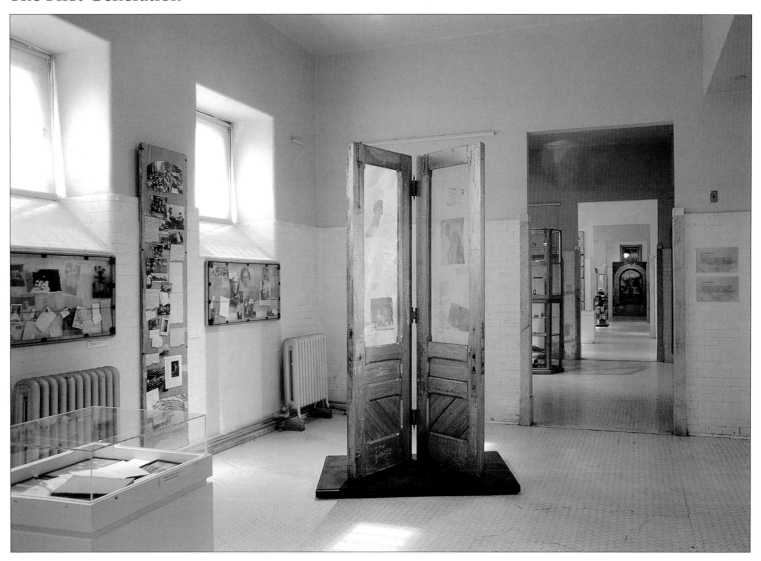

1. *The First Generation:* Overview of second room in Ellis Island exhibit.

The First Generation
"Meglio poco che niente"
"Better little than nothing"

Despite the motivation behind the dream, the reality of surviving in America brought many immigrants to wonder if they had made the right decision. For the first generation on American soil…yes, there was work in America, but what else? Family life suffered because wives and children often were left behind for long periods in the *paese*. Through centuries of inbred conditioning to hard work, immigrants survived by maintaining the ethic of perseverance, of bending the back to the load and continuing on. Education was another way to move beyond this situation.

La prima generazione
"Meglio poco che niente"

Nonostante la motivazione del sogno, la realtà di sopravvivere in America ha portato tanti immigrati a chiedersi se avevano preso la decisione giusta. Per la prima generazione sul suolo americano…Sì, il lavoro c'era in America, ma che altro? La vita familiare ne soffriva perché moglie e bambini spesso venivano lasciati nel paese d'origine per lunghi periodi. Condizionati dai secoli di lavoro duro, gli immigrati sono sopravvissuti mantenendo l'etica del perseverare, chinare la schiena e andare avanti. L'istruzione era un altro modo per cambiare la situazione.

Work

The majority of immigrants had left their countries of origin with few resources other than a strong will to work. Most had been farm laborers in the old country. Men entered the construction trades. Women sometimes had learned sewing, which became a marketable skill in America. Mothers and children often worked together making silk or feather flowers at home in crowded apartments. No one was too young to be useful.

"VOICES"—*Life line* Interviews

My mother never worked outside the home. She did home work at home – passementerie–piping work. They give you a piece of paper with a diagram and you follow it with a machine or with hand-sewing. You know, the frogs, they used to call them. They'd have two on one side and they moved together. I did most of that. I helped her all the time. I've been working since I was born!

—Catherine D'Alena Villanova, family from Spinete, Campobasso[1]

2. Work at home for people of all ages: rolling cigars, making lace and feather flowers.

Some entered the dress trade in factories or mills. The De Iorio women all worked in factories when they first arrived. When Giovannina died in 1909, the women from her place of employment, the Aieta Tailor Shop, came to her funeral. Her death was noted in newspapers both in Italy and America.

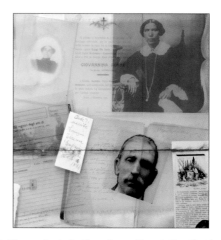

3. Giovannina's death notice, with notation that her co-workers from the Aieta Tailor shop attended the funeral.

Giovannina's Death

Profondamente commossi, partecipiamo a' nostri lettori l'infausta novella della morte, avvenuta il passato mese di Novembre in Boston, della pia signora Donna Giovannina Iorio nata Forte, la cui vita fu un continuo esercizio di tutte le virtù cristiane.

L'estinta, nata in seno della nobile famiglia Forte di Lapio, non smentì le gloriose tradizioni del suo illustre casato, e fu veramente il tipo della donna forte descritta da Salamone, essendo stata un perfetto esemplare di figlia, di sposa e di madre. Cattolica fervente, tutta carità e tutta zelo, appartenne a tutt'i sacri sodalizi esistenti nel suo Comune, ed anche al Terz'Ordine di San Francesco, e di essi, come una claustrale, osservava esattamente le regole.

We are profoundly moved to impart to our readers the unpropitious news of the death, which occurred this past month of November in Boston, of the pious woman, Donna Giovannina Iorio born Forte, whose life was a continuous exercise in all of the Christian virtues.

The deceased, born in the bosom of the noble Forte Family of Lapio, never ceased to uphold the glorious traditions of her eminent heritage and was truly the type of strong woman described by Solomon, having been a perfect example of daughter, wife and mother. A fervent Catholic, full of charity and zeal, she belonged to all of the existing sacred sodalities in her community, even to the Third Order of Saint Francis, and in them, as a devotee, she observed the rules with precision.

— Giovannina's obituary from *La Campana del Mattino*, Naples, January 25, 1910

Activism or Status Quo?

Work in the factories was dismal – 15-hour days for an average of $6.76 per week in 1910. In the infamous Triangle Shirtwaist Factory fire (1911), 146 Italian and Jewish women perished because they were locked-in by their employers! Almost all were the main providers for their families.

4. Triangle Shirtwaist fire.

Many women organized within the labor movement, and some even formed anarchist-socialist *gruppi femminili*, following the exhortation of Maria Roda, a silk-mill worker, "because we feel and suffer; we too feel, from birth, the need to be free, to be equal."[2] These groups sought to bring the emancipation of women to the forefront of labor debate. Many became members of the Industrial Workers of the World (IWW) in order to gain a voice in the American union movement. In 1919, the International Ladies' Garment Workers' Union was part of the successful strike for a 40-hour work week. It was the mill women who created the slogan "We want bread and roses too," during the Lawrence, Massachusetts textile strikes.

5. Italian Woman carrying sewing home.

She [my mother] sent us money [to Italy] every month. She was working in a glove factory. In fact, I got in [to New York] on Sunday, it was Easter Sunday. That was April 3rd. The following Wednesday I went to work in a glove factory. There was a man, he had leather palm, and then you sew the fingers, you know, with the machine. You know, a sewing machine. He had the sewing machine. So it was only a couple of days, I went to work. They were all Italian people. They spoke for me.

— Mary Sartori Molinari, born July 18, 1901, Northern Italy; came to the United States in 1920, age eighteen, passage on *La Savoie*[3]

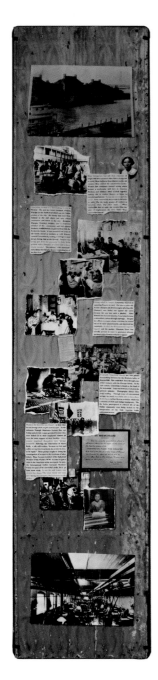

"VOICES"—Ellis Island Interviews

He worked in a factory and he would bring home homework and he would, he worked hard. And he was kind of frail and you live in…I think he used to sit on the kitchen table and put his feet on a chair to be closer to the light overhead and he would sew on collars, men's collars. And my mother would help, help him when he'd bring the homework home. And then she would have her own work during the day. She would work on, I think they were dresses. She would sew beads on the dresses and they used to have this, they call it "caralla," it's like a board that they put up in the kitchen, and they would, she would work on that. And then she would have homework for us, my brother and I. We would sew a little, they're little doilies and flowers that you would sew. It's like piecework they used to do. Before we'd go out to play we had to do that type of work. So that's about it. And then she would let us go out to play. My brother was pretty good, in fact, in sewing.

—Madeline (Maddalena) Polignano Zambrano born November 9, 1915, Putignano, Bari[4]

I talked to my cousin and he, he was here about four years before me and he was a die and toolmaker. He was working in a factory in Greenpoint, Brooklyn. Die and toolmaker and he was making twenty-four dollars a week. He was a good mechanic. And he got me a job to work with him in the factory, to pick up the trade, the die and toolmaker. So I went to work with him, he got me a room downtown in New York, in the Bowery. That's the worst place you can get a room. You should have known, those days, not today, I don't know what it is today, but that was, in those days, the worst place to live, the worst people to live. So, he got me a room there and I was working for him and I had to take a train to go to Brooklyn, to the Greenpoint, to go to work everyday. Got to buy my own food, my own laundry, I could not, eight dollars wasn't enough. So I talked to the foreman, I says, "I can't work here. I got to quit. Eight dollars is not enough." So he give me ten dollars, and ten dollars wasn't enough. He give me twelve dollars, and that just about make it. So I figured, it's no good. I went to see the Italian Consul somewhere in New York. I tell him I wanted to go back to Italy. He says, "Okay," he ask me where I was staying. I tell him down the Bowery. I give him the number, the address, right under the Third Avenue in the Bowery. [he laughs] I can never forget that. I used to cry in the evening. It's like, it's like you're dead. You hardly, you can not only make a living. So he said, "Okay," he told me, "as soon as we have a boat, as soon as we get a room on the boat, we'll call you, send you back to Italy." He agreed to send me back.

No, I wasn't happy at all. I wanted to go back to Italy because, see, up to this point I was making a better living in Italy, and I couldn't see why they talk so good about the United State, where if you don't have a job, which it wasn't easy to get a job, if you don't have a job you're starving to death! what I did most of my life.

—Carmine Martucci[5]

6. *Column of History III: Work.*

Ties to the Home Country

Although the first years were arduous, most immigrants remained in America and consistently sent support payments to their families in Italy. This influx of foreign money actually helped to stabilize the struggling economies of the rural hill towns. At one point, the Italian government actually favored mass emigration in order to alleviate its own responsibility for the depressed socio-economic conditions.

Men often labored for long periods before earning enough to pay the passage for their wives and children. In Italy, the children of immigrants were often derogatorily called *figli d'Americani* and their mothers were "white widows" because they acted as heads of the families in their husbands' absence. Many people in Italy longed to come to the "promised land," and inevitably there was also some envy because of the greater possibilities available to relatives of immigrants who received precious American dollars.

When Pop wrote to us that the papers were all ready and he sent the papers over for us to fill out and all, we were very excited about coming here. And our friends started to make fun of us, now we're going to be Americans, and we're going to have to learn how to eat raw tomatoes [she laughs] because we didn't eat raw tomatoes, and we would try to eat them, but they just wouldn't go down. And I had such visions of always being dressed in very frilly dresses and having patent leather shoes, and the streets would be paved with gold. We were so disappointed when we got here.

—Renata Nieri Maccarone, born November 14, 1919, Northern Italy; came from Italy in 1929, age nine, passage on the *Augustus*[6]

Give me your tired, your poor
Your huddled masses yearning to breathe free,
The wretched refuse of your teeming shore.
Send these, the homeless, tempest-tost to me.
I lift my lamp beside the golden door.

—*Emma Lazarus*

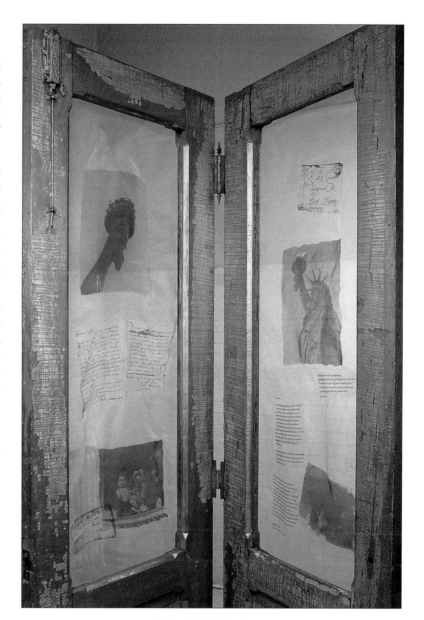

7. Detail of *Golden Door.*

Letters

Carissimo figlio,

Non puoi immaginarti quanto siamo stati contenti nel ricevere la tua cara lettera, non stare in pensiero per il denaro che l'abbiamo ricevuto, non solo le L 25 ma anche le altre L 5 che ci hai mandato. Erano state prese da un altre Decunto Vincenzo, ma però ci sono state restituite. Un' altra volta ad evitare questi sbagli mandali intestati a Miraglia Mariu fu Leonardo, ma del resto mio caro figlio non pensare al denaro perché noi amiamo il sangue e siamo contenti di ricevere tue lettere spesso ed anche senza denari non importa.

Tu dici che hai piacere di rivederci, ed anche noi però ti vorremmo vedere anche tanto ricco secondo la tua intenzione, e speriamo che Iddio te lo conceda. Se decidi di venire in Italia, farci sapere il mese. Non puoi sapere quanto piacere abbiamo avuto nel sentire che ti rivedremo, poco n'e' mancato che non siamo svenuti, tu ce lo dici, però a noi sembra un sogno. Del resto, il Signore ti faccia guadagnare bene, e così ti potremo rivedere. Non altro noi di salute stiamo bene e non mancare di ricordarci quando Iddio ti provvede. Ricambiaci i saluti a Clementina; dalle sorelle non abbiamo avuto lettere; se le scrivi non mancare di ricordarle che ci scrivessero spesso. Sante Benedizione siamo I tuoi cari genitori.

Affma.

—Vincenzo e Mariantonia

Dearest son,

You cannot imagine how happy we were to receive your dear letter. Do not be concerned about the money which we received, not only the L 25 but also the other L 5 which you sent. They had been claimed by another Vincent De Cunto, but they have been reinstated. In order to avoid these mistakes another time send them in the name of Mariu Miraglia, fu Leonardo; but for the rest, my dear son, do not think of the money because we love our blood [family] and we are content to receive your frequent letters and even without money, it doesn't matter.

You say that you will have the pleasure of seeing us again, and also us. However, we also want to see you as rich as you desire, and we hope that the Lord will grant you this.

You talk of coming to Italy. Let us know the month. You cannot know how much pleasure we had in hearing that we will see you again. We almost fainted. Although you told us, it still feels like a dream. As for the rest, may the Lord help you to earn well so that we can see each other. We are in good health and do not forget to remember how much the good Lord gives you. Please exchange our greetings with Clementina; we haven't had any letters from the sisters; if you write to them don't forget to remind them that they should write to us often. With benedictions we are your dear parents.

Affectionately,

—Vincenzo and Mariantonia

This letter on the center panels is dated 1910 from Vincenzo and Mariantonia De Cunto to their son, Ralph, who had emigrated from Potenza, Italy to Boston, Massachusetts. He never saw them again.[7]

Concettina's Story

Concettina worked in a dressmaking factory in Boston. She met her future husband, Ernesto Piscopo, in the North End, which was the Italian section of the city. His family had come from Taurasi in the mid-1800s and now owned restaurants and hotels in the city. The De Iorios had known relatives of the Piscopos in Italy.

Benjamin Piscopo, Ernesto's brother, was a respected member of the community and had opened business establishments in partnership with the Fredericks family. It was rumored that some of the hotels may also have served as brothels, which were a fact of immigrant life at the time since there were so many single men. Ernesto courted Concettina by sending a carriage to meet her at the factory at closing-time. Imagine this young girl from the provinces in Italy being greeted with a bouquet of violets and a horse-drawn carriage! The delicate *viole mammole* were always her favorite flowers, reminding her of her first love.

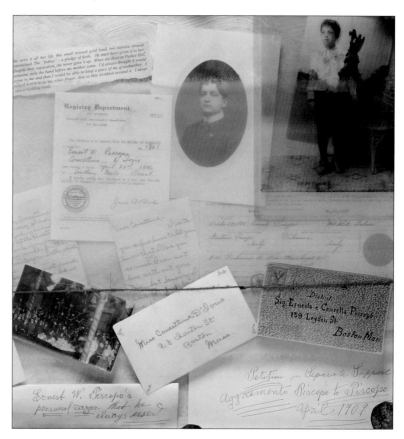

8. Love notes from Ernesto to Concettina; De Iorio-Piscopo marriage certificate; postcard from American International College with Concettina seated on far right; first letter from Italy to Ernesto and Concettina as man and wife.

39

Letters

Dear Concettina:

I write you a few lines to let you know that I love you so much that I cannot live without your love, but knowing I have got your love I live happy.

I will be up the house to see you to-night between 7-8-o'clock. Give Mamma and Annie my best regards.

I remain Your Loving Sweetheart,

—E.W. Piscopo

P.S. Scriveto anche voi una lettere, carissima bella Concettina
[Write a letter to me as well, dear beautiful Concettina].

* * *

Dear Concettina,

I am very glad you enjoyed yourself last night at the theatre and I thank you and Annie very much for the presents you both sent me. Mamma ti saluti a tutto [Mama sends regards to all].

* * *

Cara Concettina,

È lungo tempo che ho avuto l'onore di conoscervi, e pur tuttavia non mai ardito di farvi nato l'immenso amore che nutro per voi. Un silenzio più lungo sarebbe per me un tormento, permettete quindi che i sentimenti dell'anima mia, e lasciatemi la lusinga di poter un giorno ottenere la vostra mano. Incoraggiato da una risposta favorevole, mi farò un dovere esporre ai vostri genitori la sincerità dei affeti e le mie intenzioni sull avvenire. Acconsentite chi io vi esprima ancora una volta I sensi della mia più alta stima e credetemi,

Vostro,

—Ernesto W. Piscopo

9. Love note and election card, Ernest W. Piscopo.

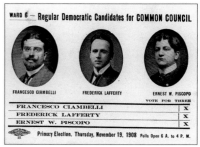

Dear Concettina,

It is some time since I have had the honor to make your acquaintance, and still nevertheless I have not dared to let you know of the immense love which I nourish for you. A longer silence would be a torment for me, therefore permit that the sentiments of my soul [exist], and allow the illusion that one day I may obtain your hand. Encouraged by a favorable response, I will make it my duty to display the sincerity of my affections and my intentions regarding the future to your parents. Please accept that I express to you one more time the sense of my highest esteem and believe me.

Yours,

—Ernesto W. Piscopo

10. *Following the Thread IV: Concettina De Iorio.*

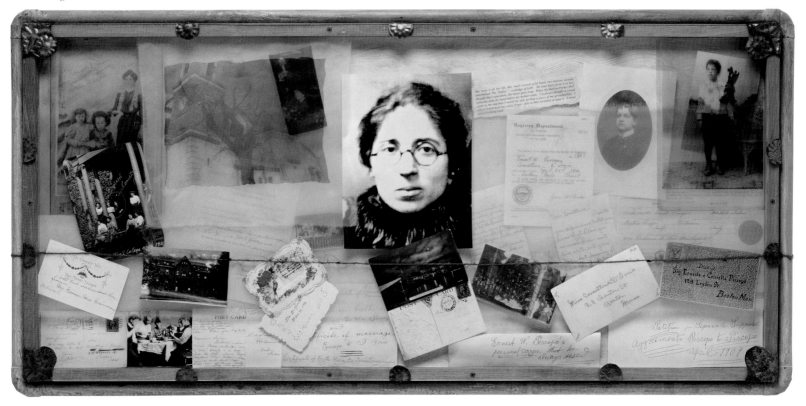

| Postcards from American International College days | Concettina's birth certificate, October 14, 1884 | | Marriage DeIorio-Piscopo, April 22, 1906 | Birth certificate for Ernesto, October 19, 1885 |

Envelope with various birth certificates

Love notes from Ernesto

Envelope with Petition for Separate Support

Greeting card for Concettina's nameday from her godfather, Davide Abbate Forte December 8, 1911

Envelope with Ernesto's "personal razor that he always used"

Ancestor Scroll: Concettina De Iorio

My grandmother's favorite color was red but she always wore black. Her whole life was ruined by her marriage to a man who betrayed her over and over again until she finally got a legal separation from him. Throughout my childhood she "lamented" her ill fortune. I was her favorite and listened to her stories hour upon hour in the attic filled with row after row of trunks and boxes piled high with covers of colored fabric. Light filtered through small windows and each sill was filled with plants which she spent hours watering. My grandmother had great will and she dominated us all. She'd bought the Gladstone Street house when it looked like a castle of stucco with shining mica in the mix. My mother collected handfuls after the rain when she was a child. She was a woman alone her whole life because the Catholic Church forbade her to remarry and so her bitterness tinged all life around her. She willed my mother to be her daughter – living together their whole lives save for a few months my mother had alone with my father in Washington, D.C., after her marriage. I was her "little sunshine" and she paid for my piano lessons so I could play the "Ave Maria" for her. She always said, "Where there's a will, there's a way," and probably if it were not for her teaching and example, I'd never be an artist because it was so hard to support myself and the kids as well as develop the work. She had an iron will, was completely dedicated to the morals of her landed gentry culture, always the lady, "Donna," who would "comandà." She traveled back to Italy with my mother when my mom was five, staying two years, then returning to America for the next thirty-two years, leaving the family home in the hands of a caretaker who allowed it to deteriorate unbeknownst to her. He even sold off some of the objects stored in the house. She was the dominant core of the family and became gentler in older days, often talking of the "via di mezzo" (the middle way), dying in a nursing home with only one leg – her precious twisted-gold "fedina" stolen off her dead finger. When we last said good-bye, I told her that I'd always loved her and she said "me too." She was my real mother on some level, cradling me when I came home from hospital, comforting me when my mother's milk made me sick. She is the reason I feel as Italian as I am. Her life had a lot of pain bundled up inside her, no place to put it except in all of her small perfect stitches. She looks straight on out of the photos, always proud.

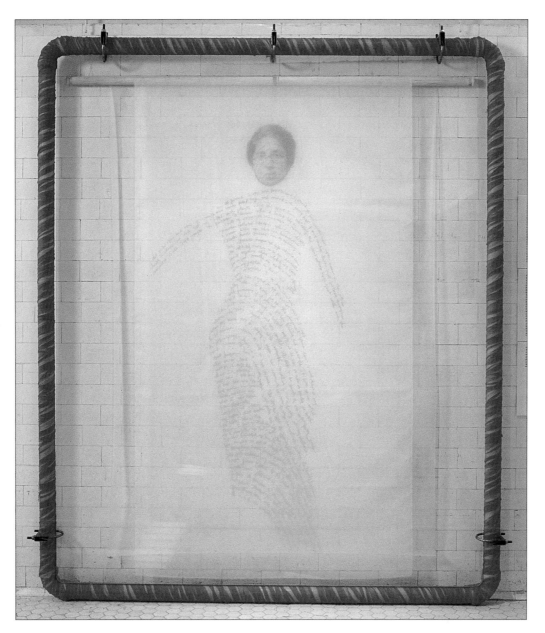

11. *Ancestor Scroll: Concettina De Iorio.*

Concettina and Ernesto – A Broken Heart

Strong-willed by nature, Concettina insisted on marrying Ernesto in 1906. She was twenty-two years old. It was a decision she lived to regret all of her life. Ernesto's own father was against the union because his son was such a playboy. Since Ernesto was born in America, Concettina became a naturalized citizen through marriage. Despite her efforts to create a home with him, he turned out to be most untrustworthy and deceived her constantly. In 1909, she filed papers for separate support and his mother, Filomena Vesce, was actually present in court to guarantee alimony payments since Ernesto refused to appear.

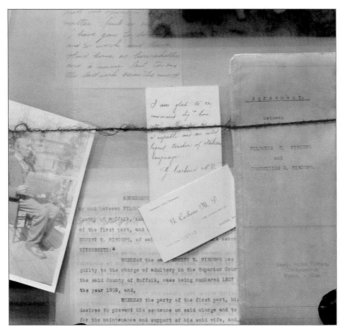

12. Petition for Separate Support, which Concettina filed against Ernesto three years after they were married.

Agreement made this first day of April,, A.D. 1909, by and between FILOMENA V. PISCOPO, of Boston, in the County of Suffolk, and Commonwealth of Massachusetts, party of the first part, and CONCETTINA D. PISCOPO, wife of ERNEST W. PISCOPO, of said Boston, party of the second part,

WITNESSETH:

WHEREAS the said ERNEST W. PISCOPO has pleaded guilty to the charge of adultery in the Superior Court for the said County of Suffolk, case being numbered 1307 for the year 1909, and,

WHEREAS the party of the first part, his mother, desires to prevent his sentence on said charge and to provide for the maintenance and support of his said wife…shall pay six(6) dollars per week every four(4) weeks as well as a fine of $100.00

—Text of legal Separation Agreement between Concettina and Ernesto

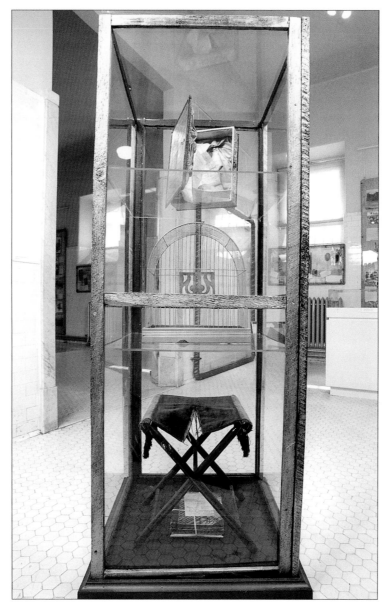

13. *Reliquary to a Broken Heart:* Contains letter from Ernesto to his lover; his love-notes to Concettina; Ernesto's schoolbooks from the private Allen School, West Newton, MA; birdcage, which is a symbol of Concettina's beloved canary; Victorian camp stool.

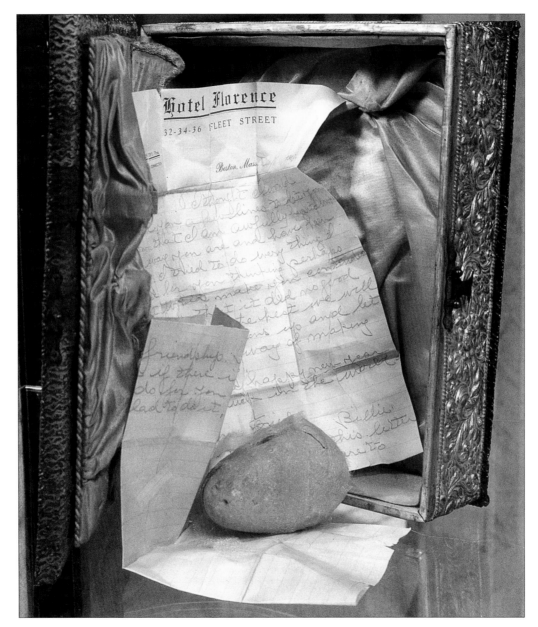

14. Ernesto's letter to lover written on Hotel Florence [a Piscopo hotel] stationery. Ernest's full name was Ernest William. His nickname was Billie in certain circles.

Ernesto's Letters to One of his Lovers

Boston, Mass. Dec. 31, 1913

Dear Margaret,

I thought I would write you a few lines to let you know that I am awfully heartbroken the way you are and have been acting. I tried to do everything I could for you thinking perhaps that would make you contented but I see that it did no good so if it is for the best we will break our relations up and let you try your way of making yourself happy.

Wishing you a happy new year and all the luck in the world. I remain

> *—Your friend, Billie*

P.S. Remember Margaret by this letter I do not mean that we are to break our friendship because at any time if there is anything I can do for you I will always be glad to do it.

<p style="text-align:center">* * *</p>

Margaret,

Don't go out for the night. I will see that you get enough, Bill

15. Back of Ernesto's letter to his lover, which has been torn and pieced together.

Ancestor Scroll: Ernesto Piscopo

My grandmother never talked about the man who married her – oh, just a bit about when they first met. He would send her "viole mammole" and sometimes pick her up after work in a horse and buggy. He was born in America but came from a family with origins in Taurasi in the province of Avellino. When I was in Italy in 1962, Taurasi had gotten electricity only a few years before, in the 1950s. Ernesto had gone to private schools in Massachusetts but despite these opportunities he turned out to be a gambler, a womanizer and a dishonest man. My grandmother insisted on marrying him. Even his father visited my grandmother's father and said "It's better that you put your daughter on the street than have her marry my son!" My grandmother was stubborn and she married him anyway. His family was wealthy but when she was angry she called them "cafone" – to her that meant that they had no breeding. My grandmother was a "Donna" – she came from a landed-gentry family in Italy – so, by marrying him, she married "beneath her class" but she said that she loved him. His family, Piscopo, owned many of the restaurants, hotels and brothels in the North End and half of Laconia, New Hampshire. My grandfather would take the money to deposit at the bank and make off with it. My grandmother would find notes in his pockets from other women. He was always going off without telling her. At one point in their lives together, he even gave her a venereal disease. She ultimately got a legal separation and left him. I saw him only once – in his coffin. We went to his wake together, my grandmother, my mother and I. He had one leg, and ended up living with the maid of his family. They had four children, and, in later years, he had a candy store on a corner in Roxbury. My mother rarely saw her own father. When she was in college she would sneak in a visit now and then. She grew up without a father. My grandmother saved everything, but there is no wedding picture of them. There are his schoolbooks from the private Allen School in West Roxbury, Massachusetts, a few early letters and a newspaper clipping that says that he was caught passing a bad check. The Piscopo name, carved in a granite lintel, may still be seen on Fleet Street in the North End of Boston. His family has the biggest gravesite and monument in the cemetery.

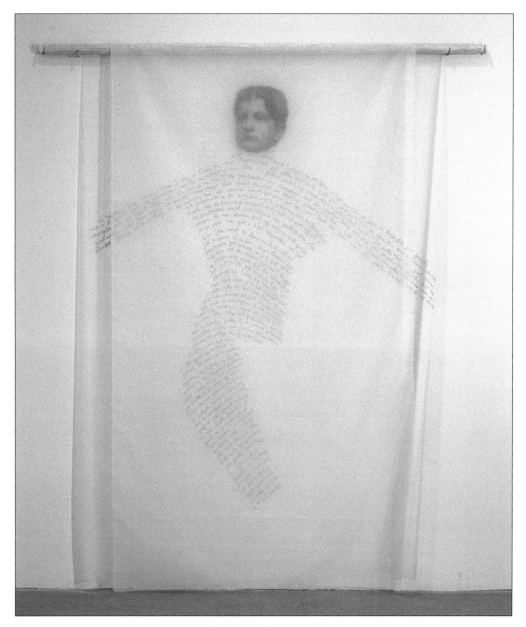

16. *Ancestor Scroll: Ernesto Piscopo.*

Education: But Not for Everyone

Education was a precious commodity for most immigrants. Some children studied at home or in settlement house schools – learning not only reading and writing but also the proper ways to keep house (American-style), care for children and even make a proposal of marriage! The majority of children had to help support the family by doing menial work at home and therefore attended school part-time or not at all.

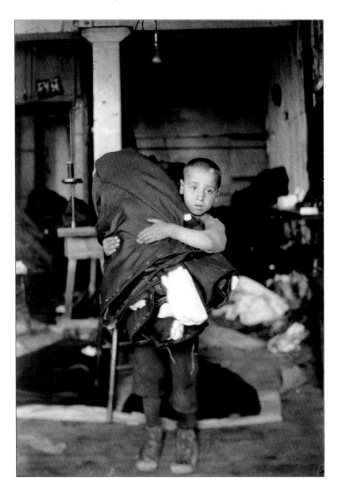

17. Boy carrying homework from New York sweatshop, 1912.

"VOICES"—Ellis Island Interviews

My father was very strict, yeah. And he wanted, in his mind, he wanted me to go to work, because when he registered me up at Town Hall, he put that I was a year older than I was. Now, this is over here. I must have been about fourteen years old, and my father wanted me to go to work

But I wanted to go to school. The principal of the school over here in Hopedale came up to the house and wanted to know why my father would not send me on to school. I was a very intelligent girl. I loved school. I loved history, I loved geography, English. And it just, abruptly, everything stopped.

I went to work in the elastic shop in Milford. It was a big loom. It scared the dickens out of me. And I worked there for two days. Then they wanted my birth certificate, because they knew I wasn't old enough. I never went back. I didn't get my birth certificate and I never went back. And my father was angry, and too bad, I didn't go. I took care, I stayed home and took care of my sister, because she was born then. My mother always ailed. She was ailing. My mother ailed all her life.

—Dena Ciaramicoli Buroni[8]

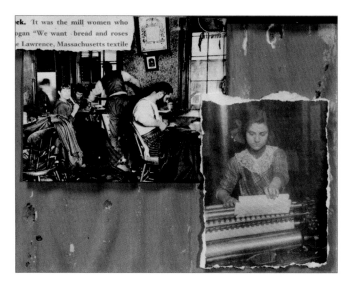

18. Tailor shop and mill girl.

"VOICES"—Life line Interviews

I went to work very young and my father wouldn't even let me finish high school. It was pretty common. Sixteen, out, go to work. He was the only worker with six children. I understood that. My first job was three dollars a week, cutting threads. That's after the operator finishes with the garment, you look at it and you cut all those long threads that are on it, you know. Now, they don't do that; they just leave the threads.

I had to bring in my whole salary. Then he gave me an allowance, a quarter a day. You ride the subway, five cents. With a quarter you rode the subway back and forth and you had lunch. But then, as I worked a few years, I got smart. I said to my boss, "Give me two envelopes, one for my father and one for me." I was a piece worker so he didn't know what I made. Hey, you know, you had to survive.

—Catherine D'Alena Villanova[9]

"VOICES"—Ellis Island Interviews

I didn't finish. I only went to two years of high school because I could not get any clothes or any new things. My brother really wanted me to continue school and go to college. I wasn't stupid but I just couldn't see that at all because I needed to have a little independence so I felt like money would give it to me. And so after two years of high school my friend and I who started school together also quit school together. We went to business college and went to work. And what a great feeling it was to give my mother money but we were always then able to keep money to buy clothes, to go to the show and do things like that. It was a different world.

—Elda Del Bino Willitts[10]

Well I started school in those two years that we were in New York. And I have very little recollection of the school except that I would sit there and not, not realize what was going on at all. And finally one day, my father refused to have any other papers except English, American papers, newspapers. He was going to learn and he refused to have any other, any Italian papers in the house. So that I would look at the papers that he would buy. And he would, he used to buy, I don't remember now what the paper was but it was a paper that ran a lot of pictures because with the pictures it would help him understand what he was reading.

So I would, of course, would look at it and of course, I would look at what I now know were comics and I would try to figure out what the comics said. And of course, I was going to school. And I can still, remember, Janet, to this very day, the day that I read and I knew what it meant. It was like a revelation to me, to be able to look at those words and I KNEW what it meant. To this day I can still remember that. Yeah. So it was like, it was like a whole opening of a new world to me, the fact that I KNEW what I had read.

—Felicita Gabaccia Salto, born August 30, 1913, Masserano, Italy; left at age six on the *Dante Alighieri*[11]

Young Entrepreneurs

Many children at eleven or twelve years of age peddled wares from door to door or sold consignment goods off pushcarts. "Street Arabs" were orphans even less fortunate who were crowded-out of the tenements onto the streets. Enterprising and independent, they sometimes moved into the Newsboys Lodging House where they could get a loan to start businesses as bootblacks or newsboys. Italians, with their strong focus on family, contributed the least of all immigrant groups to this practice of putting children out on their own – less than 2 percent in 1900 according to reformer and journalist, Jacob Riis.

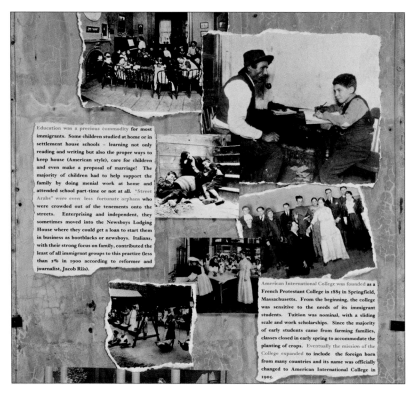

Education was a precious commodity for most immigrants. Some children studied at home or in settlement house schools – learning not only reading and writing but also the proper ways to keep house (American style), care for children and even make a proposal of marriage! The majority of children had to help support the family by doing menial work at home and attended school part-time or not at all. "Street Arabs" were even less fortunate orphans who were crowded out of the tenements onto the streets. Enterprising and independent, they sometimes moved into the Newsboys Lodging House where they could get a loan to start them in business as bootblacks or newsboys. Italians, with their strong focus on family, contributed the least of all immigrant groups to this practice (less than 2% in 1900 according to reformer and journalist, Jacob Riis).

American International College was founded as a French Protestant College in 1885 in Springfield, Massachusetts. From the beginning, the college was sensitive to the needs of its immigrant students. Tuition was nominal, with a sliding scale and work scholarships. Since the majority of early students came from farming families, classes closed in early spring to accommodate the planting of crops. Eventually the mission of the College expanded to include the foreign born from many countries and its name was officially changed to American International College in 1905.

19. Children at a settlement house school; Italian father and son, Pietro, studying at the kitchen table; detail of newsboys sleeping on a stoop; lesson on how to make a proposal of marriage.

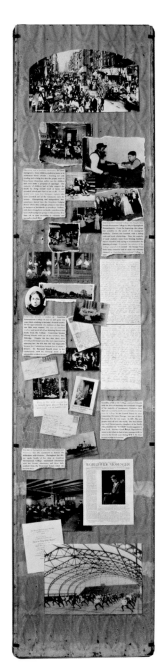

20. *Column of History IV: Education.*

College for Immigrants

American International College was founded as a French-Protestant College in 1885 in Springfield, Massachusetts. From the beginning, the college was sensitive to the needs of its immigrant students. Tuition was nominal, with a sliding scale and work scholarships. Since the majority of early students came from farming families, classes closed in early spring to accommodate the planting of crops. Eventually the mission of the college expanded to include the foreign-born from many countries and its name was officially changed to American International College in 1905.

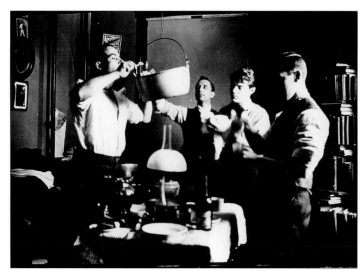

21. A humorous postcard depicting International College students "cooking" over an oil lamp in the dormitory. Inscription on back reads: "From the life of a student, January 1, 1914."

Clasp Hands across the Sea (a song for Alma Mater)

*We've gather'd here in College halls From lands across the sea;
We feel the human tie that binds our hearts in unity;
But oh! We long that those we've left in lands beyond the sea, the
blessings of this land whould know: Love, Truth and Liberty.*

*From vineyards in Italia's vales, Bulgaria's rugged heights, From
Greece, of famous classic tales, from Turkey's toils and plights,
From Russ and Ind and China vast to Sweden's frozen sea, From
Spain and France with trumpet blast we shout for Liberty.*

*Hurrah for A.I.C., for Truth and Liberty! For brothers
from all lands are we: Clasp hands across the sea.*

—Words and Music by Rev. R. De Witt Mallary, D.D.,
President American International College, 1908–1911

Concettina's New Life

During one of her many periods of separation from Ernesto, Concettina became a student at American International College and spent two years there from 1911–1913 studying to become a French teacher. Of the approximately one-hundred students at that time, one fifth were women. She was an excellent student and saved all of her debating themes and books from the college.

Concettina became lifelong friends with one of her teachers, Mrs. Frances (Fannie) Eldredge. Despite the fact that there were several professional men who were interested in marrying her, she felt that this was impossible because her Catholic religion forbade her to obtain a divorce. Dr. Raymond Bonelli, a widower who had also emigrated from Lapio, was one of these suitors and wrote to her continuously until his untimely death in an automobile accident in 1923.

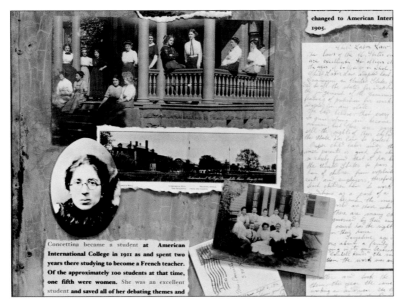

22. Concettina in photographs taken at American International College. She is the third from the left in the photo on the porch, arm-in-arm with her best friend, Arete Sarantopoulos; her theme on the subject of child labor; a postcard from Mrs. Eldredge.

Anson Hospital, Panama

October 6, 1912

My dear Mrs. Piscopo

Your letter of Sept. 15th received and I am very glad to hear from you. Am especially glad that you have gone back to school and that you are so interested in your studies. It is certainly a fine selection of subjects you are taking this year. I wish you the best of success.

You must try and explain to yourself what the cause of that unhappy feeling is and try to get rid of it. You are now no child so that you need somebody else's assistance in doing this. My own experience of life has taught me that the best thing to do is to paddle my own canoe and never to depend on other people's assistance. Of course, there are a few, very few, friends we can trust.

I am getting along famously, thank you; besides, am expecting a fairly good, promising future.

Am very glad your father and sister are well; give them my best regards. I shall always be glad to hear from you and always remain

> *Your true friend,*
>
> *—Bonelli*

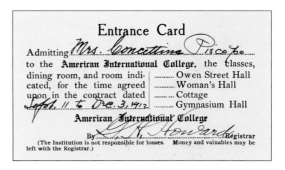

23. Concettina's AIC enrollment card, 1912.

Boston, Mass.

April 12, 1923

Dear Concettina:

Your departure for the "Old Country" came to me as a great surprise. I really did not know of it until you were already enjoying the Neapolitan Moon. It must be wonderful to see dear Lapio and the surrounding country: the land of our nativity and childhood. I wonder how many sweet memories have by now crossed your mind. I can imagine all these things—and how I crave to come there someday—But, Alas! A craving is just a craving, subject to destiny, and who knows what destiny has in store for us?

Although your note is quite brief, I do draw from it that you all must be enjoying yourselves happily—It is my sincerest wish that all of you are enjoying yourselves very much and that your happiness is unlimited.

You have escaped the severest winter in Boston's history—plenty of snow and plenty of extremely cold weather to which lack of coal added to the misery of the people; therefore, disease abounded. But at last a belated spring has set in and most of us have already forgotten the hardships which "Jack Frost" handed us—Other than this happenings in Boston are of little or no interest to us both, so I shall eliminate them and here end my short discourse—I repeat my desire for an enjoyable and happy sojourn there and an enjoyable and happy return to Boston soon, when we shall be glad to greet you:— "Welcome back"—

> *Sincerely,*
>
> *—Raymond P. Bonelli*
> *261 Hanover St.*

Dr. Bonelli's last letter to Concettina before his death.

24. Copy of *Worldwide Messenger,* the AIC Alumni news, with photo of Mrs. Eldredge, who was the Editor and also Concettina's favorite teacher and friend. Concettina had written a note regarding a former classmate on the upper left-hand corner.

College writing

Concettina became a member of the Debating Society and wrote many lively pieces on such topics as the American Constitution, Child Labor Law, etc. Her major area of concentration was the study of the French language, as it was her fond hope to become a teacher of French. She also wrote creative themes and composed poetry. It is interesting to note her increasingly more skillful grasp of the English language as she progressed in her studies.

Making Money

When we think that money are valuable in themselves we are partly mistaken, because the money in itself do not have much value except metal of which they are made, and paper money have no value at all, but it only represent money.

Bills of silver and gold only show us that gold and silver was deposited to purchase them. Bank-notes tells that money has been deposited in the bank and it will be paid on demand; but to do this the bank had to deposit a certain amount of money to Uncle Sam, so their promise cannot fail.

We have also "greenbacks" and "treasury notes"; they too represent money and they assure us that they will be paid in coin at any time we should ask.

—Excerpt from Concettina's theme, *Making Money*

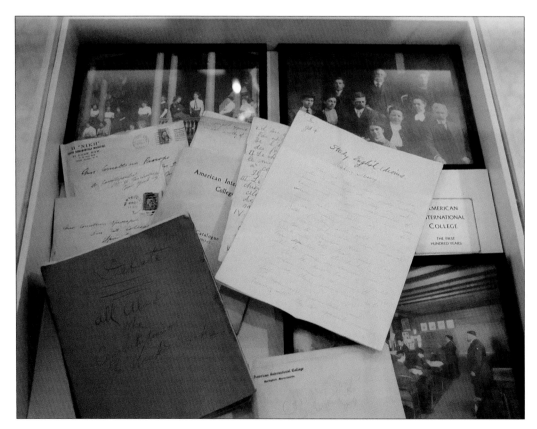

25. *American International College Installation:* debating books; photos of Concettina's professors; Prof. Giroux teaching French; her collection of A.I.C. songs; letters from Arete; A.I.C. catalogues from 1911–13; her original theme on *Making Money.*

Child Labor Law

The laws of the U. States on child labor are excellent. It obliges children between the ages of 6–11 to go to school. The Uniform Child Labor Law adopted last summer by the Commission on United States Laws and recommended to all the states for adoption, embraces in the judgment of the Commission the best features of protection for working children adopted in any state.

The law believes that every child has the right to grow strong and become a useful man or woman, but there are parents who would sell the rights of their children, therefore the State has law to protect them.

Proper child labor under the guidance of wise parents is good for children, but this is so rarely found that it has been necessary for the United States to pass laws for the protection of children from exploitation by both parents and employers, therefore the school must teach children how to work under proper conditions as a part of a sound and rounded education because the most useful people in the world are those who have been educated. There are many children that cannot be governed by their own parents, in such case the court has the right to take them away from their home.

Sometime ago I read in New York newspapers about a family that last year was sewing in its own tenement the stuffed legs on "Cambell Kids." The manifacturer who gave them the work was angry about the matter and took the work away from them. This year the same family was found working on underwear. The three children belonging to the family, the oldest of whom was eleven years old, testifyed before the New York State Factory Investigation Commission that the three of them had to run the ribbons in a dozen of corsets cover in order to earn three cents. They said that their mother earned twice that amount and their father was blind. One of the three little girls said to Miss. Watson of the Commission that she had no time to play because she had to help her mother every day until eleven o'clock at night. Isn't this pitiful to think of? This little instance shows why the law of the U.S. requires the parents to see that their children go to school and if the parents disobey this law they may be arrested and fined. Moreover if a child is employed at hard work a certain number of hours he cannot grow strong and the consequences may be disastrous.

In nearly all these states, it is a law that no child under working age shall be employed to work, but if it happens so the employer of the child may be arrested. For all these reasons, I feel that everybody should praise highly the precious laws of the United States.

—Concettina's theme on the Uniform Child Labor Law

26. *Child Labor Law.*

Ricordati

Ricordati di me quando la sera
La squilla suonerà della preghiera
Ed in quell'ora solitaria e pia,
Una prece per me volgi a Maria.

Ricordati di me quando ritorno
Farà il sole nel cielo. Il nuovo giorno
E di natura il più bel sorriso
Prega ch'io mai da te non sia divisa

Ricordati di me quando la luna
Chiara risplende sopra l'onda bruna
Ed impetra pace al mio dolente core
Che per te solo palpita d'amore.

Ricordati di me quando sul lido
Torna il nocchier lasciando il flutto infido
E prega che nemico vento mai
Rompa ti possa la fè che ti giurai.

Ricordati di me quando di morte
Schiuse vedrai per te le eterne porte
E dispogliato dal terrestre velo

Spirto immortale salirai nel cielo.
Allora ottieni dal pietoso Iddio
Che ascendere lassù potessi anch'io
E uniti negli angelici splendori
E far soglia un sol cor dei nostri cori.

Concettina

REMEMBER

Remember me when in the evening
The tolling (of the bell) sounds for prayer
And in that solitary and pious hour
Send a prayer for me to Mary.
Remember me when the sun
Returns in the sky for a new day
And with the most beautiful smile
Pray that I will never be separated from you.
Remember me when the moon
Shines clearly on the dark wave
And entreat peace to my sorrowful heart
Which quivers with love only for you.
Remember me when on the shore
The boatman returns leaving the untrustworthy fruit
And pray that a hostile wind
Will never break the faith I swore to you.
Remember me when in your death
You will see the eternal gates opening for you.
And loosed from this terrestrial veil
As an immortal spirit you ascend into heaven.
Then obtain from a merciful god
That I, too, can ascend up there
And united amidst angelic splendors
We will make of our two hearts one threshold.

27. This poem was found among Concettina's most personal papers. It is not clear whether the words are her own or copied in her hand from another source. There is no attribution of authorship, only her name, Boston and the date Sept. 9, 1911. Although this is not addressed to anyone in particular, one assumes that it was probably sent to Ernesto just before she began to attend A.I.C. It was found amidst other notes both to and from him.

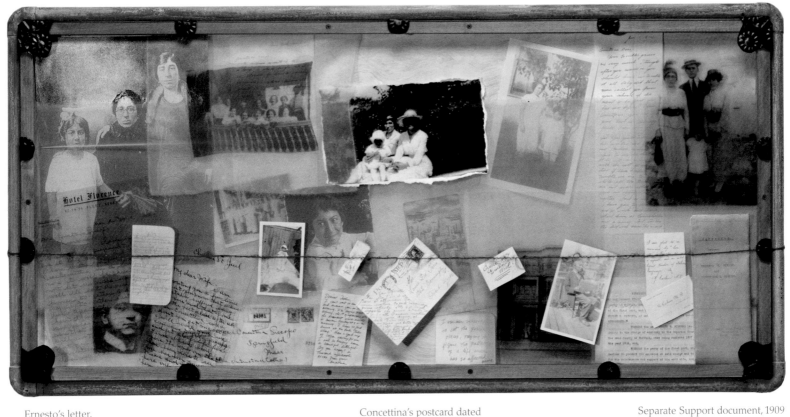

Ernesto's letter,
Florence Hotel,
December 10, 1912

Ernesto's letter,
Charles St. Jail, 1915

Concettina's postcard dated
August 31, 1917, telling of
Nina's birth in New York

Concettina's will and notes

Separate Support document, 1909

Arete's letter, January 1, 1914

Recommendation for
Concettina as Italian teacher

International Student Community

Gentility of life at American International College contrasted sharply with the lives of hardship and continual struggle of the majority of immigrants. Statistics show that only 11 women and 83 men of Italian heritage were in college in the United States in 1910.[12] For two years, Concettina De Iorio Piscopo was one of these fortunate few.

At college, she met people from all over the world. Her best friend was Arete Sarantopoulos, daughter of the family who published the "H NIKH" Greek magazine in New York. Another friend, Kyparissiotis, wrote to her when he had to leave unexpectedly to serve in the Greek army during World War I. He later became a judge in America. Throughout her life, she spoke fondly of her time at A.I.C., maintained friendships with her former classmates and drew daily comfort from the Protestant hymns, in particular "Rock of Ages," which she learned there.

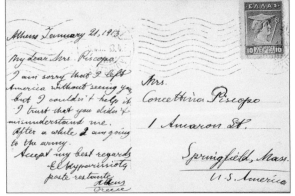

29. Kyparissiotis postcard, front and back.

Athens, January 21, 1913

My dear Mrs. Piscopo,

I am sorry that I left America without seeing you but I couldn't help it. I trust that you didn't misunderstand me. After a while I am going in the army. Accept my best regards,

> *—El. Kyparissiotis*
> *poste restante <u>Athens</u>*
> *Greece*

To be or not to be—Together?

Her days at Springfield were filled with study and discovery, but she continued to lament the difficulties with Ernesto. He constantly wrote, entreating her to leave school and rejoin him. In 1913, she succumbed to his pleas and they attempted a reconciliation at the end of the school year. Her uncle, Davide Abbate Forte, wrote from Italy expressing the sentiments of her Catholic family which espoused fidelity and forbearance above all. Concettina constantly found herself in an impossible bind between her religious faith and Ernesto's abusive behavior. At one point, he was in jail for failure to pay her support money, and he still sought an appeasement! The resolution of their relationship continued to be a dilemma for many years, as evidenced by the remaining letters and notations which she conserved.

Letters

December 10, 1912

Mrs. Concettina Piscopo

Dear Wife:

I suppose you will be more than surprised to hear from me it being such a long time that I have written to you.

Dear Concettina in a few days more it will be Christmas why not let us make up and we will all eat a nice Christmas dinner to-gether and then live happily to-gether instead of living apart the way we have been doing the last five or six years. I am more than sure that your father and sister will not object so I hope that you will think this over and let me know by a few days so that I can make preparations. I have got a good position as you know but after we have made up and our minds are settled I will go in business and have your father with me also. Write and let me know when you are coming to Boston for your Christmas vacations so I can meet you and we can go over to your home and talk things over. Be sure and write and address your letter to the hotel here so I will receive it right away. Here's hoping that you are well and that I will see you very shortly. I remain your husband.

> *—E.W. Piscopo*
> *32 Fleet Street*
> *Boston, Mass.*

Ernesto's letter to Concettina, addressed to her at American International College.

30. Davide Abbate's letter.

Long live Jesus, Long live Maria

Lapio, May 15, 1913

My dear niece,

I have waited some days to respond to your [letter] of 25 of this past April, thinking to add even that of your father to Achille, and that we responded to one and the other to save time and postal tariff.

Since there has been no letter arriving from Don Luigi, I respond, without waiting, to yours. I am therefore, extremely happy with all of the family with the news of your reconciliation with Ernesto, for which I have prayed so often to the Madonna del Carmine and he had made so many offenses. Let us hope in the meantime, and wish ourselves that the joy will be durable and perpetual, and that no disagreement will arrive to disturb it in the future. You, meanwhile, try to be obedient and respectful towards your husband and also to your mother in law, considering them always as your superiors, and forgetting completely the past displeasures. You must always be humble and prudent, and demonstrate by your deeds every interest for the family, and not for your person, even when it seems that you have every reason, because it is you who has to cede always to them even in regard to your own will and sacrificing you personal interests…

* * *

I salute you also from the part of the all in the family and I send you the good will of all those who have known with great joy of your reconciliation with your husband.

> *Affectionately,*
>
> *—Uncle Savio Abbate Davide*

Translation of excerpt from Davide Abbate Forte's letter to his niece and God-daughter, Concettina.

January 11, 1914

Concettina Dear,

Your troubles grieve me very much. I thought after your reunion you should have no trouble at all. Why did that man called you from your school if he ment to be just as bad as before? I fear, Concettina, you are too good. This is the only fault I can find in you. You yield too much to his wishes. We Greek and Italian women are slaves to our husbands. It is not so much so with the rest of nationalities. If there happens any trouble we are to blame while all the time we are not even asked to express our opinions on the matter. Such is our lot!

I have got to schools and to work and have staid home as househelper and a nurse But to me the last work seems the most difficult. Yet our lot is considered an easy one and it is spoken by the stronger sex with contempt.

There is one thing that can really console you besides Annie and Pappa and those are good books. I find great pleasure in reading books and I remember you told me you like them very much. Why not read 2-3 hours a day dear. I often wanted to send you books to read. I am reading now a most interesting book by Jane Austen. It is called "Pride and Prejudice." In the same volume bound is "Northanger Abbey" both by the same author. It is a nice bound and printed book, present from one of my teachers. Let me know dear whether you have read these. If not, I will send them to you as soon as I will read them.

I enclose you a little square made with the sewing needle and I hope you will like it.

> *Good bye dear*
>
> *—Arete*

Letter from Arete Sarantopoulos, Concettina's trusted friend from American International College.

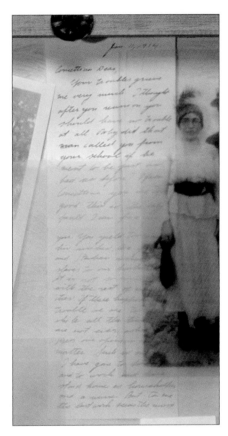

31. Text of Arete's letter to Concettina when she left school, also her feelings on equality between men and women.

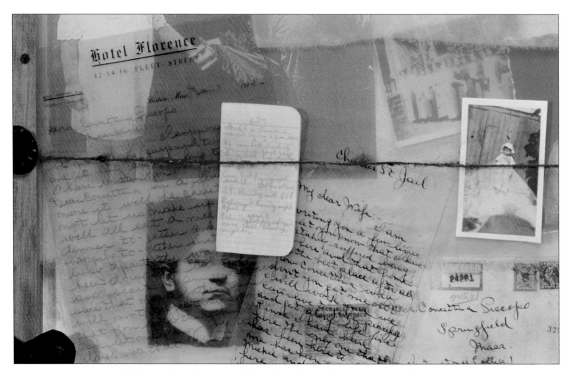

32. Letters from Ernesto to Concettina; Concettina's notes on his absences.

March 2 = Providence, returned Sunday 1 PM , alone.

He came back March 16. We made up. Stayed 4 days, Friday, Satur., Sun., Monday. Went away Tuesday, March 20 with $17.00.

Came back Sunday night, March 25.
Left March 29, Thursday with $50.00.

Returned Sunday night April 1.

Saturday, April 7, took pay, stayed away till Tuesday night.

Concettina's notes on Ernesto's irregular comings and goings.

Charles St. Jail, 1915

My dear Wife,

I am writing you a few lines to let you know that I have certainly suffered being in here and that home is the best place after all. Now Concettina why don't you get me out. I will work and we can live together peacefully and get along life fine. Since I have been here the only one that has been here to see me has been my cousin Mickie and he was here only once. I am here and I need clean clothes and my other suit. So please Concettina please give me the last chance to be good and send me to jail for a term of three to six months. You can make up with mother and I will do the same with your people and we can let the past go and only think of the future. I suppose it will be hard to get my job again but when Alex knows that we are going to live to-gether again why everything will be alright. If I don't here from you before Sunday night why I am going to withdraw my appeal and go back to the East Boston Court and get my sentence which will be down to Deer Island [prison] so you can see how much that will mean to us both. Please go and see my sister and tell her that I am awfully sorry this happened and I only wished that I had taken her advice and I never would have been here. Tell her also to go and encourage my mother and tell her that when I come home why I will be a different sort of fellow. So please Concettina please get me out as this has certainly taught me a lesson. Tell my sister also to be sure and not let my brother know if she can help it. I wish you would go to see my mother with my sister but I suppose you don't want to so you had better wait until I come home. I had a nice talk with the priest of the jail yesterday and he gave me a lot of good advice which I am going to follow. So please dear wife please get me out and make a man of me instead of sending me to jail.

—Your Husband Ernest W. Piscopo

Ernesto's letter to Concettina from the Charles Street Jail where he had been sent for failing to pay support to Concettina.

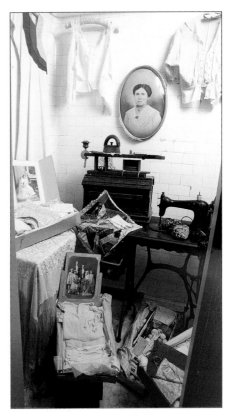

33. *Sewing: Four Generations.* Detail of closet installation at Ellis Island: Concettina's sewing machine, which she used all of her life; her hand-tinted photographic portrait. The modish dress with stripes was an original design of Nina, her daughter.

The Story of My Grandmother's *"fedina"* (engagement band)

She wore it all her life, this small twisted-gold band, two narrow strands intertwined. He must have given it to her. Despite their separation, she never gave it up. When she died on Parker Hill, someone stole the band before my mother came. I'd always thought it would come to me and then I would be able to keep a piece of my grandmother. I would watch it on her white finger, skin so thin and wrinkled around it. I never saw a wedding band. Did my grandmother feel "rejected"? Ultimately he re-married or lived with the family maid. Did she feel this all her life – that she had been rejected by his infidelities? At some point, she also rejected him and would not let him back into her bed. She was angry with him her whole life. Did she always love him? Perhaps the pain was that deep.

—Journal Notes, B. Amore, March 1999

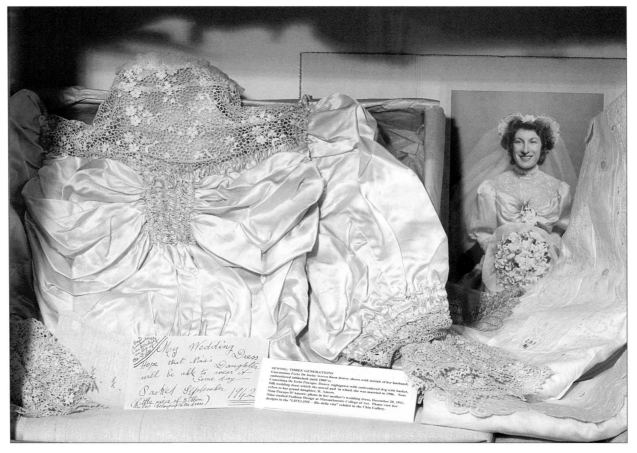

34. Detail of Concettina's wedding dress, which she sewed in 1906; photograph of her daughter, Nina, wearing
the dress in 1941, and Concettina's note to her future granddaughter when she packed it in 1942.

My Wedding Dress.
Hope that Nina's daughter will be able to wear it someday.
Packed September 1942.

Moving On

After leaving College, Concettina started her own private dressmaking business for the Brahmin ladies of Beacon Hill, who brought sketches home of the latest style from Paris which she would translate into fabric. This could have been made easier through some of her contacts with the Piscopo family. In the 1920 census, Concettina is listed as the head of the household. Luigi worked as a janitor and Eufrasia utilized her skills as a proficient needlewoman. Photographs always show Luigi reading. Through years of concentrated savings, the family finally was able to buy a three-decker house in East Boston, a section of the city that had become a hospitable home to many successive waves of immigrants. The original Yankees had seen first an influx of Jewish immigrants, then Irish, and, finally, the Italians at the turn of the nineteenth century.

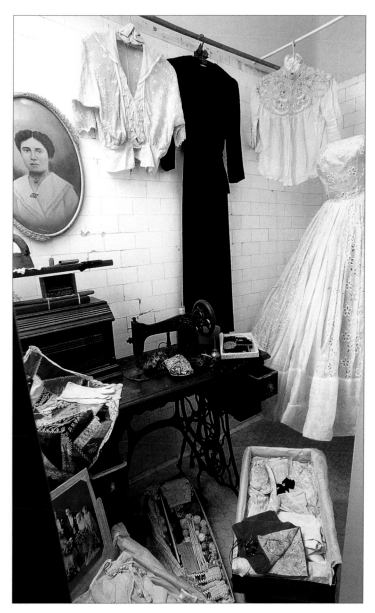

35. *Sewing: Four Generations.* Detail of black velvet dress and prom dress designed and sewn by Concettina's daughter, Nina.

The De Iorios participated in the active cultural life of the Italian community, even being invited to the inauguration of the Italy-America Cable celebration in 1925. This was an event of great importance to people on both sides of the Atlantic. Letters sent by ship had been the common mode of communication, often taking weeks or months to arrive at a destination. With the advent of the Western Union Telegraph service, Italy no longer felt an "ocean away."

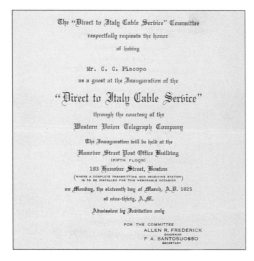

36. Text of Italy America Cable invitation addressed to Mr(s.) C. C. Piscopo.

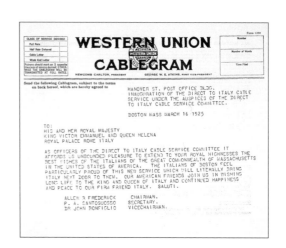

38. Cablegram to King Victor Emmanuel and Queen Helena from the Direct to Italy Cable Service Committee.

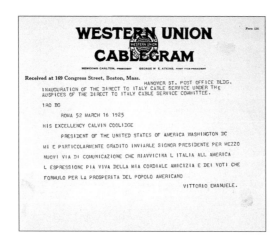

37. Cablegram from King Victor Emmanuel of Italy to President Calvin Coolidge of the United States of America.

Rome 52 March 16 1925

His Excellency Calvin Coolidge

President of the United States of America Washington DC

I am particularly pleased to send to you, Mr. President, by means of this new way of communication which brings Italy and America closer, the most lively expression of my cordial friendship and wishes which I compose for the prosperity of the American people.

—Victor Emmanuel

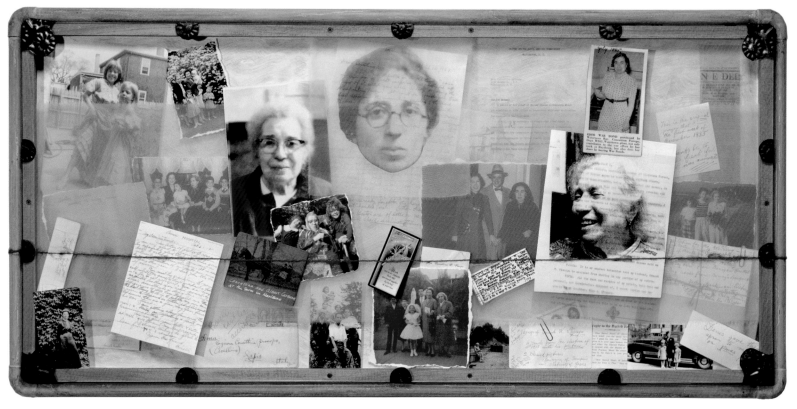

Concettina's great-granddaughters
in her dresses

Holy card from Concettina's
death in 1979

Envelope with "things of E.W.
Piscopo" November, 1965

Letter from Dr. Bonnelli

Death notice of Ernesto
Piscopo Jan. 22, 1958

Concettina's note on the 1001
prayers and her favorite prayer
to the Sacred Heart

Concettina's will expressly
excluding Ernesto from her
estate, October 17, 1952

Newspaper notice of
Dr. Bonnelli's death in
an accident, 1923

All's Well What Ends Well

"All's well what ends well," was one of Concettina's favorite sayings in her later years. She went on to live a full and challenging life as an Italian woman immigrant and single mother. In her determined fashion, she continued to provide for herself and the one child born of her marriage to Ernesto. She always worked, saving enough to purchase a second house in her Italian-American neighborhood. In 1949, when she was a forelady at the Raytheon Company, she bought the first television in her neighborhood. Her grandchildren were delighted when their living room became the hub of their small community. Their friends often sat mesmerized before the round screen with its magical moving images in black and white.

Despite the fact that in later years, Ernesto tried to reconcile with her even though he had created another family, she steadfastly refused to trust him again and specifically wrote him out of her will as late as 1952. Her Catholic faith and devotion to the Sacred Heart sustained her throughout her life. A strict sense of morals and discipline was the backbone of her existence. Concettina saw grandchildren and great-grandchildren born, and transmitted to them her love of Italy and her dedication to culture, reading and learning. She experienced the changes of nearly a century spanning the years from 1884 to 1979 and lived to be ninety-four years old.

Becoming American

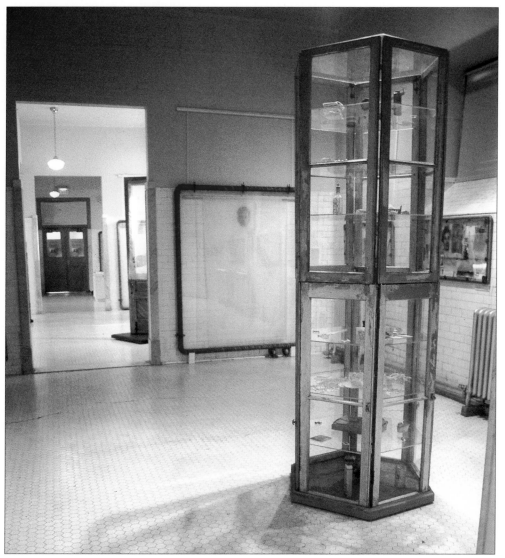

1. *Becoming American:* Overview of third room in Ellis Island exhibit.

Becoming American

"Chi lascia la via vecchia per la nuova, sa quello che lascia ma non sa quello che trova"
"He who leaves the old ways knows what he leaves, but not what he will find"

Children of immigrants, the second generation in America, faced a redefinition of their identities. Often they were not even taught to speak Italian since parents wanted them to "be American." At the same time, these parents desired strict adherence to the *"via vecchia,"* or the old ways of doing things. The fundamental values of *"la famiglia"* remained at the core of their lives, yet there were myriad conflicts about how to relate to the world outside the family. Many in this generation found themselves caught in a conflict between loyalty to family and their own independent choices.

Diventando americani

"Chi lascia la via vecchia per la nuova, sa quello che lascia ma non sa quello che trova"

I figli degli immigrati, la seconda generazione in America, dovettero affrontare una ridefinizione della loro identità. Spesso non gli fu insegnato neanche l'italiano perché i genitori volevano che diventassero "americani". Allo stesso tempo, quegli stessi genitori desideravano la loro stretta adesione alla "via vecchia", o ai vecchi modi di fare le cose. "La famiglia", il valore fondamentale della vita italiana, è rimasto al centro delle loro vite, eppure c'erano miriadi di conflitti sul come relazionarsi con il mondo esterno ad essa. Tanti di questa generazione si trovarono intrappolati in un conflitto fra la lealtà alla famiglia e l'indipendenza delle loro scelte.

Nina and Concettina

Nina, Concettina's only child, was the second generation in America. Ernesto had successfully prevailed upon Concettina to reunite and she became pregnant with Nina, whom she named after her own mother, Giovannina Forte, in the time-honored tradition of the *Mezzogiorno*. Nina was born in New York City, where Concettina had come to meet Ernesto at his request. Headstrong, pregnant, traveling by herself, she arrived at the train station. Ernesto was absent, so she remained in New York and gave birth to her daughter alone. Perhaps Concettina gave Nina the middle name, Esperanza, with the hope that Ernesto's unpredictable behavior might change with the advent of their child. This was not to be and she and Ernesto separated permanently when Nina was five years old.

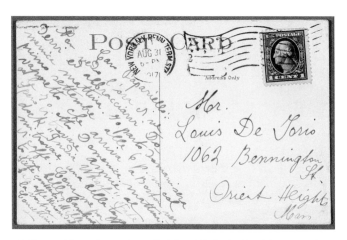

3. Postcard from Concettina to Luigi and Eufrasia (Annie) announcing her return from New York, where Nina was born on August 15, 1917.

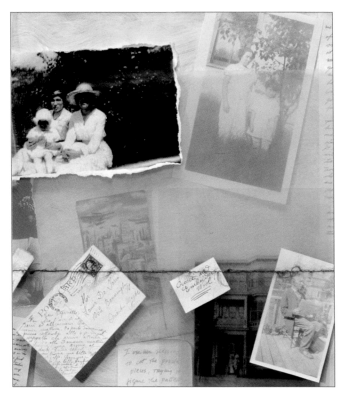

2. Postcard announcing Nina's birth; photos of Nina as a child.

Caro Papariello:

Non vedo l'ora di vedervi ed abbracciarvi Domenica mattina. Io parto domanisera primo settembre alle 6 p.m. col vaporetto che arriva a Boston verso le ore otto Domenica mattina. Spero di trovare Annie al dock "India Wharf." Fatemi trovare una bella tazza di caffé. Con me porto una bella bambina. Siete contento? Mille baci affettuosi dalla vostra Concettina.

Dear Little Father:

I can't wait for the hour to see you and embrace you Sunday morning. I am leaving tomorrow evening, the first of September at 6 PM with the steamer which will arrive in Boston around eight on Sunday morning. I hope to find Annie at the dock at India Wharf. Have a nice cup of coffee waiting for me. I'm bring a beautiful little girl. Are you happy? A thousand affectionate kisses from your Concettina.

4. Following the Thread VII: Young Nina.

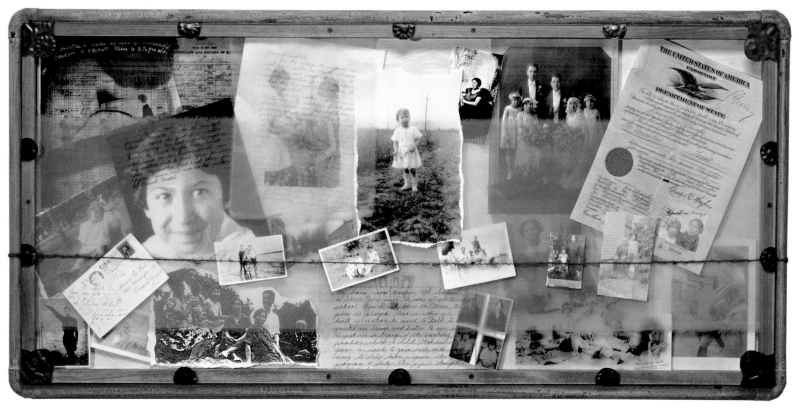

1920 U.S. Census:
De Iorio family listed
with Concettina as head
of household

Postcard of Nina's birth

Nina's birth certificate,
New York, August 15, 1917

Nina's early watercolors

Nina's autobiography recounting
her birth, and her favorite teacher,
Mr. Bremen Sinclair

U.S. passport, Nina and Concettina,
November 17, 1922

Concettina's Collections

Nina and Concettina lived most of their lives together in a mixed Italian and Irish community. Their home was a large "white-elephant" of a Victorian house shared with a boarder, cousin Henry. The house was filled with Concettina's collections. The attic of the house contained rows of trunks, stacked two or three high and covered with thick, furry gray dust. Walking through the rows was like meandering through a miniature village.

Some objects had been brought from Italy, others she had created or acquired in America. Concettina saved a variety of things, from an elegant handmade silk-and-lace collar to mundane bottles of her favorite rose toilet water. There are still labels and lists, written in her hand in both Italian and English, attached to her bundles and possessions. Sometimes the notes are merely descriptive; sometimes they name the owner of the object or its history and importance to her.

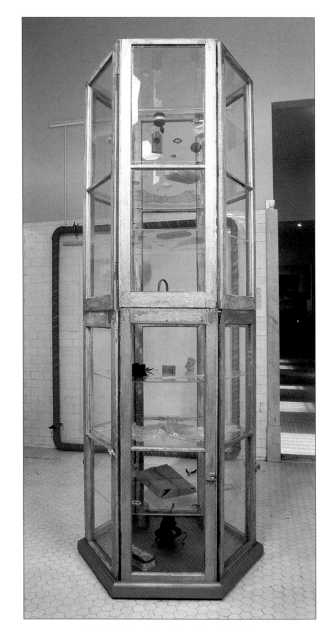

5. Gold Reliquary: Archaeology of a Life.

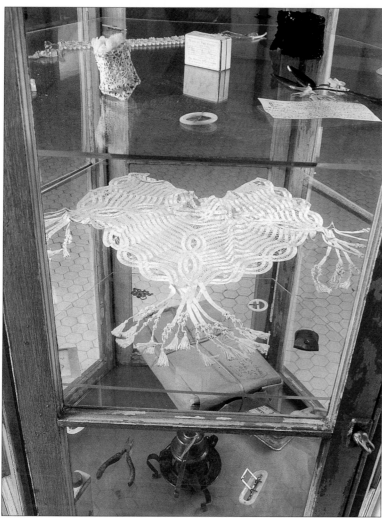

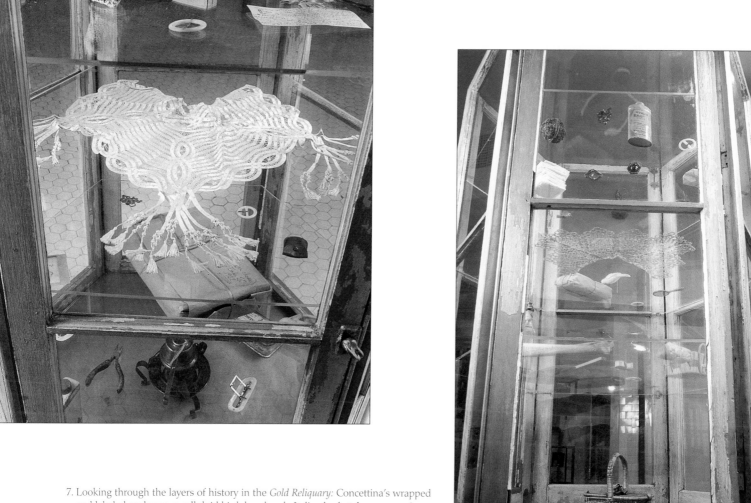

6. *Gold Reliquary* containing Concettina's own handmade silk collar with tassels; a rolled-lace collar from the nineteenth century; bead and ribbon bracelet; a pillbox which she used to store jewelry; assorted mother-of-pearl buckles; her pliers from the Raytheon Company; gift silver spoons; her traveling alcohol stove which she brought on trans-Atlantic voyages.

7. Looking through the layers of history in the *Gold Reliquary:* Concettina's wrapped and labeled packages; a celluloid bird; handmade Italian basket; her purse mirror; can of talcum powder; embroidered handkerchiefs; a roll of embroidery silk; a fan from the Piscopo restaurant, "The Grotto."

8. Example of Concettina's notes cataloguing her fabrics and objects. She would often reuse envelopes to contain the notes.

all White piece to be embroidered
Pillows finished and unfinished
Most alredy begun
Pezza di lettere seta canavaccio

ANNUAL COLLECTION
Read inside
for contents

Amount $

Mishellaneous all things
New
? ? ? ? ? ? ?

Coralli Italiani,
comperati a Napoli
insieme a Papà

Tamburino
and
4 bottles of wine (Capri)

Good and
strong
pieces
for pillow

9. *Gold Reliquary* containing celluloid kewpie doll; mother-of-pearl buckles; cloth tape measure; wrapped packages; crocheted collar of silver thread; art nouveau purse mirror.

Concettina's Mentor

Even after leaving school, Concettina continued to stay in touch with her favorite French teacher from American International College. Mrs. Eldredge continually wrote and often urged her former student to participate in Alumni meetings in Boston. She proclaimed herself Nina's "A.I.C. grandmother" and gifted her with two heirloom spoons from her family. When Concettina and her family decided to return to Italy for a trip, Mrs. Eldredge wrote a letter of concern since the situation in Europe was so unsettled. Concettina received correspondence from the College until her death in 1979.

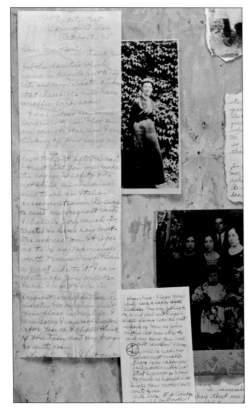

10. Photograph of Mrs. Fannie H. Eldredge and text of her letter to Concettina and postcard to Nina; photograph of Concettina and Nina in Lapio, Italy 1922–24.

October 28, 1915

Dear Mrs. Piscopo,

Thank you for the dainties which came by parcel post today. They are very delicate. I like that cheese. We will have a coffee party soon.

I was indeed very much surprised to hear that you are going to Italy now. I was thinking of your going a day or two ago, but "after the war." I trust that you will make the voyage in safety. I do not think a submarine will touch an Italian passenger steamer. Be sure to send me frequent cards. I shall be very much interested to hear how matters impress you. It is going to be an experience worth remembering: there's a <u>great</u> side to it. I earnestly hope you will return. I want to be in frequent correspondence. Remember no one has just your place in my life. I am sorry I cannot see you before you go. I shall think of you daily and my prayers go with you.

Last Sunday I put on my pretty waist. I have <u>silver</u> on my hat, so I put on the waist, instead of the gold colored lace, the white Chinese lace I once had on my <u>old</u> blue waist. Miss Davis said: "How nice you look!" It is <u>very</u> pretty. I shall take good care of it and think of you every time I wear it.

I have been busy since Saturday. Whenever I have had time, writing my annual Auxiliary letters. I am not going to send you your bill just as you are starting. I do not think it is polite or in accordance with a good-bye letter.

Remember me to your father and sister. My "Bon Voyage" is for them also.

> *With much love*

> *Fannie H. Eldredge*

Letter from Mrs. Eldredge to Concettina, which speaks to the many sides of their relationship: their friendship, the sewing that Concettina did for her, and Mrs. Eldredge's position as head of A.I.C. Alumni.

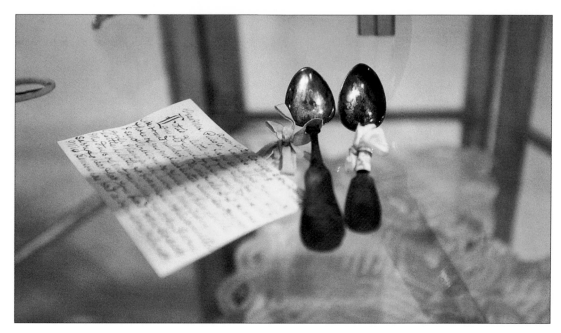

11. *Gold Reliquary* containing Mrs. Eldredge's spoons, with note explaining their history.

American International College

January 26, 1918

Dear Mrs. Piscopo:

I am sending you this little gift for the baby. It is an old family teaspoon, 70 yrs. old (in round numbers). The initials L.L. are those of my mother's sister, Lucy See Hosmer. I sent Areti one of these for her little girl. I have given away my silver little by little for I can use only a little. My days of entertainment are over. I was sorry to hear that you had been so sick. Miss Bensow has had a very sore throat, isn't wholly over it yet, and Miss Haywood has a bad cold and cough. The girls have had colds also but no one is seriously sick. I am pretty well now after my "winter colic" or whatever it was. But the back of my neck annoys me tho' it doesn't make me sick. Jan. A.I.C. Notes material is handed in to Mr. McGown. I am writing to soldiers, seeing to knitting for them etc. I must soon do Auxiliary work, not easy for me this year. If you want to send 1917–18 dues, do so. We must, at least, keep alive if war is first. Write when you can.

With love always,

F. H. Eldredge

Dear Nina: I hope you will have a happy eighth birthday. You are getting to be a big girl and I hope I shall always hear as good reports of you as your mother has been able to send me. Have you had a good vacation? I know you will be ready for school next month. I have been happy here all summer but find that I cannot go about as much as I would like. I hope your mother will write to me.

With love F.H. Eldredge
Your A.I.C. Grandmother

12. Mrs. Eldredge's postcard to Nina for her eighth birthday, August 15, 1925.

Extended Family

Concettina and Nina always lived with Luigi, who passed on in 1937. Eufrasia, Concettina's sister, also lived with them until she married Adolfo Anzalone in 1925. The De Iorio family was definitely a small one by the usual immigrant standards. Eufrasia and Adolfo had no children. Concettina never remarried. The family was close by necessity but not always peaceful. Concettina's bolder nature contrasted sharply with Eufrasia's quieter one. Still, they joined both economic, spiritual and psychological forces, often sharing dwellings, and all of them contributing to Nina's upbringing and education. Eufrasia was affectionately called *Zizi* (aunt) in the family and Adolfo was *Zio* (uncle).

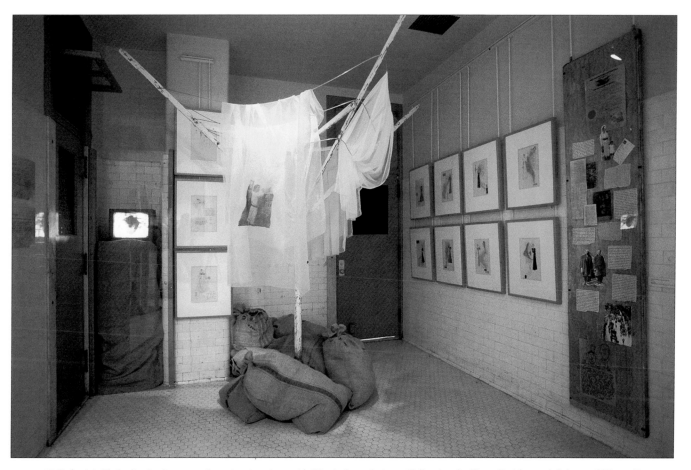

13. *Eufrasia's Clothesline* in the room, *Becoming American,* with Nina's dress designs, "Following the Thread" video and *Column of History V.*

Ancestor Scroll: Eufrasia De Iorio (*Zizi*)

Eufrasia became Annie in America. In Italy she spent most of her time with the nuns. The convent was on the edge of Lapio, a town built of stone in Avellino and it looked over a broad and deep valley. Did she look out often, as she practiced needlework, crochet, knitting and lace? She was very fast at all of these hand skills and whenever I was stuck in my knitting, she would very patiently rip it out and reknit the piece so I wouldn't have "lost" all my work. She never wanted to come to America but my grandmother, her sister, brought the whole family here. In later years, they never got along very well – arguments and hair pulling. Was Zizi angry because she was taken out of the convent? Was she angry because her husband was friendly with her sister? She married very late. Her husband was much younger – handsome with wavy hair. She was petite – maybe 4'10"– and had a kind of tight, but kind face that was lined by the time I knew her. I remember that they slept on a small single bed with their feet facing each other. Her hands were crossed on her chest. They lived in the bottom of the house, which opened onto the garden. Upstairs was rarely used and there were white covers over the black, green and rose floral upholstery. Sometimes she roasted peppers on the upstairs stove. I slept in a tiny room at the top of the stairs. Was Zio lonely because she never made love to him? I wonder if they ever made love? Maybe she only made love to God whom she visited every morning. I remember springtime walks with her to the seven o'clock mass before school, and sitting with all the old Italian ladies in black with their prayer beads. She seemed the happiest in church and I liked being with her and her friends, Mrs. Indrisano and Mrs. Giaccoppa. Mrs. Giaccoppa's frosted cookies were the best!

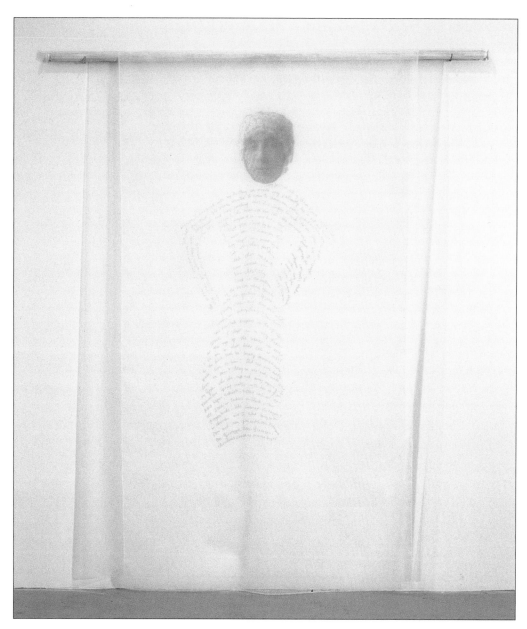

14. *Ancestor Scroll: Eufrasia De Iorio (Zizi).*

Ancestor Scroll: Adolfo Anzalone (*Zio*)

Adolfo Anzalone married into my family when my mother was eight years old. He came from a large family in Lapio. They were not of the same "class" as my grandmother's family. It seems that both Concetta and Eufrasia married "beneath their station." Adolfo was a handsome man. He wore brilliantine on his hair. Once, when the family thought I had polio, he came to visit after work and dozed off in a chair. After he left, there was an egg-shaped mark on the wall. My mother was upset but when she realized it was from my uncle's hair oil, she calmed down. She actually cut a piece of wallpaper to match the surrounding pattern and covered it! He was a man whom everyone seemed to like. When he died, many clients from his insurance business came to the wake and talked about how kind he was. An old lady remembered his visits and placed a small bouquet of purple flowers in his coffin. He bought a lot of clothes for my brothers and me, and would play with us on Sundays chanting "Ari, ari, ari e zi' monaco a cavallo e zi' monaco non voleva e zi' monaco s'accideva. S'accideva col'lo coltello, tichiri, tichiri, capo n'terra!" as he jiggled us on his knees and tumbled us backwards at the end. This was the uncle who loved the garden. I remember his hands in the dark earth, helping me look for a special blue stone I'd lost. The same hands brought me comics and cookies. The same hands held the rope tied to the inner-tube in which I floated under the dock at his house on the bay. These same hands sometimes hurt me. I waited for him every day on the rocking chair on the covered porch – waited for him to walk through the arches of old leafy trees until he came to the white-picket border of the waterfront house that he had purchased; the house which, when he died with no will, his sisters forced my aunt to buy back from them. His brother Armando, in Italy, stole from my grandmother's family home. This uncle was like a "father" to my mother. Later when she was grown, he would take her to theater and opera parties because his wife preferred church. "They" were "the couple." He bought her a first car, her first diamond ring. He was a charmer, that's for sure! He used to act in Italian plays before my time.

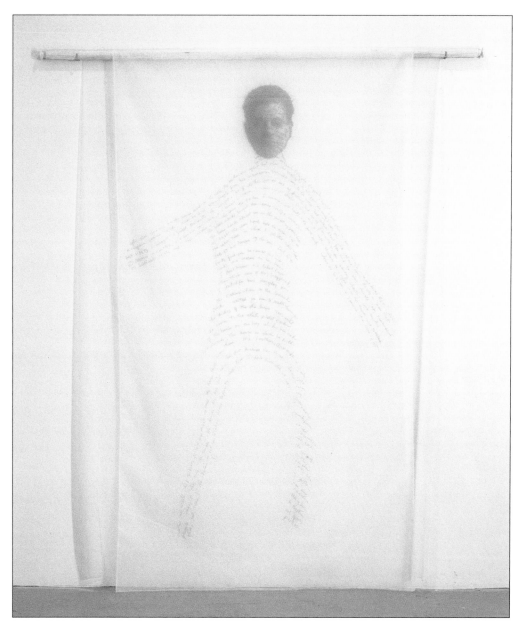

15. *Ancestor Scroll: Adolfo Anzalone* (Zio).

Drama and Song

Italian opera and theater were an integral part of Nina's cultural life. Her uncle, Adolfo, frequently acted in Italian theater productions in the North End of Boston. In New York, a Neapolitan immigrant named Eduardo Migliacco, fired from a sweatshop, became the famed satiric comedian, Farfariello, who regaled audiences with his creations spoken in mixed Italian dialect and English. He portrayed his fellow Italian "greenhorns" with insightful characterizations which not only regaled them, but also encouraged them to reflect upon their situations.

Opera also continued to be a staple offering. Opera companies could count on a full house in Italian communities and a temporary source of talent as well. "Whenever we wanted singers for the chorus, we used to go down to the wharf and get EYE-talian fishermen" reported a stagehand at an opulent opera house in San Francisco. "You'd find every one of 'em knowing their scores and singing *Ernani* and *Traviata*." In the early years, the only venue that would show Italian opera films was the Old Howard Casino, Boston's famous burlesque theater. Gradually, as succeeding generations made their way, Italians became welcome in the opera houses where their music was played.

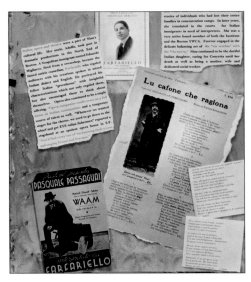

16. Farfariello with the words of one of the songs which he co-wrote in 1910, *"Lu cafone che ragiona"* ("The peasant who reasons").

COMPÀ' NTUO' MA T'ARRAGIONO O NO?

Ogge a sta terra qua lu 'mericano
cumanna, e ti pò fa chello che vò
perciò quanno ti vere il taliano,
*fosse lu Rre, lu chiamano **digò***
　　Dich' i', cu qua' ragione
　　nzurtarte li taliane?...
　　Pecché s'io so' cafone
　　tengo li paisane,
　　ca so' maste de scienza,
　　de voi professuri,
　　ca overo te ne fanno,
　　de tutti li culuri!...

Donca ne compà Ntuo'
Io t'arragiono o no?!... Eh!...[1]

COMPARE, DO I REASON OR NOT?

Today in this land here, the American
commands, and he can do whatever he wants
so, when he sees an Italian,
*even if it be the King, they call him **dego***
　　I say, with what reason
　　do you insult the Italians?
　　Because if I am a peasant
　　I have my countrymen,
　　who are masters of science,
　　of you professors,
　　and they can really play jokes,
　　Of all colors on you!
So, I say to you, "compare,"
Do I reason or not?!...Eh!...

　　　　　　　—Eduardo Migliacco (Farfariello)

Birds of Passage

Italians were called *rondini di passaggio* (birds of passage) since they would travel back and forth to Italy so often. Leaving Italy had often been less of a choice than a necessity. The South, in particular, suffered from excessive taxation imposed on them by the government situated in the North. Emigrants who were forced to leave were often left with a profound nostalgia for their homeland.

When work was slack in America, they would sometimes make a voyage to their town of origin, visit families, renew ties, then return to America to earn more precious dollars. Immigration laws changed in the United States depending on whether the government in power favored higher or lower numbers of immigrants. Sometimes the "bird" was not so free to fly whenever he chose.

"VOICES"—Ellis Island Interviews

My father went back [to Italy] in 1931, in September and he was promised a nice big job, and then he came back in the spring of 1932. Well, that didn't develop because the Depression got a little stronger. Then he went back in the fall of 1932 because here he had to pay board in a hotel. Over there, four or five, it doesn't make much difference. Then he wanted to come back, but his passport expired. The third time, the passport was only good for two years. Now it's ten years, it was five years once, you know. So he went to the consulate in Trieste to renew the passport. They won't renew it unless he leave with the whole family, see. So that, they don't want you, like, to earn the money here and send it all over there. Well, he couldn't bring the family down here because of the Depression and he didn't have the money, you know. He wanted to come back for at least nothing else, to keep his citizenship alive, you know, and probably would have been good because after that Roosevelt went in and the WPA started where I got a job. He was a good stone mason, he could have got a good job on it. One of those things. And then he got stuck and he couldn't come in. They wouldn't renew his passport. So I'm the only one who really came and stayed. They are all over there. I lost the two brothers now. I have two sisters over there and once in a while my sister comes over, you know. As a matter of fact, I go back to Italy now every two years for a visit.

—Ettore Lorenzini[2]

I was born in New York City. During the Depression, my parents brought us over to Italy, me and my two brothers, three of us. Because he had some property over there, so we lived on his property. I think I was five years old. We were living in a big house in Astoria. I know we had to climb a lot of stairs. I'd play in the Astoria Park there once in a while with Gertrude, this one girl I grew up with. But I had bigger experiences over there than here, so it overlapped these. It overlapped…My father used to go on line to get coal, stand a couple of hours on line. So he figured, he shipped us to Europe thinking it wouldn't be as bad.

My father took us over there. He did save enough for the fare. Not much more than that. Then he came back here, and my mother also. They came back, uh, make a living. So then we stood there on the farm…I know there was a lot of action going on there between Communists and Fascists and so on. Oh gee. Because then Mussolini came into power. You had to join. You had to be, you had to join. They put you in, whether you were an American or no matter what nationality. Not that I was proud of it, but I had no choice. We became Black Shirts, my brother and I. Like here the boy scouts, but it's a little more serious over there. So after a while that's why our father brought us back because, you know, it was getting a little bit too far. You know, as we're getting older they'll probably send us to Ethiopia or somewhere, you know, to fight. And you don't want that. I don't want it neither. I'm an American. But when you're there you have to do what you're told.

—Nelson Misturini, born October 11, 1917, returned to Cremona, Italy, then back to New York[3]

The Letter Never Sent

Dear Gargano, I write this letter to you
to make you see that, from the day I left,
you never fail to come into my dreams,
as the beloved comes to a lover's dream,
and as a mother comes to a son's dreams.
I dream I'm there – down in the Marsh again –
as long ago, and if you can believe me,
I'll also tell you that I hear the toll
of the bell of St. Anthony,
and when I listen to that sacred voice,
what can I do? an emigrant alone
can know the lump that rises in my throat.
I always write letters to you, but then
don't mail them all because they weigh too much,
and the mailman would have a roaring laugh
if I ever said I want to send
a letter to a mountain every day.
You have to sympathize: he's an American
and doesn't understand that you are better
than all the people who have been to school.
So, my Gargano, my beautiful Gargano,
I'm writing you this letter so you'll know
that, after forty years of this America,
one thing alone is definite: it seems
almost as if I had never made that trip,

and that the ship sailed only in my dreams
or in the books I loved to read in school.
But then I reconsider, and realize
it would be a sin for me to tell you a lie:
indeed, I did sail once upon this land,
and now three quarters of my life are gone.
In every letter that I wrote to you
and never mailed, how many times it was
in confidence I told you how I spend
the hours of my day upon this shore.
Well then, I'll tell you what I said once more.
I do my work like everybody else,
but other people go to sleep content;
Instead, I ask myself these selfsame questions:
"Why was I born? why did I ever leave?
why didn't I stay behind with all the others
on that beautiful Mountain in full bloom?"
My dear Gargano, there is no sleep for me.
I think about your teeming, glorious stars,
and to my eyes they all appear to be
in the shape of an ocean liner filled
with a throng of poor emigrants like me...
You see, you see, now I can feel the tears
as on the day I stood in Naples' harbor.
It might be better if I stopped right here...

—Joseph Tusiani (Puglia),
written in the Bronx, New York, 1991
(translated by Luigi Bonaffini)[4]

17. "Molare" (Monte Sant Angelo in the Gargano region).

Journeys

The De Iorio family made several trips back to Lapio – in 1915 as well as in 1922, when Luigi, age seventy-five, seriously considered returning there to live. Concettina's daughter, Nina, vividly recalled her time in the *paese* as a child and wrote about it in an autobiography in high school. This experience of living in Italy for nearly two years deeply influenced her. She always spoke Italian with her mother and was left with an enduring love for Italy. She returned in 1956, 32 years later, with her mother and Aunt Eufrasia (*Zizi*) to settle the remainder of the family property, made close friends there and continued to visit frequently throughout the rest of her life.

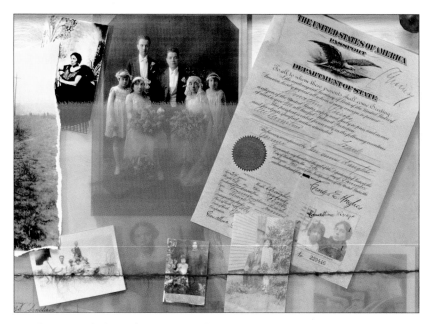

18. Passport with photo of Concettina and Nina; Nina and Nonno Luigi; photo of Nina in Lapio with unidentified woman; family picnic; Concettina in Lapio; Eufrasia and Adolfo's marriage.

August 29, 1923

Dear Mrs. Piscopo,

I earnestly hope your way will be made plain to you. I see that you wish to bring up and educate Nina as an American. Have you sent her to school at all it Italy? Of course her sickness interfered with it.

I see very plainly that it is not safe for both your sister and you to leave your father, neither for him nor for yourselves. Some designing person or persons might get all his property away from him not to mention the physical suffering he might bring on himself for lack of home care and restraint. I hope you will keep me informed. I hope he will change his mind and see things in a different light…

—Fanny Eldredge

My Autobiography

I was born August 15, 1917 at a private home on 34 2nd Street, New York, where I spent the first few months of my infancy. My mother then brought me home to Orient Heights, Massachusetts. The house on 1062 Bennington St. was my mother's and I lived there for several years. My mother had lived there for fifteen years, and was an old resider of Orient Heights.

In 1922, at the age of four, I started to go to school. At the end of that year I was promoted to the first grade. But, alas! I had not been in the first grade for more than four months when my mother took me out of school. We were going for a trip to Italy. It was a great adventure for me even though I missed school very much.

We intended to stay in Italy for a few months but we prolonged our visit to almost two years, during which time I didn't go to school. As I sit now writing, trying to remember my first impressions of different things, many happy thoughts and remembrances fill my mind even though I was but a child at the time.

I remember my first ride on a donkey that one of the peasant girls brought to my home and my mother's uncle thought it very base and undignified for me to do such a thing. He was an old aristocrat, if I may say. He is now dead and my mother wept greatly when she heard of it. I remember the peaceful, dark, cool house of my mother's other uncle. He was an old priest who liked the solitude very much. Behind his house was an enormous oleander whose perfume was worth a long tramp through the hot, dusty country lanes to get there. I spent most of my time playing. Whenever I see anyone playing hopscotch it always reminds me of one evening when my mother was out. She left me with our neighbor's daughter. We were playing a hopping game when suddenly we heard a tapping on the floor, which seemed to come from nowhere. It proved to be the old woman who lived downstairs and we were certainly bothering her. The fruit and olive orchards; the olive season, when the olives were picked and spread on the floors in dark rooms to ripen and be made into oil, for the Italian people use it very much; the great fields of yellow roses; the big purple figs falling and squashing on the ground, when overripe; the chestnuts, ripe, shooting through the air from their burrs like fire crackers. The worst of the chestnuts, the pigs ate, for there were quite a few in the village. Almost every peasant had at least one pig. On Sunday, the one day in the week on which the peasant girls donned their best clothes and came to church often starting earlier from their homes when they had something to bring to the owner of the plot on which they lived. Every Sunday there were two peasant girls who brought us a little basket of cherries or little bunches of white, yellow, and purple violets.

In the village, the peasants did not have water in faucets as we have here but went every day to the public fountain for it. In the city though, it is just like America, that is, more modern.

—Nina Piscopo

The autobiography was written in February 1933 for Miss Hall's class at Boston Latin School when she was fifteen years old.

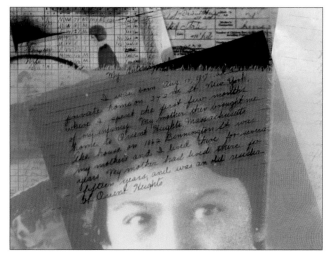

19. Nina's Autobiography describing her birth in New York and return to Boston. She was born Giovannina Assunta Esperanza Piscopo; her childhood watercolor of girls jumping rope.

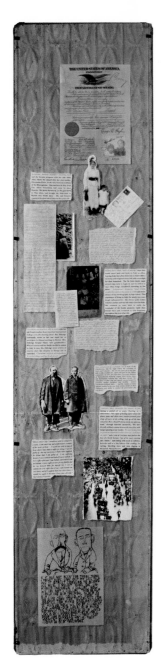

Differences and Discrimination

For every immigrant group that came, there were the common trials of being treated poorly because they didn't know English, dressed differently, cooked foods with unusual aromas, were of lesser means, etc. The Italians encountered an even more perplexing situation. Because so many had darker complexions, they bore the double burden of being foreigners as well as being considered as another race, one link higher on the labor-chain than American blacks, who were still suffering discrimination due to the history of slavery in America.

"VOICES"—Ellis Island Interviews

Well, I tell you. Over there I was the favorite, the teacher's favorite. Over here I got stuck in the back because I was a guinea. That's right. They don't, no one liked me. Then we lived in Milford with my uncle for about seven or eight months. Then my father moved to Hopedale. This where I've been all the rest of my life. And he worked at Draper Corporation as a molder. Hopedale was the worst town to live in for immigrants because it was an English town. Hopedale over here, the factory, was all English people, and they did not like the Italian people in the town. I went to school there and you don't know it was hell over there. The kids just did not like you. They made fun of you. They called me names coming home from school. Until finally one day I beat one of the girls to no end, and she was my best friend after that.

—Dena Ciaramicoli Buroni[5]

20. *Column of History V: Second Generation.*

I used to live in Astoria down by the Hellgate Bridge. I used to run all the way to Queens Plaza, over the bridge, to 72nd Street to learn how to box. Because I got tired of getting beatings…I wasn't a fighting man, but they constantly, I come home with a black eye. My mother, "Who did it? I'll kill him!" Oh, many black eyes. Oh yeah, I even got marks here, I got stabbed with pencils and so on. By golly, just because I was a foreigner, a green-horn…I didn't think of discrimination so much. In those days you probably didn't think so much about it, you know. But I was getting tired of it. I says, "By golly, I never did nothing to you guys." They were picking fights with me. You know, there's always a couple of bullies. There was a lot of, I had a lot of good friends. Oh, yeah. They would stick up for me. "Oh, leave him alone." But there were a couple of bullies there, always.

—Nelson Misturini[6]

We moved to North, what is called "North Beach" in San Francisco. It's an Italian quarter. It was just like living in Italy again, you know. I never had that feeling of [prejudice] there. Only as you got out, you know, going into the outside world so called, other than that. I mean like it's "Your mother doesn't speak English? Oh, you are a wop." When I was growing up here, there was a lot of embarrassments. And people would say, "God, if you don't speak the English language, they shouldn't be in this country," and I mean, and it hurts.

—Elda Del Bino Willitts[7]

"VOICES"—Family Interviews

The Irish would come and fight the Italians. The Italians would come and fight the Jews, the Jews would come and fight the Irish. There were three ethnic groups that were in constant combat for their territory, Italian, Jews and Irish. The North End was first populated by Jews. There's still a synagogue in the North End to this very day. Next came the Irish, next came the Italians. And if you weren't welcome, they had ways of just making you know that, for sure.

You know, as an Italian, you're somewhat prejudiced when you're talking about the Mafia. Because everybody – if there's a vowel at the end of your name, you're connected, which is a bunch of baloney, okay?

The Italians with their hands and knees and their backs and their pickaxes and everything, they built this country. Who would – where the hell did the masons come from? Where did most of the laborers come from? They came from Southern Italy.

—Tullio Baldi (second generation), interview by B. Amore, 2005, *Life line* Project, 2000-2006

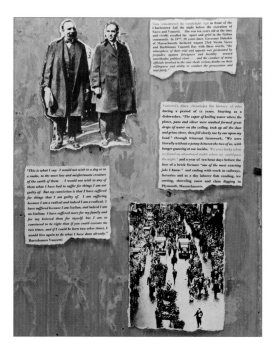

21. Sacco and Vanzetti; funeral procession in Boston.

Is the law equal for everyone?

Sometimes the discrimination was milder in form, sometimes it became a critical element in situations such as the Sacco and Vanzetti case which became a world-wide cause. The candlelight vigil at the Charlestown jail the night before the execution of Sacco and Vanzetti made a strong impression on Nina. She was ten years old at the time and vividly recalled the anger and grief in the Italian community.

In 1977, fifty years later, Governor Dukakis of Massachusetts declared August 23rd Nicola Sacco and Bartolomeo Vanzetti Day with these words: "the atmosphere of their trial and appeals was permeated by prejudice against foreigners and hostility toward unorthodox political views…and the conduct of many officials involved in the case sheds serious doubts on their willingness and ability to conduct the prosecution and trial fairly." He declared further that "any stigma and disgrace should be forever removed from the names of Nicola Sacco and Bartolomeo Vanzetti, from the names of their families and descendants" and that all people should "pause in their endeavors to reflect upon these tragic events, and draw from their historic lessons the resolve to prevent the forces of intolerance, fear, and hatred from ever again uniting to overcome the rationality, wisdom and fairness to which our legal system aspires."[8]

This is what I say: I would not wish to a dog or to a snake, to the most low and misfortunate creature of the earth of them - I would not wish to any of them what I have had to suffer for things I am not guilty of. But my conviction is that I have suffered for things that I am guilty of. I am suffering because I am a radical and indeed I am a radical; I have suffered because I am Italian, and indeed I am an Italian; I have suffered more for my family and for my beloved than for myself; but I am so convinced to be right that if you could execute me two times, and if I could be born two other times, I would live again to do what I have done already.

—Bartolomeo Vanzetti

Vanzetti's diary chronicles his history of jobs during a period of twelve years, starting as a dishwasher: *The vapor of boiling water where the plates, pans and silver were washed formed great drops of water on the ceiling, took up all the dust and grime there, then fell slowly one by one upon my head.* He then engaged in itinerant farmwork: *We were literally without a penny between the two of us, with hunger gnawing at our insides. We were lucky when we found an abandoned stable where we could pass the night.* After a year of ten-hour days before the face of a brick furnace, *one of the most exacting jobs I know,* he ended with work on railways, in factories and eventually as a day-laborer vending fish, cutting ice, shoveling snow and digging clams in Plymouth, Massachusetts.[9]

If it had not been for these thing, I might have live out my life talking at street corners to scorning men. I might have die, unmarked, unknown, a failure. Now we are not a failure. This is our career and our triumph. Never in our full life could we hope to do such work for tolerance, for joostice, for man's onderstanding of man as now we do by accident. Our words – our lives – our pains nothing! The taking of our lives – lives of a good shoemaker and a poor fish peddler – all! That last moment belongs to us – that agony is our triumph.

—Bartolomeo Vanzetti

Between Old and New

"Seguendo il sol, lasciammo il vecchio mondo" – "Following the sun, we left the old world" was the motto of Luigi Barzini's newspaper, *Corriere d'America*. Despite the proverbial "leaving," second generation children of immigrants found themselves between the Old World and the New. Nina, Concettina's daughter, constantly grappled with respect for tradition and a desire for exploration of the wider community.

Although Concettina was forward-thinking in many ways, in others she strictly adhered to the old way, or the *"via vecchia."* Her ideas of rigid physical discipline and respect for elders were deeply rooted in her *"signorile"* and *"paese"* culture. Her way was always the "right way and the only way!" She would often speak of sitting in silence at her own grandfather's table as a child, watching others eat while she went hungry as punishment for some minor transgression. Concettina and Nina lived together, loved each other and disagreed with each other all their lives.

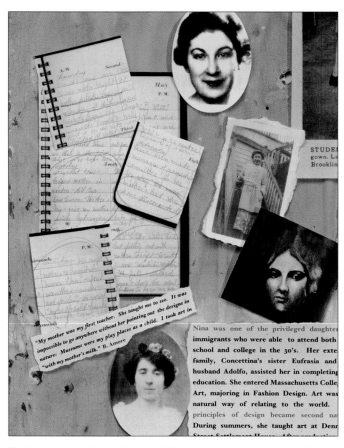

Nina was one of the privileged daughter immigrants who were able to attend both school and college in the 30's. Her exte family, Concettina's sister Eufrasia and husband Adolfo, assisted her in completing education. She entered Massachusetts Colle Art, majoring in Fashion Design. Art was natural way of relating to the world. principles of design became second na During summers, she taught art at Denr

"My mother was my first teacher. She taught me to see. It was impossible to go anywhere without her pointing out the designs in nature; Museums were my play places as a child. I took art in with my mother's milk." B. Amore

22. Excerpts from Nina's diary in which she writes of constant conflict with Concettina around such issues as use of the telephone and going out after dinner; photo of Nina smoking, which was also against Concettina's mores.

Freddie came over to see Helen tonight – mother forbade my going in – I did nevertheless – big quarrel

Stayed at home – helped mother in garden – did two homelessons – Mother's Day – gave my mother a pink hydrangea

Had a falling out with mother tonight – she's had the phone disconnected

Brought mother to hospital – Mass. Gen. – foul weather – snow – not feeling so good myself – cold – auntie and uncle came up

Tiff with Auntie and Mother about New Year's. Not going out for New Year's because of folks.

—Nina Piscopo diary entries during her college years (1935–37)

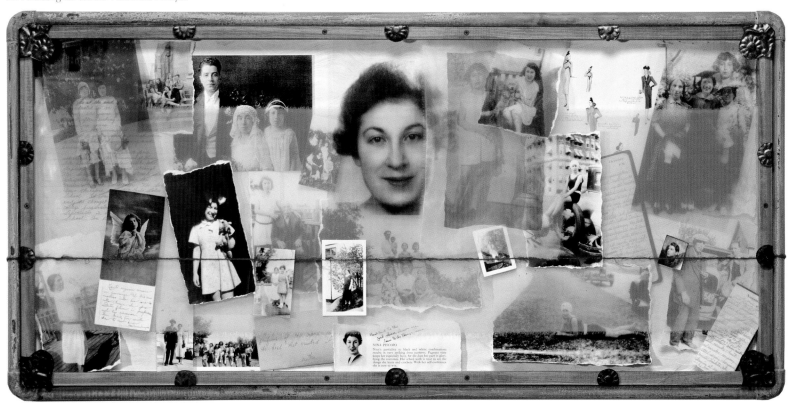

Note from Annie to
Concettina for her Nameday

Note from Nina on forgiveness
written to her daughter

Nina's Yearbook entry from
Massachusetts College of Art, 1939

Nina's sketches from
fashion design class

Nina's diary notes on her
grandfather Luigi's death

Choice and Conflict

In many families, second-generation children often did not even learn the language of their parents. The fundamental values of *"la famiglia"* remained at the core of their lives, yet there were myriad conflicts about how to relate to the "American" world outside the family. Nina spoke Italian fluently and remained active in both worlds throughout her life – living with and caring for Concettina until her death and participating in education and social work as well.

"VOICES"—Family Interviews

He didn't talk much about Italy when I was a kid. You have to have been in the era to understand how – there were so many other things, events, changes that were going on in those days, the Depression being what it was, the struggle that most people were having even to put food on the table. A lot of history, a lot of conversation and such got left behind. Wasn't time for it. There just wasn't time for it, that's all. They didn't really share any history with us.

> —Tullio Baldi (second generation), interview by B. Amore, 2005, *Life line* Project, 2000-2006

"VOICES"—Ellis Island Interviews

We were so restrained by my mother that we never really opened up to anything. My sisters had worked all the time. That's all they really knew. And I got into the outside world where things seemed to be opened up and so different. And I'd see that outside and I'd go home and there was no reasoning there, I mean, there was no logic there. It was just, they were so focused on working and doing that they couldn't understand anything else. And I really suffered through it because they couldn't understand it. They couldn't understand why I even wanted to act differently. And I would tell them. They should have, really. I got so, "God, you should have learned the language. It's embarrassing to go out and tell people you don't know." And, they were the most loving people that now I feel like I, I have a guilt complex thinking I could have even felt that way about such beautiful people and then feeling like I was a little, I was ashamed of them at the time.

> —Elda Del Bino Willitts[10]

You know, they expected the children to take care of the mother, you know. That's the way they lived in Italy. I mean, that the children take care of the parents. I mean, in Italy there is grandparents and all they, they all still live together. I mean, and that's the way she was brought up so it didn't bother her. Like now, I can't even move up with my son. I don't want to. I want to maintain my independence. That's not the way they looked at it then. Looking at it then was you lived with your children and you, they owe you a living because you brought them into this world. Like now it's the opposite. Over there you owed them because they brought you into this world.

> —Elda Del Bino Willitts[11]

I was one of the youngest in the family and the only one born here. The others were born in Sicily near Mt. Etna. I was the only one who defied my father. They all brought home their envelopes <u>unopened</u> and put them down. He took out the money and then gave them back a couple of bucks and kept the rest. I looked at him and said, "You're not going to get my money." I told him right out! He never said a word to me. I think he recognized that I was the "Americana." He figured he had to put up with it. No sense fighting it.

I broke all the rules of the Italian tradition. I made the way for the other kids growing up. I wasn't the only one that age. Everybody loved me. My aunts, my uncles, I could go anywhere and they treated me like a queen. I was the rebel, the "Americana."

All the girls on my street never went to high school. They went to work at fourteen. Well, I made up my mind when I was in the fourth grade, only nine years old, that I would become a teacher, come hell or high water! I loved my fourth grade teacher. She was nearly an angel—always rewarding us. I wanted to be like her. My oldest brother knew that. He made sure I went all the way. He kept giving me an allowance all through college. Two dollars a week got me car tickets and milk money. I brought my own sandwich. My father was kind of surprised but I think he was proud too, that I was breaking all the rules. I think he admired me for it.

> —Mary Sacco, born January 26, 1913, family from Pietra Perzia, Sicily; interview by B. Amore, 2000, *Life line* Project, 2000-2006[12]

Opportunity

Education was a key value in Concettina's life and was a legacy she passed on to her daughter and to her grandchildren. Nina was a talented student and artist. In high school she was awarded a scholarship to study at the Boston Museum of Fine Arts. The museum became her second home. She especially loved the Japanese Court and the collection of old, intricately embroidered kimonos that hung in glass cases. These had a strong influence on her sense of design.

She studied art throughout the extensive collections of the museum. Every afternoon she would sketch from the carved-marble busts and Impressionist paintings and drawings to fulfill her assignments. Evenings were spent under the stern eye of her mother.

25. *Column of History VI:*
Opportunities

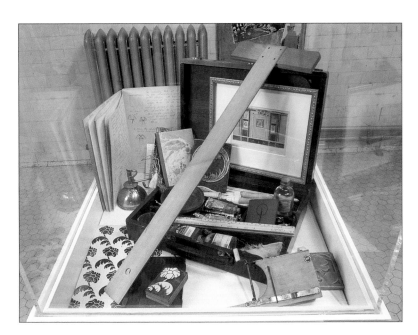

24. Nina's Art Materials. Whenever she had to select illustrations for projects, Nina would often choose art of Italian origin such as this watercolor she painted from the House of the Vettii in Pompeii; block print showing oriental influence.

Art and Freedom

Nina was one of the privileged daughters of immigrants who attended both high school and college in the 1930s. Her mother, as well as her extended family, Concettina's sister, Eufrasia, and her husband, Adolfo, assisted her in completing her education. She entered Massachusetts College of Art, majoring in Fashion Design. Art was her natural way of relating to the world. The principles of design became second nature.

During summers, she taught art at Dennison Street Settlement House. After graduating with a fifth-year teaching certificate in hand, she worked at Puritan Dress Co. in Boston until her marriage in 1941. College also gave her the opportunity for greater freedom from her mother's constant supervision, though she had to struggle constantly with the code of behavior that Concettina felt was appropriate.

My mother was my first teacher. She taught me "to see." It was impossible to go anywhere without her pointing out the designs in nature, the colors of flowers, shapes of trees, hues of a sunset. Museums were my play places as a child. I took art in "with my mother's milk."

She regaled us as children with her tales of Priscilla, her artist friend who smoked a pipe, and Santo Marino who was Director of the North End Union. We viewed my mother as an outrageous character. She was certainly different from anyone else's mother we knew!

—B. Amore

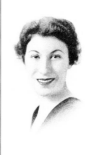

NINA PISCOPO

Nina's partiality to black and white combinations results in very striking dress patterns. Pageant time keeps her especially busy, for she does her part in glorifying the costumes. Her school work is neat as are the things she knits and crochets. With her self-confidence she is sure to win.

27. Nina's 1939 Yearbook entry, when she graduated from Massachusetts College of Art.

26. Stages of Nina's growing up.

The Art of Lounging

28. Cover and partial text of Nina's graduating portfolio, *The Art of Lounging.*

THE ART OF LOUNGING

What is so rare as a woman who will say, "Idon't want a hostess robe"? Even I, who have no definite reason for having one, dream of how lovely it would be. Every woman, wealthy or otherwise, has a desire for this garment. It doesn't necessarily mean that she is compelled to entertain at home because she has one. On the contrary she may use it as an excuse to do so!

Just imagine what a problem solver a hostess robe would be. You are having a few friends in for a Sunday night snack. You don't know just what they will wear and you know less about what you yourself will wear. Your problem is: Will you be too dressed up for them, or will you look as though you had forgotten that they were to be expected. Slip on your hostess coat, the proper thing, and be in your glory knowing that you have chosen wisely and correctly. If you are a woman, I know this must have happened to you, too, for I have yet to meet a woman in such a position and under such circumstances, in whose mind there was no doubt as to what to wear.

The design of a garment may be inspired by almost anything. I have chosen tropical fish as my source of inspiration, for their rich color and irregular shapes lend themselves beautifully to this purpose. My inspirations arise from a color, a contrast, a line, a movement, or a mood. In designing, I oftentimes think of the type of woman that would wear a certain style. It may be interesting to compare her original personality to her mood of the moment. By that, I don't mean that the

STUDENTS put finishing touches on an evening gown. Left to right, they are: Suzanne Morrissey of Brookline and Nina Piscopo of Orient Heights.

29. Newspaper clipping: "Students put finishing touches on an evening gown. Left to right are Susan Morrissey of Brookline and Nina Piscopo of Orient Heights." *Boston Herald,* February 11, 1940.

MASSACHUSETTS SCHOOL OF ART

APPLICATION FOR ANNUAL
AWARD OF HONOR

Student's Name *Nina Piscopo*
Title of Work *the Art of Lounging*
Department *Costume Design*
Date *May 19, 1939*

30. Nina's application for Annual Award of Honor.

The Art of Lounging

What is so rare as a woman who will say, "I don't want a hostess robe"? Even I, who have no definite reason for having one, dream of how lovely it would be. Every woman, wealthy or otherwise, has a desire for this garment. It doesn't necessarily mean that she is compelled to entertain at home because she has one. On the contrary she may use it as an excuse to do so!

Just imagine what a problem solver a hostess robe would be. You are having a few friends in for a Sunday night snack. You don't know just what they will wear and you know less about what you yourself will wear. Your problem is: Will you be too dressed up for them, or will you look as though you had forgotten that they were to be expected. Slip on your hostess coat, the proper thing, and be in your glory knowing that you have chosen wisely and correctly. If you are a woman, I know this must have happened to you, too, for I have yet to meet a woman in such a position and under such circumstances, in whose mind there was no doubt as to what to wear.

The design of a garment may be inspired by almost anything. I have chosen tropical fish as my source of inspiration, for their rich color and irregular shapes lend themselves beautifully to this purpose. My inspirations arise from a color, a contrast, a line, a movement or a mood. In designing, I oftentimes think of the type of woman that would wear a certain style. It may be interesting to ask ourselves what would match her mood of the moment.

This full skirted coat in of gray selveteen. It's full somberness is accentuated by the bright colored cording which winds around the body. At the front, the spirals are not applied to the velveteen, but are left loose to hook over the concealed zipper which extends down the front. Note how gracefully the cording curves to fit the body.

Heavy pink striped wool is featured in this simply cut wool coat. Try laying the stripes in various directions an interesting effect is achieved. The yokes and sleeves are cut on the bias. There's a fastening zipper at the side waist. The neck opening is large enough to slip the head through. A wide girdle of rose suede is worn with this.

The "two-piece" with many many uses. Colors — this time in alpaca. A practical luxury. The jumper dress is of bright navy cut on princess lines. There's a zipper at the side waist. The jacket is a spicy yellow with an inserted white band embroidered in rust colored yarn. The jacket opens at the neck with a little button at each side. The shoulders are slightly squared. As the jacket can be taken off and worn with other ensembles, likewise the dress. It can be worn with lacy blouses, tailored shirts, and also with sweaters.

It's white. It's warm. It's woolen. This hostess robe that is truly luxurious has long vertical pleats down the entire front. Stitched just so far it is smooth fitting over the hips. The wide girdle is stitched onto the bodice and again onto the skirt. It is not detachable. Where it is stitched onto the bodice in front, two slits are left open, and little pockets are added inside. They are embroidered in coral boucle and gold beads in the same motif that encircles the neck. There's a zipper at the side waist. At the back of the neck, three tiny material buttons fasten the neck-band over a box pleat which is open to the waist. Below the girdle this pleat is stitched two thirds of the way down.

Fringe — modern trimmer of heavy crepe to trim this robe... Giving a two piece effect. The jacket can be made removable or not. The... in back. ...front is interesting... Tiny... books and eyes... fasten the fringe together... As you can see the full skirt... rather flare... it's... accentuating small... In this case it's blue, but it would be equally beautiful in other colors such as a gold or even green — a flame color.

Intimately perfect. This hostess robe of apricot and oyster white chiffon velvet. It can be worn for dinner at home and for bridge afterwards.

The apricot color of the panels down the front is repeated in the lining of the voluminous sleeves. Fifteen tiny buttons fasten the panels together over a vestee of the white velvet. The short train makes it just formal enough to distinguish it and not label it negligee.

Another Home Wedding

This time blush rose taffeta and chiffon are combined. The flounce at the bottom is deep lace petaled chiffon. The sleeves are shirred at the shoulder and the wrist are gathered into a ring of rosebuds. This yoke is marked with a slit in the center front to allow the neck to go through, then a zipper at the side waist.

Gold kid and bottle green wool are now combined to form this coat of exquisite elegance. The high neckline closes with a zipper concealed under the top gold kid stripe.

There's another zipper at the left side waist. The sleeves and back yoke are cut in one piece. The three-quarter length sleeves are squared and fitted.

Lace. Feminine charm. The body of heavy black crepe enhances the exquisite daintiness of the tiny white lace ruffles that form the long panel down the entire front of this ultra-feminine robe. The long princess lines are slenderizing. The neck opening is large enough to slip the head through and again at the side waist a zipper takes care of the placket. The lace unit is repeated in the short sleeves.

—Nina Piscopo

32. The Art of Lounging: Nina's dress design with angelfish as inspiration, description of hostess robe and sample fabrics.

The International Institute

Nina became active as a volunteer at International Institute of Boston while she was still a student at Mass. Art and continued her involvement for fifty-nine years. The Institute was founded in 1924 with the mission of assisting immigrants with their transition to America. There, she actually met her future husband, Tony D'Amore, in 1940, the year she completed her postgraduate year at Mass. Art. The nickname for the Institute was IIB and Nina's children often said that they "grew up at the Institute" because they spent so much time there with their mother.

Through the Institute, she worked with resettling Displaced Persons after World War II and would often return home in tears relating stories of individuals who had lost their entire families in concentration camps. In later years, she translated in the courts for Italian immigrants in need of interpreters. She was a very active board member of both the Institute and the Boston YWCA. Forever engaged in the delicate balancing act of the *"via vecchia"* with the *"via nuova,"* Nina continued to be the dutiful Italian daughter, caring for Concettina, Eufrasia and Adolfo as they aged, as well as being a mother, wife and dedicated social worker.

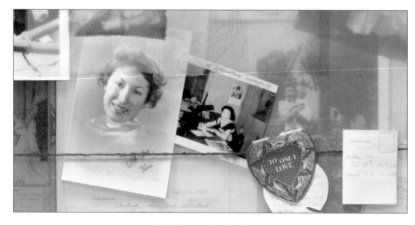

33. Nina at the Institute.

Remembering Nina D'Amore

The Last of the Old Timers

Nina D'Amore tapped me on the shoulder last April, after the IIB Annual Meeting, and told me that she's been volunteering for the Institute for over 50 years!

After several attempts to get together, Nina, who is a lovely woman whose compact energy conjures up a well-directed whirlwind, blew into my office a few days ago. At "70 years old," she is the President of the Institute's Senior Advisory Council. She has been on the IIB Board, and has a long list of projects, which she describes as a "labor of love," undertaken on behalf of the refugees and immigrants who have passed through our doors.

Nina first got involved with the Institute as a Freshman in college, in 1935, when a friend invited her to an event here sponsored by the Italicus Club, one of about 35 nationality clubs that met regularly at the Institute. Soon after she became President of Italicus, the group held a Valentine's party and invited the Italian Fellowship League to the event. It was at this event that Nina met her future husband, who was one of the leaders of the Fellowship. Her four children were "brought up at the Institute."

At that time the Institute had a staff of about 6 or 7, and the work was mostly social work, resettlement, bilingual casework, legal work and Americanization. Around 1940 resettlement was very busy with people coming from the Baltic States. Her husband went to war in 1942, and Nina got involved with the Italian prisoners of war (who were in prison on Thompson's Island, but were allowed to leave for a home-cooked Italian meal at the Institute on Sundays), Hungarian refugees and lots of war brides. The Institute had educational and cultural programs for the adults, and a volunteer-run daycare center for the children.

In the 1950s, Nina found herself working at Commonwealth Pier on behalf of IIB. She met all the people coming out of concentration camps. Displaced persons arrived from Czechoslovakia, Yugoslavia, Germany, Poland…from 8 a.m. to 8 p.m. Nina watched people get off boats and helped them through the various processing routines. They arrived with just a teaspoon and a tin cup, holding a Hershey bar. The women wore faded aprons hidden under

their rags…"and these were their prize possessions." Nina went home every night to cry.

She would pick up a group at Commonwealth Pier and get them to the correct train that would take them to the unfamiliar address they carried in their hands. More often than not, there was no language communication, but they always understood each other.

Nina recalls that, when her last child was two months old, she was leaving the Institute when the volunteer working at the Front Desk asked if she could take a young woman to the "T." During the short ride, Nina told the woman, across the language barrier, that she had a small baby at home. The woman then described to Nina how she had watched her own baby die from lack of nutrition in the displaced persons camp. The baby had been born in the camp, the mother was undernourished and could not produce her own milk. The camp provided only 4 ounces of milk daily for the baby. Nina and this woman were the same age.

The most heartwarming aspect of her work was seeing people reunited who had been separated for 30–40 years. Displaced persons were sometimes met by relatives at the Institute.

The Institute "operated on a shoestring" in those years. Nina has always been engaged in the fundraising activities for the IIB, as well as in the person-to-person direct service work. She remembers that, in 1944, the International

Ball (the major annual fundraiser for the IIB) fell on a February night when there was a horrendous blizzard. There was no public transportation or taxis. The Ball went on, and it was a grand affair. They walked to florists through the snow to gather flowers that were donated. The women made corsages to sell at the Hall. "It was just amazing to see people arrive through the storm in their Marie Antoinette costumes." After that, Nina says that it was decided to never hold the Ball in February again.

"In those times, the Institute was a mini United Nations," Nina says. The Interclub Council was made up of representatives from each nationality and sent a representative to vote on the Board. Nina was on the Junior Advisory Council, and then on the Senior Council, where she describes herself now as the youngest of 12 members. They still get together once a month and keep informed about the activities of the Institute.

Nina, who still can't pass by anyone in need without stopping to help, sums up her work with the Institute as an experience that kept her from wasting her time on earth. **"I knew it was doing something very worthwhile."**

—*The Beacon:* International Institute of Boston Newsletter, 1987

34. Following the Thread IX: Nina D'Amore.

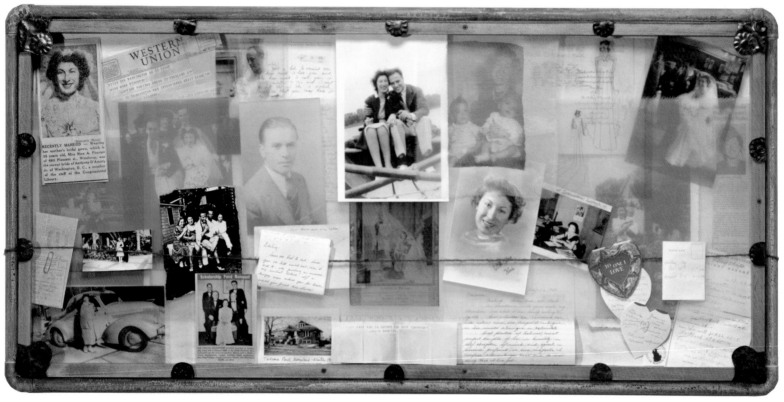

Marriage notice in the *Gazette,* the Italian Newspaper of Boston. "Recently married, wearing her mother's bridal gown which is thirty-five years old…"

Italian Fellowship League Scholarship Committee news article

Marriage certificate, December 28, 1941

Letters between Nina and Tony

News article, Nina appointed District Director of Red Feather Charity

Tony's telegrams from Washington, D.C., stating that he got the job at the Library of Congress

Airline tickets from honeymoon

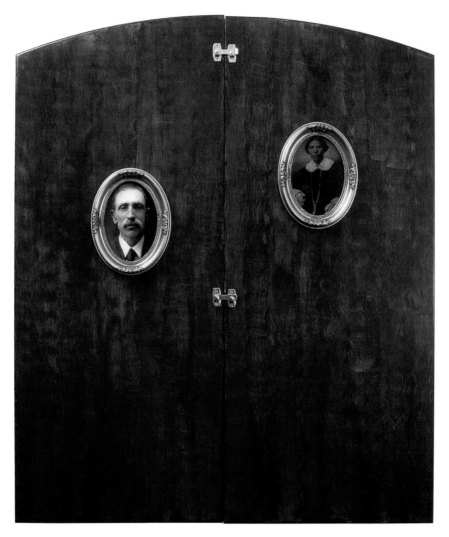

35. *De Iorio Triptych: Family Stories* (closed).

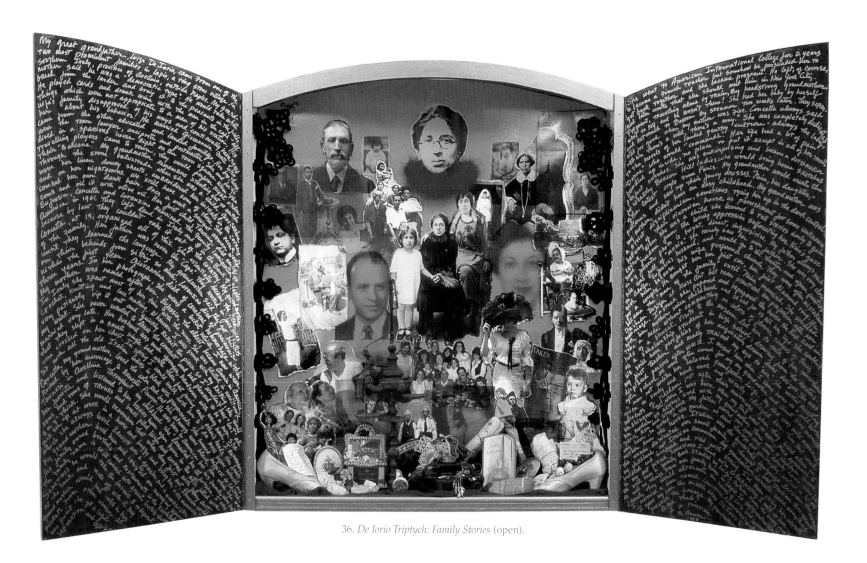

36. *De Iorio Triptych: Family Stories* (open).

111

De Iorio Triptych: Family Stories

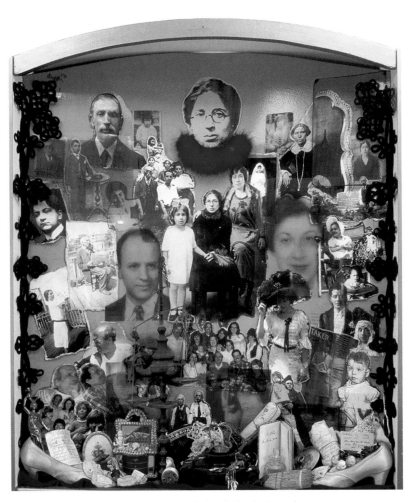

37. *De Iorio Triptych: Family Stories* (center).

My great grandfather, Luigi De Iorio, came from one of the two most prominent families in Lapio in the south of Italy. He married Giovannina Forte who came from the other educated and landed family in their small town. Luigi's family was composed of scholars and landowners who grew spices. The Forte family, true to their name, dominated the political and ecclesiastical affairs of the village. Giovannina and Luigi raised their children in the De Iorio family home on the main square where two stone lions guarded the entry portal. Teresina, their last child, died at age three. Eufrasia, Concetta and Lorenzino remained. The family emigrated to America in 1901. They left land in Italy and money in the Bank of Naples because by law, they couldn't take it out of the country. My grandmother, Concetta, at seventeen, organized all of this. They worked in factories until they learned the language. Lorenzino died of pneumonia within the first year. Giovannina died of a stroke within eight years. My mother was named after her.

Eufrasia, the eldest, worked in a factory in the early days in America but she preferred staying at home and close to her husband and the Church. She was skilled in needlework, crochet, knitting and lace-making. Concetta, my grandmother, had a much bolder and independent nature. Her whole life was ruined by her marriage to Ernesto Piscopo. He was an American citizen by birth but his family had also come from the province of Avellino. Ernesto courted Concettina with flowery notes and rides in his carriage. My grandmother loved him and insisted on marrying him. Despite his protestations of love, he continuously deceived her and his own family. There were even occasions where he stole the Piscopo Family Hotel deposits! After three years of marriage, she got a legal separation and left him. She went to American International College but during a reconciliation, she became pregnant with their only child, Nina.

Concetta lived by her favorite dictum, "Where there's a will, there's a way." Sewing was a way of life and Concetta supported the family through her talented needlework. Nina, her daughter – my mother – didn't have an easy childhood. My grandmother was a strict disciplinarian, sometimes tying her up in the dark central stairway of their Victorian house as punishment for some unknown transgression. Nina learned to tell stories early to gain some freedom from the loving oppression suffocating her.

When she was a child my mother's gaze was bright, direct, inquisitive. She rarely saw her own father. She was very close to Adolfo, Eufrasia's husband. He became the "man of the family" until Nina married. She studied fashion design at Mass. Art but never worked in her profession after her marriage and motherhood. Instead she papered and painted the house she had lived in with her mother since childhood and sewed clothes for her children. Visits to the museum led her to talk of her times there as a scholarship student in high school, drawing from the Masters. We still have portfolios of her exquisitely drawn dress designs. She also worked resettling displaced persons after World War II. I missed her when I came home to a cold house after school.

She married a man not unlike her beloved grandfather, Luigi. My dad was mild-mannered, given to study and hard work and totally idolized her. They had small moments of freedom just after their marriage when they lived alone in Washington, D.C., where I was born. When my Dad went to war, Nina returned to her mother. We always lived with my grandmother. My father worked two jobs and was rarely home. When he was home, he generally worked in the garden or read theology or philosophy, content to let my mother run the house. Italian was the household language between the women. The women dominated our small family. I thought I was Italian throughout my childhood, not Italian American. My grandmother, Concetta, saved everything, bundled and wrapped and tied with string. I've been using her objects in my art pieces. We still have a family book started by Luigi's father from the mid 1800s as well as things from our family home in Lapio. In my grandmother's family, they would alternate the names of Luigi and Lorenzo. I married a man with the last name of Lawrence and I gave my son the middle name De Iorio to preserve the lineage. My grandmother liked that!

38. Italian Bronze oil lamp (nineteenth century); Don Lorenzo's weights and measures; porcelain doll.

39. Concettina's wedding handkerchief; her silver good luck charms; inscribed book from the De Iorio Library (1858); silver hat pins; traveling alcohol stove; silver whisk broom; Concettina's pink satin shoe with handmade rosette; souvenir champagne cork from her first granddaughter's birth (1942); note to herself: *"October 14, 1974, Mrs. Concettina C. Piscopo was 90 years old!"*

40. Triptych details of Concettina's personal treasures: Silk painting of the Sacred Heart; silk embroidery threads; her favorite trinket box with porcelain doll; wedding handkerchief; tortoise-shell hair comb; beads for stringing; leather favor from Piscopo and Frederick's restaurant; base of antique oil lamp.

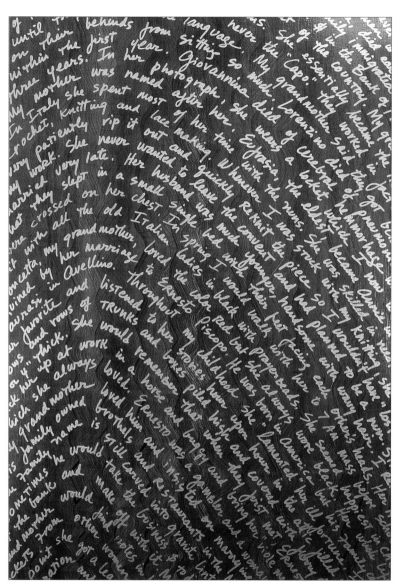

41. Detail from family stories on door of Triptych.

La Famiglia and Work

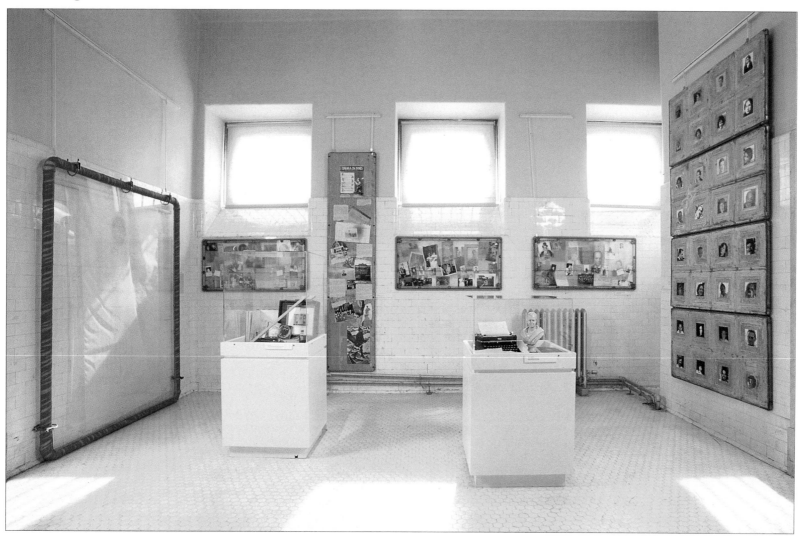

1. *La Famiglia and Work:* Overview of fourth room in Ellis Island Exhibit.

La Famiglia and Work
"Chi va piano, va sano e va lontano"
"He who takes his time, travels safely and a long way"

Most immigrant families were large, owing to the *contadino* conviction that more children meant more hands to work for the family, a value that remained at the core of Italian American life. Often, two or three generations lived together, worked together, loved and argued together. Survival had always depended on combining forces. Families continued this practice by creating businesses that made use of the ingenuity of all its members. The power and pride of the work ethic was passed to each successive generation.

La Famiglia e il Lavoro
"Chi va piano, va sano e va lontano"

La maggior parte delle famiglie d'immigranti erano piuttosto numerose in linea con la convinzione dei contadini secondo cui più figli significavano più mani per tirare avanti la famiglia, pensiero che è rimasto al cuore della vita italoamericana. Spesso due o tre generazioni vivevano insieme, lavoravano insieme, si amavano e bisticciavano insieme. La sopravvivenza dipendeva sempre dall'abitudine di unire le forze. Molte famiglie in America hanno proseguito creando insieme attività economiche che adoperavano l'ingegnosità di tutti in famiglia. Il potere e l'orgoglio dell'etica del lavoro è stato trasmesso ad ogni generazione successiva.

Antonio's Story

Antonio D'Amore, age twenty-three, emigrated from Southern Italy one year later than the De Iorios. He came from an abjectly poor family and lived in a one-room stone house in Montefalcione, Province of Avellino. His father had died when Antonio was five and his new father continually beat him. He would punish his stepson by forcing him to kneel for hours in a closet on a layer of hard, uncooked beans.

Antonio left home when he was thirteen years old. He worked in Belgium and had been working in a sugar refinery with some cousins in Marseilles, France before leaving for America. He left Naples on the steamship, *Trave,* on March 28th and arrived at Ellis Island on April 9, 1902. He never returned to Italy. Like the De Iorios, he also made his way to the North End – the Italian section of Boston – where he lived at 320 North Street with O. Talasio, the uncle who had paid his passage.

Finding Work

In the early days, Antonio would often go to North Square where the *padrone* would come and hire him for the day. *Padroni* were the bosses who hired Italian laborers. The term was originally part of the class system in rural Italy. In America, use of the word continued, although the system functioned somewhat differently. What remained the same was that the laborer was still beholden to his boss.

Some of the *padroni* really looked after their less fortunate countrymen, setting up apartments and jobs for them. Others took advantage of the immigrants' naiveté and bound them to doing business in their stores and banks. They would sponsor the passage of young men eager to leave Italy and then require the immigrants to work for low wages in squalid conditions until the loan was repaid. Obtaining a job prior to coming to America could prohibit entrance to the "golden land." This was often a double-bind for destitute villagers looking for a way to come across the ocean. If an Ellis Island inspector found out that a *padrone* had sponsored an immigrant, he could be deported back to his country of origin.

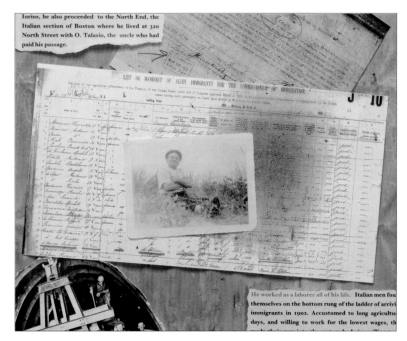

2. Antonio's ship's manifest and shipping papers.

"VOICES"—Ellis Island Interviews

When I get off the train I walk, I walk, walk, keep walk to the end of the world, I want to go to the end of the world. And now it's getting dark and now I'm hungry too; I only got fifteen cents left. And there was a store there, Italian people run the store. And I ask him if I can get a room. I want to get a job and go to work the next day. There was a sand bank there. Sand bank name was Nassau Sand and Gravel. I say I go to work in there if he can find a room for me where I can sleep. So the guy says, "No, I can't help you." But there was another Italian guy, he heard me talk to this fellow, and he says, "Come with me." And he took me in. He was a blacksmith working in the sand bank. And the next morning I went in the sand bank and went to work. Now I'm getting twenty-four dollars a day…But this is the guy that took me in, and made me, give me the sleep, give me the bed, and he give me some pork and beans to eat. That I never forgot. He didn't live, maybe a couple of years he die…So that was the only guy that helped me, and I couldn't do enough for him because I really needed the help.

—Carmine Martucci[1]

He [my father] used to, what do you call it? The hides of the animals. They used to put them in a big tub. They used to put him in there. And he had like an enclosure all around up to his waist. And from, used to, like when you squash grapes. He used to do that to the pelts to soften them, from the sweat of his body. That was his job. But, of course, times were very tough, like everybody else.

—Nelson Misturini[2]

3. *Column of History VII: Beginnings.*

Breaking the Stones

Antonio worked as a laborer all of his life. In 1902, the year he arrived, Italian men found themselves on the bottom rung of the ladder among arriving immigrants. Accustomed to long agricultural days, and willing to work for the lowest wages, they made their way into the system by taking on the work that no one else wanted. Antonio's grandson, who lived with him, remembers the solitary, small, stolid figure leaving for work at dawn carrying his pickaxe and lantern to dig the foundations of Harvard University.

Italians were considered an inferior race at the turn of the century and were often portrayed in popular culture as mustachioed villains. For this reason, they tended to recreate their familiar *paese* culture and set up self-sustaining economic and social communities as soon as possible. Despite the prejudice, many enterprising immigrants scrupulously saved and struggled to turn tribulation into opportunity, patiently waiting to purchase their own houses or a small business. Antonio's sons eventually pooled resources and bought a home in which three generations of the family lived together.

I have fought winds and cold. Hand to hand I have locked dumb stones in place and the great building rises. I have earned a bit of bread for me and mine.

 —Pietro di Donato in *Christ in Concrete*

President Woodrow Wilson, never a great friend to immigrants, listened to all the complaints about Italians taking dollars out of the country. Then he replied evenly, "But they left the subways."

I came to America because I heard the streets were paved with gold. When I got here, I found out three things: first the streets weren't paved with gold, second, they weren't paved at all, and third, I was expected to pave them.

 —Anonymous Italian immigrant

Often the object of stereotypical imagery, the Italian pick-and-shovel men had constructed more than 25,000 miles of railroad track by 1910. Their rate of pay was $1.46 for a ten-hour day, while Irish workers received $2.00 for the same amount of work.

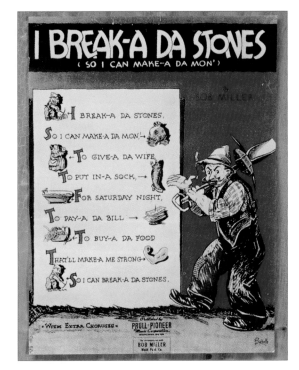

4. Derogatory sheet music cover with "Itaglish."

There were many various gangs working in the place: stone-breakers, stone-drillers, excavators, concrete workers and others, each with its own foreman. There were men loading stones of various sizes newly broken, on wagons; steam-rollers puffing along; gangs laying out first large stones, then smaller, and then sand. Over everything they put on tar and a covering of powder which we called "fine stuff."

I succeeded in getting work with the concrete gang. The road was progressing rapidly. There were rivulets over which little concrete bridges were required. Having no mixer for the concrete we had to mix the sand, stones and cement with our shovels right on the spot. And here came some of our hardest work, especially hard, as it was summer. On some of those cloudless days when the sun blazed down on us we would be carrying dusty bags full of heavy cement on our shoulders continuously. The dust mixed with the sweat beneath, burning the shoulders and itching. Very often after I had wiped my cheeks and around my neck with a dirty handkerchief I had to spread it out on the grass to dry while I staggered along through the flaming sunlight with my load. When dry the cement made the handkerchief appear petrified.

—Pascal D'Angelo in his book *Son of Italy*[3]

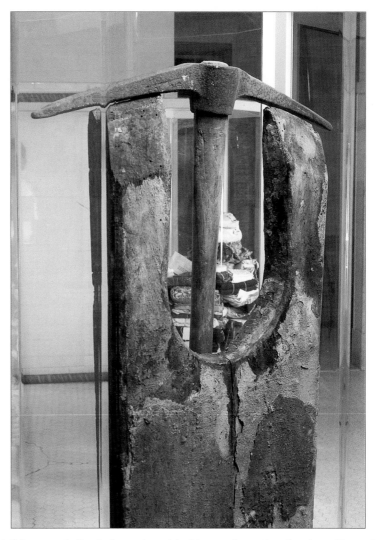

6. *Reliquary to the Two Anthonys:* Antonio's pickaxe and a portion of a winemaking cask with residue still attached. His son Anthony's *Book of Knowledge Encyclopedia* is part of the lower half.

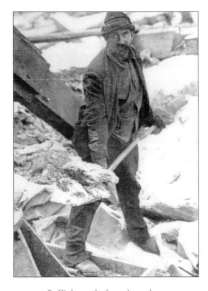

5. Pick-and-shovel worker.

Ancestor Scroll: Antonio D'Amore (*Papa Nonno*)

Umberto Antonio D'Amore, my grandfather, seemed to me to be a very mean man. All of us were afraid of him when we were little. He always sat in the same chair and leaned on his cane in front of him. When we passed from the kitchen to the living room he would try to hit us with the cane. Later I found out that he sometimes beat his children with a leather strap. When I talked with my Aunt Mary a month ago she said her father was sweet. His son, Rico, remembers him in later years visiting and bringing gifts of produce he had grown. These memories definitely differ from mine. Who can know all of the many aspects of a person? He had thirteen children, but some of them died. I knew Rico, Tony – my dad – Adolph, Mary, Dolly, Susie, Mike and Philly. The boys had one bed; the girls had another – two beds for eight children! Maybe he was mean because he had so many kids and not much money. Maybe he was really tired when he came home. He was a stonemason and a brick-layer. The first time he was in a hospital, shortly before he died, the doctor was amazed to find that he had seven or eight fractures which had healed on their own! He used to fill the cavities in his teeth with cement. My cousin Richard enjoyed making a patio with him at the old house in Roslindale. I remember watching him build a granite wall when I was about four years old. I stood behind him, noticing the weave of his heavy wool pants, and wanted to help. The granite blocks looked small enough for me to hold but when I tried to pick one up, he pushed me back or maybe I jumped back first because I was so afraid. He said I couldn't help – perhaps because I was a girl. My fingers were itching to touch the stone, but I held my hands behind my back tight, so I wouldn't be tempted to reach out. I didn't want him to hurt me. Perhaps he's even part of the reason I'm a stone carver today! Cousin Gerald told me that Papa Nonno went to work every morning carrying his pickaxe and lantern and that he helped dig the Harbor Tunnel in Boston and foundations for Harvard. He always wore a hat, even in the house – the kind of hat that had a small visor. Once or twice I saw that he had a bald head. It was so glossy it hardly looked real. At his wake, my father reached into the casket and pinched his shoe. It left a dent! The shoes weren't real. They were made of something that looked like shiny cardboard.

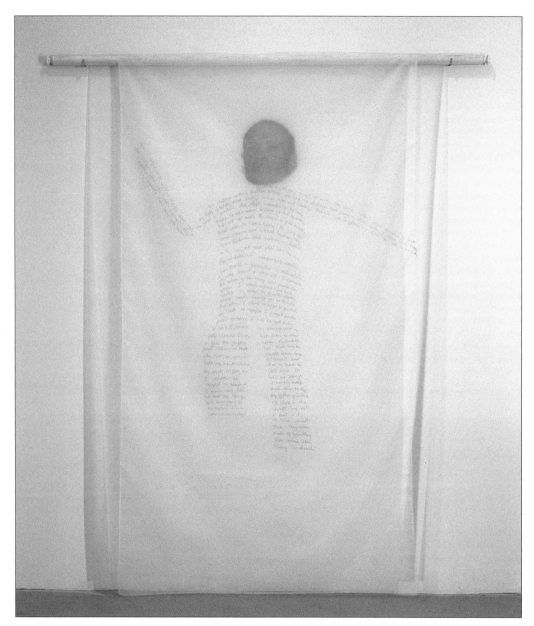

7. Ancestor Scroll: Antonio D'Amore (Papa Nonno).

Old Country Skills

A relatively small number of Italians entered America with marketable skills. They quickly found employment as artisans, stonecutters, tailors and professionals within the Italian community. Once established, they were able to train and often employ their fellow *paesani* or countrymen. Pockets of highly-skilled stone carvers settled in Barre, Vermont and in large American cities like New York and Cleveland. Monuments sculpted by these immigrant professional carvers grace Washington, D.C. – the Jefferson Memorial, Lincoln Memorial and National Cathedral, among others. The tiled ceiling of the Great Hall at Ellis Island was the work of a father-and-son team, the Guastavinos.

8. Detail of Italian carving shed; the Guastavino ceiling at Ellis Island; Italian American monument, Barre, Vermont, carved by Philip Paini from model by Giuliano Cecchinelli.

"VOICES"—Ellis Island Interviews

I worked with my father as a stonemason, stone worker you know. As a helper and things like that, you know. I worked there. My father was involved in November or December, in November they close the works down. They didn't work whole winter till maybe next April because it's outside work. Well, I was young, I don't want to stay home, so I started looking for work in my line. I wrote to a lot of companies all over the state and in New York and Pennsylvania. And there's a company right here in Pittston that responded to me and they hired me because of my mosaic ability. By then I started working on terrazzo, most of the time on terrazzo work. That's what I did most of my life. And I've been there ever since.

—Ettore Lorenzini[4]

Antonio and Maria Grazia

Antonio D'Amore met Maria Grazia Catalano in Boston. She was introduced to him by *paesani* who knew her from Montefalcione. She had come alone in search of her brother, Ricuccio. Antonio and Maria Grazia married and raised five boys and three girls. Economic circumstances were always marginal. Strict physical discipline was the order of the day. No disrespect was tolerated. The mother was the center of the household, the rock around which the stream of family life eddied. She rarely worked outside the home. Maria Grazia cared for the family and kept the household going in an emotional as well as material way.

"VOICES"—Ellis Island Interviews

Well, I think she had a great sense of humor but she was really tough. I think she, see, she was left alone with all the children in Italy. And she must have made up her mind, "I have to be the boss here," or I mean, there'd be pandemonium. And I think she did that, where she ruled with an iron, iron, uh, what is it, thumb or whatever. Nobody ever disobeyed her. All she'd have to, she would say this and that was it. We all did whatever she said.

Well [after my father died], my mother still remained a homemaker and all the children kept running the family. That's the way we were brought up. We all shared, we all, everybody gave her the money. She ran the household, if there was anything left we would do it, if there was nothing left, we would do nothing.

—Elda Del Bino Willitts[5]

Oh God, I mean, my mother, I mean, I don't think she ever threw out anything in the way of food. I mean, she would, because any leftovers we would make what are called porchetti, I mean, which would be like, well, it's a mixture. Like if she, she made a lot of soup with boiled beef in it, we used to call it bollitto because, and vegetables. It's like corned beef and cabbage but Italian style. Well, if there was any beef left, then she'd chopped that, put it with egg and cheese, and, and bread and make croquettes out of it, like croquettes. And if she had any vegetables left she would make what is called frittata. Because you chop it up and put it with egg and put it, so I don't think, other than what she had to do like the ends of asparagus that you can't eat, but if it was edible she never threw one thing away.

—Elda Del Bino Willitts[6]

When we came to this country, the people that my father boarded with, they got me a beautiful little doll for Christmas. Oh, my God, it was gorgeous. Mom let me play with it for two years, and then she sent it to Europe because my little cousins needed it more than I did. I was so heartbroken. She made a whole mess of clothes. And the clothes that she made, she had a long jacket, a lightweight jacket. I can still see it. When she got married, part of her trousseau. Then she had that made for me for my communion dress. It was white with a little tiny line of lavender. Then she made this for my communion dress, a very lightweight wool. Then she made a little dress out of it and she put a pin between the legs. That was for my baby brother. Then from that she made a coat for my doll and sent it back to Italy again!

—Renata Nieri Maccarone[7]

Ancestor Scroll: Maria Grazia Catalano *(Nonni D'Amore)*

My grandmother – my father's mother – was a strong woman. When she came from Italy, she slept in a chicken coop in Canada. Her sister, Assunta, stayed in Canada but Nonni came here. She lived at 4331 Washington Street all the time I knew her but in Italy her town was tiny – Montefalcione – in the mountains outside of Naples, Province of Avellino. I saw the house where she was born. It was made of stone, rough, and still has a small fountain in front where people fill bottles with pure water from underground. At the end of the small stone road, one can look across the valley and see the next hill town. Here, in America, she became the mother of thirteen children. I know eight of them. Five died. That family was very noisy. There was always something going on and people didn't seem to mind yelling. Sometimes Nonni D'Amore grumbled a bit but mostly she was very kind – willing to take time, and gentle but strong. I always felt good in her presence – like there was comfort. I felt safe with her. Holidays at her house were fun – lots of cooking. She would stir huge pots on the old enamel stove, make ravioli on the kitchen table, putting them to dry on a coarse sheet on my cousin's bed; always be placing more food on the table, but never pushing it on you. She smiled more than she talked and felt like the sun over all of us. How did she feel, this woman who lost five children; eight surviving. Was every line in her face one of the pains of loss? Did those losses make her more kind and patient? She never lost her Spirit. I loved her and she taught me about love and fun. When my mother went to Italy for five months, Nonni took me to the North End to visit her friends – tiny alleys, dark stairways, dim light as we sipped coffee in the kitchen leaning on the oilcloth-covered table. She cared for me.

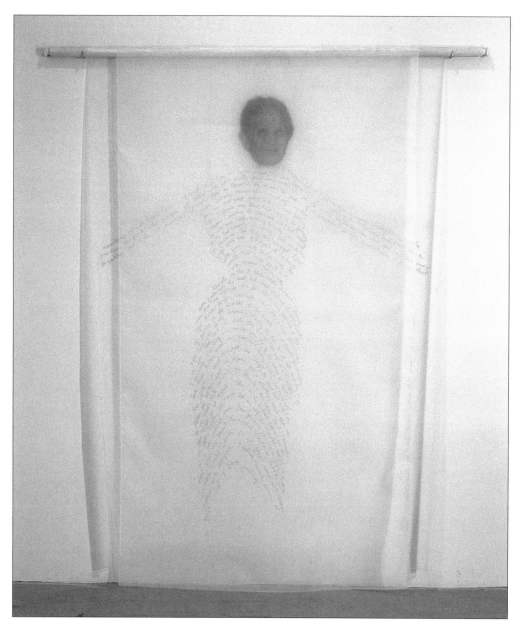

9. *Ancestor Scroll: Maria Grazia Catalano* (Nonni D'Amore).

Tenement Childhood

Two of Antonio's sons, Tony and Rico, couldn't even find jobs as shoeshine boys because they were Italian. Leaving their crowded tenement apartment where the boys slept sideways on one bed and the girls in another, they would visit the Jewish storeowners on Salem Street in Boston. As young entrepreneurs, they would each be given a bundle of socks to sell at the market. Setting up a cardboard box as their stand, they would hawk their wares.

Everyone in the immigrant Italian family worked. Work was an honored tradition in Italian life. The belief was that through work, one could overcome adversity. It was a deep source of pain for many immigrants that in Italy, no matter how hard they worked, they could not get ahead. Leaving their native soil was a decision often forced upon them by the circumstances in their homeland.

The only person who leaves his native country is a person who has been abandoned by it. Here, I found my dignity and self esteem. At least in America, you can dream. Everything starts with a dream. Freedom is the realization of your dream.

> —Les Marino, Head of Modern Continental Construction Co.,
> in a speech at a Naturalization Ceremony, Old South Church,
> Boston, August 2000

"VOICES"—Family Interviews

We all worked, just to get out of school. We'd go down to market, cardboard boxes, half-pint bottles. Then we used to take a barrel from this guy that owned it, and we'd move it over to the next guy, the next meat man and sell him the barrel for half a dollar. You had to hustle to make the buck! We sold newspapers. We shined shoes. On Saturdays, we couldn't do nothing. We used to go down and buy a case of lemons – we used to get a case of lemons for three dollars. A case of lemons would bring you ten dollars.

We picked up a guy in a dry goods store on Salem Street. He gave us some socks to sell. We pulled around and Tony had some socks. Just above E. Gray's Market, there used to be a place they used to make salami and bologna and everything there with a machine. Tony had all the socks out on a big cardboard box, you know, and he was selling them. I think it was a buck, three for a dollar or something like that. And all of a sudden, machine went down, the salami – came across the street – splattered all over everybody, the pushcarts and all of us. Tony's business was over! We didn't have to pay for the socks because we got them on consignment from the guy. That's what we used to do. We never – we never bought anything outright because if you get stuck with them, you got nothing.

> —Rico D'Amore (second generation), interview by B. Amore, 2000,
> in video "The Thread of Life in One Italian American Family"

The Café Roma was up for auction. And my father knew Jerry Nazzaro, the owner at the time. And he put in a bid and there we were. Thanks to him, I was able to work seven days a week, twelve hours a day, 365 days a year for ten bucks a week, five back for room and board. That's a true story, okay?

Hey, in those days, you brought the paycheck home to ma. You know, you didn't fool around. I remember the Marmai family. There were eight of them. They all worked including all the sons. When they got their pay envelope, they didn't dare open it up. They brought it home to ma. She gave them what they needed for their carfare or whatever for the week and the rest she kept to run the house.

Sure they always sneaked a few bucks out, of course, of course. But that was, and a lot of families were like that. Regardless of age, if you were living at home, you were not your own boss. You ran by the rules.

We speak about the good old days. Well, the good old days weren't all that good, because there was a lot of hunger, there was a lot of prejudice, there was a lot of difficulty. People had a hard, hard life. Women still had nine kids without a washing machine, without a dishwasher, without a shower, sharing a toilet out in the hall with three other families. The good old days were not such good old days.

But think about it. It's a wonderful thing. Somehow or other, unless we're paranoid about those things, the bad times really fade. The good times always rise up.

—Tullio Baldi (second generation), interview by B. Amore, 2005, *Life line* Project, 2000-2006

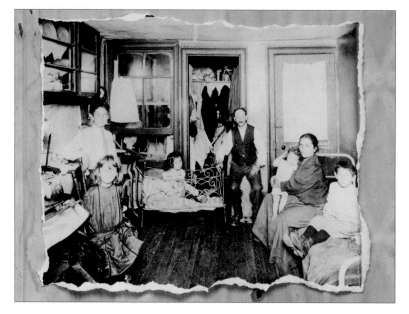

10. Tenement Room, 1910.

"VOICES"—Ellis Island Interviews

It was only a two-bedroom flat and there were ten of us, nine because he (father) went back to Asti (California) because we were not self-supporting. And I remember sleeping, there was three in every bed and I was in the middle all the time (she laughs). With two of my sisters and, uh, they used to squash me if I was sitting, sleeping in the middle so I'd sleep at the foot of the bed and that wasn't very pleasant either.

—Elda Del Bino Willitts[8]

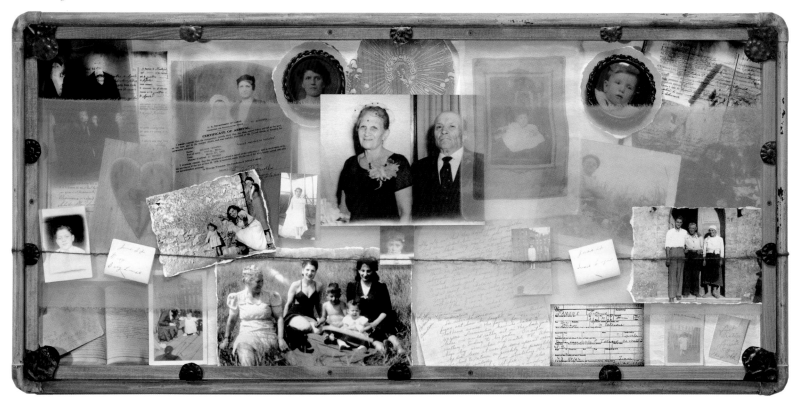

Notes and photo of Baby Louise who died at five years of age

Maria Grazia's certificate of arrival at Ellis Island on SS *Canopic* March 23, 1909

Anthony J. D'Amore's memories of his grandfather, Antonio

Antonio's birth record, Montefalcione, September 18, 1878

Maria Grazia's birth record, Montefalcione, February 17, 1891

Record of Antonio's arrival at Ellis Island on the SS *Trave*, April 9, 1902

Necessity Determines Choice

Marie, the oldest daughter, had to leave school to care for the younger children. Her seven siblings were encouraged to complete high school and go to work. Tony, his brothers and his nephew, Paul, spent summers at "Caddy Camp," sponsored by the North Bennet Street Industrial School with the purpose of bringing inner city children to the country. As a result, Tony became a lifelong golfer, an unheard of sport in his native North End. These were important experiences in exposing second- and third-generation children to the world beyond their small Italian community. Adolph, Mike and Rico also took part in the Civilian Conservation Corps created by Franklin Delano Roosevelt, which brought them far from their urban *paese* of the North End.

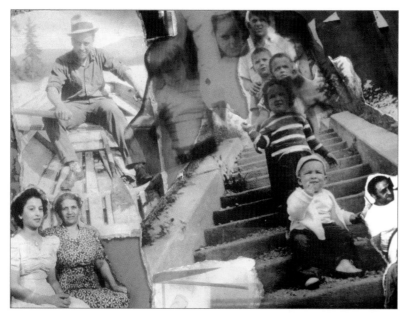

12. Tony at Caddy Camp; Maria Grazia with Dolly; group of cousins.

13. Caddy Camp Newsletter's 50th anniversary. Caddy Camp was founded in 1915 in order to encourage self-sufficiency in young men and to teach them the skills of caddying for golfers.

14. *Following The Thread XI: D'Amore Family.*

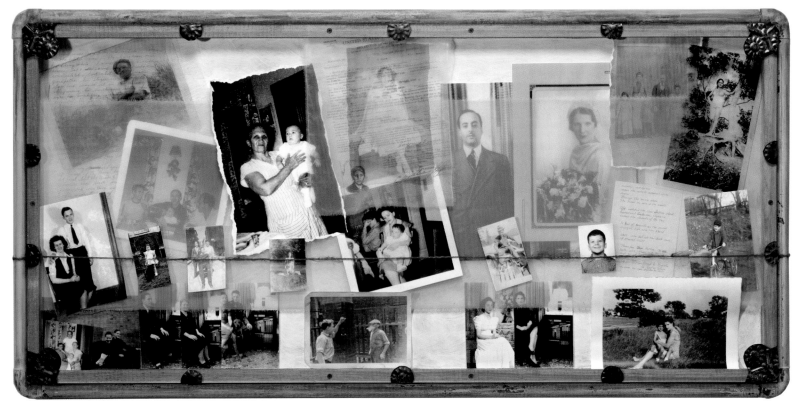

Memories of Anthony J. D'Amore, Antonio's grandson

Declaration of Intention to apply for citizenship Maria Grazia D'Amore, February 1, 1939

Poem by Marie's son, Richard Masiello, 1967, in honor of his mother

Tony D'Amore

Tony, the oldest boy, was supported by the entire family in his role as a scholar. It took everyone's energy to make up the income lost by having a student in the family. He attended Jesuit schools and entered Maryknoll Seminary for three years, but the effects of early spinal meningitis prevented him from completing his studies. He then considered medical school, then law school.

Despite graduation from Boston College and a job at the Library of Congress in Washington, D.C., after World War II he chose to start a family business with his brothers in order to fulfill his responsibility as the first son. The culture of the *"via vecchia"* was passed on to the second generation and often conflicted with the *"via nuova"* required by participation in American life. It was common for parents to expect to have a strong say in the choice of a prospective spouse, for example, and digression from this caused friction. Inevitably there arose an essential conflict, between fulfillment of self and loyalty to family.

15. Tony at Maryknoll Seminary, and graduating from Boston College in 1936.

Letters

Boston, Mass.

I wonder if you realize what a tough time <u>you're</u> going to have when you tell your mother [that we're going to be married]. I know! However, you'll have to hold your ground if you expect to win out. It seems as though your mother hopes I won't give her the pain of marrying you before you get your law degree. I don't know what I'll say to her if she asks me not to marry you – that is after you break the news.

I think you had better plan to come home on a week-end to tell her – or better still write first – and then come. Well what-ever comes we'll fight it together – to gain the happiness we so desire. It shall be, if it is God's will. I pray fervently for this help!

 —Nina Piscopo, excerpt from a letter to Tony, September 22, 1941

Washington DC

I got the greatest kick out of one of your letters, the one where you made mention of the squabble regarding my intimates – gosh – I got a laugh out of the crack, "I don't want Tony to marry until he finishes law school." Ha, ha, That's so darn funny and ironical besides, what in the hell do they want me to do – stick around until I become an old man?

You listen to me, darling, we are going to be married, regardless, get that through your sweet head. As far as concerns my family they will readily condescend to acquiesce to anything I have to say and that is de facto.

 —Tony D'Amore, excerpt from a letter to Nina, his future wife,
 September 24, 1941

ANTHONY BENVENUTO D'AMORE, A.B., 4 Lothrop Place, Boston, was born in the city December 25, 1914. He is one of those distinguished Italian gentlemen from the Hub of the Universe, whose ancestors were artisans in sunny Italy. Tony has lived beneath a religious shadow, being tutored by the Sisters in grammar school and then matriculating at Boston College High School. While at the James Street institution he was a member of the football squad and also played on the informal basketball teams, which incidentally, with golf, is his favorite sport. On his arrival at Boston College, Tony continued in the role of an athlete becoming a member of the track team and specializing in cross country running. As an entrant in the Harvard and West Point cross country meets, he gave promise of becoming a capable addition to Coach Ryder's squad, but couldn't be persuaded to run on the oval for long. "You don't get anywhere," he claimed.

Tony also joined in the activities of the Sodality, French Academy and Economics Academy, displaying at these assemblies a fine oratorical ability.

His ambition is to make use of this ability as a speaker, in our courts of law as a Catholic lawyer.

We hope that this desire will be attained for Tony is capable and possessed of a fine sense of justice in meeting difficult problems.

16. Tony's yearbook entry, which shows his serious attitude towards study as well as his sense of humor. Boston College was primarily an Irish Catholic University at the time and Tony was one of the few Italian American students.

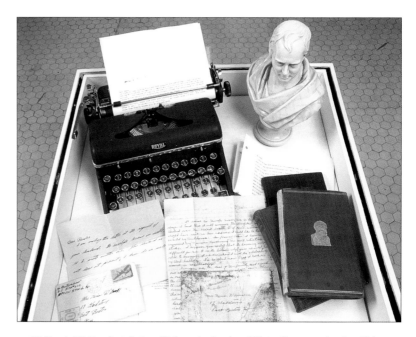

17. *Tony's Writing Installation:* Philosophy books of Plato, Socrates, the *Aeneid*; bust of Caesar; World War II letter; his portable typewriter, which was taken to Italy and back several times; letters between Tony and his eldest daughter written on the same typewriter.

18. *Following the Thread XII: Tony D'Amore.*

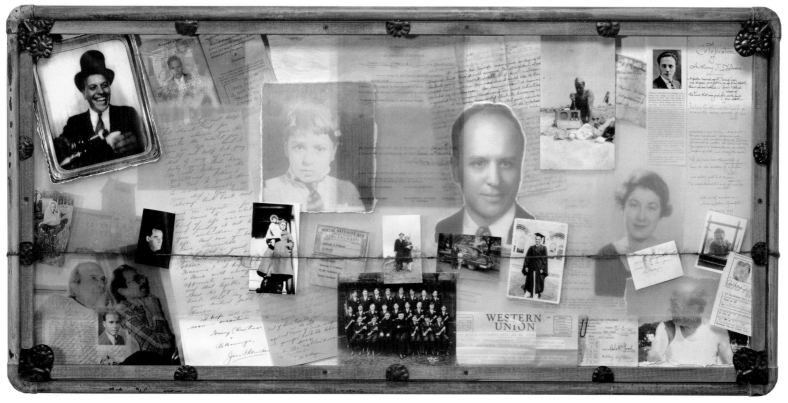

Tony's High School
Yearbook entry, 1932

Verses from "Ode to the
Setting Sun" by Francis
Thompson

Various documents from
Library of Congress

Telegram to Tony in Army
to come home for Denis'
birth, June 26, 1944

Tony's Yearbook entry for
Boston College, 1936

Tony's passport, for study
in Italy September 15, 1939

Tony's letter to Nina,
WW II, December 14, 1944

Poem in memoriam to Tony by
T. Giarraputo, October 15, 1984

Letter from seminary
friend, Fr. Jim Sheridan

Tony's U.S. Army ID,
December 30, 1943

The Family Business

This conflict between self and family was often a subtle double-bind that affected second-generation children of immigrants all their lives. Tony never lived in his home of origin after marriage but lived with and cared for his wife's mother, Concettina. Although he worked for a law firm, taught school, and considered studying law as a profession, he kept returning to the fact that he had a responsibility to his younger brothers and sisters. His nephew, Gerald, remembers him coming to the family home and explaining the idea of a dry cleaning business to his incredulous parents and siblings.

Family businesses grew as a way of staying close to *"la famiglia,"* the close-knit group which could be trusted. Often, this was also a way to participate in the larger community, albeit from a known base of support. The D'Amore family business was named Atlas Cleaners by Tony in honor of the Greek God, Atlas, who held up the world. His classical training was always an integral part of his way of thinking and expression.

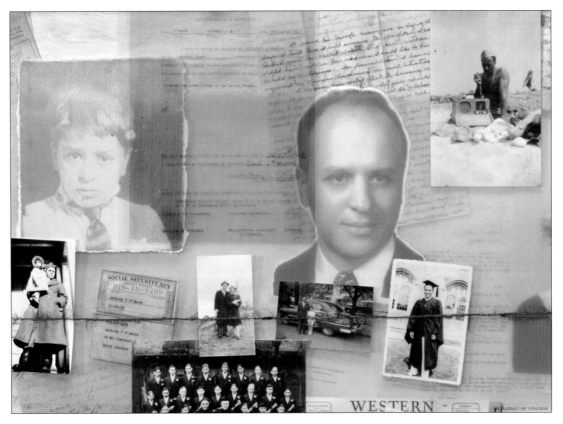

19. Various government forms from the Library of Congress listing Tony's qualifications, including his study of Chinese and Japanese, as well as his abilities in French, Spanish and Italian. He was employed at the Library of Congress from September 15, 1941 until he entered the U.S. Army on December 30, 1943.

Training for Life

"The Shop," as it was called, became the training ground in the world of employment for many of the third generation of cousins. The boys would help sort clothes, put them on hangers, and deliver them to the Coast Guard and Navy sailors who were the principal customers. The girls would help with the book-keeping and occasionally be allowed on board the Coast Guard ships, but only until puberty set it. As soon as they began to show signs of becoming "young women," they were relegated to the household to keep them "safe" from the gaze of the young sailors.

Trips in the truck with Uncle Tony were always fascinating because he would share philosophical thoughts on life and try to stimulate questioning thoughts in his young listeners. He also entertained them with his antic humor. "The Shop" was a family affair and everyone was involved in one way or another. Eventually, after twenty years, differences between the strong-minded brothers brought about the sale of the business.

20. Three of the D'Amore Brothers: Phil, Adolph, Tony; Antonio with his grandchildren; the Atlas Cleaners Truck.

"VOICES"—Family Interviews

When I worked with dad, to be honest, I never got much feedback. It was always indirect. Basically you had to figure it out for yourself. Dad rarely gave any kudos. After you did something and you were successful, you could feel more of a sense of your own worth. If he didn't say anything, that meant he approved. That was the recognition.

I remember this instance where he figuratively "threw me into the swimming pool." There was a Navy ship coming into East Boston and he sent me, at seventeen, to "handle" the ship. This meant that I had to go alone to collect the blues [uniforms] from the sailors getting off the ship. There was this other older guy trying to steal our business, so I had to change my whole way of operating. I could hardly write down names, just had to scribble the information but I kept our customers and we did a ton of business on that ship…

No, there was no sense of pride because pride was not in dad's vocabulary. There was no room for pride – just humility… I guess I grew to feel confident in myself. That's what being around him, working with him, was like. You just did the things he asked of you. You had to be a quick learner or he wouldn't give you these challenges any more.

> —Denis D'Amore (Tony's son, third generation), interview by B. Amore, October 2003, *Life line* Project, 2000-2006

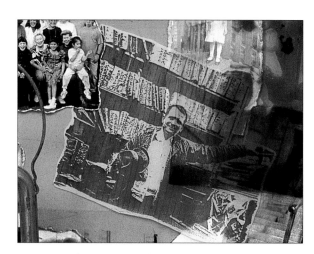

21. Mike D'Amore in the Atlas Dry Cleaners Shop.

22. *Column of History VIII: La Famiglia.*

Loyalties Questioned

Many Italians applied for U.S. citizenship during the war years to prove their allegiance to their adopted country. Maria Grazia D'Amore became a citizen in 1944. Eufrasia, Concettina's sister, became a citizen in 1940. Concettina herself, who had become naturalized through marriage to Ernesto (1906), had to go to extraordinary lengths to prove that she was an American citizen when she applied to work at the Treasury Department in Washington, D.C., and was exhorted to present this as proof of citizenship in the future. She had been in America for 38 years at this point!

Later, when working for Raytheon, an electronics company that executed defense contracts, Concettina's photograph was published in the Raytheon News because she bought a $2,000 War Bond.

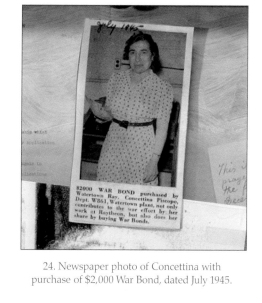

24. Newspaper photo of Concettina with purchase of $2,000 War Bond, dated July 1945.

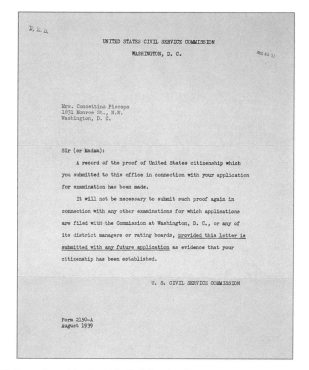

23. Letter issued by the U.S. Civil Service Commission, in August 1939, acknowledging proof of Concettina's citizenship.

$2000 WAR BOND purchased by Watertown Ray. Concettina Piscopo, Dept. W861, Watertown plant, not only contributes to the war effort by her work at Raytheon, but also does her share by buying War Bonds.

Serving America

Four of the D'Amore brothers served in the Armed Services during World War II: Adolph, Mike and Tony in the Army, Rico in the Navy. At a time when even the loyalty of Italian Americans was questioned because of Mussolini's involvement with Hitler, Italian families still sent their sons to fight for America. Tony actually volunteered for service even though he was exempt because of his work at the Library of Congress, a government agency. He was discharged from the U.S. Army in 1945 with two Bronze Stars and a Good Conduct ribbon. His brother, Mike, also served in the Asiatic Pacific Campaign. He earned two Purple Heart medals in addition to many others, and even cooked for Eleanor Roosevelt, the president's wife, when she visited the troops.

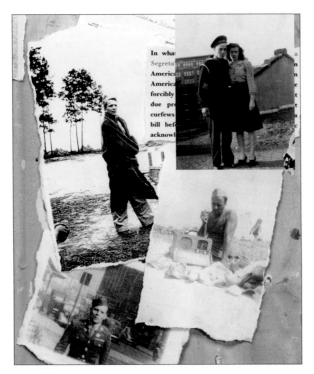

25. The four D'Amore boys in uniform.

Italian American families found themselves in an impossibly painful state, supporting America as citizens and worrying about family in Italy living under Fascism. It was customary to station Italian Americans in the Pacific rather than in Europe. However, some servicemen did have the shocking experience of fighting in the regions of their ancestors and coming face to face with distant cousins as they made their way up the "boot."

"VOICES"—Ellis Island Interviews

Oh, I loved the time that I spent there [Italy], I really did. But you know, for a GI, it was a different thing altogether. And Italy, then, was – you might say it was stripped of much of its culture. I went to Pompeii and there was nothing in Pompeii to see, because all the artifacts had been taken out and brought into the museum in Naples.

No matter where you went, there was almost nothing to see and it was all under wartime conditions and the whole waterfront had all been bombed by American planes; they were after the Germans. Matter of fact, when I pulled into the Bay of Naples, at dark, there was one of the ships the Germans had scuttled and they just took off the superstructure and built a dock, that's what they did, on many of the ships that they scuttled. They'd just take off the superstructure and they'd turn them into docks and piers.

World War II in the armed services was – were – Italians. No, there's no question about it, matter of record – the largest ethnic group because the Italians had so many big families.

—Tullio Baldi (second generation), interview by B. Amore, 2005, *Life line* Project, 2000-2006

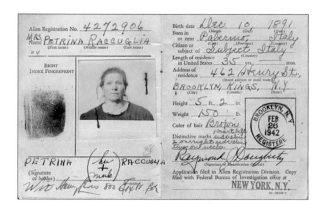

26. Alien Enemy Registration Card of Pietrina Raccuglia, who had a son serving in the U.S. Armed Forces at the time it was issued. She was so upset that her loyalty was questioned that she decided never to become a U.S. citizen.

In what has become known as *Una Storia Segreta* (A Secret Story), more than 600,000 Italian Americans were considered "enemy aliens" in America during World War II. Some were forcibly evacuated to internment camps without due process, others had to observe strict curfews and carry ID cards. The code of *omertà*, or traditional silence, kept many Italian Americans from any activism in relation to these embarrassments.

In 1999, U.S. Representatives Rick Lazio and Eliot Engel introduced before Congress "The Wartime Violation of Italian American Civil Liberties Act," which acknowledged these little-known facts. It was signed into law on November 7, 2000 by President Bill Clinton and now provides funding for documentaries and exhibits which explore this complex history.

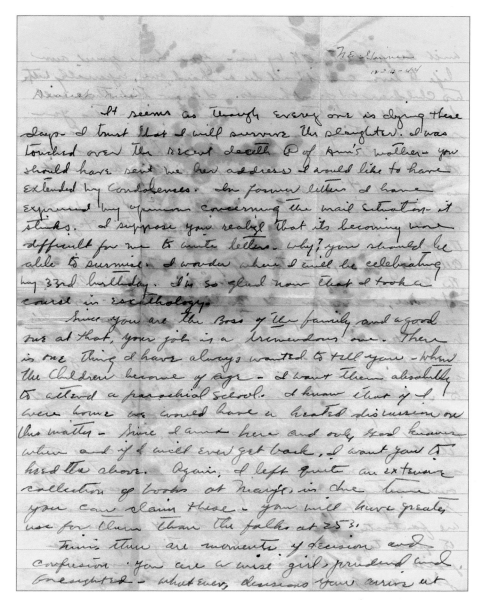

27. Partial text of war letter from Tony to Nina.

I am writing this letter at the request of your husband. The envelope became unusable, so I wrote another one. Your husband is not here at present; I know he is well.

New Guinea 12/4/44

Dearest Nina,

It seems as though everyone is dying these days. I trust that I will survive the slaughter. I was touched over the recent death of Ann's mother. You should have sent me her address I would like to have extended my condolences. In former letters I have expressed my opinion concerning the mail situation – it stinks. I suppose you realize that it's becoming more difficult for me to write letters. Why? you should be able to surmise. I wonder where I will be celebrating my 33rd birthday. I'm so glad now that I took a course in eschatology [the science of the last four things: death, judgment, heaven and hell].

Since you are the boss of the family and a good one at that, your job is a tremendous one. There is one thing I have always wanted to tell you – when the children become of age – I want them absolutely to attend a parochial school. I know that if I were home we would have a heated discussion on this matter – Since I am here and only God knows when and if I will ever get back, I want you to heed the above.

Nina, these are moment of decision and confusion…I don't want to sound like Polonius but at this stage of the game, one has to include in a letter as much as one can. All will go well, with the help of God. My reaction is the same as that of the Master "Thine not mine be done."…I must say that the few broken years we spent together were memorable ones. Among these I include the happiest moments of my life. You came to me when I needed you most – for at the time of our meeting I was certainly in a most uncertain state. Seminary, Italy, Simmons, BU. All these incidents are fantastic episodes which I can't even now seem to piece together: I needed something to give me poise and equilibrium. You did a marvelous job…Sometimes I wonder if I inveigled you into marrying me by my tales of Rabelais. If I recall you got quite a kick out of this droll Frenchman. Anyhow, I thank God for such a lovely prize – it was worth the fight.

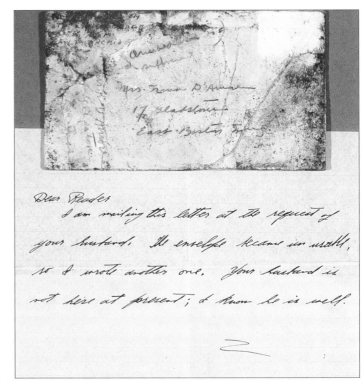

28. Muddied envelope containing a letter written by Tony to his wife, Nina, from New Guinea where he was stationed during World War II. It had been sent to her via a third person, since the original had been so damaged as to be unmailable; part of the text of the letter.

<center>* * *</center>

How anyone can crowd in one letter the events of a lifetime is beyond me…As I have before mentioned the name of Him will unravel everything. In conclusion – What happy ages love thee? What mighty parents gave birth to a soul like yours? While rivers run into the sea, while mountain shadows move across their slopes, while stars feed in the fields of heaven, ever shall your honor, your name and praises endure in whatever lands may summon me. My most profound love to you and the children. You are in perfect trinity – the be all and the end all of a worthy sojourn in a beautiful universe.

—Ever—T

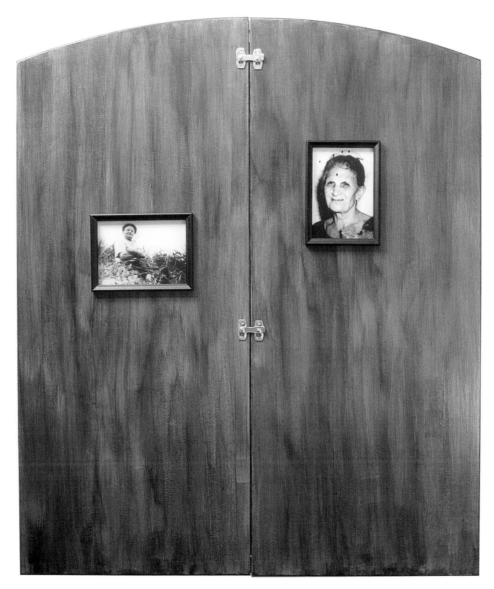

29. *D'Amore Triptych: Family Stories* (closed).

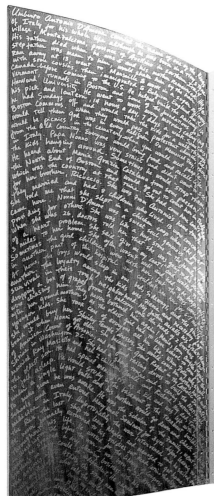
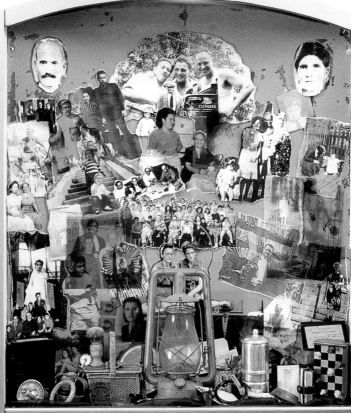

30. *D'Amore Triptych: Family Stories* (open).

D'Amore Triptych: Family Stories

Umberto Antonio D'Amore carried the name of one of the kings of Italy for his whole life although he was born in a tiny stone village, Montefalcione, Province of Avellino, in southern Italy. Long after he died, we found out that his given name at birth was actually Ruberto! He left home at thirteen and arrived in America when he was twenty-three. He worked pick-and-shovel and stone masonry all of his life. His children remember him working fourteen hours a day, seven days a week. Sometimes he had Sundays off and would take the kids for a walk through Boston Commons. When they would pass a Protestant church he would tell them God was in every religion. On Memorial Day there would be picnics in the cemetery where you would meet all the *paesani*. Everyone would bring food and recall life in Italy. Papa Nonno was very strict and didn't want to see the kids hanging around. Sometimes he would "strap" the kids. Nonni D'Amore was a sweet soul, generous and always providing for others. When she was twenty-six, doctors told her that she was going to die because of a heart problem. She said "Give me my coat," and walked the three miles to her home. Despite her courage, she often wasn't well and had to be hospitalized.

Sometimes the girl children were with her, but the boys would be in another part of the hospital and couldn't see her for six or seven months. The loyalty among the kids was fierce and necessary for survival in their tough neighborhood. My father recalls his sister, Marie, dropping a box of grapes from a balcony onto the heads of two rival brothers who were chasing him. They never bothered him again! Marie (born Angela Maria after her grandmother) as the oldest girl, supervised the younger kids. She took care of everyone all her life. When Dolly was small, she would buy her "Shirley Temple" dresses. She would comb her mother's hair and braid it when Nonni got older. She became a Grand Regent in the Catholic Daughters of America, Court of Ausonia, and ran fundraising drives to build the National Shrine in Washington, D.C. She had a sharp tongue and a compassionate nature. She married

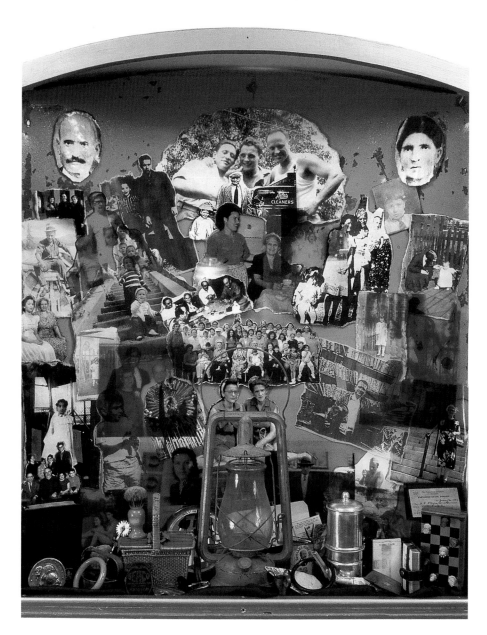

31. *D'Amore Triptych: Family Stories* (center).

Ray Masiello and had two children, Gerald and Richard. Tony, my father, was the oldest son. He had spinal meningitis as a kid and was left with a tendency to fall asleep. He would study in the basement of the tenement building under a single light bulb and his mother would go down and check on him to make sure he was awake. At one point, he went to Italy to study medicine. Unfortunately, the war intervened and he sailed on the *Rex*, the last ship to leave Naples, and managed to get home. He never returned formally to his studies, but read Latin and theology throughout his life. He worked for the Library of Congress in Washington, D.C., before the war. I was born in D.C.

The "boys," my uncles Adolph, Mike, Phil, and my dad, worked together dry cleaning uniforms for the Navy and Coast Guard ships. This meant long days starting at 6 a.m. picking up and delivering to and from various ships with names like "Edisto," "Hen and Chickens," "McCullough." Marie also helped at "the Shop." In time, Denis, Ron, Paul and some of the other cousins worked there too. We all helped write the "cuff lists" which was this litany of odd-sounding names taken from the cuffs of the uniforms where they were printed in indelible ink. The brothers really worked hard together. Tony married Nina, a fashion designer, and had four children – Bernadette, Denis, Ron and Steph. Phil, the next oldest son, accidentally shot himself in the knee with a loaded .45 when he was a kid. The gun belonged to his uncle, Zi' Ricuccio, who had won a Silver Star in World War I. Phil spent most of his childhood in a hospital because of seven or eight operations on his knee. He had one stiff finger and a limp and was always kidding around. He loved kids and "adopted" his sister Dolly's children after her early death. He would take the kids fishing and sing to the fish! Mike, the third son, married an Italian woman, Maria Mauriello, from Montefalcione. His mother had visited Italy and "chosen" Maria for him. They were really in love. Their three children are Anthony, Maria Grazia, and Michael Louis. Rico, the next boy, was the first to join the Civilian Conservation Corps. He served seven or eight years in all because he used Mike's and Phil's names to sign up again! He married Leona who had spent most of her childhood in an orphanage because her mother left the family and her father was never a "real father." They met when they were eighteen and seventeen and had two children, Bobby and Gregory. They always had the most peaceful house to visit. Adolph, the next son, studied to be a beautician and actually had started a small business. Nonni D'Amore wanted Adolph to be part of Atlas Cleaners, so he eventually joined in. He convinced his brothers to open a Locker Club for the sailors. (I used to surreptitiously read the racy novels they left behind when I was nine or ten.)

Adolph married Dolly's friend, Christine, who was Greek, and had four children, David, Denise, Sandra and Paula. Susie, the second-oldest girl, eloped with Tullio. They had seven children and she died of cancer when she was forty-three. She was always sweet-tempered. I used to help her hang laundry on the porch and near the range oil-stove where she lived in one of my grandmother's apartments. Tullio had a small corner store. We would always buy our salami from him. It used to be fun to stop by there because he would give us a little candy. My seven cousins, Pamela, Paul, Joey, Susan, Marian, Larry and Philip essentially grew up without their mother. They spent a lot of time with their grandmother, Nonni D'Amore, and Aunt Marie. Antonio and Maria Grazia had a daughter called "Baby Louise" who died from a tooth infection. The second Louise, nicknamed Dolly (because people would cry when they remembered the first Louise) was the youngest in the family. She graduated high school and worked at City Hospital. She married Nino in Italy and had three children, Susan, Joey and Margaret. She died from a heart attack at forty-nine and left Susan, at ten, to be the "mother" of the family. She always had a lot of spirit and spoke her mind no matter what

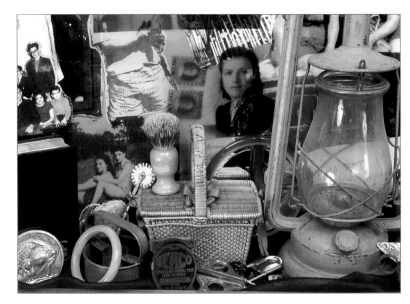

32. Tony's prayerbook from the seminary; souvenir buffalo nickel; brass ravioli cutter; shaving brush; Italian basket; cookie cutter; Antonio's work lantern; bakelite bracelets, etc.

33. Detail of family stories on door of Triptych.

anyone thought. Holidays at the D'Amore house were filled with cousins, aunts and uncles. After dinner, dishes washed, we'd play poker – mountains of pennies in the middle of the table which would gradually make their way to the corners. Philly always tried to cheat and was loudly shouted down when caught. Fights erupted with little notice and we cousins would duck outside to play freely as the adults were otherwise occupied! This side of my family was like a roiling mass of strong individuals, tough, affectionate, unpredictable and loyal.

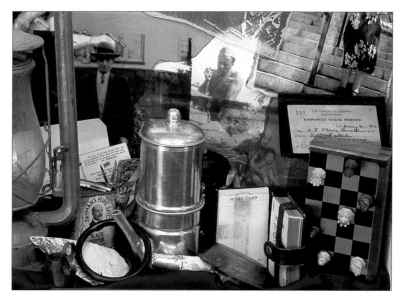

34. Caffettiera Napoletana; Tony's pass from the Library of Congress signed by poet Archibald McLeish; traveling chess kit; playing cards; *tegamino*.

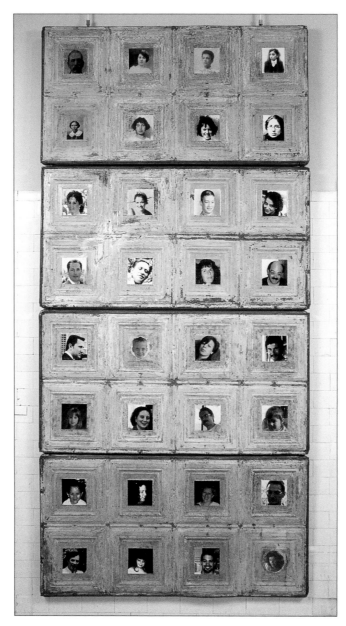

35. *Polishing the Mirror of Seven Generations:* Panels 1–4.

Return to the Roots: Yesterday and Today

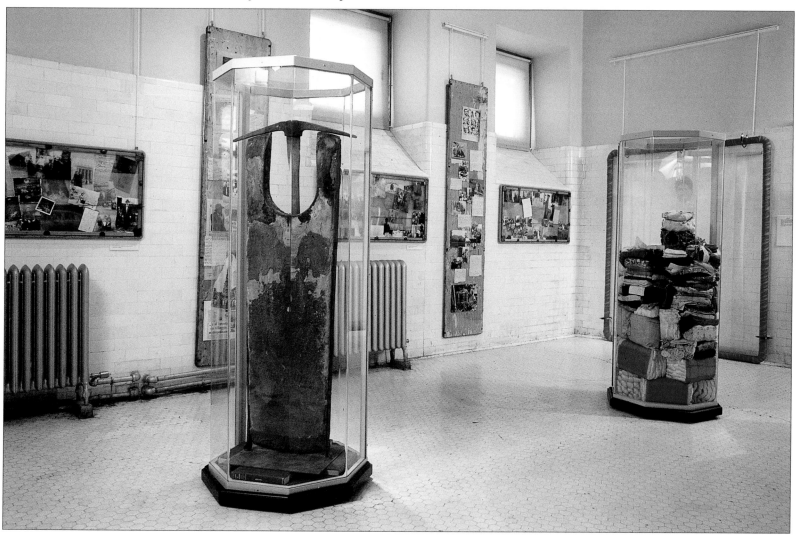

1. *Return to the Roots:* Overview of fifth room in Ellis Island Exhibit, with two reliquaries.

Yesterday and Today
"Finché c'è vita c'è speranza"
"As long as there's life, there's hope"

The seeds of family life spilled into successive generations. Living in America for more than one hundred years brought these families into a new century. Some have moved far from the old neighborhoods where their forebears first settled. Changes abound, yet ties to elements of the *"via vecchia"* still connect a number of the present generation to their Italian roots. Intermarriages, frequent trips and continual correspondence keep relationships strong. Holidays are often celebrated in the time-honored fashion, cooking the specialties of the *Nonna*. In fact, the music and food which most Italian Americans treasure sometimes resemble the culture of a hundred years ago more than that of modern Italy. This is also part of the inheritance.

Ieri ed oggi
"Finché c'è vita c'è speranza"

Il seme della vita di famiglia si propagò alle generazioni successive. Il vivere in America per più di cento anni portò queste famiglie in un secolo nuovo. Alcuni si sono trasferiti molto lontano dai vecchi quartieri, quelli in cui si erano inizialmente stabiliti i loro antenati. I cambiamenti abbondano, eppure il legame con alcuni principi della "via vecchia" continua a mantenere in contatto una parte della generazione presente alle sue radici italiane. Matrimoni, viaggi frequenti e una continua corrispondenza rinsaldano i legami. Le feste vengono spesso celebrate in maniera tradizionale, cucinando le specialità della Nonna. Infatti, il cibo e la musica che la maggior parte degli italoamericani continua a preservare gelosamente, somigliano, a volte, più alla cultura di un secolo fa che a quella dell'Italia moderna. Anche questa è parte dell'eredità.

Tony and Nina

Tony D'Amore met Nina Piscopo in 1940 and they were married in 1941, just after the attack on Pearl Harbor which propelled the United States into World War II. Tony's family used to say that he "hitched his wagon to a star," since they came from such diverse social situations. Life for their children was much richer because of these differences. Nina's family consisted of four people. Tony's family was large and gregarious, gathering every Sunday at the family home for generous meals, poker games and rowdy play among the numerous cousins. This pattern set the ground for the present bonds between the older cousins of the family. These bonds were even stronger because most family members not only lived close together, but also worked together.

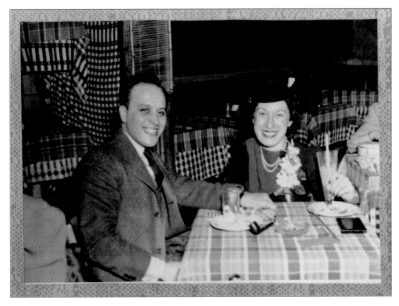

2. Engagement of Tony and Nina, October 14, 1940.

Although Tony seems to have fallen in love with Nina "at first sight," he courted her assiduously in order to win her away from her former boyfriend, Bill Peppi. Nina professed her love for him, yet continued to vacillate between the two men. At one point, Tony actually left Boston and took a job in Washington, D.C., with the Library of Congress. This spurred Nina into making a definitive choice, and she and Tony were married five months later.

Early letter from Tony to Nina:

May 23, 1940

Carissima;

Greetings, Salve and all Hail.

In accordance with your wish, my cherubim, I do what I am doing, writing this epistle. Fiat voluntas tua, carissima mea, non solum, nunc, sed semper et ubique in hoc mundo etiamque in acternitate.

Sweet phantom of lovliness; most perfect daughter of Eve, in humility, in self abnegation of mind and spirit, in reverence profound, in awe majestic I confess, acknowledge, aver and do not deny that I love you.

Tempus fugit, dear, and the scrivener's delight must come to an end, for the rumbling voice of Simon Legree, alias Fitz is calling me to the colors.

Raise the standard! All hands on deck and fifteen men on a dead man's chest, shouts Fitz in a fury of madness; of such stuff is man made.

So until we tryst and rendezvous again, I will bid you an Au Revoir. The lads in the office are certainly taking me over the coals, Nina. I will never get over it. See you Friday nite dear.

—Tony

Letter from Tony to Nina at an impasse in their relationship when he decided to leave for Washington, D.C.:

via dura est via melior

March 12, 1941

Darlin;

Some one had to act. Since you nor Bill would not, then I had to – why prolong an unnecessary mental torture. If a hungry man asked you for bread would you feed him stones.

I do love you even more than Peppi. To do what I have done has broken my heart – however weep not for me but weep for yourself and your loved ones.

God bless you Darling, more than you love Him – so try hard to love Him during the remainder of Lent – That's the best kind of mortification.

> *Always in love and friendship*
>
> *—T.*

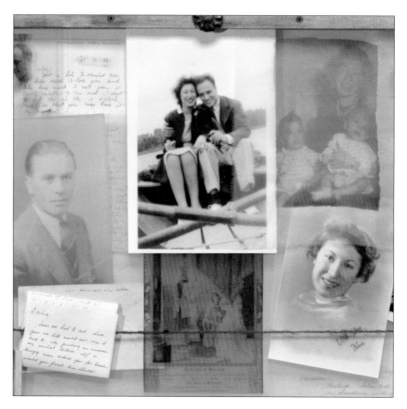

3. Tony and Nina at the start of their life journey.

Letter from Nina to Tony after she had chosen him over Bill:

Nina Piscopo
480 Pleasant Street,
Winthrop, Massachusetts

September 13, 1941

My Darling:

Just a line to remind you of how much I love you and also how much I miss you. It's twenty minutes to ten and I want to get this in the 10 o'clock mail so that you may have it by Monday…

I went to confession this afternoon and truly felt lots better – at least calmer in spirit. I have been praying constantly – even at the office in between postings – that this job you are trying for will be yours – or should I say ours? I hope that you will wait until a real definite answer is given before you return. Not that I don't want you here, beside me. Your not being here now is harder than last week for now that we're together again, the separation really is more difficult to bear. I hope to hear from you again – your last note was so formal. Anxiously awaiting news of your return—Love,

> *—Your Nina*

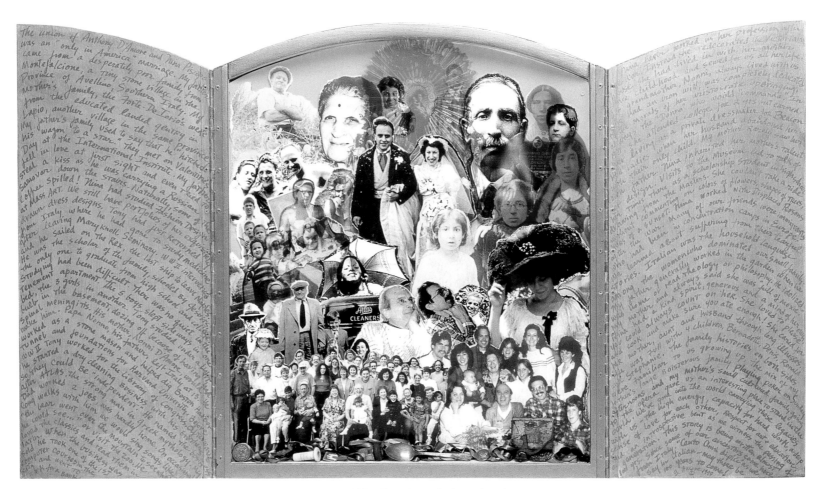

4. *Tony and Nina Triptych: Family Stories* (open).

Anthony D'Amore and Nina Piscopo Triptych

The marriage of Anthony D'Amore and Nina Piscopo was an "only in America" marriage. My father came from a working-class family from Montefalcione in southern Italy. My mother's family, the Forte-De Iorios were from the landed-gentry class in Lapio, another village in the same province. They met on Valentine's Day at the International Institute of Boston. Each of them was the head of an Italian Club and they were having their first joint meeting. My father fell in love at first sight and even tried to steal a kiss as he was carrying a Russian Samovar down the stairs! Naturally some of the coffee spilled! Nina had recently graduated from Massachusetts College of Art. Tony had just returned from his medical studies in Italy in order to avoid conscription in the Italian Army. Before World War II, Tony worked for the Library of Congress, Deptartment of Latin American Affairs.

The job was kept open for him when he finished his military service, but Nina wanted to stay in Boston so he never returned to Washington. My dad always worked two jobs and was hardly at home. I mostly remember long walks with him where we would sing funny songs like "The bear went over the mountain…" or visit the zoo. He loved the classics and read theology and philosophy for relaxation, often in Latin. When the Atlas Dry Cleaners was sold, he took one of the first computer courses in Boston, graduated second in his class, and went to work for Merchants National Bank as a supervisor. Nina never worked in her profession of fashion design after the war. She dedicated herself to resettling displaced persons after World War II. Many of our friends were immigrants who had been in concentration camps in Europe. We learned early about suffering from their tearful stories. My father generally either read or worked in the garden when he was home, content to let my mother run the house. The women spoke Italian among themselves and managed all of the family's day-to-day affairs. Nina had a generous and kind spirit and a mind of her own. My father always said she had "moxie." You could always count on her.

She loved to please you and loved to cook and make sure you had enough, enough, enough! She cared for her mother, aunt and husband through long illnesses. Life was full with four children, Bernadette, Denis, Ronald and Stephanie. The family history on both sides was familiar to us growing up. The mix of my father's large boisterous family and my mother's small, cultured family gave us an interesting place to stand in the world. We've all gone into our lives carrying these legacies with us – the high energy, capacity for hard work, a deep sense of love for each other, respect for education, and an introspective bent as we look at the passing of an entire generation and realize that we are now the older generation. This story is being written almost one hundred years since some of our ancestors came here from Italy. *"Cento Anni di più!"* as we say in Italy – may there be one hundred years more!

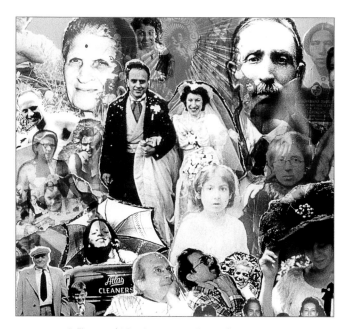

5. Tony and Nina's marriage, December 28, 1941.

Little Italies

The North End was the Little Italy of Boston, a community populated successively by Jewish, Irish, and Italian immigrants. In Little Italy, knowing English was unnecessary. Small specialty shops, bakeries, meat markets, restaurants, and cafes gave one the sense of being in a small Italian town. Sometimes streets were actually renamed for the home place. One can find an "Orsogna Square," for example, in the environs of Boston.

Such Little Italies, partially modeled on the *campanilismo* of the *Mezzogiorno*, are often called urban *paesi* and resemble the hill towns of origin. *Campanilismo* refers to the confines of a settlement within reach of the tolling village bell. In America, this eventually gave way to the concept of a larger urban neighborhood. After World War II, some of these communities became affiliated with sister cities in Italy, and those relationships continue to this day.

In Boston, among the people of an extraordinary Little Italy, there is a struggle to conserve their very identity. There is a neighborhood of fifteen thousand inhabitants, almost all originating from Sciacca, in Sicily and from Montefalcione in Irpinia. They are fighting against "gentrification." They want to remain united like a great family.

6. Urban *paese* from Naples newspaper, *IL MATTINO del Sabato*, November 25, 1983.

"VOICES"—Family Interviews

For instance, we had a bread man, a coal and ice man, a fruit and vegetable man, a watermelon man and a fish man. We even had a man who sharpened our knives and scissors who came right to our homes, or at least right outside our homes. They were the many peddlers who plied the Italian neighborhoods. We would wait for their calls, their yell, their individual distinctive sounds. We knew them all and they knew us.

> —Anthony J. D'Amore (son of second-generation American father, Italian mother), letter to B. Amore, 2000, *Life line* Project, 2000-2006

Let me tell you, it was an incredible community. It really, really was. The safest – that one mile square area in the North End, at one time, was the most densely populated place on the planet. So the number of people there in that one little spot, you could walk the streets at three o'clock in the morning – a seventeen-year-old girl and never have to worry, although seventeen-year-old girls shouldn't be out at three o'clock in the morning! The traffic was nothing like it is now, but there were a lot of horse and teams, still. The market had lots of horse and teams, even then, even at that time. Wasn't til after the war that they totally disappeared.

> —Tullio Baldi (second generation), interview by B. Amore, 2005, *Life line* Project, 2000-2006

7. Urban *paese* "…a metropolitan village is invented," from *IL MATTINO del Sabato.*

"VOICES"—Ellis Island Interviews

When we were in North Beach, it was all strictly Italian. Different dialects. There was a lot of Sicilians and southern Italy and we all blended beautifully. I mean, I don't know if I mentioned yesterday when we were talking but that's where Joe DiMaggio lived. And I knew his sisters and we lived close by. And it was a great, really a great place to grow up because you felt a home there. You had no embarrassments. I mean, you felt like you were part of an ethnic community that cared and we all really helped each other all the time.

They imported a lot of things from Italy but they also made their own. And they had the best of everything. Like the parmesan cheese, they would import big wheels of it and sell that stuff and the Italian olive oil and everything. And it was just like home then. And it's still there to this day, though. I mean, and it was there way back then – the fruit and produce and grocery business and delis and things like that. In order to bring the old world here, that's what they did.

—Elda Del Bino Willitts[1]

"Italglish"

Eventually, the language began to change, including such hybrid Italian-English words like *giobba* (job), *storo* (store), *carra* (car). Men gathered in groups outside the cafes and women strolled down the street arm-in-arm, vestiges of the famous *passeggiata* in Italy. Maintaining *la Bella Figura* was essential and nothing provided a better stage than the principal thoroughfare of Little Italy. Churches played a central role in community life. Yearly *festas* to the patron saints were organized by various social clubs representing different regions of Italy's boot. The integrity of these once insular communities is now being threatened by migration to the suburbs, rising real estate values and the strong demand for living spaces by young professionals in the inner cities.

9. Annual *Giglio* Feast in Williamsburg, Brooklyn, in honor of Saint Paulinus of Nola. The ceremonial tower, made of painted *papier maiché* over an aluminum core, is "danced" through the streets on the shoulders of 125 dedicated, able-bodied men called "lifters."

"VOICES"—Family Interviews

I can still remember some of the stories my grandfather told me about coming to America as a little boy on the boat. How his father died young and he had a stepfather, etc. How the family lived in rented tenement houses, took in boarders to make ends meet, how he decided he didn't want his children, five sons and three daughters (and another who died of a toothache), to grow up in that environment. All of this, of course, in his own version of Italian English which I soon learned to understand quite well.

—Anthony J. D'Amore (son of second-generation American father, Italian mother), letter to B. Amore, 2000, *Life line* Project, 2000-2006

Now, Italian conversations start – me to you – this one to this one, that one to that one. And everybody's talking at the same time, and everybody knows what's going on, except a neophyte, and that was Mom. This was something she wasn't used to. And she's going, "How ???" I said, "Look, once you get into this situation, you either lower your voice lower than anyone who is speaking now, or you've got to get it over anyone who is speaking now. Look the person right in the eye and go on with your conversation. You'll make out." It sounded like the Tower of Babel!

—Tullio Baldi (second generation), interview by B. Amore, 2005, *Life line* Project, 2000-2006

Building on Foundations

The value of education was stressed to the third-generation cousins, and many of them obtained college degrees and are now assisting their own children and grandchildren in attaining the same. Antonio dug the foundations of Harvard University and dreamed of his children receiving an education. Now he would be proud of his numerous grandchildren and great-grandchildren who have graduated from universities with professional degrees.

Tony, Antonio's son, continually stressed the importance of an education to his children. He equated education with freedom of choice. For him, the life of the mind held the greatest interest. He continually read the most current news and theories in fields as wide ranging as sociology, physics and literature. James Joyce's *Ulysses* and the *Summa Theologica* of Thomas Aquinas were among his favorite books. Dinner table conversations with Tony were memorable because of the lively debates that his questioning mind engendered. He loved to play devil's advocate and would contest opposing arguments with challenges to faulty reasoning and absence of logic.

"VOICES"—Ellis Island Interviews

I have a son in California. He's an architect. I go there every year. This last October I was in Italy. This October I go to California. I have four beautiful children that are all educated. I have one son that graduated from the Air Force Academy and has got a Ph.D. from MIT. One is an architect. He went to Pennsylvania University. My daughter is a schoolteacher. The other son is in New York. He works for a big company in New York. But this telecom machines and things like that. He went to Pennsylvania, Temple University on a full scholarship. They're all educated. I'm the only one that did the hard work, you know. They was all good. They all helped themselves. In those days I wouldn't have been able to send them to college.

—Ettore Lorenzini[2]

"VOICES"—Family Interviews

Dad [Tony] wanted everyone to be empowered and he impressed upon all of us, as kids, the importance of going to college. I still remember coming home late at night and finding him reading philosophy at the kitchen table!

> —Stephanie D'Amore Maruzzi (third generation), interview by B. Amore, October 2003, *Life line* Project, 2000-2006

My father was a laborer and my mother worked in a factory as a seamstress. I was the first to go to college and it was really important to my parents. Though they never pressured me to go to college, high school was not optional. They sent me to a private high school operated by Salesian priests because they believed that a mixture of discipline and education was the recipe for success.

In high school I participated in a mock trial competition as a lawyer and my school won first place in a regional competition. My class took photographs with the district judge, Judge Ferrino, and the story made the newspapers. That's when I first thought about college and becoming a lawyer. My parents kept their fingers crossed about college because during high school summer breaks I worked for my older brother as an electrician's apprentice and my parents thought I wanted to become an electrician like my older brother, who really wanted me to go to college. After scoring high grades in college, my parents thought perhaps that education was my calling in life.

I can remember during college interning in Washington, D.C., as an investigator for the Public Defender. I worked on a case involving a black man sent to prison for life for a crime he claimed he did not commit. After serving several years in a Virginia state prison, he got a new trial and was set free. For the first time in my life I had a purpose; that I could do something that might make a difference. I then went to law school nights and worked days in a law firm. I was the youngest in my class filled with older students who already had jobs. I can remember my dad picking me up at the train station and my mother having dinner ready for me when I came home late every night. They invested so much time and money to send me to school. I now work as a trial lawyer in Boston, Massachusetts.

> —Michael Louis D'Amore (son of second-generation American father, Italian mother), interview by B. Amore, September 2003, *Life line* Project, 2000-2006

Not going to college is NOT an option! My mom and dad are adamant that I go to a very good school and get a good education. School comes pretty easily for me, so it's natural. I'd like to go into a medical field.

> —Nicole (D'Amore) Maruzzi (fourth generation), interview by B. Amore, October 2003, *Life line* Project, 2000-2006

It was always understood that I would go to college. My friends who didn't go to school aren't really doing anything. College has helped me to look at things in a different way. It allows me to take more things into account before making a decision. I feel that the life lessons are far more valuable than the book learning alone. I'm definitely planning on graduate school. If it weren't for the family making it such an issue, I wouldn't have understood how important it is.

> —Andrea (D'Amore) Maruzzi (fourth generation), interview by B. Amore, October 2003, *Life line* Project, 2000-2006

10. *Following the Thread XIII: Aunts, Uncles, Cousins.*

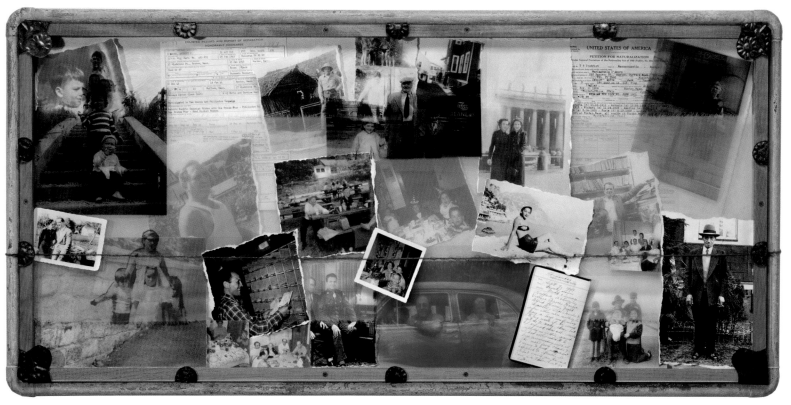

Tony's discharge from
U.S. Army, June 29, 1945

Luisa D'Amore's diary
entry from her first trip
to Italy, October 7, 1949

Ricuccio Catalano, Maria
Grazia's brother, who won
a Silver Star in World War I

Maria Grazia's
Naturalization papers

Beyond the Melting Pot

In the twenty-first century, Italian Americans have come a long way from the days when their great-grandparents were called "wops" (without papers). They are now part of a multi-ethnic society that has replaced the mythical "melting pot." Italian Americans are fully integrated into the woven texture of American life.

Walt Whitman once called America "a teeming nation of nations," and research has shown that ethnic characteristics persist through generation after generation of American life. Italian Americans, like many other groups, are in the process of finding the balance between the recognition of their ethnic inheritance, their experiences as American citizens and the stereotypical imagery sometimes imposed on them by the larger society and the media. This makes for abundant and lively interchange both in families and in Italian American cultural groups, which often serve as a conduit for third, fourth and fifth generation Italian Americans to learn more about their own history.

11. Close-up of *New York Times Magazine* cover, May 15, 1983.

Italian? American? Italian American?

"VOICES"—Family Interviews

I was well into my adulthood before I realized that I was an American. Of course I had been born in America and have lived here all my life, with the exception of eighteen months in Italy. Somehow it never occurred to me that being a citizen of the U.S.A. meant I was American. Americans were people who ate peanut butter and jelly on mushy white bread that came out of plastic packages. Me. I was Italian!…Everybody else, the Irish, Polish, Jewish, Germans – they were the 'Merigans.'

> —Anthony J. D'Amore (son of second-generation American father, Italian mother), letter to B. Amore, 2000, *Life line* Project, 2000-2006

The sense of being Italian was probably passed on more by osmosis than by any intent. I don't think my parents or grandparents intended for us to know what it was like. We just watched and did what they did. We learned what they did. Whenever they didn't want us to know what was going on, they spoke Italian. They made sure we never learned so we'd never know what they were saying. That was their little way of keeping things secret or having private conversations while the children were in the room.

But you know, we watched them cook the food and take care of the children and do things as a family. So, you learn just by watching, just by being a part of it all. Nothing you can go to school for is going to help you learn how to become anything like that. Just have to learn by being exposed to it.

Well, the traditions are probably not as strong with the children. Certainly not as strong with the grandchildren because over the years traditions get watered down. Some are almost lost, if not lost entirely. And having a lot of non-Italians in the family now, it isn't as strong with them, especially with the grandchildren as it was say with myself and my siblings, my cousins. It's quite different. But I'm not sad about that. I mean, if they wanted to learn, if there was a need to learn, we could still show them."

> —Paul (D'Amore) Baldi (third generation), interview in video "The Thread of Life in One Italian American Family"

I got a lot of my sense of being Italian through both my grandmothers. When I was very young, we lived with my father's mother until I was five. Neither of my parents spoke Italian. My mother knew a little bit – not enough to carry on a conversation. All the children were born here.

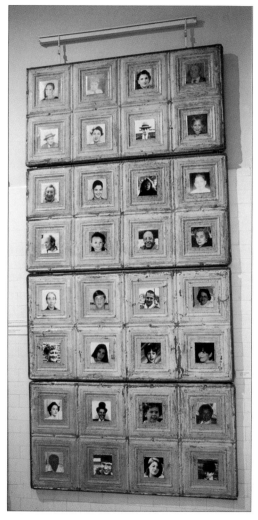

12. *Polishing the Mirror of Seven Generations:* Panels 5-8.

Both of my grandmothers worked hard all their lives. Even though they had daytime jobs, they always found time to cook. Eating was a favorite pastime with my family. I have no recollection of either grandfather, as they were not around when I was growing up. Both of my grandmothers lived to be a hundred.

I really felt American. My parents didn't think so much either way. I lived and played with different nationalities. There wasn't much difference.

—Allen Maruzzi (third generation), interview by B. Amore, 2003, *Life line* Project, 2000-2006

I always felt Italian, but, when I went there is when I realized that I really am Italian. I felt right at home. I've gone to not a lot of places, but never felt at home like I did there.

What I saw in Italy was what it was like growing up really in East Boston when I was younger. Still people outside, hanging their clothes out on the line, houses close together, seeing people walking in the streets at night. It's so – it's like our childhood. And I can already see there, when you go there, that things are changing, just like they did here. And I feel bad for kids growing up today, not having that community like we did. We had, I mean, there were twenty mothers on a street, you know, if you weren't at this one's house, you were at someone else's house, but everyone knew exactly what was going on and it was wonderful.

And, funny, growing up in East Boston, a lot of my neighbors were Irish. So I just remember all wanting to come to our house to eat…. So, even though we had the most children in – out of everyone in our neighborhood, seven kids, we still had a lot of room for someone else, and we always ate pasta, can't you tell? Pasta and beans or whatever, anything, you know, that could go a long way and not cost a lot of money.

It's so different, when you grow up Italian but you're not brought up Italian, you're brought up American and when you – you realize that, you know, you should have a lot more Italian history in you.

—Marian (D'Amore) Baldi Snyder (third generation), interview by B. Amore, 2005, *Life line* Project, 2000-2006

I do think of myself as a person with a heritage. I'm American but I have an Italian heritage. In Italy, I missed fried chicken. They don't have it. There's no Popeye's. And they don't have pizza delivery. You know, there are times I'm very happy to be in America. It's just that there are so many freedoms here that people don't really understand what they have.

> —Jeff Masiello (fourth generation), interview in video "The Thread of Life in One Italian American Family"

I'm half American, half Italian. When I tell people this, they say "Wow, that's pretty neat!" I loved being around my grandma and my grandfather – their whole Italian way. I was always so fascinated by that. Just their demeanor, the whole Italian demeanor and just the way they talked, the way they argued. When they were getting into their little Italian thing and start speaking Italian, I'm just like this lost little kid trying to understand. Thought that was neat.

> —Chris Masiello (fourth generation), interview in video "The Thread of Life in One Italian American Family"

I'm always sticking up for being Italian. I have a lot of Irish friends. And I'm like "Oh, Italians…" There's not really a difference but everybody tries to keep up with their nationality. I think that nationality is still a big thing for kids. A ton of Italian people have little Italian stickers on the back of their car, which I still haven't found but I'm looking for one. It's just like an Italian flag in a little square. And a lot of Irish people – they have Irish ones. They have shamrocks on their cars.

> —Andrea (D'Amore) Maruzzi (fourth generation), interview in video "The Thread of Life in One Italian American Family"

Well, I think that like Italian means like you have to live over in Italy and like speak the language and stuff like that. And Italian American is more sort of speaking English and living here…I've always wanted to go to Italy, you know? Nonna told me that the food was really good.

My friends, we don't talk about nationalities too much because it doesn't really matter to us. I don't think I have a lot of Italian friends. I mean, I have some but not a lot. I think it's better that it doesn't really matter because then we can date anyone we want.

> —Nicole (D'Amore) Maruzzi (fourth generation), interview in video "The Thread of Life in One Italian American Family"

I appreciated being around my Mother's Italian family. It shaped me to start dating people from other countries.

> —Maria Grazia D'Amore (daughter of second-generation American father, Italian mother), interview by B. Amore, 2003, *Life line* Project, 2000-2006

I'm a very Italianized Irishman. I remember long before Bernadette and I dated, I had to learn to say, "I'm sorry, I'm unable to speak Italian." And so she had studied at the University of Rome, and her mother of course translated for the courts. So I learned. But you have to be able to shrug with it properly. …Later, after we're married, I'm in the North End with my child and some Italian lady says "Oooh! Baby!" And so she's speaking to me in Italian. So I give her my one phrase in Italian – "Mi dispiace, ma non posso parlare italiano."– and she doesn't believe me. And just blasts off because you can't say perfectly or colloquially –"I'm sorry. I'm unable to speak Italian," and be believed if you say it like that!

You know, I look at the people in my life and my mother-in-law, my father-in-law. They're major pieces of my life, not minor pieces. And, ah, the commitments are there. So we're a few years into a fifty- or sixty-year commitment. And we've got a few good meals left. And that's what it's like being an Italian, even if you're not.

> —Gene "Gino" Lawrence (fourth-generation Irish, eleventh-generation English; married Bernadette D'Amore, later divorced, always part of the family), interview in video "The Thread of Life in One Italian American Family"

Cousins Across the Atlantic

The descendants of the original De Iorios and D'Amores continue to make frequent trips to Italy. Both Mike and Luisa from the second generation married Italians from the family's home province of Avellino. This gave the family a whole set of cousins in the third generation who read and spoke Italian. This has even encouraged some of the third and fourth generations in America to teach Italian to their children.

In fact, Italian is growing as one of the most frequently taught second languages in the public schools, as Italian Americans become ever more interested in finding their roots. The number of departments of Italian American Studies at universities is growing. Organizations such as Casa Italiana, the Italian Academy, the Dante Society, Sons and Daughters of Italy, the American Italian Historical Association, the National Italian American Foundation, The Italian American Writers Association, *Fieri, Malia,* the Calandra Institute and numerous smaller Italian and Italian American groups sustain the transmission of the rich artistic and cultural heritage.

I feel lucky to have two cultures. I chose to become an American citizen and the sense of two languages, two cultures is always with me. When I look at an American building, I think of the architectural history of Italy. This cultural dualism enriches life.

—Franco Vitiello, interview by B. Amore, 2000, *Life line* Project, 2000-2006

13. *Column of History X:*
The Ties, America/Italy.

"VOICES"—Family Interviews

14. Marie and Luisa D'Amore on one of their frequent trips to Italy.

Even when we were in Spain and we were in Seville, and one of the things I wanted to see was the Aqueducts. The stones were massive. The whole structure was massive. And it was absolutely amazing that they could accomplish feats of engineering of that magnitude back then with just manpower. And I remember putting my hands on the stone and thinking, "My ancestors built this."

> —Gerald (D'Amore) Masiello (third generation), interview in video "The Thread of Life in One Italian American Family"

Luisa (Dolly) came to Italy with her mother (Maria Grazia D'Amore). When she saw me there, she got to like me. And she says, "Maria, you're going to marry my brother." When she went back, she talked to her brother. And she sent me a letter, his picture. Then Michael wrote me a letter telling he want to meet me in Italy. And two months later, he came over. He came over the house. He met my parents. And we talk together. Then we decide, he says, "Marie, I love you. And I want to marry you."

> —Maria Mauriello D'Amore (Italian wife of Mike D'Amore), interview in video "The Thread of Life in One Italian American Family"

Just stop to think that we don't know an Italian rhyme. You know the children's rhymes? Like "Humpty Dumpty" or the other one – "Twinkle, Twinkle, Little Star." All our rhymes are in English because my mother was American. And all our Fairy Tale books are in English. I think we felt like family was more in the States. Uncle Philly and Auntie Mary used to call every other week. So Uncle Philly knew what we were doing until the day he died. I mean, he knew if we were going on a school trip. And I remember going to Paris when I was 14 years old. And I think your mother wrote to me saying, "Oh, April in Paris is just stunning."

> —Susan (D'Amore) Benevento (daughter of second-generation American mother, Italian father), interview in video "The Thread of Life in One Italian American Family"

15. Luisa D'Amore, who married Nino Benevento, with "the Italian Cousins" in Venice.

To me, it's always been like I'm an immigrant. I'm the daughter of an Italian American woman. I was born in Italy. I suppose I have to be – I am Italian because I've been living here for the rest of my life. But inside I'm not. I mean, I'm comfortable here too. You know? It's my house because it's always been my house. I always felt more American than Italian. I was thinking maybe part of it is because of my mother. Because in my mind, it's always been that she wanted to go back. That this was not her place. So maybe in a way I got influenced by this and I just want – let's say – to go home for her.

—Margaret (D'Amore) Benevento (daughter of second-generation American mother, Italian father), interview in video "The Thread of Life in One Italian American Family"

"L'America sta qua!" "America is here!" [in Italy]

—Giovanni, Joe (D'Amore) Benevento (son of second-generation American mother, Italian father), interview in video "The Thread of Life in One Italian American Family"

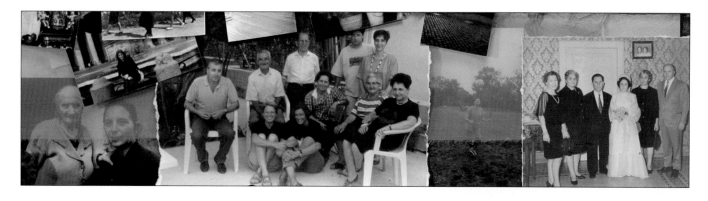

16 & 17. Cousins and friends.

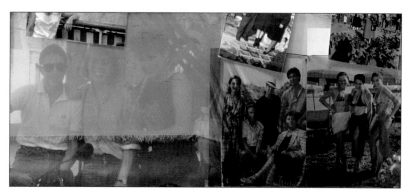

18. *Following the Thread XIV: Italian Family.*

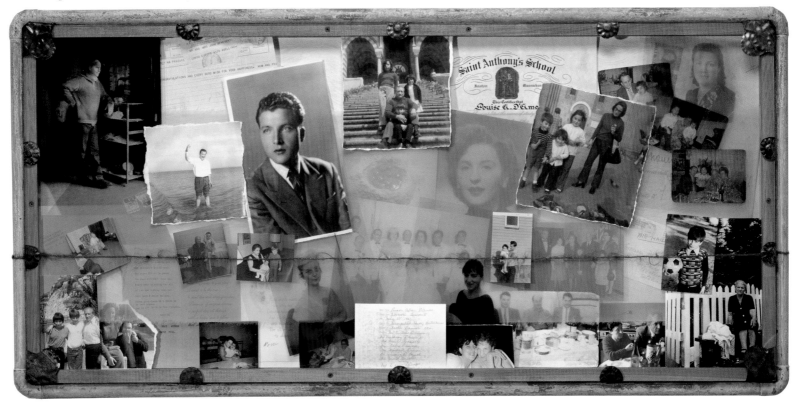

Telegram from D'Amore family to daughter, Luisa, when she married Nino Benevento in Avellino, Italy

Letters from Phil D'Amore to his nieces and nephew in Italy with gifts of American dollars

Wedding attendees to U.S. ceremony between Luisa and Nino, May 28, 1962

Luisa's diploma from St. Anthony's Grammar School, June 17, 1943

Italian passport photo of Maria Mauriello when she married Mike D'Amore

Letter from Nina to Nino Benevento informing him of Tony's illness and death, October 29, 1984

Grandparents, Grandchildren

Most of the third generation grew up in close proximity to the original immigrants and this has deeply imprinted their feelings of relating to both worlds, including the conflicting aspects of search for individuality and loyalty to family. The strict physical discipline, often harsh, which was inflicted on the second generation, and the restrictions of the *via vecchia* mentality also affected the third generation. Reconciling such experiences with the loving center of family life is not always easy. Understanding the subtle, underlying currents of these influences is often the work of a lifetime. Some of the third and fourth generations actually lived and studied in Italy, thereby making the ties even stronger.

"VOICES"—Family Interviews

It's not that they didn't have grandfathers, but theirs didn't live in the same house or the same block. They visited their grandfathers. We ate with ours...I also remember the holidays and Sundays when all my aunts, uncles and cousins would gather at my grandfather's house and there would be lots of food and homemade wine and the old Victrola. Women in the kitchen, men in the living room and kids everywhere.

—Anthony J. D'Amore (son of second-generation American father, Italian mother), letter to B. Amore 2000, *Life line* Project, 2000-2006

My grandmother decided, I don't know why, in her older years to try to teach us all to speak Italian, the grandchildren. That was a disaster because of course by that time we were totally Americanized. I was about eight at the time. She would sit us on Sunday afternoons after dinner, she would sit us on the sofa trying to teach us Italian. You know how – how well that took!

—Lynn Archangelo Masiello (third generation), interview in video "The Thread of Life in One Italian American Family"

I remember them [grandparents] as a great influence on my life – and when I still say my prayers every day, I always remember Nonni's friends and friends of the family...One used to be called Mrs. "Jamba." I used to say, "How could a lady's name be "Jamba?" And so when they pronounced it, it was like Montefalcionese [dialect]. As I got older, I realized that the name was "Ciampa."

Like I say, "All the presidents passed through my house," because everyone had to come to visit Nonni. So, for me, every Sunday was like a holiday. I remember the little white table with the little blue stripe that we had to sit at when we were children. And of course as we got older, we got to migrate over to the bigger table, you know, with the adults. Those were times that I don't forget...I think that there are not enough people left like us who really treasure their heritage. I think our family especially – especially like your children, okay, treasure their heritage. And they don't really look Italian. But they treasure their Italian heritage. My brother's children are the same way.

—Richard (D'Amore) Masiello (third generation), interview in video "The Thread of Life in One Italian American Family"

I probably feel Italian, because my grandfather always talks about it. We always have to eat pasta, obviously, three times a week. And like all the food we eat is definitely Italian. We don't usually eat anything else besides that.

Well, when I was in, I think the first and second and third grade, we had an Italian teacher come in. But then she moved back to Italy, but, for that little amount of time, I learned things. But that was the only thing I even remember. I remembered a lot of things, like I could talk it, and I knew what the numbers and the alphabet and stuff, but I don't remember anything now.

Well, they [friends] know that, we're Asian in some way. When we tell them that we're Italian, they don't really believe us, because we don't really look like it. They think it's pretty cool that two totally different cultures could fit together and have kids.

Everyone, like, on our mom's side of the family that I've met is all like mellow and laid back and tries to like do everything in a calm, orderly manner...

—Michelle Chen Baldi (fourth generation), interview by B. Amore, 2005, *Life line* Project, 2000-2006

'O nonno

Mò ca l'Italia é na nazione 'nzista,

l'emigrazione e' un fatto occasionale.

Chi vene ccà, ce vene cchiù pe' sfizio,

ce' ved'é''o munno, o tanto per cambiare.

Mò gli italiani veneno redenno:

con le scarpe di cuoio ben lucidate,

fanno 'e turisti, lucidi e alliffati,

e chi tene intenzione 'e se restà

tiene in tasca l'assegno di papà.

Cert'é ca quanno 'o nonno' mio emigraie,

partette cu 'o dolore dinto 'o core

e 'a valigia 'e cartone arrepezzata,

ma cu 'a certezza ca cu 'e braccia forte,

faticanno se fosse fatta strada.

E accussi' è stato, e 'o nonno mò se guarda

tutte e nupute suie, già sistemate,

cull'uocchie allere chine e cuntentezza.

(ma cu 'a vocca 'nu poco amariggiata,

pecchè so sanghe suio, sanghe italiano,

ma parlano sultanto americano…)

—Nino Del Duca

The Grandfather

Now that Italy is a modern nation

emigration is only occasional,

those who come here, come out of curiosity

to see the world, or only for a change

Now Italians come here smiling,

with shining leather shoes

they act like tourists, well dressed

and those who want to stay

already have their father's check signed in their pocket

It is true that when my grandfather emigrated

he left with a broken heart

and a patched cardboard suitcase

but with the certainty that with his strong arms

and hard work, he could find his way of life.

So it was, and now the grandfather

looks at his grandchildren (already established)

with cheerful eyes, full of happiness

(but with a bitter taste because his

grandchildren have his blood, Italian blood,

but they only speak English).

—Nino Del Duca[3]

I'm a big poker fan. Whenever I play with my grandfather, I always beat him. Since I was a little kid, once when my sister and my dad were playing, and I'm like, "Hey, can I play?" And I didn't even know what it was. And then I got a royal flush. And I didn't even know it!

—Christine Chen Baldi (fourth generation), interview by B. Amore, 2005, *Life line* Project, 2000-2006

19.

The history of stogies in our family? Ah, I first remember stogies in the family when Papa Nonno used to go – send me, actually, to the store with fifteen cents to buy his little blocks of red and green Parodi cigars, that to me at the time looked like twigs in a box. And he just – as soon as he got the…he'd light one up and stick it in his mouth and it stayed there until it was down to a nub. And when it got to the point where it was almost burning his lips, he'd take it out of his mouth, take out his trusty old jackknife, cut off the end if it had been burned and popped the rest of it in his mouth and chew it.

And what happened over the years was that every one of his teeth turned the color of what we used to call a "guinea rope" – which were Parodis – because they looked and smelled like rope when they burned. But, bless him, he died in his eighties and he still had every tooth in his mouth even though they were the color of walnuts. So that's how stogies came into the family. Everybody smoked cigars at one time or another. So, it's been – it's been fantastic.

I actually started smoking stogies when I was about fifteen but nobody knew it. And then I realized I was getting too sick from them so I gave them up. But about four or five years ago, I don't know what happened. I just got the urge one day to start smoking stogies, and I've been at it ever since. And it's just like continuing a family tradition.

—Gerald (D'Amore) Masiello (third generation), interview in video "The Thread of Life in One Italian American Family"

For my corredo *(dowry) I had to embroider myself twelve sheets, underwear, nightgowns. My mother filled the hope chest for me. I began when I was young. The husband's family provided the furniture for the bedroom. You made the effort for your future.*

Now people go and buy things. Day by day, year by year, sometimes they forget what's important. People don't know the difference. Probably my daughter and my sons know a little bit from me. If Maria doesn't teach her daughter the way I taught her, then she doesn't know the value of things.

My granddaughter teaches me! She comes out with words I love. I can put them in my heart and leave them there!

—Maria Mauriello D'Amore (Italian, married Mike D'Amore), interview by B. Amore, 2003, *Life line* Project, 2000-2006

My Grandmother

What can I say of this youthful old lady
who lives in a magical house

She feeds everyone who comes to the door,
no one starves, not even a mouse

Whenever I enter her kitchen,
she has the loveliest smile,

She's the happiest grandmother you'll ever meet;
her laughter is heard from a mile.

For whenever she's in her castle,
away from the entire world to see,

There's no harm or any of the tragic–
this beautiful yet youthful old lady is always

COOKING–in her house of magic.

—Poem by Christiana D'Amore
(Granddaughter of Italian grandmother and second-generation American grandfather),
June 12, 2006, *Life line* Project, 2000-2006

Italian Experiences

Concetta supported her granddaughter's year of study in Italy. Bernadette (B. Amore) attended the Faculty of Letters and Philosophy at the University of Rome for one year in 1962–1963. She returned to Carrara, Italy as a sculptor eighteen years later for independent study, followed by a Fulbright Grant in 1982. Her experiences there led her to found an international program in Vermont called the Carving Studio and Sculpture Center. She has introduced many students to marble-carving and the studios in Carrara. In 1982, her daughter, Tiffany, completed the *terza media* (third grade) at the *Scuola Tenerani* in Carrara and now speaks fluent Italian as a result of that experience.

20. Concetta's granddaughter, B. Amore, carving marble in Studio Nicoli, Carrara, 1981.

21. *Libretto d'iscrizione*, Università di Roma, B. Amore (née Bernadette D'Amore).

22. School papers of Tiffany Lawrence from her year of study in Carrara, 1982–83, during her mother's Fulbright year in Italy.

Her knowledge of the Italian language has made giant steps. Exuberant and extroverted, she has actively participated in the life of the class. Despite encountering difficulties in some subjects and taking account of the lack of some preparation, it is our opinion that she has succeeded in positively passing this academic year.

Language as a Link

Speaking Italian connects me to a lot of people who are now passed on in my family. I mean, to my grandmother. My great-aunt also spoke Italian. There are not that many people currently who speak Italian fluently in our family. I mean, everyone knows some Italian. But my mom speaks Italian. The two of us speak it every once in a while. We can go into it and speak Italian when we don't want anyone to understand. Part of what happened for me is I went to Italy with mom when I was ten. And I lived there for a year with her. And that was a different experience, in the sense that it was just the two of us. And I learned Italian. And we really lived as Italians.

It makes a strong connection between my grandmother and me. Just because she absolutely loved Italy. And because of that, I understood a side of it. I spent time doing things that maybe she had done when she was a kid. So there was that kind of bond between us.

I also went back with my grandmother and my mom when I was sixteen. And that was really a nice time because we were the only women in the family who spoke Italian. I guess it's not so much that it was this big thing that I speak Italian. It is more that, it's like a second home at this point. Italy feels pretty comfortable to me. I could live there just as easily as I could live here. Certain things culturally are different, but I guess I feel like it's a home away from home, and it's just a different kind of country.

—Tiffany (D'Amore) Lawrence (fourth generation), interview by Madeleine Dorsey in video "The Thread of Life in One Italian American Family"

23. Photo taken by Concetta's granddaughter in Lapio in 1961, which served as an inspiration for the *Odyssey* installation created in 1998.

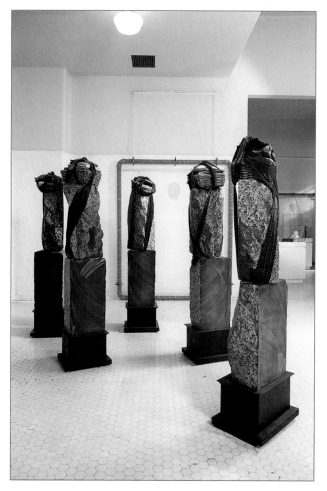

24. *Odyssey.*

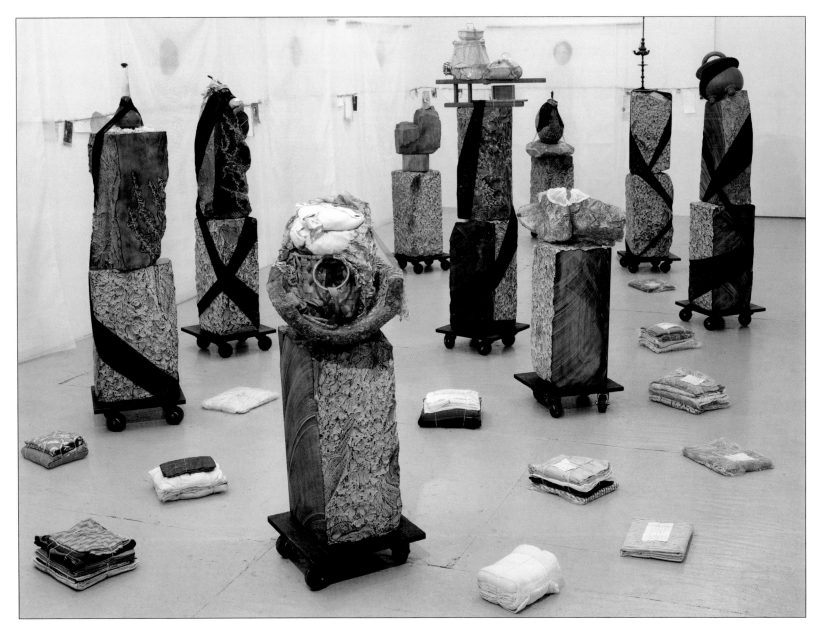

25. *Odyssey* Installation.

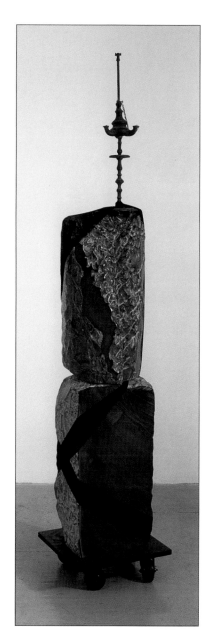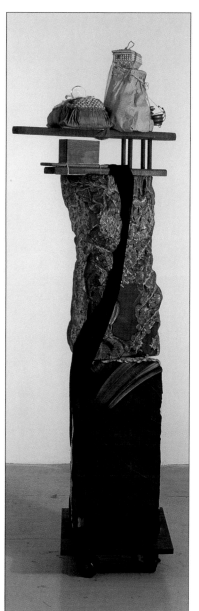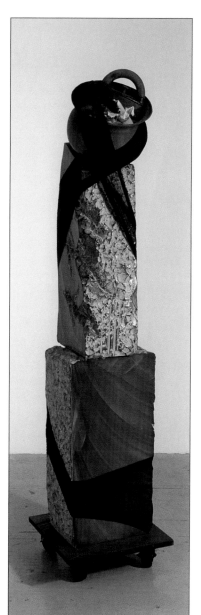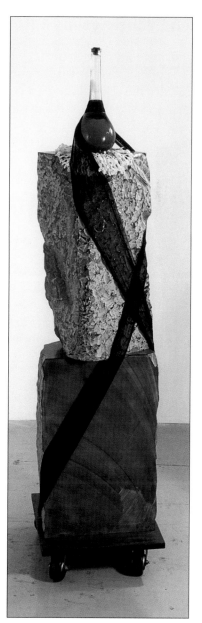

26. *Odyssey Personnages.*

The Fabric of my Life

The fabric is something that the women in my family always used. You know, my great-grandmother did extraordinary hand-work. My grandmother was a dressmaker, my mother was a fashion designer and dressmaker. And so fabric is something that has been part of my existence ever since I was a child.

And in fact – it's really interesting. I was possessed to use this fabric with the stones. And I thought I was crazy. I couldn't adjust to the idea of putting the fabric and stone together. One night late when I was in the studio ripping the fabric like this, what happened is that it took me right back to my childhood. Right back to listening to my grandmother and my mother rip the fabric or being in fabric stores where they would just rip the fabric.

My grandmother taught me something really important. She had this expression "Come vuol' andà" – "how it wants to go." And so if we were doing something with fabric on a surface and you had to make a fold, it was like she would take her hand and she would just smooth it. And even though the measurement said one thing, if the fabric wanted to lie a certain way, that was the way it had to go. And it taught me a life lesson. It's something that I have thought of over and over again, actually. Just how it wants to go.

My hands are fitting into this scissors that my grandmother used. And it's worn. You know, you look at the scissors, you feel the scissors, you feel the wear and you feel the comfort. And they're very special, actually, in terms of the way they're shaped; I've never seen any like these.

And so when I use these scissors to cut the fabric, I mean, I feel my grandmother's hand with me. They're extremely sharp. And she was so precise about her scissors. You could not use a scissors that was used for fabric for anything else.

—B. Amore (third generation), interview by Woody Dorsey in video "Following the Thread"

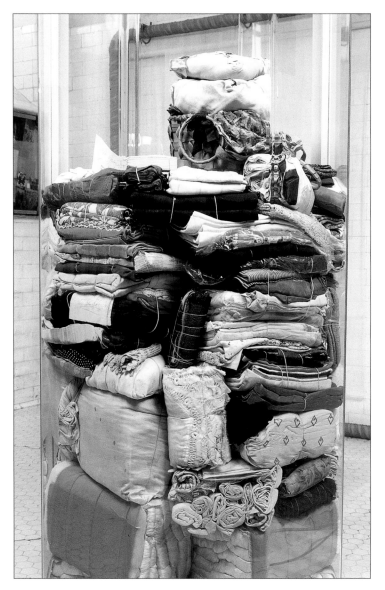

27. *Reliquary: Grandmother's Bundles,* with Concettina's fabric and dresses saved from her sewing projects and her notes written in Italian and English.

Evening Clothes

Black short coat.
Very little to be done

Black chameuse dress
Perfect hoods
and fitting

Black Lace dress
Perfect fitting
Few fine stitches
to be done

Japan Kimone Imported
New lining and
stithes

White Shark Skin Coat
size fine good and
fine fitting
16
Probaly sleeves to be raised
a bit

1 Woolen Coat (few colors; 1/2 fitted
Little hole near the
seam of the right shoulder
Some
Lining
from
the collar
Nice material
Easy to fix

1 Bleu Crepe dress with a panel in
the front of different
material (all little flowers)
3/4 down the panel there is
a quite hole: Scorced or
burned: It can be fixed::;;

3 Dark bleu crepe dress with
gray top. Vita lunga all
the way around. Skirt long

4 Pink and white wooley rayon
Veri good: Basted in
the waist line

5 Black wooley dress from Fredley
food material; Little
hole on 1 shoulder: 1 on
the other side: Long sleeves
Basted in waist line & neck

6 Black Crepe dress with yellow
zipp Wore it once

7 Black Crepe with white
daisys and leaves
(wore 3 u 4 times) (Boseweb N. York)

28. Concettina's notes describing contents of bundles. Note her thriftiness in planning to repair and refit various dresses.

177

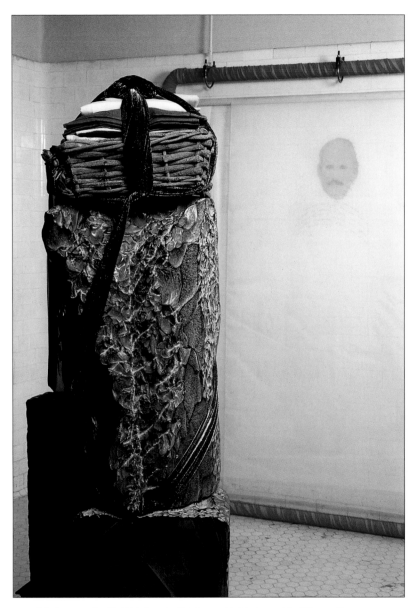

29. *Ancestor Scroll: Michelangelo Catalano,* with black marble *Odyssey Personnage* in foreground.

Ancestor Scroll: Michelangelo Catalano

Catalano, I just found out that my great-grandfather on my father's side was called "Catalano."

My Auntie Mary says that he visited the Catalans in Spain. Who knows if it's really true.

I know there was a Spanish occupation in southern Italy – Could we have some Spanish blood?

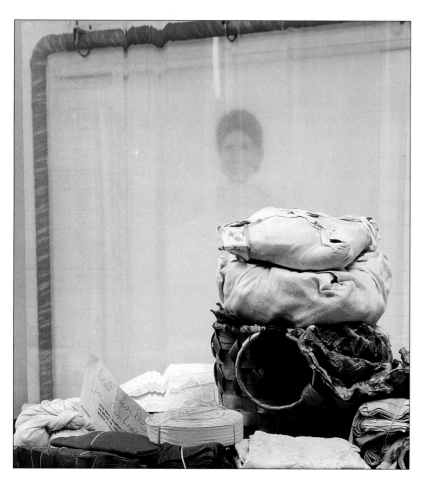

30. *Ancestor Scroll: Luisella Guarino,* with *Reliquary* in foreground.

Ancestor Scroll: Luisella Guarino (Luigia Garino)

The woman in the picture is Luisella Guarino and her husband is Michelangelo Catalano.

They both came from Montefalcione in southern Italy, Province of Avellino, just outside Naples.

Her birth certificate lists her name as Luigia, but throughout her life she was known as Luisella.

She was unusually tall for a southern Italian woman and walked with a cane when she was old.

When my father was in Italy, he bought her men's shoes to wear because her feet were so swollen.

People in the paese *were amazed, and they still tell the story more than sixty-five years later!*

This is all I know.

Legacy of Letters

In the De Iorio and D'Amore families, letters have been saved for five generations. Tony and Nina's correspondence during World War II reveals the drama of that time. The earliest letters documenting correspondences between Italy and America are dated 1901. During the 1950s and 60s, when Nina was in Italy, she would write complete descriptions of her days to her children and they actually can be read today as a travel journal. She carried on a lifelong correspondence with her poet friend, Salvatore, who had introduced her to the intimate quarters of Naples, the beloved city of his birth.

Bernadette carried on the tradition during and after her own years in Italy. This is a long legacy of history through the eyes of the ordinary people who lived it. Today, the cousins correspond primarily by e-mail and telephone to supplement the visits. Many wonder aloud at what will be left for future generations since letters have become a rarity.

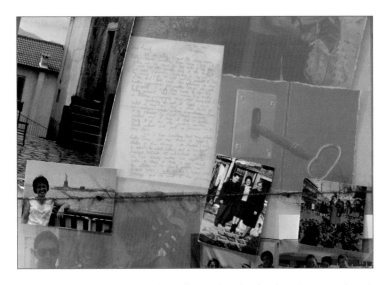

31. Example of Nina's correspondence from Italy to her family in America when she returned to settle the family property in 1956; Concettina's granddaughter, Bernadette, on her first trip to Italy, at nineteen; with Compare Gennarino and Comare Iolanda; Concettina at age seventy-four in Saint Mark's Square, Venice.

Avellino, Nov. 24, 1955

Dear Family:

We are sitting around the dining room table – lawyer; secretary, buyer, Nonni and Zizi and I, etc. – writing up the deed for the sale of the house. I went out this morning early to the bank to get some information concerning a deposit in my name – for it will not be possible to take to the U.S. – all cash. This afternoon we have another appointment for another deed – also sale of property – I really have much to do – busy every moment. That's the reason I'm writing in between – occupying these odd moments!

Yesterday we went to Lapio – and what a day. We had a case built for an antique clock which I'm bringing home – to be carried by hand. That's already packed and I have it here at Avellino ready to go. We also packed another trunk which I'll pick up tomorrow and bring here.

Now, I have something that may please Father Toma. At our house we have a statue of San Lorenzo (St. Lawrence) with a relic (the whole molar) and a most beautiful vestment all embroidered in gold. We are having another case built in order to bring it home to our church. This statue is the family patron saint, because Nonni's grandfather's name was Lorenzo and he used to have processions and feast in honor of this saint. The priest of the parish used to come to the house to remove the relic and to bring it out of the house. The Lapio Church is very disappointed at this loss. – but I thought that even as you children grow older – you can take great pride in this – visiting the church that contains this family "heirloom." You may tell Father Toma about this – and I really do hope he'll be pleased. I'm not anticipating any difficulties as to permit from the Holy See. I hope this works out all right.

All my love to you,

—Your Mummy and Nini

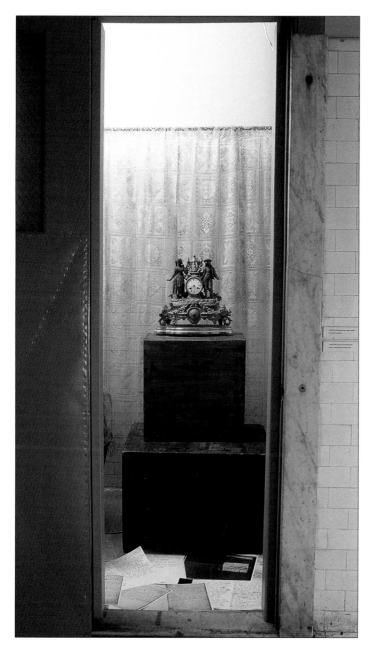

33. Statue of San Lorenzo.

32. *De Iorio Closet Installation:* Ornate nineteenth century clock and case from the De Iorio family home.

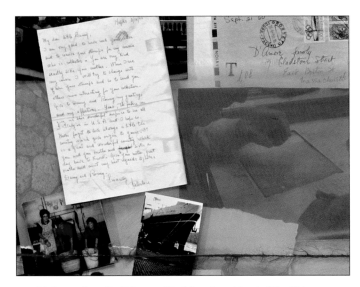

34. Letter from Dr. Salvatore Rinaldi, a close friend of the D'Amore family, to Nina's daughter when she was thirteen; Salvatore's hand with magnifying loupe forty-four years later helping with translation of the *"Diario"*; Maria Mauriello D'Amore making tomato sauce with her family; the Italian Line vessel *Cristoforo Colombo,* which carried members of the D'Amore family to and from Italy.

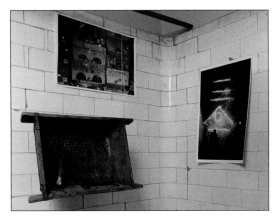

35. Artifacts from Montefalcione: Photographs of boxes of bones from cemetery vaults; fireworks on the facade of the main church, *Saint Anthony.*

Naples 2/16/56

My dear little Bunny,

I am very glad to receive your stamps for my cousin who is collector. Your are very kind exactly like your mother. When I see my cousin I will try to change with him your stamps and so to send you others more interesting for your collection –

Give to Denny and Ronny my greetings and my affections. Yes, the future can give us this wonderful surprise to see all in Italy or in U.S.A. and I hope so.

Never forget to love always a little the country which give origin to yours. It is a great and wonderful country which you and your brother and sister a day have to know. Give to your mother, great mother and aunt my best regards together Denny and Ronny.

> *Sincerely*
>
> *—Salvatore*

Holding Hands

Not only letters, but also objects have been preserved by the descendants of the original immigrants. Many of these have languished in attics or cellars and are now being valued in the light of a renewed interest in one's ancestry. Genealogical organizations are flourishing, as a nation of immigrants seeks to trace its roots.

Family objects are often a way of sensing an intimate connection with the past, supplementing the written histories which can be traced through old correspondence, documents, ships' manifests and family stories. Holding a worn object in one's hand can feel like a direct link to the ancestor and culture of origin

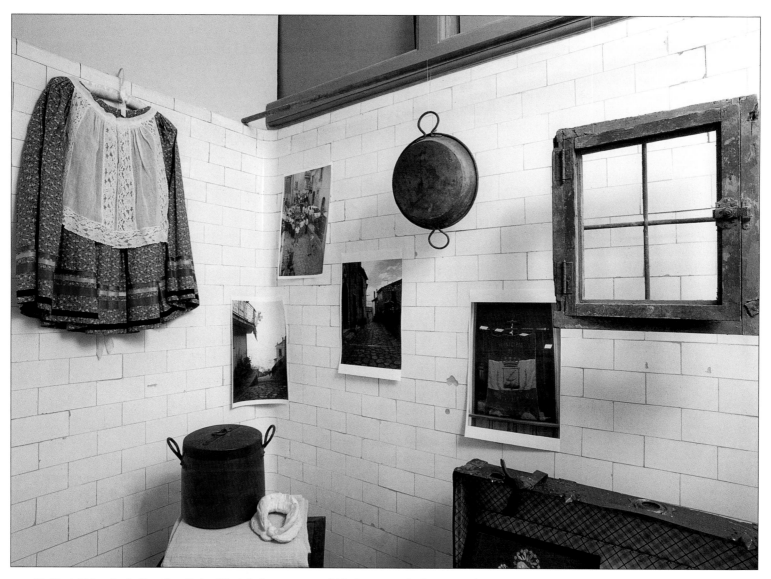

36. *Montefalcione-Lapio Closet Installation:* Nina's Italian costume, which she wore at the International Institute; handmade copper cooking utensils brought from Lapio in 1901; an old window from Montefalcione found in 2000; traditional *tarallo* baked by Michelina Guarino in Montefalcione for Easter 2000.

Bringing Nonna Back Home

Yes, it's the story of my grandmother, Luigina Pedroni Albertini, of her sewing machine. Regina was born in 1911 in Canneto Sull'Oglio, a small town in the province of Mantua in northern Italy. Her mother was a worker in a doll factory and it was famous, because they were producing toys and they were manufacturers there. And her father made baskets from vines. And the day she was born, her father bought a present for her and it was a Singer sewing machine. A beautiful, brand-new machine; it was in black enamel with all the decorations. And he thought that that could have been a present that would have helped her throughout her life.

And the sewing machine followed my grandmother through her movements and she always had it. It really was the thing that helped her survive the two wars that she saw and to raise her children and her family in difficult times. And it was also the instrument that allowed to her to be more independent in her old age. And she would do little works for her neighbors and so she could buy presents for us or she could buy something that she liked with it.

When Nonna died in 1996, I spent the last four nights with her in the hospital. And after she died, I had to go back to Florence because I was working there. And my mother and my father, my brother and other people were cleaning up her apartment. And they kept some of her personal things and they gave away some others to institutions similar to the Salvation Army.

And so, when I got back, I was looking for the sewing machine, but it was no longer there; they gave it away. And I think I was the one that knew my grandmother better and knew the story of the sewing machine. So I had a fit and, after I calmed down, I asked my uncle and aunt to come with me to fetch the sewing machine in this big building where they had all the old furniture. And we found it and it was a great emotion when we found it – but also a great disappointment, because there was a piece of paper saying "sold."

So I wanted to know who bought it, and it was a person who buys old iron to recycle. So I gave them like twice what the person promised them and I went home with my sewing machine. And I was the happiest man. Because it was just like bringing Nonna back home!

—Stefano Albertini, interview by B. Amore in video
"Following the Thread"

37. Sewing machine bought for Luigina Pedroni Albertini
 by her father on the day of her birth.

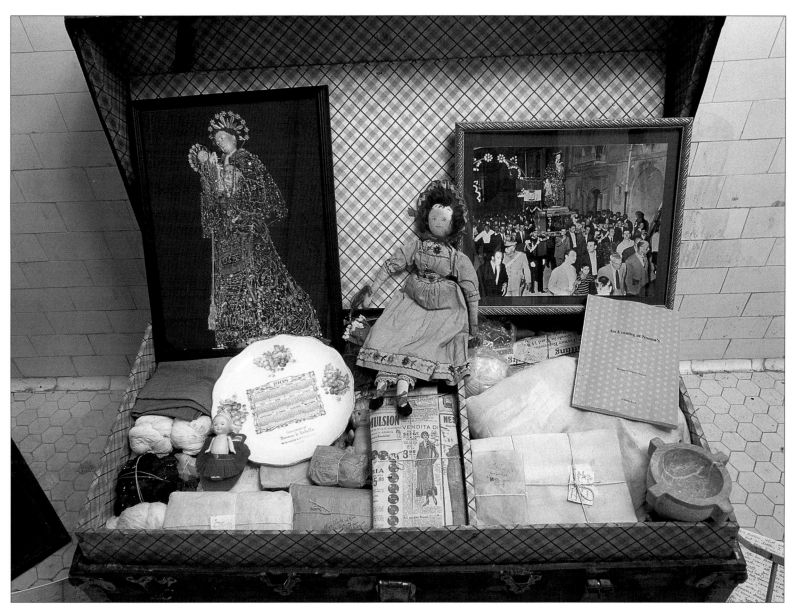

38. *Montefalcione – Lapio Closet Installation* (left to right): Piscopo family plate from 1908; Nina's childhood dolls; *An Evening at Nonna's* cookbook; processions in Montefalcione honoring Saint Anthony, patron saint of the *paese;* traditional mortar made in Lapio, 1996.

39. The traditional *pizza chiena*, Easter pie, which begins as a circle of flour and eggs.

At Nonna's Table

Food and the traditions surrounding holidays are some of the basic connections to the world of the grandparents and great-grandparents. Often Christmas and Easter baking are done in the most traditional manner which has been passed down in the intergenerational kitchen. Many third-generation cousins are more familiar with the Neapolitan songs from the early 1900s than with modern Italian rap or hip-hop because they grew up listening to these songs on the Italian radio programs. Little Italy cafes still remain the favorite meeting place (after the family kitchen) when everyone gathers. For many families, the weekly ritual of Sunday afternoons at Nonna's is less frequent but still survives as the core of holidays and special occasions.

"VOICES"—Family Interviews

Ronald: It's about 40 years that I've been doing the Easter baking. At the beginning I didn't do much of the cooking. I'd do the cleaning.

B: I think that the ring with all the eggs in it is really beautiful. I think that the eggs get used in our tradition as a symbol of new life because they make the tarallo with the eggs. In fact, I have a tarallo from Montefalcione that I'm going to put in the exhibit.

Ronald: She [Nina] taught me everything I know about Italian cooking, that's for sure. And everybody I cook for appreciates her food.

B: Well, I think it's interesting actually when you think about cooking also, which I never realized until this moment when you said that, that cooking is also a way to sort of keep sharing the gifts of a person.

Ronald: Mother's legacy is alive in a lot of different ways; one of them is definitely in food!

—Ronald D'Amore (third generation), interview in "The Thread of Life in One Italian American Family"

40.

My earliest memory – I must have been only like three years old – is my mother's sister, Katie, was making gnocchis. We had one of those old metal tables with the leaf in it and the whole table was filled with flour. They were making the dough and I used to just walk around the edges. Wherever I could reach, I would just roll with the thumb, make the gnocchis. I didn't like eating them that much but that's my first recollection of making something really Italian.

—Diane (Biancardi Ustinovich) Baldi (third generation), interview in video "The Thread of Life in One Italian American Family"

Home is where you learned to eat a seven-course meal between noon and four PM, how to handle hot chestnuts and put tangerine wedges in red wine. I truly believe Italians live a "Romance with Food."

Sundays was truly the big holiday of the week. It was the day you would wake up to the smell of garlic and onions frying in olive oil. As you lay in bed, you could hear the hiss as tomatoes were dropped into the pan. Sundays we always had gravy and macaroni. The 'Merigans called it sauce and pasta. Sunday would not be Sunday without going to Mass. Of course you couldn't eat before. You had to fast before receiving communion. The good part was we knew when we got home, we would find hot meatballs frying, and nothing tastes better than newly fried meatballs and Italian crisp bread dipped into a pot of gravy.

—Anthony J. D'Amore (son of second-generation father, Italian mother), letter to B. Amore, 2000, *Life line* Project, 2000-2006

The meals were a big deal, believe it or not. It was a frequent thing to go up over Thanksgiving weekend. We'd get out of school. Maybe we'd get out early on Wednesday. And everyone would pile into the car. We'd beat each other up for a few hours and eventually, we'd be in Boston. And my dad would never tell his mother that he was coming up. So we'd get there, and it'll be like 11:40 at night. Grandma's getting ready to go to bed. Big Pappa's like on his goodnight drink. He's sitting down eating chestnuts. "Oh, my God! Oh, hello everybody! How are you doing?"

So we'd go in, and they would be surprised. But they had enough food there to feed some third-world countries. And we'd wind up sitting up and eating for like the next three or four hours. And I'm not talking we would eat like cheese and crackers. I mean, there was lasagna and tripe and ravioli and candy bars and sprites and cokes and you name it. It was just food.

—Eric Masiello (fourth generation), interview in video "The Thread of Life in One Italian American Family"

41. Cover of *An Evening at Nonna's,* compiled, printed and hand-bound by her grandson, Clare Sean De Iorio Lawrence.

These primary connections to weekly and holiday meals at Nonna's sometimes have surprising consequences in later generations. Nina's grandson published a cookbook of her recipes six years after her death when he was living and working in Tokyo, Japan.

42. Dedication and title pages in *An Evening at Nonna's.*

An Evening at Nonna's
Recipes of Nina D'Amore

Preface

This book is many years in the making – but fear not, I'll keep the preface short. I don't know how long it took Nonna to become the best cook that any of us has ever known. She was already that good when I started remembering things about twenty-five years ago. Appropriately, the front door of Nonna's house entered into the kitchen. No matter when one arrived in that kitchen, or in what condition of stomach, food was presently forthcoming; unfailingly both superabundant and delicious. Whether hungry or not, tired or not, one had no choice but to rather complacently resign oneself to it.

Nonna's youngest son, Ronnie, and his wife, Sandi, lived in the downstairs apartment at Nonna's, and after Nonno passed away they three often ate together. Somewhere along the way, maybe eleven or twelve years ago, Sandi was inspired to start looking over Nonna's shoulder while she was cooking and note down what she was doing. (Most likely because whenever one would eat something new and savory at Nonna's and ask the recipe, Nonna would laugh. She would tell you as best she could, but she herself had no idea how much salt she was putting in, how long it was to simmer, etc.) So, Sandi scribbled down the core recipes in a notebook. She thought of putting it together to distribute to the family, input a few recipes into her Mac, but I guess the project got lost in her busy schedule.

I myself have lived quite far from 480 Pleasant Street (Nonna's home) for many years, and opportunities to eat in Nonna's kitchen have been rare. On a visit several years ago I asked Sandi to let me photocopy her notebook so that I could try my own hand when I got homesick. Of course my own subsequent sallies could not rival the Head Cook, but they are usually still better than what I can order at my local Italian restaurant.

Then one afternoon several months ago I stumbled upon a strikingly beautiful but very simply made Noh songbook (Kagetsusho by Wanya Books)…A couple of days later a friend was coming over for dinner, and so over a slow morning coffee I began looking through the photocopies of Sandi's notebook…Voilá An Evening at Nonna's. *A few notable but missing recipes have been contributed by other family members (most prominently, B.).*

Unfortunately, Nonna's unsystematic culinary methods have not been totally overcome. This is most often indicated by the rather insufficient quantifier 'some' in the ingredient list. There are also times when there seem to be some missing details. However, there is no longer any way to clear up the ambiguities (Nonna passed away several years ago). So, if you're reading word-by-word, you've got the sauce simmering, ready for the next step, and…it doesn't say how much basil! Well, don't worry too much – Nonna didn't know exactly how much basil either. Just wing it. Italian cooking is pretty simple and the recipes are good. They're often even forgiving. Everything will be all right.

 —C. Sean Lawrence, Tokyo, Japan, January 2000[4]

Old Roots

Some of the De Iorio land is still owned by fourth-generation descendants of Luigi and Giovannina. For years, *Compare* Gennarino, deeply respected by Concettina, oversaw the maintenance of the olive trees and woods. In the *compareggio* tradition, great respect is shared between families joined in this system. Concettina once took a chair and sat in it, then rose and said "When Gennaro sits in this chair, I am here," thereby giving him full power to administer her properties when she returned to America. Gennaro, his wife and daughters were Bernadette's "Italian family" during her student year in Rome and the ties continue.

October 6–13, 1962
Lapio, Avellino

Dear family,

I am now in my "second home" with my adopted family Carbone!…It is really a very secure feeling to be here in Lapio – surrounded by the silence and only the church bells which blend beautifully. I am sleeping in the big bed with the two girls – very warm and cozy!

I have been going out every morning with Comare Iolanda. We visited "i boschi" yesterday and picked grape right off the vine. I truly enjoy seeing the fruit growing naturally – very artistic and wonder-inspiring. The day before, we visited the "giardino di Zi' Abate" – and before that the larger giardino d'olivi. Our family certainly owned some beautiful lots of land!…

The family here sends their love. Thank you, Nonni, for the few lines.

With many thoughts and much love,

—Bunny (Bernadette)

East Boston, Mass:
20 Dicembre, 1962

My Dearest Sunshine,

I am feeling very happy sitting here, quiet and alone, writing to you. I have here beside me your long and affectionate letter written to me on December 3… Yesterday I sent you a postcard with a few lines, Best Wishes for the coming holidays and one dollar for a cup of espresso together with Lucia and Maruzzella…May God always guide you on the right path which will then bring you happiness.

A big hug and an affectionate kiss from your grandmother who loves you so much. Nonnie

Excerpts of letters between Italy and America during Bernadette's year of study, 1962.

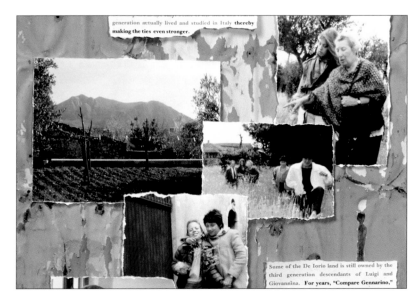

43. The De Iorio family land in Lapio with *Monte Chiusano* in the background; Nina showing her granddaughter, Larisa, where she used to play; Benevento cousins and *Compare* Gennarino in the *Giardino*; Tiffany with playmate, Rita (Maruzzella's daughter), in Lapio.

Remembering and Going Forward

Vito, the tenant-farmer now in his seventies, has worked the land since he was five years old, as did his father, Nunzio, before him; as do his sons now. A memorial plaque to Concettina and Nina has been placed in the midst of the ancient olive grove which used to be called *Il Giardino* where Concettina played as a child. Concettina's grandchild spent time there when she was a student in Rome and would recite her favorite poem, *"L'Infinito,"* looking over the valley below. Concettina's great-grandchild visited this place in the summer of 2000, nearly one hundred years since the family's departure.

I loved Italy.
I can't wait to go back.
I wish I had stayed for longer.
It was a lot of fun, meeting everybody
and seeing all of our land
and the plaque that was there
and everything for Nonni.
Reading all that about Nonni playing
there made me feel a bit strange,
to be in a place that she was
so many years before.

—Andrea (D'Amore) Maruzzi (fourth generation,
Concetta's great-granddaughter), in video,
"The Thread of Life in One Italian American Family"

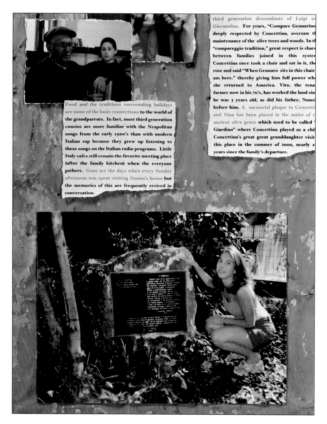

44. Vito, the tenant farmer, and his grandson, also called Vito; Concettina's great-grandchild, Andrea, in Lapio in 2000, almost 100 years since the De Iorio family left.

Wording on the Memorial Plaque

L'Infinito

Sempre caro mi fu quest'ermo colle,
e questa siepe, che da tante parte
dell'ultimo orizzonte il guardo esclude,
Ma sedendo e mirando, interminati
spazi di là da quella, e sovrumani
silenzi, e profondissima quiete
io nel pensier mi fingo; ove per poco
il cor non si spaura. E come il vento
odo stormir tra queste piante, io quello
infinito silenzio a questa voce
vo comparando: e mi sovvien l'eterno,
e le morte stagione, e la presente
e viva, el il suon di lei. Così tra questa
immensita' s'annega il pensier mio:
e il naufragar me'è dolce in questo mare.

The Infinite

This solitary hill was always dear to me
and this hedge, which excludes such
a great part of the ultimate horizon,
But sitting and gazing, endless
spaces beyond that, and superhuman
silences, and most profound quiet
I lose myself in thought; where but for little
the heart is terrified. And as I hear the wind
storm through these plants; I begin to
compare that infinite silence to
this voice: and eternity comes to me,
and the dead seasons, and the present
is alive, and the sound of her. So my
thoughts drown in this immensity;
and to be shipwrecked is sweet in this sea

—Giacomo Leopardi, 1891

È Nat' un fiorellino

Azzurro com'il cielo

Sapeva cinque parole sole

"Non ti scordar' di me."

In memoria di Concetta De Iorio Piscopo che giocava qui da bambina e che amava "il giardino" di
questo luogo e di Nina Piscopo D'Amore, sua figlia, che ha custodito care le memorie e tradizioni di Lapio.
Con amore, rispetto e gratitudine per la storia e la vita che mi hanno dato.

—B. Amore e famiglia, Giugno 1995

A tiny flower was born

As blue as the sky

It knew only five words

"Do not forget me."

In memory of Concetta De Iorio Piscopo who played here as a child and who loved "the garden" of this
place and of Nina Piscopo D'Amore, her daughter, who held dear the memories and traditions of Lapio.
With love, respect and gratitude for the history and life which they gave me.

—B. Amore and family, June 1995

Nina taught the words of the Italian poem about the forget-me-not flower to her children who later installed the
Memorial Plaque in *Il Giardino* where she had visited as a child in 1922.

45. *Following the Thread XV: Past, Present, Future.*

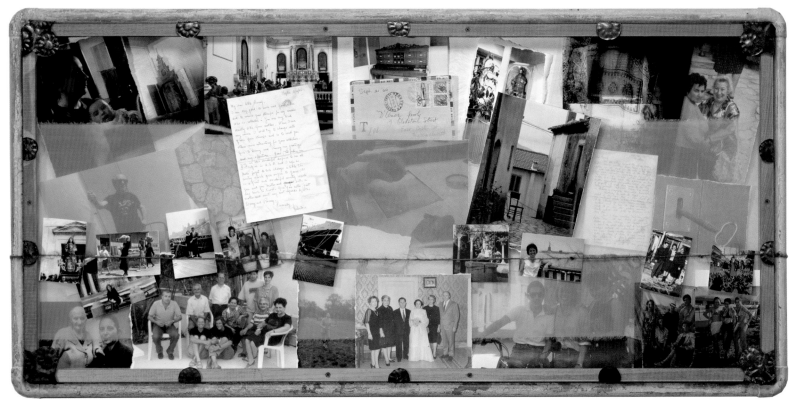

Images of Lapio Salvatore's letter Civil records in Translating the *Diario* Nina's letter Key to Church of Santa Maria
and Montefalcione Lapio Town Hall di Loreto, Lapio

Today and Tomorrow

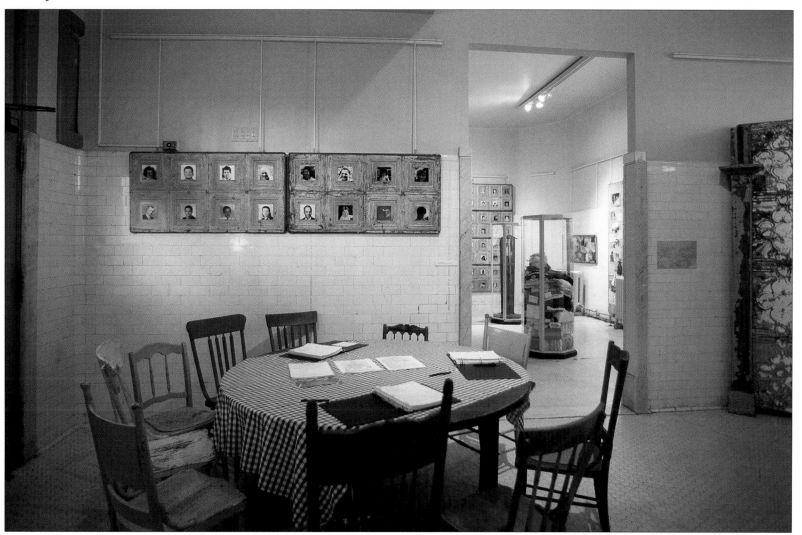

1. *Today and Tomorrow:* Partial overview of sixth room in Ellis Island exhibit. *Nonna's Table* installation in which visitors were encouraged to write their own memories and comments. It became a center of poetry readings and performances during the exhibit.

Today and Tomorrow
"Cent'anni di più!"
"One hundred years more!"

Life line is a series of stories. History is often relayed through the telling of a story. A journey through time is not a completely linear experience. There is a sense of looking "into" history, into self, finding one's own history and discovering parallels with others' experiences. My grandmother always told stories. Those early stories set me on a path of questioning and discovery. Some of them have been shared with you. What is not remembered is forgotten. We are all repositories. We hold everything we've heard and experienced. What do we do with this? Do we share? Do we pass it on? Do we hold close the knowledge? Does it die with us? Does it go beyond? What are your stories?

Oggi e domani
"Cent'anni di più!"

Filo della vita è una serie di racconti. La storia è spesso trasmessa tramite i racconti. Un viaggio nel tempo non è mai una linea diritta. Si prova una sensazione di guardare dentro la storia, dentro se stessi, trovando la propria storia e scoprendo paralleli con l'esperienza degli altri. La Nonna sempre mi raccontava le sue memorie. Quei primi racconti mi hanno messo su una strada di interrogativi e di scoperta. Alcuni di questi sono stati condivisi con voi. Quello che non viene ricordato va perso. Siamo tutti repertori. Riteniamo l'insieme di quello che abbiamo ascoltato e vissuto. Cosa facciamo di questo? Lo condividiamo? Lo passiamo avanti? Ci teniamo vicino alla conoscenza? Morirà con noi? Vivrà nel futuro? Quali sono i vostri racconti?

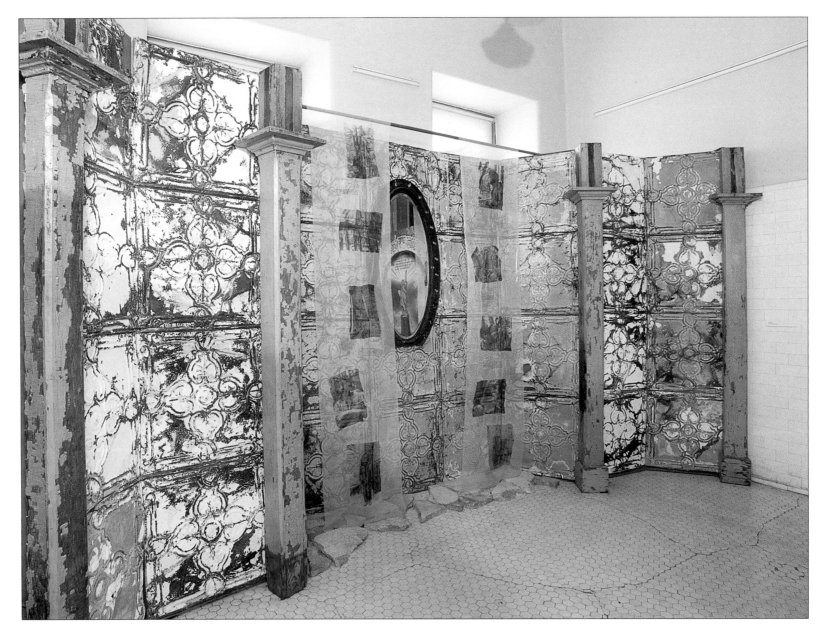

2. Altarpiece.

The Endless Story

I wear my grandmother's jewelry. My son cooks spaghetti "agli' e olio" in Tokyo, Japan. I speak Italian and I've saved all that I could of my grandmother's objects. My mother sold my grandmother's feather hats and beaded dress. I still think the beaded dress is in the closet…

Lost in the De Iorio world – translating antiquated Italian from the journal of my great-great-grandfather and my great-grandfather. The mountains of Lapio and the hills of Benson come together in this very moment, so that time is compressed and I exist in both; the drama unfolds, line by line as I seek the appropriate English word for the often barely legible nineteenth-century equivalent…

So who tells the story now? What is not remembered will be forgotten. Does time contain memory? Does memory erase time? How do we come to know and remember? Who told you stories?…

Two feelings come up, the warmth of familiar recognition and the turning of my stomach at the smallness of the worlds described. The duality of my childhood present in this instant – the pride in being Italian – that identity permeating my being, combined with the necessity of moving beyond the circumscribed world of the neighborhood's mores. Belonging and not belonging in the same instant…

The people are gone but their "things" are still here. Looking at, touching, holding them, the people become present. Perhaps that is the attachment to existing objects. I am reminded of them and they are present in some way. The past and the present are intertwined. They exist simultaneously…

The work is not about memory even though memory is a part of it. It's much more about the questions that are raised – looking into the past for clues to the present. Who were these characters who had so much influence? What in their lives caused them to take the roles they did? Why were they the ways they were which affected me so deeply?…

—B. Amore, Journal notes 1999–2000, which are printed on the transparent silk *Altarpiece* panels

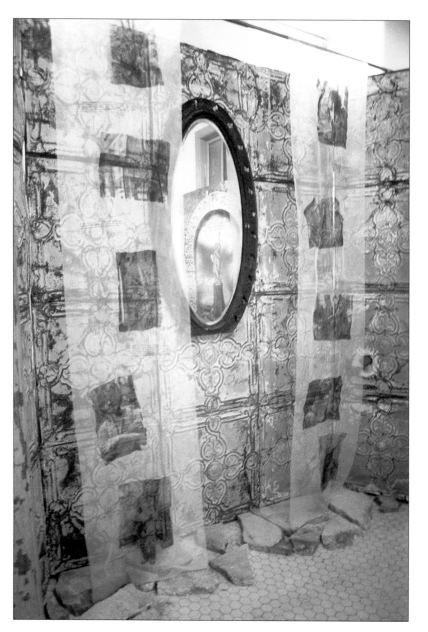

3. *Altarpiece* and details, text of Journal writings.

4. *Altarpiece* detail.

"VOICES"—Family Interviews

I can't not be an Italian part of me – even the parts that I don't like. Sometimes it means way too much emotion involved. There's always these layers of feeling. There's always this sense that there's one layer that's seen and then many layers below that, if one is listening – willing to listen or to work. But there's always more below the surface.

And I think I always felt that as a child. Because my grandmother and mother would often spill into Italian when they didn't want us to understand what was going on. So I always knew that what was said was not the whole story. There was always more. I would sort of sit at the kitchen table and listen very intently and quietly. Because I knew if I made a sound and they discovered me, I would be out the door with my brothers. But by staying there, by really straining, that was the way I learned the language actually.

> —B. Amore (third generation), interview by Madeleine Dorsey in video "The Thread of Life in One Italian American Family"

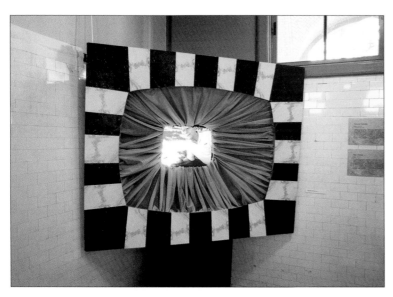

5. Television installation with "Thread of Life" video.

Fruits of the Garden

I guess where they came from in the old country, up and around Avellino and Montefalcione, they were outdoors a lot because it's an outdoor culture and it's very agriculturally oriented. I think it was difficult for them to come from that environment into a completely urban environment like Boston because Papa Nonno was a gardener and a landscapist. And he didn't have a chance to do that in the streets of Boston. So, he ended up being a laborer for the Boston Subway system, helping build the buildings at Harvard University – things of that nature. So, he was out of his element. And the only time he could get back into it was when we moved to Roslindale. And he had a plot of land that he could garden for himself, for his own enjoyment. He grew grapes. He made wine. And he loved it so much.

And he could grow just about anything. I mean, he could make a fencepost grow. That was absolutely amazing. I don't know if it was something that he learned when he was growing up or something that he developed on his own. But he could just make anything grow. He grew peach trees in his backyard with the biggest, juiciest peaches I have ever seen in my life. He had four of them. They were his pride and joy. And his tomato plants.

I can remember when I was in high school, and he was really getting on in years. And his legs started to go from kneeling down in the tunnels; his knees went. And I can remember him tending to his tomato plants in the backyard actually lying on his stomach and crawling from plant to plant.

　　—Gerald (D'Amore) Masiello (third generation), interview in video
　　　"The Thread of Life in One Italian American Family"

Whether it's the music, or the food; whether it's the mementos that we have from our past, the things we related to, but it all ties to my heritage, my Italian heritage. One, the music especially—when I play my mother's Italian songs, the Neapolitan songs, that's a really sensitive part of my past in that it reminds me of times I spent with mom, especially on weekends when she was cleaning and things like that. Just brings back those memories of being a young guy and how she related so strongly to the warmth and sensitivity of Neapolitan song.

　　—Ronald D'Amore (third generation), interview in video "The
　　　Thread of Life in One Italian American Family"

We really grew up in Nonna's house at 480 Pleasant. Interesting thing about that house was nobody ever entered through the front door. They always came into the kitchen, directly into the kitchen where Nonna was always kind of at the stove. And we had that beautiful garden out back. It was a nice gathering place for large family functions. So, the larger family was there a lot. Nobody would ever call first. Everyone would just show up. Nonna being as hospitable and gracious as she was, everything was just, you know, there for everybody that needed.

In terms of recollections about the garden, you know, it's a really special place. When I was a child, Nonno used to raise the vegetables up by the house – the squashes and beans and huge amounts of basil and tomatoes – beautiful. Nonna had the more formal rose garden and hydrangeas and the flowers. And it was always interesting because everything from the garden came to the table.

So we ate the fruits of Nonno's labor and we enjoyed the beauty of Nonna's flowers throughout the house. She was very particular. She'd pick one perfect Empire Rose and she'd bring it over and she'd say, "Look at this rose. Isn't it perfect?" You know, the color of the edging, etc.

—Larisa (D'Amore) Lawrence (fourth generation), interview in the video "The Thread of Life in One Italian American Family"

We went back for three weeks to visit Naples, Rome, Venice, the Amalfi Coast, places that I've heard of all my life but never really had an opportunity to visit at length. I remember we were in Positano at the time and in the Mediterranean ocean was there. And I hadn't intended to go swimming but I remember standing there. We had just come from Pompeii. We had taken the train around and I remember standing on the shores of the Mediterranean looking back over the bay to Naples and seeing Vesuvius and everything. And I thought "The hell with it! This is the sea that my ancestors swam in, and I've got to swim in it at least one time." It really got to me. It made me cry.

—Gerald (D'Amore) Masiello (third generation), interview in video "The Thread of Life in One Italian American Family"

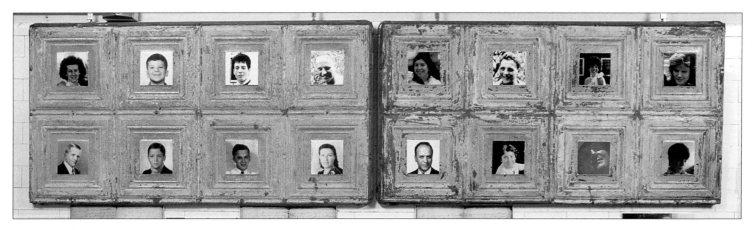

6. *Polishing the Mirror of Seven Generations:* Panels 9–10.

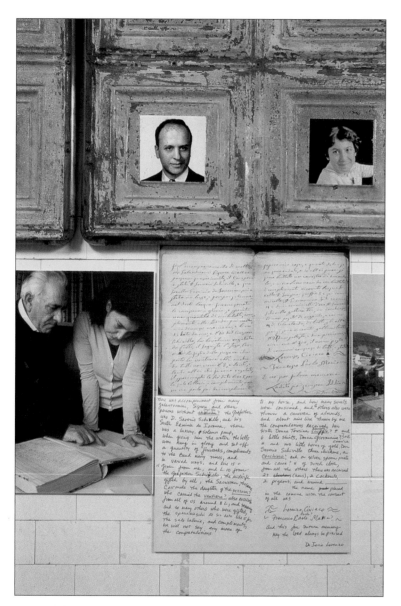

7. *Polishing the Mirror of Seven Generations:* Panels and text from the *Libro di Memorie,* with translations; Susan D'Amore Benevento researching family lineage in Montefalcione.

8. *Polishing the Mirror* panels; images of Lapio; Luigi De Iorio (below right); Clare Sean De Iorio Lawrence (above right); both reading.

AFTERWORD

I look into my mother's face	Rifletto sul viso della mamma
as a precocious child	come bambina precoce
and realize that this work	e mi rendo conto che questo lavoro
is about life	tratta di vita
and death.	e di morte.
Looking at a life time	Osservando una vita
the span of a life	la grandezza
one end of the thread to the other.	una fine del filo all'altra.
The mystery of it.	Il mistero.
The stillness before the fact of a life **lived.**	Il silenzio davanti al fatto di una vita **vissuta.**
A history **created.**	Una storia **creata.**
"filo della vita"	"filo della vita"
Fragile, passing, yet present.	Fragile, passeggera, ma presente.
—B. Amore	—B. Amore

9. Young Nina.

10: *Looking Forward, Looking Back:*
Larisa, Concettina's great-granddaughter, wearing a dress sewn and worn
by Concettina about seventy-five years before. The garden was cultivated
by Nina, Concettina's daughter, and Tony D'Amore, her husband.

Commentary on *Life line*

Essay

Cent' Anni! An Appreciation of B. Amore's **Life line: filo della vita**

by Fred Gardaphé[1]

When Italians toast an occasion, they often call out,"Cent'anni,"which means, something like,"For one hundred years."The idea is that you should enjoy times like this for at least a century. For all Americans, and especially for Italian Americans, B. Amore's exhibit *Life line–filo della vita,* is a fitting occasion for such a toast, for as this book, *An Italian American Odyssey,* documents, and as this essay argues, her work represents a long overdue response to the Italian experience in the United States and presents new ways of viewing the phenomenon of Italianness. To understand the impact Italian immigration had on the United States, it is important to know that Italian identities have been forged through complex and varied processes that have resulted in a multiplicity of identities best viewed and studied through individual cases.

When Niccolo Machiavelli penned his masterpiece, *The Prince,* Italy was a land divided and besieged by many foreign forces. In his last chapter, "An Exhortation to Free Italy from the Hands of the Barbarians," he calls for new weapons and formations to be used in warding off intruders and new leadership for Italy. In many ways, the current state of Italian American culture is in similar straits. There is a strong need for new tools and new alliances to bring a sense of identity and unification to our culture so that we can ward off the siege of total assimilation. B. Amore's art exemplifies the best possible response to the questions of what is, and what do we do to preserve, Italian American culture.

A culture is based on shared traditions created over time that are reenacted regularly so that they become rituals. These traditions are transmitted through words and actions. In the United States, we often speak of Italian Americans having two languages, but could it be we have two cultures? Too often, the two quite distinct identities are conflated and confused by those on both sides of the Atlantic. Italian Americans are as different from Italians as an egg is different from an eggplant. A familiar word connects each, but they are two very different things. There are as many different definitions of Italian Americans as there are Italian Americans, and the same goes for Italians. We have a tendency, when we use the word Italian American, to refer to a specific segment of Italian America: the children and grandchildren of those who immigrated from southern Italy at the turn of the century; and even though most of today's Italian Americans can indeed trace their past to this period of immigration, we cannot forget that there were political refugees from northern Italy during the 1850s, and that after World War II there was an entirely new wave of immigrants whose experiences were completely different from earlier immigrants. To figure out what happened when Italian immigrant culture shifted from dialects into English is the work of a lifetime. Today, we face the question of what we need to do to preserve a cultural identity, one that will not only work for us today, but one that will insure that our culture will persevere over time.

Before we can answer that question, we need to ask just what it is that needs to be preserved: a language, folk traditions, a history? We then need to determine just where these would be best preserved: in homes, churches, schools, cultural centers? And, finally, we need to determine how to preserve these: through language courses, Italian American programs in our grade schools, high schools and colleges, or through a greater Italian American presence in mainstream institutions?

For many years, Italian/American culture has been preserved in homes, and over the years, more likely than not, in basements, where grandpa made wine, where grandma had a second kitchen, and where material legacies and memories now are stored. Outside celebrations such as religious *feste* became the most important public presentation of Italian/American culture, but these annual events were never frequent enough to protect Italian/American culture from the usual mass media bombardment of negative stereotypes. It is in the mainstream institutions of education and government that Italian Americans are

only beginning to organize themselves. The public programs that might have taught Italian Americans the value of their own culture and subsequently fortified future generations, the public programs that would have challenged media-made impressions, were never created. We have kept our heads in our basements where Italian/American culture is safe inside family celebrations.

Now is the time to move beyond the basements of yesterday and out into the streets of today. The romance and tragedy of early twentieth-century immigration can no longer serve as models for identity. The key to creating a meaningful sense of Italian/American culture that means something to today's youth is first to insure that they have access to histories of their families and of their communities, and then provide them with historical and contemporary models in the areas of arts, business, and education, which they can study, emulate and transcend. We have created scholarships for higher education, but we have done little to help those applicants understand what it means to be Italian American once they enter those institutions.

B. Amore's *Life line* begins to answer these questions and many others about what parts of Italian culture have become parts of what we call American culture. Amore knows that her family legacy is precious and fragile, sometimes hanging by a thread from one generation to the next. To say that someone is "hanging on by a thread" usually means that there is a tenuous connection at best between the person and the object. But for Amore, that thread or what she calls her *filo della vita*, is anything but weak. In fact, it was by grabbing onto this thread and weaving her art around it that she has created a dynamic public work of art out of an intensely personal experience. *Life line* crosses boundaries between generations of people, as well as disciplines of art, and in the process teaches us how to turn our own lives into art, for the creation of art begins long before its execution and exhibition; true art begins in perception and the true artist not only perceives, but passes the possibilities of new perceptions through art into the minds of those who experience it.

The stuff of B. Amore's *Life line* is not rare; in fact most everyone who comes from a family that immigrated to the United States has boxes of the same materials: documents, letters, notes, holy cards, postcards, artwork, documents, certificates, passports, official and unofficial forms of identity, material goods, *biancheria* (linens), tools, photos, and other everyday objects from lives of those who came before us. For many of us, these items are stored in boxes that often are thrown out when people move or die, for it takes a lot to imagine how useful these things can be to those of us who are generations removed from the immigrant experience. This is precisely why we need artists like B. Amore. "Make the ordinary extraordinary," is one of the maxims of art and Amore does that through a number of unique vehicles and media.

I remember my experience of the show's debut. She had turned what once was a bureaucratic processing plant for immigrants into a holy space where her past melded with the history of every immigrant who wandered into the United States through Ellis Island. This celebrated sculptor and installation artist created a rallying point for the area's Italian Americans. Curated by Judy Giuriceo, the museum's curator of exhibits and media, *Life line* brought out the many dimensions of its title. Live readings, performances, and talks were arranged to coincide with the exhibit. Some even took place within the exhibit itself, turning public space into a site for extending the family. This book is a testament not only to the dynamism of Amore's exhibit, but to the life that was created by the thousands of spectators who passed through the exhibit.

Amore filled six old dormitory rooms on the museum's third floor with art in a variety of media: "Columns of History," "Ancestor Scrolls," "Family Triptychs," something called "Polishing the Mirror" – a wall installation composed of portraits of the artist's family – sculptural works entitled "Odyssey," and "Reliquaries" (my favorite comprised a wine barrel and a pickaxe) and one devoted to a broken heart.

Amore's images generated words and her words, in turn, generated images in the minds of the exhibit's viewers. What made *Life line* so powerful was the personal risk the artist took in bringing her family's history into the larger idea of American immigration history. Airing a family's dirty laundry is not something most Italians could conceive of doing in the neighborhood, let alone a public space like an art exhibit in a museum visited by hundreds of thousands of people each month. The power comes from the way she uses everyday objects from the past to tell the stories. In this way, the objects take on a sacredness as they became historical. Amore even designs works with a holiness in

mind, as in her altarpiece. The normalcy of bundles of fabric plopped in a glass case magnify the importance of the ordinary, and posting materials on old doors helps to make us see more clearly what we might normally overlook in our own daily lives. By delving deep into seven generations of her family history, Amore tapped into the universal meaning of immigration that transcended ethnicity, race, and class. *Life line* captured the words of long-gone immigrants through diaries, photographs, and pieces of everyday life that might have been discarded had not Amore reinvented their importance through art.

Amore sometimes calls *Life line* a visual memoir, but really it is a synthesis of a variety of art forms and styles. There is an interactive, performance quality that comes from the use of audiotapes of immigrant voices and traditional folk and popular music that filter through the rooms. Viewing the exhibit was a journey that ended in a room resembling a kitchen, complete with a huge table and a television, set into a hearth-like frame that runs videotape of the author at work and with her family. This is also a place Amore invited visitors to sit down and talk about their own experiences. Many of their comments are included in this book and teach us that being a descendant of Italian immigrants and being an American are one and the same thing. Amore's unique exhibit reminds us that history and art are public and private: public notices of family events, deaths, marriages, divorce, combine with news accounts, pieces of oral histories, and materials from history books, to create a mosaic of culture that testifies to the complexities that create all American identities.

Today, we can see that italianitá is a fluid concept, one that is redefined each time an artist addresses it in his or her work, each time an American chooses to relate to his or her ancestral heritage. Until we come to terms with what Italian- Americanness means to us, we cannot become good Americans. To deny or distort a part is to tamper with the whole; we must encourage a diversity within our notion of italianitá, just as we must embrace the diversity that defines America and Italy. Amore's *Life line* has taken the personal and made it public and in the process brings us all closer together.

Cent'Anni to B. Amore. Alla salute di tutti quanti!

Fred Gardaphé is Professor of American Studies at SUNY Stony Brook. His books include *Italian Signs, American Streets: The Evolution of Italian American Narrative; Dagoes Read: Tradition and the Italian/American Writer; Moustache Pete is Dead!* and *Leaving Little Italy.* His latest book is *From Wiseguys to Wise Men.* He is co-founder/co-editor of VIA: Voices in Italian Americana and editor of the Italian American Culture Series of SUNY Press.

Concetta De Iorio's Granddaughter Remembers/ B. Amore's Journey Into the Realm of Memory

by Joseph Sciorra[1]

But these flowers said remembering required effort and attention, because the pinpricks of our existence were so tiny and precious they could easily be erased by a passing wind.

—Mary Cappello, *Night Bloom*

O America, wondrous land of amnesic opportunities! It was a fantastical place, we were told, in a time before the USA Patriot Act and the Total Information Awareness System, where you could step out of steerage and jettison the shackles of the past to reinvent yourself as John Doe. Or you could eventually become a born-again ethnic, with memory loss and obfuscation of the historical record prerequisites for uncritically championing the triumphant tale of self-resolve, family cohesion, and religious conviction in the seemingly inevitable and glorified ascent in to the boardrooms and suburban townships of white America.[2] Or you could be Bernadette D'Amore, who transformed herself into B. Amore/Be Love and extended us a *Life line* to a history retold, a history reimagined.

It is wonderful that we have these images and texts assembled together in a book. Amore's extraordinary exhibition *Life line – filo della vita* was simply too much to absorb in one viewing, impossible to recall in its entirety. The exhibit was an overwhelming ensemble of objects, images, texts, media, exhibition styles, people, places, narratives, and memories that happily threatened sensory overload. Now we have the leisure in this book, *An Italian American Odyssey,* to look closely at what Amore has shared with us.

The six white-tiled rooms on Ellis Island where the exhibition was mounted are haunted spaces. Ghosts linger in the former dormitory, a "seething presence" that challenges us to retrieve biographies, stories, and desires, thus thwarting erasure, invisibility, and exclusion.[3] Amore acknowledged those disquieted spirits and their fitful sleep by christening the first chamber the "Room of Dreams" and installing a photograph in triplicate of immigrant men lying in bunks taken in that very space. The images were reprinted on Mylar and stitched to copper tubing, evoking a cot or a stretcher.

Astonishingly, the subsequent rooms were filled with the accumulated "stuff" from seven generations of the artist's family, artfully arranged for all to see. On display were the contents of an immigrant's trunk, which having passed the Ellis Island inspectors, was crammed for over a century with objects that, by all accounts, should have been junked long ago but now had returned to the point of entry, a cornucopia of historical treasures. The profusion of objects consisted of photographs reproduced from various sources and in a variety of styles, religious items (holy cards, a saint's statue, a prayer book), printed material (newspapers and books), official documents (a passenger ship's manifest, passports, marriage separation papers), household objects (a ravioli cutter, a clock, a shaving brush); tools and utensils (a pickaxe, a sewing machine, a typewriter), and various types of art work (embroidered cloth, drawings, carved stone). Texts from transcribed oral histories, diary entries, notes, postcards, letters and cable telegrams, lyrics of nursery rhymes and popular songs, poems, newspaper articles, obituaries, school papers, citations from history books and scholarly works, legal documents, and the artist's own writing filled the display. Amore's presentation was a gift from a child of immigrants, a family postcard traversing time and space to return to that global nexus of unprecedented mass migration of human labor, lingering dreams, and endless possibilities.

A number of arranged objects made an impression on me during my first visit. Here are just a few:

> A pickaxe and a section of a wine cask, standing together in an elongated hexagonal glass case like working class "ready-mades," an extension of Antonio D'Amore's weary arms and a memento of the laborer's fermented palliative.

Concetta De Iorio's tied bundles of fabrics saved from years of sewing projects, accompanied by her handwritten notes, stacked in an identical case, packets reminding us of women's exquisite artistry and the drudgery of needlework.

The inspired "Odyssey" installation, a group of five sculpted marble "personages," blocks of stone crowned with wicker baskets and wrapped in black cloth, a homage to working women who bear the burden of transported goods on their heads.

"The Art of Lounging," Nina D'Amore's 1939 graduating portfolio from the Massachusetts College of Art's department of fashion design, with its watercolor and ink illustrations of a "hostess robe and coat" for the woman – "wealthy or otherwise" – who doesn't know how her party guests will dress. These are glamorous images gleaned from Hollywood movies and Life magazine, a world far removed from la miseria of southern Italian peasantry. Lounging, indeed!

"Nonna's Table," a simple round table with a blue and white checkered tablecloth and chairs which became a gathering place for exhibition goers and the invited artists Annie Lanzillotto, Audrey Kindred, Edvige Giunta and her daughter Emily, Maria Laurino, and other members of the Collective of Italian American Women who performed their complementary work around this kitchen table of a reusable past.

How was it possible that one person, a descendant of immigrants, still had all these objects? There was the artist's great-grandfather Lorenzo De Iorio's diary, the self- proclaimed "Book of Memories," written during the nineteenth century! A household had been turned inside out, an attic emptied, a family's mundane possessions washed ashore to take refuge within this sanctuary called art. These are the things that do not survive the immigrant experience; this is what gets discarded in America.

Amore's grandmother, Concetta De Iorio, is the starting point for this collection, a person who not only accumulated personal artifacts – from a dried peach pit from a tree she planted with her father Luigi to a champagne cork from one of Amore's childhood birthday celebrations – but also labeled them with notes describing their origins and her thoughts and feelings. Writing and sewing, Concetta's life was one

created and documented in lines of ink and thread. Her note pinned to a section of material reads like an immigrant seamstress's piecework haiku:

all White piece to be embroidered
Pillows finished and unfinished
most already begin (sic)
Pezza ~ lettere' seta 'canavaccio.[4]

She was the chief curator of the great family museum, conceptualizing, cultivating, and ultimately documenting familial relationships in what anthropologist Micaela di Leonardo has called "the work of kinship."[5]

As heir to this amorphous array, Amore undertook the "pious work of salvage," retrieving and safeguarding the numerous objects.[6] Recalling the jam-packed trunks she inherited upon her mother's death in 1994, Amore stated: "They were a burden. They really were a burden. I took them on because I couldn't bear to see them lost. I kept saying I would make art out of them but I had no idea how."[7] Amore's vast art project involved the arduous task of giving shape, and thus meaning, to the scores of miscellaneous objects untethered from their original lived experiences in an effort to "offer access to the domestic interior lives they signify."[8] As folklorist Barbara Kirshenblatt-Gimblett noted, mementoes and family heirlooms are "fragments awaiting the autobiographer to repair the damage of time."[9] *Life line* reconstituted the objects' respective narratives through accretion, juxtaposition, and exposition. As the artist categorized, assembled, and finally displayed the objects, the collection, in turn, became an "articulation of the [new] collector's own 'identity'," an act of self-fashioning whereby Amore rewrote history and her place within it.[10]

Amore's work constituted what historian Pierre Nora identified as "les lieux de mémoire," or "realms of memory," cultural products such as archives, collections, and commemorations where "memory crystallizes and secretes itself" at a time when "consciousness of a break with the past is bound up with the sense that memory has been torn."[11] *Life line* examined the points where memory and history converged under conditions of displacement, rupture, and radical change over the course of a century and a half. The artist reconfigured the past into a public representation of personal and group identities that focused on individual

lives while ever mindful of the larger, global forces at work. The end result was a deft weaving of heirlooms into the broader social context, equal parts family ethnography and history lesson.

Engaging the various artifacts in dialogue involved discovering "the objective possibilities in things and the freedom to conserve the past and to create new values and a new world."[12] She superimposed images and text on discarded sheets of pressed-tin ceiling, suggesting the pitiful tenement rooms where immigrants lived and thus transformed the recycled items into both witness and indictment. One solution Amore used in her self-described "archeology of life" was to juxtapose different display strategies, including the "religious shrine," the "curio cabinet," the "ethnographic exhibition," and the "art exhibit," as well as various media such as photography, sculpture, and video. Her work stands as a testament to the power of bricolage to create new meaning and understanding of the varied objects culled from everyday life. Artist Miriam Schapiro has observed that women working in various aesthetic traditions like quilting have long used assemblage as an artistic and social strategy that she has dubbed femmage.[13] This artistic process is most evident in women's domestic altars where, according to folklorist Kay Turner, "objects and symbols are integrated into a coherent visual environment that marks their interdependence and connections with each other…[and] forge[s] new, interrelated meanings."[14] *Life line's* heightened mix of dissimilar elements provided a welcoming space for the polyphony of diverse voices found in Amore's extended Italian American household.

The exhibition unraveled and then reworked the various threads of relatives' histories in accordance with Amore's interpretation and artistic vision. Images of an individual were layered in collage-like fashion on a panel and were occasionally seen through a filter of translucent film or fabric, veiled but surfacing from beneath the receding past. Amidst the stories of struggle, fortitude, and achievement, the artist also revealed family secrets that others might have felt compelled to hide: the immigrant patriarch punishing his children with a leather strap; the suspicion of an ancestor's drinking problem; a grandfather's adultery and gambling; a relative's thievery of family belongings in Italy; and the "constant conflict" between immigrant Concetta and her American-born daughter Nina. These are the whispered stories from the great mythic narrative of the Italian American family that individual and collective omertà have historically sought to conceal.[15]

A delicate red thread ran through the exhibition, making its way across time and space, connecting us to the past and propelling us in to the future. It evoked the unraveled yarn immigrants used to remain connected to relatives left standing on the docks as they sailed away to an unknown world. It echoed the embroidered initials of Concetta De Iorio's and Giovannina Forte's biancheria, dowry linens stitched in anticipation of a new life. Ultimately, *Life line* linked us to our own families' respective stories and memories that developed in America and which grow faint with each passing generation, yet linger, sometimes painfully, just below the surface.

Acknowledgments:

I wish to thank Rosina Miller, Leonard Norman Primiano, Stephanie Romeo, and Joan Saverino for their invaluable comments to an earlier version of this article.

[1] Folklorist Joseph Sciorra is Assistant Director for Academic and Cultural Programs at the John D. Calandra Italian American Institute, Queens College, CUNY. He is the co-editor of Vincenzo Ancona's bilingual collection of verse *Malidittu la lingua/Damned Language* and the author of *R.I.P.: Memorial Wall Art*. Sciorra maintains the Web site www.italianrap.com.

[2] Robert F. Harney explores the "ethno-psychiatric uses of history" by Italian community leaders and intelligentsia in North America as attempts to assuage "ethnic self-disesteem" in his important essay "Caboto and Other *Parentela*: The Uses of the Italian Canadian Past," *From the Shores of Hardship: Italians in Canada*, Nicholas De Maria Harney, Ed. (Welland, Ontario: Éditions Soleil, 1993), 4-27. Bill Tonelli looks at memory loss and ethnic identity in his brilliant but unfortunately out-of-print memoir *The Amazing Story of the Tonelli Family in America: 12,000 Miles in a Buick in Search of Identity, Ethnicity, Geography, Kinship, and Home* (New York: Addison-Wesley Publishing Company, 1994).

[3] Avery F. Gordon, *Ghostly Matters: Haunting and the Sociological Imagination* (Minneapolis: University of Minnesota Press, 1997), 3–28.

[4] *Canovaccio* is the Italian word for dishtowel and a type of rough, hemp canvas. Thus the ambiguous Italian phrase can be translated in a number of ways: "piece of cloth ~ silk letters on a dishtowel" or "piece of cloth ~ letters on silk with a canvas backing." Even the use of the word *pezza* is open to interpretation. Thanks to Luisa Del Giudice, Augusto Ferraiuolo, Sabina Magliocco, Gloria Nardini, Placida Staro, and Edward Tuttle for their assistance in this small but not insignificant matter.

Scraps of writing by Mary Cappello's immigrant cobbler grandfather inspired her to write the beautiful and provocative book *Night Bloom: A Memoir* (Boston: Beacon Press, 1998).

[5]Micaela di Leonardo, *The Varieties of Ethnic Experience: Kinship, Class, and Gender Among California Italian-Americans* (Ithaca: Cornell University Press, 1984), 194–205.

[6]Susan Sontag, *On Photography* (New York: Dell Publishing Co., 1977), 76.

[7]Panel discussion on *Life line – filo della vita* sponsored by Queens College's John D. Calandra Italian American Institute and the Istituto Italiano di Cultura, New York City, November 14, 2000.

[8]Barbara Kirshenblatt-Gimblett, "Objects of Memory: Material Culture as Life Review," *Folk Groups and Folklore Genres: A Reader*, Elliot Oring, Ed. (Logan: Utah States University Press, 1989), 329–338.

[9]Ibid., 331. *See also* anthropologist Igor Kopytoff's essay "The Cultural Biography of Things: Commoditization as Process," *The Social Life of Things: Commodities in Cultural Perspective*, Arjun Appadurai, Ed. (New York: Cambridge University Press, 1988), 64-91, for his discussion of documenting an object's "cultural biography."

[10]Susan Stewart, *On Longing: Narratives of the Miniature, the Gigantic, the Souvenir, the Collection* (Baltimore: The John Hopkins University Press, 1984), 151-169.

[11]Pierre Nora, "Between Memory and History: *Les Lieux de Mémoire*," *Representations* 26 (Spring 1989), 7–25.

[12]Mihaly Csikszentmihalyi and Eugene Rochberg-Halton, *The Meaning of Things: Domestic Symbols and the Self* (New York: Cambridge University Press, 1987), 246.

[13]Kay Turner, *Beautiful Necessity: The Art and Meaning of Women's Altars* (New York: Thames & Hudson, 1999), 98.

[14]Ibid., 98. See also Jack Santino's "The Folk Assemblage of Autumn: Tradition and Creativity in Halloween Folk Art," *Folk Art and Folk Worlds*, John Michael Vlach and Simon J. Bronner, Ed. (Ann Arbor, Michigan: UMI Research Press, 1986), 151-169.

[15]See historian Robert A. Orsi's article "The Fault of Memory: 'Southern Italy' in the Imagination of Immigrants and the Lives of Their Children in Italian Harlem, 1920–1945," *Journal of Family History* 15.2 (1990), 133-147 for his astute reading of immigrant family dynamics and the "tragedy" of the Italian American family. Literary scholar Robert Viscusi discusses the consequences of silence for Italian Americans in "Breaking the Silence: Strategic Imperatives for Italian American Culture," *VIA: Voices in Italian Americana* 1.1 (Spring 1990), 1-13,

Italy, Interrupted

by Robert Viscusi[1]

A colleague of mine writes to me from Italy. A young woman there wishes to analyze the works of Italian American women authors in her dissertation, but her professor will not allow her to include memoirs and autobiographies among the texts she studies. Those texts must be, says the professor, literary. Autobiographies do not count as literature, any more than handbills or newspaper articles. Don't even mention bundles of letters. The professor wants plays and poems and, of course, novels.

Ah, the Old World. It is always reassuring, for an American, to see the machine of literary production engaging in its ordinary work of symbolic violence (as Pierre Bourdieu has called it) – that is, policing the borders of the deer park where the sons and daughters of people who studied in universities fifty and seventy-five years ago can continue to enforce the rules of exclusion that their parents learned at the feet of people whose parents learned those same rules fifty and seventy-five years earlier at the feet of people whose parents had learned those same rules from people who, once upon a time, had received them on tablets engraved by gnomes in tunnels under the earth. The university bourgeoisie of provincial Italy (this letter came from Abruzzo) still maintains the fences around that deer park, effectively excluding from study or discussion the works produced by people whose parents did not study in provincial universities or, if they did, somehow lost their capacity to remember the rules of small-town propriety once they had crossed the ocean and started to make sense of life as it was being lived in the raucous streets of Italian colonies in New York or Boston or Buenos Aires.

Of course, the whole thing is a myth and lie. The Italian novel does not have a very long history, as these things go, nor is it known for its capacity to model complex physical, social, or

temporal geographies. Travel books, yes. Letters, yes. Autobiographies, yes. But literary fiction, not really. Italian writing has in fact ranged widely among the class laboratories and territorial improvisations of the Italian world diaspora, but it has left behind its Galateo and its manuali della metrica and its trattati della retorica classica. In fact, the conditions of semiotic and of social reproduction in the diaspora have not merely outstripped, they have altogether avoided, the institutions of prestige long cherished by the academic salons and clerical garden parties of Italia letteraria.

All of this is by way of clearing a little space for B. Amore's *Life line*. This work ignores most of the shibboleths of generic propriety as these are acquired and transmitted by the guardians of artistic sterility in small cities perched on hills overlooking the slopes and valleys so many Italians so long ago abandoned. *Life line* accepts, it joyfully exposes and exploits, the actual media that Italians in the diaspora have employed in the construction and transmission of models for social life and for collective memory. Most of the material this work presents would seem to plant it squarely in the modern tradition of bricolage. Ephemera of every kind lie in promiscuous proximity here: letters, catalogues, journals, tickets and schedules, embroidery, photographs, newspaper clippings. If *Life line* is a work of literature – and I am indeed suggesting that it is exactly that – it calls for its own theory of reception. How is one to read a work composed in of such heterogeneous matter? It might be useful to reach into the toolbox of literary and cultural studies for a few handy devices.

Ellipsis. *Life line* examines, exploits, and exaggerates the discontinuities that afflict narrative lines in the lives of migrant peoples, when stories begin with one set of actors in one place but continue in other places with other persons and under other conditions. *Life line* uses the elliptical methods of modernist and postmodernist art – interrupted narratives, collage, and palimpsest – in assembling its mountain of articulate fragments.

Fetish. The lives of immigrants are organized around objects that develop extraordinary significance and power, quite in excess of what they might have held in a more stable context. These objects include things that carry the resonance of household divinities – pictures, statues, and medallions. But they also include things that would otherwise have had a more utilitarian resonance: clothing, crockery, cookery. Removed from their original places of occurrence and set down against strange and shifting backgrounds, such things acquire strange and surprising poetic and narrative importance. They have two specific kinds of resonance. They speak, first, of what is lost. This is the famous Freudian fetish. It derives its energy from the power of broken hearts and broken promises. *Life line* is rich in this kind of breakage and with the consequent displacement of sexual energy. Parents, siblings, lovers, husbands all have their place in the hopeless entropy of migrant affect. The second theme of fetishes is the power of what is hidden. This is the notorious commodity fetish of Karl Marx, which carries but also masks the complex history of labor relations that are required for its production, distribution, and consumption. *Life line* is rich in this kind of manufactured object, whose very finish and style, when seen amid the flotsam and jetsam of a scattered tribe, poignantly evokes the Atlantic labor market and the captives of surplus value.

Gender/Genre. The mixed genres of *Life line* dramatically reproduce this monumental destabilization of gender that accompanied the mass migration. The not-so-mute relicta of this life, accompanied by B. Amore's succinct narrative commentaries, offer a staggering spectacle of the difficulties men and women faced in their attempt to carry on with gender roles that had evolved gradually over the slow centuries under the steady gaze of a sedentary people but had little support and made little sense against the background of the international market in human labor where the immigrants were living.

Interruption. Lacanian theory offers the notion that the unconscious functions as an interruption. It changes the subject in a discourse, it stops the flow of explanation and clarification. *Life line*, one might say, is composed entirely of interruptions. No one's plan actually works. No clear notion of meaning is ever triumphant. Italy, with is endless rhetoric of self-justification and self-glorification, loses size and shape and importance on the streets of Boston, where the questions have to do with rent, clothes, train tickets, jobs, and salaries.

Life line, it should be added, also provides its own toolbox for interpretation. This work abounds with interpretive frames, offered at

every level of magnitude, so that one can approach it through a needle's eye or from the deck of a transatlantic steamer. The migration presents narrative with monumental difficulties. So much of what was said, felt, or remembered left traces in places the anthologist and the art collector would ignore. So much of what was said was never completed. So many letters never reached their intended recipients. In the center of this disrupted semiosis, B. Amore has erected this speaking monument to incomplete messages, according to incoherence and frustration their full measure of poignancy and eloquence.

Is it art? Is it literature? These are boundary questions, and it is the very purpose of Amore's enterprise to transgress boundaries and to produce a work that requires the viewer to read and the reader to view and to assemble, in whatever way possible, a representation of the world of a family living in the world of the migration. I read it as a work of literature, but that's not the only possibility. In fact, one is always forced to decide. This work does not provide any comfortable assurances. One can only hope the provincial police of Italian literature will find it threatening.

[1]Robert Viscusi is Broeklundian Professor and executive officer of the Ethyle R. Wolfe Institute for the Humanities at Brooklyn College, as well as president of the Italian American Writers Association. His books include the novel *Astoria* (American Book Award, 1996) and *Buried Caesars, and Other Secrets of Italian American Writing*.

The Temple of Immigrant Memory: B. Amore's Visual Memoir

by Edvige Giunta[1]

What is not remembered is forgotten.

—B. Amore, *An Italian American Odyssey*
Life line–filo della vita: Through Ellis Island and Beyond

Walking into the halls of *Life line*, I enter the temple of immigrant memory of the Italians of America. The impact of the encounter is akin to a visit to Morgantina, the remains of a Greek polis near Aidone, Sicily. The walls are no longer there, but the foundations of houses, temples, and the marketplace map out the contours of what some sixteen-hundred years ago was the life of a community, a community whose heritage seeps into the flesh and bones of its modern-day descendants. One summer, back from the United States for a month on the island of my birth, I walk in reverence through the paths of Morgantina. I stumble upon a mosaic outside the perimeter of what was once a home, a rectangular shape with the words "welcome" in ancient Greek. I am moved deeply by the words of these distant ancestors who greet me with words so old, so familiar. On the threshold of this home, I ponder on the encounter of past and present, the dead and the living – how it is all connected. I am similarly moved when on a Saturday morning in December 2001 I walk, my Jewish American husband and my two children, both born in the United States, in tow, into the halls where *Life line–filo della vita: An Italian American Odyssey 1901–2001* is laid out, mapping out the contours of other ancestors whose stories, too, interlock with mine.

I came to the United States in 1984. One could argue that I have little connection to the Italians who came to the United States between the late nineteenth century and the early twentieth century. But they, too,

like the Greeks of Morgantina, are my ancestors. Perhaps the greatest scar in Italian American culture is the loss of memory, the loss of connection with the places, the people, the objects of a collective past that contains its history, its poetry. *An Italian American Odyssey:* how appropriate B. Amore's choice of the word "odyssey," a word redolent of epic travels and heroic deeds, of courage and determination to survive against all odds. For far too long, the histories of Italian immigrants in the United States were the sole concern of anthropologists, sociologists, and historians whose work, although valuable, failed by itself to capture the spirit of a people and the transformative, redemptive power of culture. Writers, filmmakers, and artists do just that – they find a language to articulate that spirit, that power.

On that December day, I joined my Italian American sisters at the Museum of Immigration on Ellis Island where *Life line* had its opening. Performance poet Annie Lanzillotto had called a gathering of writers and artists to share their work in an exceptional setting. Memorializing the immigrant experience through the lens of personal story and through intimate encounters is, in my mind, the most meaningful scope this extraordinary work accomplishes. Extraordinary: I choose this word deliberately. Through her recreation of immigrant memories, B. Amore uncovers the extraordinary in the quotidian. The ordinary and the epic meet and intertwine in *Life line.*

At B. Amore's exhibit, it is impossible to be mere visitors who contemplate with detachment an artistic production. Then, again, art at its best forbids detachment. As we walk through the rooms where *Life line* is set up, we follow a thread of memories and stories, a thread that connects past and present, personal and cultural memory. The rooms flow into each other, but the journey of the visitors is not linear or seamless. We pause, wander in another direction, retrace our steps. We are overwhelmed by mementos assembled in gorgeous juxtapositions. At times, a display case serves as a reminder that this has been arranged, created. It makes the process of the encounter between the artist and her material, art and viewer transparent. But some of the objects – letters, books, clothes, linens, utensils – take you by surprise, and overwhelm you with the vibrant imprint of the human being that touched it, wrote it, worked with it. This is an epic of domesticity.

B. Amore's work straddles effortlessly the line between the elegiac and the festive. It makes me think of *la Festa dei Morti* – the Feast of Dead, celebrated on November 2nd in Italy, but also in Mexico and elsewhere in the world. When I was a child in Sicily, we waited eagerly for the visit of the Dead who would come in the early hours of the morning, while we were still asleep, and deliver gifts for us children, their descendants: pupi di zucchero – sugar dolls – in the shape of knights and princesses, fruits of marzipan, and toys. Later in the day, we would join the scattered procession of people going to the cemetery to visit the graves of family members. Many were people who had died long before we were born, people we knew only through photographs and stories. The taste of sugar still in my mouth, I watched women dressed in black carry colorful, gorgeous flowers and cry at the grave of a parent, a child, a loved one. A similar mixture of mourning and celebration permeates *Life line*. The faces look at the visitors from the Ancestor Scrolls and the Family Triptychs. Mute and eloquent at once, they want to be mourned and celebrated – they want to be remembered.

B. Amore's *Life line* accomplishes, in art, what Italian American women memoirists like Louise DeSalvo, Susanne Antonetta, Mary Cappello, Kym Ragusa, and Maria Laurino accomplish in writing. These authors use memory as subject matter and form: their writing is not just a narration of things that happened – that is the work of autobiography. Instead these memoirs offer articulations of what the writer remembers, of what memories – hers and those of others – she has been able to recover, reconstruct, and, more importantly, reinvent. These memoirs pose the questions: What does it mean to remember certain stories and not others? That we remember something differently from how our mother or sister or brother, or even a younger self remembers it? How are memories connected? How do you find ways to remember and words to tell?

The narrative of memoir follows the very structure of remembering: evocative, associative, often disjointed but always meaningful, as poetry is. The truth of memoir, as Louise DeSalvo puts its, is the truth of memory – not the truth of facts. And so with *Life line*, a visual memoir that demands that the viewer become a reader who allows herself to be trained by the work to find meaning in the crevices, in the spaces in-between, in the seams between the object and the artist's intervention,

as in the Ancestor Scrolls or the columns of marble draped with cloth and holding baskets with linen on their tops. The stone seems to move, sinuous in its hardness, deep in its impenetrable smoothness. This is how the artist remembers her family, her history. And the incompleteness of this visual history is as important as its abundance. The sheer volume of the artifacts that Amore's family preserved is almost grandiose. Yet, this wealth of objects assembled in *Life line* also highlights the gaps, the missing, the untold, the forgotten. They, too, matter and constitute the very essence of memoir. They point to the necessity to remember that which has been forgotten and that which would otherwise be forever forgotten.

Near the Greek settlement of Morgantina, an ancient Roman settlement and a prehistoric settlement have also left their human traces. These traces collectively tell one story – the story of the people who inhabited and shared at different times in history a piece of land called Morgantina. Scattered farms, fruit trees, a lamb bleating for its mother, a dog barking at strangers, a trattoria owner telling his customers of growing up in Morgantina and finding archeological remains – vases, statuettes, coins – that his family kept and displayed proudly in their home, as did other families in the area – until the Princeton archeologists took it all away to museums – these all testify to the complex ways in which past and present, cultures, people, life and art, home and museum are connected.

Life line, the work that announces itself as the Odyssey of the Italians of America, also immediately claims its mythical power and its desire to speak on behalf of all immigrants. The artist frames and presents every artifact in such a way that the viewer cannot but connect all the stories: stories of men, women, children; stories of families and communities – the story of a country. The Museum of Immigration on Ellis Island becomes the first home of *Life line*. The memories and the stories of all those immigrants who passed through that building intersect with the stories *Life line* tells and with the stories told by the writers Annie Lanzillotto gathered on that Saturday morning of December 2001. One of them was a twelve-year-old Italian American girl. Standing on a chair, surrounded by older writers, visitors, and B. Amore herself, the girl reads a memoir of her maternal grandparents' Sicilian garden, evoked with a sense of loss and desire, suspended between reality and dream. This girl is my daughter. The story she tells

on this day and her own story, too, are connected with the memories and the stories that fill the rooms of B. Amore's Italian American Odyssey – a lifeline. Every image, every object – like every memory – in *Life line* is connected and points to another, and that to yet another, in a spiral converging into the powerful, impressionistic, collective narrative of *Life line* and its evocation in this book, *An Italian American Odyssey*. These images and these objects speak – their voice is a murmur that stays with you. Sometimes it is a solitary voice; at others it is a chorus. *Life line* produces its own compelling music. It has a quiet strength. It is enduring.

Edvige Giunta is Associate Professor of English at New Jersey City University. Her books include *Writing with an Accent: Contemporary Italian American Women Authors* and *The Milk of Almonds: Italian American Women Writers on Food and Culture*. She is co-editor of *Transformations*.

Life line: *Thread of Memory*[1]

By Flavia Rando[2]

With *An Italian American Odyssey,* B. Amore – sculptor, installation artist, author, and teacher – goes home for her mother and her mother's mother, for all those who went before. The *Life line–filo della Vita* of B. Amore's installation evokes the thread thrown out by immigrants, as their ship moves away from shore/home, to those they have left behind. This thread a last fleeting link to all they have known is their hope – an umbilicus, never cut – it floats in air, then drifts under water, bleeding red into the sea. Is it now being thrown to us – to those of us who share this formation in the psyche, the experience of *Life line* is like being under water – if we reach for it, we might drown.

In this monumental work, a multi-room installation designed for Ellis Island, Amore asks us to stand within the immigrant experience, to stand as they must have stood, displaced, uprooted, overwhelmed by visual and auditory stimuli, by sights once unimaginable, by incomprehensible voices, words, inflections. The viewer is asked to follow a labyrinthine path – the path that once led immigrants to a new life – guided only by the thread of memory, a slender *Life line* to (the reconstruction of) self.

Life line is dedicated to Amore's maternal grandmother, Concetta De Iorio, "It is because of her collections of objects from the everyday to the sacred that this work exists. Her stories and legacy inspired [me]." Memories of Concetta dominate *Life line* and the viewer is held in the thrall of these memories and Amore's act of remembering. The treasured *biancheria* of three generations, *Nonna's Bundles* – exquisite elaboration of life's everyday beauty and powerful visual abstraction – are installed in numerous reliquaries and in *Four-Generation Sewing Closet,* and are critical to the visual texture and mood of Amore's work. As such, *Life line* becomes a monument to that which has been seen as ephemeral in women's lives, only secondary in the context of a family's struggle for physical survival.

Life line inundates viewers with photographs, text, music, song, sculpture, bundles of fabric as sculpture, clothing, sewing machine and pickaxe, kitchen furniture, shrines – fragments of daily life. With these fragments, Amore evokes a dream state; it is as though the work itself were created from within that dream, its focus blurred, veiled by the broken heart/s of the immigrant, a loving woman, and her loving grand-daughter. Remembering her grandmother, Concetta, and her childhood home, Amore recreates the plentitude of the imagined grand/mother, the plentitude of the imagined home carried in our dreams.

This world encompasses both adult stories heard by the child, and the unarticulated longings sensed by the child beneath the everyday. The viewer senses this subtext – uncanny, the strangeness that is the child's world – beneath history told and beauty seen. Amore's *Life line,* like Louise Bourgeois's installations, *Cells,* makes palpable the child's fearful awe as she awakens to a world of beauty and adult emotions, the excitement at significance sensed, of impressions carried just below consciousness. At the edge of awareness, the viewer senses the family table is too large, the shrine outsize, the plentitude – and here meaning adheres – almost frightening.

Amore quotes a Sicilian proverb, advice for survival in adversity: "you have eyes you no see; you have nose you no smell; you have tongue you no speak; you have hands you no touch."[3] But, if only we could speak, could say what is, what was – and here it is told, traditional wisdom subverted (for survival), and then told again – too much to tell, too much not to tell. Journal entries minutely written in gold ink trace an ellipse, their legibility sacrificed to the beauty of the mark, words can only be read through an effort of extraordinary devotion. At the periphery of consciousness, we hear familiar music rising, we listen, but it falls away. We are overwhelmed by the sensation of an as yet unknown world where the experience of the immigrant and the perception of the child of the immigrant household come together.

We see, we hear, through the veil of (Amore/grandmother's) memory. At her grandmother's death, Amore inherited, embodied in *biancheria,* Concetta's memories, cradled in fabric, secured in girlish pink ribbon and the black threads of mourning, waiting for the next generation. Her bequest, an attic filled with exquisitely unnecessary love, care, work, creativity, a work of art, its constant presence a metaphor for a life of possibility deferred, of promise held in abeyance – a great and

desperate work. Just as surely, she placed her art into the mind and heart of her granddaughter, the next artist, who, for Concetta, has brought this work into the public (first) at Ellis Island, its point of origin.

Amore uses *biancheria, Nonna's Bundles,* as sculptural material. Stone and cloth both secured in black, create an equivalence between her grandmother's *biancheria,* fabric, woven, cut, marked with thread and gesture, and the stone obelisks she sculpts, marked with chisel and gesture. The stone might have been cut with her grandfather Antonio's pickaxe placed in an adjoining reliquary. The unbearable elegance of the pickaxe suggests yet another equivalence, that between the (permanence of) stone and the immigrants' back-breaking labor working stone – and fabric – both survive to carry the continuing past to us.

(We) Italian Americans are haunted by this past; part of us is captured there. Italian culture has been described as one that looks back, and Italian-American culture looks back, at a remove, at their looking back at their loss, even as the pull of the (American) present, makes us painfully aware of (the anomaly) our response (to their past). In *Life line,* Amore interrogates the quality of memory, the hold of memory – whose memories do we carry? – and the relation of memory to mourning for a self known only through a lost home/culture. Memory, deferred and deferred again, has been the inheritance of generations of (Italian) Americans and indeed, memory/s of *Life line* haunt my imagination, much as the memory of my own childhood home and the homes of other immigrants, family, and friends I knew as a child, continue to haunt me. As I write, my own story keeps seeping out; through *Life line,* I re/experience my own history, my own inheritance. I, too, remember.

As the viewer moves through the rooms and dreams of *Life line,* she experiences an alternate reality, that is at once Amore's specific history and a moving reflection on the migrations – great and desperate work – that have been a defining experience of the (twentieth century) United States.[4] As such, it has provided an exemplar for me of visual work that has an (Italian American) autobiographical referent as well as an historical and political context – art at its most engaged.

Life line is a memorial to one woman's rebellion, to the desire for beauty and self stitched into *biancheria.* This memorial to Concetta's gesture of freedom and the cost of that gesture, hinted at by the grand-mother, imagined by the (grand)child, has been actualized by the artist, Amore. Grandmother, mother, daughter, each is revealed in her daring, dreams, and ambition. The art of *biancheria* is revealed in its significance – both resistance and endless hours of (gender appropriate) labor – to the women who were its creators, and to their (female) descendants, who may not have learned the necessary skills, but have learned reverence for the place of *biancheria* in the rituals that create identity and meaning.[5]

We carry the mothers and grandmothers, the sisters and aunts who never married with us, burned into our psyches, held by an umbilicus of thread, stitched to a memory of place. Dedicated to one woman, extended to her memory, *Life line* becomes an homage to all the women who have been the thread of life for Italian and Italian American families.

[1] This essay is dedicated to my Mother, Marie Aida Silvestri Rando – Mary, who made her life's journey with great love and courage.

[2] Flavia Rando is an art historian who teaches Gender and Sexuality Studies in the Women's Studies Program at Brooklyn College, City University of New York. A first-generation Sicilian American, she has lectured and published widely on contemporary art and feminist, queer, and ethnic identities. She is the author of "Italian American Women in the Visual Arts," with Nancy Azara and Joanne Mattera, and "Portfolio of Italian American Women Artists" in *Our Own Voices: Multidisciplinary Perspectives on Italian and Italian American Women.*

[3] Amore reports reading this in Michael Lamont's "Italian American Autobiographies," Italian Americana. *Cultural and Historical Review,* Vol. XVIII, No. 2, ed. Maria Parrino, University of Rhode Island, Feinstein College of Continuing Education, (2000):50.

[4] Acknowledging the location from which we speak has become ever more critical. We are now citizens of a nation at war in order to protect our supposed insulation from what has become the everyday suffering of many of the world's people. As we experience the growing global economy and witness the upheavals and mass migrations that have marked the turn of this century, we might see a mirror held up to the mass migrations that brought so many Italians to the United States, and revisit (questions of) the trauma of cultural and emotional rupture.

[5] Interviewing Italian-American women artists, I have been surprised and moved by their acute personal relation to the *biancheria* of their mothers and grandmothers, by the number of women who were taught to do needlework, and by the number of artists who found their first professional identity as costume designers, or textile artists. I was moved by the artists who acknowledged the importance of needlework to their mothers, "My mother always had a piece of work in her hand; my mother had Alzheimer's, she traced her hand over and over the fabrics she had loved all her life, and this made her calm."

Memory and the Art of Feminist History in B. Amore's An Italian American Odyssey

by Jennifer Mary Guglielmo[1]

B. Amore's *An Italian American Odyssey* is a precious resource. A diasporic text, it represents the linguistic, cultural, familial and psychic chords that have historically linked Southern Italy and America. As Amore transcends geopolitical boundaries, she also skillfully challenges traditional parameters of history and autobiography by resisting a single, authoritative, developmental narrative and by disrupting the national fantasy of immigrant assimilation in an inclusive, welcoming nation.

Incorporating archival research, oral history, photography, ancestral objects, family letters and diaries, this text is a collage, an internally diverse composition. Amore weaves her own memoir through the words of seven generations of her two Southern Italian families to render identity not as stable, unshifting and discrete, but as fractured, contentious, and deeply embedded in community and family history. Amore's goal is to develop a narrative that "functions as collective memory," a narrative that "becomes a sort of homeland." This enables her to excavate "the unanswered questions" of her ancestors, especially the women in her family, since it was their "deep transmission" that has given form to her life and artwork.

As an assemblage of text and images that center on women's history, Amore's methodology is liberatory: she enters the silences and absences in the dominant narrative to "deconstruct the 'truth' as I knew it." Recognizing how memory "is only like a glint of light off a faceted surface," she explores how recollection unearths "only a partial 'truth' of a moment in time, but it is 'our truth' and it is a Point of Departure." Her narrative is a "constant weaving back and forth of layers of remembered and recorded histories." By valuing and incorporating collective memory *and* the historical record, women's voices, experiences, histories emerge as central. As filmmaker Trinh T. Minh-ha reminds us: storytelling "is the oldest form of building historical consciousness in community…[and] the world's earliest archives or libraries were the memories of women."[2]

Amore's process of historical recovery is rooted in the methodology of her grandmother, Concettina De Iorio Piscopo, whose stories were Amore's "place of beginning": "It was she who taught me to drink from the fountain of memory." In so doing, Amore positions memory as sustenance, and joins with contemporary feminist theorists such as M. Jacqui Alexander for whom memory is "antidote to alienation, separation, and the amnesia that domination produces," a way to excavate "the costs of collective forgetting so deep that we have even forgotten that we have forgotten."[3]

An Italian American Odyssey summons memory by exploring the silences in history, the subordinated knowledges that Italian immigrants and their descendants developed through processes of struggle. "My search into family," Amore writes, "had as much to do with what was not said, what was not divulged in addition to all that was told." This focus on the *interority* of immigrant women's lives restores their humanity and differs dramatically from the iconic Italian immigrant woman that predominates in American culture: the stoic, nameless, emblematic subjects of the now classic turn-of-the-century photographs of Lewis Hine or Jacob Riis; or the largely dominated subjects of many cinematic and historical narratives. Amore's text transcends these flattened images as the women she presents directly challenge the patriarchal idealization of female silence, passivity, and reticence. She does this by collecting and transcribing the words of her ancestors (familial and communal) from dozens of letters, diaries, and interviews, and placing them in conversation with one another. In this way she demonstrates that history is not a single narrative but a conversation, or as literary critic Laura Hyun Yi Kang writes, "a discursive production that illuminates and occludes certain details."[4]

An Italian American Odyssey speaks to history from the deeply personal and complex emotional journey of Southern Italian migrants and their descendants at a time when more Italians lived around the globe than within the formal boundaries of the Italian nation. By humanizing this experience, Amore connects the reader to the many conflicting feelings and experiences that shape the shared human drama of mass migration and cultural change, while building a rich connection between the past and the present. This is the kind of history that we yearn for. In my undergraduate classes I've found that students enjoy history most

when it's presented not as a series of dates and events to be forced into their memories and regurgitated onto an exam, but as a tool for survival, a resource filled with lessons for the present day. History becomes more engaging when we acknowledge it as contested and subjective, as fraught with issues of power. As one of my students wrote in her class journal:

> History reveals itself in this way when we study the lives of women, especially working-class women, women of color, immigrant women, women who are often not in the formal historical record, whose papers are rarely collected & preserved in libraries. These are the women though that so many of us grew up around, we are these women.

B. Amore's *An Italian American Odyssey* does this at an extremely significant moment – globalization, mass migration, immigrant rights movements, and transnational communities are again transforming social, economic, cultural, and political landscapes across the globe. This text offers us an intimate and creative doorway into understanding the impact of global economic restructuring on people's lives. It is a story of globalization from the perspective of those at the bottom of the ladder, workers upon whose lives and bodies capitalism expanded into a world system in the early twentieth century. Amore's work teaches us the many ways migrants themselves respond to experiences of displacement, exploitation, and alienation by redefining the meanings of home, community, and American identity.

[1] Jennifer Mary Guglielmo is Assistant Professor of History and American Studies at Smith College. She is co-editor of *Are Italians White? How Race is Made in America* and is currently completing a book, *Living the Revolution: Italian Women, Transnational Labor Radicalism and Working-Class Feminism in New York City, 1880–1945*, which was awarded the Organization of American Historians Lerner-Scott Prize for Best Dissertation in U.S. Women's History.

[2] Trinh T. Minh-ha, *Woman, Native, Other: Writing Postcoloniality and Feminism* (Bloomington: University of Indiana Press, 1989).

[3] M. Jacqui Alexander, *Pedagogies of Crossing: Meditations on Feminism, Sexual Politics, Memory, and the Sacred* (Durham: Duke University press, 2005), p. 14.

[4] Laura Hyun Yi Kang, *Compositional Subjects: Enfiguring Asian/American Women* (Durham: Duke University Press, 2002), p. 225.

Supplement: Pellegrino D'Acierno[1]

Bricolage Blues: Fragments for B. Amore's Life line–filo della vita

> *These fragments I have shored against my ruins*
>
> —T.S. Eliot, *The Wasteland*

> *Glendower: I can call spirits from the vasty deep.*
>
> *Hotspur: Why so can I, or so can any man*
> *But will they come when you do call for them?*
>
> —Shakespeare, *King Henry the Fourth*, Act III, sc. i

I. THE RED THREAD:
A Memory Exercise for Life line, *itself a Memory*

Exercise

These fragments, written from memory and pro memoria, are my way of holding onto the red thread/lifeline that B. Amore extended to the visitors/voyageurs who transited through her wondrous exhibit, *Life line–filo della vita: An Italian American Odyssey 1901–2001*, in its definitive installation at the Ellis Island Immigration Museum.

That rough and frayed little red thread/lifeline, which lined the horizontal wall panels and, ribboned its way, despite breaks, around the walls of the six-room installation and, like a directional arrow or strange diacritical mark, guided the spectator through its intricate textual construction, is at once the exhibit's singular gift and the key to its interpretation.

As gift, the red thread/lifeline requires from the spectator the counter-gift of memory: the refusal to let go of it and the affiliation with the immigrant family - hers and ours - it confers. As interpretive key it, too, calls for a thick description as do each of the other objects - ordinary and extraordinary, discrete or assembled - through which B. Amore materializes the history/herstory of *la famiglia* and narrates its fable of immigrant and post-immigrant identity.

The red thread, at once vector and Ariadne's thread, opens the way to the passage-work, memory-work, and story-work that the installation imposes upon the viewer/voyageur. It inscribes the metaphor of the journey within the installation and is the viaticum for that journey. In it are condensed all the lifelines that transit through the installation; the memory-line that links the installation and its viewer to the primal scene of emigration from Italy and the original lifelines - those balls of yarn and the ritual of threads through which the immigrants, upon disembarkation from Naples, enacted their farewell to the homeland and their dear ones who remained on land; the story-line/narrative thread that, as set out in B. Amore's "visual memoir," the viewer must follow to comprehend the personal narrative of her family's history as it unfolds through seven-generations of lived life and within the context of the collective narrative of Italian American immigration and post-immigration history: the viewer thus follows a double history/story, at once private and public, that, in its embedding within the installation, counterpoints the time-line of the generational biography of the family with the time-line of social history (the Columns of History) and thus constitutes a master-narrative of immigration; the bloodline that runs through the genealogy of the De Iorio and D'Amore families set out in *Life line* and with which the viewer must become familiar by personalizing the schematic-ness of the family tree and entering into a "I-Thou" relationship with the dominant characters on the basis of the individual portraits of them constructed by B. Amore from their images, their possessions and collections of objects; the passage-line that extends through the six-rooms of the exhibition space and reiterates the spatial story of the De Iorio and D'Amore - from Lapio in Avellino to Naples, the site of the primal scene of emigration from Italy, to Ellis Island, the site of the primal scene of immigration to America, to all the subsequent passages within the diaspora; the time-lines/memory-

lines that trail behind each and every image and object in B. Amore's work of *bricolage* and through whose resonance the viewer learns the art of memory, the art of rummaging. The exhibit/installation required much more than the meditation and contemplation of traditional "museum-work": its complex textuality imposed a memory exercise and affiliative work by which the viewer passes from visitor to member of *la famiglia.*

These and other invisible or imaginary lines of transit are resumed in the visibility of the red thread that contains the instructions for reading the installation. Within the confines of the installation, the red thread in its materiality has a set of specific functions. It links the displays of fabric and bundles that commemorate the work of women - hard even though it takes the forms of softness. It activates the color coding at work in the installation, merging with the red ink of the Ancestor Scrolls and counter-pointing, for example, the gold calligraphy on the blue doors of the Triptychs. Perhaps it bears within it an allusion to Concetta's anecdote: "Concetta's favorite color was red, but she always wore black."

The red thread can be taken as the signature of the artist herself, as the indexical sign that physically links the artist's body to the bodies of the ancestors re-membered and re-collected through the medium of the installation. As a framing and cueing device, it is the primary place in the construction where the artist/narrator marks herself deictically upon the construction and, by extension, the place mark where the artist and the spectator/passenger are remarked and signified throughout.

To comprehend *Life line* it is necessary to begin and to end with the red thread, as did the ancestors, and we shall need to interrogate it further in the concluding fragments. It points the way to the problem confronting this viewer who, after leaving the installation with a happy memory, attempts to recover through writing the "time regained" in the work of art: How is one to remember the event staged by and inscribed within B. Amore's multimedia installation when that event is the advent of memory itself? How is one to remember a work of art that, in assuming the form of a memory exercise, engages the living in remembering the names and faces of the dead? If the sensuous signs of memory - literalized and enveloped in B. Amore's familial and ordinary

objects - are signs of life, what resonance or surplus value is imparted to those signs of life when they are installed within a site-specific work of art in which they become signs of art?

Again the red thread/lifeline: a sensuous sign-of-memory/sign-of-life that is elevated into a sign of art. Whatever paradoxes between voluntary and involuntary memory it may activate, the red thread is B. Amore's way of circumscribing a magical circle that calls the spirits of the ancestors to enter it so that they can speak, thereby maintaining their colloquy with their descendants, including the visitor/stranger, the newest member of the family.

Again the red thread and its historical lesson: Immigration can only be understood backwards.

Again the red thread and its writing lesson: Perhaps the only way of holding on to it and of tracing its traces is through fragmentary writing.

Learning (Counter)History from B. Amore or, The Art of Rummaging

Away with the monuments…

—Friedrich Nietzsche, *The Use and Abuse of History*

According to Jean Baudrillard, memory is a "dangerous function" because "it retrospectively gives meaning to that which did not have any," because " it retrospectively cancels out the internal illusoriness of events, which was their originality." Here Baudrillard, in *Fragments*, the third of the four installments of *Cool Memories,* is referring to that monumentalizing and reifying form of memory at work in historical consciousness that deletes from events "their original, enigmatic form,""their ambiguous, terrifying form" (Baudrillard, 1997:30).

Baudrillard is right to criticize historians' history in this way; his critique of monumental history follows in the line established by Nietzsche, with his notion of genealogy as an analysis of descent, and reiterated by Foucault who extends Nietzsche's genealogy into counter-memory, "a use of history that severs its connection to memory, its metaphysical and anthropological model, and constructs a counter-memory - a transformation of history into a totally different form of time" (Foucault, 1977:160). Such remembering brushes against the grain of normative or canonical history by focusing on discontinuities and retrieving forms of "otherness'" such as madness or sexuality that resist inscription within traditional historiography. Both Nietzsche and Foucault stress the genealogical task of tracing descent through the body, of exposing "a body totally imprinted by history…", because the body, usually exscribed from monumental history, is the site where hegemony and domination imprint themselves.

These critiques of the monumental and their invocations of counter-history/countermemory find their equivalents in the ambivalence and skepticism toward the public monument that characterize those elements of twentieth-century artistic and architectural culture that resist and contest the traditional form and function of the memorial in their works of public art, often creating what James E. Young calls "counter-monuments" (Young, 2003:240). The contemporary installment of American "memorial culture" might be seen to begin with Maya Lin's 1981 Vietnam Veterans Memorial and to culminate in the proposed 9/11 memorial, which has provoked a furious debate that refocuses and intensifies all the previous discontents with the public monument and calls into question the ability of architecture, compromised by the political and real estate demands of late capitalism, to do authentic mourning-work.

For present purposes, it is worth recalling *il Vittoriano* (The Monument to Victor Emmanuel in Rome, inaugurated in 1911), one of the most flagrantly spectacular and self-aggrandizing memorials in architectural history. It might be regarded as the starting point of twentieth-century memorial culture, even though it epitomizes the nineteenth-century view of the monument. That post-*Risorgimento* follies in the form of a Wedding Cake--monument to an imaginary nation and to an architectural kitsch that would render it a centerpiece of Fascist spectacle politics - would seem expressly designed to elicit Nietzsche famous remark, "Away with the monuments." But in commemorating the nationalistic poetry of the Risorgimento, and subsequently, incorporating The Tomb of the Unknown Soldier (World War I), it forgets the prosaic, which includes,

among other things, the fact of the Great Immigration, the underside of Unification. That there are no conspicuous memorials to the Great Immigration in Italy indicates that the choice not to memorialize certain events also determines a nation's collective memory - the collective memory of immigration migrated through steerage to Italian America - and it has fallen to B. Amore to memorialize the Great Immigration and its generational after-effects in both American and Italian terms and in a miniature and intimate way that resists the monumental.

That B. Amore has created a site-specific work of art that does rigorous genealogical-work/memory-work and confronts the tasks of commemoration and filiation/affiliation proper to "little history" - family history - is a sign that she has resisted a number of temptations to which the contemporary artist might easily succumb. After all, we live at a moment when "memory has become a best seller in a consumer society" (Jacques Le Goff, 1992:95)) and within the "context of a voracious and ever-expanding memorial culture" (Andreas Huyssens, 1999:191), of which the Ellis Island Immigration Museum itself might be taken as a symptom. How then is the contemporary artist, operating from within our postmodern comfort zone of irony, nostalgia, and retro-fitting, to create a memorial to the Great Immigration and its after-effects, without lapsing into monumental history or, even worse, a parody of it?

And by parody, I am thinking of that postmodern form of historical imagination that transforms past events into spectacles and attractions intended for memory tourists and thus for immediate consumption. That banalizing imagination might easily make the immigrant experience into one more Disney Land attraction - perhaps to be titled á la David Hockney, "Have a Nice Day, Mr. and Mrs. Immigrant!" - or into a reality TV show called Steerage which involves a six-week-long transatlantic voyage in a replica of the *SS Regina d'Italia.* Here I am, of course, being facetious, but it is necessary to place *Life line* within the cultural and artistic context from which it emerges. Yes, "memory has become a best-seller" and, as a corollary, postmodern art, having lost its traditional relation with time and memory, resorts to the compensatory gesture of spectacular forms of commemoration and, at the formal level, introduces the "shocks of the old" as memory tokens - Philip Johnson's Chippendale skyscraper (the former AT&T headquarters) and the five

orders of columns in Moore's Piazza d'Italia in New Orleans, to resort to ritually invoked examples.

Needless to say, B. Amore works against the grain of our contemporary installment of spectacle culture. Her "spectacles" are miniature and domestic, if not homely, and *Life line* which embodies - not displaces - memory, requires deliberate and patient acts of attention for it presents memory through traces not shocks. Its reception requires an apprenticeship to memory and its signs and traces.

In *Life line* different acts of memory converge and enter into dialogue: personal or individual (psychology) memory, family and generational memory, social memory, and collective or cultural memory. All of these memory registers are mediated by the narrative memory that structures the "visual memoir" into a personal story/history of the De Iorio-D'Amore family and, by extension, into a collective story/history of the Italian American family and of the immigrant or ethnic family in general. The dialogue between public history and personal memory is embedded within the installation in the form of an opposition between the vertical Columns of History (dedicated to the social history of Italian Americans in America) and the horizontal panels and the other elements dedicated to family members.

Furthermore, *Life line* as a site-specific work of art establishes a somewhat contradictory dialogue with the old Ellis Island Immigration Station and the cultural memory of the traumatic Great Immigration that has crystallized around it. But these contradictions are also at work in the new Ellis Island Immigration Museum (opened in 1990), now a memorial to immigration and thus a site of public and collective memory, especially for those descendants of the thirteen million immigrants who passed through the Golden Door and into the American Dream. Given the vitriol of the current debate on the new immigration, the tolerance of its pro-immigrant ideology mark it as monument to the politically correct multiculturalism of the late-twentieth century. The restoration, funded in part by the descendants of the first-comers, has produced a user-friendly, user-activating museum within the memorial space which includes, among other elements, archives of official documents, displays of personal possessions and mementos of all sorts and a memory bank through which

descendants can search out their heritage. Crucial to assembling this archive was the museum's outreach program:

People from all over the country rummaged from attics and closets, looking for mementos that told their own family histories of passage to America, and they were willing to share those with others through the museum, Their contributions and words, incorporated into the exhibit, give individual identities to a subject often discussed in terms of masses, and impart a sense of history as human experience
(Ivan Chermayeff, Fred Wasserman, Mary J. Shapiro, 1991).

Life line is very much in keeping with this project and, in a sense, grows out of it. On the other hand, it is concerned with the ***after-effects*** of immigration and the ethnic or diasporic identities immigration produced and continues to produce in those generationally removed from it. It does not commemorate immigration per se ("commemoration is a soft form of necrophilia," as Baudrillard points out), but rather through cultural and generational memory attempts to link the past event of immigration to the present and the future. At the heart of *Life line* is the search for personal and artistic identity. B. Amore is concerned with the life of memory, with drawing up an inventory of the infinity of traces that the historical process has deposited in her family members and herself.

Here the question of counterhistory/countermemory crops up, for *Life line* counters the Ellis Island stereotype that dominates our cultural memory - the misery of the tired, the poor, the wretched - by presenting the complexities and contradictions of the lived life of her family. By so doing, it constructs an "other" history of the immigrant who, by definition, is condemned to the position of constantly being other. Her counterhistory opposes the monumental or official history of the Great Immigration that seems to be frozen forever in one of the dignified but taciturn documentary photographs by Lewis Hines. *Life line* makes those photographs speak and extends them into a family album. Unlike the contested public memory of the absolutely traumatic Holocaust and the other catastrophes that characterize the twentieth century, the Great Immigration tends to be commemorated by rote and "naturalized" by the happy memory of the assimilated and, in effect, forgotten. Instead, B. Amore is concerned with tracing its

after-effects - the cultural and psychic identities it constructs in succeeding generations - in a way that preserves immigration's original and enigmatic force as a "soul storm" - an event at once traumatic and emancipating.

To narrate the immigration experience from the immigrant's point of view and through the agency of a narrator who is a witnesses and product of that experience is inherently an act of counterhistory/countermemory, in that it recuperates the self lost in translation and compromised by the process of "othering" at work in the dominant culture - immigrants are remainders of the historical process and thus "strangers unto themselves." Indeed, the sense of the self that got melted in the melting pot is what needs to be recuperated. Therefore, a narrative of immigration that endows, in a nonpatronizing way, its subjects with genuine interiority and describes their conflicted sense of identity - their dialogized, as opposed to their hyphenated, identity as Italian Americans - is necessarily a counterhistory, even though it is informed, as in B. Amore's case, by the pietas of family remembrance and not explicitly charged with polemical and critical intentions. If *Life line* has a polemical intention it is the refusal to construct one more monument to the self, colonized by the American Dream: on the contrary, it is a parable of acculturation rather than of assimilation, for the De Iorio-D'Amore family maintains - wills - their doubleness as Italian Americans. The installation ends with the question of whether the current generation will continue to do so, and the installation itself is a charge addressed to future generations to maintain a dialogized self, a charge to Being/Becoming Italian in the American context.

Such an act of narrative memory inserts the individual and familial stories of those who have no history outside the personal or private sphere into the master-narrative of immigration and assimilation/ acculturation. First- and second-generation immigrants are essentially posthumous people who defer their agency to their children and grandchildren. It is precisely these posthumous people who come alive and enter their "lives" through the genealogy and narrative that B. Amore sets out in *Life line*. But these posthumous people also have their own agency - however compromised - that is embedded in the routines of everyday life; they have their own art of living and their own dramaturgies of the self that need to be excavated from everyday-

ness. Indeed, the extraordinariness of her family is to be found in the secret of the ordinary, above all, within the (extra-)ordinariness of familiar objects. She places her "little story" against the Big Story of immigration and the hegemonic history of accession to the American Dream at work in the Big Story. B. Amore's genealogical narrative of identity is a "minor" and "minority" history, even though it, too, tells the generic story of assimilation/acculturation within the common culture.

Furthermore, it is a counterhistory because it recovers the meaning and originality of individual lives and those small events that constitute family history and also because it retrieves forms of "otherness" that tend to resist inscription within monumental history: the gendered otherness of women who are the lifeblood of *Life line* and whose labor, both within and outside the domus, and will to collection - will to art - are its dominant themes; the class otherness of the immigrant - the history of immigration is necessarily written from below and from the perspective of the worker and the umili - but, as we shall see, a class divide runs through the family history; the otherness of objects and of material culture as they bear upon the body, memory, and interiority.

The mention of objects takes us to formal dimension of the installation which transposes artifacts and relics into art, the implications of which will be treated below. But what is important to stress here is that *Life line*, however it may confirm the traditional master narrative of immigration, also brushes against the grain of that narrative by endowing its subjects with interiority and by embedding within its own textuality a search for memory - private and public, personal and collective - that remains provisional, a memory-in-the-making. In this light, *Life line* causes memory and the search for identity through memory.

Life line's construction begins with the physical act of rummaging through the treasury of objects and relics accumulated during seven generations of family life. As B. Amore moves to the formatting or staging of these objects into an installation, she elevates the humble and practical act of rummaging into an art form, ultimately re-assembling and collocating her rummaged objects according to the aesthetics of bricolage, the implications of which will be discussed below. Unlike Baudrillard's "cool memories," hers are still burning, and as a good rummager her passion for collection "borders on the chaos of memories"

(Benjamin, 1969:60). Those inherited objects and documents/ricordi, the treasures and detritus of seven-generations of everyday life, mediate her relation to her family. From the disorder of their accumulation and the randomness of their survival, she wrests a genealogical order and renarrativizes personal history in the name of the "god of small things."

The private family history, as displayed within the public space of the exhibit, has inscribed within it the autobiography and genesis of the artist herself. And this is the key to the installation: the role of the artist-agent that B. Amore formally assumes has been prepared for her by those ancestors who, as "memory artists," have kept the *Libro di Memorie* started by the great-great-grandfather, and who, as artists of everyday life, have exercised their agency in collecting and making objects. Within *Life line* there is a genealogy of four women artists: the great-grand-mother, Giovannina, maker of the exquisite "filet net" bedspread and dowry sheets; the grandmother, Concettina, the seamstress; the mother, Nina, the professional fashion designer; the daughter, B. Amore, the artist. The role of the artist and the disposition to rummaging/collecting have been handed down to B. Amore like the objects themselves. B. Amore is always rummaging, particularly for those objects in the family treasury and those stories in the family's oral history that have the force of anecdotes. Rummaging is the appropriate form of a counterhistory for it selects objects on the basis of their small but incisive power as anecdotes. *Life line* is an invitation to the memory to rummage.

Memory Boxes and the Lacrimae Rerum Contained Therein

Sunt lacrimae rerum et mentem mortalia tangunt.
(There are tears for things and mortal things touch the mind.)

—Virgil, *The Aeneid*

Where will B. Amore's exhibit/installation find its ultimate home? Or is its proper destiny to remain a traveling exhibit, thereby fulfilling the law of the odyssey, one of its major tropes? These questions are posed from the pages of the book - an artist's book, to be precise - that now "houses" *Life line,* after its various post-Ellis Island travels to other

venues. Through its "permanent' installation within the book, it formally take its place in "the museum without walls." But the issues related to its definitive physical realization at Ellis Island - that consummate place of immigrant memory - and in the institutional space of the Ellis Island Immigrant Museum still remain pressing. Does *Life line*, in fact, have a proper place? Does it belong in an ethnographic museum or an art museum? Does its status as an Italian American cultural text slate it for placement in a museum dedicated to the Italian American experience or, as a universal text of immigration/ethnicity, is it not better placed in a multicultural context? Does its perpetual oscillation between exhibition and installation, between collection/repository and work of *bricolage* destine it for the imaginary museum dedicated to heterotopias and dangerous hybrids?

If it were at all feasible, *Life line* should have remained permanently installed within its Ellis Island space, for there it had a maximum resonance both as an exhibition and a site-specific work of art. There it maintained a complex and contradictory dialogue with the Island of Hope, Island of Tears, the site of immigrant arrival and departure. There, in the most palimpsestic building in America, a place haunted by the ghosts of innumerable foreign bodies that now jostle for room with those memory tourists who seek to invoke them to gain access to their heritage, it had the effect of a rite of passage. There its six-room itinerary mirrored and focalized the more comprehensive pilgrimage route that today's visitors to the Ellis Island Immigration Museum are intended to make as they follow in the immigrants' footsteps. There its iconography, derived in part from Ellis Island elements - the red piping frames of the Ancestor Scrolls that alluded to the dormitory bunks, the Golden Door, the Columns of History inspired by immigrants' graffiti, on the walls, and so on - had its maximum force. There its idiosyncratically and aesthetically (dis)ordered *bricolage* of personal possessions, mementos, and photographs conversed with the systematically ordered collection of similar objects catalogued into the permanent exhibits and archives.

On the other hand, *Life line* is a work of art and not an historical or ethnographic exhibit, although it diverts and plays off these forms of archival display as well as its exhibitionary space. The installation in its function as a museum exhibit is not primarily concerned with the documentary force of objects, images, photographs and other "specimens." Its collocations of objects and relics are governed by a personal and artistic taxonomy that is intended to evoke and memorialize the immigrant imaginary. Nor is it concerned with locking these familial and domestic objects into a strict diachronic sequence that, in museological fashion, "endows each item with an evolutionary direction and weight" (Preziosi, 2003:408). As Preziosi goes on to point out, "Passage through museological space is commonly formatted as a simulation of travel through historical time." Although *Life line* plays with this convention, its formatting and sequencing is artistic and dramaturgical - not museological - and belongs to the order of the "visual memoir" and the mise-en-scène. Its focus is on individual characters and their dramaturgies of self-identity; the way they collected or made objects to create a sense of the self. B. Amore's collocations of objects and images are family portraits in the form of personal material maps: spatial biographies in the form of "autotopographies," to use a formulation by J. Gonzalez. Therefore, the passage-work imposed by *Life line* is at once temporal and spatial.

Life line transformed the former processing rooms and dormitories of the Ellis Island station into a "memory-box" - a kind of interactive and eccentric time-capsule of the present-past - and thus extended the strategies of enshrinement and memory bricolage at work in the little "memory boxes" (the family triptychs) to the entire exhibit space. In effect, B. Amore installs the immigrant or foreigner problem within the exhibition space. I say problem because *Life line* displays the fault lines and discontents, along with the contents of immigrant identity and the diasporic self it generates. By installing the problem of immigration and the cultural politics of the immigrant identity in this way, it "solicited" - in the etymological sense of "shaking up" - the edifice of the Ellis Island main building, whose architectural symbolism - welcoming façade/factory of immigration on the inside - was always fraught with contradictions. As the *AIA Guide to New York City* points out, "…this extravagant eclectic reception structure was created to greet (or is it process?) the hordes of European immigrants arriving at the turn of the century…." In other words, that official and bureaucratic space was designed to process or detain or reject and thus to reify those foreign bodies seeking entry into the Land of Opportunity,

The soliciting is effected by the appropriation and territorialization of

the panoptic space of the old Ellis Island in the name of the immigrant. Although *Life line* was intended to be read non-ironically as a commemoration of the Ellis Island experience - Isola di Lagrime, first and most traumatic stop in the Stations of the Cross of immigration - it also performed in effect a *détournement* (diversion/subversion), as the Situationists would say, on the pre-existing bureaucratic space that, despite the renovation, still haunts the building, by installing within that space an artistic and cultural text the endows the immigrant with the very interiority and agency that in the past were formally checked at the door.

In the Collection Zone: Passage-Work/Story-Work

*In a fine passage, Eugénie Lemoine-Luccioni writes of the
"intimate bond between a woman and her things."
Without things women are lost. Their things inhabit an interior…*

—Massimo Cacciari, *Posthumous People*

Cued by the red thread, the spectator/passenger follows the story as it unfolds through the sequence of six rooms: Room of Dreams, The First Generation, Becoming American, *La Famiglia* and Work, Return to the Roots, Today and Tomorrow. As Roland Barthes writes, "To understand a narrative, however, is not merely to follow the unfolding of the story, it is also to recognize its construction in 'storeys,' to project the horizontal concatenations of the narrative 'thread' onto an implicitly vertical axis…" (Barthes, 1977:87) In *Life line*'s visual narrative, the horizontal level is materialized in the lateral band of panels dedicated to individual family members and the ancestral scrolls. Although the Columns of History also belong to the horizontal level, their verticality makes them function as frames by which a spectator passes from the family story to the level or "storey" of social history. The family story is intricate, involving thirty-five or so characters, with certain main characters functioning as hinge-points. What get passed onto the vertical level are the character traits of the individual family members as gleaned from their photographs and objects and the written anecdotes dedicated to them.

Here, I have just begun to explain the "reading" or story-work the spectator is made to do. Equally important is the passage-work - the enactment of the narrative through the body and the performance of its spatial story. That spatial story has two overlapping itineraries or scripts that play off the Ellis Island site. The first involves a literalization of the metaphor of Ellis Island as the Cathedral of Immigration. The installation is structured in liturgical terms by which the ordinary lives of the family members are sacralized and enshrined. Traditional devotional forms and architectural elements of the Catholic church contest the museological or secular space: triptychs (side altars), reliquaries, icons of family "saints" (ancestor scrolls), the mirror (the mirror of salvation), the lateral panels suggestive of stations of the cross or even fresco panels, the vertical columns, analogous to the mirror of history, and the main altarpiece that concludes the installation. What results is a multi-media immigrant version of the *Biblia Pauperum,* with events in Italy as the Old Testament and the events in America as the New Testament. The effect of this family liturgy is to sacralize ordinary lives and ordinary objects and to impart to them an auratic resonance. However approximate the above correspondences may be, the liturgical formatting requires the acting out of the narrative in terms of body language and frames remembrance as a fundamental religious activity.

The second spatial story plays off the associations of Ellis Island as Palace/Palazzo of Memory that "houses" the collective memory of the Great Immigration. It involves the conversion of public and bureaucratic rooms into spaces of habitation and dwelling or, to be exact, into a collection zone. And by collection zone I mean a feminized space within the house, an interior within the interior where objects are made to dwell. Such a secret and intimate zone induces a reverie. However the sequencing of the installation through the six-rooms may simulate a passage through historical time, it also demarcates personal and domestic memory that is anchored to the interiority of the rooms. In other words, the original bureaucratic and carceral function of the dormitories and their current public function as galleries for traveling exhibitions are transformed by stagecraft into scenes and settings of the *domus*. In Italian terms, the Palazzo is transposed into a Casa; the museological exhibit is transformed into a collection zone, a space where anecdotal objects tell their stories, particularly, stories in which women express their intimate bond with things.

Therefore, *Life line* conflates the two primary spaces of Italian American habitation, the domus and the church, a mixing that often occurred within the Italian American house itself with the introduction of icons and makeshift altars, B. Amore domesticated and feminized the void of those six white rooms and the mini-voids of the closets by filling them with domestic and familiar objects of all sorts - above, all objects connected with women's being-in-the-world. Just as the entire exhibition space was rendered into a memory box, each of the rooms was rendered into a memory box. And what is a house if not a memory box? And what better way to re-territorialize Ellis Island - the Isola di Lacrime, the clearinghouse for declared memories and official dreams - than to enact a homecoming there, to install a space of memory that re-members the domus and the church, the two primary spaces in the Italian American imaginary?

Immigration Makes Good Bricoleurs: Bricolage as Life-Work/ Bricolage as Art-Work

Give us this day our daily leftovers and odds and ends
and the necessity to make a virtue of

—Bricolage Blues

According to Walter Benjamin, exile makes good dialecticians. Immigration - exile pursued by other means - makes good bricoleurs. Immigrants and foreigners construct their everyday lives and cultural identities by using whatever materials happen to be available. For them *bricolage* is a pragmatic technique of survival, a tactic for making do, for making the most out of the least, a disposition exercised in the acquisition and deployment of those objects - collected, passed on, rummaged, recycled, lost and found - with which they cobble together their existences and fit out their residencies on earth. Here I am speaking of old-style immigrants, like those represented in *Life line,* who defined themselves in terms of hand-to-mouth tactics - what Italians call the *arte dell'arrangiarsi.* Such immigrants are *bricoleurs* out of the necessity and by default.

Give us this day our daily hard labor that no one else will do
and the bread and wine of backbreaking work

Old-style immigrants are customarily defined in terms of work and the value they confer upon work. They are perhaps better described as *bricoleurs*, for even their labor - odd jobs, piecework, day or seasonal labor, with the lay-off integral to the job - is also cobbled together. Even the typical jobs slated for the old immigrants - rag picker, junkman, metal scavenger, and shoemaker - have the air of the *bricoleur* and the rummager.

It is, of course, Lévi-Strauss who, in *The Savage Mind,* dignifies the operations of the *bricoleur* - the professional do-it-yourself-man or handyman or tinkerer, to suggest rough English equivalents of the French term. He validates the kind of cobbled-together and improvised (re-)constructions or productions that the *bricoleur* creates by making do with whatever is at hand, that is, with a set of ready-made materials, tools, and techniques, and by using "devious means compared to those of the craftsman." Lévi-Strauss elevated the operations of the *bricoleur* by situating them against those of the engineer and by seeing mythical thought as a form of "intellectual *bricolage*" that is, in its way, just as rigorous as scientific thought although it operates in a completely different manner. For the moment, I want to pragmatize the notion of bricolage by seeing it as the ordinary practice or disposition that characterizes the immigrant's way of being and operating in the world and as a means of constructing an identity or world view.

Give us this day our daily fragments and bits and pieces
and the job of living through which they are assembled
into a conception of the world

The destiny of the immigrant is to construct or improvise a cultural identity in terms of whatever is at hand: the bits and pieces of the original culture that survive the passage to the new motherland, whether in the concrete form of discrete objects or in the social or symbolic form of practices, language, memories, myths, stories; the leftovers - usually class-defined - and second-hand goods, practices, dispositions of the new culture that are deposited and remaindered within the great immigrant thrift shop, the lost and found into which discarded

elements of the dominant culture find their way. Immigrant *bricolage* is to be distinguished from the current form of *bricolage* practiced by subcultures such as the punk movement that appropriate objects from the dominant culture and re-deploy them in subversive ways to create new cultural identities, e.g., the safety pin that punk culture deploys for decorative purpose. Immigrant *bricolage* is a survival technique - a survival "aesthetics" - and, it informs the immigrant's conception of the world which is borrowed from the worldviews generated by the ruling class. The immigrant conception of the world is a cobbling together, in the name of common sense, of the vestiges of those previous world-views generated by dominant groups that write their own history. Strategies belong to the ruling class; immigrants, instead, operate through tactics - hence, the importance of bricolage, the tactic of tactics.

Give us this day our daily bricolage

It is, therefore, highly significant that B. Amore, who works primarily as a sculptor and thus as an engineer, in Lévi-Strauss's sense, should operate as a *bricoleur* in *Life line*, thereby elevating the immigrant life-practice of *bricolage* into an art-practice. Although *Life line* is also an engineered construction (i.e., its structuring as a visual narrative, its sequencing), it its assembled by *bricolage* and governed by the tactical and improvised aesthetics of *bricolage*. Its basic materials are the leftovers and relics of family life that present themselves to the artist as ready-mades to be assembled and cobbled together and through which the artist maintains a dialogue with the available materials. But the same principle of *bricolage* also governs the set of available techniques - collage, montage and photomontage, assemblage, appropriation, and so on - that come to that artist as leftovers from modernism or through their postmodernist appropriation and recycling.

Lévi-Strauss has provided the following list of bricolage art-works:

Like "bricolage" on the technical plane, mythical reflection can reach brilliant unforeseen results on the intellectual plane. Conversely, attention has often been drawn to the mytho-poetical nature of "bricolage" on the plane of so-called "raw" or "naïve" art.

In architectural follies like the villa of Cheval the postman or the stage sets of George Méliès, or, again, in the case immortalized by Dickens

in Great Expectations but no doubt originally inspired by observation of Mr. Wemmick's suburban "castle" with its miniature drawbridge, its cannon firing at nine o'clock, its bed of salad and cucumbers, thanks to which its occupants could withstand a siege if necessary…

—Claude Lévi-Strauss, *The Savage Mind*[17]

Life line belongs to this list, although it is not a work of "raw" or "naïve" art and, on the other hand, lacks the whimsy and bric-a-brac effect of some of the examples. What is important is that B. Amore begins with the heterogeneous but limited repertory of objects and techniques at her disposal and then arranges or fits them together by an act of *bricolage* by which they take on a new life and a new meaning: the objects - the remains and debris of events - that signified lived life are transformed into signifiers of art and thus their ordering and re-ordering become a search for finding a meaning in them. As Lévi-Strauss affirms, the *bricoleur* "'speaks' not only with things, but also through the medium of things, giving an account of [her] personality and life by the choices [she] makes between the limited possibilities…[she] always puts something of [herself] into it" (Lévi-Strauss, 1966:21). Those "limited possibilities," anathema to Sartre and his notion of freedom, are precisely the constraints of those who define themselves through the family and the art of the family.

The Cabinet of Dr. Amore: The Resonance and Splendor of Ordinary Objects or, Concettina's Dowry/the Dowry of the Artist

The house was filled with Concettina's collections. Some objects had been brought from Italy, other she had created or acquired in America. Concettina saved everything from the most elegant handmade silk-and-lace collar to the most mundane bottles of her favorite rose toilet water. There are still labels and lists, written in both English and Italian, which are attached to her bundles and possessions. Sometimes the notes are merely descriptive; sometimes they name the owner of the object or its history and importance to her.

—B. Amore

Life line is full of cabinets - whether freestanding or built in (the **four-closet** installation), glass-enclosed or boxed (the triptychs). Whereas the triptychs or memory boxes epitomize family history in miniature form and serve as mirror structures for and relays within the six-room installation, the reliquaries have the appearance of curio cabinets that evoke the interiority of the house or at least a contamination between the interiors of domus and church.

Of the three most striking reliquaries, "The Reliquary to a Broken Heart," "Gold Reliquary," and "The Reliquary to the Two Anthonys", the first two, both dedicated to Concettina, are in effect curio cabinets. Like the intimate objects displayed in curio cabinets, Concettina's familiar objects, although curious and unusual by dint of their ordinariness, summon up reveries of intimacy that are inflected by the play between transparency and secrecy intrinsic to the curio cabinet. The most rich and strange object in these reliquaries and perhaps the exhibit itself is Concettina's silk collar with tassels, a pièce de résistance that she made by hand. (The most precious heirlooms could not be displayed for security reasons.) Around the silk collar crystallizes the reverie of fabric and fabrication that is constantly activated by the scenes of sewing and bundles of material that celebrate the work/art of women. These two reliquaries are pivots in the feminized space, the collection zone, that runs through the installation and culminates in Nonna's table, the concluding "piece" in the installation. They are key instances of what might be called the scene *madri* ("mother scenes," the Italian equivalent of what is called in English the "big scene") that dominate the installation.

They declare the importance of Concetta De Iorio-Piscopo, who is the gentle ghost in the Cabinet of Dr. Amore. She is the first and most passionate of the collectors in the line that leads through Nina to B. Amore. This genealogy of collectors, by collecting, creating, and passing on objects, assume the feminine function of the conservation of remembrance. Although Concetta is a wild collector, her objects are not chosen or assembled according to a law of eccentricity or fetishistic desire like those governing the assemblages of the old *Wunderkammerer.* Her model - utilitarian and domestic - is that of the *corredo* and her collection, which begins with the passed on objects in her mother's dowry, is that of a donna seria. The objects in her own dowry - the nightgown with initials is the most telling - are at the heart of her collection. They are the seeds that generate the more inclusive collection which comprises her own work as family seamstress and professional dressmaker - her exquisite wedding gown made to be passed down to Nina in typical Italian fashion - and the vast array of objects and documents pertinent to her personal life, her schooling and, above all, her failed marriage. There is very little bric-a-brac or chachka in the collection. The one kitsch object I recall is a celluloid kewpie doll. Concettina's connoisseurship is that of the *bricoleur.* It is Concettina's "dowry" as it is comes to be expanded by Nina and the other family members, that ultimately is passed on to B. Amore, for whom it becomes an artist's dowry. As it were, everything existed in order to find its way into *Life line.*

Life line narrates the Italian American family romance, confirming its fundamental law: Italian happiness is family happiness. On the other hand, it gives particular weight to the genealogy of strong women and to the *scene madri* that stage their identities and represent their interior lives through the objects they made and collected and, in turn, were made and "collected by." The role of the men, who define themselves primarily by physical labor, is also integral, but in two instances proves problematic. The representations of B. Amore's grandfathers - Ernesto Piscopo and Antonio D'Amore - expose the fault lines in the family history. That the *scene padri* are not as elaborated or realized as the *scene madri* is a sign of the silence or distance of the fathers whose lives are sacrificed to work. Through them, the Oedipal elements in the family romance are hinted at.

Life line begins with the good patriarch and gentleman, Don Lorenzo De Iorio (the great- great-grandfather in the maternal line of the family) who remained in Italy and witnessed the Risorgimento that would, paradoxically, generate the great exodus from the Mezzogiorno. Don Lorenzo kept the *Libro di Memorie,* and not without wit as demonstrated by his epitaph in the form of a quip that concludes: "And other notices perhaps for laughing - Goodbye." He is the first keeper of family remembrance; his role will be passed onto to the women and ultimately fulfilled in *Life line.* His son Luigi (B. Amore's great-grandfather) is the one who goes to America with his bride. He is a good but enigmatic character around whom a number of mysteries coalesce, including the enigmatic reason for leaving Italy. But that is the way it is with immigration history.

The "Reliquary to the Two Anthonys" is sculptural and its beveled exhibition case bears no suggestion of the curio cabinet. It looms there in its raw materiality and its Giacomettian strangeness: the laborer's pickaxe bears down on the vertical slab of the winemaking barrel that suggests the body of the laborer oppressed by the mental and physical burden of work. It is a proletarian fetish to hard labor, Where is the face or spirit? Have the face and the spirit been driven into the body? Its silence provokes no anecdotes. The anecdotes are provided by B. Amore's gloss that describes Antonio D'Amore, a stonemason and bricklayer by trade, as seeming to be a "very mean man" who imposed a reign of terror on the family with his disciplinarian's cane. His image in the Ancestor Scroll shows a left arm striking or flaying out. Is the arm wielding the pickaxe or the cane? B. Amore recounts a scene in which he rebuffs her attempt as a four-year old to help him build a granite wall. It is no accident that she traces her sculptor's art to him. But perhaps he was a "Christ in concrete," immured by grinding labor and the responsibility for one of those excessively large immigrant families - thirteen children overall, minus the usual casualties. Nonetheless, the taciturn Nonno Antonio, who filled his teeth with concrete, told his children that God was in every religion. And here we find one more anecdote, one that attests to the multiplicity of selves constituting human identity.

Whereas Antonio is the silence within *Life line*, Ernesto, the husband of Concettina, is the obstruction in the narrative. He is a bounder and gambler, the ladies-man who breaks Concettina's heart, the *cafone* who does not observe the laws of *serietá* governing family life. He threatens to break the *lifeline* and its forward movement. Where is one to place him in the genealogy he defies? In the immigrant family, there are those who pay the price for the assimilation and normalcy of the rest of the family with their own self-damaging. The young boy who dies an early death is a straightforward example of this. Ernesto is a more complex example of such a figure. Who knows what truancies and dalliances he committed in his nickname of Bill? His wildness violates the immigrant ideal of the *uomo di pazienza,* which all the other men in the family embody. Concettina's knows best how to place him: "It is my express intention that my husband, Ernesto W. Piscopo, be excluded from sharing any part of my estate."

Traces: Concetta as Detective and the Viewer's Remembering of the Immigrant Body through Indexical Signs

To dwell means to leave traces.

—Walter Benjamin, *The Arcades Project*

Concettina's objects are never collected solely for their display value or for their fetishistic value as commodities. Her objects are collected or created according to their immediate use value and their potential secondary use value as hand-me-downs or their retrospective use value as memory objects. She is the absolute inversion of the two most notorious twentieth-century collectors of conspicuous objects: Gabriele D'Annunzio and the fictional Citizen Kane. Nor is her collection informed by the patriotic fervor and widow-like taste of her Italian generational counterparts, famous, in the Italy of the 1920s and 1930s, for their collections of military gear and other memorabilia from World War I that preserved, in the name of a nationalistic collective memory, the memory of the war-sacrificed lives of their husbands and other family members. It is Concettina's utilitarian poetics of the object that B. Amore transposes and expands into the aesthetics of *bricolage* that governs *Life line.*

Of all the objects in Concettina's collection, the one with the most pathos is the torn love letter that Ernesto addressed to one of his flames (displayed in "The Reliquary to a Broken Heart"). Ernesto, an indiscreet collector who left the signs of his dalliances all over the place, turned Concettina from collector into detective. To determine whether her initial penchant for collection hardens into the will to collect as a compensation for the self-eliminated husband, her lost object of desire, would require a psychoanalysis. What is so remarkable about this purloined letter is its tearing. Who knows how many teardrops and curses are imprinted upon it? Its tears are the handiwork of Concettina - her "other" handiwork. It is the indexical object par excellence, a sign that links us directly to the body that handled it and tore it to pieces. Her tears and her tears (lacrime) thus makes it just as much a signifier of Concettina as of Ernesto who wrote it.

However the individual constructions in *Life line* may privilege the iconic value of the objects displayed and assembled, their indexical value as material traces of the body is crucial to understanding their force upon our imagination. Unlike the Ancestor Scrolls which are primarily iconic representations of the family members, with their red legends serving as meters of lives fully or partially lived (only the photographed faces are indexical as well as iconic), most of the material objects bear an indexical or physical relation to the bodies of the individuals who used or created them. Therefore, the most compelling objects in the installation - the torn love letter, the pickaxe, the brass ravioli cutter, Antonio's red-orange lantern, the handwritten documents and lists and signatures, included the initials woven into the sheets and into Concettina's nightgown, together with the photographs which bear both an iconic and indexical relationship to the subject - are defined by their indexicality. Although these objects give themselves up to vision, they are objects that to be fully experienced cry out to be touched and handled. It is their indexicality, as it is transmitted to the spectator through seeing and the tactile imagination, that enables the viewer to re-member the bodies of the ancestors, thereby inhabiting and, in a way, resurrecting those bodies.

The Italian American Cargo Cult: Life line as an Italian American Text

At the discussion of *Life line* at the Istituto Italiano di Cultura (December 3, 2001), I lamented the fact that it was installed after the publication of *The Italian American Heritage: A Companion to Literature and Arts,* a collection of essays, written mostly in the voice and from the perspective of the third-generation. That volume shared the same historical project that B. Amore materializes in *Life line*: to elaborate a micronarrative of the Italian American cultural experience and to situate it within the master narrative - *la storia* - of Americanization; to define the Italian American identity by inventorying the traces that the historical process has deposited in it. In *Life line* that inventorying of traces takes the material form of a "concrete memoir" that preserves the traces and shadows of the objects through which *la famiglia* constructed and maintained its identity. Many of those objects were either Italian-made or made-in-America through Italian techniques and thus reminders/remainders of Italy, a medium through which to maintain a dialogue with *la terra promessa* as

it receded and to dialogize the self in Italian and American terms. Therefore, *Life line* stands as a quintessential Italian American text, one that not only establishes an archaeology and genealogy of Italian American self-identity but also embodies the project of forging that identity: the dialectic between Being Italian and Becoming Italian.

Its insistence on objects testifies to what might be called the Italian American "cargo cult," an inversion of the Melanesian into the present-past, through which the immigrants brought with them - or better "translated," as in the sense applied to saint's relics - the cultural text of their homeland. That text was not necessarily that of the official or elite culture but the lived culture embedded within the everyday practices of *la famiglia* and the objects, the equipment for living, through which they dwelled in the *domus.* Whatever fetishistic value those objects may have in the ancestor worship or whatever use value they may have as instruments of everyday life, it is their cultural value that dominates: they are markers and indexes of Italian-ness, of identities made in Italy or by Italy in the diaspora. These cultural objects attest to the attachment to the concrete and the material - the attachment to the referent - that has always characterized all levels - elite and popular - of Italian culture. The brass ravioli cutter and *la napoletana* (the traditional flip-flop coffee pot or *macchinetta* devised by the Neapolitans) are typical examples of the cultural objects of the "cargo cult," ordinary objects through which cultural memory is reenacted through routine scenarios.

But what I regretted even more was that I experienced *Life line* after I had written the chapter in *The Italian Heritage* dedicated to the Italian American artistic tradition. That chapter, "From Stella to Stella: Italian American Visual Culture and its Contribution to the Arts in America," would have found its perfect conclusion in *Life line* which, in its way, is a culminating work in the twentieth-century history of Italian-American art as it extends from Joseph Stella through Frank Stella to the postmodernism of Robert Venturi and Vito Acconci and others. Furthermore, it is a definitive work in the canon of Italian-American women's art, an overlooked area just beginning to be mapped-out.

Life line responds to and refocuses many of the issues related to Italian American visual culture that I had been grappling with, above all, the tension between ethnic and cosmopolitan art that characterizes the

situation of the contemporary or postmodern artist who attempts to do ethnic art - by definition, an art of difference - in this period of post-ethnicity without lapsing into nostalgia or the ironically-assumed positions of naïve or primitive or folkloric art. The conditions of production of art in the twentieth century changed the status of ethnic art: transnational movements displaced national traditions and abstract art rendered problematic the very notion of ethnic art, which is linked to the figural. Given that the late twentieth century became more conceptual, more art about art, can we still speak of a visual art that directly registers the ethnic experience, that is bound to the American social text and therefore to the "referent" - that is, to exteriority and materiality? If the postmodern, as Mario Perniola maintains (*Artforum* [Summer, 1991]), is "an ethnocentricity that eliminates multiplicity and the difference of cultures by throwing all artifacts into a melting pot that erases their old boundaries and definitions" can we still speak of an "art of difference" or must we adopt categorically the universalizing formula of postethnic, postnational art?

Let me immediately indicate that *Life line* is clearly a work of "strong ethnicity" as opposed to the "weak ethnicity" characteristic of the post-modern condition. It confronts the Italian American experience directly and builds into the work a search for cultural and artistic identity But, equally important, it uses the techniques and procedures of postmodern and contemporary art - what might be called "weak art" - to do "strong things." It deploys the various techniques of contemporary art: the site-specific installation, the collage and photomontage, narrative art, abstract sculpture - albeit anthropomorphized as in the "pick-axe man" and the *Odyssey* figures - and, above all, bricolage, perhaps the defining technique of contemporary art. But B. Amore subordinates them to an overriding narrative function without bracketing them in ironic ways. The trove of familial objects presents her with "ready-mades," but they are installed and thus "assisted" without any Duchampian charge to de-define art or to deny the possibility of defining art. There is no attempt to use a painting by DaVinci for an ironing board or to hang Botticelli's from the family clothesline. Her project is to sacralize humble and negligible objects by submitting them to an elaborate process of construction and re-articulation by which they are endowed with an aura, the very aura that once belonged to the traditional work of art and, according to

Benjamin's epochal diagnosis, was destroyed by mechanical reproduction and replaced by the display-value of the work.

Life line also serves as a rear-view mirror for the Italian American visual tradition. Many of the fundamental motifs and procedures of that tradition appear in the installation: for example, the recourse to Catholic devotional and liturgical forms recall the polyptych altar-pieces employed by Joseph Stella in "New York Interpreted" (1920–1922) and the family portrait in the form of an altarpiece in Ralph Fasanella's "Family Supper" (1972); the deployment of *bricolage* as governing technique is reminiscent of Simon Rodia's Watts Tower in Los Angeles. Indeed, B. Amore has provided the interior of that "Jazz Cathedral," as Don DeLillo felicitously describes it.

Here we can posit a definition of the Italian American artist that applies to B. Amore as well as the previously cited artists: (1) dialogism with the Italian tradition; (2) direct registration of immigrant or ethnic experience either thematically or formally, the deployment of Catholic iconography - however secularized - being essential to Italian American visual culture; (3) the hybridization of artistic identity, which may or may not involve an explicit politics of Italian American identity. It should also be pointed out that B. Amore is anything but a naïve or primitive artist in the manner of Fasanella or Rodia, Her position is hybrid, reminiscent of the positions occupied by Joseph Stella and the sculptor Beniamino Bufano, both of whom constantly moved between America and Italy and maintained a dialogue with the Italian as well as American artistic tradition.

That B. Amore used black Italian marble for the Odyssey sculptures is an archetypal gesture of the Italian American artist as defined above. Those enigmatic figures which carry bundles of cloth on their heads have embedded in their materiality a dialogue with Italy and, on the other hand, they allude to the documentary photographs by Hine of immigrant women in New York as caryatids carrying boxes and bundles of clothing to be finished. The five sculptures are totems of the Italian American cargo cult and allegories of the artist and her task of bringing the weight of her bundles of memory to bear upon the present.

The Rosary of Memories and a Desire Line

Although *Life line* is an Italian-American text to the core, it is also a text of universal ethnicity, addressed to all of those Americans who derive their identities from the event of immigration and, more generally, to those "strangers unto themselves" who inhabit the diasporic condition. This was constantly reconfirmed by the responses written by the multi-ethnic visitors in the reception book, "This family is just like mine."

Nonetheless, *Life line*, like all ethnic texts, is double-voiced, addressed specifically to the Italian American insider who will find in the De Iorio-D'Amore family history a specific mirror of their own. In processing it, the Italian American spectator becomes a member of the artist's family by a symbolic act of *comparaggio* and engages in memory-work that reinforces but also troubles the collective memory of *la famiglia* and the Italian American experience in America.

For the Italian American spectator, *Life line* will serve as a rosary of memories that confirms a familiar story. But to experience it by rote and to play out a consoling game of recognitions is to forget the differences and the counterhistory lodged within it. It attempts to counter the collective memory that Italian America has of the Ellis Island experience or, at least, that part of the public memory that has been conditioned and mainstreamed by the history of stereotyping and self-stereotyping through which Italian-ness and Italian American-ness have been represented within the dominant culture. All those stereotypes lead to and from Ellis Island.

One thinks immediately of the Ellis Island episode in Coppola's *Godfather Part Two*, in which the man-child Vito Andolini, escaping from Mafia persecution in Sicily, voyages to America by himself and undergoes a traumatic processing at the Ellis Island station. Indeed, Vito's Corleone childhood rite of passage into American is doubly traumatic: it is marked by a name change by which an Ellis Island official substitutes the name of his birthplace (Corleone) for his surname (Andolini); it is also marked by the panoptic medical inspection - the medical inspection (the eye-check is a topos in the documentary photography dedicated to Ellis Island), the detection of smallpox, the marking by chalk as unfit--that culminates in his quarantining in the dormitories. That episode has come to dominate both the mass-mediated memory of immigration and the Italian American cultural memory of it. Coppola's *The Godfather* is always problematic because it sets out a master narrative of the Italian American experience within the context of a gangster or Mafia movie and in terms of the "wrong family" - the aberrant crime family rather than the normative good family. Nonetheless, the Ellis Island episode provides a powerful and moving representation of the immigrant passage because it disturbs the stereotypical images of it, many of which derive from the tradition of Ellis Island documentary photography. Coppola shoots the arrival by ship and the passage through the processing rooms through a laterally moving camera that imparts an urgent sense of movement and destiny to the immigrants' passage. Furthermore, the camera plays a game of hide-and-seek with the Statue of Liberty, which is momentarily glimpsed at two points. In its first sighting, we see, in a series of tracking shots, the crowd of immigrants, including Vito, looking at the statue from ship's deck, and, finally, through a cut from their point of view, we see the statue itself that, however, is glimpsed fleetingly and through the interference of a mast rigging. The second sighting is from the dormitory in which Vito is quarantined. Again we see Vito looking at the statue and not the statue itself; its image is reflected in the window through which Vito's gazes, clearly an indication of the distance and inaccessibility of the American Dream. The formalism of the episode is reminiscent of Steiglitz's "Steerage," the most artistically significant photograph in the documentary tradition. With Coppola, as with Steiglitz, we approach Kafka's *Amerika*.

Anterior to Coppola's episode in which the distinction between stereotype and archetype is made to collapse, there is an equally disturbing image that has etched itself in the Italian American collective memory: the famous photograph by Lewis Hine of the Italian family on the deck of a ferry looking at Manhattan from Ellis Island (1905). There is no better emblem of the misery of the tired, the poor, the wretched than this photograph by Hine, a socially consciousness photographer who moved the documentary tradition established by Jacob Riis into a new direction. He attempted to endow his immigrant subjects with dignity and character rather than photographing them as perfect victims and tenement souls as did Riis. Nonetheless, the

photograph of the Italian immigrant family is highly problematic for it, too, involves the collision between archetype and stereotype - a stereotype is an exhausted archetype, a deadened archetype. As archetype, it presents the strong immigrant family with chiseled features and determined bodies contemplating with wonder the brave new world presented by the Manhattan skyline. As stereotype, it presents foreign and class-marked (*contadino*) bodies: the mustachioed father bearing all the family possessions in a bag awkwardly affixed to his shoulder; the mother, dressed *contadina*-style, holding a girl baby in ill-fitting clothes; a little boy dressed in a sailor's outfit gazing sideways. The awestruck family seems to have been turned into stone by the Medusa of the skyline - and perhaps by the *punctum* of the photograph. In other words, the stereotype of the *morto di fame* stunned and speechless before the opening up of a new destiny

Photographs may speak volumes, but this particular photograph speaks volumes of silence. It is precisely these volumes of silence that B. Amore's *Life line* fills in with her objects, images, and written texts. It is precisely that typical Italian family that she rescues from its moment of mortification on the ferry and petrifaction within a photograph, drawing it forward into the future with the story of her family. B. Amore's herstory is marked with all sorts of difference, including its stress on the role of strong women/strong mothers who embody the ideal of *serietá*. As the bilingual title, *Life line—filo della vita* declares, it narrates a history of language identity and, at its core, it celebrates literacy and the educational process as testified to by the omnipresence of books, including those supporting the monument to the "Two Anthonys": Anthony, [Antonio], who dug the foundations of buildings at Harvard University, and his son Tony, who became the working scholar of the family. Tony, whose commitment to study is also commemorated in the writing installation dedicated to him, was graduated from Boston College and went on to work at the Library of Congress. But in order to maintain the family, he was obliged to establish, together with his brothers, the family business - Atlas Cleaners, Tony's erudite allusion to Greek mythology but also a description of his own role as atlas of the family and bearer of its law of the *"via vecchia."* Therefore, "The Reliquary of the Two Anthonys" stands as a requiem for a dream at once fulfilled (the dream of a college education) and unfulfilled (the

dream of a life dedicated to scholarly pursuits). Furthermore, *Life line* sets out a class history of marriages that reminds us of the diverse backgrounds from which immigrants emerged. It narrates a story of acculturation as opposed to assimilation, as previously mentioned.

Life line engages the Italian American spectator in intricate forms of memory-work and history-work. As such it is a corrective to the notorious cultural amnesia of those Italian Americans who have been colonized by assimilation: it stages the return of the repressed immigrant experience and is an instruction kit for remaining bi-cultural and for maintaining a dialogue with the idea of Italy. Similarly, it is a corrective to the filiopietism that erects mental and actual monuments to Italian-ness as a way of obliterating the wound of stigmatic ethnicity. Here one need only recall the monument erected to and, in part, by the Italian American community to celebrate its contribution to New Orleans: Charles Moore's Piazza d'Italia. Despite the best of architectural and cultural intentions, it celebrates the cult of Italy through the return of clichés and the play of simulacra: the map of Italy, the five orders of architecture, plus a sixth - the "Deli" order - in other words, the Italian piazza in commodity drag. There is probably more memory-work involved in the eating of a *mulfetta* than in the experiencing of this architectural pastiche. It is no wonder that the monument has being incorporated into a Loews Hotel, the New Orleans equivalent of the Venetian in Las Vegas. Such filiopietism and, its downside, victimology - call it the *Isola di Lacrime* syndrome - inform many of the histories of the Ellis Island experience written by Italian Americans. These histories rehearse the via dolorosa that leads to and from Ellis Island, erecting sentimental monuments either to the "happy immigrant" who passages to liberty - is there any such thing as the happy immigrant? - or to the "permanent stranger," the latter monument taking the form of a *sacra conversazione* in which the Madonna, together with the Angel of History, sheds crocodile tears for the trauma of immigration and the stigmatizing history of "Dagotude" that it announces. It is precisely this banalizing form of monumentalism that *Life line* counters with its pietas.

From my own perspective, I found within the installation a rosary of memories that rendered B. Amore's world familiar to me, But within that rosary, I found a number of talismanic objects that triggered the

rush of Proustian (involuntary) memory. Furthermore, even though I was lead by the red thread and deeply engaged in the story-work, I found myself creating my own desire line, my own personal pathway through the installation. This involved an absolute obsession with Concettina who was at once the most visible and invisible character in the piece. Her rosary of objects allowed me to enter her interior life without betraying its secrets. My way of following the genealogical line was somewhat contrary for I found myself siding with various members of the family and identifying with the maternal line of the family because its class-defined marriages give it complexity.

Here is my rosary of Proustian objects: the turn-of-the-century calligraphy of my father, who arrived in America in 1906; the genealogy of strong women and their categorical imperative: "Where there is a will, there is a way," my mother's favorite expression; marriages defined in terms of class difference, the intermingling of aristocratic and plebian families that belies the stereotype of immigrant class uniformity; the grandfather's cane, although in my family's case patriarchal vigilance was a matter of ensuring that the girls' skirts were not too short; the character type of Ernesto both as "cafone" or breaker of the lifeline and as what might be called the Palinurus-figure, the family-member damaged by the immigrant experience who, in some way, pays for the assimilation of the rest of the family; the wedding dress handed-down from mother to daughter and passed from sister to sister, in my family's case, along with an Italian-made bassinette; and finally the shiny cardboard shoes in which Antonio was buried. My anecdote of shoes, however, comes from outside the family circle and belongs to an American professor who dressed in L.L. Bean-style. At a flea market in Florence, he purchased, at a bargain price what appeared to be his dream pair of shoes. After a rainstorm, he discovered that the shoes - super-fakes - were those intended for a poor man's funeral. A proper burial demands an elegant pair of Italian shoes, as Concettina and Nina well knew.

The Red Thread and the Play of Transitional Objects

Many immigrants had brought on board balls of yarn, leaving one end of line with someone on land. As the ship slowly cleared the dock, the balls unwound amid the farewell shouts of the women, the fluttering of handkerchiefs, and the infants held high. After the yarn ran out, the long strips remained airborne, sustained by the wind long after those on land and those at sea had lost sight of each other.
—Luciano De Crescenzo

In this parable of departure from Naples, Luciano De Crescenzo describes the traumatic scene of emigration, even though it is enacted as a spectacle in typical Italian fashion. It will be reenacted in the even more traumatic scene of arrival to American at Ellis Island. For the majority of southern Italians of the Great immigration (1880–1920), the transatlantic voyage involved the passage from emigration to immigration, from (class) exile within the motherland to (class) exile within the promised land of America, eventually the homeland.

Life line reconnects us through the insistence of its red thread to these two "primal" scenes. It is the scene in Naples, however, that perhaps offers the secret to the trove of objects displayed and assembled in the installation. Immigration also makes good collectors, and it is through those highly cathected cultural objects that the exile or foreigner repossesses the world from which he or she has been disconnected by immigration. The collection zone becomes a substitute for the motherland or homeland.

Those balls of yarn and the play of their threads might be likened to adult-versions of those "transitional objects" and "transitional phenomena" that D. W. Winnicott identified. Transitional objects are material objects with a special value for the suckling and young child and which allow the pre-oedipal child to make the transition from the first oral relationship with the mother to the true object-relationship, e.g., the blanket a child sucks as she or he falls asleep. That the scene of departure or severing from the motherland is enacted through the play with the balls of yarn is way of establishing momentarily a neutral area of experience through illusion or spectacle and thus to stave off anxiety. Winnicott sees such an intermediate or transitional zone, "unchallenged in respect to its belonging to inner or external (shared) reality," as "constituting the greater part of the infant's experience and is retained in the intense experiencing that belongs to the arts and to religion and to imaginative living and to creative scientific work." What is important about the balls of yarn as transitional objects is their power to negotiate separation anxiety through a creative scenario and thus to serve as a preparation of the imagination for its encounter with the crossroads to be faced at Ellis Island. New directions will emerge

from that crossroads, and it will have to be left behind for the new ventures that will emerge from it. Italy or the idea of it will not be left behind, always to be re-accessed through the memory of the red thread. The immigrant's objects - as epitomized and redeemed by *Life line* - are to be understood as transitional objects, not as security blankets in the form of a ravioli cutter or stogie nor as fetishistic objects, but as a means with which the imagination negotiates the space of exile and transforms it into an in-between, a transitional space that mediates the anxiety of identity of those torn between before and now, elsewhere and here, Italy and America.

XI. Praise for B. Amore

The artist chooses his subjects. It is his way of praising.

—F. Nietzsche, *The Gay Science*

Praise to B. Amore for her pietas in narrating the life history of her family and its identity crisis, and for limning the collective memory of the immigrant family. "The pietas of narrative consists in preserving the past. Preservation is possible only through and in narrative" (Cacciari, 1996:176), Praise to B. Amore for constructing in *Life line* a *paese* or homeland through narrative in which her family and ours find their place.

Pellegrino D'Acierno is Professor of Comparative Literature and Director of the Program in Italian Studies at Hofstra University and Tiro a Segno Foundation Visiting Faculty Fellow in Italian-American Culture for 2006 at New York University. His books include *The Italian American Heritage: A Companion to Literature and Arts* and *Thirteen Ways of Crossing the Piazza: Rome as a Cinematic City.*

References

Barthes, Roland. "Introduction to the Structural Analysis of Narratives." In *Image-Music-Text*, edited and translated by Stephen Heath. (Glasglow: Fontana/Collins, 1977).

Baudrillard, Jean. *Fragments: Cool Memories III, 1991–95.* (London/New York: Verso, 1997).

Benjamin, Walter. "Unpacking My Library." In *Illuminations*. Translated by Harry Zohn. (New York: Schocken, 1969).

Cacciari, Massimo. *Posthumous People: Vienna at the Turning Point.* Translated by Rodger Friedman. (Stanford: Stanford University Press, 1996).

D'Acierno, Pellegrino, editor. *The Italian American Heritage: A Companion to Literature and Arts.* (New York and London: Garland, 1999).

Foucault, Michel. "Nietzsche, Geneaology, History." In *Language, Counter-Memory, Practice.* Translated by Donald F. Bouchard and Sherry Simon. (Ithaca, NY: Cornell University Press, 1977).

Gonzalez, J. "Autopographies." In *Prosthetic Territories: Politics and Hypertechnologies*, edited by G. Brahm and M. Driscoll. (Boulder, CO: WestviewPress, 1995).

Huyssen, Andreas. 1999. "Monumental Seduction." In *Acts of Recall: Cultural Recall in the Present*, edited by Mieke Bal, Jonathan Crewe, and Leo Spitzer. (Hanover, NH: Dartmouth College/University of New England Press, 1999).

Le Goff, Jacques. *History and Memory.* Translated by Steven Rendall and Elizabeth Claman. (New York: Columbia University Press, 1992).

Lévi-Strauss, Claude. *The Savage Mind.* (Chicago: University of Chicago Press, 1966).

Preziosi, Donald. "Collecting/Museums." In *Critical Terms for Art History* (second edition), edited by Robert S. Nelson and Richard Shiff. (Chicago: The University of Chicago Press, 2003).

Young, James E. "Memory/Monument." In *Critical Terms for Art History* (second edition), edited By Robert S. Nelson And Richard Shiff. (Chicago: The University of Chicago Press, 2003).

11. L'Arco della Memoria – The Donors' Arch

The Donors' Arch
L'Arco della Memoria

A tribute to the generosity of spirit which made the *Life line* Exhibit possible. Thank you.

Many immigrants had brought on board balls of yarn, leaving one end of the line with someone on land. As the ship slowly cleared the dock, the balls unwound amid the farewell shouts of the women, the fluttering of handkerchiefs, and the infants held high. After the yarn ran out, the long strips remained airborne, sustained by the wind long after those on land and those at sea had lost sight of each other.

—Luciano De Crescenzo

SPONSORS

Center for Migration Studies

Woody Dorsey — Market Semiotics

Pioneer Investments

International Institute of Boston

Xerox Corporation

PATRONS

Instituto Italiano di Cultura

Italian Ministry of Foreign Affairs

National Italian American Foundation

BENEFACTORS

Denis D'Amore *in loving memory of Nina and Anthony D'Amore*

De Iorio and Forte Families

Clare Sean De Iorio Lawrence

Epson

Jon Pepper

Lawrence Family *in memory of Nina and Tony D'Amore*

Staff of Ellis Island

DONORS

American International College

Anonymous Friend

Lidia Bastianich *in honor of Felidia, Becco, Lidia's KC*

Famiglia di Nino and Louise Benevento

Sandy Berbeco *in memory of Emanuel Goldberg*

Boston University Alumni Association

Bostonia Magazine

Nancy Bowers

John D. Calandra Italian American Institute, Queens College/CUNY

The Carving Studio and Sculpture Center

Center for Italian Studies at SUNY Stony Brook

Geoffrey Chandler

George, Sam and Alex Chandler

Circolo Letterario of Boston

The Collective of Italian American Women

Commission for Social Justice, Order of Sons of Italy in America, Bellmore, NY

Michael L. D'Amore, Jr. *in Memory of Michael L. D'Amore*

Dante Alighieri Society of Masachusetts

Fieri Boston

Fieri National

Greater Boston Convention and Visitors Bureau

Dan and Terry Hnatio *in memory of our grandparents and all the immigrants who walked through these doors*

Whit Humphreys

Theodore Kellogg

Paul La Camera *in memory of Anthony J. La Camera*

Larisa Lawrence

Andrew H. Larabee

Natalie Jacobson McCracken

Modern Continental Construction Company

My Italian Family

National Organization of Italian American Women

Pirandello Lyceum of Boston

Photo Ark

QRST's

Mike Smith and Donna Tognazzi *in loving memory of Enis Columbia Tognazzi*

Ira and Marilyn Trachtman *in honor of our grandparents*

Trow and Holden

Vermont College of Norwich University

CONTRIBUTORS

Anonymous Friend

Anonymous Friend

Jennifer Black

Mary Jo Bona *in honor of the Bona Family*

Emily and Gil Boro *in memory of my grandparents who took the trip, "Boro and Vener"*

Andreas Calianos

Paul Calter *in memory of Arthur Calcaterra*

Henry M. Connell

Lucy and Knox Cummin

Ronald D'Amore and Sandi Forman

Carol and Dom DeLuise *in memory of John DeLuise and Peter Arata*

Richard and Alicia Faxon

Suki Fredericks and James Maroney *in honor of Marshall M. Fredericks*

Phil, Sathya and Gabrielle Gosselin *in loving memory of Margaret Gosselin*

Ruth Hamilton *in memory of Jonathan Page Kellogg*

Elizabeth and George Hostetler

Italian American Writers Association

Italian Poetry Society of America

Eric and Nancy Kaye *in memory of John Perfito*

Laser Disc Recording Center

Tiffany Lawrence

Laxman and Siberio Family

Lorraine Levinson

Maria Lo Biondo and Charles A. Stile *in memory of George Anthony Lo Biondo And Marian Ingraldi Lo Biondo*

Sally Maraventano *in memory of Giuseppina and Antonio Lo Cascio and Salvatore G. Maraventano*

Richard Masiello

Jane F. McMahon *in memory of Samuel W. McMahon*

Mark and Sarah Mitchell

Jon Nordmeyer and Cynthia Wuu

Norwich University Adult Degree Program Class of 2000

John Porter

Don Ramey

Mary Sabbatino *in memory of Bettina and Angelo Di Rienzo, Mary and Francis Sabbatino*

San Pellegrino

Dawn Sarli *to the strength of Grace Sarli*

Dawn Sarli *in honor of the Sarli and Fasano Families*

Robert, Marian and Justin Snyder

SOHO 20 Gallery

Michael Updike

Mary and Franco Vitiello

Vershire School "memento mori"

Word and Image

FRIENDS

Margaret Abt

All Around Painters

Glen JJ Anderson in honor of Rose Meli Andersen

Muriel Angelil

Anonymous Friend

Anonymous Friend in memory of Anthony and Nina D'Amore

Charles Austin

Francis Azzarto *in honor of Frank Azzarto*

Paul and Diana Baldi

Tullio Baldi *in loving memory of Isabella Baldi, Susan Baldi, Harriette Baldi, Lawrence Baldi*

Lynne Barton

Donna Basile

Dorothea Basile *in memory of Louise Basile*

Salvatore and Franca Basile

Elda Bertagna *in memory of Teresa Lavacchielli Bertagna*

Joyce Bernard Bibeau

Frances A. Botta *in memory of Anthony C. Botta*

Sarah Bowen

Salvatore Bramante *in honor of Sebastiano and Sebastiana Bramante*

Robin Brooks

Carol Brown *in memory or Emma Hockey and family, Immigrants*

Cynthia Brown *in honor of Elizabeth S. Dorsey*

Fred X. and Stella Ehrich Brownstein

Brian and Leslie Brusa

Jim and Gretchen Butler

Frank Calabrese

Marjorie Caracciolo Hagan *in honor of Rocco Carraciolo and family*

Nancy Carnevale *in memory of Ercole Carnivale*

Geoffrey Carter

Laura Catanzaro

Jo Chanah Israelson *in memory of Sara Shapiro Levinsky, Elizabeth Levinsky Borofski and Caroline Borofski Israelson*

Art Cohn and Mary DeVries Cohn

Sandy Cohen

Janna Crafts, Livia R. Kelley, James T. Kelly

Ben Crimi

Frederick C. Curtis *in memory of Frederick G. Curtis*

Mary and Ken Davidson

Alexandria Don Angelo

Rita Donovan *in memory of John J. Donovan*

Madeleine Dorsey

Carol Driscoll

James Durrett

Hal and Cathy Evans

Susan Falkman

Susan and Patrick Farrow

Max Faugno

Angela Gambardella *in honor of the Gambardella Family*

Barbara Gerard *in memory of Eda Perrone De Bernarda*

Susan Goldhor and Aron Bernstein

William Harby

Charlotte Hastings Mahr *in memory of Walter J. Peet*

Geoffrey Hearl

Robert and Joanne Hungate

Suzanne Iasenza

David Judelson *in loving memory of Belle Judelson*

Bonny Kahane

Holly Katz and Larry Klein

Maria Laurino

Nicole Librandi *in honor of the Librandi and Lisanti Families*

Elizabeth Locke

Maria C. Marinello

Maruzzi Family

Joanne Mattera *in memory of Antonina Misci*

Mike Maung

Marianne McCauley *in honor of Maria Cammarata and Biagio Di Palermo*

Bernice Mennis *in honor of Sidney and Mary Mennis*

Don and Cheryl Mitchell *in memory of Ada Donati*

Ethan Mitchell

Jonathan and Charlene Morse

Samantha C. Morse *in honor of Valentina Bushmanova*

Mariafranca Morselli

Barbara Murphy *in honor of Agnes Lombardo Treglia on the occasion of her 85th Birthday, August 18, 2001*

Muscara Family

Melanie Maganias Nashan

Marie Natoli *in honor of the Muscara family*

Marie and Dom Natoli *in honor of The Natoli Family*

Nerius

Emily North

Celia Pearson

Mary Ellen Phair *in honor of Anthony and Rose Depoti*

Russ Rametta

Lauren Reese *in honor of Rena Eva LaBelle and Frank Griffin, Jr.*

Tina Rella *in memory of Cesare Rella*

Sanford Rosenzweig

Rosalind E. Ryll *in memory of grandparents, Walter O. Ryll and Josephine Bonzyck*

The Saccos

Nancy Santaniello *in memory of Andrew Santaniello*

Carlo Sclafani

Carol Seitchik

Janet Shapero

Joann Sicoli *in honor of Antonio F. Sicoli Sr. and Artenzia DeSanto Sicoli*

Emily Sloan and Terry Solomon

Charlene and Tom Stewart *in memory of Victor and Lucy (Di Ruvo) Parziale*

Lu Stubbs *in memory of Lucille Benvenuto Benedetti Stubbs*

Lu Stubbs *in memory of Nicoletta Benvenuto*

Olindo and Damiana Testa and Marie Loria

Joan and Bruno Ticconi *in memory of John and Florence Mencini*

David Troy

Gail Van Dyke

Keiko Van Guilder

Jo Ann Vellardito

George and Lauraine Warfield

Samantha Yelinak

An *Italian American Odyssey*

Life line – filo della vita

Through Ellis Island and Beyond

di B. Amore

Traduzione di Franco Bagnolini

DEDICA

"Dove c'è la volontà, la via si trova"

Questa mostra è dedicata a Concettina De Iorio, la mia nonna materna. È grazie alle sue collezioni di oggetti, dal quotidiano al sacro, che questo lavoro esiste. Le sue storie ed il suo lascito mi hanno ispirato una curiosità profonda per la natura umana. Che significa osservare la storia? La verità di "chi" viene rivelata? Tutto ciò che è accaduto si trova "nel passato"? Lo ricordiamo e la memoria lo rende reale? Ci chiediamo, ci interroghiamo. A volte troviamo delle risposte: a volte altre domande.

Indice

Ringraziamenti

L'elenco delle persone che desidero ringraziare è probabilmente più lungo della mia memoria. Spero così che tutti coloro che non sono qui citati per nome si considereranno da me ringraziati in spirito. Vorrei ringraziare per prima Diana Pardue, Capo dei Servizi del museo, che mi ha invitata a creare *Life line – filo della vita* per il Museo dell'Immigrazione di Ellis Island. Questa mostra ha rappresentato la base dell'attuale pubblicazione, *An Italian American Odyssey*. Judy Giuriceo, curatrice delle Mostre, è stata straordinariamente generosa col suo sostegno e col tempo che mi ha dedicato. Un ringraziamento particolare va a: Eric Byron, Assistente capo a Ellis Island; Barry Moreno e Jeff Dosick, che mi hanno aiutato nella consultazione degli archivi storici e fotografici; George Tselos, che mi è stato di aiuto per il materiale di archivio; Janet Levine e Paul Sigrist, che sono state le mie guide attraverso le centinaia di interviste da loro condotte come parte del Programma di ricerca storica sulla Statua della Libertà e su Ellis Island; Paul Roper, che è stato il "tecnico" principale, ha fatto funzionare ogni apparecchiatura e ha registrato su videonastro ogni presentazione della mostra; Mike Conklin e Robert Foley, che hanno reso disponibile ai visitatori il materiale di *Life line – filo della vita;* oltre a tutto il personale presente ad Ellis Island, dagli uomini e le donne delle pulizie agli addetti alla vigilanza, che mi hanno sostenuto col loro continuo interesse per il progetto e la loro sollecitudine per la mostra nei cinque mesi della sua permanenza al museo.

Un ringraziamento enorme va a Padre Lydio F. Tomasi, Ph.D., Direttore emerito del Center for Migration Studies, per avermi invitato a pubblicare questo libro e per la sua generosità nel mettermi a disposizione le risorse della Biblioteca del Centro e per l'accesso agli archivi fotografici nella fase di creazione di *Life line*. Diana J. Zimmerman, Direttrice della Biblioteca e degli Archivi del Center for Migration Studies, e la professoressa Mary Brown sono state consulenti inestimabili e pazienti.

Un sentito ringraziamento va a Padre Joseph Fugolo, attuale Direttore del Center for Migration Studies, per la sua continua assistenza nella realizzazione del progetto. Don Heisel, Direttore della Ricerca, è stato fedele sostenitore, ricercatore di fondi e supervisore della pubblicazione. Sia lui che Tom Sullivan, il redattore, mi hanno incoraggiato e sostenuta durante tutta la lunga avventura della pubblicazione. Le fotografie di Chris Burke, Kevin Daley, Tad Merrick e Mark Malin formano un fondamentale nucleo visivo. Senza l'eccellente design e le abilità grafiche di Jennifer Black il libro non avrebbe la bella forma che ha. Questo testo non sarebbe probabilmente nelle vostre mani se non fosse per la competenza professionale nel settore marketing di Bob Oppedisano della Fordham University Press.

La National Italian American Foundation e il Ministero degli Affari Esteri italiano meritano ringraziamenti particolari per il considerevole sostegno offerto per la pubblicazione e la traduzione di *An Italian American Odyssey*. Una sovvenzione da parte dell'*Istituto Italiano di Cultura* di New York è stata di aiuto nella creazione della mostra, *Life line*. Grazie a tutti voi che avete sostenuto *Life line* con donazioni a favore del "Donor's Arch" – L'Arco della Memoria. *Life line* è stato fondamentalmente un progetto partito dal basso, con modesta organizzazione nella raccolta di fondi, cosicché ogni donazione, non importa quanto piccola, è stata essenziale per la sua crescita.

Grazie anche per il forte sostegno offerto dal John D. Calandra Italian American Institute, dal Dipartimento di Studi Italoamericani della Stony Brook University, dal Fieri – l'Organizzazione internazionale di studenti e professionisti che celebrano la cultura italiana, da Malìa – il Collettivo delle Donne Italoamericane, dalla Italian American Writers Association, dalla National Organization of Italian American Women, dall'International Institute of Boston, dal Lower East Side Tenement Museum, da La Dante Alighieri Society of Massachusetts, dal Circolo Letterario di Boston, dal Pirandello Lyceum di Boston e il Carving Studio and Sculpture Center del Vermont.

Ethan Mitchell, Madeleine Dorsey, Samantha Yelinak e Leah Czisar mi hanno assistita in modo impareggiabile in varie fasi dell'avventura di *Life line*. Dan Hnatio ha generosamente offerto i propri servigi nella produzione del video *The Thread of Life in One Italian American Family* ("Il filo della vita in una famiglia italo americana"). Il poeta Luigi Fontanella ha contribuito con la traduzione in italiano delle introduzioni ai capitoli. I miei "lettori" volontari, in particolare Pino e Rickey Magno, i più convinti sostenitori italiani di *Life line*, mi hanno fornito ottimi consigli quando il libro era nella fase di prima stesura. Franco Bagnolini ha portato a termine lo straordinario compito di passare al setaccio i molti strati di *Life line* e ha eseguito l'eccellente traduzione del testo in italiano, ricca di sensibilità. Rosanna Scippacercola

ha pazientemente trascritto il manoscritto. Caterina Romeo e Clara Antonucci hanno portato a termine il vasto lavoro di revisione per la pubblicazione finale del testo italiano. Caterina Romeo ha anche tradotto i saggi di Jennifer Guglielmo e Joseph Sciorra.

Devo un particolare ringraziamento alla mia figlia maggiore, Larisa, per essere stata la mia "spalla forte" – sempre desiderosa di aiutarmi con la miriade di impegni della raccolta di fondi, del montaggio dei video, dell'istallazione, imballaggio e spedizione dei materiali di *Life line* nel corso degli spostamenti della mostra nelle sue differenti sedi.

Per concludere, vorrei ringraziare l'intera mia famiglia dal profondo del cuore per la sua disponibilità a condividere storie, fotografie, sostegno psicologico ed economico, e per aver avuto la pazienza di vivermi accanto durante gli anni di sforzi richiesti da *Life line*. In particolare, ho un profondo debito di gratitudine con Woody Dorsey, marito e compagno di vita, senza il cui sostegno ai più vari livelli di *Life line,* la mostra e in seguito *An Italian American Odyssey*, questo libro, non sarebbero mai esistiti.

Prefazione

Il Filo della Vita
di B. Amore

Avevo una bisnonna che abitava a due porte di distanza da noi. Io e lei eravamo sempre insieme. Ma una cosa che mi ricordo proprio è di quando abbiamo lasciato l'Italia. Pochi giorni prima, abbiamo fatto una passeggiata fino al suo terreno e lei era molto, molto triste. Mi ha detto: «Ah, adesso stai partendo per l'America. Un giorno ti ricorderai di me». «Ma» – ha aggiunto – «ricordati che, quando arriverai là, quando arriverai alla Battery, lì c'è una fila di fontane. Devi vedere che ce n'è una, vedi di scoprire qual'è, da cui non puoi bere. Perché quando bevi da quella certa fontana, ti dimenticherai di tutti noi che lasci qui». Così, quando sono arrivata alla Battery, mi sono messa a cercare la fila di fontane, ma non ho visto nessuna fila di fontane. E quindi, mi sono detta, dato che non le ho viste vuol dire che va bene così. Lei voleva anche che le scrivessi per dirle del Ponte di Brooklyn, perché aveva sentito parlare del Ponte di Brooklyn. Ma è morta prima che io potessi vedelo il ponte. Oggi, quando lo percorro in macchina, moltissime volte, penso a lei. Le sue parole mi riecheggiano nella memoria. «Adesso stai partendo per l'America. Un giorno ti ricorderai di me».

—Domenica Calabrese (Sunday Wood) [1]

Mia nonna, Concettina De Iorio Piscopo, non ha mai pronunciato le parole "Un giorno ti ricorderai di me", ma il vivere con lei ha segnato la mia vita in modo indelebile. È stata lei che mi ha insegnato a bere alla fontana della memoria. A causa sua, la "casa" era sempre in un altro luogo. Ci trovavamo in America: la "vera casa" era l'Italia – il "luogo del cuore" dove avevano origine i nostri sogni, dove la vita si era nutrita.

I racconti di mia nonna furono i primi da me ascoltati. Tutti riguardavano l'Italia, i giochi infantili là dentro Il Giardino, il nonno severo che la faceva sedere a tavola in silenzio, i viaggi in carrozza con suo padre da Lapìo, paese fra le montagne, fino a Via Caracciolo a Napoli. La sua infanzia era il mio luogo da cui cominciare. Abitavo questi racconti durante i miei primi anni.

L'italiano era la lingua della ninna nanna mentre passeggiava con me in braccio per farmi addormentare quando ero appena nata. Sono cresciuta vicino al mare sapendo sempre che esisteva un'"altra sponda" – l'Italia. C'era la sensazione sempre presente di essere sospesa tra le due, un senso fluttuante di sentimenti, un senso fluttuante di lingua, uno spostarsi disinvolto dall'idioma materno, l'italiano, all'inglese e viceversa. Il dialetto, che non mi

era permesso di usare, era la lingua dell'intimità fra le donne, la lingua dei segreti che indovinavo attraverso un ascolto attento.

Da bambina, il mio mondo era soprattutto italiano. Chiunque non era italiano era americano. Il che comprendeva gli irlandesi, gli inglesi, i francesi, gli ebrei e così via. Non c'era nulla di spregiativo espresso nei confronti di una qualsiasi altra nazionalità. Anzi, venivamo incoraggiati ad accettare chiunque, ma sicuramente io non ero americana, ero italiana! Mi ci volle del tempo, fino all'incirca ai venticinque anni. – dopo aver conseguito la laurea in Belle Arti – per rendermi conto che esistevano anche gli italoamericani; che, in realtà, non ero solo italiana, ma anche americana.

C'è sempre un senso della storia nell'essere italiano. Un momento non si esaurisce mai solo in quel dato momento. Si estende all'indietro nel tempo fino ad altri avvenimenti ad esso collegati, che sono attaccati a quello come fili appiccicosi simili alla tela di un ragno, a stento visibili, che scompaiono se chiudete gli occhi, che soffiano in una brezza della memoria la quale, in effetti, può talvolta dare la sensazione di una catena forgiata che ci lega al passato. Il passato sembrava quasi più importante del futuro. C'era per me, ragazzina, sempre la sensazione che la gente guardasse indietro piuttosto che in avanti.

La mia curiosità relativa a queste differenze tra America e Italia mi spinse a fare un anno di studi presso la Facoltà di Lettere e Filosofia dell'Università "La Sapienza" di Roma, quando avevo diciannove anni; un anno in cui, la maggior parte del tempo, l'università era in sciopero, quindi un anno dedicato ad esplorare musei e rovine, ma – cosa più importante – un anno di visite frequenti al paesino della mia nonna materna...un anno dedicato ad osservare una mucca mentre veniva uccisa sulla strada acciottolata, a seguire una statua del Cristo a grandezza naturale portata in processione sulle spalle dagli uomini del villaggio, a partecipare alla visione dei quadri dei figuranti dei "Misteri" della Passione nella settimana di Pasqua nel loro giro annuale del paese, a prendere parte alla messa nelle chiese frequentate dai miei bisnonni, ad ascoltare i canti con timbro alto e con voce nasale dalle donne che stavano in piedi davanti a sedie con sedili di paglia sui pavimenti levigati di marmo. Queste esperienze dirette e autentiche mi hanno riportata indietro ai luoghi da me abitati da bambina nei miei spazi più intimi, collegandomi, nel presente, al passato di mia nonna.

Il senso della mia eredità italiana rappresenta un punto di partenza per

molti aspetti della mia espressione creativa nell'arte come nella scrittura. L'esempio più evidente di tutto questo è dato da una mostra multimediale recentemente completata e allestita per il Museo dell'Immigrazione di Ellis Island, intitolata *Life line – filo della vita*. Talvolta, la chiamo un "memoir visivo", che presenta i destini di due famiglie del Mezzogiorno d'Italia, nel contesto storico dell'emigrazione dall'Italia e dell'assimilazione in America nei cento anni del ventesimo secolo. La mostra sta viaggiando attraverso gli Stati Uniti e l'Italia e la mia viva speranza è che essa possa diventare un'esibizione permanente in un museo italoamericano. Il sogno di pubblicarla in forma di libro, *An Italian American Odyssey*, è ora diventato realtà.

La mostra è stata progettata specificamente per il Museo di Ellis Island, ma è stata anche ideata per essere spostata in altre sedi. Ho trascorso mesi su quell'isola, studiando gli stanzoni nudi, coperti da mattonelle bianche dal pavimento al soffitto, ascoltando lo sciabordare delle onde, rimuginando tra me e me sul fatto che il mare rappresentava il collegamento tra il vecchio mondo, l'Italia, e il nuovo mondo, l'America. Queste stesse stanze sono state i dormitori degli immigrati che venivano trattenuti. Durante la mia ricerca ho riflettuto sui sogni che avevano ispirato le loro lunghe traversate e la dura realtà che li aveva accolti.

Life line intreccia le storie personali e i documenti delle mie famiglie d'origine – i De Iorio e i D'Amore – con la storia e i documenti dei cento anni d'immigrazione, dal 1901 al 2001. Dieci anni di ricerca e di creazione artistica hanno avuto il loro culmine sia nella mostra ad Ellis Island, la proverbiale "Porta d'oro" verso l'America, sia in questo libro.

Questa storia è uno specchio della vita di tutti gli emigranti che lasciarono le loro case negli ultimi decenni del diciannovesimo secolo e viaggiarono alla volta dell'America alla ricerca di "una vita migliore". Essa indaga sulla complessa ondata del cambiamento che travolse gli immigrati e successivamente influenzò i loro discendenti. Una ricerca negli archivi di Ellis Island, del Lower East Side Tenement Museum e del Center for Migration Studies, ha prodotto come risultato una quantità di fotografie storiche e di resoconti in prima persona dell'esperienza degli immigrati. Questi ultimi sono completati da interviste videoregistrate che ho fatto agli immigrati più anziani e ai loro discendenti.

Si tratta di una storia che abbraccia due paesi, raccontata in modo non tradizionale, che attraversa i confini di classe sociale, sesso, razza e identità.

L'intera mostra è simile ad un enorme santuario con cappelle minori più piccole. Sono cresciuta in un ambiente italiano cattolico dove la magia della liturgia era sempre presente: l'oro, lo scintillio, il mistero della trasformazione del pane e del vino. Questa è anche l'essenza della creazione artistica: il trasformare i materiali così che questi abbiano la possibilità di esprimere l'inesprimibile. *Life line* raccoglie espressioni di devozione popolare, trittici e altarini, ed eleva il quotidiano al rango di sacro. Racconta di esistenze umane ordinarie che furono vissute con straordinario coraggio. Siamo abituati a pensare alla storia come a un resoconto di avvenimenti importanti. La "storia dell'umanità" è, più spesso, un compendio di eventi quotidiani e di piccoli ricordi.

Nella mostra, il piccone di mio nonno, elegante nella forma e che ancora reca su di sé le cicatrici della sua fatica, diventa l'elemento centrale in un reliquiario dedicato ai due Antonii – Antonio, l'uomo del piccone e della pala, che scavò le fondamenta dell'Università di Harvard, e suo figlio, Tony, che fu in grado di inseguire il sogno di un'istruzione ma non di esaudire interamente il sogno della sua vita. Il senso del sacro era parte integrante della mia giovinezza italoamericana: non solo in chiesa, ma anche all'interno della famiglia. Certe memorie erano sacre. Quando mia nonna parlava di suo padre o di sua madre, ne parlava come se fossero stati dei santi. C'era sempre un senso di riverenza per gli antenati e per la storia.

Life line, la mostra, e *An Italian American Odyssey*, questo libro, sono una narrazione complessa che utilizza testo e stimoli visivi. Tale narrazione si sviluppa lungo il filo rosso della memoria, il filo della vita, il filo della morte, spingendosi indietro nel passato e in avanti verso il futuro. È una metafora possente dell'emigrazione. Come nella poesia di De Crescenzo, i fili di collegamento con gli antenati persistono, che ne siamo coscienti o meno. Il dolore per il sofferto cambio di luogo e l'adattamento richiesto continuano a segnare le nostre vite attraverso le generazioni, forse un po' meno di quanto questi segnarono le figlie e i figli di seconda generazione ma, comunque, ci segnano ugualmente.

La storia viene spesso raccontata attraverso gli oggetti. Molte famiglie hanno perduto i loro oggetti-talismani. Mia nonna ne ha conservati così tanti da farli diventare materiali di creazione artistica. Gli oggetti di per sé sono elementi chiave. C'è un rapporto fisico con ciascuno di essi che è collegato con gli antenati a mo' di indice. La taglierina per ravioli in ottone modellata a mano, la vecchia caffettiera napoletana, i fasci di stoffa legati e

le lenzuola di lino grezzo tessute nell'Ottocento testimoniano tutti un intero modo di vita, una cultura intera. Lo studioso Pellegrino D'Acierno riteneva che sia il filo rosso di *Life line* che questi resti di materiali funzionavano come oggetti transitori nella vita di un emigrante, simili al pollice di un lattante o alla coperta preferita di un lattante, offrendo il conforto di una presenza familiare. Guardando in alto attraverso sette strati di vetro e di oggetti in un "reliquiario" dell'altezza di tre metri, si ha la quasi sensazione di uno scavo archeologico, è come guardare in alto e attraverso la storia. I visitatori parlavano spesso di una riscoperta della propria storia familiare attraverso l'esperienza di *Life line*. In tal modo la narrazione funziona come una memoria collettiva. La narrazione stessa diventa una sorta di terra natía.

Nella mostra si trovano collocate delle figure a grandezza naturale in marmo nero del Trentino avvolte nella stoffa. Esse sono parenti strette delle donne italiane dei villaggi che trasportano brocche d'acqua e ceste di prodotti agricoli sulla testa. In America c'erano fardelli diversi, non così facilmente definibili. Le donne in pietra, alte e forti, trasportano fardelli sul capo, i fardelli della loro storia. Le pietre sono avvolte nella stoffa: la stoffa che è stata una parte così importante della mia fanciullezza, della vita di mia madre e dell'esistenza di mia nonna e della mia bisnonna. Esse usavano la stoffa per fare dei bei vestiti, ma erano spesso intrappolate all'interno dei loro ruoli tradizionali. Qui incontriamo la stoffa strappata della vita dell'emigrante in una "re-visione" della storia. Io uso la stoffa per legare insieme le cose – pezzi di esperienza – per farne un tutt'uno. Talvolta, le immagini e la stoffa sono stratificate come se le "verità" fluttuassero al di sotto di una superficie opaca, difficili a decifrarsi chiaramente.

La creazione di *Life line* è stata come uno scavare nel mio passato, con tutto quello che mi era stato insegnato nella mia famiglia italoamericana. Le mie mani sono sempre state mani da lavoratrice, come quelle di mio nonno paterno. L'etica del lavoro mi è derivata dall'esempio di famiglia. Il fatto di essere diventata una scultrice su pietra non è privo di relazioni con queste prime esperienze, che erano imbevute di un forte senso del mondo materiale. Parlo spesso di collaborare con mia nonna, usando i suoi oggetti, i suoi ricordi e le domande senza risposta della sua vita che riverberano nella mia. Le sue raccolte di oggetti, che rappresentano la mia eredità, sono diventate parte della mia espressione artistica. Vi è stata una profonda "trasmissione" da lei a me, nel senso religioso, di un passaggio di lignaggio.

La mia ricerca all'interno della famiglia aveva tanto a che vedere con ciò che non veniva detto, con ciò che non veniva divulgato in aggiunta a tutto ciò che veniva raccontato. È interessante come si possono ritenere i "fatti" delle vite effettivamente vissute, senza conoscerne davvero la verità. Vi saranno sempre domande senza risposta che provocano altre domande, un ulteriore ricorso all'immaginazione, più scrittura narrativa, più creazione artistica.

La memoria "fissa" le cose come un procedimento fotografico. Il flusso si interrompe e noi catturiamo quel "sentimento-immagine", che diventa in un certo senso come "indurito"; ma tutto ciò è un'illusione, giacché la realtà non può mai davvero essere resa immobile. Essa è mutevole sempre in movimento e anche ciò che "ricordiamo" è soltanto un bagliore di luce su una superficie sfaccettata. Se "ricordiamo" di ricordare, il ricordo assume una tinta diversa e siamo in grado di discernere che ciò che ricordiamo è in realtà solo una "verità" molto parziale di un dato momento nel tempo, ma si tratta della "nostra verità" e rappresenta un Punto di Partenza.

Per creare la mostra *Life line* ed il successivo testo scritto per questo libro, *An Italian American Odyssey*, ho dovuto decostruire la "verità" come io la conoscevo. Aprendo la scatola scolpita della memoria dove le storie giacciono nascoste, le pagine fragili e la scrittura sbiadita sono esposte a un tipo di luce diversa che di tanto in tanto conferisce trasparenza alla pagina, fornendo alla "verità" l'opportunità di poter essere "penetrata". Scruto nella storia che mi è stata data e scorgo la storia più profonda, o distinguo qualcosa che rassomiglia ad una realtà intuita. Nella mostra, vengono continuamente intrecciati e intessuti, avanti e indietro, strati di storie ricordate e registrate. Molto spesso vengono presentati dei fatti in conflitto fra loro che si riferiscono alla stessa persona. Non è forse tutto questo più vero nelle situazioni reali con le quali dobbiamo spesso fare i conti nel corso della vita?

Ho ereditato un *Libro di Memorie*, un diario che parte dal 1802 e che contiene i ricordi e le esperienze del mio trisavolo e del mio bisnonno. Ho tradotto e sto ancora traducendo molte di queste annotazioni scritte con una vecchia calligrafia in corsivo che anche i miei amici di Napoli hanno avuto molta difficoltà a leggere. Questo libro è lo strumento per entrare in un mondo profondamente intimo e commovente, dove la voce di Don Lorenzo sussurra da una distanza di quasi duecento anni, narrando le sue esperienze di gioia in occasione delle nozze di sua figlia e di dolore alla sua morte avvenuta due mesi più tardi descrivendo i dettagli di tutte le

circostanze connesse: rituali nuziali, pratiche mediche, sepolture; l'apprendere che una nevicata viene misurata in *palmi di neve* e che un fulmine può percorrere l'intera casa e appiccare il fuoco ad un materasso di lana di buona qualità. Quando leggo di lui usando i pesi della bilancia e le misure per calcolare le tasse mentre tengo in mano quegli stessi pesi e misure, quegli oggetti diventano un collegamento diretto con lui che non ho mai incontrato.

Sembra esserci un senso di responsabilità nell'abbondanza di oggetti e storie ereditati, un senso del dovere, un senso del destino. Le storie e gli oggetti sembrano avermi scelta. È sia un peso che una gioia e sembra che io non abbia alcuna scelta se accettarli o meno se devo essere davvero ciò che sono. Ogni volta che qualcosa risultava inspiegabile, la nonna lo chiamava "destino" – sempre presente, ineludibile.

Concettina, mia nonna, non ha mai scritto nel diario. Soltanto gli uomini vi scrivevano, anche se tutte le donne della sua famiglia erano istruite e sapevano leggere e scrivere, il che non era cosa da poco nella seconda metà del diciannovesimo secolo, quando l'analfabetismo superava l'80 per cento nelle province meridionali d'Italia. I suoi scritti comparvero a scuola, l'American International College, che lei frequentò dal 1911 al 1913, una delle undici ragazze italiane immigrate iscritte alla scuola superiore in quel tempo.

Era nei temi di Concettina scritti al college, dove lei parlava attraverso la voce di un'altra, in cui penso che i suoi sentimenti fossero espressi nel modo più autentico. Non nelle fotografie in cui, per la maggior parte ella compare in atteggiamento composto. C'è soltanto una foto rivelatrice, un'immagine presa di lato, in una cucina in Italia, nel 1924 circa in cui la posa fiera appare rilassata. In essa, lei è seduta, dall'aspetto più corposa del solito, con indosso un grembiule, appoggiata allo schienale della sedia, e fissa vagamente lo spazio di fronte a sé. In questa immagine, non ci sono risposte pronte. La sua vita si è disfatta. Si è separata in modo definitivo dal marito, un farabutto. E' madre di una bambina di sette anni ed è a capo della famiglia che comprende la figlia, il padre e la sorella. Essendo ritornata in Italia per due anni, forse con l'intenzione di rimanervi, appare disperatamente infelice nel paesino della sua gioventù. Concettina ripartì per l'America poco dopo e non rivide l'Italia fino al 1956, per un periodo di trentadue anni. Era sempre italiana nel contegno e nei modi, ma non poteva più adattarsi all'Italia delle sue origini. Parlava perfettamente l'inglese, ma non diventò mai "americana". Rimase sempre tra le due realtà.

Mio nonno paterno, Antonio D'Amore, lasciò l'Italia nel 1902 senza più farvi ritorno. L'Italia della sua infanzia era così dura, così controproducente, così povera, così dolente, da non farlo mai più volgere indietro. Ma non diventò mai neanche cittadino americano. Sua moglie invece rinunciò alla cittadinanza italiana, ma ritornò molte volte con i figli nella patria d'origine. Due di loro si sposarono con italiane, cosicché l' attuale generazione di cugini mantiene un rapporto vivo andando avanti e indietro attraverso l'oceano, cosa che allora, richiedeva due settimane di traversata, mentre adesso bastano otto ore. "Il Giardino" di mia nonna è ancora a mio nome.

Life line e *An Italian American Odyssey*, così come anche la mia scrittura attuale, sia in poesia che in prosa, sono un'intricata mescolanza di una miriade di stratificazioni di comprensione, di percezione e di interrogativi. Giacché le storie che venivano raccontate non riuscivano a "spiegare tutto", e malgrado l'insistenza sul fatto che "dicevano la verità", permane la necessità di volgersi indietro ricercando all'interno di noi stessi per scorgere ciò che si può vedere. C'è una canzone che mio padre era solito cantare e che diceva «L'orso si arrampicò su per la montagna per vedere ciò che si poteva vedere». Così ereditai la montagna. Forse era Lapìo, oppure Montefalcione, gli antichi paesi di montagna dell'Irpinia, di dove era originaria la mia famiglia. Mi trovo in un continuo viaggio di ricerca. Sebbene alcuni dei percorsi possano essermi familiari dalle narrazioni dei miei genitori o di mia nonna, viaggio con occhi diversi. Loro scesero giù dalla montagna diretti in America, mentre io sto risalendo la montagna portando un sacco pieno di domande sulla realtà che essi riferivano e di cui raccontavano ma anche sui vuoti presenti nella loro storia. È proprio realizzando questo lavoro che scopro più nel profondo me stessa e le mie radici. Esse si rivelano inaspettatamente nel terreno scuro e densamente compatto che sto scavando nel modo apparentemente più lento, con le mani, un po' alla volta, finché viene dissotterrato un nodo contorto quasi senza accorgermene, ma la luce lo cattura e mi mostra il cammino da intraprendere.

Guida alla mostra e al libro

La mostra *Life line* è stata concepita e realizzata nel 2000–2001 da B. Amore come installazione temporanea nei sei dormitori originari che racchiudono le gallerie della mostra itinerante al Museo dell'Immigrazione di Ellis Island. Ella ha trascorso dei mesi visitando quegli spazi, riflettendo sull'intreccio di presente e passato, e rimuginando sulla Storia delle singole storie individuali e delle esperienze condivise.

Life line è divenuta la quarta e la più completa di una serie di mostre create dall'artista B. Amore come riflessione sulla storia della sua famiglia emigrata dall'Italia all'inizio del ventesimo secolo. In questa collocazione della mostra, caratterizzata dalla specificità del sito che la ospita, Amore presenta un'interpretazione evocativa dell'esperienza personale dell'immigrazione, un'esperienza esplorata in forme più tradizionali nel Museo dell'Immigrazione di Ellis Island. *Life line* è, in effetti, un memoir visivo ambientato sullo sfondo dell'immigrazione del ventesimo secolo.

Includendo fotografie, oggetti appartenuti agli antenati, scritti di famiglia, sculture, installazioni, storie orali e video, questa mostra, che utilizza diversi media, traccia la storia della famiglia di B. Amore attraverso sette generazioni a partire dal momento in cui lasciarono l'Italia emigrando negli Stati Uniti e costruendosi in America una nuova vita. Pur rappresentando una visione artistica personale dell'autrice, in questa mostra Amore fornisce ai visitatori un luogo per riflettere sulle proprie storie familiari e sui viaggi e le lotte dei loro antenati. Queste storie visive sono collocate sullo sfondo del tessuto della storia generale dell'immigrazione, dal momento che una famiglia esiste non come un'entità isolata ma all'interno del contesto sociologico della propria epoca. In questa mostra l'esperienza degli emigranti si allarga fino a diventare una metafora dell'odissea dell'intera razza umana.

In tutti i casi, viene preservata la lingua di ogni singola persona (comprese gli errori ortografici e le peculiarità grammaticali in inglese e in italiano). Ciò vale anche per le lettere originali le interviste e le annotazioni sui diari, molte delle quali provengono da un diario inedito, il *Libro di Memorie,* scritto da Don Lorenzo De Iorio, il trisavolo di B. Amore. La maggior parte delle interviste degli immigrati provengono dal Progetto di Storia Orale di Ellis Island (Ellis Island Oral History Project) e sono elencate sotto l'intestazione "Voci" – Interviste da Ellis Island", "Voices – Ellis Island Interviews".

Il termine "prima generazione" indica la prima generazione che sbarcò in America. "Seconda generazione" designa le figlie e i figli dei primi immigrati. Per quanto possibile, Amore ha tentato di comunicare le loro storie attraverso le loro stesse parole scritte in diari, lettere e interviste. Tutte le fotografie di persone e i manufatti inclusi nella mostra sono stati ricevuti in prestito dalle famiglie D'Amore, Benevento e Masiello. Le fotografie storiche sono state utilizzate con l'autorizzazione di varie collezioni pubbliche e private. B. ha concepito e realizzato l'opera d'arte, ha scritto il testo e tradotto i documenti di famiglia compresi nell'intera mostra, come anche nel libro.

Life line è composto di vari elementi distinti all'interno di un tutt'uno. La mostra utilizza ciascuna delle sei stanze-dormitorio di Ellis Island, cosicché l'intero spazio diventa un'opera d'arte. Il disegno a forma di griglia rappresentato dalle linee orizzontali e verticali dei letti a castello originali, che inizialmente riempivano i dormitori, corre per tutta la lunghezza e rappresenta un sottile componente strutturale di ordine e continuità.

B. Amore ha affermato:

Vedo in realtà Life line *come un gioco tra l'intimità dell'esperienza personale degli emigranti e la vastità dell'impresa in cui si è imbattuta ogni persona che è passata attraverso questo edificio. Tutto il loro viaggio è finito senza alcun dubbio con l'essere qualcosa di molto più grande di quanto avessero mai potuto immaginare…* Life line *rappresenta un testamento nei confronti di quel continuo filo della storia, il senso che il passato influenza e anima il presente, che anche quando lo viviamo, il presente diventa il passato mentre procediamo verso il futuro.*

Appunti (pagina 1) da un opuscolo informativo distribuito al Museo dell'Immigrazione di Ellis Island.

Seguendo il filo

Mentre i visitatori si spostano di stanza in stanza, quindici pannelli orizzontali formano una fascia visiva quasi continua. Ognuno di essi contiene il simbolico filo rosso che rappresenta i legami metaforici con il Vecchio Mondo, come anche l'effettiva abitudine degli emigranti e dei loro parenti disposti lungo il molo di reggere i capi opposti di gomitoli di filato mentre le navi si allontanavano dai loro ancoraggi e iniziavano il viaggio verso l'America. Questo testo e le immagini di famiglia collocate su un soffice sfondo di onde suggeriscono il legame sia fisico che mistico tra il Vecchio e il Nuovo Mondo della maggior parte degli emigranti, come anche la lunga traversata che essi intrapresero.

Le cornici di questi pannelli richiamano le cornici di metallo delle file di letti a castello che un tempo si allineavano lungo tali dormitori. Il rame, con la sua patina verdognola, richiama la Statua della Libertà.

Colonne di storia

Questi dieci pannelli verticali contengono citazioni e immagini di immigrati italiani. Le storie scritte sulle "colonne" fanno riferimento all'infinitezza della storia umana sia essa scritta o ricordata. Le colonne sono state ispirate dalle "colonne di graffiti" situate al terzo piano del Museo dell'Emigrazione di Ellis Island, che esibiscono la prova verbale e visiva del numero incalcolabile di immigrati che sono passati per quell'isola.

I rotoli degli antenati

Ciascuno di questi rotoli rappresenta un antenato o un'antenata con una rappresentazione fotografica del loro viso. Disposta a strati sopra questa immagine, in modo da comporre il corpo dell'antenato, si trova la storia della vita di questa persona. Ogni "corpo" si presenta completo o incompleto tanto quanto consentito dalla storia ricordata o scritta della persona.

Trittici di famiglia

I trittici, che consistono di un pannello centrale e due laterali, fanno riferimento alle pale d'altare presenti in Europa e funzionano come memoriali delle famiglie e dei singoli individui custoditi e celebrati al loro interno. Combinando fotografie, storie scritte e oggetti manufatti, questi assemblaggi commemorano la fede e la capacità di resistenza di esistenze comuni vissute con straordinario coraggio. Le scatole chiuse o aperte rappresentano la rivelazione possibile quando si scruta dentro la propria vita e la propria storia.

Lucidando lo specchio

Questa installazione a muro include una serie di immagini fotografiche degli antenati della scultrice e dei componenti attuali della sua famiglia – in tutto, sette generazioni. Quando ci guardiamo allo specchio, in certo modo è come guardare in faccia i propri antenati. La nostra storia personale è spesso un riflesso della nostra storia familiare.

Odissea

Ciascuna delle cinque opere di scultura collocate in questa sezione rappresenta in modo simbolico un immigrato o un'immigrata che trasporta i suoi effetti personali verso il Nuovo Mondo. Queste opere sono ricavate da blocchi di marmo nero italiano scolpito e contengono oggetti appartenuti agli antenati.

Installazioni negli armadi

Ci sono quattro armadi nello spazio dei dormitori. Amore li ha utilizzati per creare dei "minimondi" all'interno del contesto del più vasto spazio espositivo. Molti oggetti personali, fotografie e documenti scritti sono stati combinati fra loro per dare l'impressione di un altro luogo e di un altro tempo.

Reliquari

Infine, la serie "Reliquari della vita comune" contiene stoffe e oggetti salvati dalla nonna della scultrice, insieme ai suoi appunti personali ad essi relativi. I reliquari contengono di solito i resti dei santi (persone straordinarie), oppure oggetti da loro toccati o benedetti. Questi reliquari racchiudono oggetti della gente "comune" che assumono una più profonda rilevanza come vestigia di vite vissute in un altro luogo e in un altro spazio.

In aggiunta a questa guida, vi è nella mostra una genealogia parziale delle sette generazioni di personaggi coinvolti nel seguire il filo della storia dagli ultimi anni del diciannovesimo fino alla fine del ventesimo secolo – in tutto cento anni. Questo testo segue il tracciato della mostra ed è diviso in sei

sezioni, allo scopo di riflettere il passaggio da una stanza all'altra. Ogni sezione si rivolge ad una particolare fase del viaggio dell'emigrante, Partenza e Arrivo, Lavoro, Assimilazione, Integrazione, Ritorno alle Radici, Domande riguardo al Futuro.

A Ellis Island i visitatori venivano portati a fare un viaggio attraverso il tempo, cominciando con le voci reali provenienti dalle interviste agli immigrati che Amore aveva selezionato dagli archivi di Ellis Island. Mentre ci si spostava attraverso le varie stanze, queste voci narravano le storie universali dell'immigrazione. Esse sono comprese in sezioni specifiche intitolate "Voci". Alcune di queste storie possono sembrarvi familiari giacché rispecchiano le esperienze della vostra stessa famiglia. Buon viaggio!

Appunti (pagina 2) da un opuscolo informativo distribuito al Museo dell'Immigrazione di Ellis Island.

Guida ai principali personaggi di *An Italian American Odyssey*

Famiglia De Iorio

Don Lorenzo De Iorio: (1820–1896) scrisse il *Libro di memorie* nell'Ottocento

Luigi De Iorio: (1847–1937) figlio di Don Lorenzo, che emigrò in America nel 1901

Giovannina Forte: (1847–1909) sposò Luigi De Iorio nel 1881 e gli diede quattro figli

Eufrasia De Iorio Anzalone: (1882–1967) figlia maggiore di Giovannina e Luigi (chiamata anche Annie)

Concetta Immacolata De Iorio Piscopo (Concettina): (1884–1979) secondogenita di Luigi e Giovannina (chiamata anche Concettina)

Lorenzino De Iorio: (1887–1902) unico figlio maschio di Giovannina e Luigi

Teresina De Iorio: (1889–1893) figlia più giovane di Giovannina e Luigi

Ernesto Piscopo: (1885–1958) sposò Concettina De Iorio (chiamato anche Billie)

Adolfo Anzalone: (1895–1952) sposò Eufrasia De Iorio

Nina Piscopo D'Amore: (1917–1994) figlia di Concettina ed Ernesto, moglie di Anthony D'Amore; madre di quattro figli, Bernadette, Denis, Ronald, Stephanie.

Famiglia D'Amore

Antonio D'Amore: (1878–1966) patriarca della famiglia D'Amore, che emigrò in America nel 1902

Luisella Guarino (Luigia Guarino) e Michelangelo Catalano: genitori di Maria Grazia Catalano D'Amore

Maria Grazia Catalano D'Amore: (1891–1974) Sposò Antonio nel 1909 e diede alla luce otto figli, tutti sopravvissuti: Tony, Marie, Phil, Mike, Rico, Susie, Adolph, Luisa (Dolly)

Anthony (Tony) D'Amore: (1913–1984) figlio più grande di Maria Grazia e Antonio; sposò Nina Piscopo nel 1941, ed ebbero quattro figli

Rico D'Amore: (1918–2003) il fratello più giovane di Tony

Luisa D'Amore: (1929–1976) figlia più giovane della famiglia D'Amore; sposò Nino Benevento di Avellino, dandogli tre figli, **Susan**, **Margaret** e **Joey** (Giuseppe), i "cugini italiani"

Bernadette D'Amore (B. Amore): (1942–) figlia primogenita di Tony e Nina

Gene "Gino" Lawrence: (1942–) ha sposato Bernadette, da cui ha in seguito divorziato, ma è rimasto sempre parte della famiglia

Larisa (D'Amore) Lawrence: (1966–) figlia maggiore di Bernadette D'Amore e Gene Lawrence

Clare Sean De Iorio (D'Amore) Lawrence: (1968–) unico figlio maschio di Bernadette D'Amore e Gene Lawrence

Tiffany (D'Amore) Lawrence: (1972–) figlia più giovane di Bernadette D'Amore e Gene Lawrence

Denis D'Amore: (1944–) figlio maggiore di Tony e Nina

Ronald D'Amore: (1946–) secondo figlio di Tony e Nina, sposato con **Sandi Forman** (1953–)

Stephanie D'Amore Maruzzi: (1952–) figlia minore di Tony e Nina

Allen Maruzzi: (1947–) marito di Stephanie D'Amore

Andrea (D'Amore) Maruzzi: (1983–) figlia maggiore di Stephanie D'Amore e Allen Maruzzi

Nicole (D'Amore) Maruzzi: (1987–) figlia minore di Stephanie D'Amore e Allen Maruzzi

Gerald (D'Amore) Masiello: (1940–) figlio maggiore di Marie D'Amore e Ray Masiello; sposò **Lynn Archangelo Masiello** (1944-)

Eric (1969–), **Jeffrey** (1973–) **and Christopher** (1975–) **Masiello:** figli di Gerald Masiello

Richard (D'Amore) Masiello: (1948–) figlio minore di Marie D'Amore e Ray Masiello

Tullio J. Baldi: (1920–) marito di Susie D'Amore

Marian (D'Amore) Baldi Snyder: (1954–) figlia minore di Susie D'Amore e Tullio Baldi

Christine Chen Baldi: (1996–) nipote in linea diretta di Susie D'Amore e Tullio Baldi

Michelle Chen Baldi: (1991–) nipote in linea diretta di Susie D'Amore e Tullio Baldi

Paul (D'Amore) Baldi: (1949–) iglio maggiore di Susie D'Amore e Tullio Baldi; sposato con **Diane Biancardi Ustinovich Baldi** (1951–)

Maria Mauriello D'Amore: (1927–) moglie di Michael D'Amore

Anthony John D'Amore: (1952–) figlio maggiore di Maria Mauriello e Michael D'Amore

Maria Grazia D'Amore: (1954–) figlia di Maria Mauriello e Michael D'Amore; madre di **Christiana** (1993–)

Michael Louis D'Amore: (1959–) figlio minore di Maria Mauriello e Michael D'Amore

Introduzione

Tanti immigrati hanno portato a bordo gomitoli di lana, lasciando un'estremità del filo con qualcuno a terra. Mentre la nave partì lentamente dal molo, i gomitoli si sfilarono fra i gridi d'addio delle donne, i battiti dei fazzoletti, ed i bambini in braccio mantenuti in alto. Dopo che la lana si esaurì, le strisce lunghe rimanevano in aria, sostenute dal vento finché non si persero di vista sia a quelli di terra sia a quelli di mare.

—Luciano De Crescenzo

An Italian American Odyssey segue i cento anni della storia intrecciata di due famiglie del Mezzogiorno d'Italia venute in America all'alba del secolo. Le loro storie diventano lo specchio delle esperienze di tanti immigrati. "La Merica" era la rinomata "terra d'oro" di opportunità e il sogno di seguire il sole verso ovest spesso ha infuocato l'immaginazione. Taluni sono partiti in cerca di avventura, la maggior parte sono partiti per sopravvivere.

Sogni

"Chi esce, riesce"

L'Ottocento ha visto una migrazione di popolazioni che non si poteva neanche concepire nei tempi precedenti. L'invenzione del motore a vapore ha reso possibile la traversata di lunghe distanze sia per nave che per treno. La povertà in tanta parte dell'Europa ha forzato la gente a partire dal paese d'origine proprio per salvarsi. Lettere scritte dagli amici in America promettevano lavoro, e così son venuti, "seguendo il sole," con la speranza di trovare una vita nuova. La realtà che li aspettava era spesso ben diversa dal sogno.

Nei primi anni del Novecento l'Italia, da poco unificata, soffriva ancora delle forti inquietudini del secolo precedente, quando Mazzini, Cavour, Crispi e Garibaldi avevano lottato per riportare l'ordine in un Paese diviso e in crisi. Il socialismo e il movimento anarchico avevano trovato terreno fertile nell'atmosfera di recessione economica e di repressione che permeava la seconda metà del diciannovesimo secolo. Le condizioni di estrema povertà dell'Italia, dalla Valle Padana alla Sicilia, costrinsero molti a partire per le nuove terre – per seguire il sole e inseguire i propri sogni di una vita più agiata in America. Almeno in America si poteva sognare. Il sogno era il primo passo, il duro lavoro il successivo. La disparità tra la promessa e l'effettiva realtà appariva come un divario ancora più ampio di quanto ognuno avrebbe potuto immaginare, ma spesso risultava migliore delle condizioni che gli immigrati si erano lasciate alle spalle.

Molti italiani, sia del Nord che del Sud, erano abituati a modelli di migrazioni stagionali. Nel Nord, gli inverni alpini costringevano i lavoratori manuali a cercare lavoro in climi più caldi durante i mesi più rigidi. Artigiani e suonatori ambulanti si spostavano abitualmente per esercitare i loro mestieri. Gruppi di lavoratori migranti seguivano da un luogo all'altro la raccolta di svariate colture agricole e la produzione del vino e dell'olio d'oliva. Abituati com'erano, per necessità, ad adattarsi a condizioni economiche mutevoli, i più avventurosi spesso partirono per "La Merica". Nel 1900, costava meno andare da Palermo a New York che da Palermo a Parigi![2] Purtuttavia, l'acquisto di un biglietto non era affare da poco per la maggior parte degli emigranti.

Il Sud d'Italia, il Meridione, era popolato principalmente da contadini che lavoravano la terra per il loro padrone. I padroni erano nobili o proprietari terrieri. Siccome ondate di emigranti abbandonarono il suolo petroso dell'Italia meridionale, i padroni si trovarono spesso senza un aiuto adeguato per coltivare i loro poderi. Nell'ultimo decennio dell'Ottocento, più di un milione e mezzo di contadini si stabilirono all'estero.[3] Nel 1924, tale numero era salito a cinque milioni e mezzo[4]. Durante l'ultima parte dell'Ottocento I proprietari terrieri del sud erano stati minacciati, in modo crescente, da un irrequieto movimento socialista, da modesti raccolti agricoli e dalla siccità. Anteriormente alla prima guerra mondiale più di due terzi dell'intera ricchezza personale era formata da immobili abitativi, mobilio e terreni da coltivare, cosicché anche una famiglia considerata benestante era profondamente influenzata dalla depressione economica.

O si è costretti a rubare o ad emigrare. Non mi è permesso rubare e non voglio farlo, perché Dio e la legge lo proibiscono. Ma in questo posto non c'è modo per me di guadagnare da vivere per me e i miei figli. E allora che posso fare? Devo emigrare: è l'unica cosa rimasta…

—Un contadino settentrionale anonimo (citazione riferita dal Vescovo Scalabrini)[5]

Mio padre ci raccontava che in Sicilia si era sfruttati dai proprietari terrieri e dalle autorità e che la migliore politica da seguire nella vita era la seguente: hai occhi ma non vedi; hai naso ma non senti odori; hai lingua ma non parli; hai mani ma non tocchi; molte volte mi sono chiesto che tipo di storia potrebbero raccontare se fossero liberi di dire tutte le difficoltà patite in Sicilia.

—Michael Lamont[6]

Partenza

Il lasciare l'Italia era una decisione straziante che nessun emigrante prendeva a cuor leggero. Abitualmente, gli uomini partivano prima delle donne e dei figli; le separazioni talvolta duravano tutta la vita. Il viaggio stesso attraverso il vasto, misterioso oceano richiedeva fino all'ultima stilla di capacità di adattamento e di perseveranza cui potevano fare appello. Gli emigranti dormivano in terza classe, che comprendeva gli spazi più in profondità al di sotto del ponte della nave – stile dormitorio – su cuccette di ferro. I materassi avvolti in sacchi di iuta, riempiti di paglia o d'erba, offrivano uno scarso livello di comodità. I pasti venivano serviti due volte al giorno e consistevano, assai spesso, in una combinazione di biscotti ammuffiti e di una broda diluita fatta passare per minestra. Molti emigranti portavano con sé da casa formaggio e biscotti e questi ultimi diventavano a bordo un prezioso alimento base. Il mal di mare era una realtà. Il tanfo del vomito unito a quello del cibo marcio e all'odore dei corpi pigiati rendeva la traversata quasi insostenibile.

"VOCI"—Interviste da Ellis Island

Sì. Pensavo che l'America era come un paradiso dove tutti... pensavo, doveva essere pieno di re e regine e principi e ognuno era ricco. Questo era quello che di solito era riferito in generale da tutti, che le strade erano fatte d'oro e che tutti se la passavano così bene qui.

Avevamo solo due valigie e questo era quello che chiamavamo un Baule Americano. È quel tipo di baule per conservare le cose che si trova nei negozi oggi, fatto di stagno o di qualcosa del genere.

La notte prima [della partenza] c'era gente dappertutto nelle tre stanze seduta qua e là sui mobili, sul pavimento, sopra le valigie, sul letto, sui tavoli. C'erano persone sedute ovunque che passavano l'ultima serata con noi fuori nel giardino davanti alla casa. Il giorno dopo l'intero paese ci accompagnò, per, diciamo, da mezzo miglio a tre quarti di miglio. Poi alcuni cominciarono a salutarci e scoppiarono i pianti. Poi raggiungemmo la casa di mio zio, che era in campagna, e ci toccò passarci davanti, e c'era una grande folla. Mia nonna, la mamma di mio padre, piangeva, e così anche la mia bisnonna. Fu un addio triste.

Fu una traversata agitata? Sì, per un paio di giorni fu molto agitata. Beh, non troppo agitata, ma era buio, molto, molto buio. Guardavamo fuori dalla finestra. Non si vedeva niente. Non c'era cielo, o alberi, o mare che riuscivi a vedere. Per almeno due giorni non si vedeva niente. Era come galleggiare in mezzo all'aria, diciamo. E c'era anche un po' di paura tra alcuni di noi. Ma tutti cominciarono a recitare una o due preghiere. Pioveva anche un po'. E tutto ciò che sapevamo là era che c'era solo la nave e noi e niente intorno a noi, a qualunque ora guardavamo fuori.

—Domenica Calabrese (Sunday Wood), nata il 30 maggio 1920 a Camparni, Calabria; partita all'età di undici anni sul *Roma*[7]

"VOCI"—Interviste da Ellis Island

Ricordo che un giorno mio padre scrisse una lettera a mia madre e voleva che noi venivamo qui in America. Lei non voleva partire, sai? Aveva trentatré anni ed era stabilita in Italia. E quindi quando mia madre ha ricevuto quella lettera, io ho cominciato a fare salti di gioia. «Dobbiamo partire, mamma. Dobbiamo andare in America.» Perché andare in America, in quei giorni era un po' come gli astronauti che partono adesso per la luna, no?

Mia madre teneva con sé il suo bagaglio. Così, non me lo scorderò mai. Fece un grosso fagotto con un sacco. E ci mise dentro tutti i gioielli di mia nonna. E lo mise nell'autobus, sopra il posto a sedere, sai, dove si poggiano i bagagli. In alto. Bene, stavamo viaggiando per le vie di Napoli, e tutto a un tratto arriva il momento di alzarsi e di scendere, e improvvisamente ecco un ragazzo, riesco ancora a vederlo davanti a me. Afferrò il fagotto di mia madre e scappò, portandosi via i suoi gioielli. Me lo vedo ancora davanti, ti giuro. Quel ragazzo. Io urlavo: «Mamma, mamma, mamma!». E lui è scomparso in un lampo.

Quanto tempo? Abbiamo lasciato Napoli il nove di dicembre e siamo arrivati solo il nove di gennaio dell'anno successivo. Un mese. Penso che deve essere stato come una delle barche di Cristoforo Colombo. Beh, sulla nave, ricordo delle cose sulla nave. Ricordo che ci davano da mangiare su piatti di stagno. Era una specie di minestra, molto salata, con dentro un po' di pastina. È tutto quello che mi ricordo. E io davo da mangiare a mia madre, perché lei non riusciva ad alzarsi. Era senza forze.

Ce lo davano [da mangiare] proprio là, no? Dovunque erano, no? Proprio sulle cuccette, o in qualunque altro posto. Mentre noi, anzi la nave, viaggiavamo, ricordo che mi infilavo di qua e di là, perché riuscivo a infilarmi in tutti i posti, sai, quando sei bambino scappi su per le scale, ti metti a guardare di qua e là. Così ho scoperto la prima e la seconda classe con i tavoli rotondi e le tovaglie. Sai, mio Dio, gli occhi mi si sono spalancati. Poi, un giorno. Non lo dimenticherò mai. Mi affaccio dalla nave, no? fino quasi nell'acqua, lì oltre la la ringhiera. Improvvisamente questi quattro uomini salgono da non so dove. Non so da dove venivano e portavano qualcosa come questa tavola con qualcosa sopra, che trasportavano sopra le loro teste. Mi segui? A un certo punto ho guardato fuori e c'è un corpo che è caduto dritto nell'oceano. Qualcuno era morto. Questo è quello che facevano quando uno moriva. Ti buttavano in mare, ai pesci. Proprio così. Non lo dimenticherò mai. Che impressione mi fece, davvero.

—Dena Ciaramicoli Buroni, nata il 26 maggio 1912 a Mondavio, provincia di Pesaro, Italia; partì per l'America all'età di 8 anni sul *Pesaro*[8]

"Mamma mia dammi cento lire

Ché in America voglio andar,

Cento lire io te le do

Ma in America no, no, no"

Ritornello di una canzone popolare italiana all'inizio del ventesimo secolo.[9]

"VOCI"—Interviste da Ellis Island

C'era una piccola stazione, circa quattro, cinque miglia dal mio paese, una stazione del treno. Dovevamo andarci a piedi. Beh, metà del paese era venuta a salutarmi. La cosa che mi è rimasta più impressa è che, quando il treno stava per partire, mia madre ci si è aggrappata, non voleva far andare via il treno. E questo ricordo rimane con me, perché lei aveva la sensazione che forse non mi avrebbe più visto, e così è stato. Mi sentivo stupido. Il fatto è, che noi eravamo nella stazione, nella sala d'aspetto, e tutti parlavano e cose del genere. Il treno arrivava dietro la curva. Il momento quando ho sentito il fischietto mi sono sentito soffocare, non riuscivo più a dire una parola. Non so perché, ma è quello che è successo. Non riuscivo a dire più niente. E meno male che c'era un mio amico, stava viaggiando in Italia, a Verona, e mi ha fatto compagnia, il mio migliore amico, stessa età e tutto il resto, no? Così, quando siamo arrivati a Milano, ho incontrato là un mio cugino, no? e da lì ho viaggiato tutta la notte. Poi siamo arrivati a Genova. Ho dovuto fare un esame medico col console americano. Per la prima volta ho dovuto firmare col mio nome al contrario. In Italia si firma sempre "Lorenzini Ettore". Qui era "Ettore Lorenzini". Sai, bisogna firmare prima col "last name", col cognome. Ma non ho mai capito perché in questo paese lo chiamano "last name", ultimo nome. Vedi, in altre parole, quando nasci, sei Lorenzini, non Ettore. Quindi dovrebbe essere il secondo nome, non so. Ma laggiù dovevi mettere "Lorenzini" per primo.

—Ettore Lorenzini, nato il 20 marzo 1913 ad Anduins, Udine; giunse in America nel 1930 all'età di diciassette anni, sul *Conte Biancamano*[10]

La Famiglia De Iorio

La famiglia De Iorio sembra aver avuto motivi complessi per lasciare l'Italia. Venivano da Lapìo, provincia di Avellino, poco lontano da Napoli. Mentre il Mezzogiorno d'Italia decadeva, è possibile che anche le loro fortune abbiano avuto una svolta negativa. È tuttora un mistero il perché esattamente partirono dall'Italia. Luigi, il padre del ramo della famiglia che emigrò, era il figlio più grande. Suo padre, Don Lorenzo, era morto nel 1896. La tradizione imponeva che il figlio maggiore divenisse a quel punto il patriarca della famiglia. Questo lo avrebbe fatto diventare il capo della famiglia De Iorio e il responsabile della supervisione sulle loro terre, ma lui non fu mai interessato a fare il padrone.

"Memoria"

Ricordo di Luigi de Iorio pel suo Caro Padre, morto adì 18 Agosto nel 1896, alle ora 21 di Sabeto, vigilia di S. Antonio di Padova, e si ricitava anche il suo drama in suo onore, successa questa disgrazia, I maestri di Feste volevano suspenderla, ma noi non vollemo, al perché il pubblico si era incingiato arrivarne, e non si poteva tralasciarla, il Signore così aveva disposto in quel giorno, come anche S. Antonio, che era tanto divoto, e speriamo che gli accogliesse in Cielo, come non tralasciava la messa ogni mattina.

—Resoconto di Luigi della morte di suo padre, Don Lorenzo, scritto nel *Libro di Memorie*, il diario non pubblicato di Don Lorenzo

Pane bianco per tutti

Luigi era un tipo democratico, influenzato dalle idee socialiste, che erano molto popolari in Italia quando lui era ragazzo. Non credeva nelle divisioni tra le classi sociali ed era solito prendere del pane bianco dalla dispensa di famiglia e mangiarlo con i contadini nei campi. Aveva l'abitudine di frequentare il caffè del paese e giocare a carte con i lavoratori. Era considerato un disonore per la famiglia a causa del suo comportamento. I Forte, la famiglia di sua moglie, che detenevano tutti i ruoli politici e religiosi importanti nel paese, lo criticavano continuamente e potrebbero aver costretto la famiglia a partire.

"VOCI"—Interviste da Ellis Island

Dei parenti di mio padre non ce n'è più nessuno in questo paese. Sono arrivati qui e se ne sono tornati indietro. Il loro stile di vita era diverso. Sai, non avrebbero mai accettato questo genere di vita. Le cose oggi sono cambiate qui in America. Ma c'erano molti contrasti allora tra l'Europa e l'America.

Questo è quello che è successo. Mio padre che comincia a vedere il modo in cui questa gente veniva trattata, e lui che faceva sedere un servitore al suo tavolo, i servitori che vivevano con loro, loro si sedevano a tavola con mio padre, che era roba da pazzi.

E allora la famiglia era abbandonata a se stessa, perché la gente, cioè, gli idealisti come mio padre e tipi come lui, loro non pensano al denaro, né al futuro. Mettono tutto per realizzare i sogni e per aiutare il prossimo e cose del genere.

—Marjorie (Maggiorana) Corsi Notini, nata il 24 giugno 1924 a Capestrano, Abruzzo[11]

Lei [mia madre] veniva da una famiglia davvero ricca, considerata in Italia veramente agiata. E mio padre era un giardiniere che curava la proprietà e allora la minacciarono e poi loro stessi, voglio dire mio cugino, dopo che lei aveva avuto il primo figlio, la presero e la ammonirono: «Non devi più vederlo. Altrimenti, sarai cacciata». Bene, mia madre ebbe un secondo figlio. Ed essi la cacciarono. E lei non vide più i suoi fratelli e sorelle, né sua madre o suo padre, a parte uno dei suoi fratelli, che era un prete. E lui rimase in rapporti amichevoli con lei. E questo è l'unico collegamento che riuscì a conservare con l'intera famiglia.

—Elda Del Bino Willits, nata il 29 aprile 1909 a Lucca; lasciò l'Italia a sette anni sul *Caserta*. Inizialmente avrebbe dovuto imbarcarsi sull'*Ancona*, che fu bombardato[12]

Rotolo di un'antenato: Luigi De Iorio

Il mio bisnonno, Luigi De Iorio, era un gentiluomo di campagna nato in una famiglia di proprietari terrieri di ceto elevato proveniente da Lapìo, un paesino di pietra nell'Italia meridionale, provincia di Avellino, non distante da Napoli. Giunse in America con moglie e figli. Chissà esattamente perché? Aveva simpatie per il movimento socialista, il che era in conflitto con i valori della famiglia. Uno dei miei fratelli si chiede se forse Luigi beveva. Ma mia madre non mi raccontò mai nulla al riguardo. Quando chiesi alla nonna, lei rispose che beveva un bicchiere al giorno. Mia madre, Nina, diceva che era gentile, modesto, svolgeva un lavoro umile nel paese d'adozione e conduceva un'esistenza tranquilla. Nella maggior parte delle sue fotografie sta leggendo. Vide morire il suo unico figlio, Lorenzino, un anno dopo il suo arrivo in America. Sua moglie morì otto anni più tardi. Mia madre gli voleva bene. Morì quando lei era al college. Mentre scrivo tutto questo, mi rendo conto che mia madre sposò un uomo per alcuni aspetti simile a suo nonno – piuttosto mite, portato alla pacatezza, allo studio e al lavoro duro. Le donne erano la forza della famiglia. Il padre di Luigi, Don Lorenzo De Iorio, mise per iscritto una storia della famiglia dalla metà dell'Ottocento su un vecchio diario. Lo abbiamo ancora. Abbiamo anche le Vite dei Santi, *che erano anch'esse appartenute a lui. Mia nonna diceva che gliele leggeva «quando erano buoni». E quindi ci sono molti misteri relativi al vero motivo per cui i De Iorio sono venuti in America e immagino che potremmo non capirlo mai. So che nella famiglia De Iorio erano soliti alternare i nomi Luigi e Lorenzo. Ho sposato un uomo il cui cognome è Lawrence (in italiano "Lorenzo"). Ho dato a mio figlio "De Iorio" come secondo nome per salvare la linea di discendenza.*

Il Libro di Memorie

Don Lorenzo De Iorio, padre di Luigi, teneva un *Libro di Memorie,* in cui annotava i resoconti di matrimoni, nascite, morti, acquisti e vendite di terre e avvenimenti nella vita del loro paesino. Molte di queste pagine forniscono un vivido ritratto della vita in un paesino rurale nell'Italia del diciannovesimo secolo. La "memoria" più antica reca la data del 1802.

Quando io parto da questo mondo,

che il Signore mi chiama,

qui sono memorie

e tutti I ricevi

e pesi dei nostri fondi

e altre notizie –

forse per ridere – Addio

Don Lorenzo De Iorio. Iscrizione sulla copertina del *Libro di Memorie*

Luigi e Giovannina

Le nozze di Luigi De Iorio con Giovannina Forte furono annotate in questo libro. Nati nello stesso anno, il 1847, avevano entrambi trentaquattro anni. I De Iorio e i Forte avevano vissuto porta a porta per generazioni. Malgrado il rango delle due famiglie nel loro paesino, la cerimonia fu semplice. Le pubblicazioni di matrimonio, annunciate pubblicamente sia in chiesa che al Comune, stavano per scadere. La sorella di Luigi, Eufrasia, era morta nemmeno un mese prima e la famiglia De Iorio era in lutto stretto, il che spiega la modestia di quelle nozze private che contrasta fortemente con i resoconti festosi di altri matrimoni tra famiglie nel *Libro di Memorie* di Don Lorenzo.

"Memoria"

Memoria: Adi 17, 9bre 1881, Fecimo sposare il figlio Luigi, con Giovannina Forte verso un ora di notte, e forse più nella nostra Cangelleria per il stato civile, mentre con la Chiesa aveva già sposte…da quattro mesi dietro perché l'ultimo giorno di publicazione che scorrevano, come del…del municipio, sicché alla detta ora,…uno di compagnia solo la nostra famiglia e quella della sposa, senza fare palesare a chi si sia indovidono, e senza biglietti di visita, mentre che l'aveva già…e ciò fù per la disgrazia sofferta di quella povera disgraziata mia figlia, nel giorno 25 8bre scorso mese caminande…anno, qui non si doveva fare nulla per detta disgrazia, ma trovandosi già sposati con la Chiesa, da quattro mesi già scorsi, questa era l'ultimo giorno di mesi sei che terminavano le publicazione dello stato civile, cosi ci è convenuto non per disprezzo, o altro di farli sposare in segretezza, e senza lusso verso come vi ho spiegato che nessuno lo conosceva. Fiat volundas tua. Lodate Iddio che ciò ha stabilito, mentre così doveva succedere.

—Don Lorenzo De Iorio, *Memoria*. Questa pagina del diario è sbiadita e strappata, cosicché molte parole sono difficili a decifrarsi. La pagina si trova in un'illustrazione che contiene anche una poesia, *Kissing My Hand*, di Leo Luke Marcello.[13]

Rotolo di un'antenata: Giovannina Forte

Giovannina Forte veniva da una famiglia istruita di proprietari terrieri. I suoi fratelli ricoprivano ruoli importanti nel proprio paese. Ermenegildo era l'avvocato e il magistrato del paese. Davide era l'*arciprete*, o pastore della Chiesa. Achille dirigeva l'ufficio postale. Giovannina e Luigi De Iorio vivevano in una grande casa spaziosa proprio nel centro del paese. Quando i suonatori ambulanti venivano a Lapìo, si esibivano proprio sotto il loro balcone. Mia nonna ricorda che si insinuava furtivamente per guardare attraverso la balaustra di pietra quando era bambina. Giovannina tesseva le lenzuola di lino per la sua dote, ricamava le sue iniziali sugli angoli e sulle sue camicie da notte ricamate – o forse erano le suore del convento a fare tutto o in parte questo lavoro? Non si pettinava mai da sola. Una volta alla settimana, una cameriera era solita pettinarla e cospargerle di unguenti le trecce scure. La sua quarta figlia, Teresina, morì presto. Il suo unico figlio maschio morì a

quattordici anni. Le altre due figlie, Concetta ed Eufrasia, sono diventate le sopravvissute della loro famiglia in America. Così Giovannina cedette alle pressioni della famiglia e seguì la figlia in America. I fratelli di Giovannina sentivano che il marito di lei, Luigi, disonorava continuamente la famiglia accompagnandosi con persone al di sotto della sua classe sociale. Quando Concetta ritornò a Lapìo nel 1922 con mia madre, che aveva cinque anni, i fratelli di Giovannina, l'avvocato e l'arciprete, fecero passare dei brutti momenti a mia nonna perché uno dei contadini aveva portato mia madre a fare un giro sull'asino. Nella sua fotografia, Giovannina porta un fermaglio che ora io stessa indosso. La sua collana di granati e i suoi orecchini d'oro sono una parte dell'eredità lasciatami.

La Tessitura

«La tessitura», pensò Giovannina «la tessitura». La sua mente vagava al telaio che era di solito il campo di una delle serve o delle donne che si prestavano a realizzare capi di biancheria per il corredo di altre donne. Da bambina, era rimasta incantata dal telaio, lo sguardo rapito dalla spoletta che correva avanti e indietro per i fili dell'ordito formando il disegno della trama. Aveva insistito per imparare ad usare il pedale pesante ma arrendevole del telaio (stando quasi all'impiedi mentre si appoggiava alla panca) con le piccole mani che spingevano la spoletta, solo fino a metà percorso la prima volta che provò. Ma con perseveranza, la chiave della sua natura, imparò la tecnica e potè tessere felicemente le lenzuola del suo stesso corredo. In un angolo, nitide, le iniziali ricamate in rosso, GF, contrassegnavano le lenzuola proprio come sue. Erano state sospese al telaio come grandi vele ondulanti nel mentre lei si apprestava a finirle. Guardando, fuori, il profilo delle colline, la sua immaginazione indugiava su quello che poteva esserci al di là. Sapeva di altri villaggi. Poteva vederli, ciascuno sulla cima della sua piccola collina, con in mezzo il panorama delle vallate. Potevano le lenzuola fare da vela trasportandola altrove? Poteva lei forse sapere, in questi momenti di astrazione, che il viaggio della sua vita l'avrebbe davvero portata addirittura oltre quelle fantasticherie?

Da emigrante a immigrato

Giovannina e Luigi De Iorio avevano 54 anni quando emigrarono in America nel 1901. I loro figli erano Eufrasia, 19 anni, Concettina, 17 anni e Lorenzino, 14 anni. Eufrasia non voleva lasciare il convento in Italia dove aveva studiato per diventare suora, ma alla fine acconsentì. Lasciarono il porto di Napoli l'11 maggio 1901, salpando sulla nave S.S. *Gallia*. Il bastimento fece scalo a Marsiglia e arrivò nel porto di New York il 29 maggio 1901. Erano classificati come lavoratori nella lista dei passeggeri della nave. Le età di Concettina e di Eufrasia erano inesatte. Lorenzino era stato messo nella lista come donna!

Tale confusione di dati fondamentali era un fatto comune durante il culmine dell'ondata di immigrazione. I De Iorio entrarono in America attraverso Ellis Island con soli 40 dollari a loro nome – cinque dei quasi 136.000 immigrati provenienti dall'Italia in quell'anno. A quel tempo il governo italiano imponeva severe restrizioni sul quantitativo di denaro che si poteva portare fuori d'Italia. Essi proseguirono per Boston dove furono accolti da paesani – gente proveniente dallo stesso villaggio d'origine, che era giunta in America prima di loro. Erano diventati immigrati.

"VOCI"—Interviste da Ellis Island

Per prima vedemmo la Statua della Libertà. E tutti in piedi sul ponte a gridare: «La libertà, la libertà! Viva la libertà!» Non sapevo che voleva dire. Pensavo che era solo la santa che proteggeva il porto. Questo è quello che pensai, che era una santa. E la nave, sembrava andare a sinistra e poi girare a destra. E vedemmo questo palazzo, bello, grande. E poi dall'altra parte c'erano palazzi molto alti, e io mi immaginavo che andavamo a vivere in uno di quei palazzi. Poi quando arrivammo, per quanto mi ricordo, la nave attraccò là. Non era una nave molto grande. Attraccò a Ellis Island…C'era un grande "baldacchino" e mio padre stava in piedi là, tra l'estremità del baldacchino e il sole che brillava di fronte a lui. Dovevamo scendere giù per gli scalini, dal basso, i nostri nomi venivano chiamati prima che noi scendevamo, perché qualcuno doveva venirci a prendere.

—Domenica Calabrese (Sunday Wood)[14]

Ellis Island—"Isola di Speranza, Isola di Lacrime"

Arrivare in America attraverso Ellis Island era spesso un'esperienza sconvolgente. Le file per sottoporsi agli esami medici erano lunghe e gli immigrati dovevano superare rigorosi controlli al fine di essere accettati come nuovi residenti in America. Degli incaricati di Società caritatevoli, come la San Rafael's Italian Benevolent Society fondata dal vescovo Scalabrini, o l'Associazione per la Protezione degli Immigrati Italiani, assistevano i nuovi arrivati per il cambio del denaro e per far loro raggiungere le proprie destinazioni al fine di garantire che venissero trattati in modo onesto.

"VOCI"—Interviste da Ellis Island

Bene, poi mi hanno assegnato un custode. Mi hanno messo addosso un cartellino. L'ho strappato subito. Non voglio andare in giro con un cartellino [ride]. Non voglio sembrare un pacco. Non so perché. Mi sono tolto subito il cartellino.

—Ettore Lorenzini[15]

"VOCI"—Interviste dal Lower East Side Tenement Museum

Gli uomini di solito arrivavano dall'Europa da soli. Le mogli o quello che erano restavano in Italia. E loro vivevano tutti in un appartamento. La storia di mio padre è che lui arrivò qui per mezzo degli svizzeri, attraverso la Francia, qualcosa del genere – arrivarono in America illegalmente a quel tempo. Anche mia madre. Lei raccontava la storia di quando arrivò qui, sapeva che doveva avere dei soldi per scendere dalla nave. Mio padre si fece prestare 25 dollari e glieli tirò verso la nave dal molo. E caddero nell'acqua! E lei era così scoraggiata.

—Josephine Baldizzi, famiglia emigrata da Palermo nel 1928[16]

La porta dell'America

C'erano esami molto severi per tutti gli immigrati quando passavano attraverso i posti di controllo ad Ellis Island. Si chiedeva loro di arrampicarsi su per una lunga scala di pietra fino al salone principale, la "Great Hall". Gli ispettori li osservavano attentamente e facevano dei segni col gesso sulle braccia di chi zoppicava, di chi aveva il fiatone, oppure che si distingueva in misura notevole. Alcuni venivano trattenuti se erano malati. Altri venivano effettivamente rimandati al loro paese d'origine. Si creava una situazione straziante quando le famiglie venivano separate in questo modo, dal momento che spesso ogni centesimo dei loro risparmi se n'era andato per pagarsi il viaggio.

E procedono in avanti, da questo recinto al successivo, di recinto in recinto, verso un banco con un piccolo sportello di metallo – il cancello dell'America. La grande maggioranza è formata da giovani uomini e donne, tra i diciassette e i trent'anni, gente di campagna, d'indole buona, giovane, piena di speranze. Stanno in piedi in una lunga fila, aspettando di passare attraverso quel cancelletto, con fagotti, scatolette di stagno, valige a buon mercato, strani pacchi, a coppie, in gruppi familiari, da soli, donne con bambini, uomini con sfilze di persone a carico, coppie giovani. Per tutto il giorno, quel filo di rosario umano attende là, si sposta in avanti a sobbalzi, ricomincia ad aspettare; per tutto il giorno ed ogni giorno, costantemente rifornito, con gli ultimi grani, quelli finali, che scivolano costantemente attraverso il cancelletto, finché le unità diventano centinaia e le centinaia, migliaia…

—H. G. Wells, 1906[17]

"VOCI"—Interviste da Ellis Island

La situazione era davvero spaventosa perché gli uomini non erano molto gentili. Erano maleducati. Ti spingevano come una mandria di bestiame. Ecco come ti trattavano. E noi andavamo da un uomo ad un altro. Ti esaminavano da tutte le parti. Bisognava superare il test. E immagino che lo abbiamo superato perché siamo arrivati negli Stati Uniti, ce l'abbiamo fatta.

—Dena Ciaramicoli Buroni[18]

Anche allora, in Italia, Ellis Island era la cosa paurosa del viaggio… perché loro, loro sapevano che potevi essere deportato, potevi essere trattenuto se qualcosa andava storta. Era cosa risaputa che bisognava superare i controlli medici, e quindi era importante stare in buona salute e passare gli esami. Avevo solo cinque anni e quest'uomo di piccola statura che era andato avanti e indietro diverse volte… mi portò a passeggiare un giorno e disse: «Sai che ti dico? Quando arriverai ad Ellis Island, ti esamineranno gli occhi con un uncino.» E poi aggiunge: «Non lasciartelo fare, perché sai cosa? Lo hanno fatto a me. E un occhio mi è caduto in tasca.» Così arriviamo lì e tutti devono passare l'esame e io mi ritrovo là sul pavimento a strillare. Non mi faccio toccare. E sai cosa? Ho superato la prova senza la visita medica. Sono riuscita a passare senza farla perché gli altri sette l'avevano passata.

—Elda Del Bino Willits[19]

La sola cosa che ricordo, siamo arrivati con la nave, noi, in effetti non siamo scesi dalla nave, quando siamo arrivati qui abbiamo dovuto passare l'esame medico. Se tutto va bene ti lasciano passare, se no devi rimanere là da qualche parte, non so dove, finché non è tutto a posto, o quasi, e allora ti lasciano entrare negli Stati Uniti. In effetti uno degli ispettori mi diceva quando mi domandava chi veniva a prendermi. Lui sa che ero da solo e sa che non avevo nessuno in America. E stava parlando con uno che mi doveva guardare, gli stava dicendo, forse dobbiamo rimandarti in Italia. Io gli dico: «Ma perché dovrei ritornare in Italia?» Dico: «Sono venuto qui per rimanere negli Stati Uniti». Dico:«Se torno indietro in Italia, penso, guarda il denaro che ho speso per arrivare fin qui; e finisco di nuovo dritto sparato nella fossa». È per questo motivo sono rimasto vicino al mio amico, così suo cognato prendeva anche me, e sono andato con lui da suo cognato. Suo cognato era là.

—Carmine Martucci, nato il 25 dicembre 1904 a Bidetto, Bari; arrivò dall'Italia nel 1919 all'età quindici anni[20]

Non avevo scambiato molta corrispondenza, sai, con lui [mio padre]. So che mia madre doveva fare una fotografia di noi ogni anno da spedirgliela per fargli vedere come crescevamo [ride]. Nel nostro paese c'era un fotografo in estate per fare fotografie ai turisti, no? Così lui scatta una foto, lei la spedisce a mio padre per fargli vedere come stavamo crescendo, no? Passano quattro anni per volta senza vederlo e davvero non so da dove salta fuori. Davvero. È stata dura per lui e dura per noi, per davvero.

Quando mi sono fermato, mio padre stava proprio fuori del treno [ride]. Scendo dal treno. Quando se n'era andato avevo tredici anni. Ne avevo diciassette. Sono sceso e lui stava proprio dietro di me ancora a guardare sul treno. Capito, guardava ancora sul treno. Perché, quando ero partito ero un ragazzino. Ora ero già un uomo, capisci.

—Ettore Lorenzini[21]

Paese nuovo, vita nuova

L'arrivo in America significò un grosso cambiamento nello stile di vita dei De Iorio. In Italia, avevano fatto parte della classe dei proprietari terrieri, il che significava che avevano posizioni rispettabili nel loro paese. Ci si rivolgeva a loro con "Don" e "Donna" invece degli abituali "Signore" e "Signora". Sia le donne che gli uomini sapevano leggere e scrivere in un'epoca in cui una percentuale tra il 70% e il 90% degli abitanti della loro regione meridionale della Campania era analfabeta.[22]

Essi recarono con sé libri dalla biblioteca di famiglia che sono ora conservati in America, come anche molti dei loro preziosi oggetti personali – biancheria tradizionale, lenzuola ricamate a mano, reliquie religiose e utensili da cucina. Le iniziali di Giovannina sono ancora visibili sugli angoli della pesante biancheria di lino tessuta che faceva parte della sua dote. Luigi e Giovannina non avevano mai lavorato in Italia. In America, l'intera famiglia trovò lavoro nelle fabbriche. Le donne si lamentavano che gli venivano le vesciche a stare sedute tanto a lungo alla macchina da cucire.

Prime lezioni

Lorenzino andò a scuola per imparare l'inglese. Seguiva la tradizione dei De Iorio di perseguire un'educazione, malgrado il fatto che fosse considerata un lusso dalla maggior parte degli immigrati. Le sue prime lezioni di inglese a scuola, come pure una sua fotografia quando era un ragazzino a Lapìo, furono conservate da Concettina. Prese un raffreddore tre o quattro mesi

dopo l'arrivo in America e in capo a sei mesi morì di polmonite. Era l'ultimo figlio maschio a portare il cognome De Iorio. La sua morte fu un grave colpo per ogni componente della famiglia ed un inizio difficile di fronte alle sfide che avrebbero dovuto fronteggiare nel loro nuovo paese. Tra coloro che andarono al funerale, elencati nel *Libro di Memorie,* c'erano molti amici della famiglia anche loro emigrati da Lapìo.

ampio. Nella transizione ricevettero aiuto dalla famiglia o dagli amici che erano arrivati prima. Tuttavia, era un compito impegnativo e sconcertante quello di passare da una società rurale molto unita con confini ben definiti ad un ambiente urbano che traboccava di opportunità.

"Memoria"

Ricordo di Lorenzino Iorio figlio di Luigi Iorio, per un capriccio si dicise di farsi una passeggiata in America, e giunsero a salutamento nel giorno 30 Maggio, ed il detto Lorenzino stava bene, dopo tre, o quattro mesi si sentiva una tosse e trascurava di curarla, gli toccò il polmone, subito medici Inglesi, medici dell'ospedale che non lo lasciavano, il Dottore G. Giovannino Carbone nostro paesano, tante e tante medicine, non ci è potuto niente, e dopo Quattro mesi di malattia ci è lasciato il giorno di Giovedi Santo dopo fattosi la Comunione, e l'estreme unzione che spirò alle 9 di mattina 27 Marzo 1902 ed è fatto un S. morte come S. Luigi Consaca, ed assistersi da solo, chiamando Gesù, Giuseppe, e Maria assistemi la morte mia, e così chiamando volò in Paradiso lasciando a noi in mezzo a dolori, e pianti, che non possiamo dementicarci giammai, e speriamo che precasse per la famiglia come lui disse prima di chiudere gli occhi.

—Luigi De Iorio, Memoria *Libro di Memorie*

La famiglia perse anche Giovannina, che morì di emorragia cerebrale nel 1909, otto anni dopo l'arrivo ad Ellis Island. Questo lasciò a Concettina la responsabilità di tirare avanti. Suo padre, Luigi, non fu mai un capo famiglia. Era un uomo gentile, che leggeva e lavorava. Il suo atteggiamento fondamentale nei confronti della vita era "vivi e lascia vivere". Eufrasia si prendeva cura della casa. Concettina era la più intraprendente. Apprese rapidamente l'inglese e ben presto abbandonò la fabbrica.

Nell'affrontare le difficoltà della risistemazione in un nuovo paese, e dell'adattamento ad un ambiente circostante radicalmente diverso, la maggior parte degli immigrati si aggrappò fortemente alla propria famiglia, che forniva loro un senso di sicurezza mentre si inserivano in un mondo più

La prima generazione
"Meglio poco che niente"

Nonostante la motivazione del sogno, la realtà di sopravvivere in America ha portato tanti immigrati a chiedersi se avevano preso la decisione giusta. Per la prima generazione sul suolo americano…Sì, il lavoro c'era in America, ma che altro? La vita familiare ne soffriva perché moglie e bambini spesso venivano lasciati nel paese d'origine per lunghi periodi. Condizionati dai secoli di lavoro duro, gli immigrati sono sopravvissuti mantenendo l'etica del perseverare, chinare la schiena e andare avanti. L'istruzione era un altro modo per cambiare la situazione.

Il lavoro

La maggioranza degli immigrati aveva lasciato il proprio paese d'origine con poche risorse se si eccettua una forte volontà di lavorare. La più parte di loro era formata da lavoratori della terra nella patria d'origine. Gli uomini entrarono nell'industria edilizia. Le donne talvolta avevano imparato il cucito, che divenne un'attività di largo mercato in America. Le madri ed i loro bambini spesso lavoravano insieme a casa, facendo fiori di seta o di piume in appartamenti affollati. Nessuno era troppo giovane per essere utile.

"VOCI"—Interviste dal *Filo della vita*

Mia madre non lavorava mai fuori di casa. Faceva del lavoro a casa – della passamaneria. Ti danno un foglio di carta con su uno schema e tu lo segui con la macchina per cucire o il cucito a mano. Sai, le "rane" le chiamavano. Ce n'erano due da una parte e si muovevano insieme. Io facevo la maggior parte di questo lavoro. La aiutavo tutto il tempo. Lavoro da quando sono nata!

> —Catherine D'Alena Villanova, famiglia proveniente da Spinete, provincia di Campobasso[1]

Alcuni entrarono nell'industria dell'abbigliamento, in fabbriche o in stabilimenti. Le donne dei De Iorio hanno lavorato tutte in fabbrica appena arrivate. Quando Giovannina morì nel 1909, le donne che lavoravano nel suo posto di lavoro, la sartoria Aieta, vennero tutte al suo funerale. La sua morte venne ricordata nei giornali sia in Italia che in America.

La morte di Giovannina

Profondamente commossi, partecipiamo a' nostri lettori l'infausta novella della morte, avvenuta il passato mese di Novembre in Boston, della pia signora Donna Giovannina Iorio nata Forte, la cui vita fu un continuo esercizio di tutte le virtù cristiane.

L'estinta, nata in seno della nobile famiglia Forte di Lapio, non smentì le gloriose tradizione del suo illustre casato, e fu veramente il tipo della donna forte descritta da Salamone, essendo stata un perfetto esemplare di figlia, di sposa e di madre. Cattolica fervente, tutta carità e tutta zelo, appartenne a tutt'i sacri sodalizi esistenti nel suo Comune, ed anche al Terz'Ordine di San Francesco, e di essi, come una claustrale, osservava esattamente le regole.

> —Necrologio di Giovannina sul "La Campana del Mattino", Napoli, 25 gennaio 1910

Attivismo o Status Quo?

Il lavoro nelle fabbriche era brutto– giornate lavorative di quindici ore, per una media di 6,76 dollari alla settimana, nel 1910. Nell'infame incendio della Triangle Shirtwaist Factory di New York nel 1911 perirono 146 giovani donne di origine italiana ed ebraica perché erano state chiuse a chiave all'interno della fabbrica dai datori di lavoro! Quasi tutte rappresentavano il principale sostegno per le loro famiglie.

Molte donne organizzarono gruppi femminili all'interno del movimento operaio e alcune formarono perfino dei gruppi femminili anarchico-socialisti, seguendo l'esortazione di Maria Roda, un'operaia di un setificio: «perché noi sentiamo e soffriamo; anche noi sentiamo, dalla nascita, il bisogno di libertà e uguaglianza.»[2] Questi gruppi cercavano di portare la questione dell'emancipazione femminile in primo piano nel dibattito sul lavoro. Molte di loro divennero componenti del sindacato degli Industrial Workers of the World (IWW) al fine di conquistarsi una voce nel movimento sindacale americano. Nel 1919, l'International Ladies Garment Workers Union aderì allo sciopero che riuscì a portare la settimana lavorativa a 40 ore. Furono le operaie che crearono lo slogan: «Vogliamo il pane ma anche le rose», durante gli scioperi nel settore tessile di Lawrence, nel Massachusetts.

"VOCI"—Interviste da Ellis Island

Lei [mia madre] ci mandava dei soldi [in Italia] ogni mese. Lavorava in una fabbrica di guanti. In effetti, sono arrivata [a New York] di domenica, era il giorno di Pasqua. Era il 3 di aprile. Il mercoledì successivo sono entrata anch'io a lavorare in una fabbrica di guanti. C'era un uomo, aveva il palmo di cuoio, e poi ci cucivi le dita, sai, con la macchina. La macchina per cucire, no? E così è stato solo per un paio di giorni, sono andata a lavorare. Erano tutte italiane. Parlavano loro per me.

> —Mary Sartori Molinari, nata il 18 luglio 1901 in Italia del nord; arrivata negli Stati Uniti nel 1920, all'età di diciotto anni, traversata su *La Savoie*[3]

Lui lavorava in fabbrica e si portava il lavoro a casa e lavorava duro. Ed era debole di salute ed era fisso là, penso che aveva l'abitudine di sedersi sul tavolo della cucina e di mettere i piedi su una sedia per essere più vicino alla luce sopra la testa e cuciva colletti, colletti da uomo. E mia madre aiutava, lo aiutava quando lui portava il lavoro a casa. E poi lei aveva il lavoro suo durante la giornata. Lavorava e lavorava, penso che erano vestiti da donna. Cuciva perline, sui vestiti, e avevano questo – lo chiamavano "caralla" – è come una tavola che mettono in cucina, e lei ci lavorava sopra. E poi aveva lavoro a casa per noi, me e mio fratello. Cucivamo piccoli, erano dei piccoli centrini e dei fiori che dovevi cucire. Era una specie di lavoro a cottimo quello che facevamo. Prima di andar fuori a giocare dovevamo fare quel tipo di lavoro. E questo è tutto. E poi ci lasciava andare fuori a giocare. E mio fratello era piuttosto bravo, infatti a cucire.

> —Madeline (Maddalena) Polignano Zambrano, nata il novembre 1915 a Putignano, provincia di Bari[4]

Ho parlato a mio cugino e lui, lui era qui da circa quattro anni prima di me e fabbricava dadi e attrezzi. Lavorava in una fabbrica, a Greenpoint, a Brooklyn. Dadi e attrezzi e guadagnava 24 dollari alla settimana. Era un bravo meccanico. E mi ha trovato un'occupazione per lavorare con lui in fabbrica, per imparare il mestiere, dadi e attrezzi. Così andai a lavorare con lui, mi trovò una camera downtown a New York, nella Bowery. È il posto peggiore dove trovare una stanza. Avresti dovuto conoscerlo in quei giorni, non oggi, non so com'è oggi, ma tutto questo era in quei giorni: il posto peggiore dove vivere, la gente peggiore con cui abitare. Così, mi ha trovato una camera là, lavoravo per lui e dovevo prendere un treno per andare a Brooklyn, al Greenpoint, ogni giorno a lavorare. Mi dovevo comprare da mangiare, dovevo pagare la lavanderia, non ce la facevo, otto dollari non bastavano. Così ho parlato al capo officina e gli ho detto: «Non posso lavorare qui. Me ne devo andare. Otto dollari non bastano.» Allora me ne ha dati dieci, e dieci dollari non bastavano. Me ne dà dodici, e con questo quasi ce la facevo. Allora ho pensato, così non va bene. Sono andato a trovare il Console d'Italia da qualche parte a New York. Gli dico che volevo tornare in Italia. «Okay» mi dice, mi chiede dove abitavo. Gli dico giù nella Bowery. Gli do il numero, l'indirizzo, proprio sotto la Terza Avenue nella Bowery. [ride]. Non me lo dimenticherò mai. Piangevo la notte. È come, è come essere morti. Quasi non ce la fai, non ce la fai a campare. Così lui ha detto:«Okay» – mi ripeté – «non appena troviamo una nave e una cabina sulla nave, ti chiameremo e ti rispediremo in Italia». Era d'accordo a rimandarmi indietro.

No, non ero felice per niente. Volevo tornare in Italia perché, vedi, a questo punto riuscivo a campare meglio in Italia, e non riuscivo a capire perché parlano così bene degli Stati Uniti dove, se non hai un lavoro, che non era una cosa facile trovare un lavoro, se non hai un lavoro muori di fame! Che è ciò che ho fatto per la maggior parte della mia vita.

> —Carmine Martucci[5]

Legami con la Patria

Anche se i primi anni furono duri, la maggior parte degli immigrati rimase in America e in modo costante spedì le proprie rimesse come sostegno alle famiglie in Italia. Questo afflusso di valuta estera aiutò effettivamente a stabilizzare le economie sempre in difficoltà dei paesi rurali di montagna. Ad un certo punto il governo italiano favoriva in effetti l'emigrazione di massa per attenuare le proprie responsabilità rispetto al le condizioni socio-economiche depresse di quelle zone.

Gli uomini spesso lavoravano per lunghi periodi prima di guadagnare abbastanza per pagare la traversata a mogli e figli. In Italia i figli di emigranti venivano chiamati sprezzantemente "figli d'Americani" e le loro madri erano le "vedove bianche", perché agivano da capofamiglia in assenza dei mariti. Molti in Italia aspiravano a venire nella "terra promessa", e inevitabilmente vi era anche un po' d'invidia a causa delle maggiori possibilità a disposizione per i parenti degli immigrati, i quali ricevevano i pregiati dollari americani.

Quando "Pop" ci ha scritto che i documenti erano tutti pronti e lui ce li ha mandati per riempirli e tutto, noi eravamo tutti eccitati all'idea di venire qui. E i nostri amici hanno cominciato a prenderci in giro, ora stiamo per diventare americani, e dobbiamo imparare a mangiare i pomodori crudi [ride] perché noi non mangiavamo i pomodori crudi, e cercavamo di farlo, ma proprio non riuscivamo a mandarli giù. E mi immaginavo di portare vestiti coi fronzolii e scarpe di pelle di vernice, e mi immaginavo strade d'oro. Siamo rimasti così delusi quando siamo arrivati.

—Renata Nieri Maccarone, nata il 14 novembre 1919 in Italia del nord; arrivò dall'Italia nel 1929, all'età di nove anni, traversata sull'*Augustus*[6]

Datemi le vostre masse stanche, povere,

che si accalcano anelando a respirare liberamente,

i rifiuti miserabili dei vostri lidi brulicanti.

Mandate a me costoro, i senza patria, gli squassati dalla tempesta.

Sollevo la mia lampada a lato della porta d'oro.

—Emma Lazarus

Lettere

Carissimo figlio,

Non puoi immaginarti quanto siamo stati contenti nel ricevere la tua cara lettera, non stare in pensiero per il denaro che l'abbiamo ricevuto, non solo le L 25 ma anche le altre L 5 che ci hai mandato. Erano state prese da un altro Decunto Vincenzo, ma però ci sono state restituite. Un' altra volta ad evitare questi sbagli mandali intestati a Miraglia Mariu fu Leonardo, ma del resto mio caro figlio non pensare al denaro perché noi amiamo il sangue e siamo contenti di ricevere tue lettere spesso ed anche senza denari non importa.

Tu dici che hai piacere di rivederci, ed anche noi però ti vorremmo vedere anche tanto ricco secondo la tua intenzione, e speriamo che Iddio te lo concedi. Se decide di venire in Italia, farci sapere il mese. Non puoi sapere quanto piacere abbiamo avuto nel sentire che ti rivedremo, poco n'e' mancato che non siamo svenuti, tu ce lo dici, pero a noi sembra un sogno. Del resto, il Signore ti faccia guadagnare bene, e così ti potremo rivedere. Non altro noi di salute stiamo bene e non mancare di ricordarci quando Iddio ti provvede. Ricambiaci i saluti a Clementina; dalle sorelle non abbiamo avuto lettere se le scrivi non mancare di ricordarle che ci scrivessero spesso. Sante Benedizione siamo I tuoi cari genitori.

Affma.

—*Vincenzo e Mariantonia*

Questa lettera presente sui pannelli centrali - datata 1910 - è di Vincenzo e Mariantonia De Cunto al loro figlio Ralph, che era emigrato dall'Italia, da Potenza, a Boston, Massachussets. Non li rivide più. Per gentile concessione della famiglia De Cunto[7].

La storia di Concettina

Concettina lavorava in una fabbrica di abbigliamento a Boston. Incontrò il suo futuro marito, Ernesto Piscopo, nel North End, che era il quartiere italiano della città. La sua famiglia era arrivata da Taurasi a metà dell'Ottocento ed era ora proprietaria di ristoranti e alberghi in città. I De Iorio avevano conosciuto parenti dei Piscopo in Italia.

Benjamin Piscopo, fratello di Ernesto, era un rispetato membro della comunità ed aveva aperto delle imprese in società con la famiglia Fredericks. Si diceva che alcuni degli alberghi potessero anche essere serviti come bordelli, che erano un dato di fatto nella vita degli immigrati a quel tempo, dal momento che c'era un gran numero di uomini soli. Ernesto fece la corte a Concettina inviandole una carrozza per andarla a prendere alla fabbrica all'ora di chiusura. Immaginate questa ragazza proveniente dalla provincia italiana salutata da un mazzetto di violette e da una carrozza trainata dai cavalli! Le delicate viole mammole sono sempre state i suoi fiori preferiti che le ricordavano il suo primo amore.

Lettere

Cara Concettina,

vi scrivo poche righe per farvi sapere che io l'amo così tanto che non posso vivere senza il vostro amore, ma sapendo che ho conquistato il vostro amore allora vivo felice.

Sarò a casa vostra per incontrarvi stasera tra le 7 e le 8.

Trasmetta i miei migliori saluti a Mamma e Annie.

> *Rimango il Vostro tenero innamorato*

> *—E.W. Piscopo*

P.S. Scriveto anche voi una lettere, carissima bella Concettina

Cara Concettina,

sono così felice che vi siate divertita ieri sera a teatro e ringrazio moltissimo voi e Annie per i regali che entrambe mi avete inviato. (Mamma ti saluti a tutto.)

Cara Concettina,

È lungo tempo che ho avuto l'onore di conoscervi, e pur tuttavia non mai ardito di farvi nato l'immenso amore che nutro per voi. Un silenzio più lungo sarebbe per me un tormento, permettete quindi che i sentimenti dell'anima mia, e lasciatemi la lusinga di poter un giorno ottenere la vostra mano. Incoraggiato da una risposta favorevole, mi farò un dovere esporre ai vostri genitori la sincerità dei affeti e le mie intenzioni sull avvenire. Acconsentite chi io vi esprima ancora una volta I sensi della mia piu' alta stima e credetemi,

> *Vostro*

> *—Ernest W. Piscopo*

Ernesto Piscopo era nato in America e anche se parlava e scriveva in italiano, questo non era sempre grammaticalmente corretto.

Rotolo di un'antenata: Concettina De Iorio

Il colore preferito di mia nonna era il rosso, ma lei vestiva sempre di nero. L'intera sua vita fu rovinata dal matrimonio con un uomo che la tradì più e più volte, finché alla fine lei ottenne una separazione legale da lui. Durante tutta la mia infanzia si lamentò della sua sorte sventurata. Ero la sua preferita e ascoltavo le sue storie per ore e ore nella soffitta gremita di file e file di casse e scatole accatastate con sopra delle coperture di stoffa colorata. La luce filtrava attraverso delle finestrelle ed ogni davanzale era pieno di piante che lei impiegava ore ad annaffiare. Mia nonna aveva una volontà forte e ci dominava tutti. Aveva acquistato la casa di Gladstone Street quando essa appariva come un castello fatto di stucco con mica luccicante nell'impasto. Mia madre ne raccoglieva manciate dopo la pioggia quando era bambina. Rimase una donna sola per tutta la vita perché la Chiesa Cattolica le proibiva di risposarsi e così la sua amarezza permeò tutta la vita intorno a sé. Costrinse mia madre a essere sua figlia – vivendo insieme a lei tutta la vita, se si eccettuano pochi mesi che mia madre ebbe tutti per sé insieme a mio padre a Washington, D.C. dopo le nozze. Io ero per lei "il suo piccolo raggio di sole" e pagò le mie lezioni di pianoforte così che potessi suonare l'"Ave Maria". Diceva sempre che "Se c'è la volontà, la via si trova" e probabilmente, se non fosse stato per il suo insegnamento ed esempio, non sarei mai diventata un'artista, perché è stato così duro mantenere me stessa e i miei piccoli e contemporaneamente portare avanti il lavoro. Aveva una volontà di ferro, era completamente dedicata ai valori morali della cultura dei proprietari terrieri, sempre la signora, "Donna", che comandava. Ritornò in Italia con mia madre quando la mamma aveva cinque anni, vi rimase due anni, ritornando poi in America per i successivi trentadue e lasciando la sua casa di famiglia nelle mani di un custode che la lasciò decadere a sua insaputa. Lui vendette perfino alcuni degli oggetti della casa. Lei era il centro dominante della famiglia e divenne più dolce nei suoi ultimi anni, spesso parlando della "via di mezzo" morendo in una casa di cura con una sola gamba – la sua preziosa fedina d'oro intrecciata rubatale dal dito sul letto di morte. Quando ci salutammo per l'ultima volta, le dissi che le avevo sempre voluto bene e lei mi rispose: «anch'io». E' stata la mia vera madre in qualche modo, che mi ha cullato quando sono tornata a casa dall'ospedale e mi ha confortato quando il latte di mia mamma mi faceva star male. Lei è il motivo per cui mi sento italiana quanto lo sono in realtà. La sua vita aveva molto dolore racchiuso nel suo intimo, nessun luogo dove metterlo se non in ciascuno dei suoi piccoli punti perfetti. Dalle foto guarda diritta in faccia, sempre con lo sguardo fiero.

Concettina ed Ernesto – Un cuore infranto

Risoluta per natura, Concettina insistette nello sposare Ernesto nel 1906. Aveva 22 anni. Fu una decisione di cui si pentì per tutta la vita. Lo stesso padre di Ernesto si opponeva a questa unione, perché suo figlio era un tale "playboy". Dal momento che Ernesto era nato in America, Concettina divenne una cittadina naturalizzata attraverso il matrimonio. Malgrado gli sforzi di lei di creare con lui una casa, egli si rivelò assolutamente non degno di fiducia e la ingannò costantemente. Nel 1909, Concettina presentò i documenti per ottenere gli alimenti e la madre di lui, Filomena Vesce, comparve in tribunale per garantire il pagamento degli stessi dal momento che Ernesto rifiutava di comparire.

Accordo firmato questo primo giorno di aprile, nell'anno del Signore 1909, da e tra FILOMENA V. PISCOPO, di Boston, Contea del Suffolk, e Stato del Massachussets, contraente della prima parte, e CONCETTINA D. PISCOPO, moglie di ERNEST W. PISCOPO, della detta Boston, contraente della seconda parte,

SI CERTIFICA *che*

POICHE' *il detto ERNEST W. PISCOPO si è dichiarato colpevole dell'accusa di adulterio davanti alla Corte d'Appello della Contea del Suffolk, caso rubricato al n. 1307 per l'anno 1909, e*

POICHE' *la contraente della prima parte, madre del predetto, desidera "prevenire" la sentenza sulla accusa citata e provvedere agli alimenti ed al sostegno economico della di lui moglie… pagherà sei (6) dollari alla settimana ogni quattro (4) settimane oltre ad una multa di $100,00.*

Testo dell'Accordo di Separazione Legale tra Concettina ed Ernesto.

Lettera di Ernesto ad una delle sue amanti

Boston, Mass. 31 dicembre 1913

Cara Margaret,

ho pensato di scriverti alcune righe per farti sapere che sono col cuore terribilmente spezzato a causa di come ti sei comportata e ti continui a comportare. Ho cercato di fare per te ogni cosa nelle mie possibilità pensando che forse ciò ti avrebbe resa contenta, ma vedo che non ha funzionato, così, se questo è per il meglio, interromperemo i nostri rapporti e ti lascerò trovare la strada che ti renda felice.

Augurandoti buon anno e ogni fortuna nel mondo. Resto

> *Il tuo amico*
>
> *—Billie*

P.S. Ricorda, Margaret, che con questa lettera non intendo dire che dobbiamo rompere la nostra amicizia, perché in qualsiasi momento, se ci sarà qualcosa che potrò fare per te io sarò sempre lieto di farlo.

Margaret,

non uscire stasera. Farò in modo che tu ne abbia abbastanza.

> *—Bill*

Rotolo di un'antenato: Ernesto Piscopo

Mia nonna non parlava mai dell'uomo che l'aveva sposata – oh, soltanto un po' di quando si incontrarono per la prima volta. Lui le mandava viole mammole e talvolta l'andava a prendere dopo il lavoro con un calesse tirato da un cavallo. Era nato in America ma veniva da una famiglia originaria di Taurasi, in provincia di Avellino. Quando ho visitato l'Italia nel 1962, a Taurasi era arrivata l'elettricità solo pochi anni prima, negli anni Cinquanta. Ernesto aveva frequentato scuole private nel Massachussets, ma malgrado queste opportunità era divenuto un giocatore d'azzardo, un donnaiolo e un disonesto. Mia nonna insistette nel volerlo sposare. Perfino il padre di lui fece visita al padre di mia nonna e gli disse: «Sarebbe meglio che mettessi tua figlia sulla strada che farle sposare mio figlio!». Ma mia nonna era ostinata e lo volle sposare. La famiglia di lui era ricca, ma quando lei era arrabbiata arrivava a chiamarli "cafoni" – per lei ciò significava che non avevano educazione. Mia nonna era invece una "Donna" – proveniva da una famiglia di proprietari terrieri in Italia – cosicché, sposandolo, si era unita ad uno di "classe sociale inferiore", ma lei affermava di amarlo. La famiglia di lui, i Piscopo, era proprietaria di molti ristoranti, alberghi e bordelli del North End di Boston e di metà della città di Laconia nel New Hampshire. Mio nonno prelevava il denaro per depositarlo in banca e se la svignava. Mia nonna trovava nelle sue tasche bigliettini provenienti da altre donne. Si allontanava sempre da casa senza informarla. Ad un certo punto della loro vita coniugale le trasmise anche una malattia venerea. Alla fine, lei ottenne una separazione legale e lo abbandonò. Lo vidi una sola volta – nella bara. Andammo alla sua veglia funebre insieme, mia nonna, mia madre ed io. Gli era rimasta una sola gamba ed aveva finito per vivere con la cameriera della sua famiglia. Aveva avuto quattro figli da quest'ultima e, negli ultimi anni, gestiva un negozio di dolciumi all'angolo di una via di Roxbury. Mia madre vedeva raramente suo padre. Quando si trovava al college lei riusciva a fargli ogni tanto una visitina di nascosto. Lei crebbe senza padre. Mia nonna ha conservato tutto, ma non esiste una foto delle loro nozze. Sono invece conservati i libri di scuola di lui, che frequentava la Allen School, una scuola privata di West Roxbury nel Massachussets, oltre ad un ritaglio di giornale che parla di lui scoperto mentre dava un assegno a vuoto, e poche delle sue prime lettere. Il cognome Piscopo lo si può ancora vedere in Fleet Street, nel North End di Boston, inciso su un architrave di granito. La sua famiglia possiede la tomba più imponente e monumentale di tutto il cimitero.

L'istruzione: ma non per tutti

L'istruzione rappresentava un'opportunità preziosa per la maggior parte degli immigrati. Alcuni bambini studiavano a casa o in scuole ospitate in centri di assistenza sociale di quartiere – imparando non soltanto a leggere e a scrivere, ma anche il modo corretto di occuparsi della casa (secondo lo stile americano), badare ai bambini e anche fare una proposta di matrimonio! La maggioranza dei bambini doveva aiutare a sostenere le proprie famiglie facendo lavoretti a casa e, perciò, frequentavano la scuola solo part-time oppure non ci andavano affatto.

"VOCI"—Interviste da Ellis Island

Mio padre era molto severo, davvero. E voleva, nella sua mente, voleva che andavo a lavorare, poiché quando mi ha registrato al Comune, ha dichiarato che avevo un anno in più. Ora, tutto questo succedeva qui. Dovevo avere più o meno quattordici anni, e mio padre voleva che andavo a lavorare.

Ma io volevo andare a scuola. Il preside della mia scuola qui a Hopedale è venuto a casa e voleva sapere perché mio padre non voleva mandarmi a scuola. Ero una ragazza molto intelligente. Mi piaceva la scuola. Mi piaceva la storia, mi piaceva la geografia, l'inglese. E, improvvisamente, tutto si fermò.

Andai a lavorare nel negozio di elastici a Milford. Era un gran telaio. Mi faceva una paura tremenda. E ci ho lavorato per due giorni. Poi hanno voluto il mio certificato di nascita, perché sapevano che non ero grande abbastanza. Non ci sono più tornata. Non gli ho portato il certificato di nascita e non ci sono più tornata. E mio padre era furioso, e – peggio per lui! – non ci sono più tornata. Ho guardato, sono rimasta a casa e ho guardato mia sorella, perché allora lei era nata. Mia madre era sempre malata. Stava male. Lei è stata malaticcia per tutta la vita.

—Dena Ciaramicoli Buroni[8]

"VOCI"—Interviste dal *Filo della Vita*

Sono andata al lavoro molto giovane e mio padre non mi ha nemmeno fatto finire la scuola superiore. Era abbastanza comune. A sedici anni, via, al lavoro. Lui era l'unico a lavorare e aveva sei figli. Lo capivo. Il mio primo lavoro era a tre dollari alla settimana, tagliare la sfilacciatura. Cioè, dopo che l'operaia aveva finito il capo di vestiario, bisognava guardare attentamente e tagliare tutti i lunghi fili che pendevano, capito? Ora non lo fanno più; lasciano semplicemente i fili.

Dovevo riportare a casa tutta la mia paga. Mio padre mi dava una piccola indennità, venticinque centesimi al giorno. Prendi la metropolitana, cinque centesimi. Con venticinque centesimi prendevi la metro avanti e indietro e ti compravi il pranzo. Ma poi, dopo che ho lavorato alcuni anni, mi sono fatta furba. Ho detto al mio capo: «Dammi due buste, una per mio padre e una per me». Ero un'operaia a cottimo, e quindi lui non sapeva quanto guadagnavo. Beh, sai, bisognava sopravvivere.

—Catherine D'Alena Villanova[9]

"VOCI"—Interviste da Ellis Island

Non ho finito. Ho frequentato soltanto due anni di scuola superiore perché non mi potevo comprare vestiti o niente altro di nuovo. Mio fratello voleva proprio che continuassi la scuola e che poi andassi al college. Non ero stupida ma non riuscivo a rendermene conto per niente, perché avevo bisogno di un po' di indipendenza e così pensavo che il denaro me l'avrebbe data. Quindi, dopo due anni di scuola superiore la mia amica ed io, che avevamo iniziato la scuola insieme, l'abbiamo abbandonata insieme. Siamo andate all'istituto commerciale e poi a lavorare. Che grande sensazione era di consegnare a mia madre del denaro, ma eravamo anche in grado di mettere da parte dei soldi per comprarci dei vestiti, andare ad uno spettacolo e cose del genere. Era un altro mondo.

—Elda Del Bino Willits[10]

Bene, cominciai ad andare a scuola in quei due anni che trascorremmo a New York. E ho pochissimi ricordi della scuola, eccetto il fatto che sedevo là, e non capivo assolutamente che cosa succedeva. E infine un giorno mio padre rifiutò di ricevere in casa altri giornali tranne quelli inglesi, americani, quotidiani. Voleva imparare e rifiutò di avere altri giornali, giornali italiani in casa. Così che potessi sfogliare quei giornali che lui comprava. Ed era solito comprare non ricordo quale quotidiano, ma era un giornale con molte fotografie, perché le immagini lo aiutavano a capire ciò che leggeva.

Così, naturalmente, lo guardavo anch'io e naturalmente, guardavo in particolare quello che ora so che erano i fumetti; cercavo di capire che cosa dicevano. E poi, certo, andavo a scuola. E riesco ancora a ricordare, Janet, ancora oggi, il giorno in cui lessi e capii il significato. Fu per me come una rivelazione, l'essere in grado di guardare quelle parole e CAPIRE cosa significavano. Me lo ricordo ancora oggi. Sì. Così, fu come, fu come il completo dischiudersi di un nuovo mondo per me, il fatto che CAPIVO ciò che avevo letto.

—Felicita Gabaccia Salto, nata il 30 agosto 1913 a Masserano (Biella), Italia; partì all'età di sei anni sulla *Dante Alighieri*[11]

Giovani Imprenditori

Molti ragazzini di undici o dodici anni vendevano articoli vari da porta a porta o merci in deposito da carretti a mano. Gli "arabi di strada" erano degli orfani anche meno fortunati che venivano cacciati fuori dai casamenti affollati e messi direttamente sulle strade. Intraprendenti e indipendenti, essi talvolta si spostavano nella Newsboys Lodging House (pensione per strilloni di giornali), dove potevano ottenere un prestito per iniziare piccole attività commerciali come lustrascarpe o strilloni di giornali. Gli italiani, col loro forte senso della famiglia, contribuirono con la percentuale più bassa fra tutti i gruppi di immigrati – meno del 2% nel 1900, secondo il riformatore e giornalista Jacob Riis – a questa pratica di mettere i figli fuori casa a cavarsela da soli.

College per immigrati

L'American International College (A.I.C.) fu fondato come College francese protestante nel 1885 a Springfield nel Massachussets. Fin dall'inizio, questo college si dimostrò sensibile ai bisogni degli studenti immigrati. Le tasse scolastiche erano "nominali", con un meccanismo di scala mobile e di borse di studio. Poiché la maggioranza dei primi studenti proveniva da famiglie di agricoltori, le lezioni finivano all'inizio della primavera per consentire la messa a dimora delle colture. Alla fine, la missione di questo college si allargò fino ad includere gli studenti nati all'estero provenienti da molti paesi e il suo nome fu ufficialmente cambiato in American International College nel 1905.

Ci siamo riuniti qui nelle aule del college Da terre al di là dell'oceano;

sentiamo il vincolo umano che lega I nostri cuori in unità;

ma, oh! Desideriamo ardentemente che coloro
che abbiamo lasciato In terre al di là dell'oceano,

conoscano le benedizioni di questo Paese: Amore, Verità e Libertà.

Dalle vigne delle vallate d'Italia, Dalle aspre alture della Bulgaria

dalla Grecia delle famose opere classiche,
Dalle tribolazioni e dai travagli della Turchia,

dalla Russia e dall'India e dalla vasta Cina
fino al mare gelato della Svezia,

dalla Spagna e dalla Francia con squillo di trombe
Invochiamo la Libertà.

Hurrah per l'A.I.C., per la Verità e la Libertà!

Perché i fratelli provenienti da tutti i Paesi, siamo noi:
Stringiamoci le mani attraverso l'oceano.

—Parole e musica del Rev. R. De Witt Mallary, D.D., Presidente
dell'American International College, 1908–1911

La nuova vita di Concettina

Durante uno dei molti periodi di separazione da Ernesto, Concettina divenne studentessa dell'American International College e vi trascorse due anni - dal 1911 al 1913 – studiando per diventare insegnante di francese. Dei circa 100 studenti presenti in quel periodo, un quinto era di sesso femminile. Ella fu una studentessa eccellente e conservò tutti i temi scolastici e i libri del college.

Tra Concettina ed una delle sue insegnanti, Mrs. Frances (Fannie) Eldredge, nacque un'amicizia che durò tutta la vita. Malgrado il fatto che ci fossero diversi professionisti che aspiravano a sposarla, lei lo considerò sempre impossibile perché la sua fede cattolica le impediva di ottenere il divorzio. Il dottor Raymond Bonelli, un vedovo anche lui emigrato da Lapìo, era uno di questi pretendenti e le scrisse continuamente fino a quando, nel 1923, morì prematuramente in un incidente d'auto.

Ospedale Anson, Panama

6 ottobre 1912

Mia cara signora Piscopo,

ho ricevuto la Vostra lettera del 15 settembre e sono molto lieto di avere Vostre notizie. Sono particolarmente contento che siate tornata a scuola e siate così interessata ai Vostri studi. E' certamente bella la gamma di materie scelte quest'anno. Vi auguro il miglior successo.

Dovete cercare di spiegare a Voi stessa qual è la causa di questa sensazione di infelicità e provare a sbarazzarvene. Voi non siete più una bambina e non avete più bisogno dell'assistenza di qualcuno per far ciò. La mia personale esperienza di vita mi ha insegnato che la miglior cosa da fare è di provvedere a se stessi senza aiuto altrui e di non dipendere mai dall'assistenza di altre persone. Naturalmente, esistono pochi, davvero pochi, amici su cui contare.

Me la sto cavando alla grande, grazie; inoltre, mi aspetto un futuro molto buono e promettente.

Sono molto felice che Vostro padre e Vostra sorella stiano bene; trasmettete loro i miei migliori saluti.

Sarò sempre lieto di ricevere notizie da Voi e rimango

il suo sincero amico

Bonelli

Boston, Mass.

12 aprile 1923

Cara Concettina,

la notizia della Vostra partenza per l'"Old Country" (il "Vecchio Mondo") mi è giunta con grande sorpresa. Davvero non l'ho saputo fino al momento in cui Voi già contemplavate la Luna Napoletana. Deve essere stato meraviglioso rivedere il caro Lapìo e la regione circostante: terra della nostra nascita e della nostra infanzia. Mi chiedo quanti dolci ricordi abbiano oramai attraversato la Vostra mente. Posso immaginare tutto ciò - e quanto bramo viaggiare fin là un qualche giorno. Ma, ahimé! Un desiderio è solo un desiderio, soggetto al destino, e chi sa quale destino c'è in serbo per noi?

Sebbene la Vostra lettera sia molto breve, traggo da essa che voi tutti dovete trascorrere felicemente questo periodo - è mio sincerissimo desiderio che tutti voi trascorriate ore liete e che la vostra felicità sia senza limiti.

Voi siete sfuggita al più rigido inverno nella storia di Boston - una quantità enorme di neve e un clima estremamente freddo, ai quali si è aggiunta la mancanza di carbone aumentando le sofferenze della popolazione; come conseguenza, c'è stata una gran quantità di malattie. Ma finalmente è arrivata una tardiva primavera e la maggior parte di noi ha già dimenticato le asprezze che il "Jack Frost" (l'inverno) ci ha ammannito. Altri avvenimenti qui a Boston sono di poco o nessun interesse per entrambi, così li eliminerò finendo qui la mia breve relazione. Ripeto il mio desiderio che là possiate avere un soggiorno piacevole e felice e l'augurio di un pronto e felice ritorno a Boston, dove saremo lieti di salutarvi con un "Bentornati".

Sinceramente,

— Raymond P. Bonelli
 261, Hanover Str.

Questa è l'ultima lettera del Dott. Bonelli a Concettina prima della morte di lui.

Temi dal College

Concettina divenne membro della Debating Society e scrisse molti articoli vivaci su temi come la Costituzione americana, la legislazione sul lavoro infantile, ecc. Il settore su cui si concentrò in modo particolare fu lo studio della lingua francese, dal momento che nutriva un'appassionata speranza di diventare un'insegnante di francese. Scrisse anche di argomenti creativi e compose delle poesie. E' interessante notare il progressivo aumento della sua padronanza della lingua inglese con il procedere negli studi.

Fare Denaro

Quando pensiamo che il denaro è un valore in sé, ci sbagliamo in parte, poiché il denaro in sé non ha molto valore eccetto che per il metallo di cui sono composti, [sic] e il denaro cartaceo non ne ha alcuno, ma rappresenta soltanto il denaro.

I titoli d'argento e d'oro ci mostrano soltanto che dell'oro e dell'argento era stato depositato per acquistarli Le banconote ci dice [sic] che del denaro è stato depositato in banca e che esso sarà pagato su richiesta; ma per far questo la banca stessa ha dovuto depositare un certo ammontare di denaro presso "Uncle Sam" (il governo), così che la sua promessa non corra il rischio di non essere onorata.

Abbiamo anche i "greenbacks"(banconote) e i "Treasury Notes"(buoni del Tesoro); anch'essi rappresentano il denaro e ci garantiscono che verranno pagati in moneta nel momento in cui lo chiederemo.

Estratto dal tema di Concettina dal titolo *Fare Denaro*.

Legislazione sul Lavoro Infantile

Le leggi degli Stati Uniti sul lavoro infantile sono eccellenti. Esse fanno obbligo ai bambini dai 6 agli 11 anni di andare a scuola. La "Uniform Child Labor Law" adottata la scorsa estate dalla Commissione (parlamentare) sulle Leggi degli Stati Uniti e raccomandata a tutti gli Stati perchè l'adottino, abbraccia nel giudizio della Commissione le migliori caratteristiche delle leggi per la protezione dei bambini che lavorano adottate in qualsiasi altro Stato.

La legge ritiene che ogni bambino abbia il diritto di crescere forte e diventare un uomo o una donna utile alla collettività, ma vi sono genitori pronti a vendere i diritti dei propri figli; per questo lo Stato ha una legge per proteggerli.

Un lavoro infantile che sia adatto a loro e fatto sotto la guida di genitori saggi è positivo per i fanciulli, ma lo si trova così raramente che è stato necessario che gli Stati Uniti approvassero leggi per la protezione dei bambini dallo sfruttamento sia dei genitori che dei datori di lavoro; perciò la scuola deve insegnare ai fanciulli come lavorare in condizioni adeguate come parte di un'educazione solida e ben fatta, giacché le persone più utili al mondo sono quelle istruite. Vi sono molti bambini che non possono essere gestiti dai propri genitori e in tal caso il tribunale ha il diritto di sottrarli al loro ambiente familiare.

Qualche tempo fa lessi, nei giornali di New York, di una famiglia che l'anno scorso cuciva nella propria abitazione le zampe impagliate dei "Cambell Kids". Il produttore, che aveva affidato loro il lavoro, era adirato al riguardo e glielo tolse. Quest'anno si è scoperto che la stessa famiglia rifiniva biancheria intima. Le tre bambine appartenenti alla famiglia, la più grande delle quali aveva undici anni, testimoniarono davanti alla New York State Factory Investigation Commission (Commissione d'Indagine sulle Fabbriche dello Stato di New York) che tre di loro dovevano infilare nastri in una dozzina di copricorsetti per guadagnare tre centesimi. Aggiunsero che la loro mamma guadagnava tre volte tanto e che il padre era cieco. Una delle tre ragazzine raccontò a Miss Watson, membro della Commissione, che non aveva tempo per giocare, perché ogni giorno doveva aiutare sua madre fino alle undici di sera. Tutto ciò non ispira compassione? Questo piccolo esempio dimostra perché la legislazione degli Stati Uniti prescrive che i genitori vigilino affinché i loro figli vadano a scuola e prevede che essi possano essere arrestati e multati, se trasgrediscono questa legge. Per di più, se un bambino viene impiegato in un lavoro duro per un certo numero di ore, non può crescere forte e le conseguenze possono essere disastrose.

In quasi tutti questi Stati, c'è una legge che vieta ai bambini al di sotto dell'età lavorativa di essere impiegati nel lavoro, e che se così accade, il datore di lavoro del minore è passibile di arresso. Per tutte queste ragioni, ritengo che tutti dovrebbero elogiare grandemente le preziose leggi degli Stati Uniti.

—Tema di Concettina sull'argomento della *Legislazione sul Lavoro Infantile*

Ricordati

Ricordati di me quando la sera
La squilla suonerà della preghiera
Ed in quell' ora solitaria e pia
Una prece per me volgi a Maria.

Ricordati di me quando ritorno
Sarà il sole nel cielo al nuovo giorno
Prega ch'io mai di te non sia divisa.

Ricordati di me quando la luna
Chiara risplende sopra l'onda bruna
Ed impetra pace al mio dolente core
Che per te solo palpita d'amore.

Ricordati di me quando sul lido
Torna il nocchier lasciando il frutto infido
E prega che nemico vento mai
Rompa ti possa la fe' che ti giurai.

Ricordati di me quando di morte
Schiuse vedrai per te le eterne porte
E dispogliato dal terrestre velo
Spirito immortale salirai nel cielo.

Allora ottieni dal pietoso Iddio
Che ascendere lassù potessi anch'io
E uniti negli angelici splendori
E far soglia un sol cor dei nostri cori.

Questa poesia fu trovata fra le carte più riservate di Concettina. Non è chiaro se le parole dei versi siano sue o copiate con la sua mano da un'altra fonte. Non c'è nessuna attribuzione di paternità del componimento, se non il suo nome, il luogo –Boston - e la data - 9 settembre 1911. Sebbene non indirizzata a qualcuno in particolare, si può dedurre che fu probabilmente spedita ad Ernesto proprio prima che lei cominciasse a frequentare l'American International College. Fu scoperta fra altre carte indirizzate a o provenienti da lui.

Comunità Internazionale di Studenti

La raffinatezza della vita nell'American International College contrastava acutamente con l'asprezza dell'esistenza e la continua lotta della maggioranza degli immigrati. Le statistiche dimostrano che, nel 1910, solo 11 donne e 83 uomini di origine italiana frequentavano un college universitario negli Stati Uniti.[12] Per due anni Concettina De Iorio Piscopo fu una di questi pochi fortunati.

Al College incontrò gente da tutto il mondo. La sua migliore amica fu Arete Sarantopoulos, figlia della famiglia che pubblicava la rivista greca "H NIKH" a New York. Un altro amico, Kyparissiotis, le scrisse quando dovette partire inaspettatamente per prestare servizio nell'esercito greco durante la Prima Guerra Mondiale. Più tardi egli divenne giudice negli Stati Uniti. Durante tutta la sua vita, Concettina parlò con affetto del periodo trascorso all' A.I.C., mantenne rapporti amichevoli con i suoi ex compagni di classe e ricavò una consolazione quotidiana dall'ascolto degli inni Protestanti, in particolare *Rock of Ages*, che aveva appreso là.

Atene, 21 gennaio 1913

Mia cara signora Piscopo,

sono spiacente di aver lasciato l'America senza incontrarla, ma non ho potuto farne a meno. Confido che lei non mi abbia frainteso. Tra poco andrò nell'esercito. Invio i miei migliori saluti.

—El. Kyparissiotis,
fermo posta, <u>Atene</u>
Grecia

Essere o non essere—Insieme?

I giorni di Concettina a Springfield furono intensamente occupati dallo studio e dalle scoperte, ma lei continuò a lamentarsi delle difficoltà con Ernesto, che continuò a scriverle, supplicandola di lasciare la scuola e riunirsi a lui. Nel 1913 lei cedette alle sue insistenze ed insieme tentarono una riconciliazione alla fine dell'anno scolastico. Lo zio di lei, Davide Abbate Forte, le scrisse dall'Italia per esprimerle i sentimenti della sua famiglia d'origine di fede cattolica, che abbracciava al di sopra di tutto i valori della fedeltà e della sopportazione. Concettina si trovò costantemente stretta in un impossibile intreccio tra la sua fede religiosa e il comportamento offensivo di Ernesto. Ad un certo momento, lui si ritrovò in carcere per non averle pagato gli alimenti, continuando, tuttavia, a cercare ancora una pacificazione! La risoluzione del loro rapporto continuò ad essere un dilemma, come testimoniano le lettere e le annotazioni da lei conservate.

Lettere

10 dicembre 1912

Alla signora Concettina Piscopo

Mia cara moglie,

immagino che sarai più che sorpresa nell'avere notizie da me, considerando il lungo periodo trascorso dall'ultima mia lettera.

Cara Concettina, tra pochi giorni sarà Natale, perché non rimediamo e non ci sediamo insieme davanti ad un cenone di Natale e ricominciamo a vivere felicemente insieme invece di rimanere separati come abbiamo fatto per gli ultimi cinque o sei anni? Sono più che sicuro che tuo padre e tua sorella non avranno niente da ridire, così spero che vorrai ripensarci e farmi sapere entro pochi giorni così che possa fare i preparativi. Come sai, ho una buona posizione professionale e, dopo che ci saremo rappacificati e le nostre menti si saranno decise, mi rimetterò in affari e avrò tuo padre al mio fianco. Scrivimi e fammi sapere quando verrai a Boston per le tue vacanze di Natale così da poterti incontrare e recarci a casa tua per discutere. Assicúrati di scrivere indirizzando la lettera qui all'albergo, così che possa riceverla immediatamente. Spero che tu stia bene e che potrò vederti molto presto. Rimango tuo marito,

E.W. Piscopo

32, Fleet Street

Boston, Mass.

Lettera di Ernesto a Concettina a lei indirizzata all'American International College.

Viva Gesù e Viva Maria

Lapio. 15-5-913

Mia cara nipote

Ho aspettato alcuni giorni per rispondere alla tua del 23. p.p. Aprile, credendo che giungesse anche quella di tua padre ad Achille, e si rispondeva all'una ed all'altra per risparmio di tempo e di tassa postale –

Non essendo arrivata lettera di D. Luigi; rispondo, senza aspettare di più, alla tua. Sono adunque oltremodo lieto con tutti di famiglia della tua riconciliazione con Ernesto per la quale tanto ho pregato la Madonna del Carmine ed ha fatto tanti reati. Speriamo intanto, e ci auguriamo che la gioia della pace sia duratura e perpetua, e che nessun dissenso abbia a turbarla in avvenire – Tu intanto procura di essere obbediente e rispettosa a tuo marito ed anche a tua suocera, considerandoli sempre come tuoi superiori e dimenticando in tutto le passate dispiacenze. Devi essere sempre umile e prudente, e mostrare infatti ogni interesse per la famiglia e non per la tua persona, anche quando ti sembri di avere ogni ragione, poiché sei tu che devi cedere sempre a loro anche rinnegando la tua volontà e sacrificando i tuoi interessi personali [...].

* * *

Ti saluto anche da parte di tutti di famiglia e ti mando i rallegramenti di tutti color che hanno saputo con grande gioia la tua riconciliazione col marito.

Affmo

Zio Davide Abb Forte

Estratti dalla lettera di Davide Abbate Forte a sua nipote e figlioccia Concettina.

11 gennaio, 1914

Concettina cara,

i tuoi affanni mi addolorano molto. Pensavo che, dopo il vostro riunirvi, non avresti avuto più problemi. Perché quell'uomo ti ha fatto abbandonare il college se voleva continuare a comportarsi così male proprio come prima? Ho paura, Concettina, che tu sia troppo buona. Questo è l'unico difetto che trovo in te. Cedi troppo ai suoi desideri. Noi donne greche e italiane siamo schiave dei nostri mariti. Non è così nelle altre culture nazionali. Se capita qualche problema, siamo noi ad essere rimproverate, mentre non ci viene mai nemmeno chiesto di esprimere le nostre opinioni in materia. Questa è la nostra sorte!

Sono andata a scuola e a lavorare e me ne sono stata anche a casa a fare i mestieri e fare l'infermiera. Ma l'ultimo lavoro a me sembra il più difficile. Tuttavia il nostro compito è considerato lieve e il sesso più forte ne parla con disprezzo.

C'è solo una cosa che può realmente consolarti oltre ad Annie e a Papà, e sono i buoni libri. Ricavo un gran piacere dal leggere i libri e ricordo mi dicesti che piacciono molto anche a te. Perché non leggere 2-3 ore al giorno, cara? Ho spesso avuto l'intenzione di spedirti dei libri da leggere. Sto leggendo ora un romanzo interessantissimo di Jane Austen, il cui titolo è Pride and Prejudice. Nello stesso volume rilegato c'è Northanger Abbey, della stessa autrice. E' un bel volume a stampa rilegato, regalo di uno dei miei insegnanti. Fammi sapere, cara, se li hai letti. Se non lo hai fatto, te li spedirò non appena li avrò finiti. Ti accludo un piccolo quadrato di pizzo fatto ad ago e spero che ti piacerà.

Ciao, cara.

—Arete

Lettera proveniente da Arete Sarantopoulos, amica fidata di Concettina ai tempi dell'American International College.

2 marzo – Providence, ritornato domenica all'una del pomeriggio, da Solo.

Lui è tornato il 16 marzo. Abbiamo fatto pace. Rimasto quattro giorni, venerdì, sabato, domenica e lunedì. Ripartito martedì 20 marzo, con 17 dollari.

Tornato domenica sera, 25 marzo. Ripartito il 29 marzo, giovedì, con 50 dollari.

Ritornato domenica sera, 1° aprile.

Sabato 7 aprile, ritirata la paga, rimasto fuori fino a martedì sera.

Appunti di Concettina sulle irregolari entrate e uscite di Ernesto

Charles Street Jail, 1915

Mia cara moglie,

ti scrivo poche righe per farti sapere che ho certamente sofferto a trovarmi qui e che certo la casa è dopotutto il miglior luogo dove stare. Ora, Concettina, perché non mi fai uscire di qui? Lavorerò e potremo vivere insieme pacificamente, portando avanti bene la nostra esistenza. Da quando sono qui, l'unico che è venuto a trovarmi è stato mio cugino Mickie, ma è venuto una sola volta. Sono qui e ho bisogno di indumenti puliti e dell'altro mio vestito. Per piacere, Concettina, per piacere, concedimi l'ultima possibilità di comportarmi bene e mandami in carcere per un periodo da tre a sei mesi. Puoi fare pace con mia madre e io farò lo stesso con la tua famiglia, e possiamo lasciar perdere il passato e pensare solo al futuro. Immagino che sarà dura ottenere di nuovo il mio lavoro, ma quando Alex saprà che stiamo per tornare a vivere insieme ogni cosa andrà a posto. Se non ricevo notizie da te entro domenica sera, ritirerò il mio ricorso e mi presenterò all'East Boston Court (Tribunale di Boston Est) per ricevere la mia sentenza di condanna a Deer Island (prigione), così capirai quanto questo può significare per entrambi. Per favore, vai a trovare mia sorella e dille che sono terribilmente dispiaciuto che sia accaduto questo e che se solo avessi seguito il suo consigli non mi sarei mai ritrovato qui. Dille anche di andare a confortare mia madre e che quando tornerò a casa certamente sarò una persona diversa. Allora, Concettina, per favore fammi uscire giacché questa esperienza mi è certamente stata di lezione. Di' a mia sorella di stare tranquilla e di non far sapere niente a mio fratello se ci riesce. Desidererei che tu andassi con mia

sorella a trovare mia madre, ma credo non vorrai farlo, così faresti meglio ad aspettare che io torni a casa. Ieri ho fatto una bella chiacchierata con il prete del carcere e mi ha dato un sacco di buoni consigli che intendo seguire. Ti prego, mia cara moglie, fammi uscire di qui e fai di me un uomo anziché spedirmi in prigione.

—Tuo marito Ernest W. Piscopo

Lettera di Ernesto a Concettina dal carcere di Charles Street, dove era stato mandato per non aver pagato gli alimenti alla moglie.

La storia della fedina di fidanzamento di mia nonna

La portò per tutta la vita, questa piccola lamina d'oro intrecciata, due sottili fili attorcigliati. Deve avergliela regalata lui. Malgrado la loro separazione, lei non vi rinunciò mai. Quando mia nonna morì a Parker Hill, (un ospedale), qualcuno rubò la fedina prima che mia madre facesse in tempo ad arrivare. Avevo sempre pensato che sarebbe stata lasciata a me e che così sarei stata in grado di conservare un frammento di mia nonna. La contemplavo sul suo dito, la sua pelle così sottile e rugosa intorno ad essa. Non le vidi mai invece una fede nuziale. E' possibile che mia nonna si sentì "rifiutata"? Alla fine, lui si risposò, o visse con la cameriera. Forse lei ebbe questa sensazione per tutta la sua vita – che le sue infedeltà significassero il rifiuto di lei? Da un certo punto di vista, anche lei lo rifiutò e non gli permise di rientrare nel suo letto. Rimase adirata nei suo confronti per tutta la vita. E lei lo amò sempre? E il dolore fu per questo così profondo?

—Appunti per un diario, B. Amore, marzo 1999

Andando avanti

Una volta lasciato il college, Concettina iniziò la sua attività privata di sartoria per donna per le "Brahmin ladies" (l'aristocrazia) di Beacon Hill, che portavano a casa degli schizzi delle creazioni all'ultima moda di Parigi - che lei avrebbe trasferito nei tessuti. Questa attività avrebbe potuto essere resa più agevole dai contatti con la famiglia Piscopo. Nel censimento del 1920, Concettina risulta indicata come capofamiglia. Luigi lavorava come portiere ed Eufrasia utilizzava la sua competenza di esperta cucitrice. Le fotografie mostrano sempre Luigi intento a leggere. Con il risultato dei risparmi di anni la famiglia fu infine in grado di comprare una casa di tre piani a East Boston, un quartiere della città divenuto una dimora ospitale per molte ondate successive di immigrati. Gli originali abitanti Yankees avevano prima assistito ad un afflusso di immigrati ebrei, poi irlandesi ed, infine, italiani sul finire del diciannovesimo secolo.

I De Iorio parteciparono attivamente alla vita culturale della comunità italiana venendo perfino invitati all'inaugurazione delle celebrazioni della Italy – America Cable (collegamento Italia-America via cavo) nel 1925. Questo fu un evento di grande importanza per le popolazioni di entrambe le sponde dell'Atlantico. Le lettere spedite per nave avevano rappresentato la via di comunicazione più comune, impiegando spesso settimane o mesi per giungere a destinazione. Con l'avvento del servizio telegrafico della Western Union, l'Italia non si sentì più "lontana un oceano".

WESTERN UNION CABLEGRAM

Hanover St. Post Office Building

Inauguration of the Direct to Italy Cable Service under the auspices of the Direct to Italy Cable Service Committee

Roma 52 March 16 1925

His Excellency Calvin Coolidge

President of the United States of America/Washington DC

Mi è particolarmente gradito inviarle Signor Presidente per mezzo nuova via di comunicazione che riavvicina l'Italia all'America l'espressione più viva della mia cordiale amicizia e dei voti che formulo per la prosperità del popolo Americano

Vittorio Emanuele

Cablogramma inviato dal Re d'Italia Vittorio Emanuele III al Presidente degli Stati Uniti d'America Calvin Coolidge

WESTERN UNION CABLEGRAM

Hanover St. Post Office Bldg.

Inauguration of the Direct to Italy Cable Service under the auspices of the Direct to Italy Cable Service Committee

Boston, Mass March 16, 1925

Alle Vostre Reali Maestà

Re Vittorio Emanuele e Regina Elena

Palazzo Reale Roma Italy

Come ufficiale del Comitato dell'Italy Cable Service (Servizio di collegamento diretto con l'Italia via cavo), è con immenso piacere che estendiamo alle Vostre Reali Altezze i migliori auguri da parte degli italiani del Great Commonwealth of Massachusetts, negli Stati Uniti D'America. Gli italiani di

Boston vanno particolarmente fieri di questo nuovo servizio che porterà letteralmente l'Italia nella loro porta accanto. I nostri amici americani si uniscono a noi dell'augurare lunga vita al Re e alla Regina d'Italia e ininterrotta felicità e pace al nostro fermo alleato l'Italia. Saluti.

Allen R. Frederick Chairman
P. A. Santosuosso Secretary
Dr. John Bonfiglio Vicechairman

Cablogramma inviato dal Direct to Italy Cable Service Committee al Re Vittorio Emanuele III e alla Regina Elena.

Tutto bene quel che finisce bene

"Tutto bene quel che finisce bene", era uno dei proverbi preferiti di Concettina durante i suoi ultimi anni. Lei continuò a vivere un'esistenza piena e ricca di sfide in quanto donna italiana, immigrata e madre "single". Con la sua solita determinazione, continuò a provvedere a sé e all'unica figlia nata dal suo matrimonio con Ernesto. Lavorò sempre, risparmiando abbastanza denaro da acquistare una seconda casa nel suo quartiere italoamericano. Nel 1949, quando era caporeparto alla Raytheon Company, comprò il primo televisore di tutto il vicinato. I suoi nipoti furono deliziati quando il soggiorno divenne il fulcro della loro piccola comunità. I loro amici sedevano spesso come incantati di fronte allo schermo tondo, in bianco e nero, con le sue magiche immagini in movimento.

Malgrado il fatto che negli ultimi anni Ernesto cercò di riconciliarsi con Concettina pur avendo costituito una nuova famiglia, lei rifiutò risolutamente di credergli di nuovo e, nel 1952, lo escluse specificamente dal suo testamento. La sua fede cattolica e la devozione al Sacro Cuore la sostennero per tutta la vita. Un forte senso della morale e della disciplina rappresentarono la spina dorsale della sua esistenza. Concettina vide nascere nipoti e bisnipoti e a loro trasmise il suo amore per l'Italia e la sua dedizione alla cultura, alla lettura e all'istruzione. Sperimentò le trasformazioni di quasi un secolo abbracciando con la sua vita gli anni dal 1884 al 1979 e visse fino a novantaquattro anni compiuti.

Diventando americani

"Chi lascia la via vecchia per la nuova, sa quello che lascia ma non sa quello che trova"

I figli degli immigrati, la seconda generazione in America, dovettero affrontare una ridefinizione della loro identità. Spesso non gli fu insegnato neanche l'italiano perché i genitori volevano che diventassero "americani". Allo stesso tempo, quegli stessi genitori desideravano la loro stretta adesione alla "via vecchia", o ai vecchi modi di fare le cose. "La famiglia", il valore fondamentale della vita italiana, è rimasto al centro delle loro vite, eppure c'erano miriadi di conflitti sul come relazionarsi con il mondo esterno ad essa. Tanti di questa generazione si trovarono intrappolati in un conflitto fra la lealtà alla famiglia e l'indipendenza delle loro scelte.

Nina e Concettina

Nina, l'unica figlia di Concettina, apparteneva alla seconda generazione vissuta in America. Ernesto era riuscito a convincere Concettina a ritornare insieme e lei rimase incinta di Nina, che chiamò così in onore di sua mamma, Giovannina Forte, come si usava allora nel rispetto della tradizione del Mezzogiorno. Nina nacque a New York, dove Concettina era andata a raggiungere Ernesto su richiesta di quest'ultimo. Testarda, incinta, e dopo aver viaggiato da sola, arrivò alla stazione. Ernesto non c'era, quindi lei rimase a New York e diede alla luce sua figlia da sola. Forse Concettina diede a Nina il secondo nome di Esperanza, con la speranza che il comportamento imprevedibile di Ernesto potesse cambiare con la nascita della loro figlia. Ciò non avvenne e lei ed Ernesto si separarono definitivamente quando Nina aveva cinque anni.

Caro Papariello,

non vedo l'ora di vedervi ed abbracciarvi Domenica mattina. Io parto domani sera, primo settembre, alle 6 p.m. col vaporetto che arriva a Boston verso le ore otto Domenica mattina. Spero di trovare Annie al dock "India Wharf". Fatemi trovare una bella tazza di caffè. Con me porto una bella bambina. Siete contento? Mille baci affettuosi dalla vostra Concettina.

> —Cartolina spedita da Concettina a Luigi ed Eufrasia (Annie) che annunciava il suo ritorno da New York, dove Nina era nata il 15 agosto 1917

Le Collezioni di Concettina

Nina e Concettina vissero gran parte della loro vita insieme, in una comunità mista italo-irlandese. La loro casa era una grande abitazione vittoriana "white elephant" condivisa con un pensionante, il cugino Henry. La casa era piena delle collezioni di Concettina. La soffitta della casa conteneva file di bauli accatastati, due o tre uno sull'altro, e ricoperti da uno spesso strato di polvere grigia lanoso. Camminare lungo quelle file di bauli era come girovagare per un villaggio in miniatura.

Alcuni oggetti erano stati portati dall'Italia, altri lei li aveva creati o acquistati in America. Concettina conservava una varietà di cose, da un elegante colletto di seta e merletto fatto a mano, alle comuni bottigliette della sua acqua di colonia alle rose preferita. Attaccate ai suoi pacchetti e alle sue proprietà personali, ci sono ancora etichette e liste scritte a mano, sia in italiano che in inglese A volte le note sono semplicemente descrittive, a volte nominano il proprietario dell'oggetto o la sua storia e l'importanza che avevano per lei.

La mentore di Concettina

Anche dopo aver lasciato la scuola, Concettina continuò a rimanere in contatto con la sua insegnante preferita di francese dell'American International College. La signora Eldredge le scriveva di continuo e spesso esortava la sua ex studentessa a partecipare ai raduni dei vecchi alunni a Boston. Ella si autoproclamò la "A.I.C. grandmother" (nonna) di Nina e le regalò due cucchiai presi dai suoi cimeli di famiglia. Quando Concettina e la sua famiglia decisero di ritornare in Italia per un viaggio, la signora Eldredge scrisse una lettera preoccupata visto che la situazione in Europa era così instabile. Concettina ricevette corrispondenza dal College fino alla sua morte, avvenuta nel 1979.

28 ottobre 1915

Cara signora Piscopo,

grazie per le leccornie che sono arrivate oggi con la posta. Sono molto delicate. Mi piace molto quel formaggio. Faremo subito un "coffee party" (festa).

Sono stata proprio molto sorpresa di sapere che stai per partire per l'Italia proprio adesso. Uno o due giorni fa pensavo alla tua partenza, ma "dopo la guerra". Confido che farai il viaggio in tutta sicurezza. Non penso che un sottomarino possa attaccare un vaporetto passeggeri italiano. Assicurati di mandarmi spesso delle cartoline. Sono davvero molto curiosa di conoscere quali saranno le tue impressioni. Sarà un'esperienza che vale la pena di ricordare: questo è per certi versi un evento. Spero seriamente che tu ritorni. Voglio che ci scriviamo di frequente. Ricordati che nessun'altro occupa il posto che tu hai nella mia vita. Mi dispiace non vederti prima che tu parta. Ti penserò tutti i giorni e che le mie preghiere ti accompagnino.

Domenica scorsa ho messo la mia camicetta "buona". C'era dell'<u>argento</u> sul mio cappello, così, sulla camicetta, invece del merletto dorato ho messo, quello bianco cinese che una volta portavo sulla mia <u>vecchia</u> camicetta blu. La signorina Davis ha detto: «Come sta bene!». E' <u>molto</u> carino. Io ne avrò molta cura e penserò a te tutte le volte che lo indosserò.

Da sabato sono molto occupata. Sebbene abbia trovato tempo per scrivere le mie annuali "Auxiliary letters". Non ti invierò il conto proprio adesso che stai per partire. Non penso sia educato o che si confaccia a una lettera di addio.

Ricordami a tuo padre e a tua sorella. Il mio "bon voyage" è anche per loro

 Con molto amore.

 Fannie H. Eldredge

Lettera della signora Eldredge a Concettina che riferisce molti degli aspetti del loro rapporto: la loro amicizia, il lavoro di cucito che Concettina fece per lei, e la posizione della signora Eldredge a capo della A.I.C. Auxiliary di Alunni.

American International College
26 gennaio 1918

Cara signora Piscopo,

ti invio questo piccolo regalo per la bambina. È un vecchio cucchiaio da tè di famiglia che ha 70 anni (tondi tondi). Le iniziali L.L. sono quelle della sorella di mia madre, Lucy See Hosmer. Ho mandato ad Areti uno di questi per la sua piccola bimba. Ho dato via il mio argento poco a poco perché ne posso usare veramente poco. Ho messo fine ai miei ricevimenti. Mi è dispiaciuto sapere che sei stata così male. La signorina Bensow ha avuto la gola molto infiammata, e non è ancora guarita, e la signorina Haywood ha un brutto raffreddore e la tosse. Anche le ragazze hanno avuto il raffreddore ma nessuna è seriamente ammalata. Sto abbastanza bene dopo la mia "colica invernale" o qualsiasi altra cosa fosse. Ho un fastidio alla nuca anche se non mi fa molto male. Il materiale per le Note di gennaio dell'A.I.C. è in mano al signor Mc Gown. Sto scrivendo ai soldati, vedendo se posso fare dei lavori a maglia per loro, etc... Devo al più presto fare del lavoro per l'Auxiliary, quest'anno non è facile per me. Se vuoi mandarmi le quote del 1917-18, fallo. Dobbiamo, almeno, sopravvivere se la guerra viene prima di tutto. Scrivimi quando puoi.

 Sempre con amore,

 F. H. Eldredge

Cara Nina,

spero che tu trascorrerai un felice ottavo compleanno. Stai diventando una ragazzina grande e spero che sentirò sempre delle belle cose sul tuo conto come quelle che tua madre ha potuto mandarmi. Hai trascorso una bella vacanza? So che sarai pronta per andare a scuola il mese prossimo. Sono stata bene qui tutta l'estate ma trovo che non posso andare in giro quanto vorrei. Spero che tua madre mi scriverà.

Con amore F. H. Eldredge

La tua A.I.C. Grandmother

—Cartolina postale inviata da Mrs. Eldredge a Nina per il suo ottavo compleanno, 15 agosto 1925

Una famiglia allargata

Concettina e Nina vissero sempre con Luigi, che morì nel 1937. Eufrasia, la sorella di Concettina, visse con loro fino a quando non sposò Adolfo Anzalone, nel 1925. La famiglia De Iorio era una famiglia davvero piccola per gli standard abituali degli immigrati. Eufrasia e Adolfo non avevano figli. Concettina non si risposò mai. La famiglia stava unita per necessità ma non sempre pacificamente. La natura più coraggiosa di Concettina contrastava nettamente con quella più quieta di Eufrasia. Ciò nonostante misero in comune risorse economiche, spirituali e psicologiche, spesso condividendo le abitazioni e tutti contribuirono all'educazione e all'istruzione di Nina. Eufrasia fu chiamata affettuosamente in famiglia "Zizi" (zia) e Adolfo era lo "Zio".

Rotolo di un'antenata: Eufrasia De Iorio (Zizi)

Eufrasia diventò Annie in America. In Italia aveva trascorso molto del suo tempo con le suore. Il convento si trovava al limitare di Lapio, un paese tutto fatto di pietra vicino ad Avellino e si affacciava su una vasta e profonda vallata. Guardava spesso fuori mentre ricamava, lavorava all'uncinetto, a maglia e faceva merletti. Era molto veloce in tutti questi lavori manuali e ogni qual volta io mi inceppavo con i miei lavori a maglia, scuciva e ricuciva pazientemente il pezzo in modo da non farmi "perdere" tutto il lavoro fatto. Non aveva mai voluto venire in America ma mia nonna, sua sorella, portò qui l'intera famiglia. Negli ultimi anni non andarono mai molto d'accordo, ebbero discussioni e tirate di capelli. Zizi era arrabbiata perché l'avevano portata via dal convento? Era arrabbiata perché suo marito aveva buoni rapporti con sua sorella? Si sposò molto tardi. Suo marito era molto più giovane di lei, bello con i capelli ondulati. Lei era bassa - forse mt. 1.50 - e aveva un viso tirato ma gentile, segnato dal tempo, quando la conobbi. Mi ricordo che dormivano in un piccolo letto singolo l'uno rivolto verso i piedi dell'altra. Lei teneva le mani incrociate sul petto. Vivevano al pianterreno, la parte che che dava sul giardino. Il piano di sopra veniva usato raramente e c'erano teli bianchi sopra le tappezzerie floreali nere, verdi e rosa. A volte arrostiva i peperoni sul fornello al piano di sopra. Io dormivo in una cameretta in cima alle scale. Lo Zio si sentiva solo perché lei non faceva mai l'amore con lui? Mi chiedo se l'abbiano mai fatto. Forse lei faceva l'amore solo con Dio che andava a trovare ogni mattina. Mi ricordo le passeggiate con lei in primavera per andare alla messa delle sette, prima della scuola, dove sedevo con tutte le vecchie signore italiane vestite di nero e con il loro rosario. Sembrava la più felice della chiesa e mi piaceva stare con lei e con le sue amiche, la signora Indrisano e la signora Giaccoppa. I biscotti glassati della signora Giaccoppa erano i migliori!

Rotolo di un antenato: Adolfo Anzalone (Zio)

Adolfo Anzalone entrò a far parte della mia famiglia quando mia madre aveva otto anni. Veniva da una famiglia numerosa di Lapìo. Non era della stessa classe sociale della famiglia di mia nonna. Pare che sia Concetta che Eufrasia fecero dei matrimoni "al di sotto del loro rango". Adolfo era un uomo affascinante. Metteva la brillantina nei capelli. Una volta, quando in famiglia si pensava che avessi la poliomielite, venne a farmi visita dopo il lavoro e si assopì su una poltrona. Quando andò via, sul muro c'era una macchia a forma di uovo. Mia madre era sconvolta, ma quando si rese conto che veniva dall'olio per capelli dello zio, si calmò. Ritagliò un pezzo di carta da parati in modo da farlo combaciare con il motivo circostante e poterla coprire! Era un uomo che sembrava piacere a tutti. Quando morì, molti clienti della sua agenzia di assicurazioni vennero alla veglia funebre e parlarono di quanto fosse gentile. Una vecchia signora si ricordò delle sue visite e mise nella sua bara un piccolo mazzo di fiori viola. Portava molti vestiti per me e per i miei fratelli e giocava con noi tutte le domeniche canticchiando: «Ari, ari, ari e zi' monaco a cavallo a zi' monaco non voleva e o zi' monaco s'accideva. S' accideva co'lo coltello, tichiri, tichiri, capo n'terra!» mentre ci dondolava sulle sue ginocchia e alla fine ci lanciava all'indietro. Lui era lo zio che amava il giardino. Ricordo le sue mani nella terra nera, mentre mi aiutava a cercare una pietra blu speciale che avevo perso. Le stesse mani mi portavano fumetti e biscotti. Le stesse mani tenevano la fune legata alla camera d'aria nella quale galleggiavo sotto la banchina della sua casa al mare. Queste stesse mani a volte mi facevano male. Lo aspettavo ogni giorno sulla sedia a dondolo del portico - guardandolo camminare attraverso archi di vecchi alberi ricchi di foglie fino a quando arrivava al bordo dello steccato bianco della casa sulla baia che aveva comprato; la casa che, quando lui morì senza lasciare testamento, le sue sorelle obbligarono mia zia a riacquistare da loro. Suo fratello Armando, in Italia, rubò dalla casa di famiglia di mia nonna. Per la mia mamma, questo zio era come un "padre". Più tardi quando lei crebbe, lui la portava a teatro e all'opera perché sua moglie preferiva la chiesa. "Loro" erano "la coppia". Lui le comprò la sua prima macchina e il suo primo anello di diamanti. Era una persona affascinante, non v'era dubbio! Recitava nelle commedie italiane prima che io nascessi.

Teatro e canzoni

L'opera italiana e il teatro erano parte integrante della vita culturale di Nina. Suo zio, Adolfo, recitava spesso nelle produzioni teatrali italiane nel North End di Boston. A New York, un immigrato napoletano di nome Eduardo Migliaccio, licenziato da uno "sweatshop" (laboratorio di produzione a cottimo), divenne il famoso attore comico satirico, Farfariello, che intratteneva il pubblico con le sue creazioni di dialoghi misti in dialetto napoletano e inglese. Delineava i suoi compagni italiani "greenhorns" (nuovi arrivati), con delle caratterizzazioni così penetranti che, non solo li intrattenevano, ma li invitavano a riflettere sulla loro condizione.

Anche l'opera continuava ad essere un'attrazione principale. Le compagnie, nelle comunità di italiani, potevano contare sul pienone e anche su una temporanea risorsa di talenti. «Se volevamo cantanti per il coro, andavamo al molo e trovavamo pescatori italiani», diceva un macchinista di un sontuoso teatro dell'opera di San Francisco. «Scoprivi che ciascuno di loro conosceva lo spartito e cantava l'Ernani e la Traviata».

Nei primi anni l'unico posto che faceva vedere i film delle opere italiane era l'Old Howard Casino, il famoso teatro burlesco di Boston. Gradualmente, quando le generazioni successive ebbero fatto strada, gli italiani divennero i benvenuti nei teatri dell'opera dove veniva suonata la loro musica.

COMPÀ' NTUO' MA T'ARRAGIONO O NO?

Ogge a sta terra qua lu 'mericano
cumanna, e ti pò fa chello che vò
perciò quanno ti vere il taliano,
fosse lu Rre, lu chiamano **digò**
 Dich' i', cu qua' ragione
 nzurtarte li taliane?...
 Pecché s'io so' cafone
 tengo li paisane,
 ca so' maste de scienza,
 de voi professuri,
 ca overo te ne fanno,
 de tutti li culuri!...

Donca ne compà Ntuo'
Io t'arragiono o no?!... Eh!...[1]

Lu cafone che ragiona una delle canzoni di cui Eduardo Migliaccio (Farfariello)
fu co-autore nel 1910

Rondini di Passaggio

Gli italiani erano chiamati "rondini di passaggio" dal momento che andavano e tornavano dall'Italia così frequentemente. Spesso, lasciare l'Italia, era stata una necessità più che una scelta. Il Sud, in particolare, soffriva di un'eccessiva tassazione imposta dal governo situato al Nord. Gli emigranti, costretti a partire, conservavano spesso una profonda nostalgia di casa.

Quando la richiesta di lavoro in America si affievoliva, essi, a volte, facevano un viaggio nel loro paese d'origine, andavano a trovare le famiglie, rinnovavano i legami, e tornavano in America per guadagnare ancora più dollari preziosi. Negli Stati Uniti, le leggi per l'immigrazione cambiavano a seconda che il governo al potere fosse favorevole all'ingresso di una quantità di immigrati più alta o più bassa. A volte la "rondine" non era poi così libera di volare ogni qualvolta lo voleva.

"VOCI"—Interviste da Ellis Island

Mio padre tornò [in Italia] nel 1931, in settembre, e poi gli fu promesso un buon lavoro, grosso, e tornò nella primavera del 1932. Beh, la cosa non ebbe seguito perché la Depressione diventò un po' più forte. Allora se ne tornò nell'autunno del 1932 perché qui doveva pagarsi la pensione in un albergo. Laggiù quattro o cinque non faceva molta differenza. Dopo voleva tornare, ma il passaporto era scaduto. La terza volta il passaporto era valido solo per due anni. Adesso dura dieci anni, una volta, sai, ne durava cinque. Così andò al consolato a Trieste per rinnovare il passaporto. Non volevano rinnovarglielo a meno che lui non partisse con tutta la famiglia, sai... Questo perché non vogliono che, per esempio, tu guadagni i soldi qui e li mandi tutti laggiù. Beh, mio padre non poteva portare la famiglia quaggiù per colpa della Depressione, e non aveva i soldi per farlo, sai. Lui voleva ritornare, quantomeno per mantenere viva la sua cittadinanza, sai, e forse sarebbe stato bene perché dopo si insediò Roosevelt e iniziò il WPA, dove io ottenni un lavoro. Lui era un bravo muratore e perciò avrebbe potuto ottenere un buon lavoro. Fu una di quelle cose... E poi rimase bloccato e non poté rientrare. Non volevano rinnovargli il passaporto. Quindi sono veramente il solo che è venuto e restato. Gli altri sono tutti laggiù. Ho appena perso i miei due fratelli. Ho due sorelle laggiù e una volta ogni tanto mia sorella viene a trovarmi, sai. Di fatto, io adesso torno in Italia ogni due anni per una visita.

—Ettore Lorenzini[2]

Sono nato a New York. Durante la Depressione i miei genitori ci portarono in Italia, a me e ai miei due fratelli, tutti e tre. Perché lui aveva certe proprietà laggiù, e così noi vivevamo nella sua proprietà. Penso che avevo cinque anni. Ad Astoria vivevamo in una grande casa. So che dovevamo salire tante scale. Giocavo nel parco di Astoria ogni tanto con Gertrude, questa ragazza con cui sono cresciuto. Ma ho avuto esperienze più grandi là che qua, quindi questo le sovrapponeva. Sovrapponeva... Mio padre era solito fare la fila per prendere il carbone, rimaneva un paio d'ore in fila. Quindi decise, ci imbarcò per l'Europa pensando che non sarebbe stato così male.

Mio padre ci portò laggiù. Aveva messo da parte abbastanza soldi per il viaggio. Non molto di più. Dopo tornò qui e anche mia madre. Tornarono, uh, per guadagnarsi la vita. E così noi rimanemmo lì alla fattoria... So che c'erano molti scontri lì tra i comunisti e i fascisti e così via. Oh Gesù! Perché poi Mussolini arrivò al potere. Tu ti dovevi aggregare. Dovevi essere, dovevi aderire. Ti infilavano dentro, anche se eri americano o di qualsiasi altra nazionalità. Non che fossi fiero di questo, ma non avevo scelta. Io e mio fratello diventammo Camicie Nere. Come i boy scout qui, ma è un po' più serio laggiù. Quindi dopo un po', è per questo che nostro padre ci riportò, indietro, sai, perché la situazione stava andando un po' troppo in là. Sai, appena saremmo cresciuti ci avrebbero probabilmente mandato in Etiopia o da qualche altra parte, sai, a combattere. E tu non vuoi. E non volevo nemmeno io. Io sono un americano. Ma quando stai lì devi fare quello che ti dicono.

—Nelson Misturini, nato l'11 ottobre 1917, tornato a Cremona, in Italia, poi ritornato a New York[3]

La léttera ma' 'mpustata

Gargane mia, te scrive questa lettera
pe' ffàrete capì che, dallu iurne
che sso' partute, me vì sempe 'nzonne
come vè 'nzonne allu zite la zita,
come vè 'nzonne allu figghie la mamma.
Me sònne che mme trove, come pprima,
ammeze la Padula e, sse mme cride,
te diche pure che sente sunà
la campana 'la Cchiesia de Sant'Antóne
e, quanne annòsele dda voce santa,
che pozze fà? tegne nu nùdeche 'ncanna
che ssule chi è emigrante pò capì.
Te scrive sempe, ma tutte li lettere
non te li 'mposte, ché pésene assà,
e llu pustere ce mettesse a rrire
se lli dicesse che vogghie mannà
na lettera lu iurne a nna Muntagna.
L'ha' cumpatì: iè mmerecane nate
e non capisce che ssi' mmegghie tu
de tutte quiddi ch'ànne studijate.
Dunqua, Gargane mie, Gargane belle,
te scrive questa lettera pe' ddìcete
che, doppe quarant'anne de 'sta Mereca,
na cosa sola è certa: quasa quasa
me pare che non zo' manche partute
e cche ddu bastemente l'ej sunnate
o viste inte li libbra de lla scola.
Ma po' ce penze e m'accorge che facce
peccate se tte diche na buscìa:
sope ddu bastemente ce so' state,
inte sta terra so pure sbarcate,

e tre quarte de vita so ppassate.
In ogni lettera che tt'eje scritte
e ppo' non eje 'mpustate, quanta vote
t'eje ditte 'ncumpedenza come passe
inte sta terra la iurnata mia.
Embè, mo tte lu diche n'ata vota.
Fatije come ttutte quante l'ati,
ma l'ati ce repòsene cuntente;
invece i' me facce sti dumanne:
"Pecché so nnate? pecché so partute?
pecché non zo' rrumaste pure i'
sope ddu bbelle Monte risciurute?"
Gargane mia, iàvete che durmì!
Penze a ddi stelle fute fute e bbelle
e tutte quante me pàrene fatte
a fforma de nu bastemente chijne
de povere emigrante come me...
Lu vi', lu vi', che mmo me vè lu chiante
comme ddu iurne allu pórte de Nàpele?
E allora è megghie che me ferme qua...
Non mi prolunghe...'Ntante tu ssalùteme
tutte li strate 'lu paiese mia,
pure l'appartamente ricche e bbelle
che ci hanne frabbecate tutte quante,
e requijemmaterna ddi cappelle,
ah, li cappelle de llu Campesante
ddova dda santa de Mamma Lucia
stà sutterrata cu la crona 'mmane...
Cara Muntagna mia, sti duje uuasce,
iune è ppe' gghiessa, l'atu jè ppe' tte.
Cu ttant'affette e amore,

—Joseph Tusiani (Puglia)
(da *Bronx, America*, 1991)[4]

Viaggi

La famiglia De Iorio fece diversi viaggi di ritorno a Lapío, nel 1915 così come nel 1922, quando Luigi, a 75 anni, pensò seriamente di ritornare lì per viverci. La figlia di Concettina, Nina, ricordava nitidamente il periodo passato in paese da bambina e, alla scuola superiore, scrisse su questo un'autobiografia. L'esperienza di vivere in Italia per quasi due anni la influenzò profondamente. Parlava sempre in italiano con sua mamma e le restò un amore infinito per l'Italia. Ritornò nel 1956, 32 anni dopo, con sua madre e zia Eufrasia (Zizi) per mettere a posto ciò che restava delle proprietà di famiglia, si fece degli amici cari e continuò a tornare in visita di frequente per il resto della sua vita.

29 agosto 1923

Cara signora Piscopo,

Spero sinceramente che ti sarà più chiara la strada. Comprendo che vuoi crescere ed istruire Nina come un'americana. L'hai mai mandata a scuola in Italia? Ovviamente la sua malattia ha interferito.

Capisco molto chiaramente che non è sicuro per tua sorella e per te lasciare tuo padre, né per lui né per voi. Delle persone intriganti potrebbero portagli via tutte le sue proprietà senza menzionare la sofferenza fisica che potrebbe provare per la mancanza di assistenza e per le costrizioni. Spero che mi terrai informata. Spero che lui cambi idea e veda le cose sotto una luce differente…

—Fanny Eldredge

La Mia Autobiografia

Sono nata il 15 agosto del 1917 a New York in una casa privata, al numero 34 della 2nd Street, dove ho trascorso i primi mesi della mia infanzia. Poi mia madre mi portò a casa, ad Orient Heights nel Massachusetts. La casa al 1062 di Bennington Street era di mia mamma e ho vissuto lì per parecchi anni. Mia madre aveva vissuto lì per quindici anni ed era una vecchia residente di Orient Heights.

Nel 1922, a quattro anni, iniziai ad andare a scuola. Alla fine di quell'anno fui promossa in prima elementare. Ma ahimè! Stavo in prima elementare da soli quattro mesi, quando mia mamma mi ritirò dalla scuola. Partivamo per un viaggio in Italia. Fu una grande avventura per me anche se la scuola mi mancava molto.

Pensavamo di restare in Italia per qualche mese ma prolungammo la nostra visita per quasi due anni, durante i quali non andai a scuola. Mentre ora sto scrivendo, cercando di ricordare le mie prime impressioni su diverse cose, molti pensieri e ricordi felici riempiono la mia mente anche se ero solo una bambina a quel tempo.

Ricordo la mia prima cavalcata su un asino, che una delle contadine portò a casa mia, e lo zio di mia madre pensò che fosse davvero molto sbagliato e non degno di me fare una cosa simile. Lui era un vecchio aristocratico, se posso dire così. Adesso è morto e mia madre pianse molto quando lo seppe. Ricordo la casa silenziosa, scura e fresca di un altro zio di mia mamma. Era un vecchio prete a cui piaceva molto la solitudine. Dietro la sua casa c'era un oleandro enorme così profumato che valeva la lunga camminata da fare attraverso i sentieri di campagna caldi e polverosi per arrivarci. Trascorrevo la maggior parte del tempo giocando. Ogni volta che vedo qualcuno giocare al "gioco del mondo" mi ricordo di una sera in cui mia madre era uscita. Mi aveva lasciato con la figlia del nostro vicino. Stavamo giocando a saltellare quando, all'improvviso, sentimmo un colpetto sul pavimento che sembrava provenire dal nulla. Si rivelò essere la vecchia signora che viveva al piano di sotto la stavamo sicuramente infastidendo. Il frutteto e l'uliveto: la stagione delle olive, quando le olive venivano raccolte e sparpagliate sul pavimento di stanze scure per farle maturare e trasformarle in olio, perché gli italiani lo usavano molto; i vasti campi di rose gialle; i grandi fichi viola che cadevano e si spiaccicavano a terra, quando erano troppo maturi; le castagne, mature,

sparate nell'aria come petardi dai loro ricci. Le castagne peggiori le mangiavano i maiali, perché ce n'erano molti in paese. Quasi ogni contadino aveva almeno un maiale. La domenica, l'unico giorno della settimana in cui le giovani contadine indossavano i loro vestiti migliori e venivano in chiesa, spesso partendo presto dalle loro case, quando avevano qualcosa la portavano al proprietario dell'appezzamento di terreno dove vivevano. Ogni domenica c'erano due contadine che ci portavano un cestino di ciliegie o dei mazzolini di violette gialle, bianche e viola.

Nel paese, i contadini non avevano l'acqua dal rubinetto come ce l'abbiamo qui ma andavano ogni giorno a prenderla alla fontana pubblica. In città invece è come in America, cioè, più moderno.

—Nina Piscopo

L'autobiografia fu scritta nel febbraio del 1933, quando Nina aveva 15 anni, per la classe della signorina Hall alla Latin School di Boston

Differenze e Discriminazione

Ogni gruppo di immigrati che arrivava, sperimentava le solite tribolazioni dell' essere maltrattati perché non conoscevano l'inglese, si vestivano in modo differente, cucinavano cibo con aromi inconsueti, avevano pochi mezzi, ecc. Gli italiani si imbattevano in una situazione perfino più disorientante. Visto che molti di loro avevano una carnagione più scura, essi incorrevano nel doppio peso di essere stranieri e di essere considerati di un'altra razza, appena un gradino più sù nella scala del lavoro rispetto ai neri d'America, che soffrivano ancora delle discriminazioni dovute alla storia della schiavitù in America.

"VOCI"—Interviste da Ellis Island

Bene, stai a sentire. Laggiù ero la preferita, la preferita della maestra. Quaggiù venivo, mi piazzavano all'ultimo banco perché ero una "guinea" (così venivano chiamati dispregiativamente gli immigrati italiani). Era così. A loro non, non piacevo a nessuno. Poi abitammo a Milford con mio zio per circa sette otto mesi. Poi mio padre si trasferì a Hopedale. E lì sono rimasta per tutto il resto della mia vita. Lui lavorava alla Draper Corporation come formatore. Hopedale era la città peggiore in cui vivere per gli immigrati perché era una città inglese. Là a Hopedale, la fabbrica, era tutta di inglesi e a loro non piaceva avere gli italiani in città. Andai a scuola lì e non sai che inferno era. Ai bambini semplicemente non gli garbavi. Si prendevano gioco di te. Mi coprivano d'insulti mentre tornavo a casa da scuola. Fino a quando un giorno picchiai una delle ragazze senza fermarmi e dopo lei diventò la mia migliore amica.

—Dena Ciaramicoli Buroni[5]

Vivevo ad Astoria vicino al Ponte di Hellgate. Correvo fino alla Queens Plaza, sopra il ponte, per tutta la 72nd Street per imparare il pugilato. Perché ero stanco di prendere botte…Non ero un attaccabrighe, ma loro continuamente… tornavo a casa con un occhio nero. E mia madre: «Chi è stato? Lo uccido». Oh, tanti occhi neri. Oh si, ho perfino dei segni qui, mi bucavano con le matite e così via. Perbacco, solo perché ero uno straniero, un 'greenhorn' [nuovo arrivato]…Non pensavo tanto alle discriminazioni. A quell'epoca non ci pensavo troppo, sai. Ma questa situazione mi stava stancando. Dico io, «perbacco non vi ho mai fatto niente, ragazzi». Andavano cercando la lite con me. Lo sai, no? ci sono sempre un paio di bulli. C'erano molti… avevo molti buoni amici. Oh, si. Si sarebbero battuti per me. «Oh, lascialo in pace». Ma lì c'erano sempre un paio di teppisti.

—Nelson Misturini[6]

Ci trasferimmo a nord, quello che a San Francisco si chiamava "North Beach". E' un quartiere italiano. Sai, era come vivere di nuovo in Italia. Lì non ho mai avuto quella sensazione [di pregiudizio]. Solo quando uscivi fuori, sai, e andavi nel così detto mondo esterno, era diverso. Voglio dire, come «Tua madre non parla inglese? Oh, sei una "wop"» (without ordinary papers, senza documenti regolari, era un epiteto rivolto agli immigrati). Quando ero ragazzina qui, c'erano molti imbarazzi. E la gente diceva: «Dio, se non parlano inglese, non dovrebbero stare in questo paese» e, voglio dire, questo fa male.

—Elda Del Bino Willitts[7]

"VOCI"—Interviste familiari

Gli irlandesi venivano e si scontravano con gli italiani. Gli italiani venivano e si scontravano con gli ebrei, gli ebrei venivano e si scontravano con gli irlandesi. C'erano tre gruppi etnici in lotta continua per il territorio: italiani, ebrei e irlandesi. Prima, il North End era popolato dagli ebrei. Nel North End c'è una sinagoga ancora adesso. Dopo arrivarono gli irlandesi, poi gli italiani. E se non eri il benvenuto, sapevano come fartelo capire in tanti modi, senza dubbio.

Sai, come italiano, sei in qualche modo esposto al pregiudizio quando si parla di mafia. Perché tutti... se c'è una vocale alla fine del tuo nome, ci sei implicato, il che è un mucchio di frottole, ok?

Gli italiani hanno costruito questo paese con le loro mani, le loro ginocchia, le loro spalle, i loro picconi e tutto il resto. Chi avrebbe...da dove diamine venivano i muratori? Da dove veniva la maggior parte dei manovali? Venivano dal Sud Italia.

—Tullio Baldi (seconda generazione) intervista di B. Amore, 2005, Progetto Life line, 2000-2006

La legge è uguale per tutti?

A volte la discriminazione era più leggera nella forma, a volte diventava un elemento critico in situazioni come quella del caso Sacco e Vanzetti che diventò una causa mondiale. La veglia a lume di candela davanti alla prigione di Charlestown la notte prima dell'esecuzione di Sacco e Vanzetti fece una grande impressione su Nina. All'epoca lei aveva 10 anni e ricordava vividamente la rabbia e il dolore della comunità italiana.

Nel 1977, cinquanta anni dopo, il governatore del Massachusetts, Dukakis, dichiarò il 23 agosto il giorno dedicato a Nicola Sacco e Bartolomeo Vanzetti con queste parole: «l'atmosfera nel corso del loro processo e degli altri appelli fu permeata dal pregiudizio contro gli stranieri e dall'ostilità verso visioni politiche non ortodosse [...] e il comportamento di molti funzionari pubblici implicati nel caso solleva seri dubbi sulle loro buone intenzioni e sulla capacità di condurre il dibattimento e processarli in modo imparziale». Dukakis dichiarò inoltre che «ogni stigma e disonore doveva essere per sempre rimosso dai nomi di Nicola Sacco e Bartolomeo Vanzetti, dai nomi delle loro famiglie e discendenti» e che tutte le persone avrebbero dovuto «fermarsi nelle loro imprese per riflettere su questi tragici eventi e trarre, dalle lezioni della storia, la determinazione per impedire che le forze dell'intolleranza, della paura e dell'odio non si coalizzino mai più per superare la ragione, la saggezza e la giustizia alle quali aspira il nostro sistema legale».[8]

Questo è quello che dico: non augurerei a un cane o a un serpente, alla più bassa e sfortunata creatura della terra, non augurerei a nessuno di essi quello che ho dovuto soffrire per delle cose di cui non sono colpevole. Ma la mia convinzione è che ho sofferto per cose di cui sono colpevole. Sto soffrendo perché sono un radicale e, infatti, sono un radicale; ho sofferto perché sono italiano e, infatti, sono italiano; ho sofferto più per la mia famiglia e per i miei cari che per me stesso; ma sono così convinto di aver ragione che se poteste giustiziarmi due volte, e se potessi nascere altre due volte, vorrei vivere ancora facendo quello che ho fatto.

—Bartolomeo Vanzetti

Il diario di Vanzetti narra di dodici anni della sua storia lavorativa cominciata come lavapiatti:

Il vapore dell'acqua bollente dove venivano lavati i piatti, le padelle e l'argenteria, formava grandi gocce di acqua sul soffitto, che portavano via tutta la polvere e la sporcizia da lì e poi cadevano lentamente, una ad una, sulla mia testa.

Egli intraprese, poi, un lavoro agricolo itinerante:

Eravamo tutti e due letteralmente senza un soldo, con una fame che ci tormentava dall'interno. Eravamo fortunati quando trovavamo una stalla abbandonata dove potevamo passare la notte.

Dopo un anno fatto di dieci ore al giorno passate davanti all'imboccatura di una fornace di mattoni, «uno dei lavori più impegnativi che conosco» egli finì per lavorare per le ferrovie, nelle fabbriche e, infine, come lavoratore a giornata vendendo pesce, tagliando ghiaccio, spalando neve e scavando molluschi a Plymouth, nel Massachusetts.[9]

Se non fosse stato per queste cose, avrei potuto vivere la mia vita parlando agli angoli delle strade con uomini che mi dileggiavano. Sarei potuto morire, inosservato, sconosciuto, un fallito. Adesso non siamo dei falliti. Questa è la nostra carriera e il nostro trionfo. Mai nella nostra intera vita avremmo sperato di fare un'opera simile per la tolleranza, per la giustizia, per la comprensione degli uomini come quella che stiamo facendo adesso per caso. Le nostre parole – le nostre vite – i nostri dolori, niente! Il prendere le nostre vite – le vite di un buon calzolaio e di un povero venditore ambulante di pesce – tutto! Quell'ultimo momento ci appartiene – quell'agonia è il nostro trionfo.

—Bartolomeo Vanzetti

Tra Vecchio e Nuovo

«Seguendo il sol, lasciammo il vecchio mondo» era il motto del giornale di Luigi Barzini, il *Corriere d'America*. Nonostante la proverbiale "partenza", i figli degli immigrati, la seconda generazione, si trovò tra il Vecchio e il Nuovo Mondo. Nina, la figlia di Concettina, lottava costantemente tra il rispetto per la tradizione e il desiderio di esplorazione della comunità più ampia.

Anche se Concettina era, per molti versi, di larghe vedute, per altri aderiva strettamente alle vecchie consuetudini o la "via vecchia". Le sue idee riguardo alla necessità di una rigida disciplina fisica e al rispetto dovuto agli anziani erano profondamente radicate nella sua cultura "signorile" e "di paese". Ogni sua convinzione era sempre C'è una via soltanto, la via giusta. Spesso parlava di quando, bambina, se ne doveva stare seduta in silenzio alla tavola di suo nonno a guardare gli altri mangiare mentre era affamata, come punizione per qualche piccola trasgressione fatta. Concettina e Nina vissero insieme, amandosi l'un l'altra e non andando d'accordo per tutta la vita.

Freddie è venuto a trovare Helen stasera – mamma mi ha proibito di entrare – io l'ho fatto lo stesso – gran litigio!

Rimasta a casa – aiutato mamma in giardino – fatto due compiti per scuola – festa della mamma – ho regalato a mia mamma un'ortensia rosa.

Avuto un litigio con mamma stasera – lei ha fatto staccare il telefono

Ho portato la mamma in ospedale – Mass. Gen. – tempo schifoso – neve – non mi sento tanto bene neanche io – freddo – sono venuti la zia e lo zio.

Battibecco con zia e mamma a proposito di Capodanno. Non siamo andati fuori per Capodanno per colpa dei parenti.

—Annotazioni sul diario di Nina Piscopo durante gli anni del college (1935-1937)

Scelta e conflitto

In molte famiglie, i bambini della seconda generazione, spesso non imparavano la lingua dei loro genitori. I valori fondamentali de "la famiglia" rimanevano al centro delle loro vite anche se c'erano una miriade di conflitti sul come relazionarsi al mondo "americano" al fuori dalla famiglia. Nina parlava italiano correntemente e rimase attiva in entrambi i mondi per tutta la sua vita – vivendo e prendendosi cura di Concettina fino alla sua morte e partecipando contemporaneamente all'istruzione e al lavoro sociale.

"VOCI"—Interviste familiari

Lui non parlava molto dell'Italia quando ero bambino. Devi averci vissuto in quell'epoca per capire come... c'erano tante altre cose, circostanze, cambiamenti che si succedevano in quegli anni, la Depressione era quello che era, e la maggior parte delle persone combatteva una lotta anche per mettere un piatto a tavola. Molte storie, molte conversazioni venivano lasciate alle spalle. Non era il momento. Non c'era tempo per tutto questo, basta. Loro non hanno condiviso nessuna storia con noi, per davvero.

—Tullio Baldi (seconda generazione), intervista di B. Amore, 2005, Progetto *Life line*, 2000-2006

"VOCI"—Interviste da Ellis Island

Eravamo così frenati da mia madre che non ci siamo mai aperte a niente. Le mie sorelle avevano solo e sempre lavorato. Questa era l'unica cosa che conoscevano. E io sono uscita all'esterno, un mondo dove le cose sembravano essere più aperte e così diverse. E una volta visto questo esterno, tornavo a casa e lì non c'era modo di ragionare, voglio dire, non c'era nessuna logica lì. Il fatto era che, loro erano così concentrati sul lavoro e sulle cose da fare, che non risucivano a capire nient'altro. Ed io ho davvero sofferto di questo perché loro non lo potevano capire. Non riuscivano nemmeno a capire perché volevo comportarmi diversamente. E io glielo dicevo. Loro avrebbero veramente dovuto...Io diventavo così... «Per Dio, avreste dovuto imparare la lingua. E' imbarazzante uscire e dire alle persone che non la sapete». E loro erano persone così affettuose che adesso mi sento come se, io provo un senso di colpa al solo pensiero di aver provato quei sentimenti nei confronti di persone così splendide e poi di avere sentito un po'... Io mi vergognavo di loro a quei tempi.

—Elda Del Bino Willitts[10]

Sai, loro si aspettavano che i figli si prendessero cura della madre. Quello era il modo di vivere in Italia. Voglio dire, che i figli si prendono cura dei genitori. Voglio dire, in Italia ci sono i nonni e tutti gli altri e loro ancora vivono tutti insieme. Voglio dire, che questo era il modo in cui lei era stata cresciuta perciò non le dava fastidio. Come stanno le cose adesso, non posso nemmeno spostarmi a vivere con mio figlio. Non lo voglio nemmeno. Voglio mantenere la mia indipendenza. Non è questa la maniera in cui la pensavano allora. Allora si pensava che tu ne ne andavi a vivere tu e i tuoi figli, che loro ti dovevano mantenere perchè tu li avevi messi al mondo. Come è adesso è tutto il contrario. Laggiù tu eri in debito con loro perché loro ti avevano messo al mondo.

—Elda Del Bino Willitts[11]

Ero una delle più giovani della famiglia e l'unica nata qui. Gli altri erano nati in Sicilia vicino all'Etna. Sono stata l'unica che ha sfidato mio padre. Portavano tutti a casa le loro buste chiuse e le mettevano giù. Lui tirava fuori i soldi e dopo gli dava un paio di "bucks" (dollari) e si teneva il resto. Io lo guardai e gli dissi «Non avrai i miei soldi» Gli dissi proprio così! Non mi disse mai una parola. Penso avesse capito che io ero l' "americana". Si convinse che doveva sopportarlo. Non aveva senso opporsi.

Ho infranto tutte le regole della tradizione italiana. Ho aperto la strada agli altri ragazzini che stavano crescendo. Non ero l'unica di quell'età. Tutti mi volevano bene. Le mie zie, i miei zii, potevo andare dovunque che mi trattavano come una regina. Ero la ribelle, l'"americana".

Tutte le ragazze che abitavano nella mia strada non andarono mai alle scuole superiori. Andarono a lavorare a quattordici anni. Beh, io ho deciso quando ero in quarta elementare, a soli nove anni, che sarei diventata un'insegnante, volere o volare! Volevo molto bene alla mia insegnante di quarta elementare. Era quasi un angelo, ci ricompensava sempre. Io volevo essere come lei. Mio fratello maggiore lo sapeva. E si assicurò che andassi sempre avanti. Continuò a darmi una paghetta per tutta la durata del college. Con due dollari alla settimana ci pagavo i mezzi di trasporto e mi restavano i soldi per il latte. Mi portavo il panino da casa. Mio padre era piuttosto sorpreso ma penso che fosse anche orgoglioso, del fatto che stavo infrangendo tutte le regole. Penso che lui mi ammirasse per questo.

—Mary Sacco, nata il 26 gennaio 1913, la famiglia veniva da Pietra Perzia, in Sicilia, Progetto *Life line*, 2000-2006[12]

Opportunità

L'istruzione era un valore chiave nella vita di Concettina ed era un'eredità che trasmise a sua figlia e ai suoi nipoti. Nina era una studentessa piena di talento e un'artista. Alla scuola superiore vinse una borsa di studio per frequentare i corsi al Museo delle Belle Arti di Boston. Il museo divenne la sua seconda casa. Amava in modo particolare il cortile giapponese e la collezione di vecchi kimono fastosamente ricamati appesi in teche di vetro. Furono questi ad influenzare fortemente il suo senso del design.

Studiò l'arte attraverso le vaste collezioni del museo. Ogni pomeriggio faceva degli schizzi dei busti scolpiti nel marmo e dei dipinti degli impressionisti e dei disegni per portare a termine i suoi compiti. Le sere le trascorreva sotto l'occhio vigile di sua madre.

Arte e libertà

Nina era una di quelle figlie di immigrati privilegiate che, negli anni Trenta, riuscirono a frequentare sia la scuola superiore che il college. Sua madre, con la tutta la sua famiglia, la sorella Eufrasia e suo marito Adolfo, la aiutarono a portare a termine la sua istruzione. Nina entrò al Massachusetts College of Art, specializzandosi in Disegno per la Moda. L'arte era il suo modo naturale di relazionarsi al mondo. I principi del design diventarono per lei una seconda natura.

Durante l'estate, insegnava arte alla Dennison Street Settlement House. Dopo la laurea e con in mano un certificato d'insegnamento conseguito al quinto anno, lavorò al Puritan Dress Co. a Boston fino a quando si sposò, nel 1941. Il College le consentì anche una maggiore libertà dalla costante supervisione di sua madre, anche se dovette costantemente lottare contro il codice di comportamento che Concettina riteneva appropriato.

Ricordi

Mia madre fu la mia prima maestra. Lei mi insegnò "a vedere". Era impossibile andare da qualsiasi parte senza che lei mi indicasse le forme della natura, i colori dei fiori, la foggia degli alberi, le tinte di un tramonto. Quand'ero bambina, i musei erano la mia stanza dei giochi. Ho assimilato l'arte "dal latte di mia madre".

Quando eravamo bambini, lei ci intratteneva con le storie su Priscilla, la sua amica artista che fumava la pipa e su Santo Marino che era il direttore della North End Union. Vedevamo mia madre come un personaggio molto affascinante. Era sicuramente diversa dalle altre madri che conoscevamo!

—B. Amore

The Art of Lounging
(L'arte del rilassarsi)

E' così raro sentire una donna che dice «non voglio un abito da ricevimento?» Perfino io, che non ho nessuna ragione per averne uno, sogno di come sarebbe bello. Ogni donna, che sia ricca o meno, ha desiderio di un indumento simile. Non significa necessariamente che è obbligata a dare dei ricevimenti a casa solo perché ne possiede uno. Al contrario, potrebbe usarlo come una scusa per farlo!

Immagina quanti problemi può risolvere un vestito da ricevimento. Metti che una domenica hai invitato a casa pochi amici per uno spuntino serale. Non sai cosa indosseranno loro e, ancor meno, sai cosa indosserai, tu stessa. Il problema che sarai vestita troppo bene per loro o potrai apparire come una che ha dimenticato di averli invitati. Indossa il tuo vestito da ricevimento, la cosa indicata, e sentiti a tuo agio sapendo che hai deciso saggiamente e appropriatamente. Se sei una donna, so che ti è già successo, perché non ho ancora incontrato una donna che in simili circostanze, e in questa posizione, non abbia avuto nella sua mente il dubbio su cosa indossare.

Il disegno di un indumento può essere ispirato da qualsiasi cosa. Io ho scelto pesci tropicali come fonte d'ispirazione, per i loro ricchi colori e per le forme irregolari che li rendevano belli per questo scopo. La mia ispirazione nasce da un colore, un contrasto, una linea, un movimento o uno stato d'animo. Nel disegnare, penso, il più delle volte, al tipo di donna che indosserebbe un certo stile. Potrebbe essere interessante chiederci cosa starebbe bene con il suo stato d'animo del momento.

—Una parte del testo del portfolio di laurea di Nina Piscopo, *The Art of Lounging,* che lei usò per concorrere all'Annual Award of Honor il 19 maggio 1939

Pizzo. Charme femminile. Il corpo del crêpe nero pesante accresce la squisita delicatezza delle minuscole increspature del pizzo bianco che formano il lungo pannello sul davanti di questo vestito ultrafemminile. Le lunghe linee principessa slanciano. L'apertura del collo è larga abbastanza da infilarci la testa e ancora sul lato del corpetto una cerniera ne consente l'apertura. La decorazione di pizzo è ripresa nelle maniche corte.

—Descrizione di Nina, che accompagnava uno dei disegni del
suo portfolio di laurea, *The Art of Lounging*

L'Istituto Internazionale

Mentre era studentessa al Mass. Art, Nina partecipò alle attività dell'Istituto Internazionale di Boston come volontaria, un coinvolgimento che durò per 59 anni. L'Istituto era stato fondato nel 1924, allo scopo di assistere gli immigrati al loro arrivo in America. Lì, nel 1940, Nina incontrò il suo futuro marito, Tony D'Amore, lo stesso anno in cui completò il corso post-laurea al Massachusetts College of Art. Il nomignolo affibbiato all'Istituto era IIB e i figli di Nina dicevano spesso che loro "erano cresciuti all'Istituto" perché avevano passato così tanto tempo lì con la loro mamma.

Con l'Istituto, Nina lavorò per trovare una nuova sistemazione ai rifugiati, dopo la Seconda Guerra Mondiale e tornava spesso a casa in lacrime, raccontandoci storie di persone che avevano perso intere famiglie nei campi di concentramento. Negli ultimi anni, faceva da traduttrice nei tribunali per gli immigrati italiani che avevano bisogno di interpreti. Lei era un membro molto attivo del comitato sia dell'Istituto che dell'YWCA di Boston. Perennemente coinvolta nel delicato atto di bilanciamento tra la "via vecchia" e la "via nuova", Nina continuò ad essere la figlia italiana obbediente, prendendosi cura di Concettina, Eufrasia e Adolfo che invecchiavano, pur essendo allo stesso tempo mamma, moglie e dedicandosi al lavoro nel sociale.

Ricordando Nina D'Amore
"L'ultima rappresentante dei 'Vecchi tempi'"

Nina D'Amore mi ha dato un colpettino sulla spalla lo scorso aprile, dopo il meeting annuale dell'IIB, e mi ha detto che era volontaria dell'Istituto da più di 50 anni!

Dopo diversi tentativi di vederci, Nina, che è una donna amabile, la cui energia compatta evoca un vortice d'aria ben orientato, è piombata nel mio ufficio pochi giorni fa. A 70 anni è il presidente del Senior Advisory Council dell'Istituto. E' stata nel comitato direttivo dell'IIB e ha una lunga lista di progetti, che descrive come un "lavoro d'amore" intrapreso per conto dei rifugiati e immigrati che sono passati attraverso le nostre porte.

Nina prima fu coinvolta nelle attività dell'Istituto come matricola del primo anno di college, nel 1935, quando un amico la invitò ad un evento sponsorizzato dal Club Italicus, uno dei circa 35 club di varia nazionalità che si incontravano regolarmente all'Istituto. Subito dopo era diventata presidente dell'Italicus, il gruppo organizzò una festa di San Valentino e invitò all'evento l'Italian Fellowship League. Fu nel corso di questo evento che Nina incontrò il suo futuro marito, uno dei leader della Fellowship. I suoi quattro figli "crebbero nell'Istituto".

A quel tempo l'Istituto aveva uno staff di circa 6-7 persone e il lavoro era prevalentemente di carattere sociale: centri di accoglienza e risistemazione, assistenza sociale bilingue, lavoro legale e americanizzazione. Verso il 1940 il centro di risistemazione era pieno di persone che venivano dai paesi baltici. Suo marito andò in guerra nel 1942 e Nina cominciò a lavorare con i prigionieri di guerra italiani (che erano in prigione a Thompson Island, ma potevano lasciarla temporaneamente, la domenica, per un pranzo italiano fatto in casa all'Istituto), con i rifugiati ungheresi e tante spose di guerra. L'Istituto aveva programmi culturali e di istruzione per gli adulti, e un centro diurno per bambini gestito da volontari.

Negli anni Cinquanta Nina si trovò a lavorare alla banchina d'attracco "Commonwealth" per conto dell' IIB. Lì, incontrò molte persone scampate ai campi di concentramento. I rifugiati arrivavano dalla Repubblica Ceca, dalla Jugoslavia, dalla Germania, dalla Polonia. Dalle otto di mattina alle otto di sera, Nina guardava le persone scendere dalle navi e le aiutava con le varie

procedure di routine. Arrivavano con solo un cucchiaino e una tazza di stagno, tenendo una "Hershey bar" (barretta di cioccolato). Sotto i loro stracci, le donne indossavano grembiuli sbiaditi nascosti …«e queste erano le loro cose di valore». Nina tornava a casa a piangere, ogni sera.

Prendeva un gruppo alla banchina "Commonwealth" e lo conduceva al treno che li avrebbe portati a destinazione a quell'indirizzo ignoto che stringevano tra le mani. Molto spesso, non c'era la possibilità di parlare, eppure riuscivano a comprendersi.

Nina ricorda che quando la sua ultima figlia aveva due mesi, lei stava uscendo dall'Istituto quando la volontaria che lavorava al banco di ricevimento le chiese se poteva accompagnare una giovane donna alla "T" (metropolitana). Durante il breve tragitto, nonostante le barriere linguistiche, Nina raccontò alla donna che aveva una bimba a casa. La donna allora descrisse a Nina di come aveva visto morire il proprio figlio, in un campo profughi, per mancanza di cibo. Il bambino era nato nel campo ed essendo denutrita, la madre non riusciva a produrre il latte necessario. Il campo le passava solo 200 grammi di latte al giorno per il bambino. Nina e questa donna avevano la stessa età.

L'aspetto più rincuorante del suo lavoro era vedere le persone riunite dopo essere state separate per 30-40 anni. All'Istituto, a volte, i rifugiati ritrovavano dei parenti.

In quegli anni le risorse dell'Istituto erano ridotte all'osso. Nina era sempre stata coinvolta nelle attività di raccolta fondi per l'IIB, così come nell'assistenza diretta alle persone. Lei ricorda che, nel 1944, il Ballo Internazionale (la principale occasione per la raccolta di fondi annuale per il IIB) capitò in una sera di febbraio durante la quale ci fu un'orrenda bufera di vento e neve. Non c'erano mezzi pubblici né taxi. Il Ballo continuò e si rivelò un ottimo affare. I volontari camminavano nella neve per andare dai fiorai a prendere i fiori che erano stati donati per l'occasione. Le donne ne facevano dei piccoli mazzolini da appuntare, per venderli all'ingresso. «Era davvero stupefacente vedere arrivare le persone nel mezzo della tempesta nei loro costumi da Maria Antonietta». Dopo questo episodio, Nina dice che fu deciso di non tenere mai più il Ballo nel mese di febbraio.

In quel periodo l'Istituto era una piccola «Organizzazione delle Nazioni Unite» dice Nina. L'Interclub Council era composto da rappresentanti di ogni nazionalità e inviava un rappresentante con diritto di voto nel Comitato. Nina fece parte dello Junior Advisory Council prima e poi del Senior Council, dove adesso si descrive come la più giovane dei 12 membri. Essi si incontrano ancora una volta al mese e si tengono informati sulle attività dell'Istituto.

Nina, che non può passare davanti a qualcuno bisognoso senza fermarsi ad aiutarlo, riassume il suo lavoro all'Istituto come un'esperienza che le ha permesso di non sprecare il suo tempo sulla terra. **«Sapevo che c'era da fare qualcosa di molto utile».**

—"The Beacon": Bollettino informativo dell'Istituto di Boston Internazionale, 1987

Il Trittico De Iorio : Storie Familiari

Il mio bisnonno, Luigi De Iorio, veniva da una delle due famiglie più in vista di Lapio, nel sud Italia. Si sposò con Giovannina Forte che veniva dall'altra colta famiglia terriera del paesino. La famiglia di Luigi era composta da studiosi e proprietari terrieri che coltivavano spezie. La famiglia Forte, fedele al suo nome, dominava gli affari politici ed ecclesiastici del paese. Giovannina e Luigi crebbero i loro figli nella casa di famiglia dei De Iorio, nella piazza principale, con due leoni di pietra a guardia del portone d'ingresso. Teresina, la loro ultima figlia, morì a tre anni. Rimasero Eufrasia, Concetta e Lorenzino. La famiglia emigrò in America 1901. Lasciarono in Italia la terra e i soldi al Banco di Napoli, perché per legge non si potevano portare fuori dalla nazione. Mia nonna, Concetta, organizzò tutto questo a soli 17 anni. Lavorarono in fabbrica finché non impararono la lingua. Lorenzino morì di polmonite durante il primo anno trascorso in America. Giovannina morì di un ictus nel giro di otto anni. A mia madre fu dato il suo nome.

Eufrasia, la più grande, lavorava in una fabbrica, nei primi giorni in America, ma preferì poi restare a casa, vicino a suo marito e alla chiesa. Era esperta nel ricamo, nel lavoro all'uncinetto e ai ferri e nei merletti. Concetta, mia nonna, aveva una natura più coraggiosa e indipendente La sua intera vita venne rovinata dal suo matrimonio con Ernesto Piscopo. Lui era cittadino americano dalla nascita, ma anche la sua famiglia veniva dalla provincia di Avellino. Ernesto corteggiava Concettina con bigliettini romantici e passeggiate nella sua carrozza. Mia nonna lo amava e insistette per sposarlo. Nonostante i suoi proclami di amore, continuamente ingannò lei e la sua famiglia. Ci furono pure alcune occasioni in cui arrivò a rubare i depositi dell'hotel di famiglia dei Piscopo! Dopo tre anni di matrimonio, lei ottenne la separazione legale e lo lasciò. Poi andò all'American International College, ma durante una riconciliazione rimase incinta della sua unica figlia, Nina.

Concetta viveva secondo il suo detto preferito «Dove c'è la volontà, la via si trova». Cucire diventò uno stile di vita. Attraverso la maestria del suo lavoro di cucito Concettina mantenne la famiglia. Nina, sua figlia – mia madre – non ebbe un'infanzia facile. Mia nonna imponeva una disciplina ferrea e a volte la legava nello scalone buio della loro casa vittoriana come punizione per chissà quale ignota trasgressione. Nina imparò abbastanza presto ad inventare storie per ottenere un po' di libertà da quell'oppressione amorevole che la soffocava. Quando era bambina, lo sguardo di mia madre era brillante, diretto, inquisitorio. Raramente vedeva suo padre. Era molto vicina ad Adolfo, il marito di Eufrasia. Fu lui "l'uomo di famiglia" finché Nina non si sposò. Lei studiò Disegno per la Moda al Mass. Art ma non lavorò mai nel suo campo, dopo il matrimonio e la maternità. Invece era capace a mettere la carta da parati e imbiancare la casa dove aveva vissuto con sua madre fin dall'infanzia e cuciva vestiti per i suoi bambini. Le visite al museo la inducevano a parlare del tempo passato lì grazie alla borsa di studio della scuola superiore, disegnando e imitando i capolavori. Conserviamo ancora dei portfolio con le sue squisite creazioni di moda. Lavorava anche nell'accoglienza ai rifugiati dopo la Seconda Guerra Mondiale. Mi mancava quando tornavo ad una casa fredda dopo la scuola.

Sposò un uomo non troppo diverso dal suo amato nonno, Luigi. Mio padre era di maniere gentili, era dedito allo studio e al lavoro duro e la adorava nella maniera più assoluta. Essi ebbero piccoli momenti di libertà subito dopo il matrimonio quando vissero da soli a Washington DC, dove sono nata. Quando mio padre andò in guerra, Nina tornò da sua madre. Abbiamo sempre vissuto con mia nonna. Mio padre faceva due lavori e raramente stava a casa. Quando c'era, lavorava generalmente in giardino o leggeva scritti teologici o filosofici, felice di lasciare a mia madre la gestione della casa. L'italiano era la ligua dell'intimità fra le donne. Le donne dominavano le nostre piccole famiglie. Durante la mia infanzia pensavo di essere un'italiana e non un'italo-americana. Mia nonna Concetta conservava ogni cosa impacchettata, avvolta e legata con lo spago. Sto usando i suoi oggetti nelle mie creazioni artistiche. Abbiamo ancora un libro di famiglia iniziato dal padre di Luigi, a metà del 1800, e una serie di cose provenienti dalla casa di famiglia a Lapio. Nella famiglia di mia nonna, si alternavano i nomi di Luigi e Lorenzo. Ho sposato un uomo che di cognome si chiama Lawrence (Lorenzo), e ho dato a mio figlio come secondo nome De Iorio per preservare la discendenza. A mia nonna questa cosa piacque tanto!

La Famiglia e il Lavoro

"Chi va piano, va sano e va lontano"

La maggior parte delle famiglie d'immigranti erano piuttosto numerose in linea con la convinzione dei contadini secondo cui più figli significavano più mani per tirare avanti la famiglia, pensiero che è rimasto al cuore della vita italoamericana. Spesso due o tre generazioni vivevano insieme, lavoravano insieme, si amavano e bisticciavano insieme. La sopravvivenza dipendeva sempre dall'abitudine di unire le forze. Molte famiglie in America hanno proseguito creando insieme attività economiche che adoperavano l'ingegnosità di tutti in famiglia. Il potere e l'orgoglio dell'etica del lavoro è stato trasmesso ad ogni generazione successiva.

La storia di Antonio

Antonio D'Amore, 23 anni, emigrò dall'Italia meridionale un anno dopo i De Iorio. Veniva da una famiglia molto povera e viveva in una casetta di pietra di una sola stanza a Montefalcione, provincia di Avellino. Il suo papà era morto quando Antonio aveva cinque anni e il nuovo padre lo picchiava in continuazione. Era solito punire il figliastro costringendolo a stare per ore in un ripostiglio, inginocchiato su uno strato di fagioli, secchi e duri.

Antonio andò via da casa quando aveva tredici anni. Lavorò in Belgio e, prima di partire per l'America, aveva lavorato con alcuni cugini in uno zuccherificio di Marsiglia, in Francia. Partì da Napoli sul bastimento *Trave* il 28 marzo e arrivò ad Ellis Island il 9 aprile 1902. Non ritornò mai più in Italia. Come i De Iorio, anche lui si diresse verso il North End, il quartiere italiano di Boston, dove visse al n. 320 di North Street assieme a O. Talasio, lo zio che gli aveva pagato la traversata.

Trovare un lavoro

Nei primi tempi, Antonio era solito recarsi a North Square dove sarebbe arrivato il "padrone" per assumerlo a giornata. I "padroni" erano i capi che ingaggiavano i lavoratori italiani. Il termine faceva parte, in origine, del sistema di classi sociali nell'Italia rurale. In America se ne era continuato l'uso, sebbene il sistema funzionasse in modo un po' diverso. Ciò che restava uguale era che il lavoratore continuava ad essere sottoposto al suo "boss".

Alcuni dei "padroni" si occupavano davvero dei loro connazionali meno fortunati, fornendo loro un alloggio e un impiego. Altri sfruttavano l'ingenuità degli immigranti e li costringevano a servirsi dei loro negozi e delle loro banche. Erano loro a pagare la traversata per mare ai giovani ansiosi di lasciare l'Italia, per poi esigere che gli immigranti lavorassero in squallide condizioni, con salari bassi, finché il prestito non fosse stato restituito. Procurarsi un lavoro prima dello sbarco in America poteva tradursi in un divieto d'entrata nella "terra d'oro". Questo rappresentava spesso un doppio vincolo per i poveri contadini che cercavano un modo per attraversare l'oceano. Se un ispettore di Ellis Island scopriva che un "padrone" aveva patrocinato la traversata di un immigrante, quest'ultimo poteva essere rimpatriato d'autorità al paese d'origine.

"VOCI"—Interviste da Ellis Island

Quando scesi dal treno, cammina, cammina, camminai fino alla fine del mondo, voglio arrivare fino alla fine del mondo. E poi si sta facendo sera e ho anche fame; mi sono rimasti soltanto 15 cents. E c'era un negozio là, lo gestivano degli italiani. Gli ho chiesto se potevo avere una camera. Volevo trovare un lavoro e andare a lavorare il giorno dopo. C'era un deposito di sabbia là. Il suo nome era "Nassau Sand and Gravel". Dissi: «Vado a lavorare là se lui mi trova una stanza dove posso dormire». Allora lui mi disse: «No, non ti posso aiutare». Ma c'era un altro tizio italiano, mi sentì mentre parlavo col primo e disse: «Vieni con me». E mi prese con lui. Era un fabbro che lavorava al deposito di sabbia. La mattina dopo andai là e cominciai a lavorare. Ora guadagno ventiquattro dollari al giorno… Ma è stato lui che che mi ha fatto entrare, e mi ha insegnato il mestiere, mi ha dato da dormire, mi ha dato un letto e mi ha dato da mangiare, un po' di carne di maiale e dei fagioli. Questo non me lo dimentico. Dopo nemmeno due anni morì…Eh già, lui è stato l'unico che mi ha aiutato e io non ho potuto fare abbastanza per lui perché davvero avevo bisogno di un aiuto.

—Carmine Martucci[1]

Mio padre lavorava con … come si dice? …le pelli degli animali. Le mettevano in una grande vasca. E ci mettevano pure lui là dentro. E aveva tutt'intorno un recinto che gli arrivava fino all'altezza della vita. E da lì lui faceva come quando si pigia l'uva. Faceva questo trattamento alle pelli per ammorbidirle, col sudore del suo corpo. Questo era il suo lavoro. Certo, i tempi erano molto duri, come per tutti.

—Nelson Misturini[2]

Spaccando le pietre

Antonio lavorò come bracciante per tutta la sua vita. Nel 1902, l'anno in cui arrivò negli Stati Uniti, i lavoratori italiani si ritrovarono sull'ultimo gradino della scala sociale fra gli immigranti in arrivo. Abituati alle lunghe giornate del lavoro agricolo, e disposti a lavorare anche con le paghe più basse, essi trovarono la loro strada nel sistema accettando di fare i lavori che nessun altro voleva. Il nipote di Antonio, che abitava con lui, ricorda la sua piccola figura solitaria, e solida che, prima dell'alba, partiva per il lavoro portando il suo piccone e la lanterna per scavare le fondamenta della Harvard University.

Sul finire del secolo, gli italiani erano considerati una razza inferiore ed erano spesso dipinti nella cultura popolare, come dei baffuti furfanti. Per questa ragione, essi tendevano a ricreare la loro cultura familiare di paese e ad organizzare in breve tempo, delle comunità economiche e sociali autosufficienti. Malgrado i pregiudizi, molti degli immigranti intraprendenti, risparmiarono diligentemente e lottarono per trasformare le tribolazioni in opportunità, attendendo con pazienza di poter comprare una casa o rilevare una piccola attività commerciale. I figli di Antonio alla fine, misero in comune le loro risorse e comprarono una casa nella quale vissero insieme tre generazioni della famiglia.

Ho combattuto il freddo e i venti. Mano a mano ho incastrato al loro posto pietre inerti e il grande edificio sorge. Ho guadagnato un po' di pane per me e per i miei.

—Pietro di Donato, *Christ in Concrete*

Il Presidente Woodrow Wilson, che non fu mai un grande amico degli immigranti, ascoltò tutte le lamentele a proposito degli italiani che portavano via i dollari al Paese. Poi, replicò pacatamente: «Sì, ma ci hanno lasciato le metropolitane».

Sono venuto in America perché avevo sentito dire che le strade erano pavimentate d'oro. Quando sono arrivato qui, ho scoperto tre cose: primo, che le strade non erano affatto pavimentate d'oro; secondo, che non erano pavimentate per niente; e terzo, che toccava a me pavimentarle.

—Un anonimo immigrato italiano

Spesso oggetto di immagini stereotipate, i lavoratori italiani con piccone e pala, all'alba del 1910, avevano già costruito più di 25.000 miglia di strade ferrate. La loro paga media era di 1,46 dollari per una giornata lavorativa di dieci ore, mentre, per lo stesso numero di ore, gli operai irlandesi ricevevano invece 2 dollari.

Sul posto c'erano svariate squadre di operai: spaccapietre, trivellatori, scavatori, cementisti ed altre ancora, ognuna col suo caposquadra. C'erano uomini che caricavano vagoni interi di pietre appena cavate delle più svariate dimensioni, macchine schiacciasassi che arrivavano sbuffando squadre che posavano prima le pietre più grandi, poi quelle piccole e infine sabbia. Sul tutto stendevano il catrame coprendolo di una polvere che noi chiamavamo "roba fine".

Riuscii a trovare lavoro nella squadra dei cementisti. La strada progrediva rapidamente. C'erano dei rigagnoli che andavano ricoperti con canaletti di cemento. Non avendo un'impastatrice, dovevamo mischiare sabbia pietre e cemento con i badili direttamente sul posto. E qui arrivava una delle parti più dure del nostro lavoro, ancora più duro per il fatto che era estate. In certe giornate limpide senza l'ombra di una nuvola, sotto un sole cocente, per noi era un continuo trasportare a spalla sacchi polverosi pieni di cemento. La polvere si impastava col sudore bruciandoci le spalle e facendo prurito. Molto spesso, dopo essermi asciugato col fazzoletto la faccia e il collo, lo dovevo stendere sull'erba ad asciugare e intanto io sotto il sole a picco, procedevo sbandando col mio carico sulle spalle. Una volta asciutto, il fazzoletto era come pietrificato.

—Pascal D'Angelo nel suo libro *Son of Italy* [3]

Rotolo di un antenato: Antonio D'Amore (Papa Nonno)

Umberto Antonio D'Amore, mio nonno, mi sembrava un uomo molto meschino. Tutti noi avevamo paura di lui quando eravamo piccoli. Se ne stava seduto sempre sulla stessa sedia e si appoggiava al bastone che teneva di fronte a sé. Quando passavamo dalla cucina al soggiorno cercava di colpirci col bastone. Più tardi, scoprii che alle volte picchiava i suoi figli con una cinghia di cuoio. Quando parlai con mia zia Mary un mese fa mi disse che suo padre era dolce. Suo figlio Rico se lo ricorda durante i suoi ultimi anni quando li andava a trovare portando come regali prodotti della terra da lui coltivati. Questi ricordi sono, senza alcun dubbio, diversi dai miei. Chi può conoscere i tanti aspetti di una persona? Aveva avuto tredici figli, ma alcuni di essi morirono. Ho conosciuto Rico, Tony - il mio papà - Adolfo, Mary, Dolly, Susie, Mike e Philly. I ragazzi avevano un solo letto per tutti; le ragazze ne avevano un altro - due letti per otto figli! Forse era meschino perché aveva così tanti figli e pochi soldi. Forse era davvero stanco quando tornava a casa. Era scalpellino e muratore. La prima volta che fu ricoverato in ospedale, poco prima di morire, il medico si sorprese nello scoprire che aveva sette o otto fratture che si erano risaldate da sole! Aveva l'abitudine di riempirsi le carie dei denti col cemento. Mio cugino Richard si era divertito a costruire insieme a lui un patio, alla vecchia casa di Roslindale. Ricordo mentre lo guardavo erigere un muro di granito quando avevo circa quattro anni. Stavo in piedi dietro di lui, osservando la trama dei suo pesanti pantaloni di lana, e volevo aiutarlo. I blocchi di granito mi sembravano sufficientemente piccoli da reggere, ma quando cercai di sollevarne uno, lui mi spinse indietro, o forse saltai all'indietro io per prima, perché ero così spaventata. Disse che non potevo aiutarlo, forse perché ero una femminuccia. Le dita mi prudevano per la voglia di toccare la pietra, ma tenni le mani strette dietro la schiena così da non essere tentata di allungare il braccio. Non volevo che mi facesse del male. Forse è lui addirittura, in parte, il motivo per cui sono oggi una scultrice su pietra! Il cugino Gerald mi raccontava che Papa Nonno andava al lavoro ogni mattina col piccone e la lanterna e che lavorò a scavare il tunnel sotto il porto di Boston e le fondamenta di Harvard. Indossava sempre un cappello, anche in casa, quel tipo di copricapo con una piccola visiera. Una volta o due vidi che era calvo. Il cranio era così lucido da sembrare a stento vero. Al suo risveglio, mio padre ha allungato il braccio nella bara e gli ha pizzicato la scarpa. E' rimasta l'impronta! Le scarpe non erano vere. Erano fatte di qualcosa che sembrava cartone lucido.

I mestieri del Vecchio Mondo

Un numero relativamente piccolo di italiani entrava in America come lavoratori specializzati. Questi trovavano rapidamente un impiego come artigiani, scalpellini, sarti e professionisti all'interno della stessa comunità italiana. Una volta sistematisi, essi erano in grado di addestrare e spesso di dare lavoro ai loro stessi compaesani o connazionali. Piccoli gruppi di tagliatori di pietra e marmo altamente specializzati si stabilirono a Barre, nel Vermont, e nelle grandi città americane come New York e Cleveland. Alcuni dei monumenti scolpiti da questi scultori professionali immigrati abbelliscono Washington, D.C.: il Jefferson Memorial, il Lincoln Memorial e la National Cathedral, fra gli altri. Il soffitto rivestito di mattonelle della Great Hall di Ellis Island fu opera di una squadra formata da padre e figlio, i Guastavino.

"VOCI"—Interviste da Ellis Island

Lavoravo con mio padre come muratore, sai, come artigiano su pietra. Come aiutante o cose del genere, và. Lavoravo là. Mio padre era occupato in novembre o dicembre, ma in novembre i lavori chiudevano. Non lavoravano per tutto l'inverno, mettiamo fino all'aprile successivo, perché si trattava di lavoro all'aperto. Bene, allora io ero giovane, non volevo stare a casa, così cominciai a cercare lavoro nel mio settore. Scrissi ad un sacco di società in tutto lo Stato e ad altre di New York o della Pennsylvania. E c'è una ditta proprio qui a Pittston che mi rispose e mi assunsero perchè sapevo fare i mosaici. Allora cominciai a lavorare con le pavimentazioni "a terrazzo," per lo più su questa lavorazione a terrazzo. E' questo che poi ho fatto per la maggior parte della mia vita. E da allora sono rimasto lì.

—Ettore Lorenzini[4]

Antonio e Maria Grazia

Antonio D'Amore incontrò Maria Grazia Catalano a Boston. Lei gli fu presentata da dei paesani che la conoscevano fin da quando stava a Montefalcione. Lei era arrivata da sola in America, in cerca di suo fratello, Ricuccio. Antonio e Maria Grazia si sposarono ed ebbero cinque maschi e tre femmine. Le loro condizioni economiche furono sempre incerte. Una severa disciplina fisica era la regola quotidiana. Non era tollerata nessuna mancanza di rispetto. La madre era il fulcro della casa, la roccia attorno a cui scorreva vorticoso il corso della vita familiare. Raramente lavorava fuori delle pareti domestiche. Maria Grazia si occupò della famiglia e continuò a tenerla unita sia affettivamente che materialmente.

"VOCI"—Interviste da Ellis Island

Beh, penso che lei avesse un grande senso dell'umorismo, ma era veramente tosta. Io penso, vedi... lei fu lasciata sola con tutti i figli in Italia. E deve essersi convinta dicendo: «Devo essere io a comandare qui» oppure, voglio dire, sarebbe il pandemonio. E io penso che fece proprio così, governò con un... ferro, un ferro...uh, come si dice, pollice o qualcosa del genere. Nessuno le disubbidì mai. Tutto quello che doveva fare era parlare, lei diceva così e colà e così era. Noi facevamo quello che diceva lei.

Bene, [dopo che mio padre morì], mia madre continuò a rimanere una casalinga e tutti i figli presero a mandare avanti la famiglia. Questo era il modo in cui eravamo stati educati. Tutti noi condividevamo, tutti quanti, ognuno le consegnava il denaro guadagnato. Lei gestiva la casa, se c'era qualcos'altro da fare lo facevamo, se no niente.

—Elda del Bino Willits[5]

Oh Dio, voglio dire che mia madre... voglio dire non credo che lei abbia mai buttato via del cibo. Per dire, lei faceva... perché con qualsiasi avanzo di cibo, facevamo quelli che si chiamano "porchetti", sai, che sarebbero come, beh, una specie di miscuglio. Un po' come...fai conto che lei preparava una sorta di minestra con dentro manzo bollito - lo chiamavamo "bollitto e verdure". E' come un "corned beef" con i cavoli, ma in stile italiano. Beh, se avanzava del manzo lei lo tritava, lo mescolava con uova, formaggio e pane e faceva delle crocchette, qualcosa del genere. E se aveva delle verdure faceva quella che viene chiamata frittata. Perchè si trita tutto e si mischia con le uova, così non penso che, eccetto per quello che non si poteva usare, come i gambi degli asparagi che non si possono mangiare, ma, se c'era qualcosa di commestibile, lei sicuro non buttava via niente.

—Elda Del Bino Willits[6]

Quando arrivammo in questo paese, le persone presso cui mio padre era a pensione mi regalarono una bella bambolina per Natale. Oh, mio Dio, era meravigliosa. La mamma mi ci lasciò giocare per due anni, poi la spedì in Europa, perché le mie cuginette ne avevano più bisogno di me. Mi si spezzò il cuore. Lei cuciva una gran quantità di vestiti. E i vestiti che faceva! Lei aveva una giacca lunga, una giacca di tessuto leggero. Mi sembra ancora di vederla. Quando si sposò, era parte del suo corredo. Poi la trasformò nel mio vestito della Prima comunione. Era bianco con una piccola striscia sottile color lavanda. Dunque, ci fece il vestito per la mia Prima comunione, una lana molto leggera. Poi ne ricavò un vestitino e ci sistemò una spilla tra le gambe. Quello era per il mio fratellino. Infine, ne fece un cappottino per la mia bambola e lo rispedì indietro in Italia!

—Renata Nieri Maccarone[7]

Rotolo di un'antenata: Maria Grazia Catalano (Nonni D'Amore)

Mia nonna, la madre di mio padre, era una donna forte. Quando arrivò dall'Italia, dormiva in una stia per polli in Canada. Sua sorella, Assunta, si stabilì in Canada, ma "Nonni" venne qui. Per tutto il tempo in cui la conobbi, la nonna visse al n. 4331 di Washington Street, ma in Italia il suo paese d'origine era piccolo, Montefalcione, fra le montagne non lontano da Napoli, in provincia di Avellino. Ho visitato la casa in cui lei nacque. Era di pietra grezza e di fronte c'è ancora una piccola fontana dove la gente viene a riempire le bottiglie con l'acqua pura che sgorga dal sottosuolo. Alla fine della stradina di pietre, si può gettare lo sguardo al di là della valle e scorgere su un'altra collina, il paese più vicino. Qui, in America, ebbe tredici figli. Io ne ho conosciuti otto. Cinque morirono. Quella era una famiglia molto rumorosa. Succedeva sempre qualcosa e la gente non si faceva scrupolo di urlare. Talvolta Nonni D'Amore brontolava un po' ma per lo più era molto disponibile, incline alla calma, gentile ma forte allo stesso tempo. Mi sentivo sempre bene in sua presenza, come se emanasse un senso di conforto. Con lei mi sentivo sicura. A casa sua le feste erano un divertimento, si cucinava tanto. Era solita rimestare dentro grandi pentole poggiate sul vecchio fornello smaltato, preparava ravioli sul tavolo di cucina, mettendoli ad asciugare su un lenzuolo ruvido posato sul letto di mio cugino; metteva sempre cibo in più sulla tavola, ma non insisteva mai per servirtelo. Sorrideva più di quanto parlasse e sembrava come un sole sopra tutti noi. Ma come si sarà sentita questa donna che aveva perso cinque figli, otto sopravvissuti? Forse che ogni ruga sul suo viso esprimeva il dolore di una perdita? Forse che quelle perdite l'avevano resa più gentile e paziente? Non perse mai il suo spirito. Le ho voluto bene e lei mi ha insegnato molto a proposito dell'amore e dell'allegria. Quando mia madre andò in Italia per cinque mesi, Nonni mi portava nel North End a trovare i suoi amici - vicoli stretti, scalinate scure, una luce fioca mentre sorseggiavamo il caffè in cucina, appoggiati al tavolo coperto dall'incerata. Mi voleva bene.

L'Infanzia nei casamenti

Due dei figli di Antonio, Tony e Rico, da ragazzi non riuscirono neppure a trovare lavoro come lustrascarpe perché erano italiani. Uscendo dai loro affollati appartamenti nei casamenti, dove i ragazzi dormivano l'uno accanto all'altro di fianco, in un letto, e le ragazze in un altro, essi se ne andavano dai negozianti ebrei di Salem Street a Boston. Giovani commercianti, ricevevano ciascuno un mazzo di calzini da vendere al mercato. Allestendo una scatola di cartone come bancarella, vendevano la loro merce come ambulanti.

Tutti lavoravano nella famiglia di immigranti italiani. Il lavoro era una tradizione onorata nella vita italiana. C'era il convincimento che con il lavoro si potevano superare le avversità. Per molti immigranti era una profonda fonte di dolore il fatto che in Italia, per quanto duramente lavorassero, non riuscivano ad andare avanti. Abbandonare il suolo natío era una decisione spesso imposta dalle condizioni della loro terra d'origine.

La sola persona che lascia la terra natale è un individuo che è stato abbandonato da essa. Qui, ho trovato la mia dignità e la stima in me stesso. Almeno in America si può sognare. Ogni cosa comincia con un sogno. La libertà è la realizzazione del vostro sogno.

> —Les Marino, proprietario della Modern Continental Construction Co, in un intervento alla Cerimonia di Naturalizzazione, Old South Church, Boston, agosto 2000

"VOCI"—Interviste familiari

"Lavoravamo tutti, tanto per uscire di scuola. Andavamo giù al mercato, scatoloni di cartone, bottiglie da mezza pinta. Poi ci prendevamo un barile che era di proprietà di un tale e lo portavamo fin davanti a un altro tizio, il vicino che vendeva la carne lì accanto, e gli vendevamo il barile, per mezzo dollaro. Bisognava far presto per fare il colpo! Vendevamo giornali. Lustravamo scarpe. Il sabato non potevamo far niente. Andavamo giù e compravamo una cassa di limoni – di solito prendevamo una cassa di limoni per tre dollari. Una cassa di limoni ti faceva guadagnare dieci dollari.

Conoscemmo un tale in un negozio di mercerie a Salem Street. Ci diede da vendere dei calzini. Ce ne siamo andati in giro e Tony aveva un po' di questi calzini. Proprio sopra il Mercato di E. Gray c'era un posto dove facevano i salami e la mortadella con una macchina. Tony teneva esposti tutti i calzini su una grande scatola di cartone, sai, e li vendeva. Mi pare che li metteva a un "buck" (un dollaro), tre paia per un dollaro o qualcosa del genere. Tutt'a un tratto, la macchina crollò, i salami finiti per strada schizzarono addosso a tutti quanti, ai carrettini e a tutti noi. La vendita ambulante di Tony andò all'aria! Non dovemmo pagare i calzini perché li avevamo presi in conto vendita da quell'uomo. Facevamo così noi. Non la compravamo mai la merce perché, se ti capitava un guaio non ti ritrovavi niente in mano.

> —Rico D'Amore (seconda generazione), intervista di B. D'Amore, 2000 dal video *The Thread of Life in One Italian American Family*

Il "Café Roma" stava per essere messo all'asta. Mio padre conosceva Jerry Nazzaro, che era allora il proprietario del locale, gli fece un'offerta e ci ritrovammo là. Grazie a lui, fui in grado di lavorare sette giorni alla settimana, dodici ore al giorno per 365 giorni all'anno, a dieci dollari alla settimana, di cui cinque indietro per la camera e la pensione. Questa è una storia vera, d'accordo?

Ehi, in quei giorni, si portava a casa la paga alla mamma. Sai, non si scherzava mica. Ricordo la famiglia Marmai. Erano otto. Lavoravano tutti compresi tutti i figli. Quando ricevevano la busta con la loro paga, non osavano aprirla. La portavano a casa alla mamma. Lei gli dava ciò di cui avevano bisogno per il biglietto del mezzo di trasporto e per ogni altra esigenza della settimana e il resto lo tratteneva per mandare avanti la casa.

Certo, riuscivano sempre a rubacchiare un po' di dollari, naturalmente, è chiaro. Ma le cose andavano in questo modo, e molte famiglie si comportavano così. Indipendentemente dall'età, se vivevi a casa, non eri padrone di te stesso. Dovevi stare alle regole.

Parliamo dei bei tempi andati. Beh, i bei tempi andati non erano poi così belli, perché c'era molta fame, un sacco di pregiudizi e un sacco di difficoltà. La gente faceva una vita dura, molto dura. Le donne avevano ancora nove figli senza lavabiancheria, né lavastoviglie, né docce; condividevano il piccolo gabinetto esterno sul ballatoio con altre tre famiglie. I bei tempi andati non erano poi così belli.

Ma pensaci un attimo. E' una cosa meravigliosa. In una maniera o nell'altra, a meno che siate paranoici riguardo a queste cose, i tempi duri in realtà sbiadiscono. E i tempi felici risorgono sempre.

—Tullio Baldi (seconda generazione), intervista di B. Amore, 2005, Progetto *Life line*, 2000-2006

"VOCI"—Interviste da Ellis Island

Era un appartamentino di sole due stanze e ci stavamo in dieci, anzi nove, perché lui (mio padre) era tornato ad Asti (California) dato che non eravamo economicamente autosufficienti. E mi ricordo di come dormivamo là, eravamo tre in ogni letto ed io capitavo sempre nel mezzo [ride]. Con due delle mie sorelle e quelle, uh, mi schiacciavano se stavo seduta o se dormivo in mezzo a loro, così mi stendevo in fondo al letto, ma neanche questo era particolarmente piacevole.

—Elda Del Bino Willits[8]

La necessità condiziona la scelta

Marie, la figlia più grande, dovette lasciare la scuola per occuparsi dei più piccoli. I suoi sette fratelli e sorelle vennero incoraggiati a completare le scuole superiori e poi andare a lavorare. Tony, i suoi fratelli e suo nipote Paul, trascorrevano l'estate al "Caddy Camp", sponsorizzato dalla North Bennett Street Industrial School allo scopo di portare in campagna i ragazzi di città. Come risultato Tony diventò, per tutta la vita, un giocatore di golf, uno sport di cui non si era mai sentito parlare nel suo natío North End. Queste erano esperienze importanti per far venire a contatto i figli di seconda e terza generazione con il mondo al di fuori della loro piccola comunità italiana. Adolph, Mike e Rico fecero anche parte del Civilian Conservation Corps, creato da Roosevelt, che li portò lontani dal proprio "paese urbano" del North End.

Tony D'Amore

Tony, il figlio maggiore, venne sostenuto dall'intera famiglia nel corso dei suoi studi. Ci volle l'energia di tutti per reintegrare il denaro perduto per avere uno studente in famiglia. Egli frequentò le scuole dei Gesuiti ed entrò poi nel Seminario Maryknoll per tre anni, ma le conseguenze di una precoce meningite spinale gli impedirono di completare gli studi. Prese in considerazione prima la Facoltà di Medicina, poi in seguito quella di Giurisprudenza.

Malgrado si fosse laureato presso il Boston College e avesse un lavoro presso la Biblioteca del Congresso, a Washington, D.C. dopo la Seconda Guerra Mondiale, egli scelse infine di dar vita a un'attività commerciale familiare assieme ai suoi fratelli, con l'obiettivo di far fronte alle sue responsabilità di figlio maggiore. La cultura della "via vecchia" venne trasmessa alla seconda generazione entrando spesso in conflitto con la "via nuova" richiesta dalla partecipazione alla vita americana. Per i genitori era un fatto scontato aspettarsi di avere una voce in capitolo nella scelta di una futura sposa, ad esempio, e la deviazione da questa consuetudine era motivo di frizione. Ne nacque, allora un inevitabile conflitto di fondo tra la realizzazione di sé e la fedeltà alla famiglia.

Lettere

Boston, Mass.

Mi chiedo se ti rendi conto di che razza di tempi diffiili ti aspettano quando dirai a tua madre [che ti stai per sposare] Io lo so bene! Comunque, dovrai tener duro se hai deciso di spuntarla. Sembra quasi che tua madre speri che io non le infliggerò il dolore di sposarti prima che tu ottenga la laurea in giurisprudenza. Non so che cosa le dirò se mi chiederà di non sposarti –cioè dopo che le avrai rivelato la notizia.

Credo faresti meglio a pensare di venire a casa un fine settimana per dirglielo, o meglio ancora, scriviglielo prima e poi vienila a trovare. Bene, qualsiasi cosa accada, combatteremo insieme, per ottenere la felicità che così ardentemente desideriamo. Sarà così, se questa è la volontà di Dio. Prego ferventemente per questo aiuto!

—Nina Piscopo, estratto di una lettera a Tony. Erano già fidanzati da un anno, 22 settembre 1941

Washington, D.C.

Ho ricavato il più gran divertimento da una delle tue lettere, quella dove accennavi al battibecco riguardante i miei parenti stretti - perbacco! - mi sono fatto una gran risata a causa della battuta: «Non voglio che Tony si sposi finché non avrà finito la Facoltà di Legge», Ah, ah, è così dannatamente buffo e ironico, oltretutto – che diavolo mai vogliono che faccia, che stia inchiodato a casa finché non invecchierò?

Ascoltami, tesoro, noi ci sposeremo senza preoccuparci d'altro, stampatelo nella tua testolina. Per quanto riguarda la mia famiglia, loro prontamente acconsentiranno ad aderire ad ogni cosa che avrò da dire e questo è un dato di fatto.

—Tony D'Amore, estratto di una lettera a Nina, sua futura moglie, 24 settembre 1941

L'Azienda familiare

Questo conflitto tra il proprio "io" e la famiglia fu spesso un sottile doppio legame che influenzò la seconda generazione dei figli di immigranti per tutta la vita. Tony non visse mai nella sua casa d'origine dopo le nozze, ma abitò con la madre di sua moglie, Concettina, e si prese cura di lei. Sebbene lavorasse in uno studio legale, insegnasse a scuola, e considerasse gli studi giuridici una professione, non abbandonò mai la convinzione di avere una responsabilità nei confronti dei fratelli e delle sorelle più giovani. Suo nipote Gerald, lo ricorda quando si presentò a casa della sua famiglia e avanzò la proposta di aprire una lavanderia a secco lasciando increduli genitori e fratelli .

Le aziende familiari, nacquero come un modo di stare vicino a "la famiglia", il gruppo che rappresentava il vincolo più forte, quello cui si poteva dare fiducia. Spesso, questa era anche una maniera di partecipare ad una comunità più ampia, quantunque basata su una comune base di sostegno. L'azienda familiare di lavaggio a secco dei D'Amore venne chiamata da Tony "Atlas Cleaners" in onore del dio greco, Atlante, che sorreggeva il mondo. La sua formazione classica fu sempre parte integrante del suo modo di pensare e di esprimersi.

Allenamento per la vita

'The Shop' (il negozio), come veniva chiamato, divenne il campo di addestramento al mondo del lavoro per molti dei cugini della terza generazione. I ragazzi aiutavano a selezionare i vestiti, metterli sulle grucce e riconsegnarli alla Guardia Costiera e ai militari della Marina, che erano i loro clienti principali. Le ragazze aiutavano con la contabilità e, occasionalmente, venivano ammesse a bordo delle navi della Guardia Costiera, ma soltanto fino alla pubertà. Non appena esse cominciavano a mostrare i primi segni del divenire "signorine", venivano relegate in casa per tenerle "al sicuro" dagli sguardi dei giovani marinai.

Le gite in camion con lo zio Tony erano sempre affascinanti, perchè a lui piaceva condividere le sue riflessioni filosofiche sulla vita e cercare di stimolare nei suoi giovani ascoltatori la propensione a porsi delle domande. E poi col suo umorismo beffardo, li divertiva pure. Il "Negozio" era una faccenda di famiglia ed ognuno ne era coinvolto in un modo o nell'altro. Alla fine, dopo vent'anni, le divergenze fra i fratelli, dovute al loro temperamento risoluto, causarono la vendita dell'attività.

"VOCI"—Interviste familiari

Quando lavoravo con Papà, per essere onesto, non ottenevo mai un particolare consiglio. Era sempre qualcosa di indiretto. Sostanzialmente, dovevi riuscire a capire le cose da solo. Papà raramente faceva dei "kudos" (complimenti). Dopo che avevi fatto qualcosa e avevi avuto successo, potevi apprezzare di più il senso del tuo valore. Se non diceva nulla, voleva dire che approvava. Questo era il riconoscimento.

Mi ricordo di quando, per esempio "mi gettò nella piscina", per così dire. C'era una nave della Marina che stava arrivando a East Boston e lui mi spedì da solo, a diciassette anni, ad occuparmi della nave. Ciò significava che dovevo andare a ritirare le "blues" (uniformi) dei marinai che sbarcavano. Lì c'era un altro tizio più anziano che cercava di rubarci il lavoro e così dovetti cambiare sistema. Riuscivo a stento ad annotare i nomi, avevo solo il tempo di scarabocchiare le informazioni, ma riuscì a conservare i nostri clienti e realizzammo una tonnellata di affari su quella nave.

No, non c'era nessun senso dell'orgoglio perché l'orgoglio non esisteva nel vocabolario di Papà. Non c'era posto per l'orgoglio – solo l'umiltà… Credo di essere divenuto gradualmente più fiducioso nei miei mezzi. Questo significava stargli intorno, lavorare con lui. Facevi solo le cose che ti chiedeva di fare. Dovevi essere svelto ad imparare altrimenti lui non ti avrebbe più offerto l'opportunità di quelle sfide.

—Denis D'Amore (figlio di Tony, terza generazione), intervista di B. Amore, ottobre 2003, Progetto *Life line*, 2000-2006

Lealtà messa in dubbio

Molti italiani fecero domanda per ottenere la cittadinanza americana durante gli anni della Seconda Guerra Mondiale per dimostrare la propria fedeltà alla loro patria adottiva. Maria Grazia D'Amore divenne cittadina americana nel 1944. Eufrasia, sorella di Concettina, ottenne la cittadinanza americana nel 1940. La stessa Concettina, che era stata "naturalizzata" attraverso il matrimonio con Ernesto nel 1906, quando fece domanda di lavoro al Dipartimento del Tesoro di Washington, D.C., impiegò moltissimo tempo per dimostrare che era cittadina americana e fu esortata, per il futuro, a presentare questo documento come prova della sua cittadinanza. A quella data, lei viveva in America ormai da 38 anni!

Più tardi, quando lavorava per Raytheon, una società di elettronica che eseguiva contratti per la difesa, la fotografia di Concettina venne pubblicata nella Raytheon News perché aveva comprato una "War Bond" (obbligazione di guerra) da 2000 dollari:

«War Bond da 2.000 dollari acquistata da Watertown Ray. Concettina Piscopo, Dipartimento W 861, stabilimento di Watertown, non solo contribuisce all'impegno della guerra attraverso il suo lavoro alla Raytheon, ma fa anche la sua parte acquistando obbligazioni di guerra».

—*Raytheon News*, July 1945

Servendo l'America

Quattro dei fratelli D'Amore prestarono servizio nelle Forze Armate durante la Seconda Guerra Mondiale: Adolph, Mike e Tony nell'Esercito, Rico in Marina. In un momento storico in cui anche la lealtà degli italoamericani era messa in discussione a causa dell'Alleanza di Mussolini con Hitler, le famiglie d'origine italiana continuarono a mandare i loro figli a combattere per l'America. Tony si arruolò, di fatto, come volontario per il servizio militare anche se ne era esentato a causa del suo impiego presso la Biblioteca del Congresso, che era un ente governativo. Fu congedato dall'Esercito degli Stati Uniti nel 1945 con due "Bronze Stars" (stelle al merito militare di bronzo) e un "Good Conduct Ribbon" (nastro di buona condotta). Suo fratello, Mike, prese parte anche alla campagna militare in Asia-Pacifico. Si guadagnò due "Purple Heart" (medaglie al valore per ferite riportate in guerra) oltre a molte altre ancora, e cucinò perfino per Eleanor Roosevelt, la moglie del Presidente, in visita alle truppe al fronte.

Le famiglie italoamericane si ritrovarono in una situazione intollerabilmente dolorosa, sostenendo l'America in qualità di suoi cittadini e nutrendo forti preoccupazioni per le proprie famiglie d'origine, in Italia, che vivevano sotto il Fascismo. Era abitudine dislocare gli italoamericani nel Pacifico piuttosto che inviarli in Europa. Malgrado ciò, alcuni militari subirono l'incredibile esperienza di combattere nelle regioni dei loro antenati e di trovarsi faccia a faccia con i loro cugini lontani mentre risalivano su per lo "stivale".

"VOCI"—Interviste familiari

Oh, mi è piaciuto tantissimo il periodo trascorso là [in Italia], davvero. Ma, sai, per un GI, era tutta un'altra cosa. E l'Italia, allora, si può dire che era come spogliata di gran parte della sua cultura. Sono stato a Pompei e là non c'era niente da visitare, perché tutti gli oggetti d'arte erano stati prelevati e portati nel museo a Napoli.

Dovunque si andasse, non c'era rimasto quasi niente da vedere, tutto era in condizioni di guerra e l'intera marina era stata completamente bombardata dagli aerei americani, che inseguivano i tedeschi. Di fatto, quando arrivai nel golfo di Napoli, col buio della sera, c'era una delle navi che i tedeschi avevano fatto mezza affondare aprendovi delle falle, poi avevano tolto la sovrastruttura e avevano costruito un molo – questo facevano con molte delle navi che avevano affondato, toglievano la sovrastruttura e le trasformavano in moli e banchine.

Durante la Seconda Guerra Mondiale l'esercito era...erano italiani. No, non c'è nessun dubbio al riguardo, è una cosa documentata, era il più grande gruppo etnico, perché gli italiani avevano famiglie così numerose.

—Tullio Baldi (seconda generazione), intervista di B. Amore, 2005, Progetto *Life line*, 2000-2006

In quella che adesso è nota come *Una Storia Segreta* più di 600.000 italoamericani durante la Seconda Guerra Mondiale vennero considerati in America "enemy aliens" (stranieri nemici). Alcuni furono forzatamente evacuati dalle loro case e messi in campi di internamento senza regolare processo, altri dovettero sottostare ad un rigido coprifuoco e portare sempre con sé un documento d'identità. Il codice dell' "omertà", il tradizionale silenzio, impedì a molti italoamericani una qualsiasi forma di protesta politica contro la vergogna dell'essere stati così ingiustamente etichettati. Pietrina Raccuglia, una immigrante che viveva a Brooklyn, New York, aveva un figlio che prestava servizio nelle Forze Armate degli Stati Uniti d'America nel momento in cui le fu rilasciata una "Alien Enemy Registration Card". Rimase così sconvolta dal fatto che venisse messa in discussione la sua lealtà, da decidere di non voler mai più diventare cittadina americana.

Nel 1999, i deputati Rick Lazio ed Eliot Engel presentarono al Congresso il progetto legislativo denominato "The Wartime Violation of Italian American Civil Liberties Act" (Legge sulla violazione, in tempo di guerra, delle libertà civili degli italoamericani), che riconosceva questi fatti poco noti. Essa venne ratificata dal Parlamento e firmata dall'allora Presidente Bill Clinton nel 2000 e ora prevede finanziamenti per documentari e mostre che esplorino questa complessa vicenda.

Lettera dalla guerra

Scrivo questa lettera su richiesta di suo marito. La busta è diventata inutilizzabile, così ne ho scritta un'altra. Suo marito non è qui al momento; so che sta bene.

Nuova Guinea, 4/12/1944

Carissima Nina,

sembra che muoiano tutti di questi tempi. Confido che sopravviverò al macello. Sono stato molto addolorato dalla scomparsa recente della madre di Ann. Avresti dovuto spedirmi il suo indirizzo, avrei voluto presentarle le mie condoglianze. Nelle lettere precedenti ho espresso la mia opinione sul servizio postale – fa schifo. Immagino ti rendi conto che sta diventando più difficile per me scriverti delle lettere. Perché? Dovresti essere in grado di intuirlo. Mi domando dove celebrerò il mio 33mo compleanno. Sono così contento ora di aver seguito un corso di escatologia [la scienza dei quattro valori finali: morte, giudizio universale, paradiso e inferno].

Poiché sei il "boss" della famiglia, e sei anche una in gamba, il tuo compito è davvero tremendo. C'è una cosa che ho sempre desiderato dirti: quando i bambini ne avranno l'età, voglio assolutamente che frequentino una scuola privata gestita da religiosi. So che se fossi a casa avremmo una discussione accalorata su questa questione. Dal momento che sono qui e Dio solo sa quando e se mai tornerò, voglio che tu dia retta a ciò che ti ho detto.

Nina, questi sono momenti di decisioni e di confusione… non voglio sembrare Polonio, ma in questa "fase del gioco" occorre includere in una lettera tutto quello che uno può. Tutto finirà bene, con l'aiuto di Dio. La mia reazione è la stessa del Maestro «Sia fatta la tua volontà, non la mia»… Devo dire che i pochi anni concitati che abbiamo passati insieme sono stati memorabili. Fra questi ci sono i momenti più felici della mia vita. Sei comparsa quando avevo più bisogno di te – giacché al tempo del nostro incontro io ero certamente in una situazione estremamente incerta. Seminario, Italia, Simmons, BU. Tutti questi avvenimenti sono eventi straordinari che nemmeno adesso mi riesce di mettere insieme. avevo bisogno di qualcosa che mi desse calma ed equilibrio. Hai fatto un lavoro meraviglioso… Talvolta mi chiedo se ti ho sedotto e convinto a sposarmi per mezzo dei miei racconti di Rabelais. Se ricordo bene, sei morta dal ridere con

questo buffo francese. In ogni caso, ringrazio Iddio per un così bel premio – ne è valsa la pena.

<div align="center">* * *</div>

Come qualcuno possa stipare in una sola lettera gli avvenimenti di tutta una vita è cosa che va al di là della mia comprensione… Come ho detto prima, il nome di Lui scioglierà tutto. In conclusione – quali epoche felici ti amano? Quali possenti genitori hanno dato vita ad un'anima come la tua? Nel mentre i fiumi scendono verso il mare e le ombre delle montagne attraversano i loro pendii, nel mentre le stelle si nutrono nei pascoli del cielo, il tuo onore, il tuo nome e le lodi nei tuoi confronti perdureranno in qualsivoglia terra dove vorranno inviarmi. A te e i ai nostri figli va il mio amore più profondo. Sei in una perfetta trinità – l'essere tutta e la fine tutta di un degno soggiorno in uno splendido universo.

Per sempre – T

—Estratto di una lettera scritta da Tony a sua moglie Nina dalla Nuova Guinea, dove era di stanza durante la Seconda Guerra Mondiale. Le era stata inviata tramite una terza persona perchè la busta originale era stata così danneggiata da risultare illegibile.

Trittico D'Amore: Storie Familiarli

Umberto Antonio D'Amore portò il nome di uno dei re d'Italia per tutta la sua vita sebbene fosse nato in un paesino fatto di pietra, Montefalcione, in provincia di Avellino, nell'Italia meridionale. Molto tempo dopo la sua morte, scoprimmo che il nome datogli alla nascita era in realtà Ruberto! Egli lasciò la sua casa all'età di tredici anni e giunse in America quando ne aveva ventitre. Lavorò di piccone e pala e come muratore su pietra per tutta la vita. I suoi figli ricordano che lavorava quattordici ore al giorno, sette giorni alla settimana. Talvolta aveva le domeniche libere ed era solito portare i figli a passeggio per i Boston Commons. Quando passavano davanti ad una chiesa protestante, diceva loro che Dio era presente in ogni religione. Nel giorno del Memorial Day era tradizione fare delle scampagnate al cimitero dove si incontravano tutti i paesani. Ognuno portava qualcosa da mangiare e ricordava la vita in Italia. Papa Nonno era molto severo e non voleva vedere i bambini ciondolare in giro. Alle volte li prendeva a cinghiate. Nonni D'Amore era un'anima dolce, generosa e sempre pronta a prendersi cura degli altri. Quando aveva ventisei anni, i dottori le dissero che era destinata a morire a causa di un problema cardiaco. La sua risposta fu: «Datemi il mio cappotto» e se ne andò percorrendo a piedi le tre miglia fino a casa. Malgrado il suo coraggio, spesso non stava bene e doveva essere ricoverata in ospedale.

Talvolta le ragazze stavano con lei, ma i ragazzi sarebbero stati messi in una parte diversa dell'ospedale e non l'avrebbero potuta incontrare per sei-sette mesi. La solidarietà fra i ragazzi era molto forte e necessaria per sopravvivere all'asprezza del vicinato. Mio padre ricorda quando sua sorella, Marie, scaraventò una cassetta d'uva da un balcone sulla testa di due fratelli, suoi rivali, che lo inseguivano. Da allora non lo importunarono più! Marie (nata Angela Maria dal nome della nonna), la figlia maggiore, controllava i fratellini e le sorelline più giovani. Si prese cura di tutti per tutta la vita. Quando Dolly era piccola, lei le comprava vestitini alla Shirley Temple. Era solita pettinare i capelli della mamma e fare le trecce alla Nonna quando questa cominciò ad invecchiare. Divenne "Grand Regent" (Gran Reggente) dell'associazione delle Catholic Daughters of America di Court of Ausonia, e gestiva campagne per la raccolta di fondi per la costruzione del "National Shrine" di Washington, D.C.. Aveva una lingua tagliente e un'indole compassionevole. Sposò Ray Masiello ed ebbe due figli, Gerald e Richard. Tony, mio padre, era il figlio maschio più grande. Da bambino soffrì di meningite spinale che gli lasciò una tendenza ad addormentarsi. Studiava

nella cantina del suo casamento alla luce di una lampadina e sua madre era solita scendere laggiù per andare a sincerarsi che fosse sveglio. Ad un certo punto, se ne andò in Italia per studiare medicina. Sfortunatamente, sopraggiunse la guerra e lui si imbarcò sul Rex, l'ultima nave a lasciare Napoli, e riuscì a rientrare in patria. Non tornò mai ufficialmente ai suoi studi, ma continuò a leggere opere in latino e di teologia per tutta la vita. Prima della guerra, lavorò per la Biblioteca del Congresso a Washington, D.C. Io nacqui nel Distretto di Columbia.

I "ragazzi", cioè i miei zii, Adolph, Mike, Phil e mio padre, lavoravano insieme lavando a secco uniformi militari per gli equipaggi della Marina e delle imbarcazioni della Guardia Costiera. Il che significava lunghe giornate di lavoro che cominciavano alle 6 del mattino, col ritiro e la consegna della merce dalle diverse navi che avevano nomi come "Edisto", "Hen and Chickens", "Mc Cullough". Marie, inoltre, aiutava nel "The Shop". Nel corso degli anni, Denis, Ron, Paul ed alcuni degli altri cugini lavorarono là anch'essi. Aiutavamo tutti a registrare gli "elenchi dei risvolti", che erano una litania di nomi dai suoni più strani ricavati dai risvolti delle uniformi dove erano stampati con inchiostro indelebile. I fratelli faticavano davvero tutti insieme. Tony sposò Nina, una disegnatrice di moda, ed ebbe quattro figli: Bernadette, Denis, Ron e Steph. Phil, il secondo figlio maschio, si colpì accidentalmente al ginocchio con una "calibro 45" carica, quando era un ragazzino. La pistola apparteneva a suo zio, Zi' Ricuccio, che aveva ricevuto una medaglia d'argento, "Silver Star" (stella al merito militare d'argento) nella Prima Guerra Mondiale. Phil trascorse la maggior parte della sua infanzia in ospedale, perché dovette sottoporsi a 7-8 operazioni al ginocchio. Aveva un dito rigido e un'andatura zoppicante e scherzava sempre. Amava i bambini e "adottò" i figli di sua sorella Dolly dopo la prematura morte di lei. Portava i bambini a pescare e a cantare canzoni ai pesci. Mike, il terzo figlio, sposò una donna italiana, Maria Mauriello, di Montefalcione. Sua madre era andata in Italia e aveva "scelto" per lui Maria. Erano davvero innamorati. Anthony, Maria Grazia e Michael Louis sono i loro tre figli. Rico, il quarto fratello fu il primo ad arruolarsi nel Civilian Conservation Corps. Rimase in servizio complessivamente per 7 o 8 anni, perchè usò i nomi dei fratelli Mike e Phil per poter ripetere la ferma. Sposò Leona, che aveva trascorso la maggior parte della sua infanzia in un orfanotrofio, perché sua madre aveva abbandonato la famiglia e suo padre non fu mai un "vero padre". Essi si incontrarono quando avevano 18 e 17 anni rispettivamente ed ebbero due figli, Bobby e Gregory. La loro era sempre la

casa più tranquilla da visitare. Adolph, il più giovane dei fratelli, studiò da estetista e aveva effettivamente avviato una piccola attività. Nonni D'Amore voleva che Adolph facesse parte dell'azienda di lavaggio a secco "Atlas Cleaners", cosicché alla fine anche lui vi entrò. Convinse i fratelli ad aprire un "Locker Club" (circolo con spogliatoio e armadietti) per i marinai (quando avevo nove o dieci anni, io avevo l'abitudine di leggere di nascosto i romanzi "osé" che loro abbandonavano là).

Adolph sposò un'amica di sua sorella Dolly, Christine, che era greca ed ebbe quattro figli, David, Denise, Sandra e Paula. Susie, la seconda figlia, scappò di casa per sposarsi con Tullio. Ebbero 7 figli e lei morì di cancro all'età di 43 anni. Ebbe sempre un carattere dolce. Ero solita aiutarla ad appendere il bucato nel porticato e accanto alla stufa a petrolio della cucina dove abitava in uno degli appartamenti di mia nonna. Tullio aveva un negozietto all'angolo. Da lui compravamo sempre il salame. Era divertente fermarsi là perché ci dava sempre un dolcetto. I miei sette cugini, Pamela, Paul, Joey, Susan, Marian, Larry e Philip, crebbero sostanzialmente senza mamma. Trascorrevano moltissimo tempo con la loro nonna paterna, Nonni D'Amore e la zia Marie. Antonio e Maria Grazia ebbero anche una figlia, chiamata "Baby Louise", che morì per colpa di un'infezione ad un dente. La seconda Louise, soprannominata Dolly (perché la gente scoppiava a piangere quando ricordava la prima Louise), era la più giovane della famiglia. Prese il diploma della high school e lavorò al City Hospital. Dolly sposò Nino in Italia ed ebbe tre figli: Susan, Joey e Margaret. Dolly morì per un attacco cardiaco a 49 anni e lasciò Susan, che aveva solo 10 anni, a fare la "mamma" di famiglia. Aveva sempre una grande energia e manifestava le sue idee, non tenendo conto del giudizio degli altri. Le feste a casa D'Amore erano sempre piene di cugini, zii e zie. Dopo cena, una volta rigovernata la cucina, eravamo soliti giocare a poker – montagne di centesimi al centro della tavola che si spostavano gradualmente verso i vari angoli. Philly cercava sempre di barare e veniva clamorosamente rimproverato quando veniva colto in fallo. Scoppiavano risse senza che nessuno se ne curasse e noi cugini uscivamo fuori a giocare senza alcun controllo mentre gli adulti erano occupati altrimenti! Questa parte della mia famiglia era come una massa di individui forti, duri, affezionati, imprevedibili e leali.

Ritorno alle radici: ieri e oggi
"Finché c'è vita c'è speranza"

Il seme della vita di famiglia si propagò alle generazioni successive. Il vivere in America per più di cento anni portò queste famiglie in un secolo nuovo. Alcuni si sono trasferiti molto lontano dai vecchi quartieri, quelli in cui si erano inizialmente stabiliti i loro antenati. I cambiamenti abbondano, eppure il legame con alcuni principi della "via vecchia" continua a mantenere in contatto una parte della generazione presente alle sue radici italiane. Matrimoni, viaggi frequenti e una continua corrispondenza rinsaldano i legami. Le feste vengono spesso celebrate in maniera tradizionale, cucinando le specialità della *Nonna*. Infatti, il cibo e la musica che la maggior parte degli italoamericani continua a preservare gelosamente, somigliano, a volte, più alla cultura di un secolo fa che a quella dell'Italia moderna. Anche questa è parte dell'eredità.

Tony e Nina

Tony D'Amore incontrò Nina Piscopo nel 1940 ed essi si sposarono nel 1941, subito dopo l'attacco a Pearl Harbor che spinse gli Stati Uniti ad entrare nella Seconda Guerra Mondiale. La famiglia di Tony era solita dire che lui aveva «agganciato il suo carretto a una stella», dal momento che i due provenivano da condizioni sociali diverse. La vita dei loro figli fu però più ricca grazie a queste differenze. La famiglia di Nina era formata da quattro persone. La famiglia di Tony era numerosa e socievole, si radunava ogni domenica nella casa di famiglia per godere dei pasti abbondanti, delle partite a poker e i dei giochi turbolenti dei numerosi cugini. Questa usanza pose le basi del legame che ancora esiste nella nostra famiglia, fra i cugini più anziani. Questi legami erano anche più forti giacché la maggior parte dei membri della famiglia non soltanto viveva a stretto contatto, ma perdippiù lavorava insieme.

Sebbene pare che Tony si fosse innamorato di Nina "a prima vista", egli la corteggiò assiduamente per poterla sottrarre al suo precedente innamorato, Bill Peppi. Nina si dichiarava innamorata di lui e, tuttavia, continuò a tentennare indecisa tra i due uomini. Ad un certo punto, Tony lasciò Boston e trovò un impiego a Washington, D.C., presso la Biblioteca del Congresso. Fu questo a spingere Nina verso una scelta definitiva e lei e Tony si sposarono cinque mesi più tardi.

Una delle prime lettere di Tony a Nina

23 maggio 1940

Carissima,

saluti, salve e ave a tutti.

Seguendo il tuo desiderio, mio cherubino, adempio a ciò che sto facendo, scrivendoti questa epistola. Fiat voluntas tua, carissima mea, non solum, nunc, sed semper et ubique in hoc mundo etiamque in aeternitate.

Dolce visione di bellezza; perfettissima figlia di Eva, in umiltà, in autoabnegazione di mente e di spirito, con profondo senso di reverenza, in grandiosa e timorosa ammirazione, confesso, riconosco, dichiaro solennemente e non nego di amarti.

Tempus fugit, mia cara, e la delizia dello scrivente deve giungere a un termine, poiché la voce tonante di Simon Legree, alias Fitz, mi sta chiamando "ai colori" (a difendere la bandiera).

Solleva lo stendardo! «Tutte le mani sul ponte e quindici uomini sul petto del morto», grida Fitz in un accesso di follia; di questa stoffa è fatto l'uomo.

Così fino al prossimo appuntamento e rendez-vous, desidero inviarti un "au revoir". I ragazzi dell'ufficio mi "metteranno in croce", Nina. Non ce la farò mai. Ci vediamo venerdì sera, cara.

—Tony

Lettera di Tony a Nina, quando lui decise di partire per Washington, D.C. e la loro relazione sembrò finita in un vicolo cieco.

«via dura est via melior»

12 marzo 1941

Tesoro,

qualcuno doveva agire. Dal momento che né tu né Bill lo avreste fatto, l'ho dovuto fare io. Perché prolungare un tormento della mente se non è necessario? Se un uomo affamato ti chiedesse del pane, gli offriresti da mangiare delle pietre?

Io ti amo ancora di più di Peppi. Fare ciò che ho fatto mi ha spezzato il cuore. Non piangere per me, comunque, ma piangi per te stessa e per i tuoi cari.

Dio ti benedica, cara, più di quanto tu ami Lui, e sforzati duramente di amarLo durante il resto della Quaresima. Questo è il miglior genere di mortificazione.

Sempre con amore e amicizia

—T

Lettera di Nina a Tony dopo che lei lo aveva preferito a Bill

Nina Piscopo

480, Pleasant Street, Winthrop, Massachussets

13 settembre 1941

Mio caro,

solo due righe per ricordarti quanto ti amo e anche quanto mi manchi. Sono le dieci meno dieci e voglio spedire questa mia con la posta delle dieci, così che tu possa riceverla per lunedì…

Mi sono confessata questo pomeriggio e mi sono veramente sentita molto meglio, più calma almeno nello spirito. Ho continuato a pregare costantemente – anche nell'ufficio nel mentre aspettavo di spedirti la lettera – affinché questo impiego dove sei in prova, diventi tuo – o dovrei dire nostro? Spero che aspetterai di aver ottenuto una risposta definitiva prima di ritornare. Non che non voglia che tu sia qui, accanto a me. Il tuo non essere qui ora è più duro di quanto lo è stato la scorsa settimana perché, ora che stiamo di nuovo insieme, la separazione è davvero più difficile da sopportare. Spero di avere di nuovo notizie da te – l'ultimo tuo scritto era così formale. Attendendo ansiosamente notizie del tuo ritorno. Tutto il mio amore.

—la tua Nina

Il Trittico di Anthony D'Amore e Nina Piscopo

Le nozze di Anthony D'Amore e Nina Piscopo furono un matrimonio che poteva avere luogo "soltanto in America". Mio padre proveniva, infatti, da una famiglia contadina di Montefalcione, nel Mezzogiorno d'Italia. La famiglia di mia madre, i Forte–De Iorio, apparteneva alla classe dei proprietari terrieri di Lapìo, un altro paese della stessa provincia. Loro si incontrarono il giorno di San Valentino all'International Institute di Boston. Ciascuno dei due era a capo di uno dei Circoli Italiani che stavano celebrando il loro primo incontro congiunto. Mio padre s'innamorò di lei a prima vista e, mentre portava un Samovar russo giù per le scale, cercò perfino di rubarle un bacio! Naturalmente, un po' di caffè si versò! Nina si era da poco laureata al Massachussets College of Art. Tony era appena rientrato dai suoi studi di medicina in Italia, per evitare la chiamata di leva nell'Esercito italiano. Prima dell'entrata in guerra degli Stati Uniti nella Seconda Guerra Mondiale, Tony aveva lavorato presso la Biblioteca del Congresso, al Dipartimento degli Affari Latino Americani.

L'impiego gli era stato conservato perchè potesse rientrare, una volta terminato il servizio militare in guerra, ma Nina voleva restare a Boston, cosicché lui non ritornò mai più a Washington. Mio padre ebbe sempre due lavori e per questo non era quasi mai a casa. Ricordo soprattutto le lunghe passeggiate fatte con lui, quando eravamo soliti cantare canzoni buffe, come "The bear went over the mountain" (l'orso si arrampicò sulla montagna), o quando andavamo in visita allo zoo. Lui amava i classici e leggeva per diletto, libri di teologia e filosofia, spesso scritti in latino. Quando la "Atlas Dry Cleaners" venne venduta, egli si iscrisse ad uno dei primi corsi di computer tenuti a Boston, risultò il secondo della classe, nella graduatoria finale del diploma e andò poi a lavorare per la Merchants National Bank come capoufficio. Nina non esercitò mai la professione di disegnatrice di moda, dopo la guerra. Subito dopo la Seconda Guerra Mondiale, ella si dedicò alla sistemazione dei profughi. Molti dei nostri amici erano immigrati che venivano dai campi di concentramento, in Europa. Noi apprendemmo presto cos'era la sofferenza dalle loro storie dolorose. Di solito, quando era a casa, mio padre leggeva o lavorava in giardino, ben contento di lasciare la gestione della casa a mia madre. Le donne parlavano italiano tra di loro e si occupavano di tutte le faccende quotidiane. Nina aveva uno spirito generoso e gentile e una sua autonomia

mentale. Mio padre diceva sempre che lei aveva "moxie" (grinta). Su di lei potevi sempre contare.

Le piaceva accontentarci e amava cucinare e assicurarsi che fossimo sazi, sazi, sazi! Fu lei a prendersi cura di sua madre, di sua zia e di suo marito stesso nel corso delle loro lunghe malattie. La sua era una vita piena, con quattro figli - Bernadette, Denis, Ronald, Stephanie. Crescendo, avevamo dimestichezza con la storia delle nostre famiglie, sia quella materna che quella paterna. La mescolanza della famiglia di mio padre, numerosa e chiassosa, con quella di mia madre, più piccola e colta, ci fornì un posto interessante in cui collocarci nel mondo. Siamo andati ognuno per la sua strada portando con noi l'eredità di una grande energia, della capacità di lavorare duramente, di un profondo, vicendevole sentimento d'amore, del rispetto per l'istruzione e di un'inclinazione introspettiva, mentre guardiamo svanire un'intera generazione e ci rendiamo conto di essere noi, adesso, la generazione più anziana. Questa storia viene scritta a distanza di quasi cento anni dall'arrivo di alcuni dei nostri antenati dall'Italia. «Cento Anni di più!» come diciamo in Italia.

Little Italies

Il North End era la "Little Italy" di Boston, una comunità popolata, in ondate successive, da immigranti ebrei, poi da irlandesi e in seguito da italiani. A "Little Italy" non era necessario conoscere l'inglese. I negozietti che offrivano prodotti caratteristici, fornai, mercati della carne, ristoranti e caffè davano la sensazione di trovarsi in una cittadina italiana. Talvolta le strade venivano effettivamente ribattezzate con il nome del luogo d'origine. Nei dintorni di Boston, si può trovare, ad esempio, una "Orsogna Square".

Queste "Little Italy", parzialmente modellate sullo spirito campanilistico del Mezzogiorno, vengono spesso chiamate "paesi urbani" ed assomigliano ai paesi collinari delle origini. La parola campanilismo fa riferimento ai confini di un insediamento raggiungibili dal rintocco della campana del villaggio. In America, questo concetto ha ceduto il posto a quello di più vasto quartiere urbano. Dopo la Seconda Guerra Mondiale, alcune di queste comunità stabilirono dei gemellaggi con alcune città in Italia, rapporti, questi, che continuano ancora oggi.

A Boston, fra la gente di una straordinaria Little Italy in lotta per conservare la propria identità. Un quartiere di quindicimila abitanti, originari quasi tutti di Sciacca, in Sicilia e di Montefalcione, in Irpinia. Si battono contro la "gentrification", vogliono restare uniti come una grande famiglia.

> —Da *"IL MATTINO del Sabato", quotidiano di Napoli,* 25 novembre 1983

"VOCI"—Interviste familiari

Per esempio, avevamo un fornaio, un carbonaio e un gelataio, un venditore di frutta e verdura, un uomo che vendeva i cocomeri ed un pescivendolo. Avevamo anche un arrotino che affilava coltelli e forbici, che veniva fino a casa, o almeno davanti alla porta. Questi erano i tanti venditori ambulanti che giravano per i quartieri italiani. Aspettavamo le loro grida di richiamo, quelle caratteristiche intonazioni della voce che li distinguevano l'uno dall'altro. Li conoscevamo tutti e loro conoscevano noi.

> —Anthony J. D'Amore (figlio di padre americano di seconda generazione e di madre italiana), lettera a B. Amore, 2000, Progetto *Life line,* 2000-2006

Lasciamelo dire, era davvero una comunità incredibile. Lo era per davvero. Quell'area di un miglio quadrato nel North End, la più sicura, fu, per un certo periodo, il luogo più densamente abitato del pianeta.

La gente era talmente tanta in quello spazio così piccolo che si poteva girare per le strade alle tre di notte, anche una ragazza di diciassette anni, senza nessuna preoccupazione, anche se le ragazze di diciassette anni non dovrebbero stare per strada alle tre del mattino! Il traffico non era niente in confronto ad oggi, c'erano però un sacco di cavalli e di pariglie. A quel mercato, c'era ancora, una gran quantità di cavalli da tiro. Fu solo dopo la guerra che sparirono completamente.

> —Tullio Baldi (seconda generazione), intervista di B. D'Amore, 2005, Progetto *Life line,* 2000-2006

"VOCI"—Interviste da Ellis Island

Quando vivevamo a North Beach, l'ambiente era tutto rigorosamente italiano. Dialetti differenti. C'erano un sacco di siciliani e di gente che veniva dal Sud dell'Italia e ci mescolavamo a meraviglia. Voglio dire, non so se te l'ho detto ieri quando parlavamo, ma quello è il posto dove viveva Joe Di Maggio. E io conoscevo le sue sorelle e abitavamo vicino. Ed era davvero un gran bel posto dove vivere e crescere, perché là ti sentivi a casa. Non c'era nessun imbarazzo. Voglio dire, ti sentivi parte di una comunità etnica che sì, ci teneva a te e veramente ci aiutavamo sempre l'uno con l'altro.

Importavano un sacco di cose dall'Italia, ma ne producevano anche loro stessi. E avevano il meglio di ogni cosa. Fai conto, il formaggio parmigiano, loro ne importavano grosse "forme" e lo vendevano, e l'olio d'oliva italiano e tutto il resto. Ed era proprio come essere a casa, allora. E oggi è ancora così, malgrado tutto. Voglio dire, stava lì da tempo, allora, la frutta e la verdura, gli articoli di drogheria e di gastronomia e cose del genere. Facevano tutto questo per portare qui il "Vecchio Mondo".

—Elda Del Bino Willits[1]

"Italglish" / L' "italiese"

Alla fine, la lingua cominciò a modificarsi fino a comprendere parole ibride italo-inglesi come "giobba" (job), "storo" (store), "carra" (car). Gli uomini si radunavano in gruppi fuori dei caffè e le donne passeggiavano lungo la strada a braccetto, vestigia della famosa "passeggiata" in Italia. Fare una bella figura era essenziale e niente forniva un palcoscenico migliore della via principale di Little Italy. Le chiese giocavano un ruolo centrale nella vita della comunità. Le "feste" annuali dei santi patroni venivano organizzate da vari circoli sociali che rappresentavano le differenti regioni dello stivale d'Italia. L'integrità di queste comunità, una volta di tipo insulare, è minacciata adesso dalla migrazione verso i sobborghi, dal valore crescente delle proprietà immobiliari e dalla forte domanda di spazi abitativi nel cuore della città, da parte di giovani professionisti.

"VOCI"—Interviste familiari

Ancora mi ricordo alcune delle storie che mi raccontava mio nonno di quando, ancora bambino, era venuto in America con la nave. Di come suo padre morì giovane e lui aveva un patrigno, ecc. E che la famiglia viveva in affitto in un casamento, teneva dei pensionanti per far quandrare il bilancio, e di quando decise che non voleva che i suoi figli, cinque ragazzi e tre ragazze (più un altro che morì per un infezione ad un dente), crescessero in quell'ambiente. Tutto questo, naturalmente, nella sua personale versione di "italiano-inglese", che presto imparai a capire abbastanza bene.

—Anthony J. D'Amore (figlio di padre americano di seconda generazione, e di madre italiana), lettera a B. Amore, 2000, Progetto *Life line*, 2000-2006

Guarda, adesso comincia la conversazione all'italiana – io e te – questo che parla con quest'altro, quello invece con quell'altro. E tutti parlano contemporaneamente e ognuno capisce quello che sta succedendo, eccetto un neofita, e questo era mamma. Lei non ci era abituata a questa cosa. E allora lei fa «Come???» e le ho detto: «Guarda, una volta che ti trovi in questa situazione, o abbassi la voce, parli più basso di tutti quelli che parlano in quel momento, oppure la devi alzare più forte di tutti quelli che stanno parlando. Guarda la persona dritta negli occhi e vai avanti con la conversazione. Ce la farai». Sembrava la Torre di Babele!

—Tullio Baldi (seconda generazione), intervista di B. Amore, 2005, Progetto *Life line*, 2000-2006

Costruendo sulle fondamenta

L'importanza dell'istruzione venne rimarcata con i cugini di terza generazione e molti di loro si diplomarono al college e adesso aiutano figli e nipoti a raggiungere lo stesso risultato. Antonio scavò le fondamenta della Harvard University sognando che i suoi figli potessero ricevere un'istruzione. Adesso sarebbe fiero dei suoi tanti nipoti e pronipoti che sono venuti fuori dall'università da professionisti titolati.

Tony, il figlio di Antonio non perdeva occasione per sottolineare con i suoi figli l'importanza dell'istruzione. La equiparava alla libertà di scelta. Per lui la vita intellettiva era il più grande degli interessi. Leggeva continuamente le novità e le teorie più recenti a proposito delle più svariate discipline, dalla sociologia alla fisica e alla letteratura. *L'Ulisse* di Joyce e la *Summa Teologica* di Tommaso d'Aquino erano fra i suoi libri preferiti. Le conversazioni con Tony, a cena, erano memorabili per i vivaci dibattiti che la sua mente curiosa sapeva suscitare. Gli piaceva recitare il ruolo dell'avvocato del diavolo ed era solito contrastare le argomentazioni contrarie con accuse di scorrettezza dei ragionamenti e assenza di logica.

"VOCI"—Interviste da Ellis Island

Ho un figlio in California. Fa l'architetto. Vado là ogni anno. L'ottobre scorso ero in Italia. Il prossimo ottobre andrò in California. Ho quattro bei figli che sono tutti istruiti. Ho un figlio laureato all'Accademia Aeronautica con un Ph.D. preso al MIT. Un altro figlio è architetto. Ha frequentato la Pennsylvania University. Mia figlia insegna a scuola. L'altro figlio sta a New York. Lavora là per una grossa società di attrezzature per le telecomunicazioni o cose del genere. È stato in Pennsylvania alla Temple University, con una borsa di studio completa. Loro hanno studiato tutti. Io sono l'unico che ha dovuto adattarsi alla fatica, sai. Loro sono stati tutti bravi. Se la sono cavata da soli. A quei tempi non avrei potuto mandarli al college.

—Ettore Lorenzini[2]

"VOCI"—Interviste familiari

Papà [Tony] voleva che ognuno di noi sviluppasse le sue capacità e ci inculcò fin da bambini, l'importanza di andare al college. Ricordo ancora di quando, tornando a casa tardi la sera lo trovavo seduto al tavolo di cucina a leggere libri di filosofia!

 —Stephanie D'Amore Maruzzi (terza generazione), intervista di
 B. Amore, ottobre 2003, Progetto *Life line*, 2000-2006

Mio padre era un manovale e mia madre lavorava in fabbrica come cucitrice. Sono stato il primo ad andare al "college" e questa era davvero una cosa importante per i miei genitori. Anche se loro non fecero mai pressione su di me per mandarmi al "college", la "high school" non fu una scelta casuale. Mi mandarono in una scuola secondaria privata gestita dai Salesiani perché erano convinti che la ricetta del successo fosse un misto di disciplina e di istruzione.

Alla "high school" presi parte alla rappresentazione simulata di un processo in tribunale, in qualità di avvocato, e la mia scuola vinse il primo premio in una gara regionale. La mia classe scattò delle fotografie con il magistrato distrettuale, il giudice Ferrino e la storia finì sui giornali. Quella fu la prima volta in cui pensai di andare al "college" e diventare avvocato. I miei genitori fecero gli scongiuri riguardo al "college", perchè durante le vacanze estive lavoravo col mio fratello maggiore come apprendista elettricista e i miei genitori temevano che volessi diventare elettricista proprio come mio fratello, il quale, invece, voleva che andassi al "college". Quando, al "college", cominciai a prendere dei voti alti, i miei genitori si convinsero che forse gli studi erano la vocazione della mia vita.

Ricordo ancora quando ero studente nel "college" e lavoravo come stagista a Washington, D.C., come investigatore per conto dell'avvocato d'ufficio. Lavoravo su un caso che riguardava un nero condannato all'ergastolo per un delitto che asseriva di non aver commesso. Dopo aver passato alcuni anni in una prigione dello Stato della Virginia, costui ottenne un nuovo processo e venne prosciolto. Per la prima volta nella mia vita avevo uno scopo: ero in grado di fare qualcosa che poteva fare la differenza. Fu allora che frequentai i corsi serali della Facoltà di Giurisprudenza mentre di giorno lavoravo in uno studio legale. Ero il più giovane in una classe piena di studenti più grandi che lavoravano già. Mi ricordo che tornavo a casa tardi ogni sera, e che mio padre mi veniva a prendere alla stazione ferroviaria e mia madre mi teneva pronta la cena. Loro misero a disposizione tempo e denaro per mandarmi all'Università. Adesso lavoro come avvocato dibattimentale a Boston, Massachusetts.

—Michael Louis D'Amore (figlio di padre americano di seconda generazione, e di madre italiana), intervista di B. Amore, settembre 2003, Progetto *Life line*, 2000-2006

NON si prende proprio in considerazione l'ipotesi di NON andare al "college". Mamma e Papà sono irremovibili sul fatto che frequenti un'ottima scuola e riceva una buona istruzione. Lo studio mi riesce molto facile, mi viene naturale. Vorrei fare qualcosa nel campo della medicina.

—Nicole (D'Amore) Maruzzi (quarta generazione), intervista di B. Amore, ottobre 2003, Progetto *Life line*, 2000-2006

Era stato sempre sottinteso che sarei andata al "college". I miei amici che non sono andati a scuola non fanno niente, in realtà. Il "college" mi ha aiutato a guardare al mondo che ci circonda in modo diverso. Mi consente di tener conto di più cose prima di prendere una decisione. Sento che le lezioni di vita sono di gran lunga più preziose che apprendere da solo sui libri di scuola. Sto definitivamente programmando altri studi dopo la laurea. Se non fosse stato per la mia famiglia che ci teneva così tanto, non ne avrei mai capito l'importanza.

—Andrea (D'Amore) Maruzzi (quarta generazione), intervista di B. Amore, ottobre 2003, Progetto *Life line*, 2000-2006

Oltre il "Melting Pot"

Nel ventunesimo secolo, gli italoamericani hanno percorso un lungo cammino rispetto ai giorni in cui i loro bisnonni erano venivano chiamati "wops" ("without papers", senza titolo di cittadinanza). Ora, essi fanno parte della società multietnica, che ha sostituito il classico mito del "melting pot" (crogiolo). Gli italoamericani sono pienamente integrati nel tessuto della vita americana.

Walt Whitman, una volta, definì l'America "una brulicante nazione di nazioni" e la ricerca ha mostrato che, nella vita americana, le caratteristiche etniche continuano a perdurare di generazione in generazione. Gli italoamericani, così come molti altri gruppi, si trovano in una fase in cui cercano un equilibrio tra il riconoscimento della loro eredità etnica, la loro esperienza di cittadini americani e le definizioni di un immaginario stereotipato che i media e la società più in generale, gli hanno talvolta inflitto. Ciò comporta un considerevole e vivace interscambio, sia all'interno delle famiglie che dei gruppi culturali italoamericani che spesso funzionano come tramite, per gli italoamericani di terza, quarta e quinta generazione, rispetto all'apprendimento della loro storia.

Italiani? Americani? Italoamericani?

"VOCI"—Interviste familiari

Ero entrato da tempo nell'età adulta quando mi resi conto che ero americano. Certo, ero nato in America e avevo vissuto qui tutta la mia vita, tranne diciotto mesi passati in Italia. In un modo o nell'altro non mi passò mai per la testa che essere un cittadino degli Stati Uniti d'America significava essere americano. Gli americani erano gente che mangiava burro di noccioline e marmellata spalmati su pane bianco molliccio tirato fuori dai sacchetti di plastica. Io? Io ero italiano!... Tutti gli altri, irlandesi, polacchi, ebrei, tedeschi, quelli erano i "merigani".

—Anthony J. D'Amore (figlio di padre americano di seconda generazione, e di madre italiana), lettera a B. Amore, 2000, Progetto *Life line*, 2000-2006

Il senso dell'essere italiani veniva probabilmente trasmesso più per osmosi che per una qualche specifica volontà. Non credo che i miei genitori o i miei nonni intendessero farci sapere di che cosa si trattava. Noi, semplicemente, osservavamo e facevamo ciò che facevano loro. Imparavamo da quello che facevano. Quando non volevano che capissimo cosa succedeva, loro parlavano in italiano. Si assicuravano che non imparassimo così non avremmo mai capito quello che dicevano. Questo era la loro piccola trovata per tenere le cose segrete o avere conversazioni private mentre i figli si trovavano nella stanza.

Ma sai, le guardavamo cucinare il cibo e prenderci cura dei bambini come succede in famiglia. Si impara così, guardando, sentendosi semplicemente parte di un tutto. Niente di quello che vai ad imparare a scuola ti aiuterà a capire come fare certe cose. Le impari soltanto vivendole.

Beh, le tradizioni non sono probabilmente altrettanto forti con i figli. Certamente non sono più così forti per i nipoti, poiché col passare degli anni le tradizioni si annacquano. Alcune sono quasi perdute, se non interamente scomparse. Ed essendoci, ora, in famiglia tanti che non sono italiani, per loro non possono essere così forti, specialmente per i nipoti, non possono essere sentite come succedeva a me o ai miei fratelli e cugini. La situazione è del tutto diversa. Ma non mi sento triste per questo. Voglio dire, se volessero conoscere, se sentissero la necessità di sapere, potremmo ancora mostrargliele queste tradizioni.

—Paul (D'Amore) Baldi (terza generazione), intervista dal video *The Thread of Life in One Italian American Family*

Devo la gran parte del mio sentirmi italiano a entrambe le mie nonne. Quando ero molto piccolo e fino all'età di cinque anni, abbiamo vissuto con la madre di mio padre. Nessuno dei miei genitori sapeva parlare italiano. Mia madre lo conosceva un po', ma non abbastanza da sostenere una conversazione. Tutti i figli erano nati qui.

Le mie nonne lavorarono entrambe duramente, per tutta la vita. Anche se avevano lavori diurni, trovavano sempre il tempo per cucinare. Il cibo era uno dei passatempi preferiti dai miei familiari. Non ho alcun ricordo dell'uno e dell'altro nonno, dal momento che non ce li avevo intorno me mentre crescevo. Le mie nonne vissero tutte e due fino a cent'anni.

In realtà, io mi sentivo americano. I miei genitori non ci davano troppo peso a queste cose. Vivevo e giocavo in mezzo a bambini di differenti nazionalità. Non faceva poi una grande differenza.

—Allen Maruzzi (terza generazione), intervista di B. Amore, 2003, Progetto *Life line*, 2000-2006

Mi sono sempre sentita italiana, ma, quando andai là, in Italia, ebbene fu in quel momento che capii che sono davvero italiana. Mi sono sentita proprio a casa. Non sono stata in molti posti, ma non mi sono mai sentita a casa come là.

Ciò che vidi in Italia è che era davvero come quando ero più giovane e stavo nel quartiere di East Boston. Ancora gente fuori di casa che stendeva i panni sulla cordicella, le case vicine le une alle altre, il contemplare le persone che camminavano per le strade a tarda sera. È così, proprio come durante la mia infanzia. E mi rendo già conto, quando vai là, che le cose stanno cambiando, esattamente come è successo qui. E mi spiace per i bambini che crescono oggi, senza avere intorno a sé quella comunità che abbiamo avuto noi. Avevamo...voglio dire... c'erano venti mamme sulla stessa via, sai, e se non stavi a casa di una, stavi a casa dell'altra, ma ognuno sapeva esattamente cosa succedeva e questo era meraviglioso.

E, la cosa buffa, quando crescevo nell'East Boston, è che molti dei miei vicini erano irlandesi. Mi ricordo che tutti volevano venire a mangiare a casa nostra. Così, anche se avevamo la famiglia più numerosa, rispetto ad ogni altra famiglia del vicinato, sette figli, c'era lo stesso un sacco di posto per qualcun altro e mangiavamo sempre pasta, ci crederesti? Pasta o fagioli o qualsiasi altra cosa che potesse conservarsi a lungo e non costasse un sacco di soldi.

È così diverso quando cresci in un ambiente italiano, ma non sei educato all'italiana, sei educato all'americana e quando tu te ne rendi conto, sai, capisci che dovresti avere molta più storia italiana dentro di te.

—Marian (D'Amore) Baldi Snyder (terza generazione), intervista di B. Amore, 2005, Progetto *Life line*, 2000-2006

Penso a me come a uno che ha una eredità. Sono americano ma ho un'eredità italiana. In Italia, mi mancava il pollo fritto. Non ce l'hanno. Non c'è "Popeye". E non consegnano la pizza a domicilio. Sai, ci sono dei momenti in cui sono molto felice di vivere in America. È che qui ci sono così tante libertà che la gente non si rende conto di che cosa ha.

—Jeff Masiello (quarta generazione), intervista dal video
The Thread of Life in One Italian American Family

Sono per metà americano, per metà italiano. Quando lo dico la gente commenta: «Wow è fantastico!». Mi piaceva stare intorno a mia nonna e a mio nonno, mi piaceva il loro modo di vita integralmente italiano, ne restavo sempre talmente affascinato. Proprio dal loro contegno, da tutti gli atteggiamenti italiani e dalla maniera in cui parlavano, in cui discutevano. Quando si lasciavano andare e cominciavano a parlare in italiano, mi sentivo come un bambino sperduto che cerca di capire. Mi sembrava così bello.

—Chris Masiello (quarta generazione) intervista dal video
The Thread of Life in One Italian American Family

Difendo sempre il mio essere italiana. Ho tanti amici irlandesi. E sono una che dice «Oh, gli italiani...». Non fa realmente differenza, ma ognuno cerca di sostenere le proprie origini. Io credo che le origini nazionali rappresentino ancora un grosso valore per i giovani. Tanti italiani hanno piccoli autoadesivi in italiano sulle loro macchine; io non ne ho ancora trovato uno ma lo sto cercando. È come una bandiera italiana che sventola in una piazzetta. E moltissimi irlandesi hanno i loro adesivi. Loro sulle macchine hanno il trifoglio d'Irlanda.

—Andrea (D'Amore) Maruzzi (quarta generazione) intervista dal video *The Thread of Life in One Italian American Family*

Bene, penso che essere italiano significa dover vivere là in Italia e parlare la lingua e cose del genere. Un italoamericano è più uno che parla inglese e vive qui... ho sempre desiderato andare in Italia, sai? La mia Nonna mi diceva che là il cibo era davvero squisito.

Con i miei amici, non parliamo troppo di nazionalità perché non è che ci interessa molto. Non mi pare di avere molti amici italiani. Cioè, ne ho, sì

—Nicole (D'Amore) Maruzzi (quarta generazione), intervista dal video *The Thread of Life in One Italian American Family*

Ho apprezzato lo stare in contatto con la famiglia italiana di mia madre. Mi ha indotto a cominciare ad uscire con gente proveniente da altre nazioni.

—Maria Grazia D'Amore (figlia di padre americano di seconda generazione, e di madre italiana), intervista di B. Amore, 2003, Progetto *Life line*, 2000-2006

Sono un irlandese molto italianizzato. Mi ricordo che, molto prima che Bernadette ed io uscissimo insieme, dovetti imparare a dire: «Mi dispiace, ma non posso parlare italiano». Lei aveva studiato all'Università di Roma, e sua madre – naturalmente – traduceva per i tribunali. Così imparai. Ma bisogna saperlo accompagnare con un'adeguata scrollata di spalle. ... Più tardi, dopo che ci fummo sposati, mi capita di trovarmi nel North End con la mia bambina e una signora italiana mi dice: «Oooh, che bella bambina!» E poi comincia a parlarmi in italiano. Allora le rispondo con l'unica frase che conosco nella sua lingua: «Mi dispiace, ma non posso parlare italiano»- e lei non mi crede. E poi piglia e sbotta perché uno non può dire con con fare perfetto o colloquiale: «Mi dispiace, ma non posso parlare italiano» ed essere creduto se lo sai dire così.

Sai, guardo le persone che fanno parte della mia vita, e mia suocera, mio suocero. Sono pezzi fondamentali, non certo secondari, della mia vita. Ah,ah, e il coinvolgimento... siamo entrati da alcuni anni nell'ordine di un vincolo che dura dai cinquanta ai sessant'anni. E abbiamo ancora dei lauti pranzi da consumare. Questo vuol dire essere italiani, anche se non lo si è.

> —Gene "Gino" Lawrence (irlandese di quarta generazione, inglese da undici generazioni; ha sposato Bernadette D'Amore, da cui ha in sequito divorziato, ma è sempre rimasto parte della famiglia), intervista dal video *The Thread of Life in One Italian American Family*

Cugini al di là dell'Atlantico

I discendenti degli originari De Iorio e D'Amore continuano a fare frequenti viaggi in Italia. Sia Mike che Luisa, che sono di seconda generazione, hanno sposato un'italiana ed un italiano provenienti dalla provincia d'origine della famiglia, Avellino. Questo fatto ha portato alla famiglia un'intera gamma di cugini di terza generazione che sapevano leggere e parlare l'italiano. Il che ha incoraggiato, inoltre, alcuni degli esponenti della terza e quarta generazione americana ad insegnare l'italiano ai propri figli.

In effetti, l'italiano sta crescendo d'importanza tra le lingue straniere più frequentemente insegnate nelle scuole pubbliche, dal momento che gli italoamericani sono sempre più interessati alla ricerca delle proprie radici. Nelle Università è in continua crescita il numero dei dipartimenti di Studi Italoamericani. Organizzazioni come la Casa Italiana, l'Italian Academy, la Dante Society, l'associazione Sons and Daughters of Italy, la American Italian Historical Association, la National Italian American Foundation, la Italian American Writers Association, Fieri, Malia, il Calandra Institute e numerosi altri gruppi minori, americani ed italoamericani, sostengono la trasmissione di una ricca eredità artistica e culturale.

Mi sento fortunato ad avere due culture. Ho scelto di diventare cittadino americano e il sentimento di queste due lingue, di queste due culture mi accompagna sempre. Quando guardo un palazzo americano penso alla storia architettonica dell'Italia. Questo dualismo culturale arricchisce la vita.

> —Franco Vitiello, intervista di B. Amore, 2000, Progetto *Life line*, 2000-2006

"VOCI"—Interviste familiari

Anche quando eravamo in Spagna, e stavamo a Siviglia, una delle cose che volevo visitare erano gli acquedotti romani. Quelle pietre erano massicce. L'intera struttura era imponente. Ed era assolutamente incredibile che avessero potuto realizzarle, dei trionfi d'ingegneria di quella grandiosità, in tempi così lontani e solo con la forza delle braccia. E ricordo di aver poggiato le mani sulla pietra pensando: «Sono stati miei antenati a costruire tutto questo».

> —Gerald (D'Amore) Masiello (terza generazione), intervista dal video *The Thread of Life in One Italian American Family*

Luisa (Dolly) venne in Italia con sua madre (Maria Grazia D'Amore). Quando mi vide là, prese a benvolermi. E allora dice: «Maria, tu sposerai mio fratello». Quando tornò in America, parlò con suo fratello e mi spedì una lettera con una foto di lui. In seguito, Michael mi scrisse a sua volta una lettera dicendomi che voleva incontrarmi in Italia. E due mesi più tardi arrivò. Venne a casa mia. Incontrò i miei genitori. Parlammo insieme. Poi prendemmo la decisione, lui mi disse: «Maria, ti amo. Voglio sposarti».

> —Maria Mauriello D'Amore (moglie italiana di Mike D'Amore), intervista dal video *The Thread of Life in One Italian American Family*

Pensaci un momento, noi non conosciamo nemmeno una filastrocca in italiano. Conosci le filastrochhe dei bimbi? Tipo "Humpty Dumpty", o quell'altra, "Twinkle, Twinkle, Little Star". Tutte le filastrocche che conosciamo sono in inglese, perché mia madre era americana. E tutti i nostri libri di fiabe sono in inglese. Credo che noi sentivamo che la famiglia era più radicata negli Stati Uniti. Lo zio Philly e la zia Mary ci telefonavano ogni due settimane. Così lo zio Philly sapeva cosa cosa facevamo fino al giorno in cui morì. Voglio dire, sapeva se eravamo in gita scolastica. E ricordo di essere andata a Parigi quando avevo 14 anni. E credo che tua madre mi scrisse dicendo: «Oh, aprile a Parigi è semplicemente meraviglioso».

> —Susan (D'Amore) Benevento (figlia di madre americana di seconda generazione e di padre italiano), intervista dal video *The Thread of Life in One Italian American Family*

Per me è sempre stato come se fossi una immigrata. Sono figlia di una donna italoamericana, sono nata in Italia. Credo di essere…sono italiana perché ho vissuto qui per tutto il resto della mia vita. Ma nel mio intimo non lo sono. Voglio dire, sto bene anche qui. Lo sai, no? Questa è la mia casa, perché lo è sempre stata. Ma io mi sono sempre sentita più americana che italiana. Penso che questo sia dovuto, in parte, a mia madre. Perché nella mia mente ho sempre pensato che lei volesse ritornare [in America]. Che questo non era il suo posto. Così, forse, per certi versi, sono stata influenzata desidero semplicemente, diciamo così, tornare a casa per lei.

> —Margaret (D'Amore) Benevento (figlia di madre americana di seconda generazione e di padre italiano), intervista dal video *The Thread of Life in One Italian American Family*

"L'America sta qua!"[In Italia]

> —Giovanni Joe (D'Amore) Benevento (figlio di madre americana di seconda generazione e di padre italiano), intervista dal video *The Thread of Life in One Italian American Family*

Nonni e nipoti

La maggior parte di coloro che appartengono alla terza generazione crebbe a contatto stretto con gli immigrati originari e questo ha profondamente influenzato i loro sentimenti nel relazionarsi con entrambi i mondi, compresi quegli aspetti conflittuali della ricerca della propria individualità in contrasto con la lealtà alla famiglia. La severa disciplina fisica, spesso molto dura, inflitta alla seconda generazione e le restrizioni dettate dalla "via vecchia", influenzarono anche la terza generazione. Riconciliare queste esperienze con il centro degli affetti familiari non è sempre facile. Comprendere i rivoli sottili e sottesi di tali influenze comporta spesso l'impegno di tutta una vita. Alcuni degli appartenenti alla terza e quarta generazione hanno perdippiù vissuto e studiato in Italia, rendendo i vincoli ancora più forti.

'O nonno

Mò ca l'Italia é na nazione 'nzista,

l'emigrazione e' un fatto occasionale.

Chi vene ccà, ce vene cchiù pe' sfizio,

ce' ved'é 'o munno, o tanto per cambiare.

Mò gli italiani veneno redenno:

con le scarpe di cuoio ben lucidate,

fanno 'e turisti, lucidi e alliffati,

e chi tene intenzione 'e se restà

tiene in tasca l'assegno di papà.

Cert'é ca quanno 'o nonno' mio emigraie,

partette cu 'o dolore dinto 'o core

e 'a valigia 'e cartone arrepezzata,

ma cu 'a certezza ca cu 'e braccia forte,

faticanno se fosse fatta strada.

E accussi' è stato, e 'o nonno mò se guarda

tutte e nupute suie, già sistemate,

cull'uocchie allere chine e cuntentezza.

(ma cu 'a vocca 'nu poco amariggiata,

pecchè so sanghe suio, sanghe italiano,

ma parlano sultanto americano…)

—Nino Del Duca

"VOCI"—Interviste familiari

Non è che loro non avevano dei nonni, ma i loro non vivevano nella stessa casa o nello stesso isolato. Loro li andavano a trovare i loro nonni. Noi ci mangiavamo insieme con i nostri… ricordo anche i giorni di festa e le domeniche quando tutte le mie zie, gli zii e i cugini si riunivano a casa di mio nonno e c'era una gran quantità di cibo e di vino fatto in casa e il vecchio Victrola (marca di fonografo). Le donne in cucina, gli uomini in soggiorno e i bambini ovunque.

—Anthony J. D'Amore (figlio di padre americano di seconda generazione e di madre italiana), lettera a B. Amore, 2000, Progetto *Life line*, 2000-2006

Mia nonna decise, non so perché, in tarda età, di provare a insegnarci a noi tutti, i suoi nipoti, a parlare l'italiano. Il tentativo risultò un disastro, perché naturalmente a quel punto eravamo totalmente americanizzati. Io avevo allora circa otto anni. La domenica pomeriggio, dopo il pranzo, lei ci faceva sedere sul divano e tentava di insegnarci l'italiano. Tu lo sai no? Lo sai come ha funzionato!

—Lynn Archangelo Masiello (terza generazione), intervista dal video *The Thread of Life in One Italian American Family*

Li ricordo [i nonni] come qualcosa che ha avuto una una grande influenza sulla mia vita e quando recito le mie preghiere ogni giorno ricordo sempre gli amici dei nonni e gli amici di famiglia… C'era una che la chiamavano la signora "Jamba". Io mi domandavo: «Ma come può essere che una signora si chiami Jamba?» E che quando lo pronunciavano loro, lo facevano alla montefalcionese. Una volta cresciuto, mi resi conto che il nome era "Ciampa".

Sai come dico io? «Tutti i presidenti sono passati per la mia casa» perché tutti dovevano venire a far visita a Nonni (D'Amore). Così per me, ogni domenica era come una festa. Ricordo il tavolino bianco con le righine azzurre attorno al quale dovevamo sederci quando eravamo bambini. E, naturalmente, quando diventammo più grandi, dovemmo spostarci al tavolo più grande, sai, con gli adulti. Quelli erano tempi che non posso dimenticare… Credo che non ci siano rimaste poi tante persone che fanno realmente tesoro della propria eredità come noi. Penso che la nostra famiglia, ci tenga in modo particolare, a preservare la sua eredità, come nel caso, per esempio, dei tuoi figli. E loro non hanno nemmeno l'aspetto di italiani. Ma ci tengono alla loro eredità italiana. E i figli di mio fratello fanno lo stesso.

Richard (D'Amore) Masiello (terza generazione), intervista dal video *The Thread of Life in One Italian American Family*

Forse mi sento italiana perché mio nonno ne parla sempre. E, ovviamente, ci tocca sempre mangiare la pasta, tre volte alla settimana. E per esempio, tutto quello che mangiamo è assolutamente italiano. Di solito non mangiamo nient'altro che questo.

Beh, quando ero, credo al primo, secondo al terzo anno delle elementari avevamo una insegnante italiana. Ma poi lei tornò in Italia; però, in poco tempo, ho imparato delle cose. Però mi ricordo solo di questa cosa. Prima mi ricordavo un sacco di cose, tipo che potevo parlarla [la lingua], e conoscevo i numeri, l'alfabeto, queste cose qui, ma adesso non mi viene in mente niente.

Loro [gli amici] sanno che, in un certo senso, noi siamo asiatici. Quando gli diciamo che siamo italiani, non ci credono perché non lo sembriamo per niente. Loro pensano che sia davvero fantastico che due culture totalmente differenti possano andare d'accordo e fare bambini.

Tutti quelli che conosco della famiglia di mia madre sono calmi e tranquilli cercano di fare ogni cosa con calma e in maniera precisa.

—Michelle Chen Baldi (quarta generazione), intervista di B. Amore, 2005, Progetto *Life line*, 2000-2006

Sono una grande appassionata di poker. Ogni volta che gioco con il nonno lo batto sempre. Fin da quando ero bambina, quando mia sorella e mio padre giocavano, io dicevo: «Ehi, posso giocare anch'io?» E non sapevo nemmeno che cos'era. Alla fine mi venne una "Royal Flush" (scala reale). E non me ne ero neanche accorta!

—Christine Chen Baldi (quarta generazione), intervista di B. Amore, 2005, Progetto *Life line*, 2000-2006

Nonna

*Cosa posso mai dirvi di una giovane vecchia signora
che vive davvero in un posto incantato*

*E nutre chiunque le arrivi alla porta,
nemmeno un topino è mai morto affamato*

*Le volte che entro in cucina,
le trovo sul volto il più gran bel sorriso,*

*E un ridere forte che arriva lontano,
la nonna più allegra che ho preso per mano*

*E tutte le volte che sta in quel castello,
nascosta per bene alla vista del mondo,*

*la giovane nonna, bellissima vecchia,
cucina e cucina ed il male svanisce*

*sbiadisce, scolora ogni tragica cosa,
ogni triste pensiero in gramaglie ammantato*

*in casa di lei dove l'aria riposa,
quella casa di lei che è un castello fatato.*

—Poesia scritta da Christiana D'Amore (nipote di nonna italiana e di nonno americano di seconda generazione) 12, giugno 2006, Progetto *Life line*, 2000-2006

Per il mio corredo dovetti ricamare personalmente dodici lenzuola, biancheria intima e camicie da notte. Mia madre riempì per me il cassetto con il corredo da sposa. Cominciai quando ero giovane. La famiglia del marito comprò il mobilio per la camera matrimoniale. Si faceva uno sforzo per il proprio futuro.

Adesso la gente va e compra di tutto. Giorno dopo giorno, anno dopo anno, talvolta dimenticano ciò che è importante. Le persone non conoscono la differenza. Probabilmente mia figlia e i miei figli hanno imparato un po' da me. Ma se Maria non insegna a sua figlia quello che io ho insegnato a lei, allora quella non conoscerà mai il valore delle cose.

Mia nipote mi fa scuola! Se ne esce con delle parole che mi fanno innamorare. Le posso mettere nel mio cuore e lasciarle lì.

—Maria Mauriello D'Amore (italiana sposata con Mike D'Amore), intervista di B. Amore, 2003, Progetto *Life line*, 2000-2006

La storia degli "stogies" (sigari italiani) nella nostra famiglia? Ah, me li ricordo gli "stogies", arrivarono per la prima volta in famiglia quando Papa Nonno andava – o, per la verità, mi spediva al negozio con quindici centesimi per comprare i suoi pacchetti rossi e verdi di sigari Parodi, che a me, a quei tempi, sembravano ramoscelli in scatola. E lui, appena li aveva in mano, se ne accendeva uno e se lo ficcava in bocca, dove restava finché era ridotto a un mozzicone. E quando si era consumato, al punto in cui quasi gli bruciava le labbra, lo tirava fuori dalla bocca, estraeva il suo vecchio e fidato coltello a serramanico, tagliava l'estremità bruciata del sigaro, si cacciava in bocca quello che era rimasto e lo masticava.

E ciò che è successo è che poi nel corso degli anni i denti diventavano di un colore di quello che noi chiamavamo "guinea rope" (la fune dei guinea), che erano poi i Parodi, perché ne avevano l'aspetto e puzzavano come una fune bruciata. Ma, beato lui, che morì ad oltre ottant'anni e aveva ancora tutti i denti anche se del colore delle noci. È così che gli "stogies" entrarono nella mia famiglia. Tutti hanno fumato sigari una volta o l'altra. Per cui è stato... è stato fantastico.

Veramente ho cominciato a fumare gli "stogies" quando avevo circa quindici anni, ma nessuno lo sapeva. Poi mi resi conto che mi stavo ammalando a causa loro, per cui smisi. Ma circa quattro o cinque anni fa, non so cosa mi è successo. Ma un giorno sentii proprio una voglia di ricominciare a fumare gli "stogies", e da allora non ho più smesso. È stato un po' come continuare una tradizione di famiglia.

—Gerald (D'Amore) Masiello (terza generazione), intervista dal video *The Thread of Life in One Italian American Family*

Esperienze Italiane

Concettina si fece carico delle spese l'anno in cui sua nipote andò a studiare in Italia. Bernadette (B. Amore) frequentò la Facoltà di Lettere e Filosofia dell'Università di Roma durante l'anno accademico 1962-63. B. tornò in Italia, a Carrara, come scultrice, diciotto anni più tardi per studiare autonomamente, e poi nel 1982 con una borsa di studio Fulbright. Quelle sue esperienze la portarono ad istituire, nel Vermont, un programma internazionale chiamato il "Carving Studio and Sculture Center" che ha avvicinato molti studenti alla scultura su marmo e ai laboratori artistici di Carrara. Nel 1982, sua figlia Tiffany completò la terza media alla scuola media "Tenerani" di Carrara e, come risultato di quella esperienza, ora parla correntemente italiano.

La sua conoscenza della lingua italiana ha fatto passi da gigante. Esuberante ed estroversa, ha partecipato attivamente alla vita della classe. Pur incontrando difficoltà in molte materie e tenendo conto di una certa carenza di preparazione, è nostro convincimento che è riuscita a superare positivamente questo anno scolastico.

—Estratto della pagella scolastica di Tiffany Lawrence (quarta generazione) nel corso del suo anno di studi alla Scuola Media Pietro Tenerani di Carrara, a.s. 1982-83, durante l'anno in cui sua madre studiò in Italia con la borsa di studio Fulbright

La lingua come legame

Parlare italiano mi collega a molte persone della mia famiglia che sono ormai morte. Prendi, ad esempio, mia nonna. Anche la mia prozia parlava italiano. Non ci sono molte persone nella nostra famiglia che attualmente parlano correntemente l'italiano. Cioè, tutti conoscono alcune parole. Ma la mia mamma lo parla. Noi due parliamo in italiano ogni tanto. Possiamo farvi ricorso e parlarla, quando vogliamo che nessuno ci capisca. In parte è perché sono stata con la mamma in Italia quando avevo dieci anni. E ho vissuto un anno intero là con lei. E questa è stata un'esperienza diversa, nel senso che eravamo soltanto noi due. È in quell'occasione che ho imparato l'italiano e abbiamo veramente vissuto da italiane.

Questo crea un legame forte tra mia nonna e me. Proprio perché lei amava l'Italia in modo totale. E stando là, ho capito un aspetto della cosa. Ho trascorso parte del tempo facendo cose che forse lei aveva fatto da bambina. Ed ecco perché c'era quel certo tipo di legame tra noi due.

Ci sono tornata ancora, con la nonna e la mamma, quando avevo sedici anni. E questo è stato davvero un bel periodo, perché eravamo le sole donne della famiglia che parlavano italiano. Penso che non è tanto perché parlare la lingua fosse questo gran che importante. È più il fatto che, per me è come una seconda patria, a questo punto. In Italia sto davvero a mio agio. Potrei vivere là con la stessa facilità con cui vivo qui. Certi aspetti sono culturalmente differenti ma io sento che è come una casa lontano da casa, e che è soltanto un paese diverso.

—Tiffany (D'Amore) Lawrence (quarta generazione), intervista di Madeleine Dorsey dal dal video *The Thread of Life in One Italian American Family*

La "stoffa" della mia vita

La stoffa è qualcosa che le donne della mia famiglia hanno sempre usato. Sai, la mia bisnonna faceva dei lavori fatti a mano straordinari. Mia nonna era una sarta da donna, mia madre una disegnatrice di moda e una sarta. Così, la stoffa ha fatto sempre parte della mia vita fin da bambina.

E in effetti, è davvero interessante. Ero ossessionata dall'idea di usare questa stoffa con la pietra. E ho pensato di essere matta. Non riuscivo ad adattarmi all'idea di mettere insieme la stoffa e la pietra. Una sera tardi mi trovavo nel mio "studio" e facevo a pezzi la stoffa, in questo modo, quando accadde che questo gesto mi riportò indietro alla mia infanzia. Proprio indietro a quando sentivo mia nonna e mia madre che stracciavano la stoffa, o a quando stavo nei negozi di tessuti dove squarciavano di netto la stoffa.

La mia nonna mi ha insegnato qualcosa di veramente importante. Lei usava questa espressione: «come vuol' andà». E così, se facevamo qualcosa con una stoffa distesa su una superficie e bisognava darle una piega, lei prendeva e ci passava sopra la mano come se lisciasse la stoffa. E anche se la misurazione indicava un certo valore, se il tessuto voleva disporsi in un certo modo, quella era la maniera in cui bisognava lasciarlo andare. Lei mi ha insegnato una lezione di vita. È qualcosa su cui ho riflettuto molte e molte volte, davvero. È proprio «come vuol' andà».

Le mie mani si adattano bene alle forbici che usava mia nonna. Sono consumate. Sai, guardi le forbici, le senti al tatto, ne senti l'usura ma senti anche che ti ci ritrovi a tuo agio. E sono molto speciali, davvero, per il modo in cui sono state modellate; non ne ho mai viste di simili.

Così, quando uso queste forbici per tagliare la stoffa, io dico che, sento con me la mano della nonna. Sono molto affilate. E lei era così attenta alle sue forbici. Non si può usare un paio di forbici che hanno tagliato tessuti per nessun altro scopo.

—B. Amore (terza generazione), intervista di Woody Dorsey dal video *The Thread of Life in One Italian American Family*

Rotolo di un antenato: Michelangelo Catalano

Catalano, ho appena scoperto che il mio bisnonno per parte di padre si chiamava Catalano. La mia zietta Mary dice che lui aveva fatto visita ai Catalani in Spagna. Chissà se è vero. So che c'è stata un'occupazione spagnola dell'Italia meridionale. Forse che abbiamo un po' di sangue spagnolo?

Rotolo di un'antenata: Luisella Guarino (Luigia Guarino)

La donna nella fotografia è Luisella Guarino e suo marito è Michelangelo Catalano. Provenivano entrambi da Montefalcione nell'Italia Meridionale, in provincia di Avellino, non lontano da Napoli. Il certificato di nascita riporta il suo nome come Luigia, ma per tutta la vita lei fu conosciuta come Luisella. Era insolitamente alta per essere un'italiana del Sud e, quando invecchiò, camminava con un bastone. Quando mio padre andò in Italia, le comprò delle scarpe da uomo perché i suoi piedi erano troppo gonfi. La gente del paese rimase meravigliata e, a distanza di 65 anni, ancora raccontano questa storia! È tutto ciò che so.

L'eredità delle lettere

Nelle famiglie De Iorio e D'Amore, le lettere sono state conservate per cinque generazioni. La corrispondenza tra Tony e Nina durante la Seconda Guerra Mondiale rivela il dramma di quel periodo. Le primissime lettere che documentano uno scambio di corrispondenza tra Italia ed America sono datate 1901. Durante gli anni Cinquanta e Sessanta, quando Nina era in Italia, aveva l'abitudine di scrivere ai propri figli descrizioni particolareggiate dei suoi giorni e oggi, esse possono effettivamente essere lette come un resoconto di viaggi. Per tutta la vita, ella mantenne una corrispondenza con Salvatore, il suo amico poeta che l'aveva introdotta nei quartieri più segreti di Napoli, la città prediletta in cui lui era nato.

Bernadette portò avanti questa tradizione durante e dopo gli anni trascorsi in Italia. Si tratta di una lunga eredità di storia vista attraverso gli occhi della gente comune che l'ha vissuta. Oggigiorno, i cugini comunicano principalmente attraverso la posta elettronica e il telefono come complemento le visite che si scambiano fra loro. Molti si chiedono che cosa rimarrà alle future generazioni, dal momento che le lettere sono diventate una rarità.

Avellino, 24 novembre 1955

Cara famiglia,

siamo seduti attorno al tavolo della sala da pranzo – avvocato; segretaria; acquirente; Nonni; Zizi e me, eccetera – a redigere l'atto per la vendita della casa. Questa mattina, sono andata presto in banca per avere alcune informazioni riguardo alla possibilità di fare un deposito a mio nome, dal momento che non sarà possibile trasferire il denaro negli Stati Uniti tutto in contanti. Questo pomeriggio abbiamo un altro appuntamento per un altro atto – anche questo una vendita di proprietà. Ho davvero un sacco di cose da fare, sono occupatissima ogni momento. Per questo motivo vi scrivo nella pausa tra due atti notarili, impiegando così questi ritagli di tempo

Ieri siamo stati a Lapío – e che giornata. Abbiamo fatto costruire una cassa per metterci dentro un orologio antico che sto portando a casa, da trasportare a mano. E' già impacchettato e ce l'ho qui ad Avellino pronto a partire. Abbiamo imballato anche un altro baule, che vado a prendere domani per portarlo qui.

Ora, ho qualcosa da dirvi che farà piacere a Padre Toma. Nella nostra casa c'è una statua di S. Lorenzo con una reliquia (un molare intero) e una bellissima veste tutta ricamata d'oro. Stiamo facendo fare un'altra cassa per poterlo portare a casa nella nostra chiesa. Questa statua è il santo patrono della famiglia perché il nome del nonno di "Nonni" era Lorenzo e lui organizzava processioni e feste in onore del santo. Il prete della parrocchia andava a casa sua a prendere la reliquia e portarla fuori. La chiesa di Lapío è molto addolorata di questa perdita, ma io ho pensato che anche quando voi bambini crescerete, potrete ricavare grande motivo di orgoglio nel visitare la chiesa che contiene questo cimelio di famiglia. Potete riferire questa notizia a Padre Toma e spero davvero che sarà contento. Non voglio anticipare nessuna eventuale difficoltà connessa all'autorizzazione da parte della Santa Sede. Spero che tutto finisca bene.

A voi tutto il mio affetto.

—Le vostre Mammina e Nini

Napoli, 16 febbraio 1956

Mia cara piccola Bunny,

sono stato molto contento di ricevere i tuoi francobolli per mio cugino che fa la collezione. Sei molto gentile, esattamente come tua madre. Quando vedrò mio cugino, cercherò di scambiare con lui i tuoi francobolli in modo da spedirtene altri più interessanti per la tua collezione.

Trasmettete a Denny e Ronny i miei saluti e il mio affetto. Sì, il futuro ci può riservare questa magnifica sorpresa di incontrarvi tutti in Italia o negli USA, ed è questo che spero.

Non dimenticare mai di amare sempre un po' il paese che ha dato i natali ai tuoi. È un grande e meraviglioso paese che tu, tuo fratello e tua sorella un giorno dovrete conoscere. Porgi a tua madre, tua nonna e tua zia i miei migliori saluti anche per Denny e Ronny.

Sinceramente,

—Salvatore

Tenersi per mano

Non solo lettere, ma anche oggetti sono stati conservati dai discendenti degli immigranti originari. Molti di questi sono rimasti a languire in soffitte o cantine e vengono adesso rivalutati alla luce di un rinnovato interesse per i propri antenati. Fioriscono organizzazioni impegnate nelle ricerche genealogiche, mentre una nazione di immigranti cerca di rintracciare le proprie radici.

Gli oggetti di famiglia sono spesso un modo per sentire un intimo collegamento con il passato, integrando le storie scritte che possono essere rintracciate nella vecchia corrispondenza, nei documenti, liste di imbarco delle navi e storie di famiglia. Nel tenere in mano un oggetto logorato dal tempo si può come avere la sensazione fisica di un legame diretto con l'antenato e la cultura delle origini.

"Riportando a casa la Nonna "

Sì, è la storia di mia nonna, Luigina Pedroni Albertini e della sua macchina per cucire. Regina era nata nel 1911 a Canneto sull'Oglio, una piccola cittadina in provincia di Mantova, nell'Italia settentrionale. Sua madre era operaia in una fabbrica di bambole, che era famosa perché producevano giocattoli e lì erano gli industriali e suo padre fabbricava canestri con tralci di vite. E il giorno in cui lei nacque, suo padre le comprò un regalo ed era una macchina per cucire Singer. Una bellissima macchina nuova fiammante, nera, smaltata con tutte le decorazioni. E lui pensò che quello poteva essere un regalo che l'avrebbe aiutata per tutta la vita.

Quella macchina per cucire seguì mia nonna in tutti i suoi spostamenti e rimase sempre con lei. Fu davvero la cosa che l'aiutò a sopravvivere alle due guerre mondiali cui assistette, ad allevare i figli ed a tirare avanti la famiglia in tempi difficili. E fu anche lo strumento che le consentì di essere più indipendente in età avanzata. Faceva dei lavoretti per i vicini di casa e così, con quei soldi poteva comprare dei regali per noi o acquistare qualcosa che le piaceva.

Quando Nonna morì nel 1996, passai le ultime quattro notti con lei all'ospedale. Dopo la sua morte, dovetti tornare a Firenze perché lavoravo là. E mia madre e mio padre, mio fratello ed altre persone, ripulirono il suo appartamento. Conservarono alcune delle sue cose e ne diedero via altre ad istituzioni tipo l'Esercito della Salvezza.

Cosicché, quando tornai negli USA, cercai la macchina per cucire, ma non c'era più, l'avevano data via. Penso di essere stato colui che conosceva meglio la nonna e che sapeva tutta la storia della macchina. Così ebbi uno scatto d'ira. E, dopo mi calmai e chiesi a mio zio e a mia zia di venire con me per andare a cercarla in questo grande edificio dove tenevano tutti i vecchi mobili. E la trovammo e, quando la vedemmo, fu una grande emozione, ma anche una grossa delusione perché sopra c'era un cartellino che diceva "venduta".

Allora volli sapere chi l'aveva comprata, ed era un tale che compra ferro vecchio per riciclarlo. Allora gli diedi, diciamo, il doppio di quanto gli aveva promesso quella persona e me ne tornai a casa con la macchina per cucire. Ero l'uomo più felice del mondo. Perché era come riportare a casa la nonna!

—Stefano Albertini, intervista di B. Amore dal video Following the Thread

Alla tavola della nonna

Il cibo e le tradizioni che riguardano le feste sono alcuni dei collegamenti fondamentali con il mondo dei nonni e dei bisnonni. Spesso, in occasione del Natale e della Pasqua, il cibo cotto al forno viene fatto nel modo più tradizionale, il modo in cui è stato trasmesso attraverso una "cucina intergenerazionale". Spesso, a molti dei cugini appartenenti alla terza generazione, le canzoni napoletane dei primi anni del '900 risultano più familiari del moderno rap italiano o dello hip-hop, visto che sono cresciuti ascoltando queste canzoni dai programmi della radio italiana. I piccoli caffè della "Little Italy" rimangono ancora il luogo d'incontro preferito da tutti per riunirsi (dopo la cucina di famiglia). In molte famiglie, il rito settimanale dei pomeriggi domenicali trascorsi a casa della Nonna è ormai meno frequente, ma sopravvive ancora come il cuore dei giorni di festa e delle occasioni speciali.

"VOCI"—Interviste familiari

Ronald: Sono circa 40 anni che faccio le cose cotte al forno per la Pasqua. All'inizio non mi occupavo molto della cucina. Facevo le pulizie.

B.: Penso che il pasticcio a forma di anello con dentro tutte le uova sia davvero magnifico. Credo che, nella nostra tradizione, le uova rappresentino un simbolo di vita nuova, per questo fanno il "tarallo" con le uova. E infatti, io, ho un tarallo proveniente da Montefalcione che esporrò alla mostra.

Ronald: Lei (Nina) mi ha insegnato tutto quello che so sulla cucina italiana, questo è certo. E tutti quelli per cui cucino apprezzano il suo cibo.

B.: Beh, penso che sia davvero interessante, anche quando pensi al cucinare, non mi sono mai resa conto fino al momento in cui tu lo hai detto, che la cucina è anche un modo, una maniera, per continuare a condividere quello che una persona ti ha donato.

Ronald: L'eredità della Mamma è viva in tanti modi diversi. Uno di questi è il cibo, senza dubbio!

—Ronald D'Amore (terza generazione), intervista dal video *The Thread of Life in One Italian American Family*

Il mio primo ricordo, devo aver avuto soltanto, tre anni circa, è la sorella di mia madre, Katie, che preparava gli gnocchi. Avevamo uno di quei vecchi tavoli di metallo con la prolunga e l'intero tavolo era ricoperto di farina. Stavano preparando la pasta ed io avevo l'abitudine di camminare tutt'intorno al bordo del tavolo. Dovunque riuscivo ad arrivare, facevo il gesto di arrotolare con il pollice e facevo gli gnocchi. Non mi piaceva troppo mangiarli, ma questo è il mio primo ricordo di quando ho fatto qualcosa di autenticamente italiano.

—Diane (Biancardi Ustinovich) Baldi (terza generazione) intervista dal video *The Thread of Life in One Italian American Family*

La casa è il luogo dove si imparava a consumare un pasto di sette portate tra mezzogiorno e le quattro pomeridiane, a mangiare castagne calde e a mettere spicchi di mandarino nel vino rosso. Davvero, penso che gli italiani vivano una "relazione romantica con il cibo".

La domenica era di sicuro la grande festa della settimana. Era il giorno in cui ci si svegliava con l'odore dell'aglio e delle cipolle che friggevano nell'olio d'oliva. Mentre si stava ancora sdraiati a letto, si poteva sentire lo sfrigolio dei pomodori buttati nella padella. La domenica mangiavamo sempre maccheroni con sugo di carne. I "merigani" li chiamavano pasta con la salsa. La domenica non era domenica senza andare alla messa. E naturalmente, non si poteva mangiare prima di andarci. Bisognava osservare il digiuno prima di ricevere la comunione. La cosa bella era che sapevamo che, una volta tornati a casa, avremmo trovato polpette di carne calde che friggevano, e niente è più appetitoso delle polpette di carne appena fritte e dei pezzetti di pane italiano croccante immersi in una pentola di ragù.

—Anthony J. D'Amore (figlio di padre americano di seconda generazione e di madre italiana), lettera a B. Amore, 2000, Progetto *Life line*, 2000-2006

Che ci crediate o no, i pasti erano una cosa importante. Era una cosa frequente andar su per il Thanksgiving (Giorno del Ringraziamento). Uscivamo da scuola. Forse uscivamo prima, il mercoledì, e ci infilavamo tutti in macchina. Ci accapigliavamo per ore e, alla fine, arrivavamo a Boston. E mio padre non avvisava mai sua madre che stava arrivando. Così arrivavamo là di sera, intorno alle 23.40. La Nonna si stava preparando ad andare a letto. "Big Papa" (il nonno) pure, con in mano il suo goccetto della buonanotte. Stava seduto mangiando castagne. «Oh mio Dio! Salve a tutti! Come va?».

Allora entravamo e loro rimanevano sorpresi. Ma avevano cibo sufficiente a nutrire un po' di dei paesi del terzo mondo. E andava a finire che ci sedevamo a tavola e mangiavamo per le successive tre o quattro ore. E non sto dicendo che mangiavamo formaggio e crackers. Voglio dire che c'erano lasagne, trippa, ravioli e tavolette di dolciumi e gazzosa e coca-cola e quant'altro. Era proprio cibo vero.

—Eric Masiello (quarta generazione), intervista dal video *The Thread of Life in One Italian American Family*

Queste connessioni fondamentali con i pranzi settimanali e quelle in occasione delle feste a casa della Nonna ebbero talvolta delle conseguenze sorprendenti nelle generazioni più giovani. Sei anni dopo la morte di Nina, suo nipote che viveva e lavorava in Giappone, a Tokyo, pubblicò un libro di cucina con le sue ricette.

Una Sera dalla Nonna
Le Ricette di Nina D'Amore

Prefazione

Questo libro ha richiesto molti anni per scriverlo, ma non temete, la prefazione sarà breve. Non so quanto tempo impiegò la Nonna a diventare la migliore cuoca che noi tutti abbiamo mai conosciuto. Lei era già molto brava quando io cominciai ad essere capace di ricordare, circa venticinque anni fa. E, ovviamente, la porta d'ingresso della casa di Nonna dava direttamente in cucina. Non importa a che ora uno arrivava in quella cucina, o in quali condizioni fosse il suo stomaco, di lì a poco gli veniva servito un pasto infallibilmente sovrabbondante e squisito. Che poi uno fosse affamato oppure no, stanco o meno, non aveva altra scelta che rassegnarsi di buon grado al fatto compiuto.

Il figlio più giovane della Nonna, Ronnie, e sua moglie Sandi vivevano nell'appartamento al piano inferiore della stessa casa e, dopo che il Nonno morì, loro tre mangiavano spesso insieme. Ad un certo punto, forse undici o dodici anni fa, a Sandi venne l'ispirazione di cominciare a sbirciare alle spalle della Nonna mentre lei cucinava e annotare ciò che faceva molto probabilmente perché, ogni volta che qualcuno mangiava qualcosa di nuovo e gustoso a casa di Nonna e ne chiedeva la ricetta, la Nonna scoppiava a ridere. Spiegava come meglio poteva, ma lei stessa non aveva la più pallida idea della quantità di sale da aggiungere, del tempo di cottura, e così via. Così Sandi scarabocchiò su un taccuino le ricette di base. Pensava di riunirle tutte e distribuirle alla famiglia, inserirne alcune nel suo MacIntosh, ma immagino che il progetto andò perduto tra i suoi molti impegni.

Io stesso ho vissuto piuttosto lontano dal n. 480 di Pleasant Street (l'abitazione della Nonna) per molti anni, e le opportunità di mangiare nella sua cucina sono state rare. Alcuni anni fa, durante una visita, chiesi a Sandi di farmi fotocopiare il suo taccuino, così da potermi mettere alla prova da solo, quando ne avessi sentito nostalgia. Naturalmente, le mie sortite successive non potevano rivaleggiare con la "Capo Cuoca" ma, di solito, sono migliori di quelle che posso mangiare nel ristorante italiano del quartiere.

Poi alcuni mesi fa, un pomeriggio, mi imbattei in un testo di canzoni Noh, "Kagetsusho" della Wanya Books, una raccolta realizzata in maniera molto semplice, ma sorprendentemente bella —… Un paio di giorni dopo, avevo invitato un amico a cena e così, mentre sorseggiavo lentamente un caffè mattutino, cominciai sfogliare le fotocopie del taccuino di Sandi….Voilà "Una sera dalla Nonna". Alcune ricette notevoli, che purtroppo mancavano, sono state fornite da altri componenti della famiglia (in modo più conspicuo da B.).

Sfortunatamente, non è stato possibile superare totalmente i metodi culinari non sistematici della Nonna. Ciò è assai spesso indicato dalla quantificazione piuttosto insufficiente: quegli "un poco" e "alcuni/e" presenti nella lista degli ingredienti. A volte sembrano esservi alcuni particolari mancanti e comunque non c'è ormai modo di chiarire le ambiguità (la Nonna è morta alcuni anni fa). Allora, se seguite la ricetta parola per parola, avete fatto bollire la salsa lentamente, siete pronti per la tappa successiva, ma… non vi si dice quanto basilico mettere! Beh, non preoccupatevi troppo – la stessa Nonna non sapeva esattamente quanto basilico occorreva. Provate a immaginare. La cucina italiana è abbastanza semplice e le ricette sono buone. Spesso perdonano perfino gli errori. Tutto andrà bene.

—C. Sean Lawrence (quarta generazione) Tokyo, Giappone, gennaio 2000[4]

Radici antiche

Una parte dei terreni dei De Iorio è ancora di proprietà dei discendenti di quarta generazione di Luigi e Giovannina. Per anni Compare Gennarino, profondamente rispettato da Concettina, sovrintese alla manutenzione degli ulivi e dei boschi. Nella tradizione del "comparaggio", vige un grande rispetto reciproco tra le famiglie unite da questo vincolo. Una volta, Concettina prese una sedia e vi si sedette, poi si alzò e disse: «Quando Gennaro si siede su questa sedia, io sono qui», dandogli così pieni poteri di amministrare le proprietà una volta che lei fosse tornata in America. Durante il suo anno di studi a Roma, Gennaro, sua moglie e le loro figlie furono per Bernadette la sua "famiglia italiana" e questo legame ancora persiste.

Lettere
Lapio, Avellino, 6-13 Ottobre 1962

Cara famiglia,

Mi trovo adesso nella mia "seconda casa" dai Carbone, la mia famiglia adottiva!...Da veramente un senso di sicurezza essere qui a Lapio, circondata dal silenzio a cui si fonde magnificamente l'unico suono delle campane della chiesa. Dormo nel letto grande, tiepido e accogliente, con le due ragazze!

Me ne sono andata in giro con Comare Iolanda tutti i giorni. Ieri siamo andate a "i boschi" a raccogliere l'uva direttamente dalla vite. Mi piace davvero vedere la frutta che cresce spontanea, la trovo una cosa molto artistica e capace di ispirare un sentimento di meraviglia. Il giorno prima siamo andate al "giardino di Zi Abate" e prima ancora al giardino d'olivi che è più grande. La nostra famiglia possedeva davvero dei bei terreni!

Maruzzella, Comare Iolanda ed io, abbiamo raccolto una borsa di fichi. Ne avremo mangiate una dozzina direttamente sul posto! Ci stiamo anche deliziando con le noci fresche, buonissime con un po' di vino e il pane, e poi uva e castagne. L'altra sera la Comare ha fatto una pizza di gran turco che era deliziosa, con le scarole, e poi mi ha fatto un uovo fritto "in carrozza", su una base di mozzarella buona e succosa, per colazione.

L'altra sera abbiamo ascoltato dei dischi. Tra questi c'era "Napule, o sole mio", di A. Fierro. Ce l'abbiamo anche noi a casa e questo mi ha messo un po' di nostalgia. E' proprio attraverso le canzoni che ho imparato ad amare l'Italia, e le canzoni ancora risvegliano i ricordi di quell'amore romantico e sconosciuto che è diventato un sentimento più realistico...eppure non sono ancora pronta per tornare a casa! Lucia è appena entrata nella cucina piena di fumo e adesso vi devo lasciare. La Comare sta cucinando "sartù"(di patate) al forno, stasera....finisco di scrivervi più tardi....

La famiglia qui vi manda i suoi saluti. Grazie Nonni per le poche righe. Vi scriverò più a lungo da Napoli.

Vi penso, con tanto amore

—Bunny

P.S. Baci a tutti - Lucia

Sono molto felice che Bunny è qui a Lapio e lo sarei ancora di più se qualche volta voi tutti lo foste. Bacioni cari, cari a tutti. —Maruzzella

P.P.S. Nostra cara comare Nina,

Aprofitto di questo pò di spazio per dirvi che non possiamo esprimervi con che gioia abbiamo Bernadetta in mezzo a noi. Passiamo delle belle giornate che vorremmo che non passassero mai. Baci alla cara comare Concettina. Baci a tutti. I più cari baci da me e Iolanda.

Aff. di famiglia Gennaro e Iolanda

* * *

East Boston, Mass:

20 Dicembre, 1962

My Dearest Sunshine,

Mi sento molto contenta d'essermi seduta qui, sola e quieta, per poterti scrivere la presente. Ho presso di me la tua lunga ed affettuosa lettera scrittami il 3 Dicembre. Avrei voluto scriverti prima, ma non m'è riuscito….Ieri però t'inviai una cartolina con poche frasi, Augurii per le prossime feste ed un dollaro per una tazza d'espresso insieme a Lucia e Maruzzella….

Che Iddio ti possa sempre guidare sulla via retta, che poi conduce alla felicità.

Un forte abbraccio ed un caldo bacio da me che ti voglio tanto bene.

Nonnie

> —Estratti dalla corrispondenza tra Italia America durante l'anno di studi in Italia di Bernadette, nel 1962

Ricordando e andando avanti

Vito, l'affittuario del fondo, ormai più che settantenne, lavora la terra da quando aveva cinque anni, come aveva fatto suo padre, Nunzio, prima di lui, e come fanno i suoi figli ora. Una placca bronzo in ricordo di Concettina e Nina è stata collocata nel mezzo dell'antico boschetto di ulivi, chiamato "Il Giardino", dove Concettina aveva giocato da bambina. La nipote di Concettina vi trascorreva il tempo quando era una studentessa universitaria a Roma e là, contemplando la valle sottostante, era solita recitare la sua poesia preferita, *L'Infinito*. La bisnipote di Concettina visitò questo luogo nell'estate del 2000, quasi cento anni dopo la partenza della famiglia.

Ho amato l'Italia. Non vedo l'ora di tornarci. Avrei voluto restarci più a lungo. E' stato molto bello incontrare tutte le persone e vedere tutta la nostra terra e la placca di bronzo tutto quello che ricorda "Nonni". Leggere tutte quelle cose su"Nonni" che aveva giocato là mi ha fatto sentire un po' la stranezza di trovarmi in un luogo dove lei era stata tanti anni fa.

> —Andrea Maruzzi (quarta generazione), dal video *The Thread of Life in One Italian American Family*

Iscrizione sulla placca di bronzo alla memoria

L'Infinito

Sempre caro mi fu quest'ermo colle,
e questa siepe, che da tante parte
dell'ultimo orizzonte il guardo esclude,
Ma sedendo e mirando, interminati
spazi di là da quella, e sovrumani
silenzi, e profondissima quiete
io nel pensier mi fingo; ove per poco
il cor non si spaura. E come il vento
odo stormir tra queste piante, io quello
infinito silenzio a questa voce
vo comparando: e mi sovvien l'eterno,
e le morte stagione, e la presente
e viva, el il suon di lei. Così tra questa
immensita' s'annega il pensier mio:
e il naufragar me'è dolce in questo mare.

—Giacomo Leopardi, 1819

È Nat' un fiorellino

Azzurro com'il cielo

Sapeva cinque parole sole

"Non ti scordar' di me."

In memoria di Concetta De Iorio Piscopo che giocava qui da bambina e che amava "il giardino" di questo luogo e di Nina Piscopo D'Amore, sua figlia, che ha custodito care le memorie e le tradizioni di Lapìo. Con amore, rispetto e gratitudine per la storia e la vita che mi hanno dato.

—B. Amore e famiglia
Giugno 1995

Fu Nina ad insegnare le parole della poesia sul "non ti scordar di me" ai suoi figli, che anni più tardi collocarono la placca di bronzo alla memoria nel "Il Giardino", dove lei era venuta in visita da bambina, nel 1922.

Oggi e domani
"Cent'anni di più!"

Filo della vita *è una serie di racconti. La storia è spesso trasmessa tramite i racconti. Un viaggio nel tempo non è mai una linea diritta. Si prova una sensazione di guardare dentro la storia, dentro se stessi, trovando la propria storia e scoprendo paralleli con l'esperienza degli altri. La Nonna sempre mi raccontava le sue memorie. Quei primi racconti mi hanno messo su una strada di interrogativi e di scoperta. Alcuni di questi sono stati condivisi con voi. Quello che non viene ricordato va perso. Siamo tutti repertori. Riteniamo l'insieme di quello che abbiamo ascoltato e vissuto. Cosa facciamo di questo? Lo condividiamo? Lo passiamo avanti? Ci teniamo vicino alla conoscenza? Morirà con noi? Vivrà nel futuro? Quali sono i vostri racconti?*

La storia senza fine

Porto addosso i gioielli di mia madre. Mio figlio cucina spaghetti "agli' e olio" a Tokyo, in Giappone. Parlo italiano e ho preservato tutto quello che ho potuto degli oggetti di mia nonna. Mia madre vendette i cappelli con le piume e il vestito adornato di perline della mia nonna. Penso ancora che il vestito con le perline sia nell'armadio…

Perduta nel mondo dei De Iorio, traducendo l'italiano antiquato del diario del mio quadrisavolo e del mio trisavolo, le montagne di Lapìo e le colline di Benson si congiungono in questo stesso momento, cosicché il tempo appare come compresso ed io esisto in entrambe; il dramma si rivela, riga dopo riga, mentre ricerco la parola inglese appropriata per l'equivalente del diciannovesimo secolo, spesso a stento leggibile…

Allora, chi è che racconta la storia adesso? Ciò che non si ricorda va perso. Forse che il tempo racchiude la memoria? È la memoria a cancellare il tempo? Come arriviamo a conoscere e a ricordare? Chi ti ha raccontato le storie?…

Due sentimenti vengono alla superficie, il calore della riconoscenza intima e il rivoltarsi del mio stomaco di fronte alla piccolezza dei mondi descritti. La dualità della mia infanzia presente in quest'attimo - l'orgoglio di essere italiana - quella identità che permea il mio essere, combinata con la necessità di andare oltre il mondo circoscritto del quartiere. L'appartenere e il non appartenere, nello stesso istante…

Le persone se ne sono andate ma le loro "cose" sono ancora qui. Guardandole, toccandole, tenendole in mano, le persone diventano presenti. Forse questo è il perchè dell'attaccamento agli oggetti esistenti. Io mi ricordo di loro ed essi sono presenti in qualche modo. Il passato e presente sono intrecciati. Essi esistono simultaneamente…

Questo mio lavoro non è sulla memoria, anche se la memoria è parte di esso. E' molto più avvinto dalle domande che vengono sollevate, dal guardare nel passato per scoprirci la chiave del presente. Chi erano questi personaggi che ebbero una tale influenza? Cosa nella loro vita li costrinse ad assumere i propri ruoli? Perché erano come erano e mi influenzarono così profondamente?…

—B. Amore, appunti in un diario, 1999-2000, stampati sui pannelli a Pala d'Altare

"VOCI" – Interviste familiari

Non posso non essere una parte italiana di me stessa- anche le parti che non mi piacciono. Talvolta ciò comporta troppa emozione. Ci sono sempre questi strati di sentimenti. C'è sempre questa sensazione della presenza di uno strato visibile e poi di molti strati al di sotto di quello, se uno ascolta - se è desideroso di ascoltare o di scavare. Ma c'è sempre di più al di sotto della superficie.

E penso di averla sempre provata quella sensazione da bambina. Perché mia nonna e mia madre facevano ricorso all'italiano quando non volevano che noi capissimo ciò che avveniva. Così ho sempre saputo che quello che veniva detto non era mai la storia tutta intera. C'era sempre qualcosa di più. Mi piaceva sedere al tavolo di cucina e ascoltare con grande attenzione, in silenzio. Poiché sapevo che se avessi fatto rumore e mi avessero scoperta, sarei stata messa fuori della porta con i miei fratelli. Ma stando là, e sforzandomi veramente, questo è il modo in cui davvero imparai la lingua.

—B. Amore (terza generazione), intervista di Madeleine Dorsey dal video *The Thread of Life in One Italian American Family*

Frutti del "Giardino"

Immagino che da dove provenivano, nel vecchio paese d'origine, nei dinotorni di Avellino e da Montefalcione, stavano moltissimo all'aperto perché si tratta di colture all'aperto ed è una zona fortemente agricola. Penso che deve essere stato difficile per loro passare da quell'ambiente in un ambiente completamente urbano come Boston, perché Papa Nonno sapeva coltivare la terra ed era un giardiniere. E non aveva possibilità di coltivare la terra per le strade di Boston. Così finì per fare il manovale nella Metropolitana di Boston, aiutare a costruire gli edifici della Harvard University e cose del genere. E così era fuori del suo elemento naturale. E la sola volta che poté ritornarvi fu quando ci trasferimmo a Roslindale. Lì aveva un pezzetto di terra che poteva coltivare per sé e per il suo gradimento. Coltivava l'uva. Faceva il vino. E questo gli piaceva moltissimo.

Ed era capace di far crescere praticamente ogni cosa. Cioè, era in grado di far germogliare il palo di un recinto. Era una cosa assolutamente sorprendente. Non so se l'aveva imparata crescendo, o se l'aveva appresa da solo. Ma sapeva davvero far crescere tutto. Coltivava degli alberi di pesche nel giardino dietro la casa, con le pesche più grandi e più succose che abbia mai visto nella mia vita. Ne aveva quattro. Erano il suo orgoglio e la sua gioia. E le sue piante di pomodori.

Mi ricordo ancora di quando ero alla "high school", e lui stava veramente andando in là con gli anni. E le gambe gli cominciarono a cedere come conseguenza dell'essere stato inginocchiato nelle gallerie; le sue ginocchia ebbero un cedimento. E me lo ricordo che curava le piante di pomodori nel giardinetto dietro la casa, sdraiandosi letteralmente sullo stomaco e strisciando di pianta in pianta.

—Gerald (D'Amore) Masiello (terza generazione), intervista dal video *The Thread of Life in One Italian American Family*

Forse è la musica, o forse il cibo, forse gli oggetti del nostro passato, le cose che ci riguardano, ma tutto questo mi lega alla mia eredità italiana. La musica, specialmente - quando suono le canzoni italiane di mia madre, canzoni napoletane; questo è un tasto sensibile del mio passato, perchè mi ricorda il tempo passato con mamma, specialmente i fine settimana quando lei faceva le pulizie, e cose del genere. Questo mi riporta indietro i ricordi di quando ero un giovanotto e di come lei fosse così fortemente legata al calore e al sentimento della canzone napoletana.

—Ronald D'Amore (terza generazione), intervista dal video *The Thread of Life in One Italian American Family*

In realtà, siamo cresciuti nella casa dei Nonni al 480 di Pleasant Str. Una cosa interessante a proposito di quella casa è che nessuno entrava mai dalla porta anteriore. Entravano sempre, direttamente dalla porta posteriore, in cucina dove Nonna era sempre più o meno al fornello. E avevamo quel bel giardino fuori sul retro. Era un piacevole luogo d'incontro per le grandi riunioni di famiglia. Così, l'intera famiglia si trovava spesso là. Nessuno avrebbe mai fatto prima una telefonata. Uno si presentava lì e basta. Essendo Nonna così ospitale e gentile, tutto era semplicemente là, lo sai, per chiunque ne avesse bisogno.

Per quanto riguarda i ricordi legati al giardino, lo sai no? E' davvero un luogo speciale. Quando ero una bambina, Nonno coltivava le verdure al lato della casa - zucchine, fagioli e grandi quantitativi di basilico e pomodori - bellissimi. Nonna coltivava il classico giardino di rose, ortensie e fiori. Ed era sempre molto interessante, perché ogni prodotto del giardino arrivava sulla tavola.

Così mangiavamo i frutti delle fatiche di Nonno e godevamo della bellezza dei fiori di Nonna per tutta la casa. Lei era molto particolare. Coglieva una "Rosa Imperiale" perfetta, la portava in casa e diceva: «Guardate questa rosa. Non è perfetta?» Sai, il colore del profilo, ecc.

—Larisa (D'Amore) Lawrence (quarta generazione), intervista dal video *The Thread of Life in One Italian American Family*

Tornammo per tre settimane a visitare Napoli, Roma, Venezia, la Costiera Amalfitana, luoghi di cui avevo sentito parlare tutta la vita, ma che non avevo mai realmente avuto l'opportunità di visitare per bene. Ricordo che ci trovavamo a Positano quella volta, il mar Mediterraneo era là. E io non avevo nessuna intenzione di fare il bagno, ma ricordo di essere rimasto in piedi, là. Eravamo appena arrivati da Pompei. Avevamo preso il treno e ricordo di essere rimasto in piedi sulle rive del Mediterraneo guardando indietro oltre la baia verso Napoli e scorgendo il Vesuvio e tutto il resto. E pensai: «Al diavolo! Questo è il mare dove nuotarono i miei antenati e devo nuotarci anch'io almeno una volta». Mi prese davvero. E mi fece piangere.

—Gerald (D'Amore) Masiello (terza generazione), intervista dal video *The Thread of Life in One Italian American Family*

Epilogo

Rifletto sul viso della mamma

come bambina precoce

e mi rendo conto che questo lavoro

tratta di vita

e di morte.

Osservando una vita

la grandezza

una fine del filo all'altra.

Il mistero.

Il silenzio davanti al fatto di una vita **vissuta.**

Una storia **creata.**

"filo della vita"

Fragile, passeggera, ma presente.

—B. Amore

Commenti su *Life line*

Cent'anni! Una valutazione di *Life line – filo della vita* di B. Amore

Fred Gardaphé[1]

Quando gli italiani fanno un brindisi in una particolare occasione, spesso esclamano "Cent'anni". L'idea è che ci si augura di poter godere di situazioni simili per almeno un secolo. Per tutti gli americani, e in particolare per gli italoamericani, la mostra *Life line – filo della vita* di B. Amore è un'occasione adatta per un tale brindisi, poiché, come questo libro, *An Italian American Odyssey*, documenta e questo mio saggio argomenta, il suo lavoro rappresenta una risposta da lungo tempo attesa nella esperienza degli italiani negli Stati Uniti ed offre nuovi modi per esaminare il fenomeno dell'italianità. Per comprendere l'impatto che l'immigrazione italiana ha avuto sugli Stati Uniti, è importante sapere che le identità italiane sono state forgiate attraverso processi complessi e vari, che si sono risolti in una molteplicità di identità che possono essere meglio esaminate e studiate attraverso casi individuali.

Quando Niccolò Machiavelli scrisse il suo capolavoro, *Il Principe*, l'Italia era una terra divisa e assediata da molti eserciti stranieri. Nel suo ultimo capitolo, "Un'esortazione a liberare l'Italia dalle mani dei barbari", l'autore richiede nuove armi e formazioni da usare per respingere gli invasori e una nuova guida politica per l'Italia. Per molti aspetti, l'attuale stato della cultura italoamericana è in angustie simili. C'è un forte bisogno di nuovi strumenti e nuove alleanze per conferire un senso di identità e di unificazione alla nostra cultura e per contrastare l'assedio di un'assimilazione totale. L'arte di B. Amore è la migliore risposta possibile alle domande su cos'è la cultura italoamericana e su che cosa possiamo fare per preservarla.

Una cultura è basata su tradizioni condivise, create nel tempo, messe in atto con regolarità in modo da diventare dei rituali. Tali tradizioni vengono trasmesse attraverso parole e azioni. Negli Stati Uniti parliamo spesso degli italoamericani come di una comunità che

possiede due lingue, ma potrebbe darsi che abbiamo due culture? Troppo spesso le due identità del tutto distinte vengono mescolate e confuse da coloro che vivono sulle due sponde dell'Atlantico. Gli italoamericani sono diversi dagli italiani quanto un fiore lo è da un cavolfiore. Una parola familiare li collega, ma sono due realtà molto differenti. Ci sono tante diverse definizioni degli italoamericani quanti sono gli italoamericani medesimi e lo stesso vale per gli italiani. Quando usiamo il termine "italoamericani" abbiamo la tendenza a riferirci ad uno specifico segmento di America di sangue italiano: i figli e i nipoti di coloro che immigrarono dall'Italia meridionale negli Stati Uniti a cavallo tra l''800 e il '900; e anche se la maggior parte degli italoamericani di oggi può in verità rintracciare il proprio passato in questo periodo del flusso migratorio, non possiamo dimenticare che vi furono rifugiati politici dell'Italia settentrionale durante gli anni Cinquanta del diciannovesimo secolo, e che dopo la seconda guerra mondiale vi fu un'ondata di immigrati completamente nuova, le cui esperienze erano completamente differenti da quelle degli immigrati precedenti. Il riuscire a capire cosa accadde quando la cultura degli immigrati italiani passò dai dialetti d'origine alla lingua inglese costituisce il lavoro di un'intera vita. Oggi ci troviamo a fronteggiare la questione di che cosa abbiamo bisogno per preservare una identità culturale che funzioni non soltanto per noi oggi, ma che possa assicurare che la nostra cultura persista attraverso il tempo.

Prima di rispondere a questa domanda occorre che ci chiediamo che cos'è che deve essere preservato: una lingua, delle tradizioni popolari, una storia? Dobbiamo poi determinare dove questi valori andrebbero preservati: nelle case, nelle chiese, nelle scuole, nei centri culturali? E infine dobbiamo stabilire come preservarli: per mezzo di corsi di lingua, di programmi italoamericani nelle nostre scuole elementari, superiori e università oppure attraverso una più grande presenza italoamericana nelle istituzioni tradizionali?

Per molti anni la nostra cultura italoamericana è stata preservata nelle case e, con gli anni, più spesso nei seminterrati che altrove, dove il nonno produceva il vino, dove la nonna aveva un'altra cucina, e dove ora sono custodite eredità materiali e altre memorie. Celebrazioni all'aperto come le feste religiose divennero la più importante presentazione pubblica della cultura italoamericana, ma tali eventi annuali non furono sufficientemente frequenti per proteggere la cultura italoamericana dall'abituale bombardamento di stereotipi negativi da parte dei mass media.

È nelle istituzioni tradizionali del governo e del mondo dell'istruzione che gli italoamericani hanno appena cominciato ad organizzarsi. Non sono mai stati creati i programmi pubblici che avrebbero potuto insegnare agli italoamericani il valore della propria cultura e conseguentemente rafforzare le generazioni future, né quelli che avrebbero potuto sfidare le impressioni create dai mass media. Abbiamo mantenuto la testa nei seminterrati dove la cultura italoamericana è al sicuro nell'ambito delle celebrazioni familiari.

Ormai è ora di andare oltre i seminterrati di ieri e uscire nelle strade di oggi. Il *romance* e la tragedia dell'immigrazione dell'inizio del ventesimo secolo non possono più funzionare come modelli l'identitari. La chiave per creare un senso della cultura italoamericana che indichi qualcosa ai giovani di oggi è, come prima cosa, di assicurare che essi abbiano accesso alle storie delle loro famiglie e delle loro comunità, e poi di fornire loro modelli del passato e del presente nel campo dell'arte, del commercio, delle imprese e dell'istruzione, modelli che essi possano studiare, emulare e superare. Abbiamo creato borse di studio per l'università, ma abbiamo fatto poco per aiutare gli aspiranti a quelle borse a capire cosa significa essere italoamericani una volta entrati in quelle istituzioni.

Life line– filo della vita di B. Amore comincia a rispondere a queste domande e a molte altre riguardo a quali parti della cultura italiana sono diventate parte di ciò che chiamiamo cultura americana. Amore sa che l'eredità della sua famiglia è preziosa e fragile, talvolta appesa al filo che lega una generazione alla successiva. Dire che qualcuno è "appeso a un filo" significa, in genere, che c'è un collegamento sottile, nella migliore delle ipotesi, tra la persona e l'oggetto. Ma per Amore quel filo, ciò che lei chiama *filo della vita*, è tutt'altro che debole. In effetti, è stato cercando di afferrare questo filo e intessendo la propria arte con esso che B. ha creato una dinamica opera d'arte da una esperienza intensamente personale. *Life line* scavalca i confini tra le diverse generazioni di persone, come pure tra le diverse discipline artistiche, e nel corso di tale processo ci insegna come trasformare la nostra vita in

arte, poiché la creazione artistica comincia molto prima di essere eseguita o esposta al pubblico; la vera arte comincia con la percezione e il vero artista non soltanto percepisce, ma trasmette nella mente degli spettatori le possibilità di nuove percezioni attraverso l'arte.

Gli oggetti presenti in *Life line* di B. Amore non sono rari al contrario, quasi tutti coloro che provengono da una famiglia immigrata negli Stati Uniti possiedono scatole con gli stessi materiali: documenti, lettere, appunti, santini, cartoline, oggetti d'arte, certificati, passaporti, documenti d'identità ufficiali e non ufficiali, oggetti materiali, biancheria, utensili, foto e altri oggetti di uso quotidiano provenienti dalla vita di coloro che sono venuti prima di noi. Per molti di noi questi oggetti giacciono depositati in scatoloni che vengono spesso gettati via quando le persone traslocano o muoiono, giacché ci vuole uno sforzo per immaginare quanto possano essere utili questi oggetti per quelli fra noi che sono lontani generazioni dall'esperienza della migrazione. Questo è precisamente il motivo per cui abbiamo bisogno di artisti come B. Amore. "Rendere straordinario l'ordinario" è una delle massime dell'arte e Amore lo fa attraverso una quantità di strumenti e di mezzi espressivi unici.

Ricordo la mia esperienza all'inaugurazione della mostra. Amore aveva trasformato quello che era stato una volta un impianto burocratico per il "trattamento degli immigrati" in uno spazio sacro, dove il suo passato si era mescolato con la storia di ogni immigrato che si avventurava negli Stati Uniti attraverso Ellis Island. Questa celebre scultrice e artista ha creato un punto d'incontro per gli italoamericani della zona. Curata da Judy Giuriceo, la curatrice delle mostre e dei media del museo di Ellis Island, *Life line – filo della vita* ha tirato fuori molte delle dimensioni insite nel titolo. Sono state organizzate letture dal vivo, rappresentazioni teatrali e conferenze in coincidenza con la mostra. Alcune hanno anche avuto luogo all'interno della stessa mostra, trasformando lo spazio pubblico in un luogo per allargare la famiglia. Questo libro rappresenta una testimonianza non solo del dinamismo della mostra di Amore, ma anche della vita che è stata creata dalle migliaia di spettatori che sono passati attraverso la mostra.

Amore ha riempito sei vecchi dormitori, al terzo piano del museo, di opere d'arte in una gamma di mezzi espressivi: "Colonne di storia";

"Rotoli degli antenati"; "Trittici familiari"; qualcosa denominato "Lucidando lo specchio" – un'installazione a muro composta di ritratti della famiglia dell'artista; opere di scultura intitolate "Odissea", e infine "Reliquari" (le mie preferite comprendevano un barile di vino e un piccone) e una dedicata a un cuore infranto.

Le immagini di Amore hanno generato parole e le sue parole, a loro volta, hanno generato immagini nelle menti dei visitatori della mostra. Ciò che ha reso *Life line* così potentemente efficace è stato il rischio personale che l'artista ha deciso di correre facendo convergere la storia della propria famiglia nell'idea più vasta della storia dell'immigrazione in America. Il mettere all'aria i panni sporchi di una famiglia non è una cosa che la maggior parte degli italiani potrebbe concepire di fare, tanto meno in uno spazio pubblico come una mostra d'arte, in un museo visitato da centinaia di migliaia di persone ogni mese. La forza di B. deriva dal modo in cui lei impiega oggetti d'uso quotidiano provenienti dal passato per raccontare le storie. In questa maniera gli oggetti assumono una sacralità e in questo processo divengono storici. Amore progetta perfino opere sacre, come nella sua pala d'altare. La normalità di "fagotti" di stoffa deposti in una vetrina ingigantisce l'importanza dell'ordinario, e l'affissione di materiali vari su vecchie porte ci mostra più chiaramente ciò che potremmo trovarci a trascurare nelle nostre vite quotidiane. Scavando in profondità all'interno di sette generazioni della storia della sua famiglia, Amore ha attinto al significato universale dell'immigrazione che trascendeva l'etnicità, la razza e la classe sociale. *Life line* ha catturato le parole di immigrati partiti tanto tempo fa attraverso diari, fotografie e pezzi di vita quotidiana che sarebbero potuti andare perduti se Amore non ne avesse reinventato l'importanza attraverso l'arte.

Amore talvolta chiama *Life line* un "memoir visivo", ma in realtà esso è una sintesi di una varietà di forme d'arte e di stili. C'è una qualità interattiva del risultato artistico, che deriva dall'uso di audionastri con le voci degli immigrati e musiche tradizionali folk e popolari che filtrano attraverso le sale. Visitare la mostra è stato un viaggio che è terminato in una stanza che assomigliava a una cucina, completa di un grande tavolo e di un televisore, incastonato all'interno di una cornice a forma di focolare, che faceva scorrere un videonastro dell'autrice al lavoro insieme alla sua famiglia. Questo è anche un luogo dove Amore

invitava i visitatori a sedersi e a parlare delle proprie esperienze personali. Sono compresi in questo libro molti dei loro commenti, i quali ci insegnano che essere un discendente di immigrati italiani ed essere un americano sono una cosa sola. La mostra di Amore è unica e ci ricorda che la storia e l'arte sono insieme qualcosa di pubblico e di privato: avvisi pubblici di eventi familiari, morti, matrimoni, divorzi, si combinano con resoconti di notizie, frammenti di storie raccontate oralmente, e materiali provenienti da libri di storia, per creare un mosaico culturale che testimonia delle complessità che creano tutte le identità dell'America.

Oggi vediamo che "l'italianità" è un concetto fluido, che viene ridefinito ogni volta che un artista si rivolge ad esso nel suo lavoro, ogni volta che un americano o un'americana scelgono di fare riferimento alla propria eredità ancestrale. Finché non accettiamo ciò che significa per noi l'"italoamericanità" non possiamo diventare buoni americani. Il negare o travisare una parte equivale ad alterare il tutto; dobbiamo incoraggiare una diversità all'interno del nostro concetto di italianità, esattamente come dobbiamo abbracciare la diversità che definisce i concetti di "America" e di "Italia". Life line di B. Amore ha preso il personale e lo ha reso pubblico e, nel corso di tale processo, ci rende tutti più vicini gli uni agli altri.

Cent'anni a B. Amore. Alla salute di tutti quanti!

[1] Fred Gardaphe è Professore di studi americani all'Università di Stony Brook, a Long Island, New York. I suoi libri includono *Italian Signs, American Streets: The Evolution of Italian American Narrative; Dagoes Read: Tradition and the Italian/American Writer; Moustache Pete is Dead!* e *Leaving Little Italy*. Il suo ultimo libro è *From Wiseguys to Wise Men*. È co-fondatore e co-editor della rivista VIA: Voices in Italian Americana e editor della Italian American Culture Series presso la casa editrice SUNY Press.

La nipote di Concetta De Iorio ricorda/ Il viaggio di B. Amore nel regno della memoria*

Joseph Sciorra[1]

Ma ricordare richiedeva sforzo e attenzione dicevano questi fiori, perchè le piccole cose insignificanti della nostra esistenza erano così minuscole e preziose da potersi dissolvere al soffio fugace di un vento.

—Mary Cappello, *Night Bloom*

Oh America, terra meravigliosa di "opportunità amnesiache". Era un luogo fantastico, ci dicevano, prima del Patriot Act e del Total Information Awareness System, dove potevi uscire fuori dalla terza classe e gettare a mare i ceppi del passato per reinventarti come un Pinco Pallino qualunque. Oppure alla fine potevi diventare un etnico rinato a nuova vita con perdita di memoria e offuscamento dei documenti storici, prerequisiti per ergersi acriticamente a difensori della storia trionfante di autodeterminazione, coesione familiare, e convinzione religiosa nell'ascesa, glorificata e apparentemente inevitabile, all'interno dei consigli e nei sobborghi dell'America bianca.[2] Oppure potevi essere Bernadette D'Amore, che si è trasformata in B. Amore/Be Love/Sii Amore e che ci ha teso un *filo della vita* che ci collega a una storia ri-raccontata, una storia reimmaginata.

È meraviglioso avere queste immagini e questi testi riuniti insieme in un libro. La straordinaria mostra di Amore, *Life line—filo della vita*, era semplicemente troppo per essere goduta appieno in una sola visita, impossibile ricordarla nella sua interezza. La mostra era un insieme travolgente di oggetti, immagini, testi, media, stili di esibizione, gente, luoghi, narrative, e ricordi che rischiavano allegramente di diventare un sovraccarico sensoriale. Ora abbiamo il tempo e la possibilità di guardare da vicino, in questo libro, *An Italian American Odyssey*, ciò che Amore ha condiviso con noi.

I sei stanzoni di mattonelle bianche a Ellis Island dove la mostra è stata allestita sono uno spazio stregato. Spiriti si aggirano in quello che un tempo era un dormitorio, una "presenza in fermento" che ci sfida a riscoprire biografie, storie e desideri, ostacolandone in questo modo la cancellazione, l'invisibilità e l'esclusione.[3] Amore ha riconosciuto quegli spiriti inquieti e il loro sonno agitato battezzando il primo stanzone "Stanza dei sogni" e installando, in triplice copia, la fotografia degli immigrati sdraiati in un letto a castello, fatta proprio in questo spazio. Le immagini sono state ristampate su Mylar e appuntate su tubi di rame, evocando in questo modo una branda o una barella.

Le stanze seguenti erano piene di "roba" incredibilmente accumulata per sette generazioni dalla famiglia dell'artista, sistemate con maestria in modo che tutti potessero vederla. In mostra stavano i contenuti del baule di un immigrato, che, avendo passato l'ispezione a Ellis Island, per oltre un secolo è rimasto stipato di oggetti che, comunque, avrebbero dovuto essere buttati via tanto tempo fa ma che ora sono ritornati al punto di entrata, cornucopia di tesori storici. Questa profusione di oggetti consisteva in fotografie riprodotte da varie fonti e in una varietà di stili, oggetti religiosi (santini, la statua di un santo, un libro di preghiere), materiale stampato (giornali e libri), documenti ufficiali (l'elenco dei passeggeri di una nave, passaporti, documenti di separazione), oggetti di ogni giorno (un tagliere per ravioli, un orologio, un pennello da barba), strumenti e utensili (un piccone, una macchina da cucire, una macchina da scrivere), e vari tipi di oggetti d'arte (stoffa ricamata, disegni, pietra intagliata). Testi presi da trascrizioni di storie orali, annotazioni di diari, appunti, cartoline, lettere e telegrammi, parole di filastrocche e canzoni popolari, poesie, articoli di giornale, annunci funebri, temi scolastici, citazioni da libri di storia e da lavori di ricerca, documenti legali, e gli scritti dell'artista stessa riempivano la mostra. La presentazione di Amore era il regalo di una figlia di immigrati, una cartolina di famiglia che viaggia attraverso lo spazio e il tempo per ritornare a quella connessione globale, un punto di migrazione di massa di lavoro umano senza precedenti, di sogni che perdurano e di infinite possibilità.

Tanti degli oggetti lì sistemati mi hanno profondamente colpito durante la mia prima visita. Eccone soltanto alcuni:

Un piccone e la sezione di una botte di vino, disposti in piedi insieme in una teca di vetro oblunga esagonale, come fossero oggetti "ready mades" della classe operaia, un estensione delle braccia stanche di Antonio D'Amore e un ricordo del palliativo fermentato del lavoratore.

I fagotti di stoffa legati insieme, messi da parte da Concetta De Iorio nel corso di anni di progetti di cucito, accompagnati da suoi appunti scritti a mano, ammucchiati in una teca identica, pacchetti che ci fanno pensare alla raffinata arte delle donne e al lavoro motono e pesante del cucito.

L'ispirata installazione "Odissea" ("Odyssey"), un gruppo di cinque "personaggi" scolpiti nel marmo, blocchi di pietra incoronati da cestini di vimini e avvolti in stoffa nera, un omaggio alle donne che lavoravano e che trasportavano sulla testa il peso di prodotti.

"L'arte del rilassarsi" ("The Art of Lounging"), il portfolio con i disegni del diploma di Nina D'Amore presso il Dipartimento di design per la moda al Massachusetts College of Art, con le illustrazioni ad acquerello e inchiostro di un "abito e soprabito per la padrona di casa" per la signora –"ricca o altrimenti"– che non sa come i suoi ospiti verranno vestiti. Ci sono immagini incantevoli racimolate dai film di Hollywood e dalla rivista *Life*, un mondo molto lontano dalla miseria dei contadini del sud Italia. Il dolce far niente, ma guarda un po'!

"La tavola di nonna" ("Nonna's Table"), una semplice tavola rotonda con una tovaglia a quadri bianchi e blu e sedie che diventavano un punto d'incontro per i visitatori della mostra e per le artiste invitate a partecipare, che includono Annie Lanzillotto, Audrey Kindred, Edvige Giunta e sua figlia Emily, Maria Laurino e altre donne del Collective of Italian American Women, che si sono esibite nelle loro performance, complementari alla mostra, intorno a questo tavolo da cucina proveniente da un passato da ri-usare.

Com'è possibile che una sola persona, una discendente di immigrati, avesse ancora tutti questi oggetti? C'era il diario del nonno dell'artista, Lorenzo De Iorio, che si autoproclamava *Libro di memorie*, scritto nel diciannovesimo secolo! Una casa intera era stata messa sottosopra,

una soffitta svuotata, le cose ordinarie ributtate a riva e messe in salvo, perchè trovassero rifugio in questo santuario chiamato arte. Queste sono cose che non sopravvivono all'esperienza degli immigrati; questo è ciò che in America viene scartato.

La nonna di Amore, Concetta De Iorio, è il punto di inizio di questa collezione, una persona che non soltanto ha accumulato artefatti personali – dal nocciolo rinsecchito della pesca di un albero che lei aveva piantato con il padre Luigi, al tappo di champagne di una delle feste di compleanno di Amore – ma li ha anche etichettati con appunti che ne descrivono le origini e che riportano i suoi pensieri, i suoi sentimenti. Attraverso la scrittura e il cucito la vita di Concetta è stata creata e documentata in righe di inchiostro e fili di stoffa. Il suo appunto attaccato con uno spillo a una parte del materiale sembra un haiku a cottimo di una sartina immigrata.

> *Stoffa bianca da ricamare*
> *Cuscini finiti e non finiti*
> *Tutto o quasi cominciato*
> *Pezza – lettere 'seta' canovaccio.*[4]

Era lei la curatrice principale del grande museo di famiglia, lei che ha concettualizzato, coltivato e alla fine documentato le relazioni familiari in ciò che l'antropologa Micaela Di Leonardo ha definito «il lavoro dei rapporti di sangue.»[5]

In qualità di erede di questo assortimento senza forma, Amore ha intrapreso «il lavoro pietoso del salvataggio», recuperando e salvaguardando i numerosi oggetti.[6] Riferendosi ai bauli zeppi ereditati da sua madre alla morte di lei nel 1994, Amore aveva affermato: «Erano un peso. Erano davvero un peso. Io li ho presi perché non sopportavo l'idea che andassero persi. Continuavo a dire che li avrei usati per farne dell'arte, ma non avevo nessuna idea di come».[7] Il vasto progetto artistico di Amore comportava l'arduo compito di dare forma, e quindi significato, a una quantità di oggetti eterogenei slegati dalla loro esperienza di vita originaria nello sforzo di «offrire accesso alle vite domestiche che essi significano».[8] La folklorista Barbara Kirshenblatt-Gimblett ha notato che ricordi e cimeli di famiglia sono «frammenti che aspettano che lo scrittore di autobiografia ripari il danno inflitto dal

tempo».[9] *Life line* ha rimesso insieme le narrative di ciascun oggetto attraverso l'aggiunta, la contrapposizione e l'esposizione. Mentre l'artista divideva gli oggetti in categorie, li assemblava, e alla fine li metteva in mostra, la collezione, a sua volta, diveniva «un'articolazione dell'"identità" della [nuova] collezionista», un atto di autocostruzione, attraverso il quale Amore ha riscritto la storia e ridefinito il proprio posto al suo interno.[10]

L'opera di Amore costituisce ciò che lo storico Pierre Nora ha definito *«les lieux de mémoire»*, «i regni della memoria», prodotti culturali come archivi, collezioni e commemorazioni in cui «la memoria si cristallizza e si cela» quando «la coscienza di una rottura con il passato è legata al sentire che la memoria è stata spezzata»[11]. *Life line* ha esaminato i punti in cui la memoria e la storia convergevano in condizioni di dislocazione, rottura, cambiamento radicale nel corso di un secolo e mezzo. L'artista ha riconfigurato il passato in una rappresentazione pubblica di identità personali e collettive che si concentrano su vite individuali tenendo presenti, allo stesso tempo, le più ampie forze globali in gioco. Il risultato finale è stato un'abile tessitura di cimeli familiari in un contesto sociale più ampio, tanto etnografia familiare, che lezione di storia.

Far dialogare i vari artefatti comportava la scoperta de «le oggettive possibilità nelle cose e la libertà di conservare il passato e di creare nuovi valori e un nuovo mondo».[12] Amore ha sovrapposto immagini e testo su pannelli di scarto dei soffitti di stagno, dando un'idea delle miserevoli stanzette delle case popolari dove vivevano gli immigrati, trasformando così gli oggetti riciclati sia in testimonianza, che in atto di accusa. Una delle soluzioni che Amore ha usato in quella che lei stessa descrive la sua "archeologia di vita" è stata quella di contrapporre diverse strategie espositive, inclusi "il reliquario religioso", "l'armadietto delle curiosità", "la mostra etnografica" e "la mostra d'arte", e anche di usare molti media, come la fotografia, la scultura e i video. La sua opera testimonia il potere del *bricolage* di creare nuovi significati e interpretazioni dei vari oggetti estrapolati dalla vita quotidiana. L'artista Miriam Schapiro ha osservato che le donne che hanno lavorato secondo le più varie tradizioni estetiche, come quella del quilt, usano da lungo tempo l'assemblaggio come una strategia artistica e sociale che lei ha denominato *"femmage"*.[13] Questo processo

artistico è più evidente negli altari domestici delle donne dove, secondo la folklorista Kay Turner, «gli oggetti e i simboli sono integrati in un ambiente visivo coerente che segna il loro rapporto di connessione e di interdipendenza[...] e conia nuovi significati interrelati».[14] Questo miscuglio di elementi dissimili elevato ad arte fornisce uno spazio accogliente alla polifonia di voci diverse presenti nella famiglia italo americana allargata di B. Amore.

La mostra scioglieva, per poi ritesserli, i vari fili delle storie dei parenti secondo l'interpretazione e la visione artistica di Amore. Su un pannello, a mo' di collage, erano in mostra immagini di un individuo, e a volte le si poteva osservare attraverso il filtro di una pellicola o una stoffa traslucida, velate sì, ma affioranti in superficie da un passato sempre più lontano. Tra le storie di lotta, coraggio e successo, l'artista ha rivelato anche segreti familiari che altri si sarebbero sentiti in obbligo di nascondere: l'immigrato patriarca che punisce i propri figli con una cinta di cuoio; il sospetto che uno degli antenanti bevesse un po' troppo; i tradimenti e il vizio del gioco d'azzardo del nonno; il furto di possedimenti familiari in Italia da parte di un parente; e il «conflitto costante» tra l'immigrata Concetta e sua figlia Nina, nata in America. Queste sono le storie bisbigliate della grande narrazione mitica della famiglia italoamericana che l'omertà individuale e quella collettiva hanno storicamente cercato di nascondere.[15]

Un delicato filo rosso percorreva la mostra, aprendosi la strada attraverso lo spazio e il tempo, collegandoci con il passato e proiettandoci nel futuro. Esso evocava il filo ormai sciolto con il quale gli immigrati rimanevano legati ai familiari che restavano in piedi sul molo mentre loro veleggiavano lontani verso un mondo sconosciuto; faceva eco alle iniziali ricamate sulla biancheria di Concetta De Iorio e Giovannina Forte, teli di lino della dote fatta in previsione di una nuova vita. In ultima analisi, *Life line* ci ha messo in connessione con le storie e i ricordi delle nostre rispettive famiglie, quelli che si sono sviluppati in America e che si attenuano al passare di ogni generazione, ma che tuttavia permangono, talvolta con dolore, appena sotto la superficie.

Ringraziamenti

Desidero ringraziare Rosina Miller, Leonard Norman Primiano, Stephanie Romeo, e Joan Saverino per i loro preziosisissimi commenti ad una precedente versione di quest'articolo.

*La traduzione di questo saggio è di Caterina Romeo.

[1] Il folklorista Joseph Sciorra è Vice Direttore dei programmi accademici e culturali al John D. Calandra Italian American Institute del Queens College, a New York. È co-curatore della raccolta bilingue di poesie di Vincenzo Ancona *Malidittu la lingua/Damned Language* ed autore di *R.I.P.: Memorial Wall Art*. Sciorra ha il sito web HYPERLINK "http://www.italianrap.com" www.italianrap.com

[2] Robert F. Harney esplora "l'uso "etno-psichiatrico della storia" da parte dei leader e dell'intelligenzia della comunità italiana in Nord America, come tentativo di attenuare il senso di "auto-disistima etnico" nel suo importante saggio *Caboto and Other Parentela: The Uses of the Italian Canadian Past*, in Nicholas De Maria Harney, Ed., *From the Shores of Hardship: Italians in Canada*, Welland, Ontario, Éditions Soleil, 1993, 4-27. Bill Tonelli esplora i temi della perdita della memoria e del'identità etnica nel suo brillante memoir, sfortunatamente fuori catalogo, *The Amazing Story of the Tonelli Family in America: 12,000 Miles in a Buick in Search of Identity, Ethnicity, Geography, Kinship, and Home*, New York, Addison-Wesley Publishing Company, 1994.

[3] Il corrispondente inglese di questa citazione si trova in Avery F. Gordon, *Ghostly Matters: Haunting and the Sociological Imagination*, Minneapolis, University of Minnesota Press, 1997, 3-28.

[4] Frammenti degli scritti del nonno di Mary Cappello, calzolaio immigrato, l'hanno ispirata nella scrittura del suo libro, bello e provocatorio, *Night Bloom: A Memoir*, Boston, Beacon Press, 1998.

[5] Il corrispondente inglese di questa citazione si trova in Micaela di Leonardo, *The Varieties of Ethnic Experience: Kinship, Class, and Gender Among California Italian-Americans*, Ithaca, Cornel University Press, 1984, 194-205.

[6] Il corrispondente inglese di questa citazione si trova in Susan Sontag, *On Photography*, New York, Dell Publishing Co., 1977, 76.

[7] Incontro dibattito su "Life line – *filo della vita*" sponsorizzato dal Queens College's John D. Calandra Italian American Institute e dall' Istituto Italiano di Cultura, New York City, 14 novembre, 2000.

[8] Il corrispondente inglese di questa citazione si trova in Barbara Kirshenblatt-Gimblett, *Objects of Memory: Material Culture as Life Review*, in Elliot Oring, Ed., *Folk Groups and Folklore Genres: A Reader*, Logan, Utah States University Press, 1989, 329-338.

[9] Ibid., 331. Vedi anche il saggio dell'antropologo Igor Kopytoff, *The Cultural Biography of Things: Commoditization as Process*, in Arjun Appadurai, Ed., *The Social Life of Things: Commodities in Cultural Perspective*, New York, Cambridge University Press, 1988, 64-91, per la sua disamina del processo di documentazione della "biografia culturale" di un oggetto.

[10] Il corrispondente inglese di questa citazione si trova in Susan Stewart, *On Longing: Narratives of the Miniature, the Gigantic, the Souvenir, the Collection*, Baltimore, The Johns Hopkins University Press, 1984, 151-169.

[11] Il corrispondente inglese di questa citazione si trova in Pierre Nora, *Between Memory and History: Les Lieux de Mémoire*, "Representations", 26 (Spring 1989), 7-25.

[12] Il corrispondente inglese di questa citazione si trova in Mihaly Csikszentmihalyi and Eugene Rochberg-Halton, *The Meaning of Things: Domestic Symbols and the Self*, New York, Cambridge University Press, 1987, 246.

[13] Kay Turner, *Beautiful Necessity: The Art and Meaning of Women's Altars*, New York, Thames & Hudson, 1999, 98.

[14] Il corrispondente inglese di questa citazione si trova in Ibid., 98. Vedi anche Jack Santino, *The Folk Assemblage of Autumn: Tradition and Creativity in Halloween Folk Art*, in John Michael Vlach and Simon J. Bronner, Ed., *Folk Art and Folk Worlds*, Ann Arbor, Michigan, UMI Research Press, 1986, 151-169.

[15] Vedi l'articolo di Robert A. Orsi *The Fault of Memory: "Southern Italy" in the Imagination of Immigrants and the Lives of Their Children in Italian Harlem, 1920-1945*, "Journal of Family History", 15.2, 1990, 133-147 per la sua acuta lettura delle dinamiche della famiglia immigrata e della "tragedia" della famiglia italoamericana. Lo studioso di letteratura Robert Viscusi discute le conseguenze del silenzio per gli italoamericani in *Breaking the Silence: Strategic Imperatives for Italian American Culture*, "VIA: Voices in Italian Americana" 1.1 (Spring 1990), 1-13.

Italia interrotta

Robert Viscusi[1]

Una mia collega mi scrive dall'Italia. Una studentessa universitaria di sua conoscenza desidera analizzare le opere di autrici italoamericane nella tesi, ma il suo professore non le vuole consentire di includere memoir e autobiografie fra i testi da lei studiati. Tali testi devono essere, dice il professore, "letterari". Le autobiografie non contano come opere di letteratura, non diversamente dai volantini e dagli articoli di giornali. Per non parlare dei pacchi di lettere. Il professore vuole solo opere teatrali e poesie e, naturalmente, romanzi.

Ah, il Vecchio Mondo. È sempre rassicurante, per un americano, vedere la macchina della produzione letteraria che si impegna nel suo lavoro consueto di violenza simbolica (come l'ha chiamata Pierre Bourdieu) – il che vuol dire, vigilare con piglio poliziesco i confini della riserva di cervi dove i figli e le figlie di gente che aveva studiato all'università cinquanta o settantacinque anni fa possono continuare a far valere le regole dell'esclusione che i loro genitori avevano imparato ai piedi di persone i cui genitori avevano appreso quelle stesse regole cinquanta o settantacinque anni prima ai piedi di altre persone i cui genitori avevano imparato quelle stesse regole da gente che, una volta nel passato, le aveva ricevute su tavolette intagliate da gnomi in gallerie scavate sotto terra. La borghesia universitaria dell'Italia di provincia (questa lettera proveniva dall'Abruzzo) ancora mantiene gli steccati attorno alla riserva di cervi, escludendo efficacemente dallo studio o dalla discussione le opere di persone i cui genitori non hanno studiato in università di provincia o, se lo hanno fatto, hanno in qualche modo perso la capacità di ricordare le regole della proprietà tipiche delle cittadine di provincia, una volta traversato l'oceano e iniziato a capire il senso della vita come era vissuta nelle vie risonanti di voci rauche delle colonie italiane di New York, Boston, o Buenos Aires.

Naturalmente, è tutto un mito e una menzogna. Il romanzo in Italia, di fatto, non ha una storia molto lunga, rispetto alla storia italiana, né è conosciuto per la sua capacità di modellare complesse geografie fisiche, sociali o temporali. Libri di viaggi, sì. Epistolari, sì. Autobiografie, sì. Ma narrativa, direi di no. La scrittura italiana ha in

effetti divagato ampiamente tra i laboratori di classe e le improvvisazioni – legate al territorio – della diaspora italiana nel mondo, ma si è lasciato alle spalle tanto il Galateo, che i manuali della metrica, così come anche i trattati della retorica classica. In effetti, le condizioni della semiotica e della riproduzione sociale nella diaspora hanno non soltanto superato, ma interamente evitato le istituzioni di prestigio a lungo vagheggiate dai salotti letterari e dagli esclusivi ricevimenti nei giardini dell'Italia letteraria.

Tutto ciò è detto allo scopo di sgombrare un po' il campo per la mostra di B. Amore, *Life line*, e per il presente libro, *An Italian American Odyssey*. Quest'opera ignora la maggior parte degli "shibboleth" della proprietà "generica" che vengono acquisiti e trasmessi dai guardiani di una sterilità artistica in cittadine appollaiate sulla cima di colline sovrastanti i pendii e le valli che tanti italiani abbandonarono tanto tempo fa. *Life line* accetta, espone gioiosamente e utilizza gli effettivi mezzi di comunicazione che gli italiani della diaspora hanno impiegato nella costruzione e trasmissione di modelli di vita sociale e di memoria collettiva. La maggior parte del materiale che quest'opera presenta sembra andarsi a collocare direttamente nella moderna tradizione del *bricolage*. Oggetti effimeri di ogni genere giacciono qui in una contiguità promiscua: lettere, cataloghi, giornali, biglietti e programmi, ricami, fotografie, ritagli di giornali. Se *Life line* è un'opera di letteratura – e sto in verità suggerendo che si tratta proprio di questo – essa richiede una propria teoria della ricezione. Come si deve leggere un lavoro composto di materiale così eterogeneo? Potrebbe essere utile andare a cercare nella scatola degli utensili degli studi letterari e culturali alcuni utili strumenti di lettura.

Ellissi. Life line esamina, sfrutta ed esagera le discontinuità che affliggono le linee della narrazione nelle vite dei popoli migranti, quando le storie cominciano con un gruppo di attori in un luogo ma continuano in altri luoghi con altre persone e in altre condizioni, *Life line* usa i metodi ellittici dell'arte modernista e post-modernista – narrazioni interrotte, collage e palinsesto – nel mettere insieme la sua montagna di frammenti articolati.

Feticcio. Le vite degli immigrati sono organizzate intorno ad oggetti che sviluppano una straordinaria importanza e potenza, in eccesso rispetto a quella che avrebbero potuto avere in un contesto più stabile. Tali oggetti includono cose che hanno la risonanza di divinità domestiche – quadri, statue e medaglioni. Ma comprendono altresì cose che avrebbero altrimenti avuto una risonanza più pratica: capi d'abbigliamento, vasellame e articoli di cucina. Rimossi dai loro luoghi di collocazione originari e sistemati su sfondi strani e mobili, tali oggetti acquistano una singolare e sorprendente importanza poetica e narrativa. Possiedono due specifici generi di risonanza. Parlano, dapprima, di ciò che è perduto. Questo è il famoso feticcio freudiano. Esso ricava la propria energia dalla forza dei cuori infranti e delle promesse mancate. *Life line* abbonda di questo genere di rottura con il conseguente spostamento di energia sessuale. Genitori, fratelli e sorelle, amanti, mariti, tutti hanno il loro posto nella entropia senza speranza dell'affetto che appartiene al migrante. Il secondo tema dei feticci è il potere di ciò che è nascosto. Questo è il ben noto feticcio delle merci di Karl Marx, che porta con sé, ma che allo stesso tempo maschera, la complessa storia dei rapporti di lavoro che sono richiesti per la produzione, la distribuzione e il consumo. *Life line* abbonda di questo tipo di manufatto, la cui stessa fattura e il cui stesso stile, quando li si scorge tra i relitti a rottami galleggianti di una tribù sparpagliata, evocano potentemente il mercato del lavoro attraverso l'Atlantico e i prigionieri del plusvalore.

Gender e genere (letterario). I generi letterari mescolati di *Life line* riproducono drammaticamente questa monumentale destabilizzazione dell'identità sessuale che ha accompagnato l'emigrazione di massa. Questi *relicta*, queste vestigia non-così-silenziose di tale vita, accompagnate dai concisi commenti narrativi di B. Amore, offrono uno sbalorditivo spettacolo delle difficoltà che uomini e donne dovettero fronteggiare nel loro tentativo di mantenere quei ruoli sessuali che si erano evoluti gradualmente attraverso il lento trascorrere dei secoli sotto lo sguardo fisso di un popolo sedentario, ma che fruivano di un modesto sostegno e avevano poco senso sullo sfondo del mercato internazionale della manodopera dove vivevano gli immigrati.

Interruzione. La teoria lacaniana offre il concetto dell'inconscio che funziona come un'interruzione. Esso cambia il soggetto di un discorso, interrompe il flusso della spiegazione e della chiarificazione. *Life line*, si potrebbe dire, è composto interamente di interruzioni. Nessun

programma funziona effettivamente. Nessuna nozione di significato riesce mai a trionfare. L'Italia, con la sua infinita retorica di autogiustificazione e autoesaltazione, perde forma, dimensioni e importanza nelle strade di Boston, dove le proccupazioni riguardano l'affitto, il vestiario, i biglietti ferroviari, i lavori e le paghe.

Life line, occorrerebbe aggiungere, fornisce anche strumenti propri per un'interpretazione. Quest'opera abbonda di strutture interpretative, offerte ad ogni livello di grandezza, cosicché ci si può avvicinare attraverso la cruna di un ago o dal ponte di un transatlantico. La migrazione offre alla narrazione difficoltà gigantesche. Tanto di ciò che fu detto, sentito o ricordato ha lasciato tracce in luoghi che di solito sono ignorati dal compilatore di antologie e dal collezionista di oggetti d'arte. Tanto di ciò che fu detto non fu mai portato a termine. Tante lettere non raggiunsero mai i destinatari indicati. Nel centro di questa semiosi spezzata, B. Amore ha eretto questo monumento di parole a messaggi incompleti, dando all'incoerenza e alla frustrazione la misura piena dell'intensità del dolore e dell'eloquenza.

Si tratta di arte? O di letteratura? Queste sono domande sui limiti, sui confini, e l'autentico proposito dell'impresa di Amore è quello di travalicare i confini e di produrre un'opera che richiede all'osservatore di leggere e al lettore di osservare e di mettere insieme, in un qualsiasi modo possibile, i pezzi di una rappresentazione del mondo di una famiglia che vive nel mondo dell'emigrazione. La leggo come un'opera di letteratura, ma questa non è l'unica possibilità. In effetti, uno è sempre costretto a decidere. Quest'opera non fornisce nessuna facile assicurazione. Si può solo sperare che il controllo poliziesco di stampo provinciale sulla letteratura italiana la trovi una minaccia preoccupante.

[1]Robert Viscusi è Broeklundian Professor e direttore esecutivo del Ethyle R. Wolfe Institute for the Humanities al Brooklyn College, nonché presidente della Italian American Writers Association. I suoi libri includono il romanzo *Astoria* (che ha vinto l'American Book Award nel1996) e *Buried Caesars, and Other Secrets of Italian American Writing*.

Il tempio della memoria degli immigrati: il memoir visivo di B. Amore

Edvige Giunta[1]

Ciò che non viene ricordato va perso.

—B. Amore, *An Italian American Odyssey*
Life line–filo della vita: Through Ellis Island and Beyond

Entrando nelle sale di *Life line*, penetro nel tempio della memoria degli immigrati italiani in America. L'impatto di tale incontro è simile ad una visita a Morgantina, i resti di una *polis* greca vicino ad Aidone, in Sicilia. Non ci sono più i muri, ma le fondamenta delle case e dei templi e la piazza del mercato tracciano i contorni di ciò che circa milleseicento anni fa era la vita di una comunità, la cui eredità si infiltra nella carne e nelle ossa dei suoi discendenti di oggi. Un'estate, di ritorno dagli Stati Uniti per un mese nell'isola dove sono nata, cammino con profondo rispetto attraverso i sentieri di Morgantina. Inciampo su un mosaico, fuori del perimetro di ciò che era una volta un'abitazione, una sagoma rettangolare con le parole "benvenuto" in greco antico. Sono molto commossa dalle parole di questi lontani antenati che mi salutano con parole così antiche, così familiari. Sulla soglia di questa casa rifletto sull'incontro di passato e presente, dei morti e dei vivi – su come tutto è collegato. Allo stesso modo mi commuovo quando un sabato mattina di dicembre 2001 entro, accompagnata da mio marito ebreo americano e trascinandomi dietro i miei due figli, entrambi nati negli Stati Uniti, nelle sale della mostra *Life line – filo della vita*: *An Italian American Odyssey 1901-2001*, che traccia i contorni di altri antenati le cui storie si intersecano alla mia.

Sono arrivata negli Stati Uniti nel 1984. Si potrebbe dire che sono collegata solo in piccola parte agli italiani che giunsero negli Stati Uniti tra la fine del diciannovesimo e l'inizio del ventesimo secolo. Ma

anch'essi, come i greci di Morgantina, sono i miei antenati. Forse la cicatrice più grande nella cultura italoamericana è la perdita della memoria, la perdita della connessione con i luoghi, le persone, gli oggetti di un passato collettivo che contiene la sua storia, la sua poesia. "Un'Odissea italoamericana": come è appropriata la scelta della parola "odissea" da parte di B. Amore, una parola che sa di viaggi epici e di eroiche gesta, di coraggio e di determinazione per sopravvivere contro tutte le avversità. Davvero per troppo tempo le storie degli immigranti italiani negli Stati Uniti sono state esclusiva preoccupazione di antropologi, sociologi e storici, il cui lavoro, pur apprezzabile, non è riuscito a catturare lo spirito di un popolo, né la forza della cultura che trasforma e redime. Scrittori, registi e artisti fanno esattamente questo – trovano una lingua per esprimere quello spirito, quella forza.

In quel giorno di dicembre, mi sono unita alle mie sorelle italoamericane per l'inaugurazione di *Life line* al Museo dell'Immigrazione di Ellis Island. La poetessa Annie Lanzillotto aveva convocato un gruppo di scrittrici e di artiste per condividere il proprio lavoro in un'ambientazione straordinaria. Commemorare l'esperienza degli immigrati attraverso la lente delle storie personali e attraverso incontri intimi a mio giudizio rappresenta lo scopo più significativo che questa straordinaria mostra riesce a raggiungere. Straordinaria: scelgo tale parola deliberatamente. Attraverso la ricostruzione delle memorie degli immigrati, B. Amore svela lo straordinario nel quotidiano. L'aspetto quotidiano e l'aspetto epico si incontrano e si intrecciano in *Life line*.

Alla mostra di B. Amore, è impossibile comportarsi da semplici visitatori che contemplano con distacco una produzione artistica. E poi quando l'arte è al meglio impedisce tale distacco. Mentre percorriamo le sale dov'è allestita *Life line*, seguiamo un filo di ricordi e di storie, un filo che collega il passato e il presente, la memoria personale a quella collettiva di un'intera cultura. Le stanze si succedono l'una all'altra, ma il viaggio dei visitatori non è lineare né privo di punti di congiunzione. Sostiamo, ci avventuriamo in un'altra direzione, torniamo sui nostri passi. Siamo sommersi da oggetti e ricordi messi insieme in magnifiche contrapposizioni. Ogni tanto una teca serve a farci ricordare che tutto ciò è stato creato, allestito. Ciò rende trasparente il processo d'incontro tra l'artista e il materiale da lei impiegato, tra l'oggetto d'arte e il visitatore. Ma alcuni degli oggetti – lettere, libri,

vestiti, biancheria, utensili – ci sorprendono e ci sommergono con l'impronta vibrante dell'essere umano che li ha toccati, li ha scritti, li ha usati per lavorare. Questa è un'epica della vita domestica.

L'opera di B. Amore si trova a cavallo della linea che sta tra l'elemento elegiaco e quello festoso. Mi fa pensare alla festa dei morti celebrata il 2 novembre in Italia, ma anche in Messico e altrove nel mondo. Quando ero bambina in Sicilia, attendevamo ansiosamente la visita dei Morti, che venivano nelle prime ore del mattino a portare doni per noi bambini, i loro discendenti, quando eravamo ancora addormentati: pupi di zucchero a forma di cavalieri e principesse, frutta di marzapane e giocattoli. Più tardi durante la giornata, ci univamo alla disordinata processione delle persone che si recavano al cimitero a visitare le tombe dei familiari. Molte erano persone che erano morte molto tempo prima che noi nascessimo, gente che conoscevamo soltanto attraverso fotografie e storie. Ancora col gusto dello zucchero in bocca, guardavo le donne vestite di nero che portavano fiori meravigliosi dai colori sgargianti e piangevano dinanzi alla tomba di un genitore, un figlio, una persona amata. Un'analoga mescolanza di lutto e di celebrazione permea *Life line*. I volti contemplano i visitatori dai "Rotoli degli antenati" e dai "Trittici di famiglia". Muti ed eloquenti allo stesso tempo, essi vogliono ricevere il nostro compianto ed essere celebrati – vogliono essere ricordati.

Life line di B. Amore realizza nel campo dell'arte ciò che donne italoamericane che hanno scritto memoir, come Louise De Salvo, Susanne Antonetta, Mary Cappello, Kym Ragusa e Maria Laurino, realizzano attraverso la scrittura. Queste autrici usano la memoria come contenuto e come forma: la loro scrittura non è soltanto una narrazione di cose che sono avvenute – questo è compito dell'autobiografia. Invece i loro memoir articolano ciò che ogni scrittrice ricorda, i ricordi – suoi e di altri – che lei è stata in grado di recuperare, ricostruire e, cosa più importante, reinventare. Questi memoir pongono le seguenti domande: che cosa significa ricordare certe storie e non altre? Che cosa significa il fatto che noi ricordiamo qualcosa in modo diverso da come lo ricordano nostra madre, o nostra sorella, o nostro fratello, o da come lo ricordavamo noi stessi in età più giovane? Come si collegano tra loro i ricordi? Come troviamo il modo per ricordare e le parole per raccontare?

La narrazione di un libro di memorie segue la struttura stessa del ricordare: evocativa, associativa, spesso disarticolata ma sempre significativa, come lo è la poesia. La verità del memoir, come dice Louise De Salvo, è la verità della memoria, non la verità dei fatti. E così con *Life line*, un memoir visivo che richiede che l'osservatrice diventi una lettrice che si lasci addestrare da quest'opera a trovare un significato nelle fessure, negli interstizi, nelle linee di congiunzione tra l'oggetto e l'intervento dell'artista, come nei "Rotoli degli antenati" o nelle colonne di marmo drappeggiate di stoffa, che reggono canestri di biancheria sulla loro sommità. La pietra sembra muoversi, sinuosa nella sua rigidità, profonda nella sua impenetrabile levigatezza. Questo è il modo in cui la scultrice ricorda la sua famiglia, la sua storia. E l'incompletezza di questa storia visiva è importante quanto l'abbondanza dei materiali. Il semplice quantitativo degli oggetti manufatti che la famiglia di Amore ha conservato è a dir poco grandioso. Tuttavia, questa profusione di oggetti raccolti in *Life line* mette in risalto anche le lacune, ciò che è andato perso, il non raccontato, il dimenticato. Tutto questo è importante e costituisce l'autentica essenza del memoir. Tutto ciò indica la necessità di ricordare ciò che è stato dimenticato e che altrimenti sarebbe dimenticato per sempre.

Vicino all'insediamento greco di Morgantina hanno lasciato tracce di una presenza umana anche un antico insediamento romano e uno preistorico. Queste tracce raccontano in modo collettivo una storia – la storia di gente che abitò e condivise, in periodi storici diversi, una porzione di terra chiamata Morgantina. Fattorie sparse, alberi da frutto, un agnellino che bela alla ricerca di sua madre, un cane che abbaia agli estranei, il proprietario di una trattoria che racconta ai suoi clienti di essere cresciuto a Morgantina e di aver trovato resti archeologici – vasi, statuette, monete – che la sua famiglia ha conservato ed esposto orgogliosamente nella propria casa, come hanno fatto altre famiglie della zona – finché gli archeologi della Università di Princeton hanno portato via tutto, e l'hanno messo nei musei; tutto ciò attesta i modi complessi in cui sono interconnessi passato e presente, culture, popoli, vita e arte, casa e museo.

Life line, l'opera che si annuncia come l'"Odissea italo americana", quasi immediatamente rivendica il proprio potere mitico e il proprio desiderio di parlare a nome di tutti gli immigrati. L'artista incornicia e presenta ogni manufatto in modo tale che il visitatore non può che collegare tutte le storie: storie di uomini, di donne, di bambini, storie di famiglie e di comunità – la storia di una nazione. Il Museo dell'Immigrazione a Ellis Island è diventato la prima casa ad ospitare *Life line*. I ricordi e le storie di tutti quegli immigrati passati attraverso quell'edificio si intersecano con le storie che *Life line* racconta e con le storie raccontate dalle scrittrici che Annie Lanzillotto riunì quel mattino di sabato di dicembre 2001. Una di loro era una ragazza italoamericana di dodici anni. In piedi su una sedia, circondata da scrittori e scrittrici più grandi d'età, da visitatori e dalla stessa B. Amore, la ragazza legge un breve memoir sul giardino siciliano dei suoi nonni materni, evocato con un senso di perdita e di desiderio, sospeso tra la realtà e il sogno. Quella ragazza è mia figlia. La storia che racconta quel giorno, e anche la sua stessa storia, sono connesse con i ricordi e le storie che riempiono le stanze dell'Odissea italoamericana di B. Amore – un *filo della vita*. Ogni immagine, ogni oggetto – come ogni ricordo – in *Life line* è collegato con un altro e questo con un altro ancora, in una spirale che converge verso la possente narrazione collettiva impressionistica di *Life line* e la sua evocazione in questo libro, *An Italian American Odyssey*. Queste immagini e questi oggetti parlano – la loro voce è un mormorio che rimane con noi. Talvolta è una voce solitaria; altre volte è un coro. *Life line* produce una musica irresistibile che ha una forza silenziosa. E perdura.

[1]Edvige Giunta è Professore Associato di inglese alla New Jersey City University. I suoi libri includono *Writing with an Accent: Contemporary Italian American Women Authors* e *The Milk of Almonds: Italian American Women Writers on Food and Culture*. È co-editor della rivista *Transformations*.

Life line: Filo della memoria[1]

Flavia Rando[2]

Con *An Italian American Odyssey* B. Amore – scultrice, artista, autrice e docente – torna a casa per sua madre e la madre di sua madre, per tutti quelli che se ne andarono prima di loro. Il filo della vita delle istallazioni di B. Amore evoca il filo lanciato dagli emigranti, mentre la loro nave si stacca dalla sponda/casa, a coloro che sono rimasti. Questo filo, un ultimo fuggevole legame con tutto ciò *Life line* che hanno conosciuto, è la loro speranza – un cordone ombelicale, mai reciso – che fluttua nell'aria, poi è trascinato sott'acqua, tingendo di rosso il mare. Ora esso ci viene lanciato – per quelli di noi che condividono questa formazione nella loro psiche, l'esperienza di *Life line* è come essere sott'acqua – e se allunghiamo il braccio per prenderlo, potremmo naufragare.

In quest'opera monumentale, un impianto multi-sala di installazioni progettato per Ellis Island, Amore ci chiede di far parte dell'esperienza degli immigrati, di stare lì come devono esserci stati loro, spaesati, sradicati, sopraffatti da stimoli visivi e uditivi, da visioni una volta inimmaginabili, da voci, parole e inflessioni incomprensibili. Al visitatore si chiede di seguire un percorso labirintico – quel sentiero che un tempo condusse gli immigrati verso una nuova vita – guidati soltanto dal filo della memoria, un sottile filo della vita verso (la ricostruzione di) sé.

Life line è dedicata alla nonna materna di Amore, Concetta De Iorio. «È grazie alle sue collezioni di oggetti, dal quotidiano al sacro, che questo lavoro esiste. Le sue storie ed il suo lascito [mi] hanno ispirato». I ricordi di Concetta dominano *Life line* e l'osservatore è tenuto prigioniero in queste memorie e nell'atto di ricordare di Amore. La preziosa biancheria di tre generazioni, i "Fagotti della nonna" – squisita elaborazione della bellezza quotidiana della vita e possente astrazione visiva – sono collocati in numerosi reliquiari e nell'"Armadietto del cucito di quattro generazioni" e sono essenziali per la tessitura visiva e gli umori del lavoro di Amore. Come tale, *Life line* diventa un monumento a ciò che è stato considerato effimero nella vita delle donne, soltanto secondario nel contesto della lotta della famiglia per la sopravvivenza fisica.

Life line inonda i visitatori di fotografie, testi, musica, canzoni, sculture, pacchi di stoffa come sculture, abiti, macchine per cucire e picconi, mobili di cucina, altarini – frammenti di vita quotidiana. Con tali frammenti Amore evoca una condizione di sogno; è come se il suo stesso lavoro fosse creato dall'interno di quel sogno, la sua messa a fuoco offuscata, velata dai cuori spezzati degli immigrati, una donna amorevole e la sua amorevole nipote. Ricordando la sua Concetta e la casa della sua infanzia, Amore ricrea la pienezza della nonna immaginata, la pienezza del focolare domestico che noi trasportiamo nei nostri sogni.

Questo mondo racchiude sia le storie degli adulti udite dalla bambina, che gli ardenti desideri indistinti percepiti dalla piccola sotto la superficie della vita quotidiana. Il visitatore sente questo sottotesto – perturbante, la stranezza di cui è fatto il mondo di una bambina – al di sotto della storia raccontata e della bellezza contemplata. *Life line* di Amore, analogamente alle installazioni di Louise Bourgeois, *Cells*, rende palpabile lo stupore intimorito della bimba mentre si risveglia ad un mondo di bellezza e di emozioni adulte, l'eccitamento che si prova di fronte al significato percepito di impressioni trasportate al di sotto del filo della coscienza. Al limitare della consapevolezza, l'osservatrice sente che la tavola di famiglia è troppo grande, l'altarino fuori misura, la pienezza – e qui il significato aderisce – quasi spaventevole.

Amore cita un proverbio siciliano, un consiglio per sopravvivere nelle avversità: «Hai gli occhi e non vedi; hai il naso e non odori; hai la lingua e non parli, hai le mani e non tocchi»[3]. Ma se soltanto potessimo parlare, potremmo dire ciò che è, ciò che era – e qui viene raccontata la saggezza tradizionale sovvertita (per la sopravvivenza) e poi raccontata di nuovo – troppo per dire, troppo per non dire. Annotazioni su diari scritte con grafia minuta, con inchiostro dorato, tracciano un'ellissi, la loro leggibilità sacrificata alla bellezza del tratto, le parole possono essere lette soltanto attraverso uno sforzo di straordinaria dedizione. Alla periferia della coscienza, udiamo una musica familiare, ci poniamo in ascolto, ma essa svanisce. Siamo sopraffatti dalla sensazione di un mondo ancora sconosciuto, dove si

riconciliano l'esperienza dell'immigrato e la percezione della bambina della casa dell'immigrato.

Vediamo, sentiamo, attraverso il velo della memoria (della nonna di Amore). Alla morte della nonna, Amore ereditò, nella biancheria, i ricordi di Concetta, cullati nella stoffa, fissati con un nastro rosa di fanciulla e con i fili neri del lutto, in attesa della generazione successiva. Il suo lascito, una soffitta piena di cose squisitamente non necessarie, amore, cura, lavoro, creatività, un'opera d'arte, la sua costante presenza una metafora di una vita di possibilità differenti, di una promessa tenuta sospesa – un grande e disperato lavoro. Con altrettanta sicurezza ella collocò la sua arte nella mente e nel cuore di sua nipote, l'artista di un'altra generazione, che, in nome e per conto di Concetta, ha portato questa realizzazione al pubblico (per prima cosa) ad Ellis Island, il suo Punto di Partenza.

Amore usa la biancheria, i fagotti della nonna, come materiale per scultura. La pietra e la stoffa sono entrambe fissate saldamente in nero, creando un'equivalenza tra la biancheria di sua nonna, tessuto intrecciato, tagliato, segnato con il filo e i gesti, e gli obelischi di pietra che lei scolpisce, segnati con lo scalpello e i gesti. La pietra potrebbe essere stata tagliata con il piccone di suo nonno Antonio, collocato in un reliquiario lì accanto. L'intollerabile eleganza del piccone suggerisce un'altra equivalenza, quella tra la (permanenza della) pietra e il lavoro manuale sfiancante degli immigrati che trattano la pietra e il tessuto, essi sopravvivono entrambi per portare fino a noi il passato che continua.

(Noi) italoamericani siamo ossessionati da questo passato; una parte di noi vi è imprigionata. La cultura italiana è stata descritta come una cultura che guarda indietro, e la cultura italoamericana guarda (anch'essa) indietro, ad una rimozione, al ricordo di una perdita, anche se la spinta del presente (americano) ci rende dolorosamente consapevoli della (anomalia della) nostra risposta (al loro passato).

In *Life line* Amore s'interroga sulla qualità della memoria, sulla presa della memoria (su di noi) – portiamo con noi i ricordi di chi? – e sul rapporto tra la memoria e il compianto per qualcuno conosciuto soltanto attraverso una patria e una cultura perdute. La memoria, trasmessa e ritrasmessa di nuovo, è stata l'eredità di generazioni di italoamericani, ed

invero la memoria e le memorie (ridestate da) *Life line* tormentano la mia immaginazione, più o meno quanto il ricordo della casa della mia infanzia e delle case di altri immigrati, famiglie e amici, che conobbi da bambina, continuano ad ossessionarmi. Mentre scrivo, la mia storia personale continua a filtrare: attraverso *Life line*, sperimento di nuovo la mia stessa storia, la mia stessa eredità. Anch'io ricordo.

Nel mentre la visitatrice si muove attraverso le stanze e i sogni di *Life line*, sperimenta una realtà scambievole, cioè allo stesso tempo la storia specifica di Amore e una riflessione commovente sulle migrazioni – opera grande e disperata – che sono state un'esperienza che ha definito i contorni (della storia) degli Stati Uniti (nel ventesimo secolo)[4]. Come tale, essa mi ha fornito un modello di realizzazione visiva che ha un termine di riferimento autobiografico (italoamericano) così come un contesto storico e politico – arte nella sua dimensione più impegnata.

Life line è un memoriale alla ribellione di una donna, al desiderio di bellezza e di se stessi cucito nella biancheria. Questo memoriale ai gesti di libertà di Concetta e al costo di quei gesti, accennato dalla nonna, immaginato da sua nipote, è stato realizzato da un'artista, Amore. La nonna, la madre, la figlia, ciascuna è rivelata nel proprio coraggio, nei propri sogni e nella propria ambizione. L'arte della biancheria è rivelata nel suo significato – sia di capacità di resistenza che di ore senza fine di lavoro manuale (specificatamente femminile) – alle donne che sono state le sue creatrici, e alle loro discendenti di sesso femminile, le quali, potrebbero non aver appreso le necessarie abilità artigianali, ma hanno imparato il rispetto per il posto della biancheria nei rituali che creano identità e significato.[5]

Portiamo con noi le mamme e le nonne, le sorelle e le zie che non si sposarono mai, ardenti nella nostra psiche, trattenute da un cordone ombelicale, cucite al ricordo di un luogo. Dedicato ad una donna, questo filo della vita allargato alla memoria di lei diventa un omaggio a tutte le donne che sono state il filo della vita per le famiglie italiane e italoamericane.

[1]Questo saggio è dedicato a mia Madre, Marie Aida Silvestri Rando – Mary, che ha compiuto il viaggio della sua vita con grande amore e coraggio.

[2]Flavia Rando è una storica dell'arte che insegna Gender and Sexuality Studies nell'ambito del Women's Studies Program del Brooklyn College, City University of New York. Siciliana Americana di prima generazione, ha tenuto numerose conferenze e pubblicato ampiamente in materia di arte contemporanea e identità femminista, queer ed etnica. E' autrice, con Nancy Azara e Joanne Mattera, di *Italian American Women in the Visual Arts*, e di *Portfolio of Italian American Women Artists*, pubblicati in *Our Own Voices: Multidisciplinary Perspectives on Italian and Italian American Women*.

[3]Amore riferisce di aver letto questo nel testo di Michael Lamont, *Autobiografie italoamericane*, "Italian Americana Cultural and Historical Review", (ed Maria Parrino), University of Rhode Island, Feinstein College of Continuing Education, 2000, p. 50.

[4]Il riconoscere la collocazione geografica da cui parliamo è diventato sempre più delicato. Siamo ora cittadini di una nazione in guerra al fine di proteggere la nostra presunta insularità da ciò che è diventata la sofferenza quotidiana di tanta gente del mondo. Mentre sperimentiamo la crescente economia globalizzata e siamo testimoni degli sconvolgimenti e delle migrazioni di massa che hanno segnato il passaggio dal XIX al XX secolo, possiamo scorgere (quasi) uno specchio innalzato sulle migrazioni di massa che portarono così tanti italiani negli Stati Uniti, e rivisitare gli interrogativi relativi al trauma della loro frattura culturale ed emotiva.

[5]Intervistando le artiste italoamericane, sono stata sorpresa e commossa dalla loro acuta relazione personale con la *biancheria* delle loro madri e delle loro nonne, dal numero di donne a cui era stato insegnato a cucire, e dal numero di artiste che avevano trovato la loro prima identità professionale come costumiste, o artiste tessili. Sono rimasta commossa dalle artiste che riconoscevano alle loro madri l'importanza del lavoro di cucito, «Mia madre aveva sempre tra le mani un lavoro da portare a termine; mia madre aveva l'Alzheimer, passava e ripassava le mani sui tessuti che aveva amato per tutta la sua vita, e questo la rasserenava».

La memoria e l'arte della storia femminista in An Italian American Odyssey *di B. Amore**

Jennifer Mary Guglielmo[1]

An Italian American Odyssey di B. Amore è una risorsa preziosa. Testo diasporico, esso rappresenta uno dei raccordi culturali, familiari e psicologici che storicamente hanno collegato il sud d'Italia e l'America. Trascendendo confini geopolitici, Amore sapientemente sfida anche i parametri tradizionali di storia e autobiografia, resistendo a una narrativa unica, autoritaria ed evolutiva e disturbando la fantasia nazionale dell'assimilazione degli immigrati in una nazione che tutti include e tutti accoglie.

Incorporando ricerca d'archivio, storia orale, fotografie, oggetti degli antenati, lettere e diari di famiglia, questo testo è un collage, una composizione diversificata al suo interno. Amore intesse la propria memoria con le parole di sette generazioni delle sue due famiglie provenienti dall'Italia meridionale per dare un senso dell'identità non come qualcosa di stabile, immobile e discreto, ma come una cosa fratturata, controversa, e profondamente radicata nella storia della famiglia e della comunità. Il proposito di Amore è di sviluppare una narrativa che «funzioni da memoria collettiva», una narrativa che «diventi una sorta di terra natia». Questo le rende possibile scavare per portare alla luce le «domande senza risposta» dei suoi antenati, specialmente delle donne della sua famiglia, dal momento che è stata la loro «trasmissione profonda» a dar forma alla sua vita e alla sua arte.

Proprio perché è un assemblaggio di testo e immagini centrato sulla storia delle donne, la metodologia di Amore in quest'opera è sovversiva: lei penetra i silenzi e le assenze nella narrativa dominante per «decostruire la"verità"come io la conoscevo». Riconoscendo che la memoria «è soltanto un bagliore di luce su una superficie sfaccettata», lei esplora come il processo del ricordare svela «solo una"verità"molto parziale di un dato momento nel tempo, ma si tratta della "nostra verità" e rappresenta un Punto di Partenza». La sua narrativa è un «tessere costantemente, avanti e indietro, di strati di storie ricordate e registrate»; dando valore alla memoria collettiva e allo stesso tempo ai

documenti storici e incorporando entrambi, le voci, le esperienze, e le storie delle donne emergono in modo centrale. Come ci ricorda la regista Trinh T. Minh-ha, il raccontare storie è «la forma più antica per formare una coscienza storica in una comunità[...] e i primi archivi e le prime librerie nel mondo erano costituiti dalla memoria delle donne».[2] Il processo di recupero storico di Amore è radicato nella metodologia di sua nonna, Concettina De Iorio Piscopo, le cui storie per l'artista hanno costituito "il luogo d'inizio": «È stata lei che mi ha insegnato a bere dalla fontana della memoria». Nel fare ciò, Amore rende la memoria un nutrimento, e si unisce a teoriche femministe contemporanee come M. Jacqui Alexander per cui la memoria è «un antidoto contro l'alienazione, la separazione, e l'amnesia che la dominazione produce», un modo per scavare «il costo dell'oblio collettivo così in profondità da avere perfino dimenticato ciò che abbiamo dimenticato».[3]

An Italian American Odyssey recupera la memoria esplorando i silenzi nella storia, i saperi subordinati che gli immigrati italiani e i loro discendenti hanno sviluppato attraverso processi di lotta. «La mia ricerca all'interno della famiglia», scrive Amore, «aveva a che vedere tanto con ciò che non veniva detto, con ciò che non veniva divulgato, quanto con tutto ciò che veniva raccontato». Quest'attenzione all'interiorità della vita delle donne immigrate ripristina la loro umanità e differisce grandemente dall'icona dell'immigrata italiana che predomina nella cultura americana: soggetto stoico, senza nome, emblematico delle fotografie della fine del secolo di Lewis Hine o Jacob Riis, che ormai sono diventate dei classici, o di molte narrative storiche e cinematografiche. Il testo di Amore transcende queste immagini appiattite poiché le donne che lei presenta mettono direttamente in discussione l'idealizzazione patriarcale del silenzio femminile, della passività, della reticenza. L'artista fa tutto ciò raccogliendo e trascrivendo le parole delle sue antenate (della famiglia e della comunità) di decine di lettere, diari, e interviste, e ponendole in conversazione tra loro. In questo modo l'artista dimostra che la storia non è una singola narrativa ma una conversazione, o, come scrive la critica letteraria Laura Hyun Yi Kang, «una produzione discorsiva che illumina e occlude certi dettagli».

An Italian American Odyssey parla alla storia dal punto di vista profondamente personale ed emotivamente complesso del viaggio delle immigrate meridionali italiane e delle loro discendenti, al tempo in cui c'erano più italiani che vivevano in giro per il mondo che all'interno dei confini della nazione italiana. Rendendo questa esperienza umana, Amore mette i lettori in comunicazione con i molti sentimenti e le molte esperienze conflittuali che danno forma al dramma condiviso della migrazione di massa e del cambiamento culturale, costruendo allo stesso tempo un profondo collegamento tra passato e presente. Questo è il tipo di storia a cui aneliamo. Nei miei corsi all'università ho notato che alle mie studentesse la storia piace di più quando non gli viene presentata come una serie di date e di eventi che devono essere inseriti a forza nella memoria per poi essere rigurgitati al momento dell'esame, ma piuttosto come uno strumento di sopravvivenza, una risorsa piena di preziosi insegnamenti per il presente. La storia diventa più coinvolgente quando riconosciamo che è soggettiva, e che si interroga su questioni di potere. Come ha scritto una mia studentessa nel diario che scriviamo in classe:

La storia si rivela in questo modo quando studiamo la vita delle donne, specialmente delle donne di classe operaia, delle donne di colore, delle donne immigrate, donne che spesso non sono in documenti storici formali, le cui carte vengono raramente raccolte e preservate in biblioteche. Però queste sono le donne intorno alle quali molte di noi sono cresciute; queste donne siamo noi.

An Italian American Odyssey di B. Amore fa tutto ciò in un momento molto significativo – globalizzazione, migrazione di massa, movimenti per i diritti degli immigrati e comunità transnazionali stanno ancora una volta trasformando i paesaggi sociali, economici, culturali e politici in tutto il mondo. Questo testo ci offre una via d'accesso intima e creativa alla comprensione dell'impatto della ristrutturazione economica globale nella vita delle persone. È una storia di globalizzazione dal punto di vista di coloro che si trovano in fondo alla scala, lavoratori e lavoratrici sulle cui vite e sui cui corpi il capitalismo si è sviluppato ed è diventato un sistema mondiale all'inizio del ventesimo secolo. L'opera di Amore ci insegna i molti modi in cui gli immigrati stessi rispondono a esperienze di dislocazione, sfruttamento e alienazione ridefinendo i significati di casa, comunità e identità americana.

*La traduzione di questo saggio è di Caterina Romeo.

[1] Jennifer Mary Guglielmo è Assistant Professor di storia e studi americani a Smith College, in Massachusetts. È la co-curatrice di *Are Italians White? How Race Is Made in America* e al momento sta completando il suo libro, *Living the Revolution: Italian Women, Transnational Labor Radicalism and Working-Class Feminism in New York City, 1880-1945*, che ha ricevuto il Lerner-Scott Prize dalla Organization of American Historians per miglior tesi di dottorato in storia delle donne degli Stati Uniti.

[2] Il corrispondente testo inglese di questa citazione si trova in Trinh T. Minh-ha, *Woman, Native, Other: Writing Postcoloniality and Feminism*, Bloomington, University of Indiana Press, 1989, p. 148 e p. 121.

[3] Il corrispondente testo inglese di questa citazione si trova in M. Jacqui Alexander, *Pedagogies of Crossing: Meditations on Feminism, Sexual Politics, Memory, and the Sacred*, Durham, Duke University Press, 2005, p. 14.

SUPPLEMENTO

Bricolage Blues: frammenti per Life line – filo della vita e An Italian American Odyssey di B. Amore

Pellegrino D'Acierno[1]

Con questi frammenti ho puntellato le mie rovine.

—T.S. Eliot, *La terra desolata*

Glendower: Io posso evocare gli spiriti dal vasto abisso.

Hotspur: Lo posso fare anch'io, e lo può fare chiunque. Ma verranno poi quando li chiamate?

—Shakespeare, *Enrico IV, III*

Il *filo rosso*: un esercizio di memoria per *Life line*, esercizio di memoria esso stesso

Questi frammenti, scritti a partire dalla memoria e come *pro memoria*, sono il mio modo di rimanere aggrappato al *filo rosso/filo della vita* che B. Amore ha porto ai visitatori/viaggiatori transitati attraverso la sua meravigliosa mostra, *Life line - filo della vita: un'Odissea italoamericana 1901-2001*, nella sua finale sistemazione al Museo dell'Immigrazione di Ellis Island.

Quel piccolo *filo rosso/filo della vita* grezzo e logoro – che fiancheggiava i pannelli orizzontali sulle pareti e, malgrado alcune interruzioni, si apriva la strada come un nastro avvolto intorno ai muri delle sei sale dedicate all'esposizione, come una freccia direzionale o uno strano segno diacritico, guidava lo spettatore attraverso l'intricata costruzione

testuale – è a un tempo il singolare dono della mostra e la chiave per la sua interpretazione.

Come dono, il *filo rosso/filo della vita* esige dallo spettatore il controregalo della memoria: il rifiuto di lasciar andare quel filo e con esso il legame con la famiglia immigrata – la sua e la nostra – che esso conferisce. Come chiave interpretativa esso, richiede, inoltre una descrizione corposa come tutti gli altri oggetti – ordinari e straordinari, separati o assemblati – attraverso i quali B. Amore materializza la storia/la sua storia de"la famiglia" e narra la favola della sua identità di immigrata e post-immigrata.

Il *filo rosso*, allo stesso tempo vettore e filo di Arianna, apre la strada all'opera che racconta un tragitto, all'azione della memoria e al lavoro del raccontare che l'impianto espositivo impone al visitatore/ viaggiatore. Esso iscrive la metafora del viaggio all'interno della mostra ed è il viatico per quel viaggio. In esso si condensano tutti *i fili della vita* che transitano attraverso l'impianto:

- il *filo della memoria* che collega l'installazione e il suo visitatore alla scena primaria dell'emigrazione dall'Italia e ai *fili della vita* originari – quei gomitoli di refe e il rituale dei fili attraverso i quali gli immigrati, al loro sbarco da Napoli, mettevano in scena l'addio alla loro patria e ai loro cari rimasti a terra;

- il *filo della storia/filo della narrazione* che, come esposto nel "memoir visivo" di B. Amore, il visitatore deve seguire per comprendere la narrazione personale della storia della famiglia di lei, nel suo dipanarsi attraverso sette generazioni di vita vissuta e all'interno del contesto della narrazione collettiva dell'immigrazione italoamericana e della storia post-migratoria. Il visitatore segue perciò una duplice storia/Storia nella storia, ad un tempo privata e pubblica, che, incastonata all'interno dell'impianto espositivo, contrappone il *filo del tempo* della biografia generazionale della famiglia al *filo del tempo* della storia sociale (le *Colonne di Storia*) e perciò costituisce la narrazione principale dell'immigrazione;

- la *linea del sangue* che corre attraverso la genealogia delle famiglie dei De Iorio e dei D'Amore esposta in *Life line* e con la quale il visitatore deve familiarizzare personificando la schematicità dell'albero

genealogico, per entrare in un rapporto "Io- Tu" con i personaggi dominanti sulla base dei loro ritratti individuali, costruiti da B. Amore a partire dalle loro immagini, dalle loro cose, dalle loro raccolte di oggetti;

- la *linea di passaggio* che si estende attraverso le sei sale dello spazio espositivo e reitera il percorso spaziale della storia dei De Iorio e dei D'Amore – da Lapío in provincia di Avellino a Napoli, il luogo della scena primaria dell'emigrazione dall'Italia, fino ad Ellis Island, il sito della scena primaria dell'immigrazione in America, a tutti i successivi passaggi della diaspora;

- i *fili del tempo/fili della memoria* che si trascina dietro ogni singolo oggetto, ogni immagine dell'opera di *bricolage* di B. Amore. É attraverso la loro risonanza che il visitatore apprende l'arte del ricordo, l'arte del rovistare.

La mostra/istallazione esigeva molto più della semplice meditazione e contemplazione richieste dalla tradizionale visita al museo; la sua complessa testualità imponeva un esercizio della memoria e un lavoro di "affiliazione" per traghettare l'osservatore dal suo status di visitatore a quello di membro de"la famiglia".

Queste ed altre invisibili o immaginarie linee di transito sono riassunte nella visibilità del *filo rosso*, che contiene le istruzioni per una lettura dell'impianto espositivo. Entro i confini di quest'ultimo, il *filo rosso* nella sua materialità adempie ad una gamma di funzioni specifiche. Collega le esposizioni di stoffa e i fagotti che commemorano il lavoro femminile – lavoro duro, anche quando assume le forme della delicatezza. Esso attiva il codice dei colori in funzione nell'impianto, fondendosi con l'inchiostro rosso dei Rotoli degli Antenati e facendo da contrappunto, ad esempio, alla calligrafia dorata sulle porte azzurre dei Trittici. Forse esso reca in sé un'allusione all'aneddoto di Concetta: «Il colore preferito di Concetta era il rosso, ma lei vestiva sempre di nero».

Il *filo rosso* può anche essere considerato come firma dell'artista stessa, un indice che lega fisicamente il corpo della scultrice ai corpi degli antenati ri-membrati e riuniti per tramite della mostra. In quanto intelaiatura ed espediente che fornisce la "battuta d'entrata", il filo rosso rappresenta l'elemento principale della costruzione, quello dove l'artista/narratrice in

maniera deittica, lascia il proprio segno sulla costruzione stessa e, per estensione, il contrassegno del luogo in cui scultrice e spettatore/passeggero vengono continuamente commentati e significati.

Per comprendere *Life line* è necessario cominciare e finire con il *filo rosso*, come hanno fatto gli antenati, un filo che dovremo interrogare ulteriormente nei frammenti conclusivi. Esso mette in luce il dilemma di questo visitatore che, una volta lasciata la mostra con un ricordo felice, tenta di recuperare attraverso la scrittura il "tempo ritrovato" nell'opera d'arte: come va ricordato l'evento messo in scena da e inciso all'interno dell'impianto multimediale da B. Amore quando quell'evento consiste nell'avvento della memoria stessa? Come va ricordata un'opera d'arte che, nell'assumere la forma di un esercizio di memoria, impegna i vivi nell'atto di ricordare i nomi e i volti dei morti? Se i segni materiali della memoria – interpretati alla lettera e avviluppati negli oggetti di famiglia e di uso quotidiano di B. Amore – sono segni di vita, quale risonanza, dunque, e quale plusvalore vengono attribuiti a quei segni di vita, nel collocarli all'interno di un'opera d'arte legata a un luogo specifico, nel quale essi divengono segni d'arte?

Di nuovo il *filo rosso / filo della vita*: un segno-della-memoria /segno-della-vita che colpisce i sensi e che è elevato a segno d'arte. Non importa quali paradossi tra memoria volontaria e involontaria esso riesca a mettere in moto, il *filo rosso* è il modo in cui B. Amore circoscrive un cerchio magico invitando gli spiriti degli antenati ad entrarvi così che possano parlare, mantenere in tal modo il colloquio con i loro discendenti, compreso il visitatore/estraneo, l'acquisizione più recente tra i membri della famiglia.

Di nuovo il *filo rosso* e la sua lezione storica: l'immigrazione può essere compresa soltanto ripercorrendo il cammino a ritroso.

Di nuovo il *filo rosso* e la sua lezione di scrittura: forse il solo modo di preservarlo e di seguirne le tracce è attraverso una scrittura frammentaria.

Dell'apprendere da B. Amore la (Contro)Storia o l'arte del rovistare

Basta con i monumenti…

—Friedrich Nietzsche, *Sull'utilità e il danno della storia per la vita.*

Secondo Jean Baudrillard, la memoria è una "funzione pericolosa", perché «conferisce significato in modo retrospettivo a ciò che non ne aveva alcuno», giacché «essa cancella in modo retrospettivo l'illusorietà interna agli eventi che era la loro originalità». Qui Baudrillard, in *Frammenti*, la terza delle quattro parti di *Cool Memories*, fa riferimento a quella forma di memoria che opera all'interno della coscienza storica, immortalando e reificando; quella che toglie agli eventi […] la loro enigmatica forza originale, «la loro forma ambigua e terrificante» (Baudrillard, 1997: 30).

Baudrillard ha ragione a muovere questa critica alla Storia degli storici la sua critica della storia monumentale segue la linea fissata da Nietzsche, col suo concetto di genealogia come analisi della discendenza, e reiterata da Foucault, che amplia il concetto nicciano di genealogia facendolo diventare "contro–memoria", «un uso della storia che tronca il collegamento con la memoria, col suo modello metafisico e antropologico, e costruisce una "contromemoria" – una trasformazione della storia in una forma totalmente differente di tempo» (Foucault, 1977: 160).

Tale attività del ricordare cozza contro la natura della storia normativa o canonica, concentrandosi sulle discontinuità e sul recupero di forme di "alterità", come la pazzia e la sessualità, che resistono all'iscrizione entro i confini della storiografia tradizionale. Sia Nietzsche che Foucault pongono l'accento sull'obiettivo genealogico di rintracciare la discendenza attraverso il corpo, di esporre «un corpo che ha subíto un totale "imprinting" da parte della storia», poiché il corpo, di solito tagliato fuori dalla storia dei grandi eventi, è il luogo dove egemonia e dominazione lasciano la loro impronta indelebile.

Queste critiche alla monumentalità e l'invocazione di una controstoria/contromemoria trovano i loro equivalenti in quello scetticismo e ambivalenza nei confronti del monumento pubblico caratteristici di alcuni elementi della cultura artistica ed architettonica del ventesimo secolo che, nelle loro opere di arte pubblica, resistono e contestano la tradizionale forma e funzione del monumento commemorativo, creando spesso ciò che James E. Young definisce «contro-monumenti» (Young 2003:240). Si può affermare che il Memoriale ai Veterani del Vietnam nel 1981 di Maya Lin segni in America l'inizio di una "cultura del memoriale" contemporanea culminata nella proposta del monumento ai caduti dell'11 Settembre, che ha provocato un furioso dibattito riportando all'attenzione intensificate, tutte le precedenti insoddisfazioni nei confronti del monumento pubblico, e che mette in discussione la capacità dell'architettura, compromessa dalle richieste politiche e immobiliari del tardo capitalismo, di realizzare un autentico lavoro del lutto.

A questo scopo, vale la pena ricordare *Il Vittoriano* (il Monumento a Vittorio Emanuele II, inaugurato a Roma nel 1911), uno dei memoriali più palesemente spettacolari e automagnificanti nella storia dell'architettura. Potrebbe essere considerato come il punto di partenza della cultura commemorativa del ventesimo secolo, anche se compendia la visione ottocentesca del monumento Quella follia post-*Risorgimentale* dall'aspetto di torta nuziale – monumento ad una nazione immaginaria e ad un gusto architettonico kitsch che l'avrebbe reso un vanto della politica della grandiosità fascista – sembrerebbe espressamente progettata per provocare il famoso commento di Nietzsche «Basta con i monumenti». Ma nel commemorare la poesia nazionalistica del Risorgimento e, nell'incorporare in seguito, la Tomba del Milite Ignoto (Prima Guerra Mondiale) essa ne dimentica l'aspetto prosaico che comprende, tra le altre cose, l'evento della Grande Emigrazione, il lato nascosto dell'Unificazione. L'inesistenza, in Italia, di un cospicuo monumento che ricordi la Grande Emigrazione indica che la scelta di non commemorare certi avvenimenti determina altresì la memoria collettiva di una nazione – la memoria collettiva dell'emigrazione migrò in terza classe verso l'America italiana – ed è toccato a B. Amore, il compito di far ricordare la Grande Immigrazione e i suoi successivi effetti generazionali,

quelli americani e quelli Italiani, in un modo miniaturizzato e intimo che resiste alle suggestioni monumentali.

Il fatto che B. Amore abbia creato un'opera d'arte specificamente localizzata, che realizza un rigoroso lavoro di ricerca della genealogia e della memoria e affronta i compiti della commemorazione e della filiazione/affiliazione propri della "storia minore" – la storia della famiglia – è un segno della sua capacità di resistere a certe tentazioni di fronte alle quali l'artista contemporaneo può facilmente soccombere. Dopo tutto, viviamo in un momento in cui «la memoria è diventata un best-seller in una società dei consumi» (Jacques Le Goff, 1992:95) e all'interno del «contesto di una cultura della memoria vorace e in continua espansione» (Andreas Huyssens, 1999:191), di cui lo stesso Museo dell'Immigrazione di Ellis Island potrebbe essere letto come un sintomo. In che modo allora l'artista contemporaneo, che opera all'interno della nostra confortevole area postmoderna fatta di ironia, nostalgia e assemblaggi retrò, può creare un monumento alla Grande Immigrazione e ai suoi effetti, senza scivolare nella storia magniloquente o, ancora peggio, nella sua parodia

E per parodia intendo quella forma postmoderna di immaginazione storica che trasforma gli eventi passati in spettacoli e attrazioni destinati ai turisti della memoria e quindi ad un consumo immediato. La banalità di una tale immaginazione riuscirebbe senz'altro a trasformare l'esperienza dell'immigrato in una ulteriore attrazione alla Disneyland – con un titolo alla David Hockney, del tipo: "Buona giornata, Signor e Signora Immigrati!" o a finire in TV in un "reality show" intitolato *Stiva*, che preveda un viaggio transatlantico di sei settimane in una copia esatta del bastimento *Regina d'Italia*. Eccomi qua, a raccontare facezie, naturalmente, ma è necessario collocare *Life line* entro il contesto culturale e artistico da cui emerge. Sí, «la memoria è diventata un best-seller» e, come corollario, l'arte postmoderna, avendo smarrito il suo tradizionale rapporto col tempo e con la memoria, fa ricorso al gesto compensatorio di una commemorazione in forme spettacolarizzate, introducendo, a livello formale, lo «shock dell'antico» come contrassegno della memoria – alla maniera del grattacielo in stile Chippendale di Philip Johnson (già quartier generale della AT&T) e dei cinque ordini di colonne nella Piazza d'Italia di Moore a New Orleans, tanto per far riferimento ad esempi più volte evocati.

Inutile dire che B. Amore lavora contro la tendenza alla spettacolarizzazione della cultura propria delle installazioni contemporanee. I suoi "spettacoli" sono domestici e miniaturizzati, se non addirittura dimessi, e *Life line* che incarna – ma non rimuove – la memoria, richiede momenti di attenzione pazienti e consapevoli, dal momento che questa mostra presenta la memoria per il tramite delle sue tracce invece che ricorrere allo shock. Da parte nostra, intenderla, richiede una pratica della memoria, dei suoi segni e delle sue tracce.

In *Life line* convergono e dialogano differenti atti di memoria: una memoria personale o individuale (aspetti psicologici), una memoria familiare e generazionale, una memoria sociale, e una memoria collettiva o culturale. Tutti questi registri della memoria vengono mediati dalla memoria narrativa che struttura il "memoir visivo" in una storia/ Storia personale, quella della famiglia DeIorio-D'Amore e, per estensione, in una storia/Storia della famiglia italoamericana e, in generale, della famiglia immigrata o etnica. Il dialogo tra storia pubblica e memoria personale è radicato all'interno stesso dell'impianto espositivo, nell'opposizione tra colonne verticali di Storia (dedicate alla storia sociale degli italoamericani in America), pannelli orizzontali e gli altri elementi dedicati ai membri della famiglia.

Per di più, *Life line*, in quanto opera d'arte specificamente localizzata, stabilisce un dialogo, per certi versi contraddittorio, con la vecchia stazione di arrivo dell'Immigrazione di Ellis Island e con la memoria culturale del trauma della Grande Immigrazione che si è cristallizzata intorno ad essa. Ma queste contraddizioni operano anche all'interno stesso del nuovo Museo dell'Immigrazione di Ellis Island (inaugurato nel 1990), che è adesso un sito commemorativo dell'immigrazione e quindi un luogo della memoria pubblica e collettiva, specialmente per quei discendenti dei tredici milioni di immigrati che attraversarono la "Porta d'Oro" ed entrarono nel Sogno Americano. Considerato il tono al vetriolo dell'attuale dibattito sulla nuova immigrazione, l'apertura della sua ideologia pro-immigrati lo contrassegna come un monumento al multiculturalismo politicamente corretto dell'ultima parte del ventesimo secolo. Il suo restauro, finanziato in parte dai discendenti dei primi venuti, ha prodotto un museo accogliente e stimolante all'interno dello spazio commemorativo che comprende, fra gli altri elementi, archivi di documenti ufficiali, esposizione di oggetti personali e oggetti ricordo di ogni genere e una banca della memoria attraverso cui i discendenti possono andare alla ricerca del proprio patrimonio ereditario. Essenziale per l'assemblaggio di questo archivio si è rivelato il programma del museo che ha esteso la richiesta di partecipazione all'intero paese:

Persone provenienti da tutto il Paese hanno rovistato tra le soffitte e gli sgabuzzini, cercando oggetti ricordo che raccontassero le storie delle loro famiglie del viaggio verso l'America, ed erano desiderose di condividere quelle storie con altri attraverso il museo. I loro contributi e le loro parole, incorporati nella mostra, forniscono identità individuali ad un argomento spesso discusso in termini di masse, ed impartiscono un senso della storia come esperienza umana
(Ivan Chermayeff, Fred Wasserman, Mary J. Shapiro, 1991).

Life line è molto in armonia con questo progetto e, in un certo senso, nasce proprio da questo. D'altro canto, la mostra si preoccupa degli effetti successivi dell'immigrazione, delle identità etniche e della diaspora che l'immigrazione ha prodotto e continua a produrre in coloro che sono generazionalmente lontani da essa. La mostra non commemora l'immigrazione in sé e per sé («la commemorazione è una forma attenuata di necrofilia», come sottolinea Baudrillard), tenta piuttosto – attraverso la memoria culturale e generazionale – di collegare l'evento passato dell'immigrazione al presente e al futuro. Al cuore di *Life line* c'è la ricerca dell'identità personale ed artistica. B. Amore è profondamente interessata alla vita della memoria, alla costruzione di un inventario dell'infinità di tracce che il procedere della storia ha depositato sui membri della sua famiglia e dentro di lei.

E qui emerge la questione della controstoria/contromemoria, giacché *Life line* va contro lo stereotipo di Ellis Island, quello della miseria degli sfiniti, dei poveri, degli sventurati che domina la nostra memoria culturale, mostrando la complessità e le contraddizioni della vita vissuta della sua famiglia. Così facendo, la mostra costruisce un'"altra" storia dell'immigrato condannato per definizione, alla condizione di essere costantemente altro. La sua controstoria si oppone alla storia ufficiale o monumentale della Grande Immigrazione che sembra congelata per sempre in una delle fotografie dignitose ma taciturne di Lewis Hine. *Life line* fa parlare quelle istantanee e le fa diventare un

album di famiglia. A differenza della contestata memoria pubblica del grande trauma dell'Olocausto e delle altre catastrofi che caratterizzano il ventesimo secolo, la Grande Immigrazione tende ad essere commemorata meccanicamente e accolta nel ricordo felice degli assimilati come un evento "naturale" per essere, di fatto, dimenticata. B. Amore, al contrario, si preoccupa di rintracciarne gli effetti susseguenti – le identità culturali e psichiche a cui da vita nelle generazioni successive – in modo da preservare la forza originale ed enigmatica dell'immigrazione in quanto "tempesta dell'anima" – evento ad un tempo traumatico e capace di emancipare.

Narrare l'esperienza dell'immigrazione dal punto di vista dell'immigrato e attraverso l'intervento di un narratore/narratrice, che è anche un testimone e un prodotto di quella esperienza, è intrinsecamente un atto di controstoria/contromemoria, nella misura in cui recupera il proprio "sé" perduto nella traduzione e compromesso dal processo di costruzione dell'alterità in atto nella cultura dominante – gli immigrati sono residui del processo storico e perciò "stranieri nei confronti di se stessi". In verità, il senso del proprio "sé" che si è fuso nel crogiolo è proprio ciò che ha bisogno di essere recuperato. Perciò, una narrazione dell'immigrazione che, senza alcuna condiscendenza, fornisce, ai suoi soggetti una genuina interiorità e descrive il loro combattuto senso di identità – la loro identità dialogica in contrasto con quella oppositiva di italo-americani sancita dal trattino – è necessariamente una controstoria, anche quando è pervasa, come nel caso di B. Amore, dalla pietas dei ricordi familiari e non esplicitamente caricata di intenzioni polemiche e critiche. Se Life line ha un intento polemico, esso sta nel rifiuto di costruire un altro monumento a quelli che si sono fatti colonizzare dal Sogno Americano: al contrario, essa rappresenta una parabola di acculturazione piuttosto che di assimilazione, giacché ciò che la famiglia De Iorio-D'Amore mantiene – e lascia in eredità – è la propria duplicità di italo americani. La mostra termina domandandosi se la generazione attuale continuerà a fare così e l'impianto espositivo in sé rappresenta una richiesta di responsabilità indirizzata alle future generazioni il compito di conservare un "sé" dialogico, un impegno ad Essere/Divenire Italiani nel contesto americano.

Un tale atto di memoria narrativa inserisce le storie individuali e familiari di coloro che, al di fuori dalla sfera personale o privata, non hanno una storia, nella narrazione dominante dell'immigrazione e del processo di assimilazione/acculturazione. Gli immigrati di prima e seconda generazione sono essenzialmente delle persone postume che rinviano la propria capacità di agire ai propri figli e nipoti. Sono precisamente questi sopravvissuti che tornano vivi ed entrano nelle loro "vite" attraverso la genealogia e la narrazione che B. Amore espone in Life line. Ma questi sopravvissuti posseggono anche loro una propria capacità d'azione – per quanto compromessa – che è radicata nella routine della vita quotidiana; possiedono una propria arte del vivere e personali drammaturgie del "sé" che hanno bisogno di essere strappate alla quotidianità. In verità, la straordinarietà della famiglia di B. Amore sta nel segreto della vita ordinaria, soprattutto all'interno della (stra-)ordinarietà degli oggetti familiari. Ella colloca la propria "piccola storia" sullo sfondo della Grande Storia dell'immigrazione e della storia egemonica dell'accesso al Sogno Americano sottesa alla Grande Storia. La narrazione genealogica dell'identità di B. Amore è una storia "minore" e "delle minoranze", anche se, a sua volta, racconta la storia generale della assimilazione/acculturazione all'interno della cultura comune.

Inoltre è una controstoria perché recupera il significato e l'originalità delle singole vite e di quei piccoli eventi che costituiscono la storia di una famiglia ed anche perché essa recupera forme di "alterità" che tendono a resistere al proprio inserimento all'interno della storia ufficiale:

- l'alterità di genere delle donne, che sono la linfa vitale di Life line e il cui duro lavoro, sia all'interno che all'esterno delle pareti domestiche, la cui volontà di preservare – e la pulsione per l'arte – sono i suoi temi dominanti;

- l'alterità di classe degli immigrati – la storia dell'immigrazione è necessariamente scritta dal basso e dalla prospettiva degli operai e degli umili – ma, come vedremo, una divisione di classe corre all'interno della storia della famiglia;

- l'alterità degli oggetti e della cultura materiale nell'atto in cui gravano sul corpo, sulla memoria, sull'interiorità.

La menzione degli oggetti ci conduce alla dimensione formale dell'impianto, che trasforma i manufatti artigianali e le reliquie in

oggetti d'arte, le cui implicazioni verranno trattate più tardi. Ma ciò che è importante sottolineare qui e che *Life line*, anche se può confermare la narrazione dominante dell'immigrazione, si contrappone anche a tale narrazione fornendo un'interiorità ai propri soggetti e incapsulando all'interno della sua testualità una ricerca della memoria – privata e pubblica, personale e collettiva – che rimane provvisoria, una memoria in via di formazione. In questo senso *Life line* provoca la memoria e la ricerca dell'identità attraverso la memoria.

La costruzione di *Life line* comincia con l'attività materiale del rovistare tra il patrimonio di oggetti e reliquie accumulati nel corso di sette generazioni di vita familiare. Mentre procede all'organizzazione e all'allestimento di questi oggetti in un impianto espositivo, B. Amore eleva l'atto umile e pratico del rovistare ad una forma d'arte, finendo con il riassemblare e collocare gli oggetti rintracciati rovistando secondo l'estetica del *bricolage*, le cui implicazioni saranno discusse più avanti. A differenza delle «cool memories», le "memorie raffreddate" di Baudrillard, le sue sono ancora brucianti, e da buona rovistatrice la sua passione per la raccolta di oggetti «confina con il caos dei ricordi» (Benjamin, 1969:60). Quegli oggetti ereditati e i documenti/ricordi, i tesori e i detriti di sette generazioni di vita quotidiana, mediano il suo rapporto con la famiglia. Dal disordine del loro accumulo e dalla casualità del loro essere sopravvissuti, B. Amore ricava con difficoltà un ordine genealogico, ri-narrativizza la storia personale in nome del "Dio delle piccole cose".

La storia privata della sua famiglia, esposta nello spazio pubblico della mostra, reca inscritta al proprio interno l'autobiografia e la genesi dell'artista stessa. E questa è la chiave di accesso alla mostra: il ruolo dell'artista-agente, che B. Amore assume formalmente, è stato preparato per lei da quegli antenati che, come "artisti della memoria", hanno conservato il *Libro di Memorie* iniziato dal trisavolo e, come artisti del quotidiano, hanno esercitato la loro capacità di azione raccogliendo e costruendo oggetti. All'interno di *Life line* c'è una genealogia di quattro donne artiste: la bisnonna Giovannina, autrice dello squisito copriletto a punto filet e delle lenzuola della dote; la nonna Concettina, la cucitrice; la madre Nina, la stilista professionale; la figlia B. Amore, l'artista. Cosi come gli oggetti, a B. Amore sono stati tramandati il ruolo dell'artista e il gusto del collezionare/rovistare.

Amore è costantemente alla ricerca soprattutto di quegli oggetti del patrimonio di famiglia e di quelle storie trasmesse oralmente che hanno la forza degli aneddoti. Rovistare è la forma appropriata di una controstoria, dal momento che seleziona gli oggetti sulla base del loro potere di aneddoti, piccolo ma incisivo, *Life line* è un invito a rovistare rivolto alla memoria.

Le scatole della memoria e le Lacrimae Rerum ivi contenute

Sunt lacrimae rerum et mentem mortalia tangunt

—Virgilio, *Eneide*

Dove troverà la sua sede definitiva la mostra/installazione di B. Amore? O forse il suo destino più adeguato è quello di rimanere una mostra itinerante, adempiendo in tal modo alla legge dell'odissea, uno dei suoi tropi principali? Queste sono le domande poste dalle pagine del libro *An Italian American Odyssey* – il libro di un'artista, per essere precisi – che ora "ospita" *Life line* dopo i suoi vari spostamenti da Ellis Island verso altre sedi. Attraverso la sua collocazione "permanente" all'interno del libro, la mostra prende formalmente posto nel "museo senza mura". Ma le questioni relative alla sua definitiva, concreta collocazione ad Ellis Island – questo luogo compiuto della memoria degli immigrati – e nello spazio istituzionale del Museo dell'Immigrazione a Ellis Island rimangono tuttora pressanti. Ma, esiste poi davvero uno spazio adeguato per *Life line*? E' più consona a un museo etnografico o a un museo d'arte? Il suo status di testo culturale italoamericano lo candida per una sua collocazione in un museo dedicato all'esperienza italoamericana o, piuttosto, in quanto testo universale dell'immigrazione/etnicità, sarebbe meglio collocato in un contesto multiculturale? Forse che la sua perpetua oscillazione tra mostra e impianto espositivo, tra raccolta d'oggetti/ miniera d'informazioni e opera di *bricolage* lo destina al museo immaginario dedicato alle eterotopie e agli ibridi pericolosi?

Fosse stato possibile, la mostra *Life line* sarebbe dovuta rimanere, permanentemente all'interno dello spazio occupato ad Ellis Island, poiché là aveva il massimo della risonanza sia come installazione che

come opera d'arte legata a un sito specifico. Là manteneva un dialogo complesso e contraddittorio con "l'Isola della Speranza, l'Isola delle Lacrime," il posto dell'arrivo e della partenza degli immigrati. Là, nell'edificio che più di ogni altro in America, ha forma di palinsesto, un luogo invaso dai fantasmi di innumerevoli corpi stranieri che ora si fanno strada a gomitate per conquistarsi uno spazio tra quei turisti della memoria i quali cercano di invocarli per guadagnarsi l'accesso alla propria eredità, la mostra aveva l'effetto di un rito di transito. Là, il suo itinerario attraverso sei sale rispecchiava ed evidenziava il percorso di un pellegrinaggio più ampio che gli odierni visitatori del Museo dell'Immigrazione di Ellis Island sono chiamati a fare mentre seguono le orme degli immigrati. Là, la sua iconografia, derivata in parte dagli stessi elementi presenti ad Ellis Island – le strutture dei tubi rossi dei Rotoli degli Antenati che alludevano alle cuccette dei dormitori, la Porta d'Oro, le Colonne di Storia, ispirate ai graffiti degli immigrati, sui muri, e così via – riceveva la sua massima forza. Là, il suo *bricolage* idiosincraticamente ed esteticamente (dis)ordinato di cose personali, di oggetti ricordo e fotografie dialogava con la collezione metodicamente ordinata di oggetti similari catalogati nelle mostre permanenti e negli archivi.

D'altro canto *Life line* è un'opera d'arte e non una mostra storica o etnografica, nonostante essa si discosti in maniera provocatoria da queste forme di esposizione da archivio e dal suo stesso spazio espositivo. Nella sua funzione di mostra museale, l'installazione, non è interessata principalmente alla forza documentaria degli oggetti, delle immagini, fotografie e altri "esemplari". La collocazione di oggetti e reliquie è guidata da un intento classificatorio personale ed artistico che intende evocare e commemorare l'immaginario degli immigrati. La mostra non ha nemmeno intenzione di fissare questi oggetti domestici e di famiglia in una stretta sequenza diacronica che, secondo i dettami museali, «attribuisce ad ogni singolo articolo una direzione e un peso in senso evolutivo» (Preziosi, 2003:408). Come Preziosi procede a sottolineare, «il passaggio attraverso lo spazio museale è generalmente strutturato come la simulazione di un viaggio attraverso il tempo storico». Sebbene *Life line* giochi con questa convenzione, l'organizzazione della sequenza espositiva è artistica e drammaturgica – non museale – e appartiene alla categoria del "memoir visivo" e della *mise-en-scène*. La sua attenzione si concentra sui singoli personaggi e sulle loro drammaturgie di ricerca della propria identità; sul modo in cui hanno raccolto o creato oggetti per costruire un senso del proprio sé. Le collocazioni di oggetti e immagini da parte di B. Amore rappresentano altrettanti ritratti di famiglia sotto la forma di tangibili mappe personali: biografie spaziali in forma di "autotopografie", per usare una formulazione di J. Gonzalez. E' per questo che il "lavoro del transito" imposto da *Life line* è insieme temporale e spaziale.

Life line ha trasformato le stanze in cui venivano "smistati" gli immigrati e i dormitori dello stazionamento di Ellis Island in una "scatola della memoria" – una sorta di macchina del tempo eccentrica e interattiva del passato/presente – ampliando in questo modo all'intero spazio espositivo le strategie della preservazione e del *bricolage* della memoria in atto nelle piccole "scatole della memoria" (i trittici familiari). Di fatto, B. Amore colloca il problema dell'immigrato o dello straniero all'interno dello spazio espositivo. Parlo di problema perché insieme agli appagamenti *Life line* mostra le manzanze e i disagi, dell'identità dell'immigrato e del sé diasporico che esso genera. Collocando in tal modo il problema dell'immigrazione e la politica culturale dell'identità dell'immigrato, la mostra "sollecitava" – nel senso etimologico di "scuotere" – l'edificio principale di Ellis Island, il cui simbolismo architettonico – accogliente facciata/fabbrica dell'immigrazione – è stato sempre gravido di contraddizioni. Come sottolinea la AIA Guide to New York City (Guida AIA alla Città di New York) «questa stravagante, eclettica struttura ricettiva fu creata per dare il benvenuto (o forse per vagliare?) le orde di immigrati europei che arrivavano tra la fine del XIX e l'inizio del XX secolo». In altre parole, quello spazio ufficiale e burocratico fu progettato per valutare, detenere, o rigettare, e quindi per reificare, quei corpi estranei che aspiravano ad entrare nella Terra delle Opportunità.

La "sollecitazione" viene operata attraverso l'appropriazione e la territorializzazione dello spazio panottico della vecchia Ellis Island in nome degli immigrati. Sebbene *Life line* sia stata concepita per essere letta in modo non ironico, come commemorazione dell'esperienza di Ellis Island –"Isola delle Lacrime", prima e più drammatica sosta fra le Stazioni della Croce dell'Immigrazione – essa ha anche operato, di fatto, un *détournement* (deviazione, sconvolgimento radicale), come direbbero i Situazionisti, sul preesistente spazio burocratico che,

malgrado il restauro, ancora incombe sull'edificio, installando all'interno di quello spazio un testo artistico e culturale che fornisce all'immigrato quella stessa interiorità e autonomia che nel passato venivano formalmente ispezionate al portone d'ingresso.

Nella Zona della collezione: "lavoro di transito"/opera di storia

In un bel brano, Eugénie Lemoine-Luccioni scrive dell' "intimo legame tra le donne e i loro oggetti". Senza oggetti le donne sono perdute. I loro oggetti abitano un'interiorità…

—Massimo Cacciari, *Sopravvissuti*

Guidato dal filo rosso, lo spettatore/viandante segue la storia mentre questa si dipana attraverso la sequenza delle sei stanze: Stanza dei sogni, La prima generazione, Diventando americani, La famiglia e il lavoro, Ritorno alle radici, Oggi e Domani. Come scrive Roland Barthes, «comprendere una narrazione, non significa comunque, seguire soltanto lo svolgersi della storia, vuol dire anche riconoscerne la costruzione in "piani", proiettare le concatenazioni orizzontali del "filo" narrativo in un asse implicitamente verticale» (Barthes, 1977:87). Nella narrazione visiva di *Life line*, il livello orizzontale si concretizza nella fascia laterale di pannelli dedicata ai singoli membri della famiglia e ai rotoli degli antenati. Sebbene le Colonne di Storia appartengano anch'esse al livello orizzontale, la loro verticalità le fa funzionare come impalcature attraverso cui un visitatore passa dalla storia della famiglia al livello, o "piano", della storia sociale. La storia della famiglia è intricata, dato che coinvolge circa trentacinque personaggi, di cui alcuni principali che funzionano da punti-cardine. Ciò che passa sul livello verticale sono i tratti dei carattere dei singoli membri della famiglia pazientemente ricostruiti attraverso le loro fotografie, gli oggetti e gli aneddoti scritti a loro dedicati.

Fin qui, ho appena cominciato a spiegare la "lettura" o opera-di-storia che il visitatore è chiamato a fare. Egualmente importante è il "lavoro del transito" – la ri-attuazione della narrazione attraverso il corpo e la performance della sua storia spaziale. Questa ha due itinerari o copioni

che si sovrappongono, contendendosi il sito di Ellis Island. Il primo comporta una interpretazione in senso letterale della metafora di Ellis Island in quanto Cattedrale dell'Immigrazione. L'impianto è strutturato in termini liturgici per mezzo dei quali le vite ordinarie dei membri della famiglia vengono sacralizzate e racchiuse in reliquiari. Le forme tradizionali di devozione e gli elementi architettonici della Chiesa cattolica confutano lo spazio museale o secolare: i trittici (altarini con ante laterali), i reliquiari, le icone dei "santi" di famiglia (rotoli degli antenati), lo specchio (lo specchio della salvezza), i pannelli laterali che suggeriscono le stazioni della via crucis o anche i pannelli affrescati, le colonne verticali, analoghe allo specchio della storia, e l'altare principale che conclude l'impianto espositivo. Il risultato è una versione multimediale da immigrati della *Biblia Pauperum*, con un "Vecchio Testamento" ambientato in Italia e gli eventi di un "Nuovo Testamento" collocati in America. L'effetto di questa liturgia di famiglia è quello di sacralizzare le vite comuni e gli oggetti ordinari e di conferire ad essi una risonanza più elevata. Per quanto approssimative possano essere le corrispondenze di cui sopra, la strutturazione liturgica richiede l'espressione della narrazione in termini di linguaggio corporeo e di strutture del ricordo intesa come fondamentale attività religiosa.

La seconda storia spaziale sfida i riferimenti a Ellis Island come Palazzo della Memoria che "ospita" la memoria collettiva della Grande Immigrazione. Essa comporta la trasformazione di stanze destinate ad un uso pubblico e amministrativo in spazi abitativi, luoghi di residenza o, per essere esatti, in una zona di collezione. E come zona di collezione, intendo uno spazio femminilizzato all'interno della casa, un interno entro i confini dell'interno dove gli oggetti sono costretti a rimanere. Un'area così segreta e intima induce ad un sogno ad occhi aperti. Per quanto la sequenza dell'istallazione lungo le sei stanze possa simulare un passaggio attraverso il tempo storico, essa segna anche i confini della memoria personale e domestica che è ancorata alla interiorità delle sale. In altre parole, l'originaria funzione burocratica e "carceraria" dei dormitori e la loro attuale funzione pubblica di gallerie per mostre itineranti vengono trasformate, con tecnica teatrale, in scene e ambientazioni della domus. Per usare una terminologia italiana, il Palazzo viene trasformato in una Casa,

l'esibizione museale in uno spazio di raccolta, una zona dove oggetti aneddotici raccontano le loro storie, in modo particolare quelle storie in cui le donne esprimono il loro intimo legame con le cose.

Per questo, *Life line* unisce i due spazi principali dell'abitazione italoamericana, la domus e la chiesa, una mescolanza che spesso si realizzava all'interno della stessa casa degli italoamericani con l'introduzione di icone e altarini improvvisati. B. Amore, ha addomesticato e femminilizzato il vuoto dei sei stanzoni bianchi e i mini-vuoti degli sgabuzzini, riempiendoli con oggetti domestici e familiari di ogni sorta – e per di più, tutti oggetti connessi con lo "stare-al-mondo" delle donne. Così come l'intero spazio espositivo è stato trasformato in una scatola della memoria, ogni singola sala della mostra è divenuta una scatola della memoria. E cos'è una casa se non una scatola della memoria? E quale miglior modo di re-territorializzare Ellis Island – "l'Isola delle Lacrime", la camera di compensazione per memorie dichiarate e sogni ufficiali – che inscenarvi un ritorno a casa, installarvi uno spazio della memoria che ri-membri la domus e la chiesa, i due spazi primari dell'immaginario italoamericano?

L'immigrazione crea dei buoni *bricoleur*: il *bricolage* come attività di ogni giorno / il bricolage come opera d'arte

Dacci quest'oggi i nostri avanzi e rimasugli quotidiani
e facci fare di necessità virtù

—"*Bricolage* Blues"

Secondo Walter Benjamin, l'esilio aguzza le capacità dialettiche. L'immigrazione – un esilio perseguito con altri mezzi – crea dei bravi *bricoleur*. Immigrati e stranieri costruiscono le loro vite quotidiane e le loro identità culturali usando tutti i materiali disponibili. Per loro il *bricolage* è una concreta tecnica di sopravvivenza, una tattica per fare ciò che va fatto, per ricavare il massimo a partire dal minimo, una inclinazione che si esercita nell'acquisizione e nell'impiego di quegli oggetti – raccolti, passati di mano in mano, esplorati, riciclati, perduti e ritrovati – con i quali essi accomodano le proprie esistenze ed equipaggiano le loro residenze

terrene. Mi riferisco agli immigrati vecchio-stile, come quelli rappresentati in *Life line* , che si definivano in termini di tattiche di sopravvivenza – ciò che gli italiani chiamano l'arte dell'arrangiarsi. Tali immigrati sono dei *bricoleur* per necessità e per carenza.

Dacci oggi il nostro duro lavoro quotidiano che nessun altro vorrebbe
fare e il pane e il vino frutto di una fatica spossante

Gli immigrati vecchio-stile vengono abitualmente definiti in termini di lavoro e del valore che essi vi conferiscono. Ma forse andrebbero meglio descritti come bricoleur, giacchè la forma del loro lavoro– lavoretti occasionali, lavoro a cottimo, lavoro giornaliero o stagionale dove il licenziamento è parte integrante dell'attività – è anch'esso un lavoro improvvisato. Persino i tipici mestieri destinati ai vecchi immigrati – lo straccivendolo, il rigattiere, il raccoglitore di metallo riciclabile, il ciabattino – suggeriscono l'idea del *bricoleur* e del rovistatore.

È, naturalmente, Levi-Strauss che, ne *Il pensiero selvaggio* conferisce dignità alle attività del *bricoleur* – l'uomo fai-da-te, tuttofare, o riparatore professionale – tanto per suggerire degli equivalenti imprecisi del termine francese. Egli avvalora il tipo di (ri-)costruzioni o produzioni arraffazzonate e improvvisate che il bricoleur crea adoperandosi con qualsiasi cosa abbia sotto mano, e cioè con un insieme di materiali comuni, arnesi e tecniche e impiegando «mezzi contorti in confronto a quelli dell'artigiano». Levi Strauss ha elevato le attività del *bricoleur* mettendole a confronto con quelle dell' ingegnere e reputando il pensiero mitico come una forma di «*bricolage* intellettuale», cioè, a suo modo, un pensiero rigoroso tanto quanto il pensiero scientifico, sebbene operi in maniera completamente diversa. Per il momento, intendo dar corpo al concetto di *bricolage*, leggendolo come quella consuetudine o inclinazione che caratterizza il modo dell'immigrato di essere ed operare nel mondo e come un mezzo per costruirsi un'identità o una visione del mondo.

Dacci oggi i nostri frammenti quotidiani, e i ritagli e i cocci
e il lavoro del vivere che li ha assemblati in una concezione del mondo.

Il destino dell'immigrato è di costruire o improvvisare un'identità culturale con ciò che si trova a disposizione: i pezzi della cultura originale che sopravvivono al passaggio nella nuova patria sia nella

forma concreta di oggetti specifici che nella forma sociale e simbolica di pratiche, lingua, memorie, miti, storie; gli avanzi – di solito definiti dall'appartenenza di classe – e gli oggetti di seconda mano, le pratiche, le concezioni della nuova cultura depositate e svendute nei grandi negozi dell'usato degli immigrati, le cose perdute e ritrovate fra le quali trovavano posto elementi di scarto dalla cultura dominante. Il *bricolage* degli immigrati va distinto dalla forma corrente di *bricolage* praticato da quelle sottoculture, come il movimento punk, che si appropriano di oggetti della cultura dominante e li riutilizzano in modi sovversivi al fine di creare nuove identità culturali, come, ad esempio, la spilla da balia che la cultura punk ricicla a scopi decorativi. Il *bricolage* degli immigrati è una tecnica di sopravvivenza – una "estetica" della sopravvivenza – ed essa informa la concezione del mondo dell'immigrato, presa in prestito dalle concezioni del mondo prodotte dalla classe dominante. La visione del mondo dell'immigrato è un ricucire nel nome del comune buonsenso, le vestigia di quelle precedenti concezioni del mondo generate dai gruppi dominanti, quelli che scrivono la propria storia. Le strategie appartengono alla classe dominante; gli immigrati, invece, agiscono per tattiche – da qui, l'importanza del *bricolage*, tattica delle tattiche.

Dacci oggi il nostro bricolage quotidiano

E' perciò altamente significativo che in *Life line* B. Amore, che è principalmente una scultrice e perciò un "ingegnere", nel senso di Lévi-Strauss, operi come una bricoleur, elevando il *bricolage* la pratica-di-vita dell'immigrato, a pratica-d'arte. Sebbene *Life line* sia anche una costruzione ingegneristica (per la sua strutturazione in forma di narrazione visiva, per l'ordine di concatenazione), essa è assemblata con la tecnica del *bricolage*, è governata dall'estetica tattica e improvvisata del *bricolage*. Suoi materiali di base sono gli avanzi e le reliquie della vita familiare, che si presentano all'artista come oggetti già pronti per essere assemblati e combinati e attraverso i quali l'artista mantiene un dialogo con i materiali a disposizione. Ma lo stesso principio del *bricolage* guida altresì la gamma delle tecniche disponibili –"collage", montaggio e fotomontaggio, assemblaggio, l'impossessarsi di materiali e tecniche altrui, e così via – che giungono all'artista come residui del modernismo o mediate dall'appropriazione e dal riciclaggio post-modernista.

Lévi-Strauss ha fatto un elenco di opere d'arte di *bricolage*:

> *Come il bricolage sul piano tecnico, il riflesso dell'elemento mitico può raggiungere risultati brillanti e imprevisti sul piano intellettuale., L'attenzione è stata spesso attirata, invece, verso la natura mitologico-poetica del bricolage, sul piano della cosiddetta arte "povera" o "naïf".*

> *Nelle follie architettoniche come la villa di Cheval, "le facteur" o gli apparati scenici di George Méliès, o, ancora, nel caso immortalato da Charles Dickens in* Grandi speranze *ma senza dubbio originariamente ispirato dall'osservazione del "castello" suburbano di Mr. Wemmick col suo ponte levatoio in miniatura, il cannone che spara alle nove del mattino, l'aiuola di insalata e cetrioli, grazie alla quale i suoi abitanti avrebbero potuto resistere ad un assedio, se necessario…*

> —Claude Lévi-Strauss, *Il pensiero selvaggio*[17]

Life line appartiene a questo elenco, sebbene non sia un'opera di arte "povera" o "naïf" e, manchi, d'altra parte, del carattere bizzarro e dell'effetto chincaglieria di alcuni degli esempi fatti. Ciò che è importante è che B. Amore comincia con il repertorio eterogeneo ma limitato di oggetti e tecniche a sua disposizione, per poi sistemarli o montarli insieme con un'azione di *bricolage* per mezzo della quale essi assumono una nuova vita e un nuovo significato. Gli oggetti – scampoli e residui degli avvenimenti - che significavano vita vissuta, vengono trasformati in significanti d'arte e per questo il loro ordinamento e ri-ordinamento diventa una ricerca per trovare un significato al loro interno. Come afferma Lévi-Strauss, il bricoleur «"parla" non soltanto con gli oggetti, ma anche per mezzo degli oggetti, facendo un resoconto della sua personalità e della sua vita operando una scelta fra un numero limitato di possibilità […] [lei] mette sempre qualcosa di sé nell'opera» (Lévi-Strauss, 1966: 21). Queste "possibilità limitate", una maledizione secondo Sartre e il suo concetto di libertà, sono esattamente i vincoli di coloro che si definiscono attraverso la famiglia e l'arte della famiglia.

"Das Kabinett des Dottor Amore": la risonanza e lo splendore degli oggetti comuni o, la dote di Concettina / la dote dell'artista

La casa era piena delle collezioni di Concettina [...] Alcuni oggetti erano stati portati dall'Italia, altri lei li aveva creati o acquistati in America. Concettina conservava una varietà di cose, da un elegante colletto di seta e merletto fato a mano, alle comuni bottigliette della sua acqua di colonia alle rose preferita. Attaccate ai suoi pacchetti e alle sue proprietà personali, ci sono ancora etichette e liste scritte a mano, sia in italiano che in inglese.

A volte le note sono semplicemente descrittive, a volte nominano il proprietario dell'oggetto o la sua storia e l'importanza che avevano per lei.

—B. Amore

Life line è piena di armadi –liberi oppure incassati (come l'installazione dei quattro guardaroba), racchiusi da una vetrinetta o in guisa di scatola (i trittici). Mentre i trittici o le scatole della memoria riassumono la storia della famiglia in forma miniaturizzata e servono come strutture riflettenti e di collegamento all'interno delle sei sale espositive, i reliquiari hanno l'aspetto di teche da collezione, che evocano l'interiorità della casa o quantomeno una contaminazione tra gli interni della domus e della chiesa.

Dei tre reliquiari più interessanti, Reliquiario per un cuore spezzato, Il reliquiario d'oro e Reliquiario per i due Antonii, i primi due, entrambi dedicati a Concettina, sono in effetti armadietti da collezione. Come gli oggetti intimi esposti nelle teche da collezione, gli oggetti di famiglia di Concettina, per quanto curiosi e inconsueti in virtù della loro ordinarietà, evocano fantasticherie di intimità declinate dal gioco tra trasparenza e segretezza proprio della teca. L'oggetto più singolare e prezioso contenuto in questi reliquiari e forse nell'intera mostra, è il colletto di seta con nappine di Concettina, *una pièce de résistance* lei stessa. (I cimeli di famiglia più importanti non sono stati esposti per ragioni di sicurezza). Intorno al collare di seta si cristallizza il sogno della stoffa e della manifattura, costantemente attivato dalle scene di cucito e dai fagotti di stoffa che celebrano il lavoro/arte delle donne. Questi due reliquiari sono il fulcro dello spazio femminilizzato, la zona

della collezione che percorre l'impianto espositivo e culmina con La tavola della Nonna, il "pezzo" conclusivo della mostra. Sono esempi chiave di quelle che si potrebbero definire le scene madri (l'equivalente italiano di ciò che viene indicato in inglese come "big scene") che dominano l'impianto.

Essi proclamano l'importanza di Concetta De Iorio-Piscopo, che è il fantasma dai tratti delicati nell'armadietto di B. Amore. Lei è la prima e la più appassionata fra le collezioniste nel solco che conduce attraverso Nina fino a B. Amore. Nel raccogliere, creare e tramandare, oggetti, questa genealogia di collezioniste assume la funzione femminile della conservazione del ricordo. Sebbene Concetta sia una collezionista sfrenata, i suoi oggetti non sono scelti o assemblati secondo una legge di eccentricità o un desiderio feticistico come quelli che governano le raccolte delle vecchie *Wunderkammerer*. Il suo modello – pratico e domestico – è quello del corredo e la sua collezione, che comincia con gli oggetti ereditati dalla dote di sua madre, è quella di una donna seria. Gli oggetti della sua stessa dote – la vestaglia con le iniziali è quello più significativo– sono il centro della sua collezione. Sono i semi che generano la più ampia collezione che comprende il suo lavoro di sarta e stilista professionale – il prezioso abito da sposa fatto per essere tramandato a Nina secondo la tipica abitudine italiana – e il vasto assortimento di oggetti e di documenti pertinenti alla sua vita personale, alla sua carriera scolastica e, soprattutto, al suo matrimonio fallito. Ci sono davvero pochissime cianfrusaglie nella collezione. L'unico oggetto kitsch che ricordo è una bamboletta di celluloide da lunapark. La competenza di Concettina è quella del bricoleur. È il corredo arricchito da Nina e dagli altri componenti della famiglia, che alla fine viene trasmesso a B. Amore, divenendo la dote di un'artista. Ogni cosa esisteva, per così dire, al fine di trovare il suo sbocco in *Life line*.

Life line narra il romanzo della famiglia italoamericana, confermando la sua legge fondamentale: la felicità degli italiani è una felicità di famiglia. D'altra parte, essa dà particolare peso alla genealogia di donne forti e alle "scene madri" che rappresentano le loro identità e ritraggono le loro vite interiori attraverso gli oggetti che esse hanno creato e raccolto e che, a loro volta, sono stati creati e "raccolti". Il ruolo degli uomini, che si definiscono principalmente attraverso il lavoro

manuale, è anch'esso essenziale, ma si dimostra problematico in due casi. Le immagini dei nonni di B. Amore – Ernesto Piscopo e Antonio D'Amore – presentano le mancanze nella storia della famiglia. Che le "scene padri" non siano altrettanto elaborate e concretate delle "scene madri" è un segno del silenzio o della distanza dei padri le cui vite sono sacrificate al lavoro. E' attraverso di essi che gli elementi edipici del romanzo di famiglia vengono fatti filtrare.

Life line comincia con il buon patriarca, il gentiluomo Don Lorenzo De Iorio (trisavolo nel ramo materno della famiglia) che rimasto in Italia fu testimone del Risorgimento che avrebbe, paradossalmente, generato il grande esodo dal Mezzogiorno. Don Lorenzo conservò il *Libro di Memorie* e non senza una certa arguzia, come dimostra il suo epitaffio in forma di motto di spirito che così conclude: «E altre notizie, forse per ridere – Addio». Egli è il primo custode dei ricordi di famiglia; ruolo che verrà trasmesso alle donne per realizzarsi infine in *Life line*. Suo figlio Luigi (bisnonno di B. Amore) è colui che va in America con la sua sposa. Ha un buon carattere, anche se enigmatico; attorno a lui si addensa un buon numero di misteri, compreso l'enigma del motivo della sua partenza dall'Italia. Ma così vanno le cose nella storia dell'immigrazione.

Il Reliquiario per i due Antonii è di tipo scultoreo la scatola levigata in cui è esposto non evoca in alcun modo la teca da collezione. Appare in lontananza là nella sua grezza materialità e nella sua astrusità giacomettiana: il piccone del manovale piomba sull'asse verticale della tinozza, rimandando al corpo del lavoratore oppresso dal peso mentale e fisico della fatica. Si tratta di feticismo proletario per il duro lavoro. Dov'è l'apparenza, dove lo spirito? Forse che anima e parvenza sono stati ricacciati nel corpo? Il suo è un silenzio che non suscita racconti. Gli aneddoti vengono dalla chiosa di B. Amore, che descrive Antonio D'Amore, per mestiere tagliapietre e muratore, che sembrava "un uomo molto meschino" e che inflisse un regime del terrore in famiglia col bastone della disciplina. Nel Rotolo dell'Antenato la sua immagine lo mostra con il braccio sinistro levato o in atto di colpire. Ma quel braccio impugna il piccone o il bastone? B. Amore racconta un episodio in cui lui respinge il tentativo di lei, che aveva solo quattro anni, di aiutarlo a costruire un muro di granito. Non a caso B. fa risalire a lui la sua arte di scultrice. Ma forse lui era un "Christ in Concrete",

imprigionato da una fatica opprimente e dalla responsabilità di una di quelle famiglie di immigrati eccessivamente numerose– tredici figli in totale, meno le consuete perdite per fatalità. Ciononostante, il taciturno Nonno Antonio che si riempiva denti col cemento, raccontava ai suoi figli che Dio esiste in tutte le religioni. E questo è un altro esempio che testimonia della molteplicità dei Sé che costituiscono l'identità umana.

Laddove Antonio rappresenta il silenzio all'interno di *Life line*, Ernesto, il marito di Concettina, è l'elemento che impedisce la narrazione. E' un mascalzone, un giocatore d'azzardo, il donnaiolo che spezza il cuore di Concettina, il cafone che non osserva le regole della serietà che governano la vita familiare. E' lui che minaccia di rompere il *filo della vita* e il suo procedere. Dove collocarlo nella genealogia che lui sfida? Nella famiglia degli immigrati, vi sono coloro che pagano il prezzo dell'assimilazione e della normalità del resto della famiglia con il proprio autodanneggiamento. Il ragazzino che muore di morte precoce ne è un esempio diretto. Ernesto è un esempio più complesso di tale figura. Chissà quante volte marinò la scuola e quante le avventure amorose in cui si cacciò facendosi chiamare Bill? Il suo comportamento spregiudicato víola l'ideale dell'immigrato dell'uomo di pazienza, impersonato da tutti gli altri uomini della famiglia. Concettina sa perfettamente come sistemarlo: «E' mia espressa intenzione che mio marito, Ernesto W. Piscopo, venga escluso dal condividere una qualsiasi parte del mio patrimonio».

Tracce: Concetta come detective e del visitatore che ricorda il corpo dell'immigrato per mezzo di segni indicizzanti

Abitare significa lasciare delle tracce.

—Walter Benjamin, *The Arcades Project*

Gli oggetti di Concettina non sono mai collezionati unicamente per per essere sfoggiati o per il loro valore feticistico in quanto beni. I suoi oggetti vengono raccolti o creati in base al loro immediato valore d'uso, alla loro potenzialità di essere riadoperati, come i vestiti smessi,

o al loro valore d'uso retrospettivo, in quanto oggetti della memoria. Ella è l'assoluto contrario dei due più noti collezionisti di oggetti più appariscenti del ventesimo secolo, Gabriele D'Annunzio e il Citizen Kane del cinema. La sua collezione non è neanche pervasa dal fervore patriottico e dal tipico gusto vedovile delle sue controparti italiane appartenenti alla stessa generazione – famose, nell'Italia degli anni Venti e Trenta del secolo scorso, per le loro collezioni di equipaggiamenti militari ed altri cimeli della I Guerra mondiale – le quali conservavano, in nome di una memoria collettiva nazionalistica, il ricordo delle vite dei mariti e degli altri membri della famiglia sacrificate in guerra. E' la poetica strumentale dell'oggetto di Concettina che B. Amore trasferisce e dilata nell'estetica del *bricolage* che governa *Life line*.

Di tutti gli oggetti della collezione di Concettina, quello più ricco di pathos è la lettera d'amore stracciata indirizzata da Ernesto ad una delle sue fiamme (esposta nel Reliquiario per un cuore spezzato). Ernesto, un collezionista incauto che lasciava ovunque i segni delle sue avventure, trasformò Concettina da collezionista in detective. Per determinare se la sua originaria inclinazione di collezionista si inasprisca in una determinazione all'accumulo come compensazione per l'autoallontanamento del marito, per la perdita del suo oggetto del desiderio, occorrerebbe la psicoanalisi. Ciò che è più interessante di questa lettera sottratta è il fatto di essere lacerata. Chi può sapere quante lacrime e maledizioni sono impresse su di essa? Le sue lacrime sono il lavoro fatto a mano di Concettina, il suo "altro" lavoro artigianale. Si tratta dell'oggetto indicizzante *par excellence*, un segno che ci lega direttamente al corpo che lo maneggiò e lo ridusse in pezzi. Strappi e lacrime sono ciò che la rende un significante sia di Concettina che di Ernesto che la scrisse.

Sebbene le costruzioni individuali in *Life line* possano privilegiare il valore iconico degli oggetti esposti e assemblati; il loro valore indicizzante in quanto tracce materiali del corpo è cruciale per comprenderne la forza esercitata sulla nostra immaginazione. A differenza dei Rotoli degli Antenati, che sono soprattutto rappresentazioni iconiche dei membri della famiglia, con le loro didascalie rosse che funzionano da metro di misura per vite pienamente o parzialmente vissute (solo i volti fotografati sono sia

indici che icone), la maggior parte degli oggetti materiali ha una relazione indicizzante o fisica con i corpi degli individui che li hanno usati o creati. Perciò, gli oggetti più suggestivi della mostra – la lettera d'amore stracciata, il piccone, il tagliaravioli di ottone, la lanterna rosso-arancione di Antonio, i documenti manoscritti, gli elenchi e le firme, incluse le iniziali tessute a mano sulle lenzuola e sulla camicia da notte di Concettina – insieme alle fotografie, che possiedono un rapporto iconico e indicizzante con l'oggetto cui si riferiscono, sono definiti in termini della loro indicizzabilità. Sebbene questi oggetti si offrano alla visione, essi sono oggetti che per essere pienamente esperiti anelano ad essere toccati e maneggiati. È la loro indicizzabilità, trasmessa all'osservatore attraverso la vista e l'immaginazione tattile, che consente al visitatore di ri-membrare i corpi degli antenati e perciò abitare e, in un certo qual modo, far risorgere quei corpi.

Il culto del Cargo: Life line come testo italoamericano

Nel corso della discussione su *Life line* tenutasi all'Istituto Italiano di Cultura (3 dicembre 2001), lamentavo il fatto che la mostra si fosse tenuta dopo la pubblicazione di *The Italian American Heritage: A Companion to Literature and Arts (L'eredità italoamericana: una guida alla letteratura e alle arti)*, una raccolta di saggi scritti principalmente dalle voci e dalla prospettiva della terza generazione. Quel volume aderiva a quello stesso progetto storico che B. Amore concretizza in *Life line*: elaborare una micronarrazione dell'esperienza culturale italoamericana e collocarla all'interno della narrazione dominante – la storia – dell'americanizzazione; definire l'identità italoamericana facendo l'inventario delle tracce che il processo storico vi ha depositato. In *Life line* questa inventariazione di tracce assume la forma materiale di un "memoir tangibile" che conserva le tracce e le ombre degli oggetti attraverso i quali la famiglia ha costruito e preservato la sua identità. Molti di quegli oggetti erano fatti in Italia o prodotti in America con tecniche italiane e per questo divenivano ricordi/residui dell'Italia, un mezzo attraverso cui mantenere un dialogo con la terra promessa mentre essa si allontanava e dialogare con il proprio sé in termini sia italiani che americani. Perciò, *Life line* si pone come quintessenza di un testo italoamericano, uno che non soltanto fonda un'archeologia e una genealogia dell'autoidentità italoamericana, ma racchiude altresì il

progetto di forgiare quell'identità: la dialettica tra l'essere italiano e il divenire italiano.

La sua insistenza sugli oggetti testimonia di ciò che potrebbe essere chiamato "il culto del Cargo" italoamericano, un rovesciamento di quello melanesiano nel passato/presente, attraverso il quale gli immigrati portarono con sé – o meglio traslarono, – nella stessa accezione applicata alle reliquie di un santo – il testo culturale della loro madrepatria. Quel testo non era necessariamente quello della cultura ufficiale o elitaria, ma la cultura viva radicata nelle pratiche quotidiane de "la famiglia" e negli oggetti, il necessrio per vivere, attraverso cui essi abitarono la domus. Quale che sia il loro valore di feticci nella venerazione degli antenati, o il valore d'uso che essi possono avere come strumenti della vita quotidiana, è il loro valore culturale che si impone: essi sono marcatori e indici di italianità, di identità costruite in Italia o dall'Italia nella diaspora. Questi oggetti culturali attestano l'attaccamento all'elemento concreto e materiale – l'attaccamento al referente – che ha sempre caratterizzato tutti i livelli - d'élite o popolari – della cultura italiana. Il tagliaravioli di ottone e la napoletana (la tradizionale caffettiera che si capovolge, o macchinetta escogitata dai napoletani) sono tipici esempi degli oggetti culturali del "culto del Cargo", oggetti d'uso comune attraverso cui la memoria culturale viene fatta rivivere all'interno di scenari consueti.

Ma ciò che mi è spiaciuto ancora di più è di aver fatto l'esperienza di *Life line* soltanto dopo aver scritto il capitolo sull'eredità italiana dedicato alla tradizione artistica italoamericana. Quel capitolo *From Stella to Stella: Italian American Visual Culture and its Contribution to the Arts in America (Da Stella a Stella: la cultura visiva italoamericana e il suo contributo alle arti in America)* avrebbe trovato la sua perfetta conclusione in *Life line* che, a suo modo, rappresenta un punto culminante nella storia dell'arte italoamericana del ventesimo secolo che si estende da Joseph Stella a Frank Stella fino al postmodernismo di Robert Venturi, Vito Acconci e altri. Per di più, è un'opera decisiva nel canone dell'arte delle donne italoamericane, un'area trascurata che comincia appena adesso ad essere cartografata.

Life line si presta a rimettere a fuoco molte delle questioni relative alla cultura visiva italoamericana con cui mi ero già cimentato; soprattutto, la tensione tra l'arte etnica e quella cosmopolita che caratterizza la situazione dell'artista contemporaneo o postmoderno che cerca di fare arte etnica – per definizione, un'arte della differenza – in questo periodo di post-etnicità, senza scivolare nella nostalgia o assumere ironicamente le posizioni dell'arte naïf, di quella primitiva o di quella folcloristica. Le condizioni di produzione dell'arte nel ventesimo secolo hanno cambiato lo status dell'arte etnica: i movimenti transnazionali hanno dislocato le tradizioni nazionali e l'arte astratta ha reso problematico lo stesso concetto di arte etnica, che è legato all'aspetto figurale. Posto che il tardo ventesimo secolo è diventato più concettuale – più arte intorno all'arte – possiamo ancora parlare di un'arte visiva che registra direttamente l'esperienza etnica, legata com'è al tema sociale americano e perciò al "referente", vale a dire alla esteriorità e alla materialità? Se, come sostiene Mario Perniola (Artforum [Estate, 1991]), il postmoderno è «una etnocentricità che elimina la molteplicità e la differenza di culture, gettando tutti i manufatti artistici in un crogiolo che cancella i loro vecchi confini e definizioni», possiamo ancora parlare di un'"arte della differenza", o dobbiamo adottare categoricamente la formula universalizzante dell'arte post-etnica, post-nazionale?

Lasciatemi suggerire subito che *Life line* è chiaramente un'opera fortemente etnica, il contrario della "etnicità' debole" caratteristica della condizione postmoderna. Essa affronta l'esperienza italoamericana direttamente e colloca all'interno dell'opera una ricerca di identità artistica e culturale. Ma, egualmente importante, è l'uso che essa fa delle tecniche e delle procedure dell'arte postmoderna e contemporanea - ciò che si potrebbe definire "arte debole" - per realizzare "cose forti". *Life line* usa le varie tecniche dell'arte contemporanea: l'installazione legata alla specificità del sito, il collage e il fotomontaggio, la narrazione, la scultura astratta – quantunque antropomorfizzata come nel caso dell'"uomo con piccone" e nelle figure dell'Odissea – e, soprattutto, il *bricolage*, la tecnica forse più caratteristica dell'arte contemporanea. Ma B. Amore le subordina ad una funzione narrativa di primaria importanza senza metterle ironicamente fra parentesi. Il tesoro degli oggetti familiari le regala degli "oggetti comuni", ma essi vengono collocati e perciò "assistiti" senza nessun compito duchampiano di de-definire l'arte o di negare la

possibilità di definire l'arte. Non c'è nessuna velleità di usare un dipinto di Leonardo da Vinci come asse da stiro o appendere un Botticelli alla corda del bucato. Il progetto di B. Amore è di sacralizzare oggetti umili e trascurabili sottoponendoli ad un elaborato processo di costruzione e di ri-articolazione per mezzo del quale essi vengono dotati di un'aura, l'autentica aura che una volta apparteneva all'opera d'arte tradizionale e che, secondo la diagnosi epocale di Benjamin, venne distrutta dalla riproduzione meccanica e sostituita con il valore espositivo dell'opera.

Life line funziona anche come specchietto retrovisore per la tradizione visiva degli italoamericani. Molti dei motivi e delle procedure fondamentali di quella tradizione fanno la loro comparsa nell'impianto espositivo, il ricorso a forme cattoliche liturgiche e devozionali, ad esempio richiama le pale d'altare politiche impiegate da Joseph Stella in *New York Interpreted* (1920-22) e il ritratto di famiglia in forma di pala d'altare nella *Family Supper* di Ralph Fasanella (1972); l'uso del *bricolage* come tecnica principale ricorda La Watts Tower a Los Angeles, di Simon Rodia. In verità, B. Amore ha fornito l'interno di quella «Cattedrale del Jazz», così felicemente descritta da Don DeLillo.

Qui possiamo ipotizzare una definizione dell'artista italoamericana che si applica a B. Amore come agli altri artisti precedentemente citati: (1) dialogismo con la tradizione italiana; (2) registrazione diretta dell'esperienza etnica o degli immigrati, sia a livello tematico che formale, essendo essenziale per la cultura visiva italoamericana l'uso dell'iconografia cattolica – benché secolarizzata; (3) ibridazione dell'identità artistica, che può implicare o meno una esplicita rivendicazione di identità italoamericana. Andrebbe anche sottolineato che B. Amore è tutto fuorché una artista naïf o primitiva alla maniera di Fasanella o Rodia. La sua posizione è ibrida, ricorda le posizioni prese da Joseph Stella e dallo scultore Beniamino Bufano, i quali entrambi si muovevano costantemente tra l'America e l'Italia e mantennero un dialogo sia con la tradizione artistica italiana che con quella americana.

Che per le sculture dell'Odissea B. Amore abbia usato marmo nero italiano è un gesto archetipico dell'artista italoamericano nei termini in cui è stato appena definito. Quelle figure enigmatiche che trasportano sul capo fagotti di stoffa portano racchiuso nella loro materialità un dialogo con l'Italia e, mentre alludono alle fotografie documentarie di Hine, delle donne immigrate a New York che, come cariatidi trasportano scatoloni e fagotti di abiti da rifinire. Le cinque sculture sono totem del culto italoamericano del Cargo e allegorie dell'artista, del suo compito di portare il peso dei suoi fardelli della memoria perchè gravi sul presente.

Il rosario delle memorie e un filo del desiderio

Sebbene *Life line* sia nel profondo un testo italoamericano, esso è anche un testo di etnicità universale, indirizzato a tutti quegli americani che derivano le loro identità dall'evento dell'immigrazione e, più genericamente, rivolto a quegli "stranieri a se stessi" che vivono la condizione della diaspora. Ciò è stato costantemente riconfermato dalle risposte scritte dai visitatori multietnici nel registro delle firme della mostra: «Questa famiglia è proprio come la mia».

Malgrado Ciò, *Life line*, come tutti i testi etnici, ha una doppia voce, indirizzata specificamente a quell'insider italoamericano che troverà nella storia della famiglia De Iorio-D'Amore un preciso specchio della propria. Nell'elaborarla, lo spettatore italoamericano diviene un membro della famiglia dell'artista attraverso un atto simbolico di "comparaggio" e si impegna in un lavoro della memoria che rafforza e complica allo stesso tempo la memoria collettiva della famiglia e dell'esperienza italoamericana in America.

Al visitatore italoamericano, *Life line* servirà come un rosario di memorie che conferma una storia familiare. Ma farne un'esperienza meccanica e baloccarsi con un consolante gioco di riconoscimenti vuol dire dimenticare le differenze e la controstoria in essa presenti. La mostra tenta di opporsi alla memoria collettiva che l'America di origine italiana ha dell'esperienza di Ellis Island o, almeno, quella parte della memoria pubblica che è stata condizionata e addomesticata da una storia di (auto)stereotipizzazione attraverso cui l'italianità e l'italoamericanità sono state rappresentate all'interno della cultura dominante. Tutti quegli stereotipi portano a, o partono da Ellis Island.

Il pensiero corre immediatamente all'episodio di Ellis Island ne *Il Padrino*- Parte Seconda di Coppola, episodio in cui il figlio Vito Andolini, sfuggendo alla persecuzione della Mafia in Sicilia, intraprende da solo un viaggio per mare alla volta dell'America e una volta arrivato alla stazione di Ellis Island, subisce un trattamento traumatico. Di fatto, il rito adolescenziale di passaggio allo status di americano è per Vito Corleone doppiamente traumatico: segnato dal cambiamento di nome quando il funzionario di Ellis Island sostituisce al suo cognome (Andolini) il nome del suo paese natale (Corleone); è altresí contrassegnato dall'indagine medica panottica – la visita medica (il controllo degli occhi è un topos della fotografia documentaria dedicata ad Ellis Island), la diagnosi di vaiolo, il segno col gesso per marcare l'inabilità– che culmina nell'assegnazione alla quarantena nei dormitori. Quell'episodio è arrivato a dominare sia la memoria massmediatica dell'immigrazione che la memoria culturale italoamericana. Il Padrino di Coppola è sempre problematico, perché presenta una narrazione dominante dell'esperienza italoamericana nel contesto di un film sulla Mafia o sul mondo dei gangster e lo fa attraverso la "famiglia sbagliata" – l'aberrante famiglia criminale al posto della normativa famiglia onesta. Ciononostante, l'episodio di Ellis Island fornisce una rappresentazione potente e commovente della traversata degli immigrati, poiché interferendo con le sue immagini stereotipate, molte delle quali derivano dalla tradizione delle fotografie documentarie di Ellis Island, Coppola filma l'arrivo con la nave e l'attraversamento delle stanze destinate alle visite mediche con una macchina da presa che spostandosi lateralmente trasmette il senso dell'impellenza del movimento e del destino al passaggio degli immigrati. Inoltre, la cinecamera gioca a rimpiattino con la Statua della Libertà, lasciandola appena intravede in due momenti. Nel suo primo avvistamento, vediamo, attraverso una serie di carrellate, la folla degli immigrati, Vito compreso, che guarda la statua dal ponte della nave e, infine, attraverso una soggettiva dal loro punto di vista, appare la statua che, comunque, si intravede fuggevolmente e attraverso l'interferenza delle sartie di un pennone. Il secondo avvistamento avviene dalla prospettiva del dormitorio in cui Vito è trattenuto in quarantena. Vediamo di nuovo Vito che guarda la statua, ma non esattamente la statua; l'immagine di essa riflessa nella finestra attraverso cui Vito guarda fissamente, è chiaramente una indicazione della distanza e dell'inaccessibilità del Sogno Americano. Il formalismo di questa scena ricorda *Steerage* di Stieglitz, la fotografia più artisticamente significativa nella tradizione documentaria. Con Coppola, come con Stieglitz, ci avviciniamo alla Amerika di Kafka.

Prima della scena di Coppola in cui viene a crollare la distinzione tra stereotipo e archetipo, c'è un'altra immagine ugualmente grave che si è incisa nella memoria collettiva degli italoamericani: la famosa fotografia, scattata da Lewis Hine, della famiglia italiana sul ponte di un traghetto nell'atto di guardare Manhattan da Ellis Island (1905). Non esiste emblema migliore della miseria degli stremati, dei poveri, dei derelitti di questa fotografia di Hine, un fotografo con una coscienza sociale, che spostò la tradizione documentaria iniziata da Jacab Riis in una nuova direzione. Egli tentò di conferire agli immigrati, i soggetti delle sue istantanee, dignità e carattere, piuttosto che fotografarli come perfette vittime e figure da caseggiato popolare, come aveva fatto Riis. Ciononostante, la fotografia della famiglia di immigrati italiani è altamente problematica perché essa, implica, inoltre, un conflitto fra archetipo e stereotipo – uno stereotipo è un archetipo logorato, un archetipo smorzato. In quanto archetipo, essa presenta una solida famiglia di immigrati con lineamenti finemente cesellati e corpi risoluti nell'atto di contemplare con meraviglia il mondo nuovo offerto dal profilo dell'orizzonte di Manhattan. Come stereotipo, essa presenta dei corpi stranieri e marcati dall'appartenenza di classe (contadini): il padre baffuto caricato di tutti gli oggetti posseduti dalla famiglia racchiusi in un sacco goffamente appeso alla spalla; la madre, vestita da contadina, che regge una bambina con un abitino informe; un ragazzino vestito da marinaretto che guarda fissamente di lato. La famiglia ammaliata sembra essere stata trasformata in pietra dalla Medusa dell'orizzonte – e forse dal *punctum* del fotografo. In altre parole, lo stereotipo del morto di fame stordito e senza parole davanti allo schiudersi di un nuovo destino.

Le fotografie possono essere molto eloquenti, ma questa particolare fotografia ha l'eloquenza dei silenzi. È precisamente questa eloquenza del silenzio che *Life line* di B. Amore riempie con i suoi oggetti, immagini e testi scritti. È esattamente quella tipica famiglia italiana che lei salva dal suo momento di mortificazione sul traghetto e di pietrificazione nella cornice di una fotografia, e lo fa proiettandola nel

futuro attraverso la storia della sua stessa famiglia. La storia personale di B. Amore è segnata da differenze di ogni tipo, compresa la sua enfasi sul ruolo di quelle donne e madri forti, che personificano l'ideale di serietà. Come annuncia il titolo bilingue, *Life line - filo della vita*, essa narra una storia di identità linguistica e, nel profondo, celebra l'istruzione e il processo educativo testimoniato dall'onnipresenza dei libri, inclusi quelli che sostengono il monumento ai Due Antonii: Antonio, che scavò le fondamenta degli edifici della Harvard University, e suo figlio Tony, che diventò lo "studioso- lavoratore" della famiglia. Tony, la cui dedizione allo studio è commemorata anche nell'installazione sulla scrittura a lui dedicata, si laureò al Boston College e andò a lavorare alla Library of Congress. Ma al fine di mantenere la famiglia, egli fu costretto a fondare, insieme ai suoi fratelli, l'azienda di famiglia – la "Atlas Cleaners", (Lavanderia Atlante), allusione erudita di Tony alla mitologia greca, ma anche descrizione del suo personale ruolo di Atlante della famiglia depositario della sua legge della "via vecchia". Perciò, il Reliquiario per i due Antonii funge da requiem per un sogno allo stesso tempo raggiunto (il sogno di una istruzione universitaria) e non realizzato (il sogno di una vita dedicata allo studio e alla ricerca). Inoltre, *Life line* esibisce una storia di matrimoni che è anche una storia di classe che ricorda le diverse posizioni di provenienza degli immigrati. Essa, come si è già detto, narra una storia di acculturazione opponendola a quella dell'assimilazione.

Life line coinvolge il visitatore italoamericano nelle forme intricate di un lavoro-della-memoria e di un lavoro sulla storia. In questo senso, essa agisce come un correttivo della ben nota amnesia culturale di quegli italoamericani che sono stati colonizzati per assimilazione: inscena il ritorno della repressa esperienza migratoria, è un kit di strumenti per rimanere bi-culturali e per mantenere un dialogo con l'idea dell'Italia. Allo stesso modo, essa è un correttivo di quel tipo di filopietismo che erige alla italianità monumenti reali e immaginari tesi a cancellare le ferite di una etnicità stigmatizzante. Basta soltanto ricordare il monumento eretto a, e in parte dalla, comunità italoamericana per celebrare il suo contributo alla città di New Orleans: la Piazza d'Italia di Charles Moore. Nonostante le ottime intenzioni architettoniche e culturali, essa celebra il culto dell'Italia attraverso il ritorno di clichés e il

gioco dei simulacri: la carta geografica dell'Italia, i cinque ordini architettonici più un sesto – l'ordine bottegaio – in altre parole, la piazza italiana in un travestimento mercificato. C'è forse un coinvolgimento più forte del lavoro-della-memoria nel mangiare una *mulfetta* che nell'esperienza di un simile pastiche architettonico. Non è una sorpresa che il monumento sia stato incorporato nel Loews Hotel , l'equivalente a New Orleans del Venetian di Las Vegas. È questo filopietismo e, il suo lato nascosto, la vittimologia – chiamiamola sindrome dell'"Isola delle Lacrime" – a modellare molte delle storie sull'esperienza di Ellis Island scritte da italoamericani. Queste storie ripetono la via dolorosa che conduce e parte da Ellis Island, erigendo monumenti sentimentali sia all'"immigrato felice" traghettato verso la libertà – ma esiste davvero qualcosa che somigli all'"immigrato felice"? – sia al "forestiero perpetuo", quest'ultimo sotto forma di una sacra conversazione in cui la Madonna, assieme all'"Angelo della Storia", versa lacrime di coccodrillo sul trauma dell'immigrazione e la storia disonorante della "dagotudine" (da Dago, termine spregiativo che indicava gli immigrati italiani o latini) che essa annuncia. È precisamente questa forma banalizzante di monumentalismo che *Life line* contrasta con la sua *pietas*.

Dalla mia personale prospettiva, ho trovato all'interno dell'impianto espositivo un rosario di memorie che mi hanno reso familiare il mondo di B. Amore. Ma dentro quel rosario, ho scoperto una serie di oggetti magici che hanno innescato la corsa precipitosa della (involontaria) memoria proustiana. Per di più, anche se guidato dal filo rosso e fortemente coinvolto nel lavoro-sulla-storia, mi sono ritrovato a inventare il mio personale filo del desiderio, il mio percorso personale attraverso l'installazione. Ciò ha comportato un ossessione totalizzante per Concettina, che era, allo stesso tempo, il personaggio più visibile e il più invisibile della pièce. Il suo rosario di oggetti mi ha consentito di entrare nel suo mondo interiore senza tradirne i segreti. Il mio modo di seguire la linea genealogica è stato per certi versi opposto poiché mi sono ritrovato a schierarmi con vari membri della famiglia e ad identificarmi con la sua linea materna, questo perché in essa quei matrimoni segnati dall'appartenenza di classe le conferiscono una maggiore complessità.

Eccolo, il mio rosario di oggetti proustiani: la calligrafia di fine secolo di mio padre, che arrivò in America nel 1906; una genealogia di donne

forti con i loro imperativi categorici – «Quando c'è la volontà, la via si trova» - l'espressione preferita di mia madre; i matrimoni segnati dalle differenze sociali – il mescolarsi di famiglie aristocratiche e plebee che smentisce lo stereotipo della uniformità di classe degli immigrati; il bastone del nonno - anche se, nel caso della mia famiglia, la vigilanza del patriarca si riduceva a garantire che le gonne delle ragazze non fossero troppo corte; il tipo di personaggio alla Ernesto inteso sia come cafone che come trasgressore del *filo della vita* - come ciò che potrebbe essere chiamato "la figura di Palinuro" il componente della famiglia segnato dall'esperienza dell'immigrazione che, in qualche modo, paga il prezzo dell'assimilazione del resto della famiglia; l'abito da sposa, passato di mano in mano da madre a figlia e da sorella a sorella - e nel caso della mia famiglia, accompagnato da una culla di vimini di fattura italiana; e infine le scarpe lucide di cartone con le quali fu sepolto Antonio. Il mio aneddoto sulle scarpe nasce, comunque, al di fuori del circolo familiare e appartiene ad un professore americano che vestiva al modo di L. L. Bean. Ad un mercato delle pulci di Firenze, egli aveva acquistato, ad un prezzo d'occasione, quello che gli sembrava essere il paio di scarpe sognato. Fu dopo un nubifragio, che scoprì la pessima qualità delle scarpe concepite per il funerale di un povero. Un funerale adeguato richiede un elegante paio di scarpe italiane, come ben sapevano Nina e Concettina.

Il filo rosso e il gioco degli oggetti transizionali

Tanti immigrati hanno portato a bordo gomitoli di lana, lasciando un'estremità del filo con qualcuno a terra. Mentre la nave partì lentamente dal molo, i gomitoli si sfilarono fra i gridi d'addio delle donne, i battiti dei fazzoletti, ed i bambini in braccio mantenuti in alto. Dopo che la lana si esaurì, le strisce lunghe rimanevano in aria, sostenute dal vento finché non si persero di vista sia a quelli di terra sia a quelli di mare.

—Luciano De Crescenzo

In questa parabola della partenza da Napoli, Luciano De Crescenzo descrive la scena traumatica dell'emigrazione, anche se è rappresentata come spettacolo secondo la tipica abitudine italiana.

Questa sarà poi recitata di nuovo nell'ancor più drammatica scena dell'arrivo in America, ad Ellis Island. Per la maggioranza degli italiani del Sud coinvolti nella Grande Immigrazione (1880-1920), la traversata transatlantica implicava il passaggio dall'emigrazione all'immigrazione, dall'esilio (di classe) all'interno della patria d'origine all'esilio (di classe) nella terra promessa rappresentata dall'America, che sarebbe diventata infine la nuova patria.

Attraverso l'insistenza sul filo rosso, *Life line* ci ricollega a queste due scene primarie. E', comunque, la scena di Napoli ad offrire forse il segreto del tesoro di oggetti esposti e raccolti nell'impianto espositivo. L'immigrazione produce anche dei buoni collezionisti, ed è attraverso questi oggetti culturali altamente cateptici che l'esiliato o lo straniero si riappropria del mondo da cui è stato staccato a causa dell'immigrazione. La zona della collezione diviene un sostituto della madrepatria o della terra madre.

Quei gomitoli di refe e il gioco di quei fili potrebbero essere paragonati ad una versione adulta di quegli "oggetti transizionali" o "fenomeni transizionali", identificati da D.W. Winnicott. Gli "oggetti transizionali" sono oggetti materiali dotati un valore speciale per il lattante e il bambino e che consentono al bambino in fase pre-edipica di realizzare la transizione dal primo rapporto orale con la madre all'autentica relazione oggettuale, ciò che accade, ad esempio, con la coperta che il bambino succhia quando si addormenta. Inscenare il momento della partenza o del distacco dalla madrepatria attraverso il gioco dei gomitoli di filo è un modo di stabilire, per un attimo, attraverso l'illusione o lo spettacolo, un'area neutrale di esperienza e perciò di allontanare l'ansia. Winnicott considera quest'area intermedia o transizionale, «non gravata dalla questione dell'appartenenza alla realtà interiore o a quella esterna (condivisa)», come «ciò che costituisce la parte più consistente dell'esperienza dell'infante, che viene ritenuta in quelle esperienze intense che appartengono al mondo delle arti, alla religione, alla vita dell'immaginazione e al lavoro scientifico creativo». Ciò che è importante a proposito dei gomitoli di filo intesi come "oggetti transizionali" è il loro potere di negoziare l'ansia della separazione attraverso uno scenario creativo e perciò di servire come preparazione dell'immaginazione all'incontro con le scelte cruciali da affrontare una volta giunti ad Ellis Island. Da quel

"crocevia" scaturiranno nuove indicazioni e bisognerà lasciarselo alle spalle in vista delle nuove avventure che da lì avranno inizio. L'Italia o l'idea di essa non verrà gettata alle spalle, sempre sarà possibile riacquisirla attraverso il ricordo del filo rosso. Gli oggetti dell'immigrato – riassunti e riscattati da *Life line* – vanno interpretati come "oggetti transizionali", non come coperte che offrono un riparo sotto forma di un tagliaravioli o di un sigaro scadente, né come oggetti feticistici, ma come un mezzo attraverso cui l'immaginazione negozia lo spazio dell'esilio e lo trasforma in uno spazio "transizionale", intermedio, che riesce a mediare l'ansia identitaria di coloro che sono lacerati tra il passato e il presente, l'altrove e il qui, l'Italia e l'America.

Lode per B. Amore

L'artista sceglie i suoi soggetti. E questo' il suo modo di lodare.

—F. Nietzsche, *La gaia scienza*

Una lode a B. Amore per la sua *pietas* nel narrare la storia della vita della sua famiglia e della sua crisi di identità, e per aver descritto la memoria collettiva della famiglia immigrata. «La *pietas* della narrazione consiste nel preservare il passato, Solo attraverso e nella narrazione è possibile preservare» (Cacciari, 1996:176). Una lode a B. Amore per aver costruito in *Life line,* attraverso la narrazione, un paese o una patria in cui trovano posto la sua famiglia e le nostre.

¹ Pellegrino D'Acierno è Professore di Letteratura Comparata e Direttore del Programma di Studi Italiani alla Hofstra University, NJ e titolare di una fellowship della Tiro a Segno Foundation per il 2006, come Visiting Faculty Fellow in Cultura italoamericana presso la New York University. Tra le sue pubblicazioni: *The Italian American Heritage: A Companion to Literature* and *Arts e Thirteen Ways of Crossing the Piazza: Rome as a Cinematic City.*

Bibliografia

Roland Barthes, *Introduction to the Structural Analysis of Narratives*, in, Stephen Heath Ed.and Transl., *Image - Music –Text*, Glasgow, Fontana/Collins, 1977.

Jean Baudrillard, *Fragments: Cool Memories III, 1991-95*, London/New York,Verso, 1997.

Walter Benjamin, *Unpacking My Library*, in Illuminations, Trans. Harry Zohn, New York, Schocken, 1969.

Massimo Cacciari, *Posthumous People: Vienna at the Turning Point*, Transl. Roger Friedman, Stanford, Stanford University Press, 1996.

Pellegrino D'Acierno Ed., *The Italian American Heritage: A Companion to Literature and Art*, New York and London, Garland. 1999.

Michel Foucault, *Nietzsche, Genealogy, History*, in *Language, Counter-Memory, Practice*, Transl., Donald F. Bouchard and Sherry Simon Ithaca, NY, Cornell University Press, 1977

J Gonzalez, Autographies, G. Brahm and M. Driscoll Eds., in *Prosthetic Territories: Politics and Hypertechnologies*, Boulder, CO, Westview Press, 1995.

Andreas Huyssen, Mieke Bal, Jonathan Crewe, and Leo Spitzer Eds., *Monumental Seduction, in Acts of Recall: Cultural Recall in the Present*, Hanover, NH, Dartmouth College/University of New England Press, 1999.

Jacques Le Goff, *History and Memory*, Transl.Steven Rendall and Elizabeth Claman, New York, Columbia University Press, 1992.

Claude Lévi-Strauss, *The Savage Mind*, Chicago, University of Chicago Press, 1966.

Donald Preziosi, Robert S. Nelson and Richard Shiff Eds., *Collecting/Museums, in Critical Terms for Art History* (second edition), Chicago, The University of Chicago Press, 2003.

James E Young, *Memory/Monument*, in Robert S. Nelson and Richard Shiff Eds., Critical Terms for Art History (second edition), Chicago, The University of Chicago Press, 2003.

Endnotes

1. Dreams

[1] Calabrese, Dominica (Sunday Wood), Interview by Janet Levine. *Ellis Island Interview 130: Statue of Liberty Ellis Island Oral History Project.* March 25, 1992. 4.

[2] Duggan, Christopher, *A Concise History of Italy* (Cambridge University Press, 1994), 175.

[3] Duggan, 159.

[4] Hoobler, Dorothy and Thomas, *The Italian American Family Album* (New York: Oxford University Press, 1985), 31.

[5] Tomasi, Archbishop Silvano M., *For the Love of Immigrants: Migration Writings and Letters of Bishop John Baptist Scalabrini 1839–1905* (New York: Center for Migration Studies, 2000), 4.

[6] Lamont, Michael, "Italian American Autobiographies," in *Italian Americana.* Vol. XVIII, No. 2 of *Cultural and Historical Review,* ed. Maria Parrino (University of Rhode Island, Feinstein College of Continuing Education: 2000), 50.

[7] Calabrese. 9, 21, 27.

[8] Buroni, Dena Ciaramicoli, Interview by Janet Levine. *Ellis Island Interview 181: Statue of Liberty Ellis Island Oral History Project.* June 24, 1992. 5, 8.

[9] Tomasi, Silvano M. *et al., Images: A Pictorial History of Italian Americans* (New York: Center for Migration Studies), 1986. 42.

[10] Lorenzini, Ettore, Interview by Debra Heid. *Ellis Island Interview 162: Statue of Liberty Ellis Island Oral History Project.* May 26, 1992. 9–10.

[11] Notini, Marjorie (Maggiorana) Corsi, Interview by Janet Levine. *Ellis Island Interview 206: Statue of Liberty Ellis Island Oral History Project.* September 1, 1992. 34.

[12] Willitts, Elda Del Bino, Interview by Paul E. Sigrist, Jr. *Ellis Island Interview 8: Statue of Liberty Ellis Island Oral History Project.* November 5, 1990, April 30, 1999, May 1, 1999. 49.

[13] Marcello, Leo Luke, *Nothing Grows in One Place Forever: Poems of a Sicilian American* (St. Louis: Time Being Books, 1998), 29.

[14] Calabrese. 28.

[15] Lorenzini. 17.

[16] Baldizzi, Josephine, Interview by Carl Biers. Collection of *The Lower East Side Tenement Museum.* July 10, 1989. 22.

[17] Wells, H. G., *The Future in America: A Search After Realities* (Granville Publishing, [1906] 1987).

[18] Buroni. 9.

[19] Willitts. 18–19.

[20] Martucci, Carmine, Interview by Paul E. Sigrist, Jr. *Ellis Island Interview 148: Statue of Liberty Ellis Island Oral History Project.* May 8, 1992. 26–27.

[21] Lorenzini. 18–19.

[22] Duggan. 152, 154.

2. The First Generation

[1] Villanova, Catherine D'Alena, Interview by B. Amore in video "Following the Thread." June 2000.

[2] Guglielmo, Jennifer, "Italian American Women's Political Activism in New York City 1890s–1940s." in *The Italians of New York: Five Centuries of Struggle and Achievement.* Ed. Philip V. Cannistraro. The New York Historical Society, 1999. 105.

[3]Molinari, Mary Sartori, Interview by Paul E. Sigrist, Jr. *Ellis Island Interview 170: Statue of Liberty Ellis Island Oral History Project*. September 1, 1992. 15.

[4]Zambrano, Madeline (Madallena) Polignano, Interview by Paul E. Sigrist, Jr. *Ellis Island Interview 76: Statue of Liberty Ellis Island Oral History Project*. August 27, 1991. 22.

[5]Martucci, Carmine, Interview by Paul E. Sigrist, Jr. *Ellis Island Interview 148: Statue of Liberty Ellis Island Oral History Project*. May 8, 1992. 31–34.

[6]Maccarone, Renata Nieri, Interview by Janet Levine, *Ellis Island Interview 194: Statue of Liberty Ellis Island Oral History Project*. July 20, 1992. 30.

[7]De Cunto Family Letters, courtesy of Mary De Cunto Vitiello and Vincent De Cunto.

[8]Buroni, Dena Ciaramicoli, Interview by Janet Levine, *Ellis Island Interview 181: Statue of Liberty Ellis Island Oral History Project*. June 24, 1992. 30.

[9]Villanova, Catherine D'Elena, Interview in "Following the Thread." Produced and directed by B. Amore, 2000. Videocassette.

[10]Willitts, Elda Del Bino, Interview by Paul E. Sigrist, Jr. *Ellis Island Interview 8: Statue of Liberty Ellis Island Oral History Project*. November 5, 1990, April 30, 1999, May 1, 1999. 112.

[11]Salto, Felicita Gabaccia, Interview by Janet Levine. *Ellis Island Interview 56: Statue of Liberty Ellis Island Oral History Project*. July 19, 1991. 28.

[12]Gambino, Richard, *Blood of My Blood: The Dilemma of the Italian Americans* (Toronto: Guernica Editions, Inc., 2000), 255.

3. Becoming American

[1]Tomasi, Silvano M. *et al., Images: A Pictorial History of Italian Americans.* New York: Center for Migration Studies. 1986. 21.

[2]Lorenzini, Ettore, Interview by Debra Heid. *Ellis Island Interview 162: Statue of Liberty Ellis Island History Project*. May 26, 1992. 22.

[3]Misturini, Nelson, Interview by Janet Levine. *Ellis Island Interview 192: Statue of Liberty Ellis Island History Project*. July 19, 1992. 8.

[4]Joseph Tusiani, Translator, Luigi Bonaffini. *Dialect Poetry of Southern Italy* (New York, Toronto: Legas, 1997), 210.

[5]Buroni, Dena Ciaramicoli, Interview by Janet Levine. *Ellis Island Interview 181: Statue of Liberty Ellis Island Oral History Project*. June 24, 1992. 13.

[6]Misturini, Nelson, Interview by Janet Levine. *Ellis Island Interview 192: Statue of Liberty Ellis Island History Project,* July 19, 1992. 46–48.

[7]Willitts, Elda Del Bino, Interview by Paul E. Sigrist, Jr. *Ellis Island Interview 8: Statue of Liberty Ellis Island History Project*. November 5, 1990, April 30, 1999, May 1, 1999. 34, 74.

[8]Dukakis, Michael S., "A Proclamation," *Sacco and Vanzetti Project*. July 19, 1977. <http://www.saccovanzettiproject.org/pages/context/dukakis.htm>

[9]Vanzetti, Bartolomeo, *The Story of a Proletarian Life* (Boston: New Trial League, 1923), 13.

[10]Willitts. 108.

[11]Ibid. 92.

[12]Sacco, Mary, Interview by B. Amore. *Lifeline* project. February 24, 2000.

4. La Famiglia and Work

[1]Carmine Martucci. Interview by Paul E. Sigrist, Jr. *Ellis Island Interview 148: Statue of Liberty Ellis Island Oral History Project.* May 8, 1992. 37–8.

[2]Nelson Misturini, Interview by Janet Levine. *Ellis Island Interview 192: Statue of Liberty Ellis Island Oral History Project.* July 19, 1992. 3.

[3]Pascal D'Angelo, *Son of Italy.* (Guernica, 2003), 111–112. Pascal D'Angelo, *Son of Italy.* (Edizioni: Il Grappolo, 2000). 130.

[4]Ettore Lorenzini, Interview by Debra Heid. *Ellis Island Interview 162: Statue of Liberty Ellis Island History Project.* May 26, 1992. 20.

[5]Elda Del Bino Willitts, Interview by Paul E. Sigrist, Jr. *Ellis Island Interview 8: Statue of Liberty Ellis Island History Project.* November 5, 1990, April 30, 1999, May 1, 1999. 33, 54.

[6]Ibid. 99.

[7]Maccarone, Renata Nieri, Interview by Paul E. Sigrist, Jr. *Ellis Island Interview 194: Statue of Liberty Ellis Island Oral History Project.* July 20, 1992. 28.

[8]Willitts, 30.

5. Return to the Roots: Yesterday and Today

[1]Willitts, Elda Del Bino, Interview by Paul E. Sigrist, Jr. *Ellis Island Interview 8: Statue of Liberty Ellis Island History Project.* November 5, 1990, April 30, 1999, May 1, 1999. 96.

[2]Lorenzini, Ettore, Interview by Debra Heid. *Ellis Island Interview 162: Statue of Liberty Ellis Island History Project.* May 26, 1992. 23.

[3]Del Duca, Nino. "Io stongo 'e casa 'America." (Lettere Italiane Guida, 2005).

[4]Lawrence, C. Sean, *An Evening at Nonna's: Recipes of Nina D'Amore* (Tokyo: Mantis Press 2000).

List of Illustrations

1. Dreams

1. View of the six rooms of *Life line* exhibit at Ellis Island from the *Room of Dreams*. *Life line* was inaugurated in the former dormitory rooms which have now become galleries for traveling exhibitions. Photograph courtesy of: Ellis Island Archives.

2. *Column of History I: Why did we come?* (Tin, photo, copper, plexiglas; 93" x 24" x 2") Photographs courtesy of: Center for Migration Studies; Touring Club of Milan and Ellis Island Museum; Lewis W. Hine/New York Public Library; Sherman Collection, Ellis Island Museum.

3. Detail of *Column of History I*. Photographs courtesy of: Touring Club of Milan and Ellis Island Museum; Center for Migration Studies.

4. An Italian song popular at the turn of the nineteenth century and two young girls, Angela Piazza and Maria Carmela Calimeri, arriving at Ellis Island. Photograph courtesy of: Center for Migration Studies.

5. Photograph of Don Lorenzo De Iorio on his deathbed.

6. *Following the Thread I: Luigi De Iorio* (Copper, wood, photo, fabric, thread; 24" x 48" x 3").

7. *Ancestor Scroll: Luigi De Iorio* (Silk, acetate, wood, photo; 72" x 60" x 3").

8. *Libro di Memorie*: "Book of Memories" written by Don Lorenzo De Iorio (1820–1896).

9. *Libro di Memorie* page with account of Luigi and Giovannina's marriage written by Don Lorenzo De Iorio; copy of their marriage certificate.

10. *Following the Thread II: Giovannina Forte* (Copper, wood, photo, fabric, thread; 24" x 48" x 3").

11. *Ancestor Scroll: Giovannina Forte* (Silk, acetate, wood, photo; 72" x 60" x 3").

12. Ship's manifest with information on De Iorio family's arrival at Ellis Island in 1901.

13. Luigi De Iorio's passport issued by the Kingdom of Italy, King Victor Emmanuel I.

14. *Column of History II: Arrival* (Tin, photo, copper, Plexiglas; 93" x 24" x 2"). Photographs courtesy of: Sherman Collection, Ellis Island Museum; Center for Migration Studies.

15. Details of arrival at Ellis Island; pamphlets from Benevolent Societies. Photographs courtesy of: Center for Migration Studies; Sherman Collection, Ellis Island Museum.

16. *Dormitory Room Panel:* Detained immigrants in bunks at Ellis Island. This is only extant photograph of dormitory rooms. (Photo on Mylar, copper, fabric, cable; each panel 36" x 60" x 2"). Photograph courtesy of: Ellis Island Archives.

17. Close-up of Italian girl being examined; San Rafael Society agent assisting an immigrant through the entry process. Photographs courtesy of: Sherman Collection, Ellis Island Museum; Center for Migration Studies.

18. Pasqualina Mottola, Concettina's first teacher when she was four years old, in Lapio.

19. *De Iorio Closet Installation (De Iorio):* Details of *biancheria* with hand-crocheted edging; gold silk bedspread; linen lace overlay; amphora with De Iorio initials; mortar and pestle; Don Lorenzo's copy of *Book of Saints*.

20. Artifacts from the De Iorio family home in Lapio, Italy, mid-to-late nineteenth century.

21. De Iorio family selected artifacts: Concettina's dowry nightgown and prayer book; books from the De Iorio family library (1858); Luigi's seal; bronze statue of Saint Peter from the Vatican resting on silk lace; a copper-and-tin *tegamino* (small pan) for cooking.

22. De Iorio family selected artifacts: Details of Giovannina's dowry knife with her initials; two reliquaries (S. Filomena); *Libro di Memorie;* Luigi's passport; Giovannina's portrait; wedding cup; Don Lorenzo's weights and measures; handmade tin-and-copper *tegamino*; handmade brass ravioli cutter.

23. *Great-Grandmother's Ocean Installation:* Dowry bedspread made by Giovannina Forte using the rare "filet net" method of creating an openwork pattern with diminutive crochet hooks. Each square was made separately, then joined with the others.

24. Giovannina's *biancheria* with embroidered initials on woven-linen dowry sheet; broken hand-carved marble mortar.

25. Concettina's embroidery on her wedding nightgown, with her initials and small dog carrying basket.

26. Giovannina's initials embroidered on her woven-linen dowry sheet.

27. Lorenzino's first lessons in English.

28. *Following the Thread III: Lorenzino De Iorio* (Copper, wood, photo, fabric, thread; 24" x 48" x 3").

29. Original and translation of the account of Lorenzino's death and funeral written in the *Libro di Memorie* by his father, Luigi; photograph of Luigi in front of the De Iorio family gravestone.

2. The First Generation

1. *The First Generation:* Overview of second room in Ellis Island exhibit.

2. Work at home for people of all ages: rolling cigars, making lace and feather flowers. Photographs courtesy of: Center for Migration Studies; Jacob Riis/National Archives; Lewis Hine/George Eastman House.

3. Giovannina's death notice, with notation that her co-workers from the Aieta Tailor shop attended the funeral.

4. Triangle Shirtwaist fire. Photographs courtesy of: Brown Bros.; Center for Migration Studies (International Socialist Review, 1911).

5. Italian woman carrying sewing home. Photograph courtesy of: Lewis Hine/Library of Congress.

6. *Column of History III: Work* (Tin, photo, copper, plexiglas; 93" x 24" x 2"). Photographs courtesy of: Sherman Collection, Ellis Island Museum; Center for Migration Studies; Lewis W. Hine/George Eastman House; Lewis W. Hine/Library of Congress; Brown Bros.; Lewis W. Hine/New York Public Library.

7. *Golden Door* (detail) (Gilded wood, photo on organza; 96" x 55" x 3"). Photographs courtesy of: Lewis Hine/Library of Congress; Italian Community Center of Milwaukee; B. Amore.

8. Love notes from Ernesto to Concettina; De Iorio-Piscopo marriage certificate; postcard from American International College with Concettina seated on far right; first letter from Italy to Ernesto and Concettina as man and wife.

9. Love note and election card, Ernest W. Piscopo.

10. *Following the Thread IV: Concettina De Iorio* (Copper, wood, photo, fabric, thread; 24" x 48" x 3").

11. *Ancestor Scroll: Concettina De Iorio* (Silk, acetate, pipe, wood, photo; 81" x 69" x 3").

12. Petition for Separate Support, which Concettina filed against Ernesto three years after they were married.

13. *Reliquary to a Broken Heart:* Contains letter from Ernesto to his lover; his love notes to Concettina; Ernesto's school books from the Allen School, West Newton, MA; birdcage, which is a symbol of Concettina's beloved canary; Victorian camp stool (Gilded wood, mixed media: 61" x 27" x 27").

14. Ernesto's letter to a lover written on Hotel Florence [a Piscopo-owned hotel] stationery. Ernest's full name was Ernest William. His nickname was Billie in certain circles.

15. Back of Ernesto's letter to his lover which has been torn and pieced together.

16. *Ancestor Scroll: Ernesto Piscopo* (Silk, acetate, wood; 72" x 60" x 3").

17. Boy carrying homework from New York sweatshop, 1912. Photograph courtesy of: Lewis W. Hine/George Eastman House.

18. Tailor shop and mill girl (detail of *Column of History III*). Photograph courtesy of: Center for Migration Studies; Lewis W. Hine/New York Public Library.

19. Children at a settlement house school; Italian father and son, Pietro, studying at the kitchen table; detail of newsboys sleeping on a stoop; lesson on how to make a proposal of marriage. Photographs courtesy of: Center for Migration Studies; Jacob Riis/Museum of the City of New York.

20. *Column of History IV: Education* (Tin, photo, copper, plexiglas; 93" x 24" x 2"). Photographs courtesy of: Jacob Riis/Museum of the City of New York; Center for Migration Studies.

21. A humorous postcard depicting International College students "cooking" over an oil lamp in the dormitory. Inscription on back reads: "From the life of a student, January 1, 1914."

22. Concettina in photographs taken at American International College. She is third from the left in the photo on the porch, arm-in-arm with her best friend, Arete Sarantopolous; her theme on the subject of child labor; a postcard from Mrs. Eldredge.

23. Concettina's AIC enrollment card, 1912.

24. Copy of *Worldwide Messenger*, the AIC Alumni news, with photo of Mrs. Eldredge, who was the Editor and also Concettina's favorite teacher and friend. Concettina had written a note regarding a former classmate on the upper left hand corner.

25. *American International College Installation:* Debating books; photos of Concettina's professors; Prof. Giroux teaching French; her collection of AIC songs; letters from Arete; AIC catalogs from 1911–1913; her original theme on Making Money.

26. Child Labor Law.

27. *Ricordati* poem found with other notes saved by Concettina.

28. *Following the Thread V: Concettina Piscopo* (Copper, wood, photo, thread; 24" x 48" x 3").

29. Kyparissiotis postcard, front and back.

30. Davide Abbate Forte's letter.

31. Text of Arete's letter to Concettina when she left school, also her feelings on equality between men and women.

32. Letters from Ernesto to Concettina; Concettina's notes on his absences.

33. *Sewing: Four Generations:* Detail of closet installation at Ellis Island: Concettina's sewing machine, which she used all of her life; her hand-tinted photographic portrait. The modish dress with stripes was an original design of Nina, her daughter.

34. Detail of Concettina's wedding dress, which she sewed in 1906; photograph of her daughter, Nina, wearing the dress in 1941, and Concettina's note to her future granddaughter when she packed it in 1942.

35. *Sewing: Four Generations.* Detail of black velvet dress and prom dress designed and sewn by Concettina's daughter, Nina.

36. Text of Italy America Cable invitation addressed to Mr(s.) C. C. Piscopo.

37. Cablegram from King Victor Emmanuel of Italy to President Calvin Coolidge of the United States of America.

38. Cablegram to King Victor Emmanuel and Queen Helena from the Direct to Italy Cable Service Committee.

39. *Following the Thread VI: Concettina – A Life* (Copper, wood, photo, fabric, thread; 24" x 48" x 3").

3. Becoming American

1. *Becoming American:* Overview of third room in Ellis Island exhibit.

2. Postcard announcing Nina's birth; photos of Nina as a child.

3. Postcard from Concettina to Luigi and Eufrasia (Annie) announcing her return from New York, where Nina was born on August 15, 1917.

4. *Following the Thread VII: Young Nina* (Copper, wood, photo, fabric, thread; 24" x 48" x 3").

5. *Gold Reliquary: Archeology of a Life* (Wood, glass, grandmother's artifacts; 96" x 40" x 40").

6. *Gold Reliquary* containing Concettina's own handmade silk collar with tassels; a rolled-lace collar from the nineteenth century; a pillbox which she used to store jewelry; assorted mother-of-pearl buckles; her pliers from the Raytheon Company; gift silver spoons; her traveling alcohol stove which she brought on trans-Atlantic voyages.

7. Looking through the layers of history in the *Gold Reliquary:* Concettina's wrapped and labeled packages; a celluloid bird; handmade Italian basket; her purse mirror; can of talcum powder; embroidered handkerchiefs; a roll of embroidery silk; a fan from the Piscopo restaurant, "The Grotto."

8. Example of Concettina's notes cataloguing her fabrics and objects. She would often reuse envelopes to contain the notes.

9. *Gold Reliquary* containing celluloid kewpie doll; mother-of-pearl buckles; cloth tape measure; wrapped packages; crocheted collar of silver thread; art nouveau purse mirror.

10. Photograph of Mrs. Fannie H. Eldredge, and text of her letter to Concettina and postcard to Nina; photograph of Concettina and Nina in Lapio, 1922–24.

11. *Gold Reliquary* containing Mrs. Eldredge's spoons, with note explaining their history.

12. Mrs. Eldredge's postcard to Nina for her eighth birthday, August 15, 1925.

13. *Eufrasia's Clothesline* in the room, *Becoming American,* with Nina's dress designs, *Following the Thread* video and *Column of History V.*

14. *Ancestor Scroll: Eufrasia De Iorio (Zizi)* (Silk, acetate, wood, photo; 72" x 60" x 3").

15. *Ancestor Scroll: Adolfo Anzalone (Zio)* (Silk, acetate, wood, photo; 72" x 60" x 3").

16. Farfariello with the words of one of the songs he co-wrote in 1910, *"Lu cafone che ragiona"* ("The peasant who reasons"). Photographs courtesy of: Center for Migration Studies.

17. "Molare" (Monte Sant Angelo in the Gargano region); photo by Francesco Raffaele.

18. Passport with photo of Concettina and Nina; Nina and Nonno Luigi; photo of Nina in Lapio with unidentified woman; family picnic; Concettina in Lapio; Eufrasia and Adolfo's marriage.

19. Nina's Autobiography describing her birth in New York and return to Boston. She was born Giovannina Assunta Esperanza Piscopo; her childhood watercolor of girls jumping rope.

20. *Column of History V: Second Generation* (Tin, photo, copper, plexiglas; 93" x 24" x 2"). Photographs courtesy of: New York Public Library; *The Boston Globe; The Nation.*

21. Sacco and Vanzetti; funeral procession in Boston. Photographs courtesy of: New York Public Library; *The Boston Globe.*

22. Excerpts from Nina's diary in which she writes of constant conflict with Concettina around such issues as telephone use and going out after dinner; photo of Nina smoking, which was also against Concettina's mores.

23. *Following the Thread VIII: Nina Piscopo* (Copper, wood, photo, fabric, thread; 24" x 48" x 3").

24. Nina's art materials. Whenever she had to select illustrations for projects, Nina would often choose art of Italian origin, such as this watercolor she painted from the House of the Vettii in Pompeii; block print showing oriental influence.

25. *Column of History VI: Opportunities* (Tin, copper, photo, plexiglas; 93" x 24" x 2"). Photographs courtesy of: Center for Migration Studies.

26. Stages of Nina's growing up.

27. Nina's 1939 Yearbook entry, when she graduated from Massachusetts College of Art.

28. Cover and text of Nina's graduating portfolio, *The Art of Lounging.*

29. Newspaper clipping: *"Students put finishing touches on an evening gown. Left to right are Susan Morrissey of Brookline and Nina Piscopo of Orient Heights."* Boston Herald, February 11, 1940.

30. Nina's application for Annual Award of Honor.

31. Nina's designs from *The Art of Lounging.*

32. *The Art of Lounging:* Nina's dress design with angelfish as inspiration; description of hostess robe; sample fabrics.

33. Nina at the Institute.

34. *Following the Thread IX: Nina D'Amore* (Copper, wood, photo, fabric, thread; 24" x 48" x 3").

35. *De Iorio Triptych: Family Stories* (closed) (Wood, tin, photo, mixed media, family artifacts; 41" x 36" x 10").

36. *De Iorio Triptych: Family Stories* (open) (Wood, tin, photo, mixed media, family artifacts; 41" x 72" x 10").

37. *De Iorio Triptych: Family Stories* (center) (Wood, tin, photo, mixed media, family artifacts; 41" x 36" x 10").

38. Italian bronze oil lamp (nineteenth century); Don Lorenzo's weights and measures; porcelain doll.

39. Concettina's wedding handkerchief; her silver good luck charms; inscribed book from the De Iorio Library (1858); silver hat pins, traveling alcohol stove; silver whisk broom; Concettina's pink satin shoe with handmade rosette; souvenir champagne cork from her first granddaughter's birth (1942); note to herself: *"October 14, 1974, Mrs. Concettina C. Piscopo was 90 years old!"*

40. Triptych details of Concettina's personal treasures: Silk painting of the Sacred Heart; silk embroidery threads; favorite trinket box with porcelain doll; wedding handkerchief; tortoise shell hair comb; beads for stringing; leather favor from Piscopo and Frederick's restaurant; base of antique oil lamp.

41. Detail of family stories on door of Triptych.

4. La Famiglia and Work

1. *La Famiglia and Work:* Overview of the fourth room in Ellis Island exhibit.

2. Antonio's ship's manifest and shipping papers.

3. *Column of History VII: Beginnings* (Tin, copper, photo, plexiglas; 93" x 24" x 2"). Photographs courtesy of: the Balch Institute; Italian Academy, Columbia University; Center for Migration Studies.

4. Derogatory sheet music cover with "Itaglish." Photograph courtesy of: The Balch Institute Collections, the Historical Society of Pennsylvania.

5. Pick-and-shovel worker. Photograph courtesy of: Center for Migration Studies.

6. *Reliquary to the Two Anthonys:* Antonio's pickaxe and a portion of a winemaking cask with residue still attached. His son Anthony's *Book of Knowledge Encyclopedia* is part of the lower half.

7. *Ancestor Scroll: Antonio D'Amore (Papa Nonno)* (Silk, acetate, wood, photo; 72" x 60" x 3").

8. Detail of Italian carving shed; the Gustavino ceiling at Ellis Island; Italian American monument, Barre, Vermont, carved by Philip Paini from model by Giuliano Cecchinelli. Photographs courtesy of Center for Migration Studies; B. Amore.

9. *Ancestor Scroll: Maria Grazia Catalano (Nonni D'Amore)* (Silk, acetate, wood, photo; 72" x 60" x 3").

10. Tenement Room, 1910. Photograph courtesy of: Jacob Riis/Museum of the City of New York.

11. *Following the Thread X: Antonio and Maria Grazia* (Copper, wood, photo, fabric, thread; 24" x 48" x 3").

12. Tony at Caddy Camp; Maria Grazia with Dolly; group of cousins.

13. Caddy Camp Newsletter's 50th anniversary. Caddy Camp was founded in 1915 in order to encourage self-sufficiency in young men and to teach them the skill of caddying for golfers.

14. *Following the Thread XI: D'Amore Family* (Copper, wood, photo, fabric, thread; 24" x 48" x 3").

15. Tony at Maryknoll Seminary and graduating from Boston College in 1936.

16. Tony's yearbook entry, which shows his serious attitude toward study as well as his sense of humor. Boston College was primarily an Irish-Catholic University at the time, and Tony was one of the few Italian American students.

17. *Tony's Writing Installation:* Philosophy books of Plato, Socrates and *Aeneid;* bust of Caesar; World War II letter; portable typewriter, which was taken to Italy and back several times; letters between Tony and his eldest daughter written on the same typewriter.

18. *Following the Thread XII: Tony D'Amore* (Copper, wood, photo, fabric, thread; 24" x 48" x 3").

19. Various government forms from the Library of Congress listing Tony's qualifications, including his study of Chinese and Japanese, as well as his abilities in French, Spanish and Italian. He was employed at the Library of Congress from September 15, 1941 until he enlisted in the U.S. Army on December 30, 1943.

20. Three of the D'Amore brothers: Phil, Adolph and Tony; Antonio with his grandchildren; the Atlas Cleaners truck.

21. Mike D'Amore in the Atlas Dry Cleaners shop.

22. *Column of History VIII: La Famiglia* (Tin, photo, copper, plexiglas; 93" x 24" x 2"). Photographs courtesy of: Jacob Riis/Museum of the City of New York; Center for Migration Studies.

23. Letter issued by the U.S. Civil Service Commission, in August 1939, acknowledging proof of Concettina's citizenship.

24. Newspaper photo of Concettina with purchase of $2,000 War Bond, dated July 1945.

25. The four D'Amore boys in uniform.

26. Alien Enemy Registration Card of Pietrina Raccuglia, who had a son serving in the U.S. Armed Forces at the time it was issued. She was so upset that her loyalty be questioned that she decided never to become a U.S. citizen. Photograph courtesy of: Pietrina Raccuglia.

27. Partial text of war letter from Tony to Nina.

28. Muddied envelope containing a letter written by Tony to his wife, Nina, from New Guinea, where he was stationed during World War II. It had been sent to her via a third person, since the original had been so damaged as to be unmailable; part of the text of the letter.

29. *D'Amore Triptych: Family Stories* (closed) (Wood, tin, photo, mixed media, family artifacts; 41" x 36" x 10").

30. *D'Amore Triptych: Family Stories* (open) (Wood, tin, photo, mixed media, family artifacts; 41" x 72" x 10").

31. *D'Amore Triptych: Family Stories* (center) (Wood, tin, photo, mixed media, family artifacts; 41" x 36" x 10").

32. Tony's prayerbook from the seminary; souvenir buffalo nickel; brass ravioli cutter; shaving brush; Italian basket; cookie cutter; Antonio's work lantern; Bakelite bracelets; etc.

33. Detail of family stories on door of triptych.

34. Caffettiera Napoletana; Tony's pass from the Library of Congress, signed by poet Archibald McLeish; travelling chess kit; playing cards; *tegamino*.

35. *Polishing the Mirror of Seven Generations;* Panels 1–4.

5. Return to the Roots: Yesterday and Today

1. *Return to the Roots:* Overview of fifth room in Ellis Island exhibit, with two reliquaries.

2. Engagement of Tony and Nina, October 14, 1940.

3. Tony and Nina at the start of their life journey.

4. *Tony and Nina Triptych: Family Stories* (open) (Wood, photo, mixed media; 22" x 39" x 3").

5. Tony and Nina's marriage, December 28, 1941.

6. Urban *paese* from Naples newspaper, *IL MATTINO del Sabato*, November 25, 1983.

7. Urban *paese* "…a metropolitan village is invented," from *IL MATTINO del Sabato*.

8. *Column of History IX: The Ties, Italy/America* (Tin, photo, copper, plexiglas; 93" x 24" x 2).

9. Annual *Giglio* Feast in Williamsburg, Brooklyn, in honor of Saint Paulinus of Nola. The ceremonial tower, made of painted *papier maiché* over an aluminum core, is "danced" through the streets on the shoulders of 125 dedicated and able-bodied men called "lifters." Photograph courtesy of: Center for Migration Studies.

10. *Following the Thread XIII: Aunts, Uncles, Cousins* (Copper, wood, photo, fabric, thread; 24" x 48" x 3").

11. Close-up of *New York Times Magazine* cover, May 15, 1983. Photograph courtesy of: *The New York Times*.

12. *Polishing the Mirror of Seven Generations:* Panels 5–8.

13. *Column of History X: The Ties, America/Italy* (Tin, photo, copper, plexiglas; 93" x 24" x 2). Photographs courtesy of: *The New York Times;* Italian Academy, Columbia University; Casa Italiana Zarilli Marimó, New York University.

14. Marie and Luisa D'Amore on one of their frequent trips to Italy.

15. Luisa D'Amore, who married Nino Benevento, with "the Italian Cousins" in Venice.

16. Cousins and friends.

17. Cousins and friends.

18. *Following the Thread XIV: Italian Family* (Copper, wood, photo, fabric, thread; 24" x 48" x 3").

19. With permission of Dominic Suraci Keating, Avanti Cigar Co, Scranton, Pennsylvania.

20. Concettina's granddaughter, B. Amore, carving marble in Studio Nicoli, Carrara, Italy, 1981.

21. *Libretto d'iscrizione* 1967, Università di Roma, B. Amore (neé Bernadette D'Amore), 1961.

22. School papers of Tiffany Lawrence from her year of study in Carrara, 1982–83, during her mother's Fulbright year in Italy.

23. Photo taken by Concettina's granddaughter in Lapio in 1961, which served as an inspiration for the *Odyssey* installation created in 1998.

24. *Odyssey* (Trentino marble, fabric, mixed media, family artifacts; each 72" x 16" x 18").

25. *Odyssey* Installation (Trentino marble, fabric, mixed media, family artifacts; each 72" x 16" x 18").

26. *Odyssey Personnages* (Trentino marble, fabric, mixed media, family artifacts; each 72" x 16" x 18").

27. *Reliquary: Grandmother's Bundles,* with Concettina's fabric and dresses saved from her sewing projects and her notes written in Italian and English.

28. Concettina's notes describing contents of bundles. Note her thriftiness in planning to repair and refit various dresses.

29. *Ancestor Scroll: Catalano,* with *Odyssey Personage* in foreground (Silk, acetate, wood, photo; 72" x 60" x 3").

30. *Ancestor Scroll: Luisella Guarino (Luigia Garino),* with Reliquary in foreground (Silk, acetate, wood, photo; 72" x 60" x 3").

31. Example of Nina's correspondence from Italy to her family in America when she returned to settle the family property in 1956; Concettina's granddaughter, Bernadette, on her first trip to Italy, at nineteen; with Compare Gennarino and Comare Iolanda; Concettina at age seventy-four in Saint Mark's Square, Venice.

32. *De Iorio Closet Installation:* Ornate nineteenth-century clock and case from the De Iorio family home.

33. Statue of San Lorenzo.

34. Letter from Dr. Salvatore Rinaldi, a close friend of the D'Amore family, to Nina's daughter when she was thirteen; Salvatore's hand with magnifying loupe forty-four years later, helping with the translation of the *Diario;* Maria Mauriello D'Amore making tomato sauce with her family; the Italian Line vessel, *Cristoforo Colombo,* which carried members of the D'Amore family to and from Italy.

35. Artifacts from Montefalcione: Photographs of boxes of bones from cemetery vaults; fireworks on the facade of the main church, *Saint Anthony.*

36. *Montefalcione-Lapio Closet Installation:* Nina's Italian costume, which she wore at the International Institute; handmade copper cooking utensils brought from Lapio in 1901; an old window from Montefalcione found in 2000; traditional *tarallo* baked by Michelina Guarino in Montefalcione for Easter 2000.

37. Sewing machine bought for Luigina Pedroni Albertini by her father on the day of her birth.

38. *Montefalcione-Lapio Closet Installation* (left to right): Piscopo family plate from 1908, Nina's childhood dolls, *An Evening at Nonna's* cookbook; processions in Montefalcione honoring Saint Anthony, patron saint of the *paese;* traditional mortar made in Lapio, 1996.

39. The traditional *pizza chiena,* Easter pie, which begins as a circle of flour and eggs.

40. Ron D'Amore's hands preparing the dough for the *pizza chiena*.

41. Cover of An *Evening at Nonna's*, compiled, printed and hand-bound by her grandson Clare Sean De Iorio Lawrence.

42. Dedication and title pages in *An Evening at Nonna's*.

43. The Delorio family land in Lapio, with *Monte Chiusano* in the background; Nina showing her granddaughter, Larisa, where she used to play; Benevento cousins and *Compare* Gennarino in the *Giardino;* Tiffany with playmate, Rita (Maruzzella's daughter), in Lapio.

44. Vito, the tenant-farmer, and his grandson, also called Vito; Concettina's great-grandchild, Andrea, in Lapio, 2000, almost 100 years since the De Iorio family left.

45. *Following the Thread XV: Past, Present, Future* (Copper, wood, photo, fabric, thread; 24" x 48" x 3").

5. Today and Tomorrow

1. *Today and Tomorrow:* Partial overview of sixth room in Ellis Island exhibit. *Nonna's Table* installation in which visitors were encouraged to write their own memories and comments. It became a center of poetry readings and performances during the exhibit.

2. *Altarpiece* (Tin, wood, stone, silk, photo; 72" x 180" x 60").

3. *Altarpiece* and details, text of Journal writings. Photographs courtesy of: Center for Migration Studies/T.J. Marino.

4. *Altarpiece* detail. Photographs courtesy of: Center for Migration Studies/T.J. Marino.

5. Television installation with *Thread of Life* video.

6. *Polishing the Mirror of Seven Generations:* Panels 9–10.

7. *Polishing the Mirror of Seven Generations:* Panels and text from the *Libro di Memorie,* with translations; Susan D'Amore Benevento researching family lineage in Montefalcione.

8. *Polishing the Mirror* panels; images of Lapio; Luigi De Iorio (below right); Clare Sean De Iorio Lawrence (above right).

9. Young Nina.

10. *"Looking Forward, Looking Back":* Larisa, Concettina's great-granddaughter, wearing a dress sewn and worn by Concettina seventy-five years before. The garden was cultivated by Nina, Concettina's daughter, and Tony D'Amore, her husband.

11. *L'Arco della Memoria* - The Donors' Arch.

Bibliography

Albright, Carol Bonomo *et al. Italian Americana.* Vol. XVIII, No. 2 of *Cultural and Historical Review.* University of Rhode Island, Feinstein College of Continuing Education, 2000.

Alland Sr., Alexander. *Jacob A. Riis: Photographer & Citizen.* New York: Aperture, 1993.

Allen, Leslie. *Liberty: The Statue and the American Dream.* New York: The Statue of Liberty-Ellis Island Foundation, Summit Books, 1985.

America & Lewis Hine. Produced by Nina Rosenblum and Daniel V. Allentuck, Directed by Nina Rosenblum. 60 min. New Video Group, 1996. Videocassette.

Amore, B. *Life line Project, 2000-2006*

Amore, B. *Following the Thread.* Produced by B. Amore and Madeleine Dorsey, Directed by B. Amore. 30 min., 2000. Videocassette.

Amore, B. *The Thread of Life in One Italian American Family.* Produced by B. Amore and Larisa Lawrence, Directed by B. Amore. 45 min. Hnatio Productions, 2000. Videocassette.

Barolini, Helen. *Umbertina.* New York: The Feminist Press at The City University of New York, 1999.

Bertini, Tullio Bruno. *Trapped in Tuscany Liberated by the Buffalo Soldiers: The True World War II Story of Tullio Bruno Bertini.* Boston: Dante University Press, 1998.

Bevilacqua, Piero *et al.,* eds. *Storia Dell'Emigrazione Italiana: Partenze.* Roma, Donzelli Editore, 2001.

Bevilacqua, Piero *et al.,* eds. *Storia Dell'Emigrazione Italiana: Arrivi.* Roma, Donzelli Editore, 2002.

Bierman, Carol. *Journey to Ellis Island: How My Father Came to America.* New York: Hyperion/Madison Press, 1998.

Bonaffini, Luigi. *Dialect Poetry of Southern Italy.* New York, Toronto: Legas, 1997.

Bond, L.E. *Statue of Liberty: Beacon of Promise.* Millennium ed. Santa Barbara: Albion Publishing Group, 2000.

Buroni, Dena Ciaramicoli. "Mondavio, Italy." Interview by Janet Levine. *Ellis Island Interview 181: Statue of Liberty Ellis Island Oral History Project.* June 24, 1992.

Calabrese, Dominica (Sunday Wood). "Comparni, Italy." Interview by Janet Levine. *Ellis Island Interview 130: Statue of Liberty Ellis Island Oral History Project.* March 25, 1992.

Carbone, Cesare. *Lapio: una terra, la sua storia, il suo costume.* Anno, 2002.

Ciongoli, A. Kenneth and Jay Parini, eds., *Beyond the Godfather: Italian American Writers on the Real Italian American Experience.* University Press of New England, 1997.

Coan, Peter Morton. *Ellis Island Interviews: In Their Own Words.* New York: Facts on File, 1997.

Cohen, Miriam. *Workshop to Office: Two Generations of Italian Women in New York City, 1900–1950.* New York: Cornell University Press, 1992.

D'Acierno, Pellegrino, eds. *The Italian American Heritage: A Companion to Literature and Arts.* Garland Reference Library of the Humanities; vol. 1473. New York: Garland Publishing, Inc., 1999.

D'Amore, Mario. *Montefalcione: Ieri E Oggi 1946–1996,* 1996.

D'Angelo, Pascal. *Son of Italy* Guernica, 2003.

D'Angelo, Pascal. *Son of Italy.* Edizioni: Il Grappolo, 2000.

De Iorio, Lorenzo. *Libro di Memorie.* Unpublished manuscript. Lapio, 1896.

Del Duca, Nino. *Il stongo 'e casa 'America.* Lettere Italiane Guida, 2005.

De Salvo, Louise. *Vertigo: A Memoir.* Dutton: Penguin Group Publishing, 1996.

di Donato, Pietro di. *Christ in Concrete.* Signet Classic: Penguin Group Publishing, 1993.

DiStasi, Lawrence, ed. *The Big Book of Italian American Culture* (formerly titled *Dream Streets*). Berkeley: Sanniti Publications, 1996.

Dukakis, Michael S. *"A Proclamation" Sacco and Vanzetti Project,* July 19, 1977. <http://www.saccovanzettiproject.org/pages/context/dukakis.htm>

Duggan, Christopher. *A Concise History of Italy.* Cambridge University Press, 1994.

Ellis Island. Produced and Directed by Lisa Bourgoujian. 3 videos, 50 min. each. The History Channel/A&E/New Video Group, 1997. Videocassette.

Ferraro, Geraldine A. and Catherine Whitney. *Framing A Life: A Family Memoir.* Scribner: Simon & Schuster Inc., 1998.

Gambino, Richard. *Blood of My Blood: the Dilemma of the Italian Americans.* 2nd ed. Toronto: Guernica Editions Inc., 2000.

Gardaphé, Fred L. *et al.,* eds. *Voices in Italian Americana.* Vol.II, No. 2 of *A Literary and Cultural Review.* Bordighera Incorporated, 2000.

Gillian, Maria Mazziotti and Jennifer Gillian, eds. *Growing Up Ethnic in America: Contemporary Fiction About Learning to Be American.* New York: Penguin Group Publishing, 1999.

Gillian, Maria Mazziotti and Jennifer Gillian, eds. *Identity Lessons: Contemporary Writing About Learning to Be American.* New York: Penguin Group, 1999.

Giunta, Edvige. *Writing with an Accent: Contemporary Italian American Women Authors.* New York: Palgrave, 2002.

Jennifer Guglielmo. "Italian American Women's Political Activism in New York City 1890's–1940's." In *The Italians of New York: Five Centuries of Struggle and Achievement,* edited by Philip V. Cannistraro. The New York Historical Society, 1999.

Gumina, Deanna Paoli. *The Italians of San Francisco 1850–1930.* 3rd ed. New York: Center for Migration Studies, 1999.

Handlin, Oscar. *Boston's Immigrants 1790–1880: A Study in Acculturation.* Revised ed. Cambridge: The Belknap Press of Harvard University Press, 1991.

Harrison, Barbera Grizzuti. *The Astonishing World: Essays.* New York: Ticknor & Fields, 1992.

Haycraft, John. *Italian Labyrinth.* Penguin Group Publishing, 1987.

Hoobler, Thomas and Dorothy. *The Italian American Family Album.* New York: Oxford University Press, 1994.

Island of Hope, Island of Tears: The Story of Ellis Island and the American Immigration Experience. Produced by Charles Guggenheim. Approx. 30 min. Guggenheim Productions Inc. Videocassette.

Italians in America. Produced by Craig Haffner and Donna E. Lusitana. Directed by Laura Verklan. 2 videos, 50 min. each. The History Channel/A&E/New Video, 1998. Videocassette.

Jones, Susan, ed. *Ellis Island: Echoes from a Nation's Past.* 3rd printing. New York: Aperture, 1997.

La Gumina, Salvatore J. *et al.,* eds. *The Italian American Experience: An Encyclopedia.* Garland Reference Library of the Humanities vol. 1535. New York: Garland Publishing, Inc., 2000.

Lamont, Michael. "Italian American Autobiographies," In *Italian Americana*. Vol. XVIII, No. 2 of *Cultural and Historical Review,* ed. Maria Parrino. University of Rhode Island, Feinstein College of Continuing Education, (2000):50.

La Sorte, Michael. *La Merica: Images of Italian Greenhorn Experience.* Philadelphia: Temple University Press, 1985.

Laurino, Maria. *Were You Always an Italian?: Ancestors and Other Icons of Italian America.* New York: W.W. Norton & Company, 2000.

Lawrence, C. Sean. *An Evening at Nonna's: Recipes of Nina D'Amore.* Tokyo, Japan: Mantis Press, 2000.

Lorenzino, Ettore. Anduins, "Udine." Interview by Debra Heid. *Ellis Island Interview 162: Statue of Liberty Ellis Island Oral History Project.* May 26, 1992.

Maccarone, Renata Nieri, Northern Italy. Interview by Janet Levine, *Ellis Island Interview 194: Statue of Liberty Ellis Island Oral History Project*, July 20, 1992.

McLaughlin, Virginia Yans and Marjorie Lightman. *Ellis Island and the Peopling of America: The Official Guide.* New York: The New Press, 1997.

Mangione, Jerre and Ben Morreale. *La Storia: Five Centuries of the Italian American Experience.* Harper Collins Publishers, 1993.

Mannino, Mary Ann Vigilante. *Revisionary Identities: Strategies of Empowerment in the Writing of Italian/American Women.* New York: Peter Lang Publishing, 2000.

Marcello, Leo Luke. *Nothing Grows in One Place Forever: Poems of a Sicilian American.* St. Louis, Missouri: Time Being Books, 1998.

Marchi, Cesare. *Quando Eravamo Povera Gente.* Nona ed. Biblioteca Universale Rizzoli, Superbur Saggi, 1999.

Marchione, William P. *Images of America: Italian Americans of Greater Boston, A Proud Tradition.* Charleston, Arcadia Publishing, 1999.

Marotta, Kenny. *A House on the Piazza.* Toronto: Guernica, 1998.

Martucci, Carmine. "Province of Bari." Interview by Paul Sigrist, *Ellis Island Interview 148: Statue of Liberty Ellis Island Oral History Project.* May 8, 1992.

Miller, Natalie. *The Statue of Liberty.* 2nd ed. Connecticut: Children's Press, 1992.

Misturini, Nelson. "Cremona, Italy." Interview by Janet Levine. *Ellis Island Interview 192: Statue of Liberty Ellis Island Oral History Project.* July 19, 1992.

Molinari, Mary Sartori. "Northern Italy." Interview by Paul E. Sigrist, Jr. *Ellis Island Interview 170: Statue of Liberty Ellis Island Oral History Project.* June 12, 1992.

Montanelli, Indro. *L'Italia Del Risorgimento 1831-1861.* sesta ed. Biblioteca Universale Rizzoli, Superbur Saggi, 2001.

Notini, Marjorie (Maggiorana) "Corsi. Capestrano, Abbruzzi." Interview by Janet Levine. *Ellis Island Interview 206: Statue of Liberty Ellis Island Oral History Project.* September 1, 1992.

Orsi, Robert Anthony. *The Madonna of 115th Street: Faith and Community in Italian Harlem, 1880–1950.* Yale University Press, 1985.

Parrino, Maria, ed. *Italian American Autobiographies.* Rhode Island: Italian American Publications/University of Rhode Island, 1993.

Perec, Georges, with Robert Bober. *Ellis Island.* Trans. Harry Mathews and Jessica Blatt. New York: The New Press, 1995.

Puzo, Mario. *The Fortunate Pilgrim.* New York: Fawcett Columbine Book, The Ballantine Publishing Group, 1998.

Reeves, Pamela. *Ellis Island: Gateway to the American Dream.* New York: Crescent Books, 1993.

Riccio, Anthony V. *Portrait of an Italian American Neighborhood: The North End of Boston.* New York: Center for Migration Studies, 1998.

Riis, Jacob A. *How the Other Half Lives: Studies Among the Tenements of New York.* New York: Dover Publications, Inc., 1971.

Salto, Felicita Gabaccia. "Masserano, Italy." *Interview by Janet Levine. Ellis Island Interview 56: Statue of Liberty Ellis Island Oral History Project.* July 19, 1991.

Sammarco, Anthony Mitchell. *Images of America: East Boston.* Reprinted. Charleston: Arcadia, 2001.

Sensi-Isolani, Paola and Phylis Cancilla Martinelli, eds. *Struggle and Success: An Anthology of the Italian Immigrant Experience in California.* New York: Center for Migration Studies, 1993.

Stave, Bruce M. and John F. Sutherland with Aldo Salerno. *From the Old Country: An Oral History of European Migration to America.* New York: Twayne Publishers, 1994.

Stolfi, Emanuele. *Italiani nel Mondo.* Milano: Mondadori, 2003.

Talese, Gay. *Unto the Sons.* New York: Ivy Books, 1992.

Tamburri, Anthony Julian *et al.,* eds. *From the Margin: Writings in Italian America.* Revised ed. Indiana: Purdue University Press, 2000.

The Italian Americans. Produced by Roy Hammond. Approx 90 min. WLIW21 Public Television, 1997. Videocassette.

The Italian Americans II: A Beautiful Song. Produced by Roy Hammond *et al.* Approx 90 min. WLIW21 New York, 1998. Videocassette.

Tomasi, Silvano M. *et al. Images: A Pictorial History of Italian Americans.* 2nd ed. New York: Center of Migration Studies, Inc. 1986.

Tomasi, Archbishop Silvano M. ed. *For the Love of Immigrants: Migration Writings and Letters of Bishop John Baptist Scalabrini 1839–1905.* New York: Center for Migration Studies, 2000.

Tomasi, Mari. *Like Lesser Gods.* 2nd printing. Vermont: The New England Press, 1999.

Tusiano, Joseph. "Gargano" (poem translated by Luigi Bonaffini). *Dialect Poetry of Southern Italy.* New York, Toronto: Legas, 1997.

Vanzetti, Bartolomeo. *The Story of a Proletarian Life.* Boston: New Trial League, 1923.

Viscusi, Robert. *Astoria.* 2nd printing. Toronto: Guernica, 1996.

Weatherford, Doris. *Foreign and Female: Immigrant Women in America 1840–1930.* Revised ed. New York: Facts on File, Inc., 1995.

Wells, H.G. *The Future in America: A Search After Realities.* Granville Pub. 1906–1987.

Whyte, William Foote. *Street Corner Society: The Social Structure of an Italian Slum.* 4th ed. Chicago: The University of Chicago Press, 1993.

Willitts, Elda Del Bino. "Lucca, Florence." Interview by Paul E. Sigrist, Jr. *Ellis Island Interview 8: Statue of Liberty Ellis Island Oral History Project.* November 5, 1990, April 30, 1999, May 1, 1999.

Zambrano, Madeline (Madallena) Polignano. "Putignano, Bari." Interview by Paul E. Sigrist, Jr. *Ellis Island Interview 76: Statue of Liberty Ellis Island Oral History Project,* August 27, 1991.

Index